RAILROADS OF NEVADA

VOLUME II

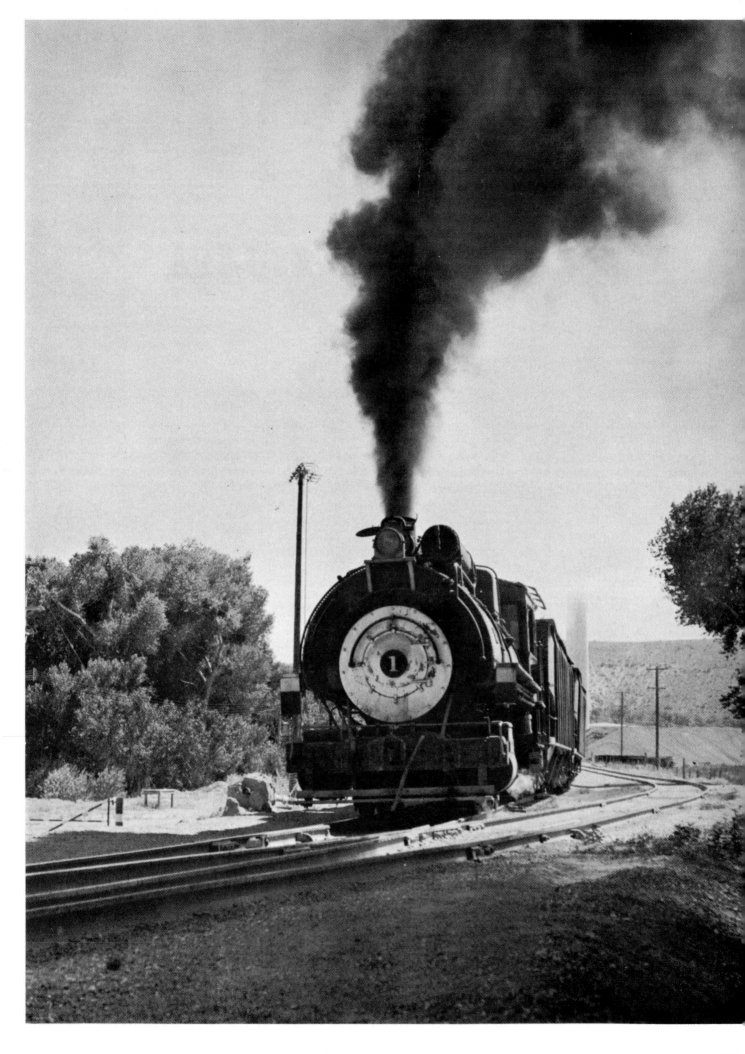

RAILROADS OF NEVADA
AND EASTERN CALIFORNIA

Volume II,
The Southern Roads

DAVID F. MYRICK

University of Nevada Press
Reno Las Vegas London

Railroads of Nevada and Eastern California by David F. Myrick: Volume I was originally published by Howell-North Books of Berkeley, California, in 1962; it was reprinted by Howell North Books of San Diego, California, in 1980; the University of Nevada Press edition reproduces the original except for changes to the front matter, which has been modified to reflect the new publisher, and the addition of a new preface by the author. Volume II was originally published by Howell-North Books of Berkeley, California, in 1963; the University of Nevada Press edition reproduces the original except for changes to the front matter, which has been modified to reflect the new publisher, and to the Roster of Locomotives at the back of the book, which was updated by the author. In both volumes, minor corrections to the text have been made throughout and newly designed dust jackets have been provided; the folding map included in Howell-North's original edition has been reduced in size and now appears as an endsheet in each volume.

Library of Congress Cataloging-in-Publication Data
Myrick, David F.
 Railroads of Nevada and eastern California / David F. Myrick.
 p. cm.
 Reprint, with revisions. Originally published:
Berkeley, Calif. : Howell-North Books. 1962–1963.
 Includes index.
 Contents: v. 1. The northern roads — v. 2. The southern roads.
 ISBN 0-87417-195-4 (set : alk. paper) —
 ISBN 0-87417-193-8 (vol. 1 : alk. paper) —
 ISBN 0-87417-194-6 (vol. 2 : alk. paper)
 1. Railroads—Nevada—History. 2. Railroads—California—History.
 I. Title.
HE2771.N3M9 1992
385'.06'5793—dc20 92-21672
 CIP

University of Nevada Press, Reno, Nevada 89557 USA

Jacket design by Ann Lowe

Printed in the United States of America
9 8 7 6 5 4 3 2

Frontispiece: Low slung and smoky, yet powerful for the job—Mojave Northern No. 1. (Southwestern Portland Cement Co.)

CONTENTS

PREFACE *ix*

ACKNOWLEDGMENTS *xi*

LAS VEGAS AND TONOPAH RAILROAD 455

The Gold Roads — Discovery of gold at Bullfrog, 1904 — Montgomery-Shoshone mine — Founding of Rhyolite — Senator Clark's early survey — Borax Smith incorporates Tonopah & Tidewater, starts work at Las Vegas — Discouraged by Clark, Smith sells out and moves to Ludlow — Life in Rhyolite — J. Ross Clark begins construction of LV&T at Las Vegas — First train to Indian Springs — LV&T obtains right of way through Gold Center, Beatty and Rhyolite — Mining and town lot excitement — Transvaal — First train to Gold Center — Celebration at Beatty — Tracks reach Rhyolite — Construction to Goldfield — Goldfield banking situation — Passenger service — Operating problems — Abandonment and sale of Beatty-Goldfield line to Bullfrog Goldfield R.R.— U. S. Railroad Administration — Final abandonment in 1918.

BULLFROG GOLDFIELD RAILROAD 504

Purpose of railroad — Bullfrog Syndicate financing problems — Construction begins — Doubt as to exact point of beginning — Delays in construction — Completed to Beatty — Celebration — Pushed on to Rhyolite — Conditions at Rhyolite — Springdale mail order bride — Pioneer — Operating and financial difficulties — T&T takes over — Purchases part of LV&T from Goldfield to Beatty — Rhyolite branch abandoned — Threatened abandonment of entire line in 1919 — T&T agrees to operate BG RR — Second fire at Goldfield — Traffic continues to shrink — Entire line abandoned in 1928.

LIDA VALLEY RAILROAD 536

Naming of Lida — Proposed railroads to Lida and Hornsilver (Gold Point) — Lida Valley Railroad incorporated and surveyed — Project abandoned before grading began.

BONNIE CLAIRE AND UBEHEBE 539

Mines at nearby Gold Mountain — Proposed railroads to Gold Mountain — Short branch built by LV&T — Ubehebe Mining District — Proposed railroad of Ubehebe Copper Mines & Smelter Company — Panic of 1907 halts project — Bonnie Clare and Gold Mountain Railroad incorporated but no construction takes place.

TONOPAH AND TIDEWATER RAILROAD 544

Terrors of Death Valley — Early borax mining — Borax Smith acquires Lila C. mine — Pacific Coast Borax Company formed — Unsuccessful traction engine — T&T incorporated — Work begins at Las Vegas on railroad to Lila C. — After difficulties with Clark, Smith moves to Ludlow to begin again — Rails reach Silver Lake — Stage to Crackerjack — Year required to build the 12 miles through Amargosa Canyon — Trains operate to Sperry, then Tecopa, later Zabriskie — Construction ends when rails reach Gold Center — Trackage rights to Rhyolite over BG RR — Dismal financial picture — Takes over operation of BG RR — Life and times at Ludlow and along the railroad — Lila C. Railroad — Borax mines shut down at Ryan, traffic reduced — Abandonment Ludlow-Crucero — Entire abandonment, 1940 — Rails removed, 1942-43.

TECOPA RAILROAD COMPANY 593

Early mining activity at Resting Springs — Gunsight and Noonday mines acquired by Tecopa Consolidated Mining Company — Tecopa Railroad built — Mine and railroad become dormant — Tracks removed.

GREENWATER 597

Greenwater copper mine promotion — Early prospecting and development — Transportation routes to Greenwater — Proposed railroads to Greenwater — Collapse of Greenwater boom and desertion of the camp.

AMERICAN CARRARA MARBLE COMPANY 604

Opening of marble quarry — Carrara Townsite Day — Cable railroad built — Electric service halted — Quarry closed.

DEATH VALLEY RAILROAD 608

Exhaustion of Lila C. at (old) Ryan — Operations moved to Biddy McCarty mine at (new) Ryan — T&T denied authority for extension — Death Valley Railroad formed — Narrow gauge railroad built — Baby Gauge Railroad operates to Widow mine — Extension built to clay pits at Ash Meadows — Discovery of borax at Boron — Subsequent development at Boron and shutting down Ryan.

THE SALT LAKE ROUTE 622

Early Union Pacific plans to build from Salt Lake City to Southern California — UP subsidiary grades line from Milford to Pioche in 1890 — Rail laying halted after a few miles — Project abandoned with Panic of 1893 — Utah and Pacific formed, builds from Milford to Uvada in 1899 — Senator Clark buys Los Angeles Terminal Ry. as nucleus of railroad to Salt Lake City — Clark forms San Pedro, Los Angeles and Salt Lake RR (Salt Lake Route) — Harriman of Union Pacific opposes Clark's plans — Clark-Harriman War, April 1901 — Litigation between both parties — Both forces grading railroad — Work halted, unannounced truce followed by negotiations — Clark sells half interest to UP — Work resumed on east and west sections after 19 months of inactivity — Early Las Vegas — Rails joined and line opened — Location of meeting of rails — Washouts: 1905; in Meadow Valley 1906, 1907, 1910 — Line reopened June 1910 after nearly six months — High Line built, 1912 — St. Thomas branch — UP acquires full ownership — Oil found on Terminal Island.

PIOCHE AND ITS RAILROADS 684

Early mineral discoveries — Pioche founded — Mining boom — Life in Pioche — Railroads to outside world projected — Description of Bullionville — Pioche and Bullionville (Central Nevada-Nevada Central) constructed — Slump in mining — Railroad abandoned — Pioche Pacific Transportation Company (Jackrabbit Railroad) built to Royal City (Jackrabbit) — Revival of mining at Pioche, followed by dull times — Delamar (708) — Discovery — Various names: Monkey Wrench, Ferguson, Helene, etc. — Mining development and production — Mines sold to Capt. De Lamar, resold to Bamberger — End of mining at Delamar — Caliente & Pioche RR (UP) builds to Pioche (713) — Prince Consolidated RR built to Prince Mine — Difficult times at Pioche and Bristol — Prince Mine — Virginia Louise litigation — Gemmill & Squires take over Prince Mine — Combined Metals, Inc. (E. H. Snyder) operates mines at Pioche — Pioche Mines Company — Bristol Silver Mines Company acquires Jackrabbit branch of Pioche Pacific — Slowdown with depression of early 1930's — Mines reopened at Pioche, Prince and Bristol — Attempts to abandon Hill Line of Pioche Pacific finally realized — Development of Caselton Shaft — UP rehabilitates Prince RR — Caselton Mill built — Jackrabbit branch abandoned — Situation since 1957.

SIX COMPANIES, INC. 734

Colorado River overflows its banks — U. S. Bureau of Reclamation studies dam sites along river — Black Canyon selected — Dam construction authorized by Congress — Three railroads planned — Union Pacific builds branch to Boulder City — U. S. Government Construction RR completed to Himix — Six Companies RR: Lawler to Gravel Plant, then across Colorado River to Arizona Gravel Deposits, Gravel Plant to Lomix (Canyon Railroad) — Operations of railroad and completion of Hoover Dam — Abandonment of Six Companies RR and U. S. Government Construction RR.

YELLOW PINE MINING COMPANY 753

Potosi, early development — Mule powered tramway — Empire Zinc Company — Goodsprings, founding and early mining activity — Formation of Yellow Pine Mining Company — Construction of narrow gauge from Jean to Goodsprings — Boom times at Goodsprings — Opening of Fayle Hotel — Jesse Knight heads Yellow Pine Mining Company — Mine shuts down, railroad abandoned.

Salt Lake Route — Supplemental Lines (760): Salt Lake Route spur to limestone quarry at Baxter — Arden Plaster Company narrow gauge railroad to its gypsum mine — Blue Diamond branch of Salt Lake Route — Las Vegas spurs — Caliente Ballast Pit spur.

ATLANTIC & PACIFIC RAILROAD 762

Mojave Desert description — Congressional authority given A&P and Southern Pacific RR to build railroad from Missouri to San Francisco — A&P taken over by St. Louis and San Francisco — Santa Fe joins SL&SF in construction of western division of A&P — Lines of SP RR reach Mojave and Los Angeles — SP RR builds from Mojave to The Needles to connect with A&P — Colorado River Bridge problems — Monoghan & Murphy store — SP turns over Mojave-Needles line to A&P — More trouble with Colorado River — New bridge of 1890 at Topock — Life along the line — Bagdad, Newberry Springs — A&P conveyed to Santa Fe — Santa Fe and SP trade lines — New Colorado River Bridge, 1945 — Cadiz-Parker line — Scotty's *Coyote Special* — Famous trains.

RANDSBURG RAILWAY COMPANY 793

Discoveries at Goler Canyon, followed by Yellow Aster Mine in Rand Mountains — Randsburg Railway formed by New York men — Built from Kramer to Johannesburg — Suspected to be part of Vanderbilt coast to coast scheme — Ore shipped to mill at Barstow — Line sold to Santa Fe — Dull times — Discovery and excitement of Kelly Mine — Railroad abandoned in 1933.

TRONA RAILWAY COMPANY 798

Borax found at Searles Lake — Subsequent development of deposits — Survey by Raymond Ashton for railroad — Trona Railway formed and built from Searles to Trona — First excursion — Operations — Expansion of American Potash & Chemical Corporation.

EPSOM SALTS RAILROAD (MONORAIL) 808

Thomas Wright locates epsom salts in Owlshead Mountains — Monorail considered answer to transportation needs — American Magnesium Company formed — Description of track and equipment — Problems of operation — Poor results of mine and from monorail — Abandonment.

CALICO AND ITS SILVER RAILROAD 814

Early silver discoveries — Town of Calico settled — Life in Calico — Discovery of borax — Description of Main Street — Daggett & Calico RR organized but not built — Oro Grande Mining Company builds narrow gauge from Waterloo Mine to mill at Mojave River, then sells out to Waterloo Mining Company — Slump in silver prices in 1890's closes mines — Later mining operations — Restoration of Calico as tourist attraction — Calico & Odessa RR in operation.

BORATE & DAGGETT RAILROAD 823

Operations of Pacific Coast Borax Company at Borate — Steam traction engine used — Narrow gauge built from Borate to Daggett — Mines become too expensive to operate — PCB Co. moves operations to Lila C. near Death Valley — Railroad dismantled.

Western Mineral Company's railroad — Boric acid produced by W. P. Bartlett — Mule powered short line.

Columbia Mine railroad — American Borax Company built narrow gauge from Columbia Mine to Daggett — Operations — Mill and railroad moved to Tick Canyon.

LUDLOW AND SOUTHERN RAILWAY COMPANY 827

Rochester (Buckeye) Mining District dates back to 1880's — Organization and construction of Ludlow and Southern Railway — Life in Camp Rochester (Stagg P.O.) — Mother Preston at Ludlow — Ludlow and Southern equipment — Acquisition by Pacific Mines Corporation — Subsequent owners — Mine closed down — Round house fire — Rails torn up.

AMBOY-SALTUS 835

Amboy-Bristol Lake — Gypsum — Pacific Cement Plaster Company builds mill and narrow gauge railroad at Amboy — Relocation of mill and trackage — Plant closed down in 1924 — Saltus-Bristol Lake — Quarrying salt — Construction of railroad — Operations by California Salt Company.

NEVADA SOUTHERN RAILWAY 841

Isaac C. Blake builds mill at Needles — Proposes to build Nevada Southern Railway north from Goffs to Goodsprings and Pioche — Built to Manvel (Barnwell), construction stopped — Discovery and description of Vanderbilt — Slump follows boom at Vanderbilt — Nevada Southern goes into bankruptcy to emerge as California Eastern Railway — California Eastern pushes line down to Ivanpah — Santa Fe acquires California Eastern — Operations — Abandonment.

SEARCHLIGHT AND ITS RAILROADS 848

Naming of town — Quartette Mining Company builds 16-mile narrow gauge railroad from mine to mill at Colorado River — Boom at Searchlight — Railroad operations — Mill moved to mine, railroad becomes unnecessary and is abandoned — Searchlight and Northern Railroad surveys route to Salt Lake Route — Santa Fe forms Barnwell & Searchlight Railway to build to Searchlight — Manpower problems — Terminal on property of Searchlight Townsite Company — Railroad Days celebration — Serious washouts and abandonment.

MOHAVE AND MILLTOWN RAILWAY 854

Leland group of gold mines sold to Mount Mohave Gold Mining Company — Proposed railroads — Mohave and Milltown Railway incorporated — Colorado River ferry franchise secured — Needles, Arizona, description — Railroad built as narrow gauge to Leland Mine — Operations — Severe washouts, operations cease.

MOJAVE NORTHERN RAILROAD 857

Gold and silver found near Oro Grande in early days — Pioneer limestone quarries in California — Golden State Portland Cement Company builds mill at Oro Grande — Connecting railroad built to quarries — Mrs. E. M. Potts — Company absorbed by Riverside Portland Cement Company — Mill closed in 1928 and railroad operations ceased.

Southwestern Portland Cement Company plant developed at Leon, near Victorville (864) — Mojave Northern Railroad built to quarries at Powell — Passenger business limited — Spur built to No. 12 Quarry in 1939 — New quarries on Black Mountain — Branch built to Bell Mountain — Rails extended to Reserve Quarry on Black Mountain in 1951.

Other railroads in area — Proposed San Bernardino Mountain Railroad — Adelanto spur — AT&SF Cushenberry branch.

RENO STREETCAR LINES 866

Proposals of 1889 — Other proposals: Reno Electric Railway and Land Company, Nevada Power and Transportation Company and Reno Suburban Railway Company — Streetcar connection desired with new SP shops at Sparks — O'Sullivan wins franchise, forms Reno Transit Company and Washoe County Traction Company — Little work done — Franchise passes into other hands, then project abandoned — Dr. Reid and associates form Nevada Transit Company — Construction begins — First streetcar in Nevada operated November 20, 1904 — Extensions on Virginia Street, Reno, to Truckee River, then to Pine Street — Second Street line built — Property sold and renamed Reno Traction Company — Captain Hopkins' proposed line to Steamboat Springs — V&T talks of partial electrification — Nevada Interurban Railway formed to build to Moana Springs (872) — Line completed November 1907 — Riverside Railroad Company proposes line to Lawton Springs — Some construction but road never completed — Other proposed lines — Reno Traction line to University — "Streetcar War" — Moana Springs description — Operating problems — Traction Company builds line down Wells Street — Temporary line to Fair Grounds — Abandonment of local lines in Reno 1920 — Abandonment of Nevada Interurban 1920 — Efforts made to improve Reno-Sparks service — Reno terminal moved in 1925 — Bus competition forces abandonment of Reno Traction Company — Last car September 7, 1927.

ROSTER OF LOCOMOTIVES 884

INDEX to Volumes I and II 909

The landmarks left by the former railroads encompassed in this second volume are no different than those of the more northerly latitudes whose histories were set forth in Volume I. Most of the short lines have vanished; true, a scar remains on a hillside or a long brush-covered hump traverses a plain but the rails have long been gone for use elsewhere or to the angry blast furnaces pouring forth iron for new purposes.

The earliest railroads in Volume II date back to 1872, just three years after the completion of the Central Pacific. Pioche, in Southeastern Nevada, was then a most active mining community. To take the silver-lead ores down to the mills, a short narrow gauge railroad was built, destined never to physically connect with another railroad; its closest neighbor was some 200 miles away. Other railroads were built in the nineteenth century, but except for the SP main line across the Mojave Desert to Needles, few stretched for more than a dozen or so miles.

Jim Butler changed all that in 1900. His accidental discovery of silver ore resulted in the founding of Tonopah and rekindled the interest of prospectors and miners in Nevada. Sparks from the Tonopah excitement fanned all over the state and into California. Bullfrog, Rhyolite, Johnnie, Death Valley, Skidoo, Greenwater and Tecopa became household words throughout the country, first to be blessed then to be cursed as events unfolded. Real discoveries of very rich ore which could be mined in quantity were found and developed, Goldfield being the outstanding example. Other ledges were found and were quickly transformed into mines, thanks to an excited public clamoring for an opportunity to become millionaires overnight. Promoters, many of questionable ethics, were obliging enough to help the unwary become separated from their hard-earned money. When a ledge was about to become a "wonderful mine," a townsite was speedily platted near the alleged ore body. Newspapers were inaugurated, not to inform the local citizens of outside news, but to tell the world at large of the wonders of the new mining camp. Newspapers of Rhyolite were regularly on sale at newsstands in Eastern cities and the public could follow in close detail the latest developments of the town and particularly the surrounding mines. With amazing regularity, there was always news to report on the excellent progress of the mines.

With a fortune amassed from Montana copper, Senator Clark, with Harriman as his silent partner, built the Salt Lake Route and the desert vastness shrank immediately. Tonopah and Goldfield were proven mining camps with substantial populations served by the solitary, money-making Tonopah and Goldfield Railroad. This was too much for ambitious men such as Senator Clark and his brother, J. Ross Clark, and F. M. "Borax" Smith to allow to remain unchallenged, so they set about building their own railroads to tap this lucrative region from the south. The T&G people tried unsuccessfully to head them off by building a railroad to the south from Goldfield.

The construction of the Las Vegas and Tonopah and the Tonopah and Tidewater, to be sure, drained some business from the prosperous T&G but such enterprise drained more from the pockets of Clark and Smith and their associates. Had these two men built the LV&T and the T&T as an avowed charitable contribution to society, they might have been rewarded in Heaven; certainly there was no reward on earth for them for their diligent efforts.

Of all the short line railroads built in Nevada, few have made sufficient money to pay regular dividends on the scale of major trunk line railroads. The list of dividend payers is a mere handful: V&T, E&P, NN, T&G and, in some years, the N-C-O and the C&C make up the northern lines. In the southern part of the area, only the Trona Railway has reported consistent earnings entirely thanks to the potash shipments of its owner. In years gone by, the Death Valley Railroad reported

handsome dividends. The lack of dividends and net income was not always the true measure of a little road's usefulness, for it oftentimes made possible the operation of an otherwise isolated mine.

In searching for abandoned railroad grades, the Tonopah and Tidewater deserves special mention. In appearance, embankments along the highways used to control great surges of water dropped by desert cloudbursts resemble those of a former T&T grade. Both are generally free of sagebrush but the T&T grades are longer and, at places, abandoned ties confirm the former railroad.

Though the railroads, abandoned many years ago, have been forgotten, the general scene is undergoing constant change. For example, in the eight months following the publication of Volume I in December 1962, several changes have been noted. On New Year's Eve, Carson City celebrants witnessed the burning of the block-long freight house once kept busy by the V&T. At nearby Franktown, the main house of the plush and famed Flying M-E divorcee ranch burned September 5, 1963. Further east, along the Humboldt River, the SP replaced five of its 28 bridges crossing this river. The former through riveted-truss bridges, built at the time of the CP reconstruction of 1902-3, gave way to 30-foot prestressed concrete slabs thus permitting wider and higher clearances. The proposed joint use of the WP tracks between Flanigan and Weso, Nevada, by SP became a reality September 23, 1963.

Renewed economic life in Tonopah was reflected in foundations for new houses which threaten to disturb some of the old T&G right of way east of the Mizpah Shaft. Military installations are the cause of Tonopah's renewed prosperity, not increased metal prices. Although the price of silver has advanced sharply recently and is now selling at $1.29 an ounce (July 1963) — the highest since 1919-20 when it reached an all-time peak of $1.37½, there has been no rush to reopen dormant mines. Sustained high price levels in silver, lead and zinc might bring about the reopening of many Nevada mines, assuming that production and transportation costs can be kept at reasonable levels.

To round out the story of mechanical transport in this area, and to include additional photographs of trains and towns which space limitations excluded from these two volumes, a supplementary volume is now in preparation. In it are chapters on boats on the lakes and rivers of Nevada and Eastern California. Although little is generally known of these early steamers, their stories have been uncovered and, along with them, a limited number of pictures. Other chapters discuss tramways, flumes, while still others will cover the more important projected steam railroads and streetcar lines. A corporate directory of the railroads contained in these two volumes as well as many other obscure projected lines will be included. As mentioned in Volume I, correspondence is invited on matters pertaining to these volumes. Letters to the author should be addressed to him care of the publisher.

DAVID F. MYRICK

San Francisco, California

1963

ACKNOWLEDGMENTS

The disappearing railroads, vanishing records, fading pictures and waning memories made the compilation of the histories of the railroads and mining camps recorded in this volume no less challenging than in the first. Fortunately many people were able and willing to aid in this work and to them, I tender my sincere thanks. Not only does this include individuals identified below, but also the anonymous people in various governmental agencies, libraries, corporation offices and historical societies across the nation.

Countless times general assistance in the preparation of this book has been rendered by the following:

Walter Averett, the late Don Ashbaugh, Mrs. Clara Beatty, Mrs. Myrtle Myles, Mrs. Andy Welliver, Miss Delle Boyd, Dr. Effie Mona Mack, Donald and Nancy Bowers, Lucius Beebe, Fred L. Green, E. W. Darrah, Dr. Russell Elliott, Louis D. Gordon, Grahame and Paula Hardy, John Koontz, Mrs. Emily P. Wood, Mrs. Byrd Sawyer and Jeff Springmeyer, all residents of Nevada.

In California, I have received assistance from Brian Thompson, Gilbert Kneiss, Hugh Tolford, William A. Pennington, Stanley Borden, Robert Hancocks, Henry Carlisle, Guy L. Dunscomb, Jack Gibson, James de T. Abajian, William A. Sansburn, Dr. George P. Hammond, Dr. John B. Tompkins, Robert Becker, Mrs. Helen Bretnor, Allan R. Ottley, M. Woodward Cook, Colin Eldridge, L. Burr Belden, Nel Murbarger, O. J. Fisk, Richard C. Lingenfelter, Roy Graves, William B. Beatty, Col. Fred B. Rogers and Dr. John Hussey.

For special items in the Las Vegas and Tonopah chapter, I am indebted to Mrs. Olive Redman Wilson, Mrs. Zella Vincent of Beatty (the first lady to be married in Las Vegas), H. K. Hall, E. S. Hall, Jr., former residents of Beatty and Rhyolite, Mrs. Marion Porter Grace, the late Don Ashbaugh, Mr. and Mrs. H. H. Heisler, now owners and occupants of the LV&T station at Rhyolite, Mrs. Gladys Wells and Robert W. Edwards.

Eugene Rebarb, Oro Parker and John Landsdale provided helpful data concerning the Bullfrog Goldfield R.R. As the T&T was the last of the Gold Roads, this made it possible to find people with vivid memories of the life and times of this road. Among them were Harry P. Gower, Mrs. Vernie Sherraden, Mrs. H. E. (Venus) Pendergast, Frank C. Hord, E. Lester Orr, Rollin K. Jamieson, W. H. Brown, Carl Rankin, Harry W. Rosenberg, Ralph and William Parkinson, W. W. Cahill, C. R. "Father" Ferguson, Mrs. Dora French, Mrs. Charles Brown and the late Senator Brown. Many of these people, particularly Harry P. Gower, were also closely identified with the Death Valley Railroad. Recollections of A. B. Perkins added to the story of Carrara, Nevada.

Information concerning the Salt Lake Route, now the Union Pacific's strong link with Los Angeles, came from A. E. Stoddard, W. B. Groome, Jim Ady, Allan Krieg and Robert W. Edwards. William V. Wright and Jack Oakes augmented the story of early Las Veges.

The little railroad from Tecopa to the mines is more complete thanks to Dr. Leon D. Godshall, son of its former owner. Greenwater, in spite of all the promotion of the 1907 era, has been scarcely recorded photographically and it was only after a great deal of searching all over the country that pictures were found. Miss Lucille Fry of the Library of the University of Colorado has my thanks for her special help in this instance. Additional information came from John Landsdale and Col. Thomas W. Miller.

At Pioche, I am particularly indebted to Mr. and Mrs. James G. Hulse, L. K. Requa, E. H. Snyder, Paul and David Gemmill, E. Lytle, Dr. James W. Hulse and William H. Roberts, formerly a director of the Pioche-Pacific Railroad, for their assistance in finding answers to missing questions and locating elusive pictures. California's former governor, Goodwin J. Knight, having lived in Goodsprings, Nevada, was kind enough to supply considerable background material. Other valuable data concerning the little railroad at Goodsprings came from the late Harold Jarman and L. F. Jacobson.

The short-lived but most active railroad to the Hoover Dam had an interesting history which is now preserved, thanks to Grant S. Allen, the late Don Ashbaugh and Tom Price. I would also like to acknowledge the assistance of the Boulder City

office of the Bureau of Reclamation for certain factual data and pictures and also R. J. Nemmers of *Compressed Air Magazine* (Ingersoll-Rand) for pictures and for allowing me to examine important articles.

For information on the railroad between Mojave and Needles, now owned by the Santa Fe Railway, I thank E. S. Marsh, Frank Grossman, Phil Kauke and the late Charles Battye. Frank Royer recalled some of his personal experiences in the construction of the Randsburg Railway. Walter Alf, a long time resident of Daggett, supplied considerable data concerning the four little railroads around Calico. Others contributing to this chapter were Mrs. J. R. (Lucy) Lane, an early resident of Calico, and Harry P. Gower. William H. Robison, a veteran employee of the gypsum and salt railroads in the Amboy area, added to the information of these roads given by Walter Alf and Phil Kauke.

Short in miles and short in information would have been the story of the Ludlow & Southern were it not for Frank Royer, Donald Love, Mrs. Vernie Sherraden and Alvin Fickewirth.

Needles residents Phil Kauke, Mrs. Tim Kelley, Al Williams and the late Charles Battye filled in the many details of the little known Mohave and Milltown Railroad. Research by John M. Smith also contributed to this chapter.

The Trona Railway, a very active short line, story is told in words and pictures from Raymond Ashton, G. H. Sturtevant and P. N. Myers, its president.

To Dr. Richard H. Jahns, my thanks for pictures and for considerable data and assistance in the Monorail chapter.

To Garner A. Beckett, former president of the Riverside Portland Cement Co. and to George E. Warren, chairman of the Southwestern Portland Cement Co., my thanks for information and pictures. Others aiding in this chapter were Frank Grossman, Allan C. Chickering, Jr., and H. Putman Livermore.

For a relatively recent commonly used enterprise, surprisingly little is known about the two family-operated streetcar lines of Reno. Fortunately members of both families are available. My thanks to Mrs. Kay Berrum McInnes and Ted Berrum for data concerning the Moana Springs line and to J. B. Linabary, Richard Morris and Stanley Palmer for their help concerning the Reno-Sparks line.

In developing the rosters, I had the help of many people, including nationally known experts in this field. Among them were H. L. Goldsmith, Gerald M. Best, Doug S. Richter, R. P. Middlebrook, S. R. Wood, Jack Holst, P. Allen Copeland, Stanley T. Borden, Joseph Strapac, Don Roberts, Ralph Ranger and J. F. Kirkland of B-L-H. To all of them, my sincere thanks.

As in the first volume, constant searching yielded many pictures, and, from these, some five hundred have been selected for use in this volume. Individual credit is given to each picture (except where the source is not known or those taken by the author) but the following fine collections deserve special notice and I appreciate the aid of all contributors in this area. They include, in addition to those previously mentioned, the Nevada Historical Society, Sewell Thomas, Louis D. Gordon, D. A. Painter, R. P. Middlebrook, the late William Ver Plank, Heron Manufacturing Co., the late Charles Battye, Hugh Tolford, the late Frank Green whose photographs were rescued from oblivion by W. C. Hendrick, the photographs of E. S. Holt of the LV&T and Rhyolite. Others who have helped greatly in this area are J. Lee Rauch, Dr. Ed Carpenter, W. B. Groome, Harry P. Gower, Bob Weaver, L. Burr Belden, Walter Averett, Robert W. Edwards as well as the U. S. Geological Survey, the Trona Railway, Union Pacific, Santa Fe and Southern Pacific.

The passes, used to decorate the end papers of both volumes are from the collections of Mrs. Olive Redman Wilson, Alvin Fickewirth and particularly from the collection of Grahame Hardy.

The data for the development of the maps was compiled from many sources, including railroad valuation maps, U. S. Geological Survey maps and from field trips. My thanks are tendered to Miss Carolyn Henderson, Mrs. Jean Molleskog, Miss Anna S. Elliott and Stanley Borden for their assistance. The fine detailed maps are from the skilled hand of Robert B. Adams.

Editorial assistance was contributed by Brian Thompson, E. P. Humphrey, Jr., and Stanley Borden. Miss Nancy Dry typed the rosters of locomotives. Mrs. Alice F. Simpson did special research at the California State Library at Sacramento. My sincere thanks to Robert B. Adams for his contribution in the editing of this history.

In addition to countless interviews and many miles of field trips, much information came from the transcripts and decisions of court cases and particularly old newspapers. The four great files of Nevada newspapers are to be found in the Nevada Historical Society, the University of Nevada,

the Nevada State Library and the Bancroft Library of the University of California. Other material was found in these libraries as well as the libraries of the University of California at Los Angeles, the Henry E. Huntington Library and Art Gallery, the California Division of Mines, California Historical Society, the Eastern California Museum Association, Arizona Pioneer Historical Society, Inyo County Free Library, Stanford University Library. Other local libraries included the Santa Barbara Public Library, San Diego Public Library, Plumas County Library, while distant libraries consulted included the Library of Congress, the National Archives, Association of American Railroads and the New York Public Library.

The files of the Nevada Public Service Commission provided much useful data and again my thanks to the staff of the Commission, particularly Miss Austin, for their help. The Interstate Commerce Commission opened up its vast treasure house of railroad records and this information has been spread upon the pages of these two volumes.

A special personal tribute should go to Charles Moran, the former president of the Nevada-California-Oregon Railway, who passed away in New York on Christmas Eve of 1962, just a few weeks after the first volume was published. Over a dozen years ago this author set out to uncover the history of the N-C-O and after much research a brief version of its story was published in 1955. It was, to a large measure, due to Mr. Moran's interest and encouragement that this came about. With this as a starting point, the decision was made in 1957 to tell the story of all the railroads of Nevada and Eastern California. These two volumes mark the culmination of that effort.

DAVID F. MYRICK

Telegraph Hill, San Francisco
October 1963

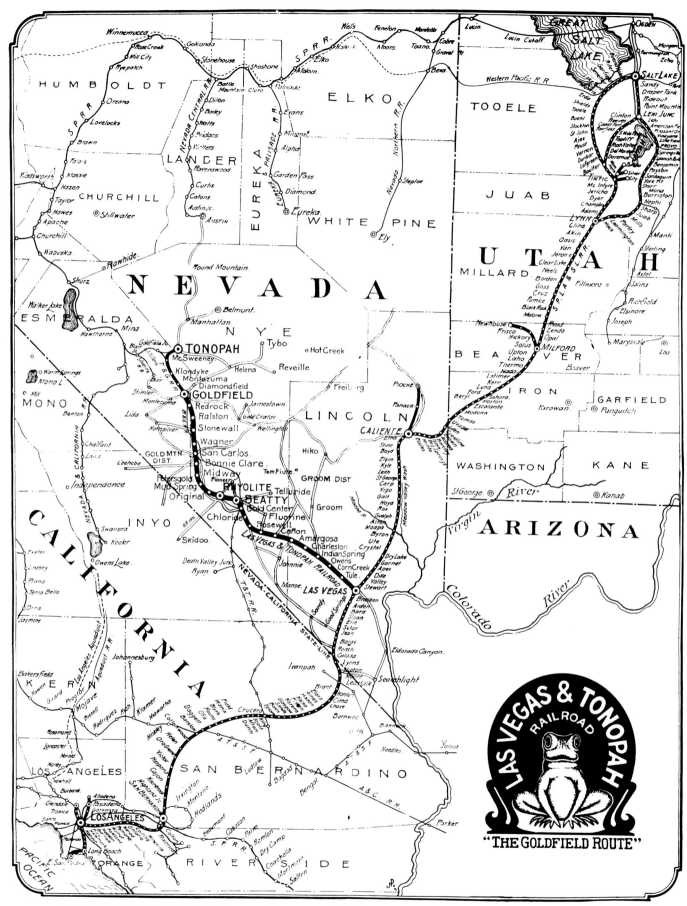

FOR BEST SERVICE see that your Ticket reads and your Freight is Routed
over the LAS VEGAS & TONOPAH R. R.

LAS VEGAS & TONOPAH RAILROAD

Introductory — The Gold Roads

Tonopah, Goldfield and Bullfrog-Rhyolite were the principal centers and settings for Nevada's last mining bonanzas. Of this triumvirate, the stories of the first two localities have largely been told in Volume I under the chapter entitled "Tonopah and Goldfield Railroad." The T&G was a carrier built to connect with railroads running to the north and was one whose traffic largely was derived and delivered via northern connections.

The Bullfrog District (of which Rhyolite was the center) was the Johnny-come-lately of the mining camp booms, surging to prominence in 1904-07 and declining with equal (or greater) rapidity in the ensuing years. As a new camp of undetermined potential, it could not be overlooked, and three separate railroads — the Bullfrog Goldfield, the Tonopah & Tidewater, and the Las Vegas & Tonopah — were projected and built by three separate, strong-willed and equally determined and capable men — John Brock, "Borax" Smith and Senator Clark (supplemented by J. Ross Clark, his brother).

Of the three railroads, the Bullfrog Goldfield was the weakest sister; being eternally dominated during its entire existence by one of the other lines — first by its parent Tonopah & Goldfield, then by the Tonopah & Tidewater, later by the Las Vegas & Tonopah, and finally back under the wing of the Tonopah & Tidewater. Because of the interlocutory nature of these arrangements, it is difficult to isolate the story of any one of these lines to the exclusion of all others.

To make each railroad's history relatively complete unto itself, and at the risk of being repetitive where operations interlock, the individual story of each road is presented in toto from that road's aspects, so certain matters unavoidably must be covered twice to accomplish this objective.

———◆◆———

Senator Clark had his hands full.

By January 1905 he had pushed his first major railroad, the San Pedro, Los Angeles and Salt Lake (Salt Lake Route) to completion, after compro-

mising with the UP in the battle at the eastern end. The joining of the rails on January 30, 1905, was a major achievement. Now he could look about and analyze the situation.

What he saw left him with rather mixed emotions. Six months previously, in July 1904, "Borax" Smith had incorporated his Tonopah & Tidewater Railroad and made extensive surveys of diverse routes by means of which he might reach his Lila C. borax mine. One of the routes under consideration began at Las Vegas, where connection would be made with Senator Clark's SP, LA&SL, and extended northwesterly to the mine. After discussing the matter with Clark, Smith felt his project had the Senator's blessing and made plans to begin work.

From Senator Clark's viewpoint what he did not know (and what bothered him the most) were the problematical implications of the title of Smith's road — Tonopah & Tidewater. No local mining road per se would carry such broad designations without some justification, so what lay behind this expansive thinking? An investigation appeared to be in order, the results of which were to provide Clark with much food for thought.

Primarily, the discovery of rich ore at Tonopah and later at Goldfield in the early 1900's had instigated a wide search for minerals in southern Nevada. Considerable optimism had been felt that such lost mines as the famed Breyfogle could be found, since even the outcroppings at booming Tonopah had been completely missed in all earlier wanderings. True, some prospectors had covered the territory, but the majority of the nineteenth century's successful mines had been located in northern and central Nevada where more prevalent water and transportation had made life easier for prospectors and miners alike.

Among the searchers for overlooked ores which, it was hoped, would put them on "Easy Street," were two prospectors of long standing, Ed Cross and Frank "Shorty" Harris. While wandering in the hills just west of the Amargosa River, Cross found an odd appearing rock and showed it to his more experienced partner. "Shorty" took one look at it and pronounced that they were rich. Quickly

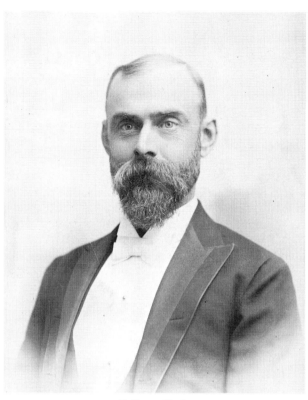

J. Ross Clark
(Mrs. Peter Eben.)

the two men staked out their Original Bullfrog claim and gathered samples for assay. The day was August 9, 1904.

Two stories prevail regarding the origin of the Bullfrog name. One states that the original lump of ore discovered was speckled in a manner similar to that of a bullfrog; the other contends that the name was derived from Ed Cross' favorite song, "Oh, the bulldog on the bank and the bullfrog in the pool . . ." In spite of his friends' objections, Ed liked to sing this song frequently and, in his words, "the word 'bullfrog' became sort of a household word, and I determined to call my first location by that name."

The news of their find was too good for the partners to keep to themselves, so they took their "jewelry ore" and set out to spread the news. Although not many people were traveling through the desert wastelands to the south of Goldfield that summer, the few that the partners did meet managed to pass the word along. As one old-timer commented, "You don't have to tell news like that to anyone; it just travels all by itself." On arrival of the partners in Goldfield, two things happened — Shorty Harris sold and gambled away his half interest in

the claim; and, excited by the good news, many people flocked to the new Bullfrog Mining District to try their luck.

Developments followed thick and fast. People swarmed over the area. A second, important strike was made on Bonanza Mountain when the Denver claim was located early in 1905. This was followed by the National Bank claim across the flat to the east on Ladd Mountain, and then the big strike in February 1905 when, in exchange for $5 and a pair of overalls (quite worn out at that), an Indian named Shoshone Mike led E. A. (Bob) Montgomery to the site of what later became the fabulous Montgomery-Shoshone mine, principal producer of the District.

The tremendous activity attracted people by the thousands. In November 1904 the town of Rhyolite was staked out, and by January 15, 1905, it was platted. A month later Pete Busch began offering lots for sale. About a mile to the south and a little to the west of Rhyolite the townsite of Bullfrog was located, while along the connecting street between lay Squattersville. Other townsites (mostly tents) boomed for a short time, then died. Amargosa was moved in its entirety to Bullfrog in the short span of one day. Bonanza, at the south side of Ladd Mountain, was moved and absorbed into Rhyolite.

Water in the area was scarce, but fortunately whiskey plentiful. When *The Rhyolite Herald* began publishing early in May 1905, its columns reported that there were 20 saloons in town and added the comforting remark that more were being built. The reception given to the first purveyor of such beverages, as recalled by an eye witness, most certainly must have encouraged others. Although the witness' spelling was substandard, his tale was colorful as he wrote: "I remember a fellar drove down from Goldfield with the first wagonload of whiskey. He got within a few miles of where he was goen and they made him stop. He got off his wagon and set up a bar on two kegs of whiskey. He never did get to Bullfrog that trip. That was a wild time — sort of christen for Bullfrog. Drinks were supposed to be four-bits, but the bartender kept whatever money you gave him. That bartender didn't have time to make any change. He was busy. He just kept what mony he got and if you didn't have any money you just drank anyway."

Four stage lines commenced operating between Goldfield and the Bullfrog Mining District. The Kitchen stage made the 80-mile trip in 10 hours at a cost of $18 (22½ cents a mile) each way. It was

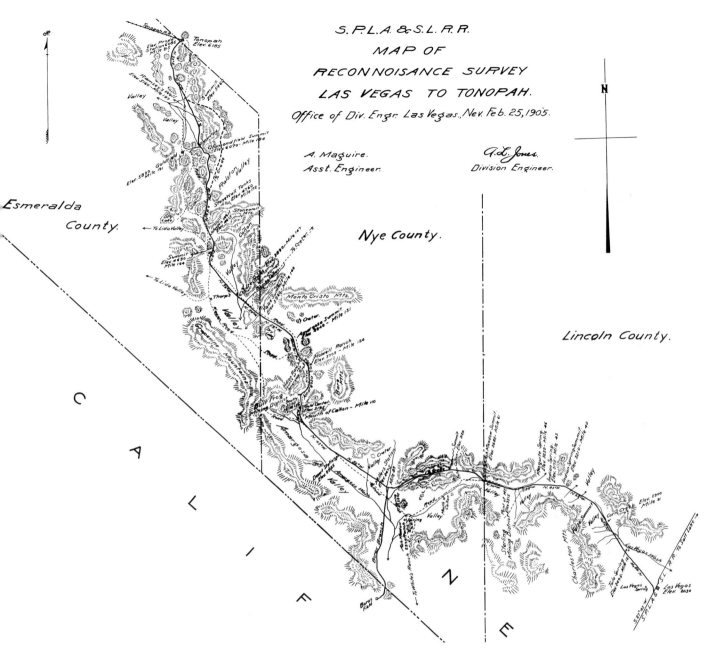

S. P. L. A. & S. L. R. R.
MAP OF
RECONNOISANCE SURVEY
LAS VEGAS TO TONOPAH.
Office of Div. Engr. Las Vegas., Nev. Feb. 25, 1905.

A. Maguire.
Asst. Engineer.

G. L. Jones.
Division Engineer.

not until May 1905 that the Tonopah and Gold-field Auto Company offered the first horseless service with two Winton automobiles plus a scouting car. The trials and tribulations of desert drivers and driving were amply illustrated when, near Beatty, an axle on one of the Wintons broke on its first trip. Since a spare axle was only one of the many items of parts and supplies which were an integral part of each scheduled safari, only a short delay was encountered while the replacement was made.

This, then, was the picture which presented itself to Senator Clark as he began his investigations early in 1905. The situation looked promising. The new bonanzas at Bullfrog and Rhyolite were developing nicely, while a few miles beyond, at Goldfield and (farther) at Tonopah, the mines had already proved themselves to be promising producers. The area was just about ripe for a railroad; perhaps "Borax" Smith was being sly, like a fox. Undoubtedly it would be well for Clark to protect his interests.

Immediately Clark had his Salt Lake Route engineers survey for a railroad route all the way from Las Vegas to Tonopah. The map of this reconnaissance survey, dated February 25, 1905, shows

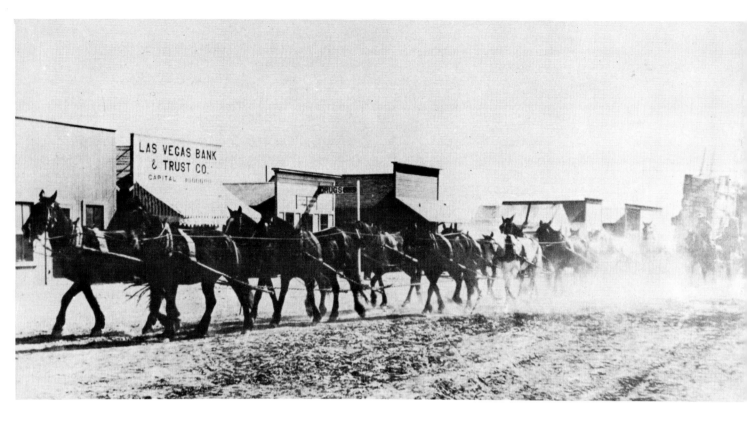

In 1912 Las Vegas, Nevada, was a typical western frontier town comprised of tents, false-front buildings and more substantial structures. Horses were the prime motive power, and dirt streets prevailed. Old Fort Las Vegas *(bottom left)* still stood in crumbling disuse, reminder of more primitive times, while the expansive facilities of the Salt Lake Route and the connecting Las Vegas & Tonopah Railroad were indicative harbingers of the mechanical age to come. *(All photos Nevada Historical Society.)*

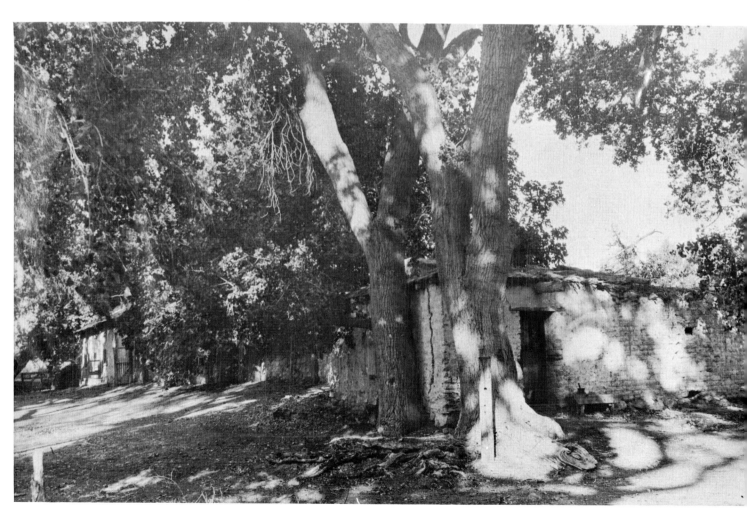

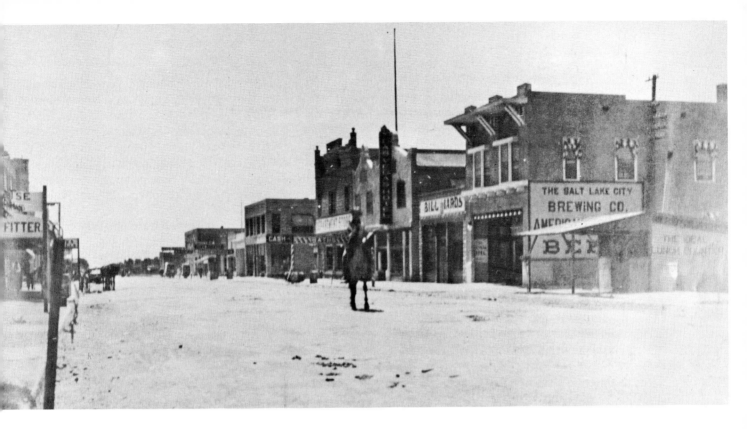

Junction Point of the Salt Lake Route and Las Vegas and Tonopah R. R. at Las Vegas, Nevada

a number of deviations from the ultimate route as finally constructed. For example, from Beatty northward the line was projected eastward up the Amargosa Canyon (the route actually used by the Bullfrog Goldfield Railroad), thus bypassing the Bullfrog Mining District which lay a good five miles to the west. Approaching Goldfield, the line was to pass over Diamondfield Summit, but was to swing northerly at that point to Tonopah and bypass Goldfield thus saving a 250-foot drop in elevation. In fact, an alternate grade projection started at the southern end of Ralston Valley and looped eastward (reducing the Diamondfield climb by .5% to 1%) and passed through a more northerly summit which was 610 feet lower than that at Diamondfield. Thus it would appear that the original objective of the line was to reach Tonopah directly and to serve the intermediate mining districts of Bullfrog and Goldfield with branches. Circumstances were to alter that conception of the situation considerably.

The biggest thorn in Senator Clark's side, and one of his own engendering, was "Borax" Smith and his T&T. In effect, Clark had invited Smith into the picture; so Clark would have to get him out. But Smith was going ahead with his plans, and already was assembling men and materials at the budding center of Las Vegas preparatory to starting construction. Discouraging him was not going to be an easy matter.

Clark's second major problem concerned his erstwhile partner in the Salt Lake Route — Harriman and the UP. Although the initial reconnaissance surveys for the line to Tonopah had been made by Salt Lake Route engineers, Harriman (representing the UP's 50% interest in the Salt Lake Route) refused to go along with Clark in his thinking as to the necessity or the advisability of building the road. The lack of agreement between the two partners meant that the Salt Lake Route would not build the line and that Clark, if he persisted in going ahead with his plans, would have to proceed

Barely visible in this latter day photo is the northward grade of the Las Vegas & Tonopah from its former junction point with the Salt Lake Route at Las Vegas. The

LV&T was abandoned in 1918, and the rails were removed the following year. (*Don Ashbaugh Collection.*)

alone. Clark's answer, on September 22, 1905, was the incorporation of the Las Vegas and Tonopah Railroad under the laws of Utah.

To discourage his competition, Clark first organized the Nevada Rapid Transit Company which commenced surveying and constructing an auto road to Rhyolite, the grade of which largely paralleled the right-of-way of Smith's Tonopah & Tidewater. The suspiciousness of this physical demonstration as an overture was somewhat lost, because it was customary in those days for highway carriers to build their own roads in many places. The fact that Supt. Frank Grace had 15 teams and 22 men busy grading the road attracted little more than idle curiosity. Grace was soon to have his own problems anyway, for competition arrived in the form of the Nevada Trading and Transportation Company, an auto stage line which offered to take passengers the entire distance between Las Vegas and Rhyolite (about 140 miles) for the lowly fare of $40.

If Smith ignored this first hint of trouble, Clark's second barb was more pointed. The bills for T&T freight delivered in Las Vegas began to be issued, and any similarity between the rates actually charged and the special, lower rates which Smith had understood would be charged was strictly an oversight on the part of the Salt Lake Route. To his disgust, Smith also found that any differences of opinion could only be settled in favor of the delivering carrier — the Salt Lake Route. Clark's attrition was taking its toll.

The climax came in the middle of August 1905 when Smith was ready to start laying track on his completed roadbed and needed physical connection with the Salt Lake Route over which to roll his cars. In response to his request, the SP, LA&SL voiced an emphatic "No," confounding the issue by refusing to give any reasons for the astounding denial and placing all in authority beyond reach for comment. Senator Clark was conveniently out of the country and could not be contacted.

Faced with an impossible situation, Smith was left with no alternative. He abandoned his attempts to build a railroad north from Las Vegas and moved his base of operations to Ludlow where a more amicable Santa Fe agreed to furnish the necessary connections. It was not until months later that C. O. Whittemore, Clark's attorney, admitted that Clark had been planning his own railroad to the gold fields and could see no reason to encourage Smith with lower freight rates on construction supplies. The impasse apparently stemmed from

the fact that Clark wanted to build a through line and had offered Smith the opportunity to build a branch line to his borax mines, an offer which Smith had considered at the time to be unsatisfactory.

The LV&T Starts Out

Clark was in business in a hurry. In October 1905 he consummated a deal with Smith for purchase of the T&T's former terminal site plus its approximately nine miles of completed grade north from Las Vegas (some reports indicate there were 12 miles of completed grade), and included in the purchase were all of the rail and accessories which the T&T had assembled on location. Switches for the connection with the Salt Lake Route (physical location about one mile southwest of the present Las Vegas passenger station) arrived the early part of November, and before the end of the month the grading contract had been let to Deal Bros. & Mendenhall of Springville, Utah. Soon 35 carloads of railroad ties had been accumulated at the site, not including the additional supply of those which had been left behind by Smith and sufficient rails were on hand to cover the first 12 miles of line. Arthur Maguire, chief engineer of the LV&T, was busy surveying (new) advance routes from Gold Center to points west of Rhyolite.

For Rhyolite was growing up in a hurry, too. H. D. and L. D. Porter opened their store (the stone facade still stands) to deal in hardware, groceries and lumber. The partners also engaged in

New housing at Las Vegas frequently encroached upon and obscured the former LV&T right-of-way. (*Don Ashbaugh Collection.*)

teaming and as a sideline offered choice mining claims for sale. Other Porter stores were located in Beatty, Keane Springs (in the South Bullfrog District) and Johannesburg. Amusement centered around Bullfrog's new swimming pool (14 by 40 feet), or one could provide his own entertainment by claiming ownership of Rhyolite's (main) Golden Street.

Every so often a drunk would stake his claim and attempt to prove his ownership by sending lead flying in all directions. The townspeople would swear at him but few would exchange shots, preferring the more safe and more certain course of keeping out of sight until the drunk exhausted both his ammunition and himself and eventually passed out. At that point his body would be picked up and laid to one side until he sobered up. If he became a nuisance by repeating the performance too frequently, a quiet but determined delegation would await his ultimate recovery and impose the supreme penalty — banishment. The unpopular individual would then be firmly escorted to the edge of town, provided with a full canteen and given the stern and final admonition: "Don't come back!" The advice was always heeded, and a number of canteens were reported to have been issued by citizens of Rhyolite as well as of Greenwater and Skidoo.

One of the most notorious of such characters was "Diamondfield" Jack Davis who, although sentenced to be hanged on five distinct occasions, invariably managed to elude the noose. In his more sober moments, Davis operated a stage line from Goldfield to Rhyolite for a time. Once, when quite drunk, he shot up Golden Street and invited all the "so and so's" in town to stick their heads out so he could shoot them. Sheriff MacDonald had had about enough of such shenanigans and decided that this time it was now or never. He walked boldly down the street toward Jack and was met by the warning, "Don't come any nearer, Mac, or I'll kill you sure as hell." "Give me your gun," the sheriff replied as he kept on approaching; "You're drunk!" With that, Jack meekly handed over his gun.

Life in Rhyolite was not entirely one of fun and frolic, however. There were businesses to be conducted, and more were in the process of building. Three water pipelines were built into town; four banks were inaugurated; and three newspapers commenced publication to serve the area. All told, approximately 85 mining companies were incorporated and brokerage houses used a sizeable por-

tion of their expense budgets to take major, full-page advertisements in the newspapers to sing the praises of the local mining stocks. The names of most of the companies had a substantial, wealthy ring to them to inspire confidence; one exception of undetermined psychological approach was incorporated under the aegis of The Bullfrog Terrible Mining Company.

All in all, the outlook for residents of Rhyolite and the Bullfrog District in the fall of 1905 was both pleasant and prosperous. The mines were blossoming; business was booming; and the citizens were looking forward to the advent of three distinct railroads — two from the south and one from the north. The Las Vegas & Tonopah was rapidly being pushed forward by the Clark interests after a late start; the Tonopah & Tidewater of Borax Smith was finally getting under way out of Ludlow in its second beginning; and a Bullfrog Goldfield Railroad had just been incorporated, and its promoter, John Brock (of Tonopah & Goldfield Railroad fame), was already forecasting an early completion of the line to Bullfrog. Such a wealth of transportation projects demanded a busy and growing area and Rhyolite seemed ready to meet that obligation, being itself the center of a cluster of satellite towns. To the southwest was Bullfrog; to the east was Beatty. And just south of Beatty, immediately beyond the narrows of the Amargosa River lay the erstwhile metropolis of Gold Center — at least it was about to become one, if advertisements in the local newspapers could be believed. In addition, locally, the Tonopah-Goldfield Trust Company had sufficient confidence in the future of Rhyolite to erect a two-story bank building, while the LV&T Railroad had already secured a 200 ft. by 1400 ft. tract of land for the future location of its railroad yards.

Difficult to realize in retrospect is the fact that Las Vegas, at the southern juncture of the LV&T with the Salt Lake Route, was a mere tent camp just then turning into a town. The burgeoning community, now six months old, consisted almost entirely of a few railroad and construction workers intent on the building of the LV&T. Since the entire settlement could hardly be considered a supply source, a permanent commissary camp including boarding accommodations for 100 men was built and a material yard was started.

Unlike most beginning railroad projects, the financing of construction of the LV&T presented no real problems. Senator William A. Clark and his brother, J. Ross Clark, were in a position to

underwrite the entire cost of the road. Senator Clark, aided by the complete absence of income taxes at that time, had been able to amass a personal fortune variously estimated to be well in excess of $100,000,000, the principal source of such income being profits earned in (Butte) Montana copper mining. Indicative of the adage that "The rich get richer . . .", there is an oft-told tale that back in the late 1880's someone sold this already wealthy man an Arizona gold mine for a purportedly exorbitant $80,000. The mine turned out to be "salted" with gold, but overlooked by the vendors were the rich beds of copper buried in the soil of what became the United Verde of Jerome. Reportedly Senator Clark ultimately refused an offer of $25,000,000 for the property simply because he did not know what to do with the extra money! (The story makes likeable reading, but it is not true, as Senator Clark was an experienced mining man and knew what he was doing when he bought the copper mine.)

Also backing the Senator was Richard C. Kerens, an ambassador who amassed a fortune in railroad construction and, although Senator Clark sparked the new railroad, it was J. Ross Clark who headed the LV&T as its president. Arthur Maguire was the chief engineer, and Frank M. Grace became the superintendent. Charles O. Whittemore, a tireless worker, was appointed general counsel and also became the "press, public and community relations man" (as he might be described today), although J. Ross Clark assumed a large portion of these latter responsibilities personally. The record left by this group of men in the form of reported speeches, interviews and letters demonstrates an abnormal amount of frankness, candor and honesty in dealing with the press and the public, an integrity which stands out far above the contemporary practices of the times for clandestine evasiveness in such matters. Almost invariably when Clark or Whittemore made a public promise, it was met in full; and those promises which were not met (such as the inability to meet the promised date of completion of the railroad into the Bullfrog District) were broken due to factors beyond their control.

By the end of the year 1905 the project appeared more attractive than ever. Additional notoriety and prestige attached to Rhyolite when none other than Senator William Stewart moved to town. Stewart earlier had been an attorney who had made a fortune in Comstock mining litigation, only to lose it in various mining ventures. Now, ensconced in his new adobe home with his wife and daughter, he opened a Rhyolite law office and also arranged to augment his livelihood by building a chicken house for 200 chickens. After spending 32 years in the U. S. Senate, Stewart, then 78, stated that he wanted to spend his remaining days with the boys and that it was better to wear out than to rust out.

At the same time down in Las Vegas, 124 miles away, graders for the railroad began to arrive. On December 28, 1905, LV&T locomotive No. 1 was delivered on location for use on the first construction train. The following week, on January 4, 1906, 75 men began spiking down the first rails, using an Improved Harris Track Layer. An additional 325 men utilizing 150 teams were employed in the grading operation, and the initial progress was rapid, thanks to the earlier grading work of the T&T. Two weeks later the railhead had been extended 10 miles out from Las Vegas, and a month after the start of construction the rails reached out for 24 miles to a point just beyond Corn Creek. By this time the graders were working some 30 miles out, and the advance grading camps were strung out at points up to 53 miles away — almost halfway to Bullfrog. Distances were increasing, so the motive power roster was doubled with the receipt of a second, larger locomotive.

In spite of the progress being made in construction, rumors began to develop that the railroad would stop work at Mile Post 44, near Indian Creek (soon to be called Indian Springs). Rhyolite became concerned and sent F. O. Frazier of the newly organized Rhyolite Board of Trade down to Las Vegas to call on J. Ross Clark and ascertain the details. Clark assured Frazier that the railroad had no intention of stopping at Indian Creek (except possibly for water) and that the railroad would definitely be built through to the Bullfrog District. In addition, at the close of the interview, Clark also arranged for Frazier to ride out over the new line with Frank Grace to the end of track, thereby shortening the time of his return trip to Rhyolite.

Judge Lorin O. Ray of Rhyolite received equally sincere consideration when he visited LV&T general counsel, Charles O. Whittemore, in Salt Lake City. Whittemore pointed out that building the railroad through Beatty, over Doris Montgomery Pass and along the north side of Rhyolite to skirt Bonanza Mountain would shorten all of the ore wagon hauls from the mines to the railroad, but that it would add tremendously to the cost of construction of the railroad due to the heavy rock

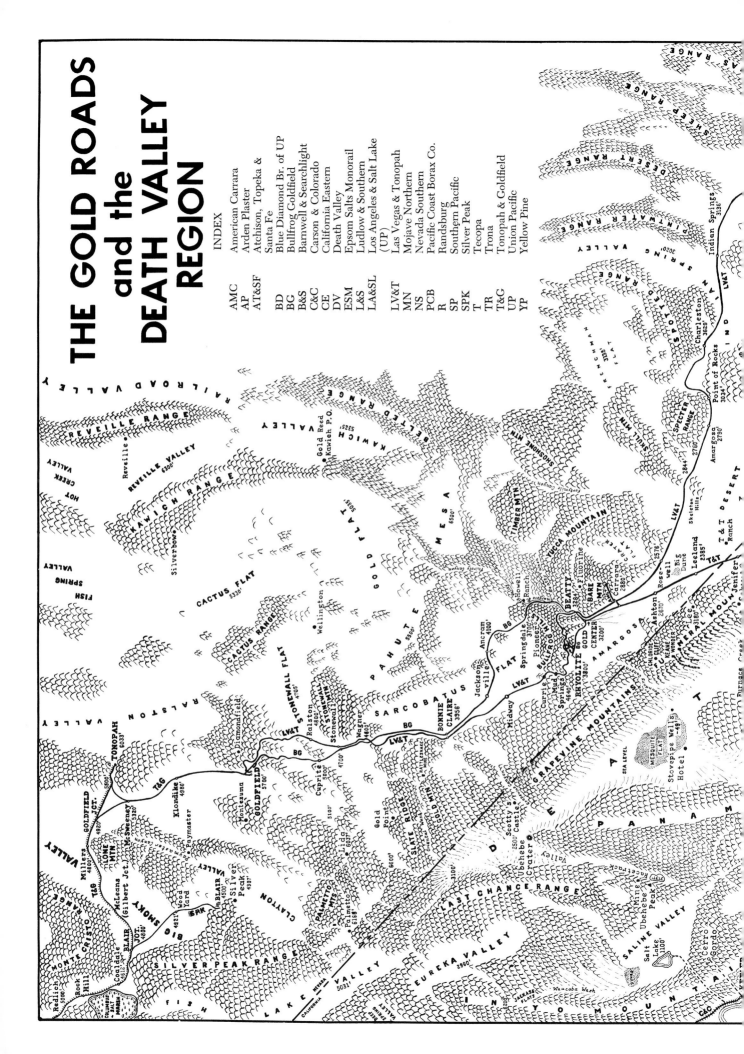

THE GOLD ROADS and the DEATH VALLEY REGION

INDEX

AMC	American Carrara
AP	Arden Plaster
AT&SF	Atchison, Topeka & Santa Fe
BD	Blue Diamond Br. of UP
BG	Bullfrog Goldfield
B&S	Barnwell & Searchlight
C&C	Carson & Colorado
CE	California Eastern
DV	Death Valley
ESM	Epsom Salts Monorail
L&S	Ludlow & Southern
LA&SL	Los Angeles & Salt Lake (UP)
LV&T	Las Vegas & Tonopah
MN	Mojave Northern
NS	Nevada Southern
PCB	Pacific Coast Borax Co.
R	Randsburg
SP	Southern Pacific
SPK	Silver Peak
T	Trona
TR	Tecopa
T&G	Tonopah & Goldfield
UP	Union Pacific
YP	Yellow Pine

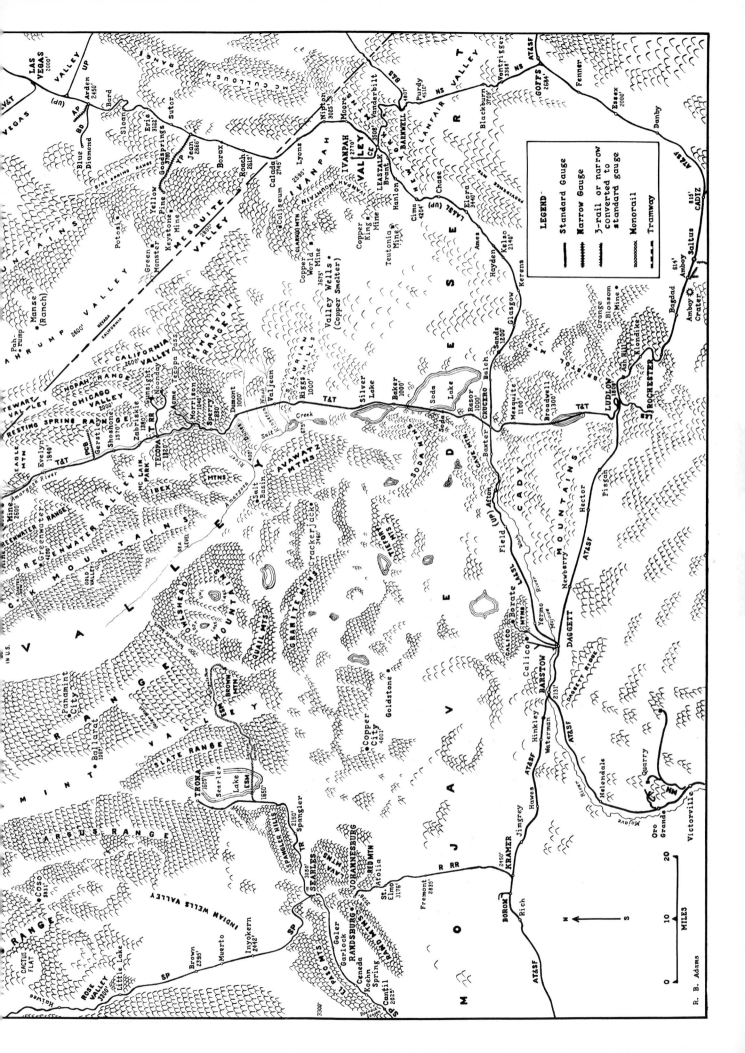

work necessary as well as the added cost of operation of such a hilly line. Whittemore hoped that the railroad would secure the cooperation of the mine owners in procuring permission to cross the mining claims in the vicinity of Rhyolite so the job would have as few impediments as possible. He did not hesitate to point out that it would probably cost as much to build the 16-mile "High Line" from Gold Center and Beatty through Rhyolite to Mud Springs (summit) as it would cost to build the entire 116 miles of line from Las Vegas to Gold Center. Perhaps he was right. If one drives over the old right-of-way of the LV&T today, passing through rock cuts and over fills, it is easy to appreciate the probable validity of this statement. Compared with the Bullfrog Goldfield's easy way around the south base of the hills, the situation is even more dramatic.

Everyone took heart when, on March 1, 1906, the first regular LV&T train operation commenced. True, it was only a mixed train with an over-all speed of 18 m.p.h., and it only ran from Las Vegas as far as Indian Springs (43.6 miles); but it represented a start of life-giving service and helped to reduce the time of travel between Rhyolite and Las Vegas. Lawrence Kimball's stages connected with the trains at Indian Springs, providing an overnight stay at Ash Meadows on the northbound run and at Indian Springs southbound. Travel aboard the steam cars for the balance of the trip was indeed a welcome relief.

Bob Montgomery became the defendant in a grubstake lawsuit involving his Montgomery-Shoshone mine at Rhyolite. When his claim to full title ultimately was sustained by the court, the legal victory just naturally called for a rousing champagne celebration at the new Montgomery Hotel in Beatty. The two-story hostelry had been completed just a few months previous and was destined to become the scene of many of the important local banquets and celebrations. The importance of Montgomery's legal victory was not completely evident at the time, but the following month the clear title to the property made it possible for Montgomery to sell the mine to agents of Charles Schwab (the steel king) for a reported $5,000,000.

Banquets and celebrations became a form of local pride and distinction nearly akin to that of a royal reception. Amazng in the extreme was the resourcefulness of the people living on the sagebrush covered desert to create a formidable banquet on virtually the shortest of notices. When the Rhyolite Board of Trade wanted to arrange one

such Sunday banquet at the Southern Hotel in Rhyolite in honor of a visit by LV&T's J. Ross Clark, Whittemore and Maguire, provision was made for an ultimate total of 80 people to sit down to a five-course dinner topped off with Mumm's Extra Dry, while carnations tastefully decorated each place setting. Speeches, toasts and the reading of telegrams from dignitaries enlivened the repast, following which Clark entered his plea for LV&T consideration. Outlining the difficulties of building the proposed "High Line" through Rhyolite, he indicated his approval of the route and stated that the LV&T would adopt it if the citizens were willing to furnish the necessary grounds for a depot together with a right-of-way through the various mining claims. In conclusion he added a few words of comment concerning the attitude of certain newspapers which had knocked the project, then ended by assuring his audience that the Las Vegas & Tonopah Railroad would be built.

In aftermath, Whittemore arose to pay many nice compliments about the district, referring to its marvelous deposits of mineral wealth. Then he went on to comment, "When a railroad is established, it usually remains for many years. We simply ask for the ground on which to lay those bands of steel." Little did he or the assemblage realize the shallow mineralizations of the mines which ultimately forced abandonment of those rails within the short span of a dozen years. Instead, his words struck home and were given added emphasis by Judge Ray who urged the people to act wisely in the right-of-way matter. The Judge then digressed from the railroad subject to urge the donation of a site for a new Nevada state capitol in Rhyolite, an even more presumptive project.

At a mass meeting the following night, people jammed into the Arcade Hall to listen to, then authorize the Right-of-Way Committee of the Rhyolite Board of Trade to enter into an agreement with the LV&T to supply a right-of-way through town. The authorization was predicated on three conditions: that work on the railroad line be commenced within a reasonable time; that the railroad be completed within a period of six months; and that the route thus built constitute a portion of the main line of such railroad (and not just a branch). The LV&T not only acquiesced in these stipulations but clinched the bargain by making similar right-of-way agreements with the Beatty Promotion Committee and with the Tonopah-Goldfield Trust Company at Gold Center. As though to cap the climax before leaving with the

agreements, both Clark and Whittemore expressed their confidence in the future of the district by purchasing 25,000 shares of the Mayflower Bullfrog mine, 50,000 shares of the Bonanza Mountain Gold Mining Company and 25,000 shares of the Eastern Contact.

Construction continued to move forward on the LV&T. By the middle of March 1906, 53 miles of tracks had been laid, and the graders were working some 84 miles from Las Vegas. The average work for a normal day comprised about one mile of completed grading accomplished to two miles of finished track laid. One local reporter, either with his tongue in his cheek or else with a complete lack of historical background and experience, was observed to comment: "One day last week the track layers beat the world's record, laying two miles and 140 feet!"

Unfortunately, the pace could not be maintained. On March 24, 1906, a four-day storm washed out the main line of Senator Clark's SP, LA&SL (Salt Lake Route) in the Meadow Valley Wash, and J. Ross Clark's LV&T construction crews were conscripted to help repair the damage. For 22 days the transcontinental line was closed to traffic, while work on the LV&T was halted for over a month.

In spite of this setback, the LV&T was still far ahead in the three-way race to bring rails to the Bullfrog District and Rhyolite. To the north, John Brock and his Bullfrog Goldfield Railroad were repeating their forecasts of building a railroad, but formation of the Bullfrog Syndicate to finance the line was just being accomplished. Borax Smith's Tonopah & Tidewater was producing the best showing, but even that was relatively inconsequential. Although T&T graders were working about 80 miles south of Rhyolite, actual rail laying had only just crossed Silver Lake and the big (future) obstacle, the Amargosa Canyon, had not been attempted. Smith was optimistic, however, and taking a cue from the public pronouncements of Clark's purchases of local mining stocks, Smith demonstrated his faith in the Rhyolite-Bullfrog future by purchasing 100,000 shares of Yankee Girl. In spite of the impressive volume, the dollar amount was a far more conservative figure considering that Yankee Girl was selling at 10-12 cents a share on the exchange.

On the basis of current progress, it had been estimated that LV&T rails would reach Beatty about the 1st of May, 1906, following which three additional months would be required to complete

the High Line. With the heavy rock work and the necessary deep embankments, the cost would be approximately 10 times greater than that for a railroad around the hills a mile to the south of Rhyolite, as had been surveyed the previous September. Moreover, the heavy 3% grade from Beatty to the Doris Montgomery Summit would require double-heading up the hill which, in turn, would increase operating expenses as against those for a lower line. The big advantage of the High Line was that it brought the rails close to the mines so that the ores from many mines could be dumped directly from the mine cars into the waiting gondolas. Since the Montgomery-Shoshone, the leading producer, was situated far up on a hill above town, arrangements were made to service that mine with a special spur, even though a 4% grade was required to reach the objective. It was also agreed that, if traffic warranted, special spurs would be built to the Gold Bar and the Mayflower mines. Production of these mines, however, never reached their optimistic estimates and failed to warrant direct rail connections.

Had the railroad followed the easier route a mile to the south, the added cost to the mine owners of hauling ore by wagon to the railhead would have priced many of the low-grade ores out of the market. As matters stood, it was generally agreed that the railroad's freight rates would be set in such manner as to permit the profitable shipment to the Salt Lake smelters of ores of a value of $25 per ton.

Excitement was in the air, everywhere, in the Bullfrog District. New, rich discoveries were constantly being announced. Transvaal (for example), just six miles east of Beatty, was only two weeks old in early April 1906; but it was enjoying a sizeable boom. It had already outgrown its original name of Nyopolis; it boasted 75 tents, four saloons, a galaxy of brokers and an equal complement of real estate men. Over the period of the next month some 700-800 people descended upon the location and set up housekeeping.

As each new strike was reported, excitement became compounded. People rushed off to find the riches they had hoped to find in the last several boom camps. Of course they were disappointed again, but soon there would be a new boom, a new camp, and another chance. The same wild excitement carried over into spuriously heavy speculations in mining stocks and in town lots. Brokers of the former, with no conscience and no Securities and Exchange Commission to be their guide and

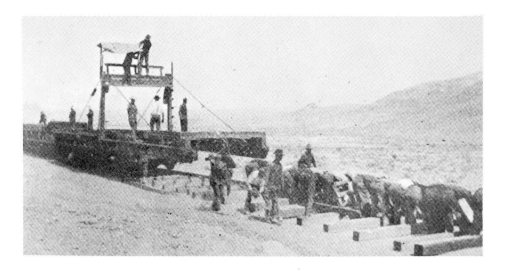

In June 1906 the graders at Gold Center *(top, right)* could almost see their primary objective of Rhyolite, lying behind Ladd Mountain in the distant foreground at far left. Instead of a straight push across the desert their circuitous 7-mile route lay up the valley of the Amargosa River to Beatty (around the range of hills in the foreground and out of the picture to the right), then a sharp swing left to pass up and over Doris Montgomery Summit *(center, background)* before descending to the upper elevations of Rhyolite proper. *(A. E. Holt photo, Nevada Historical Society.)*

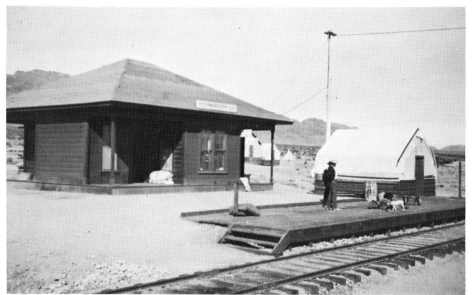

On October 10, 1906 *(right, center and bottom)*, the majority of tracks had been laid and workers were busy putting finishing touches to the side tracks. *(A. E. Holt photos, Nevada Historical Society.)*

Utilizing an early version of Harris Track Laying Machine (shown above about 30 miles north of Las Vegas), workers managed to position a maximum of about two miles of main line rails per day. The Amargosa station, whose reinforced canvas tent serves as temporary baggage room, was originally called Johnnie when the rails first reached there in the spring of 1906. The name was changed in August of the same year. *(Both photos, Nevada Historical Society.)*

Days later the mixed train *(bottom, left)* proceeded south over the new trackage behind a leased SP Vauclain Compound No. 1774. *(Munro S. Brown.)*

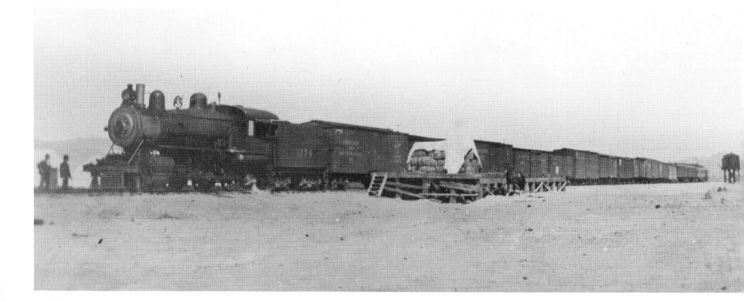

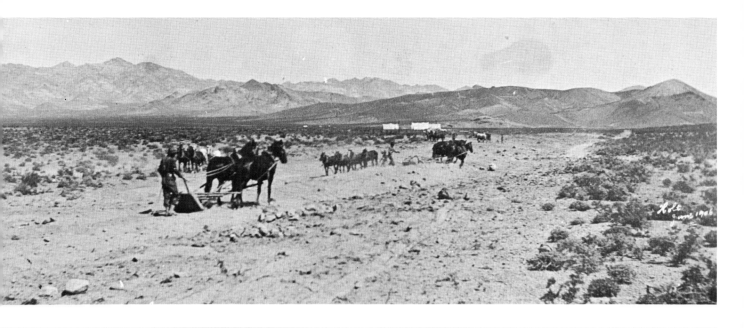

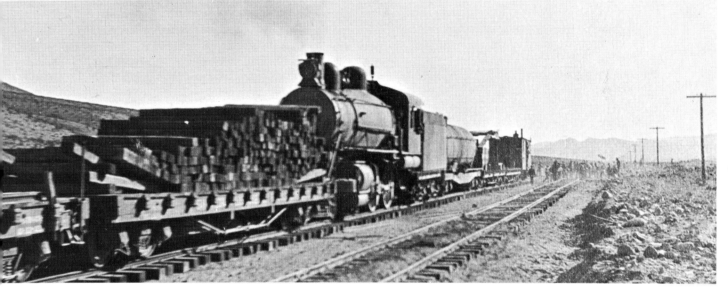

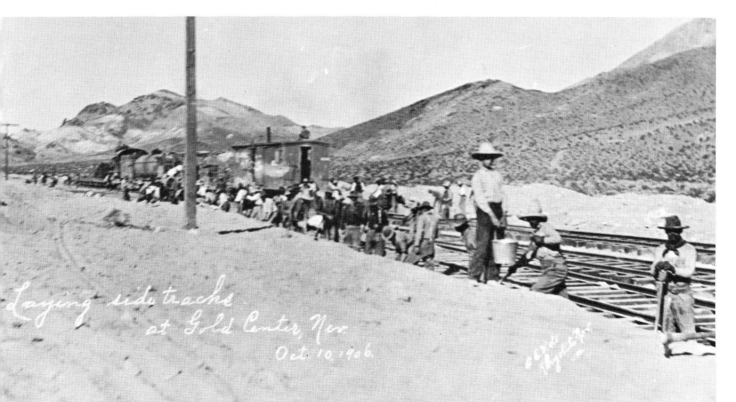

Laying side track
at Gold Center, Nev.
Oct. 10. 1906.

mentor, plugged the individual mining stocks of all and sundry in full-page newspaper advertisements without regard to value or worth. Shares of Transvaal Extension Mining Company, for example, were being offered at 15 cents a share; or as Gordon Campbell & Co. of Goldfield proclaimed in large, clear type, "We advise immediate purchase of Keane Wonder. This should double in price within the next 30 days."

Land speculators joined in the scramble for wealth. When superintendent Grace of the LV&T announced that he would install a siding at Johnnie station (the name was changed to Amargosa in August 1906) in order to serve the booming mining camp off-line about 13 miles to the south, land grabbers immediately began beating the drums. One imaginative broker in Rhyolite ran the following full-page ad in the paper; "YOU MUST HURRY or you won't get a lot in Johnnie. They are selling like red lemonade at a circus and already one-quarter of the townsite has been sold to shrewd investors who know a good thing when they see it, and they can see a good thing in Johnnie. For maps and full particulars call . . ."

By April 1906 the Salt Lake Route had been repaired and once more trains were running. The borrowed LV&T construction forces were returned to home grounds to resume work where they had left off. By April 20 the grade had been completed to Rose and Palmer's Well (a name which subsequently was abbreviated to Rosewell), at a point about 100 miles from Las Vegas. In early May an advance grading crew was establishing headquarters just west of Beatty on the Doris Montgomery grade, and a few days later the regular graders established a second camp at Gold Center preparatory to starting work for the yard tracks to be installed at that point. The yard, station buildings, switches and turntable were laid out by W. C. Bryan, and a 2,000-foot side track was planned for use in making up trains. Other switches would lead to team tracks and house tracks.

When Timetable No. 4 went into effect on May 25, 1906, regular trains were scheduled as far as Johnnie station (74.5 miles); track laying was progressing between there and Rosewell (100 miles); and the regular graders were filling in the last 10-mile gap to Gold Center (116 miles). A new station called Owens had been established 28 miles north of Las Vegas to serve the sawmill of the Lincoln County Lumber Company near Charleston Peak, which was turning out timber for the Schwab mines at Rhyolite.

Rhyolite was continuing to look forward to the arrival of its first railroad. The Board of Trade had been busy securing the right-of-way through donations of land by the mine owners. Those few who refused to donate were paid in cash for outright purchase of the necessary property, the money coming from a supplemental cash fund also donated for that particular purpose. Most of the mine owners were very cooperative as the proximity of railroad transportation would mean a terrific saving to them of time, money and expense in the marketing of their ores. J. C. McCormack, president of the Golden Sceptre, offered a right-of-way gratis over his McCormack Addition, and by the time the grading contract was let covering the section through Rhyolite, the rail pathway wound across such mining claims as Bell Boy, Ruby, Cyclops, Tramp No. 1 and Mumm's Extra Dry.

Rhyolite's town proper was continuing to expand as well, both in buildings and in population. When Dr. Grigsby erected his combination dental office and residence on Golden Street, he little dreamed that one day it would become a landmark. Although the wood and plaster components have disappeared with the years, the cement front of the building with its three symmetrical arches can still be seen today just north of the Cook Bank Building.

The pathos of some of the human problems of living on the desert was not to be denied. When the baby boy of Mr. and Mrs. Thomas Kilker became very sick, it was considered best to take him to a sea level altitude and climate. Mrs. Kilker boarded the stage to Johnnie with the baby in her arms and rode to the railhead, then transferred to the cars of the LV&T for the trip to Las Vegas. When the infant's condition became worse while en route, she telegraphed for her husband who hired a special rig for a fast ride to Johnnie. Arriving just after the train had left, he managed to secure a handcar and pushed on, somehow hurting his hand in the cogwheel of the car. His unscheduled arrival in Las Vegas was both tardy and disheartening; his wife had gone on to Los Angeles, and the baby had died en route.

By the middle of June 1906 the LV&T was progressing as well as could be expected. Grading had been completed all the way through to Gold Center on the outskirts of Beatty, but due to the scarcity of labor at that time, the rails were still 29 miles short of that goal. The other roads were faring no better. Smith's T&T had completed about 75 miles of track north from Ludlow, then stalled on the

southern approach to the Amargosa Canyon. The heat of the summer plus the scarcity of labor brought the entire project to a stop. The Bullfrog Goldfield (to the north) had only commenced track laying at Goldfield on May 8, and in spite of the more favorable altitude and climate, the same shortage of workers persisted to delay all progress.

To counteract the deteriorating morale, H. T. Greene, general freight and passenger agent of the LV&T, spent a week in Rhyolite getting acquainted with the merchants and ore shippers. When asked about freight rates over the forthcoming line, Greene commented: "We have not made up the tariff schedule between Las Vegas and the Bullfrog District towns, and probably we will not be ready to announce rates until the road is finished. I will say, however, that we do not mean to hold up the people. This has been demonstrated in the passenger fare, which is 6 cents a mile as compared with the 10-cents-a-mile rate on the Tonopah & Goldfield Railroad. We will be just as reasonable with our freight tariffs as our passenger rate. Mr. Clark has promised fair rates and you will get them. If you people have low-grade ores that you want to move to the smelters, I think we can fix things all right."

The heat of Rhyolite's second (1906) summer of existence was terrific. Most welcome indeed was the new swimming pool of Charlton & Hill, the tank of which the proprietors claimed was a little longer than that of any other pool in the District, and the Patrick water just a little wetter. Over in Bullfrog, one mentally deranged individual developed an extreme phobia toward typhoid fever germs and managed to set fire to the town's empty hotel early one morning; the resulting holocaust moved the townsite one step further toward extinction. In Beatty, on the other hand, the four-month-old Montgomery Hotel was about to be rechristened with E. S. Hoyt as its new manager. Of more importance than Hoyt's impressive record of 20 years in the hotel business was the awe-inspiring rumor (unconfirmed) that he was Senator Clark's brother-in-law and that the Senator himself was scheduled to visit the District in July for the first time.

The rumor partly must have been founded on fact, for Senator Clark did visit Rhyolite. His private railroad car rolled south over SP (N&C) rails to Mina where it was picked up by the Tonopah & Goldfield Railroad and brought the rest of the way to Goldfield. Here the rail journey abruptly

BEATTY

Key to Numbered Buildings
1 Montgomery Hotel
2 H. D. & L. D. Porter Store
3 Christensen's Store (P.O.)
4 Palmer's Store
5 School
6 Exchange Club (& Hotel)
7 LV&T Boarding House
8 LV&T Beatty Depot
 (MP 118.4)
9 BG RR Water Tank
10 BG RR Beatty Depot
11 LV&T Engine House

Notes: After June 1914, the BG RR track from Points A to B was abandoned. Also abandoned was the BG RR track from Gold Center to Rhyolite, and the BG RR used the former LV&T track to Rhyolite. The connection at Beatty (dotted line) was built at that time.

The present highway from Las Vegas (US 95) enters Beatty on 2nd Street and continues northeast on Main Street to Goldfield. Turn southwest on Main Street for the road to Rhyolite and Death Valley (Daylight Pass).

LV&T to Rhyolite and Goldfield
2nd
3rd
MONTGOMERY
MAIN ST.
BG RR to Goldfield
LV&T (Later T&T)
BG RR
—A
Amargosa Narrows
B—
BEATTY JCT. (M.P. 117.)
Ice House
Amargosa River Crossing
BG RR (Later T&T)
LV&T to Las Vegas
GOLD CENTER
N
BG RR (also T&T) to Rhyolite (Aban. 1914)
BG T&T
End of T&T Ownership 1907
T&T to Ludlow
GOLD CENTER (LV&T M.P. 116.1)
0 1/2
MILE

ended at the junction with the unfinished Bullfrog Goldfield Railroad, while the Senator incommodiously finished his expedition by auto to Rhyolite.

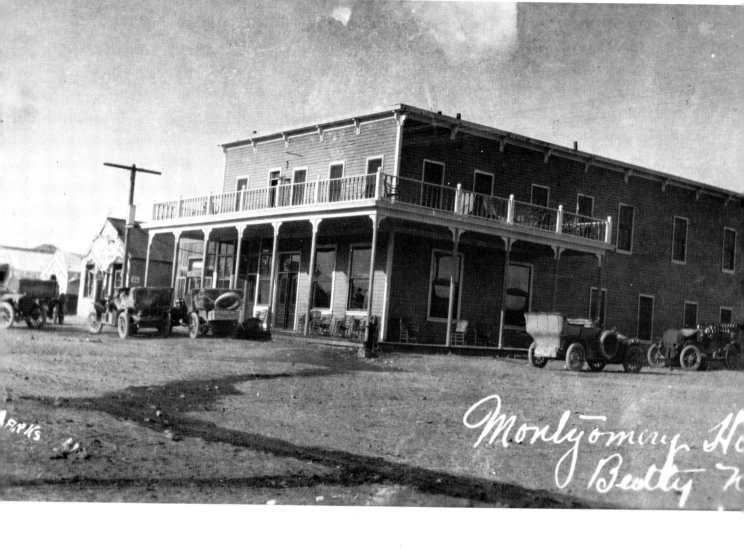

Montgomery H... Beatty N... [handwritten]

A. FIRKS [handwritten]

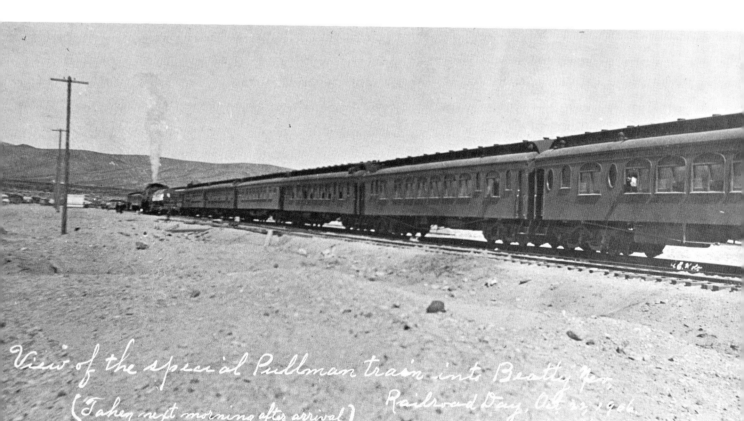

View of the special Pullman train into Beatty No. Railroad Day Oct ... 1906 (Taken next morning after arrival) [handwritten]

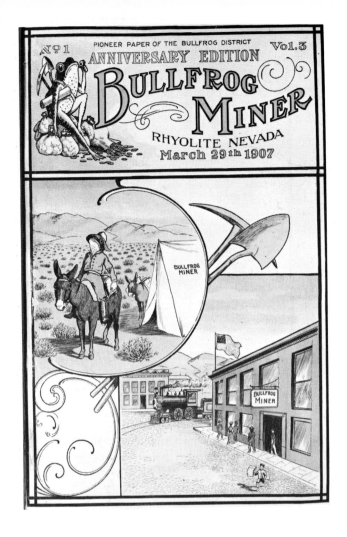

Pride of Southern Nevada was the Montgomery Hotel in Beatty, shown *(far left)* in its palmier days when miners and nabobs shared the desert luxury of its appointments. In later years, when Beatty was on the wane and the boom at nearby Pioneer was on the ascendancy, the hotel was moved to follow the new excitement, only to be lost in the fire that swept Pioneer into ashes. The small building to the left of the hotel was the home of the *Bullfrog Miner* and is shown before that publication moved to Rhyolite. Subsequently the forepart of the building served as a justice court, to the rear of which Mrs. Gray conducted her laundry business. Walter Marks, the photographer, also served as town barber.*(H. K. Hall Collection.)*

Eleven Pullmans, a day coach, a diner and two special cars of visiting dignitaries comprised the lengthy train shown *(below, left)* on the morning after its tardy arrival for Beatty's Railroad Days on October 22-23, 1906. The event was anticlimactic, for regular passenger service to town had been inaugurated four days before. *(Nevada Historical Society.)*

The Exchange Block in Beatty *(below)* was built over 50 years ago. The high-wheeled autos of the 1920's are gone; the street has been paved; but visitors today are still being served drinks across a modern bar. *(H. K. Hall Collection.)*

Good use was made of the available time during Clark's visit. The route of the LV&T for the 21 miles west from Rhyolite to Mud Springs Summit was carefully examined, as were the Montgomery-Shoshone mine and the LV&T yards at Gold Center. Reporters' questions were skillfully parried with generalizations. Clark said he was so engrossed with his other business interests and senatorial duties that he had not found time to invest in the Bullfrog District, but that he was putting up a good share of the money for the building of the railroad. He stated that the LV&T had not purchased or taken over the grade of the Bullfrog Goldfield Railroad [as the *Goldfield Sun* had so errantly reported the previous week], but that the LV&T had planned to and would build its own line between Rhyolite and Goldfield. Further, he emphatically denied the statement that the Harriman (UP) interests owned 51% of the Salt Lake Route, although he failed to elucidate that, according to the agreement, it was a joint 50-50 arrangement.

During the period of Senator Clark's visit, in Rhyolite his private car made a grand 1,000-mile tour of its own. It was deadheaded from Goldfield back north to Reno, then westward to California and south to a connection with the Salt Lake Route, which then hauled it eastward again to Las Vegas for delivery to the LV&T and a final haul northward to the end of line at Rosewell. Clark met it at Rosewell following his exit southward from Rhyolite in the same manner in which he had arrived — by auto. Inspection of the balance of the LV&T route was an important part of his itinerary.

When LV&T Timetable No. 5 became effective on July 5, 1906, Rosewell was the indicated end of track. No. 11, the daily mixed train, left Las Vegas at 7:00 A.M. and covered the 100-mile distance to Rosewell at 12:10 P.M. Returning, the same train become No. 10 and left town at 1:30 P.M. for a carded arrival at Las Vegas at 6:10 P.M. A most reassuring note was appended to the schedule to indicate that No. 10 (the afternoon train) would delay its departure from Rosewell whenever necessary due to the non-arrival of No. 11 (the morning train) at the earlier hour. Obviously the company wished to avoid every possibility of the same train meeting itself on the single track line.

The single set of equipment for trains Nos. 10 and 11, plus the relatively tight turn-around scheduled for Rosewell, favored some travelers and worked a distinct hardship for others. People could leave Rhyolite by stage at seven in the morning, make connection with the LV&T at Rosewell

and arrive in Las Vegas in time to catch the overnight sleeper for following morning delivery at Los Angeles. Travelers from the other direction, however, had a contrastingly more difficult time. The Salt Lake City train from the east was scheduled to arrive in Las Vegas just one-half hour after the LV&T train had left for the north. In fact, the latter's frequent and vexatiously delayed departures usually meant that Salt Lake City passengers would just be rolling into town as the LV&T train was smokily and visibly diminishing off in the distance. The frustrating 23½-hour wait in the torrid heat of a Las Vegas summer caused the editor of *The Rhyolite Herald* to remark: "That place hasn't any well-established reputation as a summer resort, and but few people hesitate to take the first train to Rhyolite." The situation could not be corrected, however, until October 1906 when two sets of LV&T equipment were finally put on, thus permitting a readjustment of the schedule.

Rosewell continued to be the end of LV&T track for over a month as all rail laying ceased due to a strike of the Sailors Union of the Pacific. A shipload of cross ties lay at anchor in Los Angeles Harbor, but none could be delivered on location so that work could proceed. Instead, Rosewell made news of a different kind when an idled Mexican laborer, loaded with a quarrelsome quantity of strong drink, visited the tent of a "sporting woman" and threatened to cut her throat from ear to ear. The woman managed to escape to a nearby saloon where the aid of more friendly inebriates was enlisted. One man succeeded in firing a revolver into the air in an attempt to scare the Mexican from the woman's tent, but the effort backfired when the Mexican reacted by heading straight for the saloon, his large knife in his hand and a glint in his eye. The woman took refuge in an empty barrel, leaving her cohorts to face, shoot and instantly kill the Mexican as he entered the saloon. Since women were scarce in the desert country, no immediate charges were filed against the unoffical "game warden" for possession of the revolver.

Flash floods hit the LV&T during August 1906, but the damage was not so severe that grading could not continue on the High Line between Beatty and Rhyolite. By the middle of the month, the 3% grade to the Doris Montgomery Summit was virtually completed, and, to the west, the "big cut" in the notch (used by the present auto road today) was finished. Downhill to Rhyolite, the cuts and fills were nearly ready for the laying of the rails.

474 —

Early in September the track-laying machine began working again when a supply of ties (reportedly loaned by Borax Smith to Clark) was received. Tracks crept forward over the 16 miles from Rosewell toward Gold Center. Two weeks later the people of Rhyolite could look down to the flat and see the smoke of the construction train far out on the Amargosa Desert to the south of Gold Center. Excitement was in the air; the end at last seemed near. Since the Right-of-Way Committee, in spite of all their efforts, were still contending with some unpleasant matters over small sections of property needed to complete the line through Rhyolite, grading was started to the west of town along the side of Bonanza Mountain beneath the Golden Sceptre workings. The few loose ends would be joined together at a later date.

Settlement of the Sailors Union strike at Los Angeles Harbor signalled the release of the shipload of ties which had been impounded by the inactivity at that locality for many months. The arrival of the first 10 carloads of ties at Las Vegas by the end of September plus the promise of a shipment of steel rail for delivery the following week seemed to be adequate assurance that the line would be completed to Beatty in short order. The forecast was justified. On Sunday, October 7, 1906, the first construction train pulled into Gold Center (116 miles from Las Vegas) bearing Governor Sparks and other fellow Democrats. The following (Monday) night they held a rally at Slim's Adobe which was somewhat anticlimactical as the Republicans, with ex-Senator Stewart as chairman, had already held theirs just two days before, utilizing the same facilities.

On Friday, October 12, 1906, the first regular passenger train to Gold Center arrived, and in honor of the occasion was allowed to proceed over skeltonized track to Beatty. Some people commented that the number of railroad officials on board might have had something to do with the special dispensation, for Gold Center became the official terminus of the railroad for all scheduled trains until Thursday, October 18, when the last two miles to Beatty were placed in regular operation.

J. A. Cottrell was the agent in charge during the first hectic week at Gold Center, while George F. Knight handled affairs at the Beatty station. Freight arrived in such large quantities the teamsters were unable to cope with the deluge. Lumber was particularly welcomed by the mine operators and prospective home owners, and a building boom

ensued at Rhyolite. Passengers between Beatty and Rhyolite were hauled over Doris Montgomery Pass by stage at a dollar a head.

The advent of the first scheduled train to Beatty became the cause celebre for a big impromptu celebration. Guns were fired by a large number of citizens and pandemonium reigned, while the hills echoed and re-echoed the noise of the powder blasts mixed with the commotions of the populace. This was the real thing — the main event. The forthcoming Beatty official Railroad Days, scheduled for October 22-23, 1906, could not help but be anticlimactic.

To J. Ross Clark, the event signalled a new and different honor for he had won the race to the Bullfrog District, arriving a full six months ahead of his nearest competitor and slightly more than a year before the last of the three railroads would complete its rails to the area. The achievement was significant. Fortunately for Clark, he could not look ahead to see that when the time came to pull up those same rails, his LV&T would be the first to go, to be followed by the BG another 10 years later, while the presently ignominious T&T would outlast them all by another dozen or so years.

Obviously there were no premonitions to dampen the enthusiasm of the populace either. Beatty's Railroad Days started off with a delegation of local boosters voyaging to Las Vegas to meet the special trains from Salt Lake City and Los Angeles which were bringing celebrants from these distant localities. At Las Vegas the two specials were combined into one big train of 11 Pullmans, a day coach, a diner and two special cars of visiting dignitaries. With this auspicious assemblage, the lengthy LV&T train set forth across the desert on its northbound run to Beatty. Unfortunately, a mechanical breakdown occurred late in the day which delayed the celebrants a matter of hours, but the time was gainfully utilized. While the excursion was stalled on the desert, the visitors busied themselves in building bonfires, marching around the sands under the leadership of the Los Angeles band, and making speeches whenever a crowd gathered about one of the campfires. When the difficulty with the equipment was finally corrected, the entourage resumed its journey, and the special finally arrived at Beatty at 8:30 P.M., over four hours behind schedule.

The lateness of the hour had no apparent effect upon the warmth of Beatty's welcome. People flocked to the railroad to watch the arrival of the

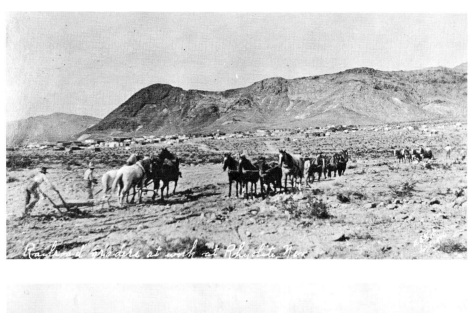

Railroad graders at work at Rhyolite, Nev.

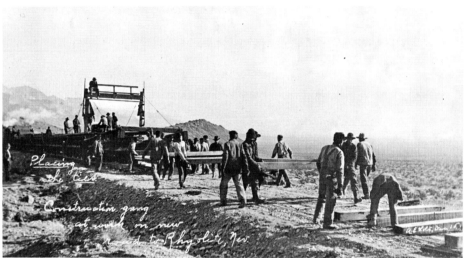

Placing the ties

Construction gang at work on new road to Rhyolite, Nev.

Building the LV&T over the hill from Beatty to Rhyolite was not a difficult task. Major problem was keeping the grade to a minimum for operating efficiency. On these pages *(top to bottom)* are seen the graders preparing the roadbed in September 1906, the track gang spacing ties and laying rail on December 14 and 15, a panorama of the work as the rail train approached Rhyolite, and two views of the first train as it left town on December 16, 1906. All photos were taken on the west slope of Doris Montgomery Summit. In the panoramic view, note the drainage dikes extending uphill from the roadbed, an extensive precaution in all desert railroad construction to control the abnormal waters resulting from flash floods. In the final view of the first train heading east, the famous Montgomery-Shoshone mine is visible on the mountainside at upper left. *(All photos A. E. Holt, Nevada Historical Society.)*

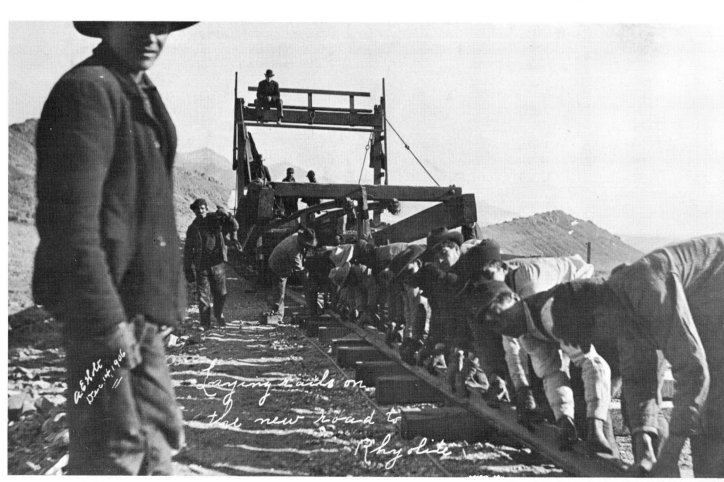

Laying rails on the new road to Rhyolite

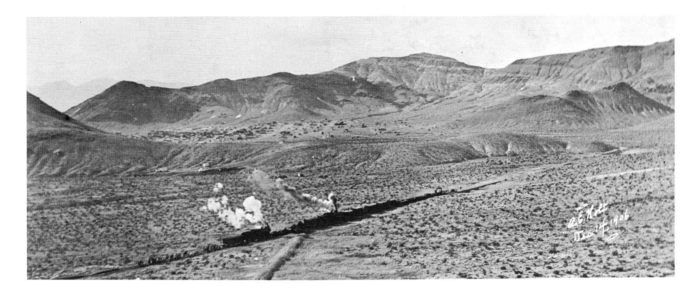

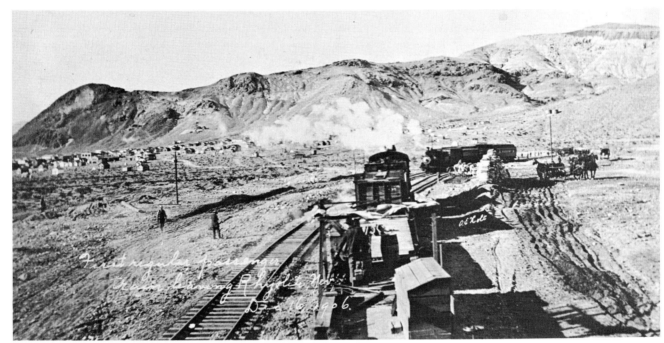

First regular passenger
train ... of Rhyolite, Nev.
Dec. 16, 1906.

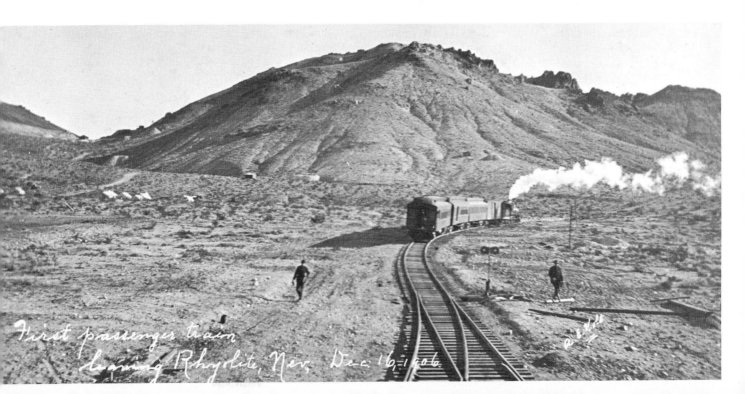

First passenger train
leaving Rhyolite, Nev. Dec 16, 1906.

train. Then the band led the excursionists back through the bunting-draped town (even the watering trough sustained its share of decoration) to the Montgomery Hotel where "standing room was soon as scarce as in a Brooklyn Bridge rush." The local editor became so impressed by the reception that he wrote in the next edition of his paper: "Under the brilliant rays of the rich October moon, amid shouts of hundreds of citizens, the first excursion train pulled into Beatty Monday night [October 22]. It was an auspicious occasion, and Nature passed its O.K. upon the proceedings from start to finish. The sun came out gloriously the following morning, and the wind, which is so often too much in evidence, forgot to blow in."

Tuesday, October 23, 1906, was the big day. The visitors were taken to Rhyolite to witness the various rock-drilling contests in which Vic Tamney and Will Martin won the doubles prize of $250 for a 34¾-inch hole, while Joe Black won the singles contest with its $150 prize for a 23½-inch hole. The mines themselves attracted many of the visitors, and in the afternoon they followed up this interest by taking the special train from Beatty to Gold Center to see the great mining tunnel under construction. A firing of 60 rounds of giant powder signalled the initial greeting, following which the guests were given gold pans and a chance to try their luck. No finds of large nuggets were reported, but everyone enjoyed the sport.

The final banquet that evening was marked by important speeches. J. Ross Clark, who was somewhat perturbed over reports that the LV&T would stop a few miles west of Rhyolite near Gold Bar, assured all and sundry that the survey to Goldfield was practically finished and that the grading contract had been let. In turn, C. O. Whittemore complimented the committees on the success of their efforts and declared that Beatty's Railroad Day celebration "marked the camp's emancipation from the slavery of the desert."

As though to prove the point, the following week 12 carloads of machinery arrived for Fred H. Vahrenkamp's new mill at Bonnie Claire to the north, and 12 more carloads were reportedly on the way. To publicize the new mill, the first eight cars were decorated with special streamers. Of the outbound freight, the Tramps Consolidated made the first shipment consisting of 42 tons of ore.

Still excited over the intense activity of Beatty's Railroad Days, the residents of Rhyolite thought it would be only proper that a similar celebration be held when the rails reached their town. *The Rhyo-*

lite Herald advocated that a complete trainload of some 20-25 cars of ore be sent out as part of the celebration to publicize and advertise the Bullfrog District. Mine owners backed up the idea — the Tramps Consolidated promised three or four cars; the Gibralter promised the same; the Skookum would send a car, provided it would be the first car in the procession; the Gold Bar would send two cars; and the Diamond and the Happy Hooligan each promised a car.

As the days advanced into fall, the people's ardor began to cool and more mature thinking started to prevail. The Rhyolite Board of Trade voted to postpone the big event until spring, possibly as late as April (1907). Thus far that august body had managed to exact $1,044.50 in contributions to the cause, but they deemed it more appropriate that part of the money be loaned to the school fund to make repairs to the schoolhouse. It was felt that in order to make a good showing for the anticipated volume of visitors, the town should be cleaned up and an effort be made to confine the red-light district to its present limits and keep it from spreading.

In the middle of November 1906 the LV&T pressed forward again. Starting from Beatty and heading for Rhyolite over the summit of Doris Montgomery Pass, the track layers began setting the ties and rails in place up the 3% grade. The pressure was on, and Rhyolite's Right-of-Way Committee was forced to complete its job. The necessary land to connect the various segments of roadbed had to be acquired, and this the Committee was only able to do by pledging their personal funds to finance the purchases, hopefully anticipating that voluntary contributions from all concerned would enable them to make up the difference. Over the summit and down the more gentle west slope of the mountain went the track, and in the early evening of Friday, December 14, 1906, the first train pulled into the east end of Rhyolite, immediately behind the track layers who were putting the finishing touches to the yards at the freight depot in Eddy's Addition.

Over 100 people were on that first train, including 45 passengers in an extra Pullman from Los Angeles who had taken advantage of the earlier special rates advertised for Rhyolite's Railroad Day before it was decided to postpone the event. Regular daily service commenced the following day, each train during the first week bringing in two coaches loaded with people to swell Rhyolite's rapidly growing population. On Tuesday,

December 18, freight shipments started arriving, inaugurated by three carloads of lumber for the Montgomery-Shoshone plus three carloads of general merchandise. Each additional train continued to bring in more cars to the point that, before the end of the week, over 100 cars of freight which had previously been accumulated on sidings all the way from Las Vegas to Gold Center had been delivered in Rhyolite and were jamming the 105-car capacity yard. As fast as they could be emptied, the returning cars were loaded with sacked ore from the Montgomery-Shoshone and the other mines.

As soon as the yards were finished, rail laying continued westward through town. By the end of the first week of service, the tracks were almost up to Main Street and grading had been completed for two blocks farther into the heart of the residential district. It was announced that plans had been made to halt the track work at Bonanza Mountain and not to resume until a considerable amount of grading had been accomplished on the extension west and north of Goldfield.

Meanwhile passenger traffic continued to boom. Both incoming coaches were filled to capacity nearly every day. Special Christmas excursion rates boosted Rhyolite ticket sales to approximately $1,000 per day. Freight carloadings continued heavy, and the normal force at the tent freight depot had to be augmented by the addition of three more checkers and a cashier. The impact of the influx of this steady stream of men and materials was felt in the town as well. Lots on Golden Street, which had caused much clucking when they were sold for $500 each a year ago, now changed hands at $5,000 and up. Corner lots were commanding $10,000 and more. Every service and every facility was being taxed to the utmost.

After Christmas 1906 but very little track laying was done pending completion of the grade around Bonanza Mountain on the Goldfield extension. By January 1907 even the new construction appeared to have slowed to a crawl despite Clark's public assurances that the LV&T would be continued on to Goldfield and would not be consolidated with Brock's Bullfrog Goldfield Railroad.

Toward the end of January a surprise meeting between Clark and superintendent Hedden of the BG aroused the public's suspicions anew. Clark hastily explained that right-of-way matters, and not possibilities of a merger, were the topics of discussion. "Never even considered such a step," he said. "The Brock road crosses our wye at Beatty

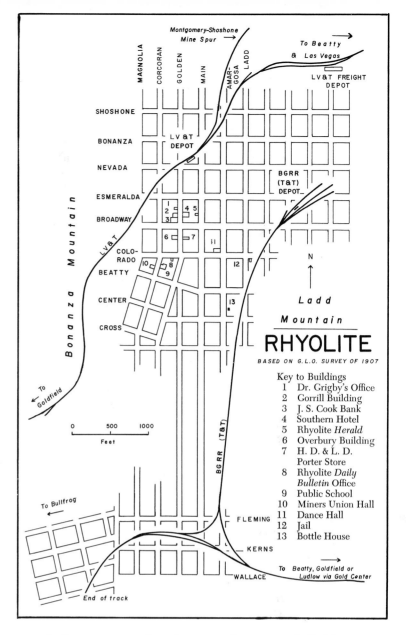

Key to Buildings
1 Dr. Grigby's Office
2 Gorrill Building
3 J. S. Cook Bank
4 Southern Hotel
5 Rhyolite *Herald*
6 Overbury Building
7 H. D. & L. D. Porter Store
8 Rhyolite *Daily Bulletin* Office
9 Public School
10 Miners Union Hall
11 Dance Hall
12 Jail
13 Bottle House

and also our main line between Beatty and Gold Center, and these matters were satisfactorily adjusted at our conference. We *will* continue construction to Goldfield. I do not know when track laying will be resumed as there is considerable rock work to be done around Bonanza Mountain in the vicinity of the Gibraltar workings. We haven't done anything on the grade at that point, but we have worked on either side of the mountain. We have 2,000 tons of rails on the way and expect the balance of the rails for the Goldfield end will be finished and en route from the east by the first of March. At least we have been assured of this by the mills. We have 20 miles of ties on hand at the yards in Las Vegas." And there the matter was allowed to rest for a period of several months.

Meanwhile, with lumber arriving in great quantities for use in the mines or for new housing at

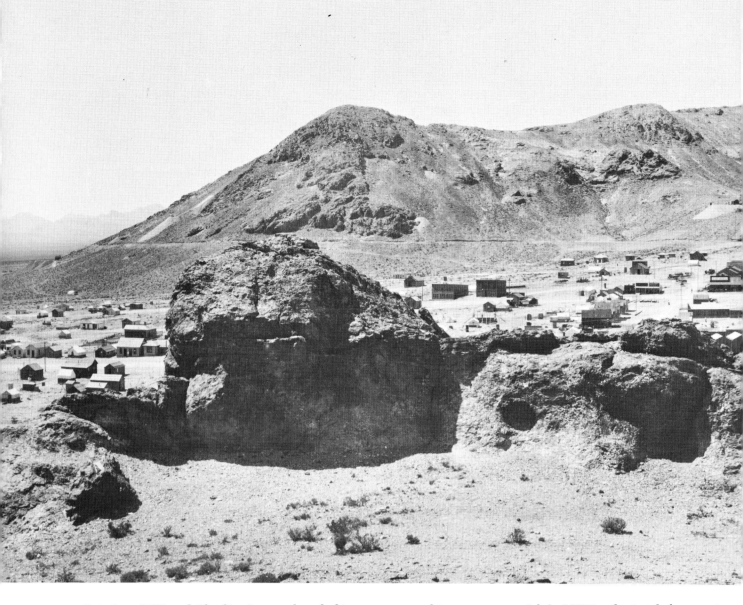

It is June 1907, and Rhyolite (as seen here looking westerly) has almost reached the peak of its expansion although, unrealized by its residents, the peak of the boom has already been passed. The tallest, white building (just right of center) is the John T. Overberry building, completed and opened at the end of May. The J. S. Cook Bank building had not been erected but was built in the vacant lot adjoining the Gorrill Building (next 2-story, white structure to right). LV&T rails stretch from center right (where the LV&T's stone station subsequently was erected), horizontally through the residential area behind the business district to the foot of Bonanza Mountain where the Harris Track Laying Machine may be seen standing below the mine shaft. The vacant grade of the Goldfield extension continues to the left around the shoulder of Bonanza Mountain.

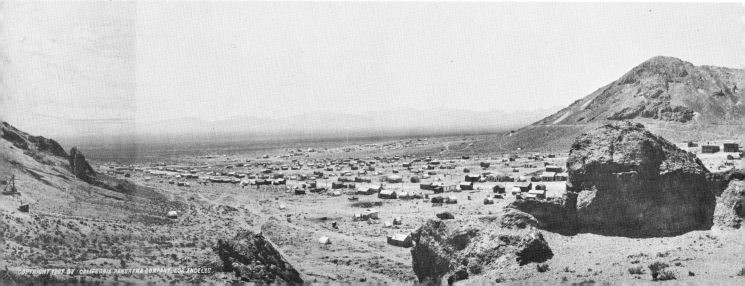

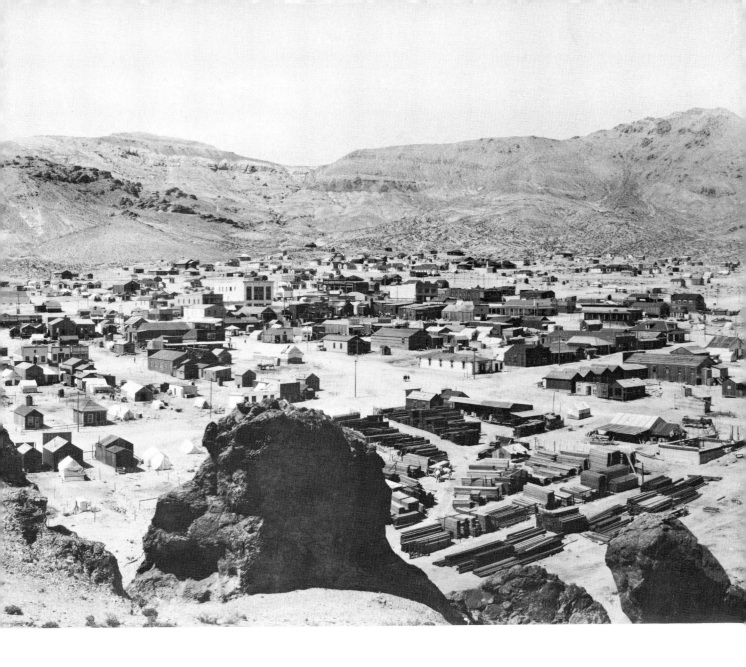

The left hand extension of this impressive panorama (*bottom of page*) looks across what was known as Squattersville to Bullfrog under the LV&T grade on Bonanza Mountain (*left, center*).

In the (*bottom*) right hand extension, the Rhyolite freight yards of the LV&T are visible at the extreme right center, while a locomotive shunts a cut of cars just to left at the foot of the small hill. (*California Panorama Co. photo.*)

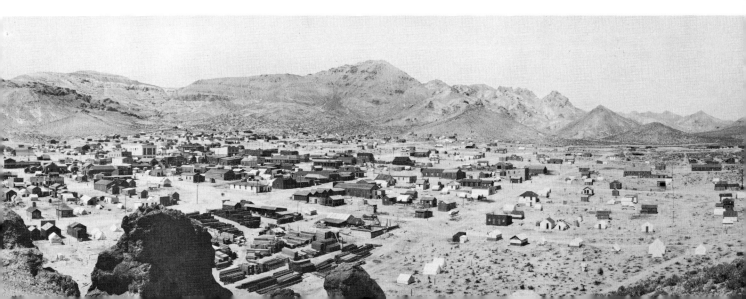

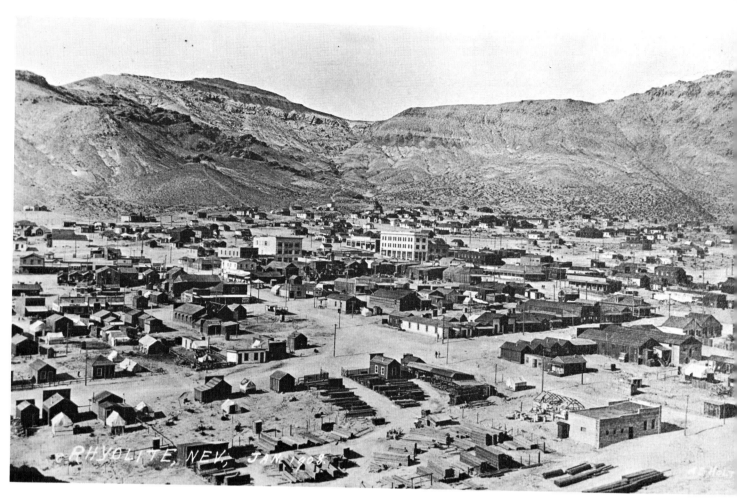

RHYOLITE, NEV, JAN 190?

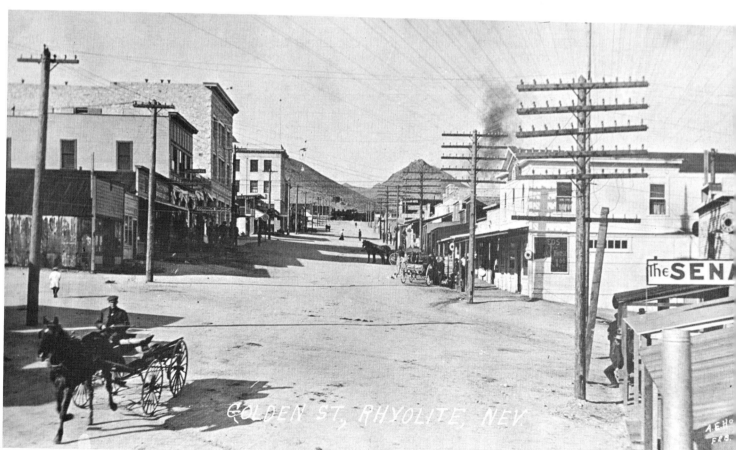

GOLDEN ST, RHYOLITE, NEV

The SEN

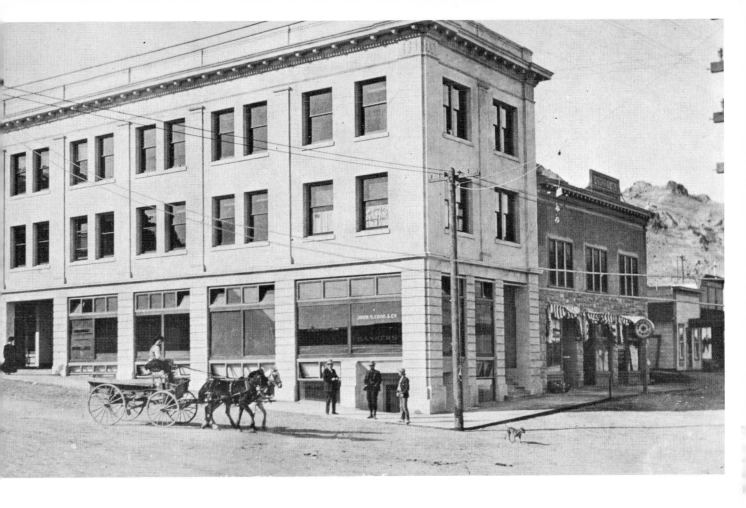

Rhyolite attained its maturity with the erection in 1907 of the 3-story John S. Cook & Co. Bank Building shown *(top, left)* in panorama and *(above)* in detail. Pride of the town were its Italian Marble stairway, stained glass windows from Italy and baseboards of Honduras mahogany. The Post Office occupied the basement, the bank the first floor, while brokers' offices utilized the majority of the second and third floors. Although $90,000-$100,000 had been lavished in its construction, the investment never paid off. Rhyolite was already on the decline, and by 1941 the deserted building had deteriorated to the condition shown below. *(Top, left: A. E. Holt photo, Nevada Historical Society; below: H. K. Hall photo.)*

Along Golden Street in Rhyolite lay the heart of the business district shown *(left, below)* looking northerly from the intersection with Colorado Street on a late afternoon in February 1908. The LV&T train at the head of the street is about ready to start on its run to Mud Springs Summit and Goldfield from the (then) new but unfinished stone station. In the background Busch Peak looms skyward. *(A. E. Holt photo, Nevada Historical Society.)*

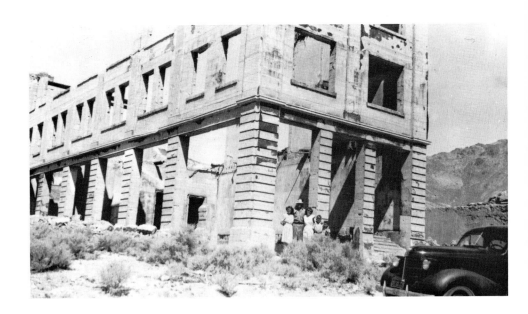

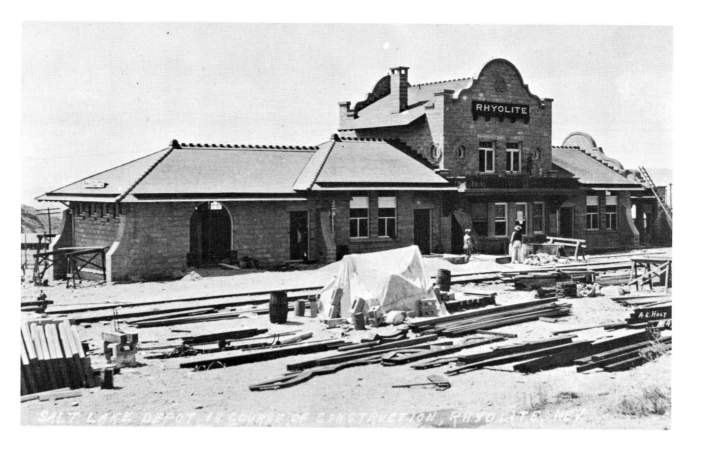

SALT LAKE DEPOT IN COURSE OF CONSTRUCTION RHYOLITE, NEV.

Stone blocks "imported" from Las Vegas were used for this impressive LV&T station on the south side of the tracks at the head of Golden Street in Rhyolite. Although work started on September 30, 1907, the building was not completed until June of the following year. The men's waiting room and baggage room were to the left in the photo, the ladies' waiting room to the right, and the agent's quarters were upstairs over the ticket office. (A. E. Holt photo.)

The view (below) looks south down Golden Street on December 28, 1906. The first LV&T eastbound train had left town but 12 days before, and work was just starting on the one mile extension of the tracks from the freight yard, across town to the foot of Bonanza Mountain. A work train blocks the Golden Street crossing, behind the locomotive of which the stone station building will be built in another year and a half. (A. E. Holt photo, Nevada Historical Society.)

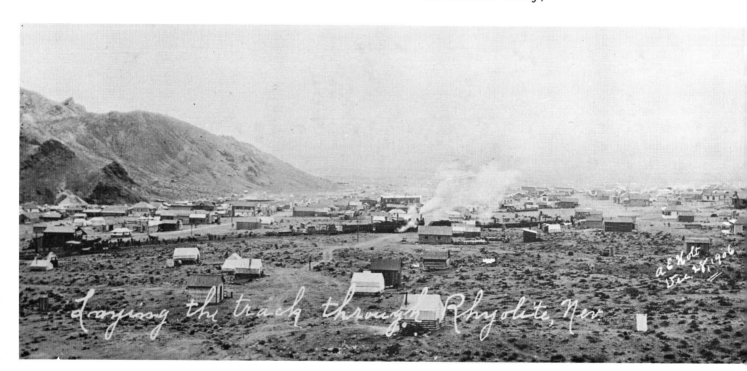

Laying the track through Rhyolite, Nev.

484 —

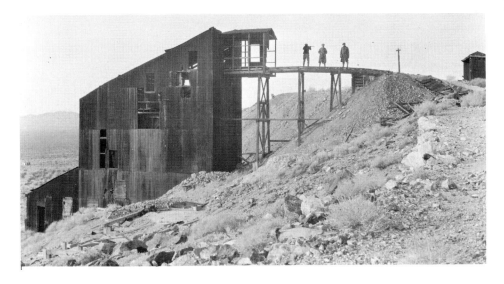

Overcoats of the hunting party suggest this is a winter season photograph of an abandoned mill to the west of Rhyolite. *(Frasher photo, Pomona.)*

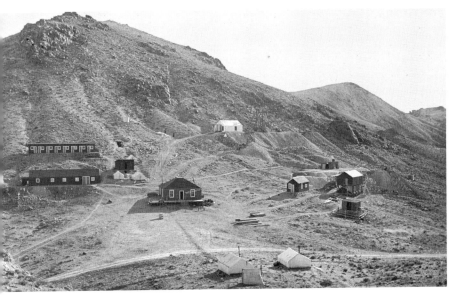

Largest and most important producer in the Rhyolite area was the Montgomery-Shoshone Mine on Montgomery Mountain shown *(left)* in its more primitive beginnings and *(below)* at its peak of activity following the coming of the railroad. The view is from the north, and Rhyolite lies just out of the picture to the right. *(Both photos: U. S. Geological Survey.)*

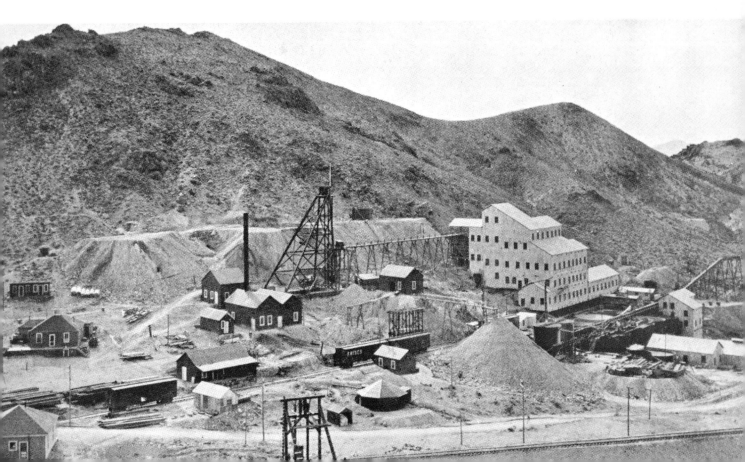

Rhyolite, the freight sheds (actually tents), the team tracks and all sidings were taxed to capacity and additional terminal facilities were sorely needed. In February 1907 work began on a new and commodious freight depot located near the warehouses of H. D. and L. D. Porter.

Passenger facilities were likewise overcrowded as special excursions for various groups brought new people into the area by the hundreds. With numerous mining camps springing up all over southern Nevada as new discoveries were made, it was not surprising that, although many excursionists returned home again, an equally large number remained. Quite reasonably, they asked themselves that, if rich ores could be found in Tonopah, Goldeld and Rhyolite, why should they not be found in such other places as Lee and Schwab some 30 miles southeast of Rhyolite? The question was academic, and one which the railroads themselves frequently asked. Thus railroad activity, usually speculative but sometimes resulting in a preliminary survey, followed these men to the new camps. Reliably, the LV&T was reported as having made surveys to both Lee and Schwab, and well they might. Brock's Bullfrog Goldfield Railroad was already in the upper reaches of the Amargosa Canyon and heading for Beatty; it was quite definitely established that they were considering a branch to Greenwater; Lee and Schwab could be served along the way. With BG grading camps already in Beatty, it would be a simple matter to continue right on with the work. Even the belated Tonopah & Tidewater was not without its reservations, and when their tracks finally reached the area, provision was made for a possible later branch to Lee.

On To Goldfield and Completion

On March 21, 1907, the first regular through Pullman service from Los Angeles was inaugurated via the daily mixed train to Rhyolite. By the end of the month the spur up the 4% grade to the Montgomery-Shoshone mine was finished, and the ores no longer needed to be dropped down the mountain in wagons but could be loaded directly into the railroad's cars. Even though the rock work on Bonanza Mountain had not yet been completed, graders were busy preparing the roadbed on the north side of the gap about 30 miles out on the 73-mile segment from Rhyolite to Goldfield. Progress was being made, however slowly, toward placing Rhyolite on the through line of the LV&T; and the danger of the town being left dangling at the end of a branch line appeared to be past.

E. W. Gillette, a retired general freight and passenger agent from the SP, LA&SL, was brought back to active duty in similar capacity on the LV&T following the passing of Harry T. Green. His tenure in office was marked by progress. Rhyolite's freight depot was finally completed and the clerks moved from their drafty tent into the new and more comfortable quarters. Plans for a new passenger station to be located just west of the temporary depot were announced.

When the Shriners' Excursion Special pulled into town with 150 people from Los Angeles, the bright uniforms and the band brought color and excitement to the adults while the combination of the Sells-Floto Circus and donated tickets generated intense interest and enthusiasm on the part of the younger generation. The change of pace helped the people forget their irksome complaints over the exorbitant $7.00 monthly telephone fee which did not even include all-night service, and tended to bring out their pride in the new stock exchange which had just been opened and the new plant of the Rhyolite Light, Heat & Power Company which turned on its first electric current on April 25.

April 25, 1907, was a day notable in the annals of Rhyolite's alter ego, Beatty, as well; for Beatty was celebrating a second Railroad Day with the arrival of the Bullfrog Goldfield Railroad and an official pounding of the golden spike. Shortly those same rails would stretch around the hills and Rhyolite, too, would enjoy the distinction of being a two-railroad town.

Completion of the Bullfrog Goldfield Railroad to Beatty was notable in other ways as well. For the first time in history, Nevada had an interior north-south rail route within the state, even though it was over the lines of five separate companies — Virginia & Truckee from Reno to Mound House; Nevada & California (SP) from Mound House to Mina; Tonopah & Goldfield from Mina to Goldfield; Bullfrog Goldfield from Goldfield to Beatty; and Las Vegas & Tonopah from Beatty to Las Vegas. True, it was too much to expect that all five of the railroads would operate in unison and close harmony, but the route did exist.

In practice, the dividing line nominally occurred at Goldfield. Shipments from that center normally were routed either northward via T&G-N&C-SP or else southward via BG-LV&T. Since the LV&T had not completed its extension from Rhyolite to Goldfield, operating harmony with the BG was essential in order to garner a share of the Goldfield

traffic. To this effect, the LV&T inaugurated Time-table No. 11 on May 1, 1907, establishing a regular passenger train (nicknamed the "Alkali Limited") which carried a through Pullman en route between Goldfield and Los Angeles via the BG, connection being made at Beatty.

By the end of May the preliminary graders had pushed the roadbed of the LV&T to within seven miles of Goldfield. To everyone's eternal relief, actual rail laying began the following month at the western edge of Rhyolite and continued on around Bonanza Mountain. The effort, however, was short-lived. Three weeks and 10 miles later, the work came to an abrupt halt when some of the track layers left the job. A carload of foreigners was brought in to provide replacements, but 10 days later the work stopped again when 100 Greeks and Austrians went on strike for higher wages. The foreman of the group refused the men's demands, loaded them in box cars and had them hauled to Beatty where they were told to leave the country. Playing the role of Pied Pipers, the outcasts tried to induce 50 other workers to join them in exile, but stubborn temperaments prevailed. A riot occurred, during which pick handles and knives played prominent parts. Quiet was not restored until several strikers had been arrested by the sheriff with the assistance of five deputies. After emotions had subsided, all of the men were released from custody on the understanding that peace would be maintained.

It would appear, according to one view, that the entire incident was unwarranted. The current wage for the men was $4.00 a day, less $1.25 for board. The *Reno Evening Gazette* reported, "The I.W.W. suggested to the boys that the board was not worth the price. The men had been boarding themselves before, but their day's pay had been $1.75-$2.00. The men also complained that the board was not good enough for them, and they demanded to be allowed to 'bach' which the company for good reasons objected."

In spite of these vicissitudes, the LV&T rails were extended to Bonnie Claire by the middle of August and the men were busy installing the yard tracks at that point. By the end of September the tracks had been pushed on through Wagner, Stonewall and Ralston to within 12 miles of Goldfield before another dispute arose to delay the delivery of materials.

This time the train crews went out on strike in an effort to obtain the higher wage rates paid to crews on the Bullfrog Goldfield Railroad. On the latter road conductors received $130 monthly and brakemen $110, while corresponding wages on the LV&T were $115 and $85, respectively. During the two-day period of the strike, all cars brought to Beatty by the BG for interchange with the LV&T remained unhandled, although after much governmental persuasion it was agreed to haul the U.S. Mail to Las Vegas. The strike was over when J. Ross Clark and Whittemore appeared on the scene and negotiated a one-year contract calling for the BG wage pattern for operations north of Beatty, and the lower Salt Lake Route (main line) wage scale for operations between Beatty and Los Vegas to the south.

On September 30, 1907, construction began on the new LV&T depot at Rhyolite under the direction of F. B. Clark, a prominent Kansas City builder. Plans called for an imposing edifice of stone blocks "imported" from Las Vegas, with ample space for a baggage room and a gents waiting room at the east end, a ticket office in the center, and a ladies waiting room at the west end. Completion was expected within 60 days, a far shorter time than it had taken to start the work. When the plans had been announced initially in the spring, there had been no anticipation of the title problems which subsequently were to delay the work. Certain lots of land had been held by owners who could not be found. Condemnation proceedings had necessitated three months of advertising as a requisite step before title could be quieted in favor of the railroad. The delay had furnished J. F. Hedden of the rival Bullfrog Goldfield Railroad with an opportunity to announce the BG's belated plans for a new station near the east end of Broadway at the northern end of their branch up the hill. It would be small and modest, he admitted, adding that it would not be as elaborate "as some of our neighbors have built on paper."

With the northern extension of the LV&T now approaching Goldfield, citizens of that town began to plan for a suitable celebration to welcome its third railroad. The Tonopah & Goldfield had arrived from the north back in September 1905; the southbound Bullfrog Goldfield had been linked to Beatty and Rhyolite; now with the northbound LV&T virtually on its doorstep and sure to be finished in October 1907, Goldfield had full reason to be proud. Not many towns, which had not had so much as a post office four years earlier, could boast of that much progress!

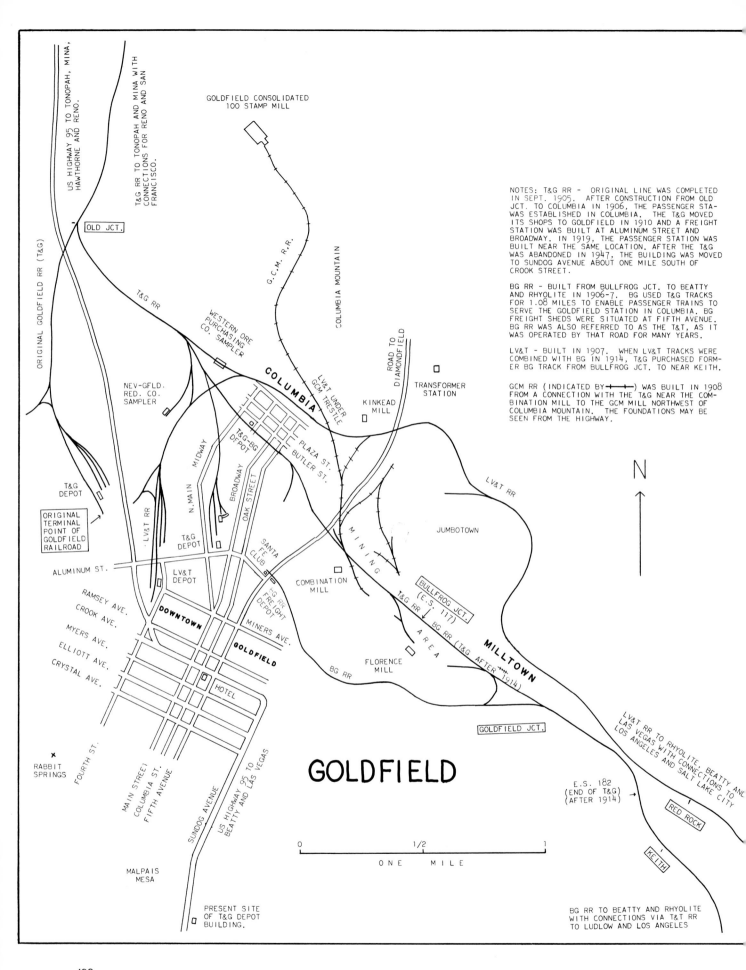

GOLDFIELD CONSOLIDATED
100 STAMP MILL

US HIGHWAY 95 TO TONOPAH, MINA, HAWTHORNE AND RENO.

T&G RR TO TONOPAH AND MINA WITH CONNECTIONS FOR RENO AND SAN FRANCISCO.

ORIGINAL GOLDFIELD RR (T&G)

OLD JCT.

T&G RR

G.C.M. R.R.

COLUMBIA MOUNTAIN

WESTERN ORE PURCHASING CO. SAMPLER

NEV-GFLD. RED. CO. SAMPLER

COLUMBIA

LV&T UNDER GCM TRESTLE

ROAD TO DIAMONDFIELD

TRANSFORMER STATION

KINKEAD MILL

PLAZA ST.
BUTLER ST.

T&G-BG DEPOT

T&G DEPOT

ORIGINAL TERMINAL POINT OF GOLDFIELD RAILROAD

LV&T RR

LV&T RR

N. MAIN
MIDWAY
BROADWAY
OAK STREET

T&G DEPOT

LV&T DEPOT

SANTA FE CLUB

BG RR FREIGHT DEPOT

ALUMINUM ST.

RAMSEY AVE.
CROOK AVE.
MYERS AVE.
ELLIOTT AVE.
CRYSTAL AVE.

DOWNTOWN

GOLDFIELD

MINERS AVE.

COMBINATION MILL

MINING

LV&T RR

JUMBOTOWN

BULLFROG JCT.
(E.S. 117)

T&G RR

BG RR (T&G AFTER 1914)

MILLTOWN

AREA

× RABBIT SPRINGS

FOURTH ST.

HOTEL

MAIN STREET
COLUMBIA ST.
FIFTH AVENUE

SUNDOG AVENUE

US HIGHWAY 95 TO BEATTY AND LAS VEGAS

BG RR

FLORENCE MILL

GOLDFIELD JCT.

GOLDFIELD

LV&T RR TO RHYOLITE, BEATTY AND LAS VEGAS WITH CONNECTIONS TO LOS ANGELES AND SALT LAKE CITY

E.S. 182
(END OF T&G)
(AFTER 1914)

RED ROCK

KEITH

MALPAIS MESA

PRESENT SITE OF T&G DEPOT BUILDING.

0 1/2 1

ONE MILE

BG RR TO BEATTY AND RHYOLITE WITH CONNECTIONS VIA T&T RR TO LUDLOW AND LOS ANGELES

NOTES: T&G RR - ORIGINAL LINE WAS COMPLETED IN SEPT. 1905. AFTER CONSTRUCTION FROM OLD JCT. TO COLUMBIA IN 1906, THE PASSENGER STA-WAS ESTABLISHED IN COLUMBIA. THE T&G MOVED ITS SHOPS TO GOLDFIELD IN 1910 AND A FREIGHT STATION WAS BUILT AT ALUMINUM STREET AND BROADWAY. IN 1919, THE PASSENGER STATION WAS BUILT NEAR THE SAME LOCATION. AFTER THE T&G WAS ABANDONED IN 1947, THE BUILDING WAS MOVED TO SUNDOG AVENUE ABOUT ONE MILE SOUTH OF CROOK STREET.

BG RR - BUILT FROM BULLFROG JCT. TO BEATTY AND RHYOLITE IN 1906-7. BG USED T&G TRACKS FOR 1.08 MILES TO ENABLE PASSENGER TRAINS TO SERVE THE GOLDFIELD STATION IN COLUMBIA. BG FREIGHT SHEDS WERE SITUATED AT FIFTH AVENUE. BG RR WAS ALSO REFERRED TO AS THE T&T, AS IT WAS OPERATED BY THAT ROAD FOR MANY YEARS.

LV&T - BUILT IN 1907. WHEN LV&T TRACKS WERE COMBINED WITH BG IN 1914, T&G PURCHASED FORM-ER BG TRACK FROM BULLFROG JCT. TO NEAR KEITH.

GCM RR (INDICATED BY ┼┼┼) WAS BUILT IN 1908 FROM A CONNECTION WITH THE T&G NEAR THE COM-BINATION MILL TO THE GCM MILL NORTHWEST OF COLUMBIA MOUNTAIN. THE FOUNDATIONS MAY BE SEEN FROM THE HIGHWAY.

N

The big day was finally arranged for October 28. Senator George Nixon would present a gold spike to Senator Clark to be pounded into trackside with the laying of the last rail, while a gigantic banner overhead would proclaim "Welcome to the Clark Road." One local wag, mindful of Senator Clark's advancing years and sedentary occupation, was quoted as having said that Clark was in training in a nearby quarry. Other preliminary scheduled events included the usual speeches, visits to the mines, open house at the Montezuma Club, a boxing match at the grand opening of the Goldfield Athletic Club, and special trains on all roads to bring the people to town.

In spite of the grandiose talk and plans for an elaborate Railroad Day celebration, all was not well beneath the surface of the economy. The long miners' strike at Goldfield earlier in the year, the end of the boom in Nevada mining promotions, a general business slump plus a tight money situation throughout the nation were having their effects upon Goldfield as well as the neighboring communities.

Goldfield's banking situation was particularly hypersensitive. On October 15, 1907, the same day that the LV&T track layers could first be sighted from town, a lady walked into John S. Cook's bank with a bad check which she tried to cash. Realizing the situation, the cashier refused to honor it and jokingly told her that the bank had no funds with which to meet it. Back outside, the lady repeated the remark, and spreading gossip soon developed many requests for withdrawals. At first the officers of the bank laughed confidently at the situation, but as the withdrawals persisted and the run enlarged, worried looks began to replace the confident smiles. In desperation they drew upon the cash resources of Tex Rickard's Northern Saloon and shortly were able to announce that $2,000,000 in gold coin was on display on tables behind the counter for all to see, and that they would pay any amount of withdrawal demanded. With the large stacks of gold coin plainly in sight, confidence among the customers returned, and an hour later deposits were once again exceeding withdrawals.

Unfortunately the economic crisis was not strictly local nor as easily resolved. Within a week some of the nation's larger banks were having troubles. The big Knickerbocker Trust Company of New York closed its doors after paying out $10,000,000 in three hours. The following day T. B. Rickey's State Bank & Trust Co., operating in five Nevada cities, closed its doors. Then the Nye & Ormsby County Bank closed its doors for three days "as a precautionary step." That night Governor Sparks declared a three-day statewide bank holiday. Fortunately the Cook Bank had already wired the Crocker National Bank in San Francisco for its cash on deposit, and the coin came to Goldfield by special train, arriving at 11:00 A.M. on Thursday, October 24, 1907, the first day of the bank holiday. The following Monday morning, when the holiday was over, the Cook Bank reopened for business as usual; some of the other banks were less fortunate.

In spite of the misfortunes of the banking industry, the LV&T continued to lay its tracks, over the summit and down the flat to the depot site which it reached on October 24. With the bank holiday in effect, Goldfield citizens were in no mood for a celebration, and in spite of the many invitations which had already been issued by the Goldfield Chamber of Commerce, Railroad Day was postponed — indefinitely. The railroad, however, went quietly about its work, installing yard and station tracks and whatever other facilities were required. The final rails were spiked in placed at 10 o'clock on the morning of Saturday, October 26, 1907, before a large and curious crowd, and that evening the first LV&T passenger train pulled into town after having stopped en route at Rhyolite for a 5:00 o'clock supper to be served to its hungry passengers.

In almost the same breath and in virtually the same unobtrusive manner, Borax Smith's Tonopah & Tidewater Railroad sneaked into Gold Center the following Wednesday, October 30, 1907. Not unexpectedly to the LV&T came the announcement that the T&T would join with the Bullfrog Goldfield Railroad to furnish a second southern route from Goldfield via Ludlow to Los Angeles and other coastal cities which would be shorter and more direct than that of the LV&T operating via Las Vegas.

With the tracks in place and operations begun over the Goldfield extension, the LV&T began to concentrate its efforts on improving the property and developing facilities. Depots at both Goldfield and Rhyolite had yet to be built, the latter still not having been completed despite the optimistic forecasts made the previous September. In fact, the station sidewalls of stone block from Las Vegas had just been finished on November 18, 1907, when the work was halted. Conflicting reasons were given for the suspension of effort. On one hand, it was

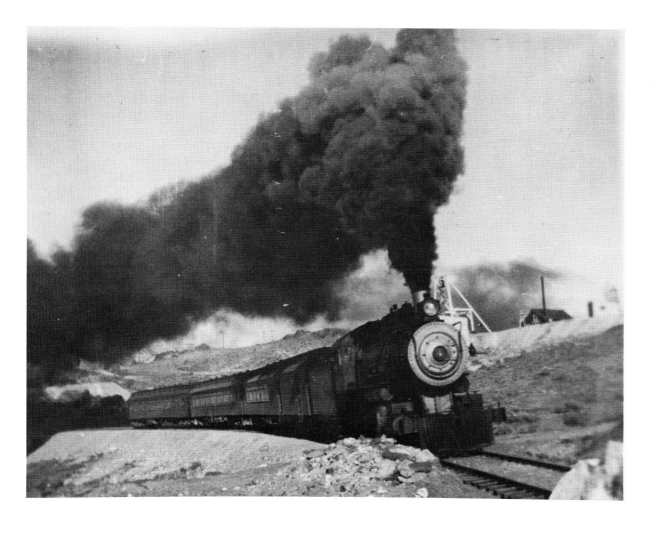

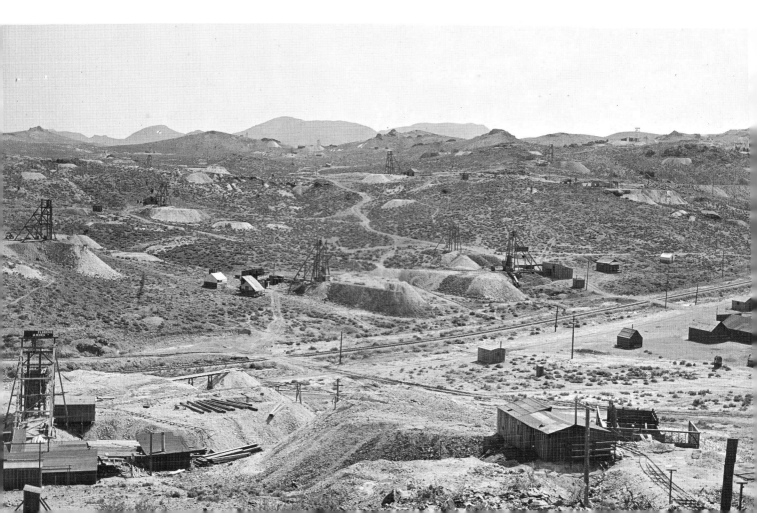

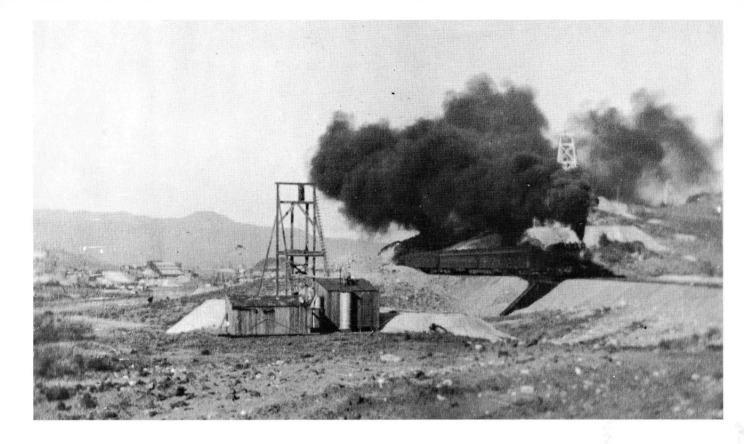

With as effusive a column of black smoke as any railfan could desire, LV&T No. 4 blasts up the hill out of Goldfield tailing a trio of varnish cars bound for Rhyolite, Beatty and Las Vegas, the latter 8 hours and 197 miles distant. No. 4 also had her moments of repose, as witness the tranquil scene *(below)* following an explosion in the Goldfield engine house. *(Two top photos: Munro S. Brown; bottom: Hendrick Collection.)*

(Left below) Looking northeast from the Florence Mill just east of Goldfield, Nevada, in January 1908, mine dumps and head frames infest the area. Immediately below and to the left is the Florence Annex, while across the BG's main line are properties of the Atlanta Mines Co. and the Portland Florence. Near the top of the hillside to the right is the low grade line of the LV&T, yet both railroads will be approximately on the same level as they pass through the notch about a mile to the east. The richest mines of the area lay out of the picture to the left. *(U. S. Geological Survey.)*

The LV&T's Goldfield station of Las Vegas stone outlasted many another building in the area. In 1945 *(above)*, some 38 years after the first train arrived the structure still looked presentable even though the trains had long been gone. Twelve years later, vandals and the weather had taken their toll, so that in 1957 *(below)* there was little to identify the structural ruins. *(Top: Al Rose photo.)*

Of the two westerly views *(page opposite)* of the Goldfield mining area and Columbia Mountain taken from Florence Hill, the one at the top is the more recent. In it may be

seen the trestle and grade of the Goldfield Consolidated Railroad (built in 1908) along the foot of Columbia Mountain, while across the BG tracks from the Mohawk Mine, trestle and ore bins (right from center) lie the works of the large Combination Mill. The earlier view *(bottom)*, swings northwesterly to show the mine fields to the north of Columbia Mountain in the direction of Diamondfield, out of the picture to the right. Buildings of the Florence Mine are in the foreground. *(Top: U. S. Geological Survey; bottom: Sewell Thomas Collection.)*

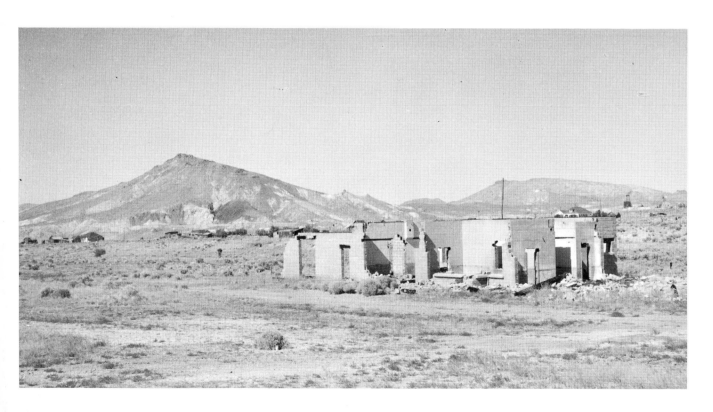

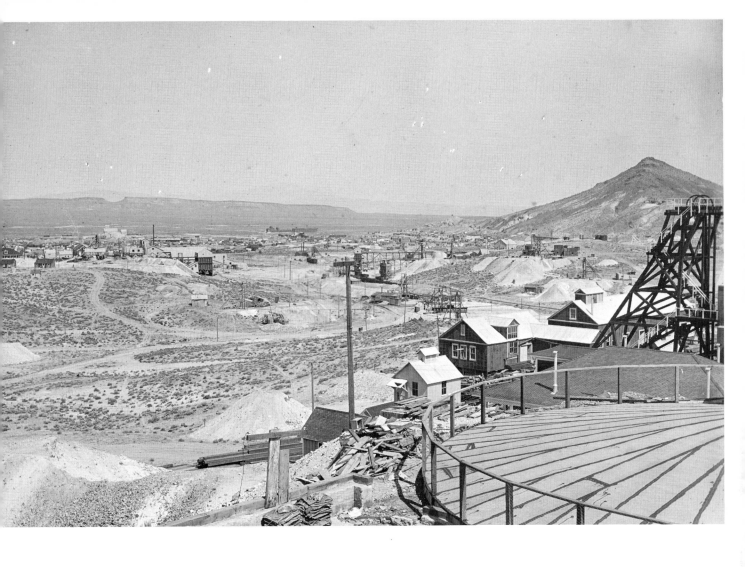

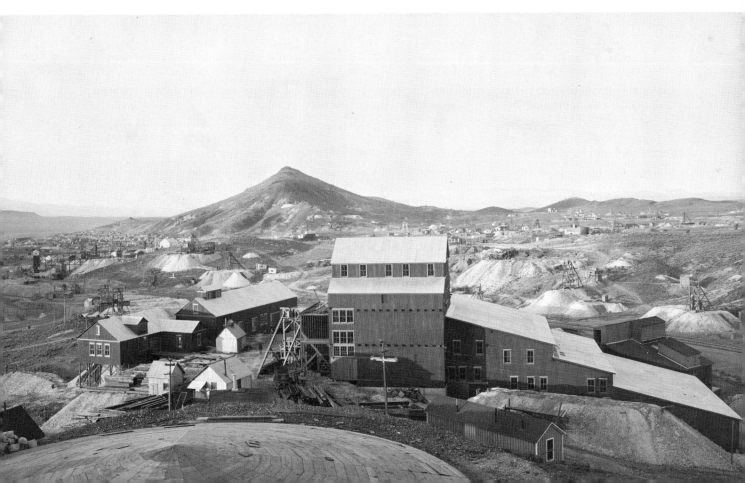

reported that differences between the carpenters and the contractor were to be blamed; on the other, reputed financial difficulties between the contractor and an uncooperative bank were cited. In any event, the delay was protracted and the work not resumed until March 27, 1908. It was early June before Agent J. A. Scott was able to set up temporary ticket and baggage rooms in one end of the building while the second story was being finished as an apartment for himself and his family.

Fortunately other depots did not present such an array of problems. New stations were established at Stonewall (21 miles south of Goldfield) and at Canon (14 miles north of Amargosa). The former provided the facilities for servicing the town of Hornsilver (now Gold Point) on the western edge of the valley, while the latter handled business for the Quartz Gold Mining Co. at Calico Hills, a development of Santa Fe Railway men. The economy of Amargosa was stimulated further by the erection of a 100-stamp mill in neighboring Johnnie, while an oil discovery near Indian Springs (31 miles south toward Las Vegas) caused all of the neighboring land to be located along the LV&T for a distance of 12 miles.

"The Old Reliable Way," as the LV&T was now advertising itself, was quite a different railroad from "The Old Reliable," as the Louisville & Nashville is familiarly called. Traffic was light, and the operating problems were heavy. Twice during 1908 the Brotherhood of Railway Trainmen filed formal complaints with the Railroad Commission of Nevada. In May the BRT was contending that there should be two brakemen on each train, an arrangement with which J. Ross Clark acquiesced. At the same time, the "Alkali Limited" suddenly became a mixed train, thereby combining two trains into one. The peace was shattered again in September when the BRT complained that the speed of the train was too great for the safety of the passengers. Clark accordingly lengthened the schedule of the Goldfield-Las Vegas run by 50 minutes and instructed the engineers not to exceed 25 miles-per-hour on the curves.

Although keeping the trains operating obviously presented numerous problems, no difficulties appeared to be experienced over the non-operating problem of demurrage (detention of a freight car beyond the normal time for loading or unloading). The standard charge of $1 a day was all that was made, thereby furnishing ample inducement for Harry Peterson, a Greek vegetable merchant in Goldfield, to keep his railroad cars on the siding for days on end until he had sold enough of the contents to pay the freight charges.

Boom to Bust

Although there was little cause to realize it, the 1907-08 era represented the peak period for business on the LV&T. Only in its first full year did the railroad make money. Operating revenues approximated $40,000 per month including passenger business of about $15,000. The future, if not bright, at least looked promising.

The Panic of 1907 and its aftermath anticipatedly was but an evanescent circumstance. Although the building booms at the mining camps had largely been satiated, it was reasonably expected that there would be continued hauling of general merchandise, whiskey, food and building materials to keep the communities established, while such outgoing ores as required further reduction at smelters would furnish traffic in the opposite direction. Underneath it all there was always the latent possibility and fervent hope that new strikes and new bonanzas along the line would generate a whole new surge of business.

Unfortunately, what actually transpired was the exact antithesis of this concept. Mining, especially during the latter part of 1908, went into a slump; people began leaving the camps; the population declined; and with the decline went the demand for goods and services. The LV&T was left holding the bag in the form of a 196-mile permanent railroad with a diminishing business to be carried. True, production from the few established mines along the route continued; but the gay, mad whirl of mining promotions and quick-and-easy profits vanished. Unemployment increased, and panhandlers, in Goldfield particularly, became commonplace.

To augment the critical situation, a number of other events occurred which were costly and tragic in nature. In August 1908 a washout near Indian Springs at the southern end of the line delayed traffic for several days. In the same month, a $40,000 fire on Amargosa Street in Rhyolite destroyed six cribs, a dance hall and a parlor house, the loss being measured in dollars of value — not in dollars of business — for business was slow anyway. In Beatty a gasoline stove exploded and burned the LV&T eating house, whereupon passengers were detrained at Rhyolite for meals. In Las Vegas a bedroll carelessly tossed to the ground proved to contain a loaded gun which was accidentally discharged, the bullet killing the conductor. A brake-

LV&T ten-wheeler No. 12 was fresh out of Alco's erecting shops when this portrait was made in January 1908. Coach No. 32 with the 4-wheel trucks and combine No. 22 with heavy 6-wheel trucks are shown at builder Pullman-Standard's plant in Chicago. *(Top: Guy L. Dunscomb Collection; bottom two: Pullman-Standard Car Mfg. Co.)*

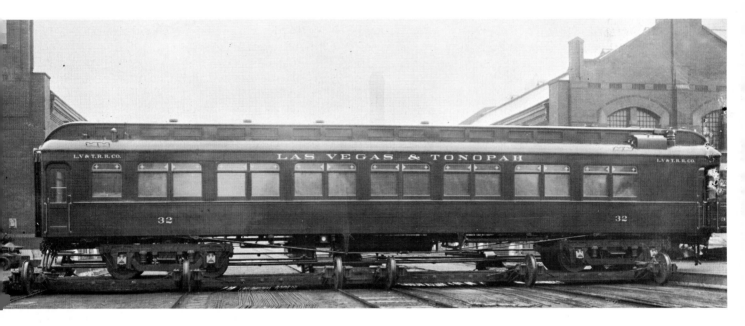

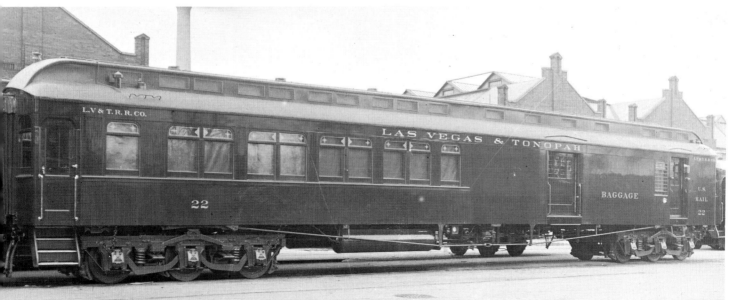

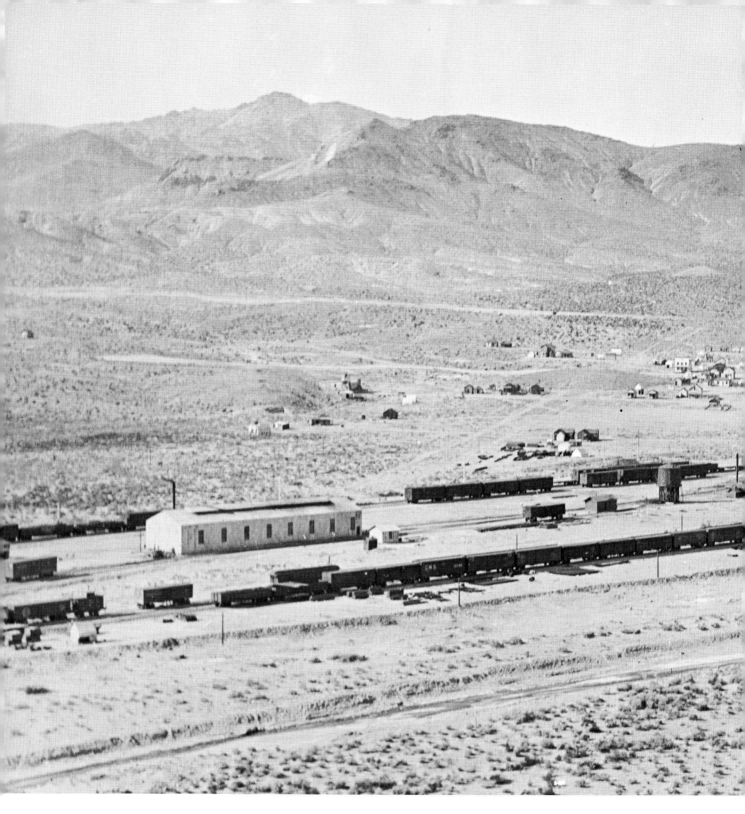

This superb panorama (facing west) of Beatty, Nevada, about 1908 illustrates the many features of the region. The BG Railroad, directly on the west bank of the Amargosa River in the foreground, has followed that watercourse down the canyon from the north (out of picture to the right) and continues along it to Gold Center at the upper end of the Amargosa Desert to the south, before swinging westerly to Bullfrog and Rhyolite. Conversely, the LV&T Railroad has approached Beatty from the south through Gold Center, crossed the BG's rails at the Amargosa Narrows and here lies parallel to and west of the BG before swinging sharply west (center right) and up the steep grade in the center background toward Doris

Montgomery Summit and Rhyolite. Behind lies the rugged range of the Bullfrog Hills.

From right to left along the BG tracks may be seen the crossing of the LV&T's wye; the pump house, water tank and cars at the BG depot at the foot of 2nd Street (present Highway 95); cattle chute; then freight yards of the BG. In similar sequence along the LV&T are the north leg of the wye; an Engineering Dept. construction car on a spur behind the LV&T's rooming house, at its south corner (on Second Street) is the tent residence of Agent Ed Hall and family; LV&T station with train on interchange track with BG; ice house and switch for south leg of wye; (low) oil

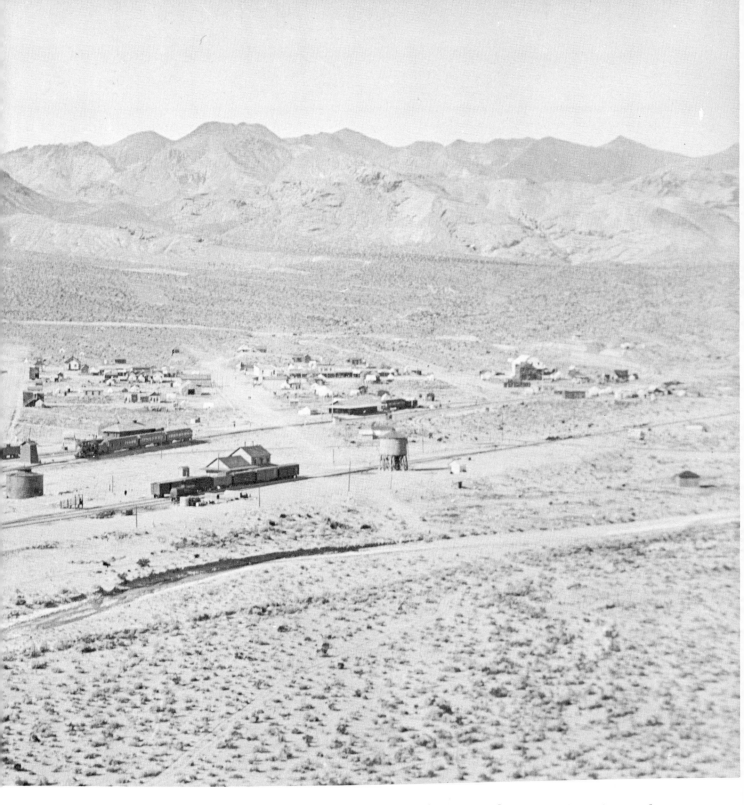

storage tank, (high) oil tank for gravity flow to locomotives, and oil pump house; water tank; sand house; two track engine house with a two-locomotive capacity for each track; tool house (small white building at northeast corner); and section foreman's house (left edge of picture). Above the LV&T engine house and to the right of the mound is the Beatty ice house, behind which the road from Rhyolite leads (right) into Main Street and the famed, 2-story Montgomery Hotel (on the northwest corner of Third Street). A block further north (on the southeast corner of Second Street is the Exchange Club, which is still in use today. A block and a half further north is the store of E. E. Palmer (2-story building with white roof), formerly Rose & Palmer. Across Main Street is his other 2-story building serving as a storehouse (first floor) and teamster quarters above. Just beyond is the curve and grade of the LV&T as it starts its climb for Doris Montgomery Summit. Seven or eight loaded freight cars were about maximum for any one engine on this climb, and trains frequently had to back into the yards for a second run for the hill after stalling on the curve. So serious was the problem, an emergency water station was located this side of the pass to Rhyolite so locomotives could tank up and refill their boilers to protect their crown sheets before tipping the hill and starting down the steep grade to Rhyolite. *(Hendrick Collection.)*

man was killed in a switching move. Still, the year ended on a somewhat happy note when the "Bull Pen," made famous in Bessie Beatty's writings, was reopened. To forecasters, the event was an indication, however incorrectly interpreted, of a business revival.

The LV&T was not alone in its sufferings. The competitive Bullfrog Goldfield as well as the Tonopah & Tidewater were also facing unhappy times. However, since Smith's T&T operated the BG as part of its own system, it competed with the LV&T over the full length of the territory served, and the T&T's shorter route to the West Coast inured to the detriment of the LV&T.

Passenger business, for example, was most discouraging. The LV&T lost money on every bit of this traffic and only continued to provide the service for the pleasure and convenience of shippers over the line. Ultimately on January 23, 1910, with the competitive BG-T&T route handling more than twice the travel via LV&T, the Pullman sleeper was taken off. Still, efforts were made to encourage

the people to travel; special excursions were offered for trips to Los Angeles to see the U. S. Naval Fleet and again during the Christmas holidays to visit the city relatives. Moreover, removal of the Pullman proved not to be the panacea anticipated; some services obviously were necessary, and a "club car" was added to the mixed train replete with a colored porter serving such delicacies as bacon and canned corn beef hash. The food was not very tasty, but it was eaten with relish as there was no other selection available.

The service was somewhat irregular. Early in 1910, after serving the usual lunch, the porter disappeared from the train at a slow-up point south of Amargosa near Charleston. The unfortunate man had been acting strangely and, being under the delusion that his enemies were about to hang him, probably disappeared in order to escape them. Section crews searched in vain for the missing man as far back over the route as Las Vegas, but to no avail. The story, as ultimately pieced together, revealed that the porter purchased a sweater and

Double-headed for the grade out of Beatty, LV&T train No. 11 with 28 cars tied behind LV&T No. 8 and BG No. 12 is just starting to roll northbound for Goldfield about 1915. The ice house, oil and tanks of the LV&T yards are visible over the cab of the lead locomotive; Bare Mountain looms in the background. *(H. K. Hall photo.)*

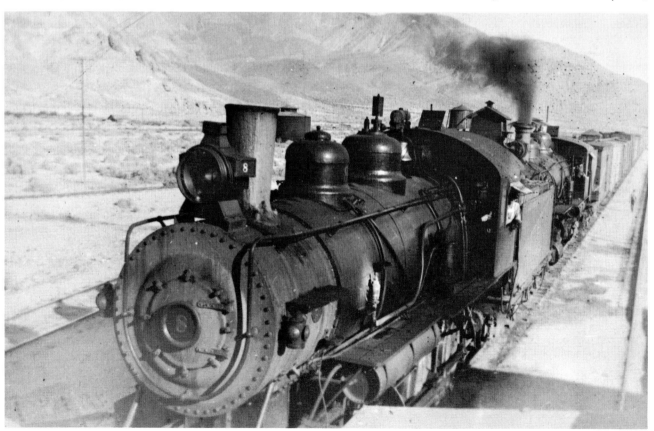

a cap from a Mexican for $2.25; then he forced the Mexican to return the money at gunpoint. Next he went to a laborer's home and demanded food and drink, saying that he would be right back as he went off into the night. Two days later and two miles from Amargosa his body was found by Indian trackers sent out by Sheriff Malley.

If the passenger service was not all that patrons might desire, the LV&T's traffic manager, C. E. Redman, tried to make up for the deficiencies in other ways. His home in Goldfield at the northern end of the line was a house supplied by the company. The Mexican section crews kept it well supplied with ice and fresh vegetables from the refrigerator cars brought in on the railroad. Visitors were always welcome (it being commonly mentioned that the general manager was always ready to add another room to the house each year), and many customers and prospective customers paused to stay with Mr. and Mrs. Redman while in Goldfield. As part of their entertainment, Redman was wont to give them a tour of the area by auto, speeding over the dry lakes and rough desert roads to neighboring camps such as Manhattan. The frequency of the trips coupled with the punitive abuse of the cars gave no cause for wonder that Redman wore out a car each year nor that Frank Grace, superintendent, tried to salvage something from the remains by putting flanged wheels on one of the discarded "Mitchell" autos for use as a track car.

Although the LV&T was undergoing difficult times, other roads in the area obviously were not escaping the ravages of the business decline. An undoubted balm to depressed spirits must have been felt by both of the Clarks when overtures were received in 1911 from President Cutter of the Tonopah & Goldfield toward possible sale of that road to the LV&T. Although the matter may have received serious consideration, the following year J. Ross Clark turned apathetic toward any negotiations following the loss of his son in the *Titanic* disaster of April 1912, and the matter was allowed to lapse.

The passage of time did little to improve the economic situation of the mining districts. Two parallel lines in an area with such a paucity of traffic just failed to make sense. The BG was the first to take positive action, but its overtures to its foster parent, the T&G, were unproductive. In November 1913 the Clarks approached the BG with a plan to combine the better portions of each of the two lines and eliminate the wasteful second

trackage between Goldfield and Rhyolite. Due to the better grades of the LV&T's line south from Goldfield to a point just south of Bonnie Claire, this portion would be retained and the BG's line abandoned. A switchover to the BG route would then permit trains to utilize the easier grades of the BG's route along the Amargosa River to Beatty while the LV&T's trackage over Mud Summit and along the hill to Rhyolite would be abandoned. Rhyolite would continue to be served via the old LV&T "High Line" from Beatty, but only as a branch line extending as far as the Tramps Mine on the west side of town. The station and yard facilities at Rhyolite would be retained as they were closest to the mines. The old BG grade, which swung south around the mountains, would be abandoned.

To accomplish this objective from a legal standpoint, those sections of the LV&T which were to be used in the combined new route were sold to the BG; those sections of the BG which were to be abandoned in favor of the revised line were sold to the LV&T. The agreement arranging this monstrous shuffle was finally consummated on June 26, 1914; the effective date of the transfer was July 1. Then the LV&T proceeded to apply to the Railroad Commission of Nevada for authority to abandon its entire line (comprising all of the undesired trackage) between Beatty and Goldfield.

Financially, the transfer presented still another problem. Since July 1, 1908, the BG had been operated by the Tonopah & Tidewater Co. as part of its route to Goldfield under a joint ownership agreement. In order to terminate this T&T ownership and interest, the original stock of the BG was wiped out, and new stock was issued in exchange for the income bonds. As part of the deal, 51% of the new stock was given to the LV&T as their portion of the new joint ownership for operating the revised line. To get the T&T off the hook, payment was made to that road of $50,000 purportedly representing moneys which the T&T had advanced for taxes. The T&T agreed to waive its claim for some $280,000 of additional moneys due them.

Thus, under the new arrangement, the LV&T lost its trackage from Beatty to Goldfield, substituting for it a 51% stock interest in the Bullfrog Goldfield. Although the BG began to make money for the first time in its history, now there was no competing line in its territory, the same could hardly be said for the LV&T which had amputated its northern arm. Beatty became the LV&T's northern terminus, with service to Rhyolite provided by

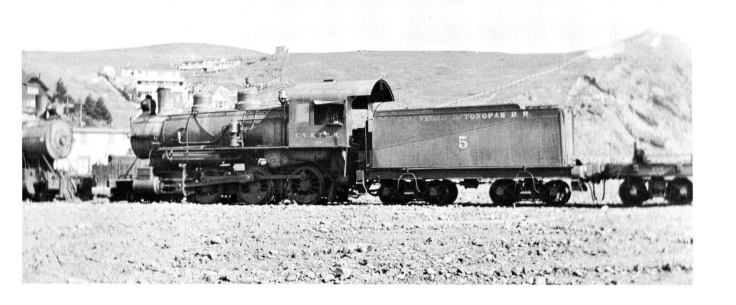

Dismemberment of the LV&T was complete and thorough following the road's abandonment. Locomotive No. 5 *(above)* became North Western Pacific No. 171 and is shown here following delivery at Tiburon, California, in 1917. No. 12 became NWP No. 129 and is shown *(above, right)* at Tiburon under the herald of her new owner. The San Diego & Arizona purchased No. 11, which is shown *(below)* as that road's No. 27 at San Diego. Even the LV&T's right of way disappeared when the major portion of the mileage between Las Vegas and Beatty was converted to highway use. Compare the 1962 view *(right, below)* with those on page 469 at the time of construction. *(Top, left and right: W. A. Silverthorn; bottom, left: Southern Pacific.)*

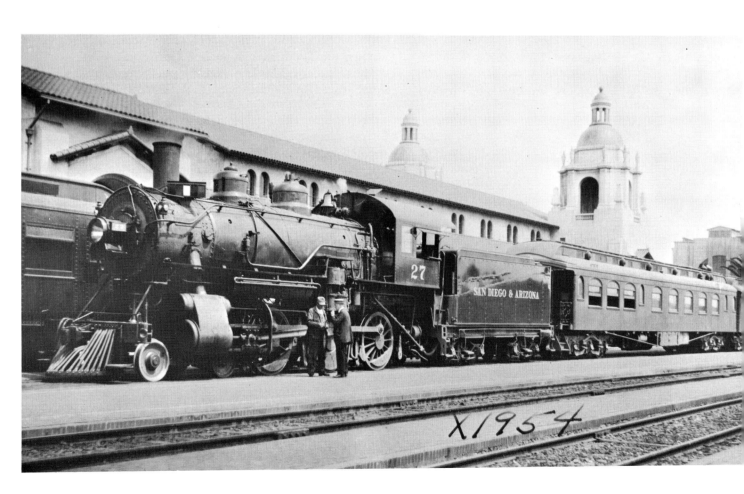

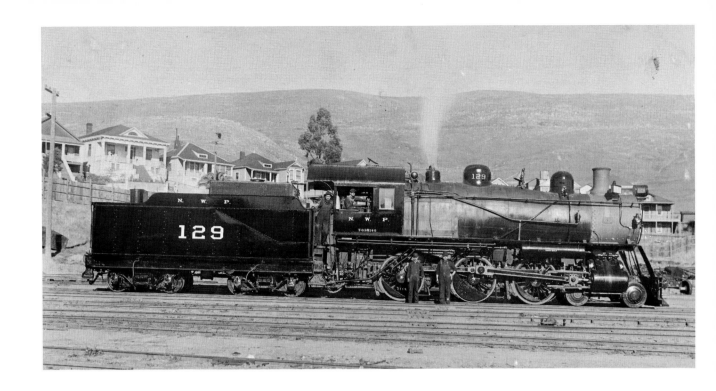

BG stub trains over the former LV&T main line to the monumental mausoleum of a station standing starkly against the skyline of a nearly deserted town. By the end of 1916 the stub train service was discontinued altogether, and within a year and a half the rails to Rhyolite were taken up.

Daily service on the LV&T's main line was maintained until February 1, 1917, when a tri-weekly schedule was inaugurated. "Go up one day and try to come back the next," local wags were saying, and they were right. The service was haphazard, and the storm clouds of World War I were forming on the horizon. On December 27, 1917, the Federal Government took over operation of all of the nation's railroads, and the LV&T was no exception. Employees continued to perform the same jobs as they had before, but no letters or memorandums could be written on the old LV&T letterhead — U. S. Railway Administration stationery had to be used.

Suddenly, less than three months after assuming control, the Federal Government threw the LV&T out of the USRA with the unflattering comment that it was "not considered essential or necessary to the uses of the Government." What was worse, a subsequent order of the Regional Director of the Railroads in San Francisco deprived the LV&T of its customary use of the Salt Lake Route's shops in Las Vegas for the repair of its locomotives and cars. In desperation the LV&T appealed to the Tonopah & Goldfield (its northern neighbor), but the T&G was obliged to decline assistance as it was unable to get enough men under the wartime conditions to do its own work. Since the LV&T was without the means to build its own shops, let alone to find and provide a staff of machinists, it was caught on the horns of a dilemma. Without proper maintenance, the days of operations were severely numbered. The next blow came from the San Francisco Freight Traffic Committee of the USRA which directed that all perishable and merchandise traffic formerly moving via Las Vegas and the LV&T should now be rerouted via Crucero and the shorter route of the Tonopah & Tidewater.

Revenues, which had declined continuously from the high of 1907-08, now began to tumble. Although in previous years the LV&T had always lost money, there were some periods when the direct operating expenses had been covered and a little money was left over for taxes and perhaps a bit of interest. By 1917, however, the operating revenues only approximated $8,000 a month, and passengers, usually numbering about eight on each

train, accounted for only $16,658 of revenue for the whole year. In 1918, the year of the traffic diversion, passengers averaged only two per trip!

High prices for scrap metal encouraged Clark to salvage as much of his investment as he could by promptly tearing up the tracks. Through a letter to the Railroad Commission of Nevada dated September 6, 1918, he explained his position and his plans for abandonment of the road. The Commission then sent a telegram to the USRA protesting the abandonment and urging that prompt action be taken. In its reply the USRA indicated substantial agreement that the road should not be abandoned, and referred the matter to its Short Line Section for a complete investigation.

Although some efforts were initiated to attempt to interest the Union Pacific (Salt Lake Route) in operating the line under lease, that road was recalcitrant and unmoved. Combined protests of the American Carrara Marble Co. and the Groom Mine near Indian Springs were likewise unavailing. On October 7, 1918, C. E. Redman wired the Commission that operations would cease on October 31. Governor Boyle of Nevada then sent a long telegram to McAdoo, head of the USRA, urging that that body take over the LV&T to preserve the important north-south link. While admitting that the road had never been profitable, Boyle drew a comparison with the experience of the Carson & Colorado which, after many years of deficits, finally became a very profitable railroad.

According to schedule, on October 31, 1918, the LV&T ceased operations. Two days later a report was published in the *Las Vegas Age* that the Federal Government had taken over the line. Following Election Day in November the *Goldfield Tribune* pointedly asked: "Did the LV&T help win the war, or was it just used to assist the Democratic campaign in Nevada?" The *Tribune* claimed that Senator Pittman persuaded President Wilson to have his son-in-law, McAdoo, take over the road during the election and then drop it.

In view of the controversy over abandonment of the LV&T, Clark delayed dismantling the line. It was his hope that some local organization would come forward to operate the road, but none did so. When it became obvious that efforts would be fruitless, dismantlement proceedings were started. Work continued throughout the majority of the year 1919 and to expedite the job, Redman invented a special apron to assist in pulling up the tracks. The bonded Mexicans, who performed the actual salvage work, after spotting a lady in the office of

the railroad, left a lasting impression on one person by refusing to call for their paychecks until they had returned to their camps and redecked themselves in broadcloth suits more proper to the occasion.

Former employees of the LV&T did not wait to witness the removal of the rails but sought employment elsewhere, many becoming affiliated with the Salt Lake Route. The physical equipment and rolling stock of the road became dissipated; for some years many LV&T locomotives graced the rosters of such railroads as the San Diego & Arizona Eastern and the Northwestern Pacific Railroad. Today they too have gone.

Ultimately the Nevada Department of Highways designated that portion of the old LV&T right-of-way between Las Vegas and Beatty as part of the state highway system, following which the highway engineer purchased all claims to the LV&T roadbed for $3,889.44. Since the ties of the railroad had been left in place during the dismantlement proceeding, the job of removing them was begun in the spring of 1919 and finished in the fall, work being suspended during the summer's heat. That fall and winter the roadbed was widened to 16 feet, and all bridges were reconstructed to the usual highway standards.

Visitors to the area will still find traces of the old right-of-way at the summit near Goldfield and in the hills of the Bullfrog-Rhyolite district; but other than these, scant traces will be found of the permanently planned railroad which Whittemore so proudly proclaimed would last for years. Probably the most permanent and most imposing monument to the enterprise is the old stone depot at Rhyolite which may still be reached by driving over the old right-of-way from Doris Montgomery Summit. For many years the only occupant of the edifice was one dead cow, later, more active operators took over and converted the structure to usage as a casino. Today it is a gift shop and information center catering to the thousands of travelers who visit Rhyolite's ghostly remains, including the unusual "bottle house" near the old Bullfrog Goldfield right-of-way. What will probably prove to be the most enduring monument of all can never be seen, for it is the sub-grade of the majority of the highway between Las Vegas and Beatty. Undoubtedly but few motorists over the route realize they are riding over the roadbed of the first railroad to reach the goldfields from the south — the Las Vegas & Tonopah.

When the LV&T tore up its rails a dozen years after the road was completed, it left few traces along the desert between Las Vegas and Beatty. A large portion of the roadbed, shown here near Beatty, is now part of Highway 95. *(Mrs. Olive Redman Wilson.)*

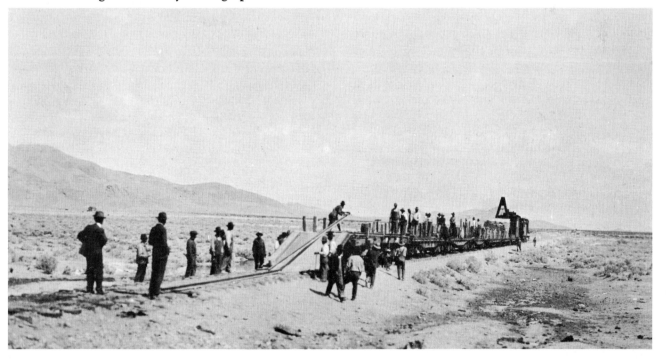

Pride of the BG was immaculate 10-wheeler No. 12 whose sparkling running gear stands in micro-prismatic splendor against the drab sootiness of the ready track and the erstwhile grime of Harry Cain's overalls. No. 12 failed to attain the ripe old age of meticulously fine machinery. In 1910, somewhere along the Amargosa River Canyon to the north of Beatty, her crown sheet let go and No. 12 exploded. The remains of her boiler were loaded on a flat car which, together with the frame and wheels in intact unit, were towed to Ludlow. Eventually, with new parts, it became SD&A No. 20. *(Both photos: Hendrick Collection.)*

BULLFROG GOLDFIELD RAILROAD

Without a doubt, the Bullfrog Goldfield was Navada's most unwanted railroad.

Born in conflict following most severe and protracted labor pains, the line suffered a childhood and adolescence of extreme malnutrition and died while attaining maturity at the ripe young age of 21. Organization was difficult to achieve, financing was an almost impossible accomplishment, and operations were never conducted as a separate entity in spite of the fact that equipment was on hand for that purpose. The BG's rails arrived on location too late to be of significant benefit to the bonanzas for which they were destined, the road was always dominated and progressively operated by its three neighboring lines (one of them twice); and as an entity, the railroad failed completely of its primary purpose in life — the discouragement of construction of competing railroads in the same territory. Thus the ultimate passing of the BG was one of joy and relief both to progenitors and competitors alike.

At just what point the beginning of this unfortunate venture took place is difficult to determine. Should it be considered to be the exact physical date of incorporation, that is irrevocably fixed as August 30, 1905. Actual preliminary surveys of the route had been made prior to that time, and serious thinking to various depths of consideration had obviously been performed under even more prior circumstances.

Certain it is that the event could not have been presaged prior to August 1904, for it was on the 9th of that month that Cross discovered the first, original Bullfrog claim (see LV&T) to the south of Goldfield and told the news in town. At that moment the narrow-gauge Tonopah Railroad had just been completed to the town of its corporate title, and preliminary surveys for a connecting Goldfield Railroad to the newest bonanza of note immediately to the south were even then in the process of completion (see Tonopah & Goldfield Railroad). Only a month earlier, near the far southern reaches of the state, "Borax" Smith had abandoned his idea of using steam tractors as a means of propulsion for borax wagons and incorporated the Tonopah & Tidewater Railroad (q.v.) with the

immediate objective of connecting his Lila C. borax mine near Death Valley with the still incomplete Salt Lake Route (SP, LA&SL) at Las Vegas. The Tonopah portion of Smith's railroad's corporate destiny at that time was but a figment of empirical imaginings provided in the abstract rather than the concrete devisings of practicality.

Thus Bullfrog lay between two advancing fronts of civilization — the newly developing Tonopah and Goldfield areas to the north, and that area to the south embraced by the developing center of Las Vegas with its advancing Salt Lake Route railroad. Each, for the moment, was most concerned with its own immediate problems of completion and

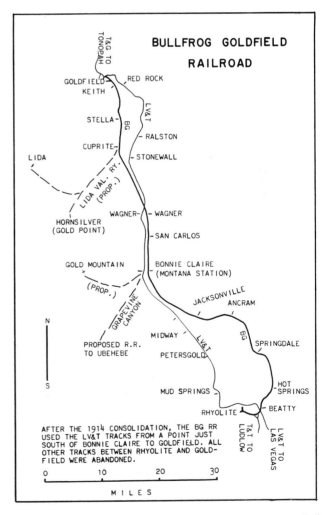

BULLFROG GOLDFIELD
RAILROAD

AFTER THE 1914 CONSOLIDATION, THE BG RR USED THE LV&T TRACKS FROM A POINT JUST SOUTH OF BONNIE CLAIRE TO GOLDFIELD. ALL OTHER TRACKS BETWEEN RHYOLITE AND GOLDFIELD WERE ABANDONED.

0 10 20 30

MILES

coordination, but time and circumstances were to become disruptive forces.

Bullfrog jumped first. Like its amphibious namesake, it leaped into prominence in unpredictable directions, spawning in prolific profusion such additional centers as Rhyolite, Beatty, Gold Center and Pioneer. Following the initial find, a second strike, the Denver Claim, was made on Bonanza Mountain immediately to the west of Rhyolite early in 1905. In February 1905 the really BIG strike of the area was made — the Montgomery-Shoshone — located on the slopes of Montgomery Mountain to the northeast. Rhyolite's population exploded under the impetus of all of this activity. Fortunately the town had been staked out in November 1904, but the growing pains were severe. Services were sorely needed, someone was going to supply them, the moot question was — who?

John Brock and his associates from the Tonopah Mining Company were vitally concerned. If the new strikes proved themselves to be substantial producers, it was imperative that they build still a third railroad to reach the new bonanzas and to control their traffic. On the other hand, the timing was most unpropitious. The turmoil, in February 1905, was terrific. The more northerly Carson & Colorado Railway was endeavoring to standard gauge that portion of its main line from Mound House to Sodaville, yet still keep that overloaded supply route open and operating. Brock's connecting Tonopah Railroad was preparing to perform the same feat. His Goldfield Railroad (to be built to standard gauge) even then was only letting the contracts for grading of the proposed line. Financing an additional railroad seemed out of the question.

By summer the situation had improved but slightly. In July the Nevada & California Railway (formerly C&C) completed its gauge conversion. In August the Tonopah Railroad followed suit. A merger of the Tonopah and the Goldfield Railroads into a combined Tonopah & Goldfield Railroad was imminent. It would take time to consolidate the position. But time was running out. Although Smith's T&T received an abrupt rebuke at the hands of the Salt Lake Route through refusal on the part of the latter to allow the former to connect with its rails, Senator Clark of the Salt Lake Route had quietly organized his own Las Vegas & Tonopah Railroad to pick up where Smith had left off and rush the line through to completion. Thus the threat of competition from the south had doubled and appeared more imminent than ever.

Brock and his associates were obliged to act. On August 30, 1905, they organized the Bullfrog Goldfield Railroad to build south from Goldfield over the 75 or 80 intervening miles to Beatty and Rhyolite. In spite of the uncertainty over the productiveness of the mines, they would have to be first on the scene to protect their interests. With both southern roads ready to build, the BG's shorter mileage was its only edge over the competition, an advantage which could be dissipated with the slightest delay.

Unfortunately the mundane routine of legal incorporation of the Bullfrog Goldfield Railroad proved to be far easier to accomplish than the more delicate task of providing funds for construction. Internal politics likewise reared its ugly head. Oscar A. Turner wanted the T&G to build to Bullfrog (not the BG) and insisted that it be done. Since Turner controlled 24% of the stock of the Tonopah Mining Company and was also a director of the T&G, John Brock, T&G president, had little alternative than to seek funds for construction in a number of places, including L. W. Halsey of New York. When Brock's efforts proved fruitless and unavailing, Turner himself took over the reins and called on Toland Bros. with equally negative results. Jay Cook III of Smith Barney & Co. indicated that he was unable (or unwilling) to help, and the Lincoln Trust Company of New York also declined assistance on the basis of lack of knowledge. The pending litigation of Teller vs. T&G (see T&G) involved the terms of the merger of the Tonopah and the Goldfield railroads and affected the financial rating of the entire enterprise. Even a new and direct approach to the problem through the issuance of Bullfrog Goldfield Railroad bonds failed to interest Charles D. Barney, as he felt that he could not sell them to investors.

By November 1905 the situation looked rather hopeless, and the BG was rapidly losing ground. The T&T had laid its first rails out of the new terminal of Ludlow, and even the LV&T was about to make a belated start. But the BG not only was not working; it wasn't even financed. Discussions had been held for the purpose of forming a private syndicate (along the lines of the most profitable Goldfield Syndicate) to build the railroad. In fact, a group of Philadelphians had been brought out to Bullfrog and Rhyolite for a personal investigation, but their impressions were definitely not flattering. In spite of the situation, however, Brock was hopeful and enthusiastically told a newspaper reporter

that a railroad would be built to the Bullfrog District.

A return visit to Rhyolite by the same group of Philadelphians early in 1906 revealed a greatly improved picture, perhaps caused in part by the arrival in Las Vegas of advance construction forces for the LV&T. Obviously Clark meant business. Moreover, Greenwater, about 70 miles south of Rhyolite along the eastern edge of Death Valley, had become a booming camp thanks to reports of rich 18% copper ores. Any railroad to Rhyolite would surely enjoy additional beneficial traffic from this new source of business. Again the syndicate group attempted to get together on a common solution to the BG Railroad problem, yet again they were unsuccessful.

Finally on March 22, 1906, the seemingly impossible was accomplished. The Bullfrog Syndicate was formed consisting of 32 individuals, each pledging between $25,000 to $50,000 per person, to form a pool of $1,000,000 with which to build the line. The job hadn't been easy, and some of the methods employed might have seemed questionable, particularly by today's standards. The members comprised many prominent Philadelphians, including the heads of two banks, railroad men, and some people who were completely unaware of the pitfalls of investments in mining and mining railroads. Through the courtesy of C. A. Higbee, some men who had been away at the time of the organization of the group returned to find that they had been signed up in their absence. Others demonstrated unwitting naiveness, such as the member, primarily engaged in the lumber business, who joined the Syndicate at the suggestion of a neighbor. Knowing nothing about Bullfrog, and hardly anything about the state of Nevada, he confidently pledged $25,000 based upon Higbee's promise that the bonds to be issued would be readily saleable at 95. In a later moment of regret he revealed that he had asked Higbee, "Then if my stock is ever worth anything I have only got to get five dollars a share to get my money back?" "That is the situation," Higbee had replied, which encouraged the lumberman to comment, "Then it is not any risk to me, and this company has been very successful, and I am very glad to go into it."

The plan as contemplated (which was based upon the successful formula used in building the Goldfield Railroad which became part of the T&G) appeared to be an attractive venture. The cost to build and equip the Bullfrog Goldfield Railroad was estimated at $1,250,000, for which equal amounts of stock and bonds would be issued. The members of the Syndicate would put up their $1,000,000 and receive in return, on a pro rata basis, the $1,250,-000 of stock as recompense for their services and their share of the risk in building the road. The $1,250,000 of 6% bonds would be sold to the public at 95% of par value, the proceeds of which would be used to repay the members of the Syndicate for their $1,000,000 advance. The discount on the bonds sold, plus expenses incurred in their marketing, would be more than made up by the increase in the value of the stock once the road was completed and operating on an anticipatedly busy and profitable basis. Members of the Syndicate could then recoup the remaining 5% of their investment and take a substantial profit in the bargain through sale of their stock.

That left only one other little matter which still required attention. The security of a *proposed* Bullfrog Goldfield Railroad would hardly be sufficient to justify public confidence in the purchase of the bonds, but if those bonds were *guaranteed* as to principal and interest by a going and profitable concern such as the T&G, their marketability would be considerably improved. Thus the proposition was made to the T&G that if it would guarantee the principal and interest of the BG RR First Mortgage Bonds, the Syndicate would turn over 51% of the BG RR stock to the T&G. The T&G directors approved the proposal on March 28, 1906, and set up a stockholders' meeting for April 30 at which to ratify the action of the Board. Considering that the majority of the T&G stock was held by the Tonopah Mining Company and that many members of the Syndicate were also officers or heavy investors in that company, it was anticipated that T&G stockholder approval would be more or less routine.

But no one counted on Louis Teller (although they might have learned from the bitter experience of the previous fall when the same individual disrupted the Tonopah and Goldfield railroad merger.) Teller was a retired Philadelphia tobacco man who, as a minority stockholder of both the T&G and the Tonopah Mining Company, felt that the proposed agreement was not as equitable as it should be. Many members of the Syndicate were also directors and officers of the T&G and of the Tonopah Mining Company, and they, rather than the T&G, stood to make substantial personal gains under the agreement. Consequently, two days before the T&G stockholders' meeting Teller sought an injunction (in Philadelphia) to prevent the

adoption of the proposed contract. Teller had met these men in court before and had won; this time he sought to show that collusion existed and that such a proposed contract providing for the guarantee of the BG bonds should be prevented. The covert fact that he had previously been offered a membership in the Syndicate, and had turned it down, theoretically at least had no bearing upon his position. He was convinced that the T&G should receive *all* of the BG RR stock (not just 51%) for guaranteeing that railroad's bonds. Furthermore, the Syndicate was taking no risk and therefore should be willing to build the road without receiving the other 49% of the stock.

As president of the T&G at that time (and being about the only official or director of the road who was not a member of the Syndicate), John Brock took a defensive position against Teller's admonitions. He told Teller he "would like businessmen to be so charitable as to take responsibility for nothing, but he had never found people that way." Later, during the trial, when asked by Teller's attorney why the directors did not borrow money individually rather than through the medium of the Syndicate, Brock replied, "I can say in the first place that they are not confined in lunatic asylums."

The legal wrangling was long and protracted, lasting over a period of 16 months. When the U.S. Circuit Court finally rendered its decision on August 30, 1907, some 475 pages of testimony had been recorded, and the court had found that no fraud or collusion had been incurred. However, in effect, Teller had achieved his purpose, for the T&G had been restrained from issuing its guaranty of the proposed BG bonds during that period. By the time the trial was over, the BG's financial problem had been circumvented; the railroad had been constructed; the boom at Bullfrog and Rhyolite had exploded; and the country was heading into the Panic of 1907. At that point any bonds, even given a gold-plated T&G guarantee, could not have been sold.

The evolution had not been easy. Blood, sweat and tears—and money—had been expended; more was yet to be spilled. The chain of events which had continued uninterruptedly from March 1906 (since just before Mr. Teller had launched his attack on the bond guaranty) deserves a more complete explanation.

With the basic plan formulated and the bonds all but guaranteed following the T&G directors' approval on March 28, the Syndicate forged ahead.

The next day (March 29, 1906) an agreement was signed between the Bullfrog Goldfield Railroad and the Amargosa Construction Co. (in effect the construction part of the Syndicate headed by Arthur Brock, brother of John Brock). Under its terms, the Construction Company agreed to build a 79-mile railroad from Goldfield to Bullfrog in accordance with the survey of Richard W. Welsh, Chief Engineer of the BG. Rail was to be 65-pound; sidings were to be provided for 5% of the total length and the builder was to furnish six locomotives, 20 freight cars, three passenger cars and two head-end cars. Payment was to be made in bonds and stock of the railroad company.

The arrangement was strictly one of legal convenience, for Arthur Brock also served as trustee and manager for the Syndicate, and it was to him that the members made their payments of approximately 25% of their pledges. Overseeing the manager was an executive committee composed of Rudolph Ellis, Henry W. Biddle and W. Hinckle Smith, all fine Philadelphia names; and based upon the strength of the Syndicate as represented by this imposing array of talent, the Fidelity Trust Company and the Fourth Street National Bank advanced from $600,000 to $700,000 on loan with which to build the railroad.

In April 1906 Brock was repeating his announcement that the Bullfrog Goldfield Railroad would be built to the Bullfrog District, if anything with even greater force and conviction. Amplification of the arrangements was made when he announced that two locomotives had been ordered, that work would begin immediately, and that Carnegie was rolling rails in Pittsburgh. One eager reporter from *The Rhyolite Herald* added even greater interest to his story when he ad-libbed: "While Mr. Brock would neither confirm nor deny the report, it is understood that this is the beginning of a through line to Los Angeles."

John F. Hedden became superintendent of the new Bullfrog Goldfield Railroad. The job was more of inheritance than one of selection. Hedden had been a former superintendent of the Central New England Railway before joining the Tonopah & Goldfield in the same capacity; his affiliation with the BG resulted largely from gravitational pull, there being no available more capable of handling the job in conjunction with his other duties.

The record of early construction of the Bullfrog Goldfield Railroad is indistinct due to a rather complete lack of corroborating evidence. That work began in the Goldfield area is certain; the

exact spot, however is a matter of conjecture. In the chapter on the Tonopah & Goldfield Railroad (page 259, Volume I), that road was reported as planning its line from Old Jct. southeasterly through Columbia to Bullfrog Jct. and Milltown as early as December 1905 with construction starting in March 1906. Work was halted at the Combination claim, just short of the goal, over a technical property dispute. On the other hand, Bullfrog Goldfield ownership of at least a portion of this route is twice indicated in other records. An early map prepared by the Bullfrog Goldfield indicates ownership (or anticipated ownership, if the map represents a survey) of a route commencing at Old Jct. (on the T&G) and following the route actually constructed by the T&G through Columbia (along Montana Street) to Milltown. This intent is questionably substantiated by a report from *The Goldfield Review* that the first earth was turned by McLean and Ottman, the contractors, on April 30, 1906, in Columbia to mark the initial grading of the Bullfrog Goldfield Railroad.

The questionability of the evidence of Bullfrog Goldfield ownership and construction rests upon the fact that T&G Valuation Maps on file with the Interstate Commerce Commission always show this trackage as T&G-owned property, and such maps are generally considered as reliable information. In addition, further evidence as to the beginning of BG ownership of any portion of this questionable trackage is found in the BG's report to the I.C.C. for the year ending June 30, 1908, wherein the reported owned mileage extended 80 miles from Milltown (not Goldfield or Columbia) to Beatty and Rhyolite. Further amplification in the same report states that operations were conducted [under trackage rights] over 1.10 miles of railroad owned by the T&G between Milltown and Goldfield [Goldfield Station at Columbia]. From this it also appears that the BG's track from Goldfield Jct. (at Milltown) down to the BG's freight terminal on Fifth Avenue in Goldfield was considered to be a side track and therefore was not reported separately.

The evidence thus presented invites two natural questions, neither of which have thus far been resolved. Was the reported BG railroad grade from Old Jct. (or from Columbia) to Milltown an actual railroad effort which duplicated the T&G's facilities constructed? Or was the reported BG railroad grade in actuality a subterfuge and substitution of the new Bullfrog Goldfield name as the negotiating party for the right-of-way in deference to that of

the T&G which had run into unresolved conflict with the mine owners? In view of the interlocking directorships of the two railroads, the latter view appears to be the more correct; but no substantiation or clarification of the situation has been found.

It has been ascertained that the first Bullfrog Goldfield rails were laid on May 8, 1906, and that track laying got off to a fast start. The pace quickly slackened, however, for only two miles were completed by the end of the first month, thus pushing the railroad up the sharp 3½% grade east of Milltown and over the pass to the vicinity of Keith on the far side. Graders, meanwhile, had prepared the roadbed for an additional four miles downhill in the direction of Cuprite.

The effort was anachronistic. Advance grading crews of the LV&T had already reached Beatty from Las Vegas, and even Borax Smith's surveyors for his Tonopah & Tidewater were stirring up the dust of the Amargosa Desert between Ash Meadows and Gold Center.

The original route of the BG RR as surveyed along the east side of Sarcobatus Flat and the Ralston Desert was the subject of considerable criticism on the part of Goldfield merchants as it placed the rails so far distant from the westerly mining towns of Lida and Gold Mountain that it failed materially to shorten the wagon hauls. Newspaper editorials supported the merchants' viewpoint and emphasized additionally that Borax Smith's survey for the T&T passed right through Gold Mountain (although it was admitted that that portion of the road might never be built). The point was made and the BG instituted new surveys to relocate the railroad to the west. To the engineers who performed the task, the summer desert sun must have been unpleasantly warm and uncomfortable, for several consoled themselves with liquor and women. News of the exploits of one audacious (but married) surveyor drifted all the way back to his family in Ohio with such resultant furor that the man was fired.

Numerous cuts and fills created significant delays in the progress of construction out of Goldfield. One large cut just east of Milltown halted all rail laying for almost two months until it was finally completed on August 17, 1906. Mayhap the difficulty was slightly overemphasized, for rails were hard to get from the mills at this time and the first regular shipment had just arrived in town a few days before the breakthrough was completed.

In passing through Rhyolite on his way to Greenwater, John Brock paused long enough to utter a few stimulating words of encouragement regarding the BG Railroad. Work would now go faster he contended, and notwithstanding ugly rumors to the contrary, the railroad would be completed to Rhyolite before cold weather. Fortunately he failed to define what constituted "cold weather," for the Bullfrog Goldfield trains were not to be seen in the area until late the following spring.

In September 1906 the rails stretched 15 miles from Goldfield (Columbia) to Cuprite (name of a very high grade copper ore). The next 21 miles to Montana Station (Bonnie Claire) were relatively easy ones to construct inasmuch as the majority of the way lay along the floor of the valley. By late October the track was in place and ready for service. The lateness of the season was dramatized by the arrival in Beatty of the first (competing) LV&T passenger train out of Las Vegas. The BG has lost the race to the Rhyolite District although it could still win second place, for Borax Smith's Tonopah & Tidewater was bogged down in the wilds of Amargosa Canyon to the south.

Three feet of snow on the ground in December 1906 slowed BG construction to a snail's pace. Impassable roads caused a three-week suspension of auto service to Rhyolite, while the supply lines in from the north were almost completely plugged by the freight blockade on the T&G. A revision of plans was obviously necessary, and "Rhyolite by February 15" became the new goal. Apparently the LV&T did not experience any such difficulties for that road's first trains to Rhyolite commenced operating on December 14.

January 1907 did not start the new year off in much better style. By the middle of the month grading had to be suspended temporarily because the mud was too deep, so the slack time was utilized in moving the grading camp from Hick's Hot Springs to Johnston's Spring, the latter point being but two miles north of Beatty. As fast as the ground firmed up sufficiently to enable work to be done, grading was continued with the result that by the following month the job was nearly completed.

In spite of this, progress was still disappointing. Shortages, first of rails and then of ties, caused the track laying to lag some 15 miles behind the finished grade. As a consequence, but little advance notice was given of their inauguration of regular train service between Goldfield and Montana Sta-

tion (36 miles) on February 2, 1907. Only 20 people climbed aboard that first train by the time of departure, and no one could even approximate the time of return. For the operation was most impromptu. South from Montana (Bonnie Claire) to the end of the line, a reclassification to work train status would prevail, while no set schedule at all was provided for the return trip — announcement was merely made that the train would return in the evening. Autos were provided at the southern end of the line for the one-hour trip to Beatty for those desiring that accommodation.

President Brock and Supt. Hedden went down in February, ostensibly to view the work. Word leaked out, however, that the real purpose of their visit concerned a branch line to be built from Gold Center to Greenwater, where Brock maintained an interest in the Greenwater Copper Mines and Smelter Co. (see Greenwater). The subject provided an excellent topic for speculation and discussion, even though nothing in the manner of concrete action ever materialized.

Even before the railroad was completed, rumors were circulated that the BG was to be sold or merged. Local sojourners found the topic as appealing as the weather in striking up an acquaintance over a glass of beer or a shot of whiskey at the corner saloon. Newspapers played up each new angle as a stimulant to their circulation growth to the ultimate redundant extreme of reporting on the reporters, as witness this select tidbit from *The Rhyolite Herald* of March 8, 1907: "Mr. Elkins is interested in the Brock Road and said the rumor of the sale of the road was news to him. Mr. Brock corroborated Mr. Elkins' statement, saying that the newspapers sold their road for them at frequent intervals, but they still continue to hold it."

In spite of the disturbing aspects of phantom sales and mergeless mergers, work on the BG did progress. On March 17, 1907, Timetable No. 5 became effective, scheduling regular service (both ways) from Goldfield all the way to Springdale (11 miles from Beatty).

#12		#11
8:30 A.M.	Lv. Goldfield	Ar. 5:00 P.M.
10:30	Cuprite	2:50
11:30	Bonnie Claire	2:20
12:45 P.M.	Amargosa	1:40
1:00 P.M.	Ar. Springdale	Lv. 1:15 P.M.

Although speed was never to become an important element of BG service, the lackadaisical aver-

age of 14 miles per hour on the down trip and 16½ miles per hour on the return would tend to indicate either a precautionary slow order over the new track laid on soft ground or else an unofficial quasi-mixed train of dubious distinction. In any event, passengers used the new facility in preference to other existing modes of travel, arriving in Beatty from the south via LV&T, transferring to auto stages for the short jump betwen railheads, thence via BG to Goldfield.

During this winter and spring period of 1907 the LV&T had not been sitting idly by and watching the BG's progress. Although LV&T rails ended at Rhyolite, the line of fresh grade extended to within seven miles of the northern (Goldfield) terminus and threatened to beard the (BG) lion in his den before his full growth had been attained. The BG's offensive action of blocking any invasion of its territory had now became a defensive one, and there was every possibility it might be turned into a near rout.

During April 1907, using ties and rails loaned by the LV&T, the BG completed its track into Beatty. Another accomplishment in the same month was the completion of the grading to the first (BG) depot site in Rhyolite, located at the bottom of the grade near Senator Stewart's residence in the old Bonanza Townsite. Additionally, work continued on the extension of the roadbed around the southwestern side of Ladd Mountain and on up the slope into Rhyolite proper to serve the mines to the east of town as well as eventually to furnish passenger service (however roundabout) to the town. Another projected spur headed westerly from the foot of Ladd Mountain across the flat to serve the Tramps mine in which both Brock and the Bullitt Building crowd were interested. In actuality, an elongated tail of the wye track in the direction of Bullfrog was the only track to be built in that direction.

According to one report from Goldfield, an "unofficial" BG last spike was driven at 8 o'clock on the morning of April 18, 1907, to the accompaniment of an equally unofficial and impromptu commemoration. Detonations of dynamite had been considered by the workers, but when a scouring of the countryside revealed a paucity of that explosive, a salvo of shotgun blasts was determined upon as the next best thing. Thus the spike maul's last blow was struck with dignity, if not by dignitary.

April 25, 1907, became the official BIG DAY for Beatty, the alleged "Chicago of the West." Presumably it was a promoter that told a visiting reporter from the *Goldfield Daily Tribune*: "Say, wire the people of Goldfield that we have money to spend and urge them to come down and help us get rid of it." Goldfield responded en masse, as did most of the towns in the surrounding area, while other visitors from such far away points as Los Angeles and Salt Lake City also appeared on the scene. And spent it they did. A thousand yards of bunting decorated the buildings, and many of the 1,000-odd visitors became "gaily" decorated as the day wore on. The welcoming address was given by Dr. W. S. Phillips, the Beatty booster, while the Hon. George D. Meiklejohn, as principal speaker, elaborated on the broad subject of Bullfrog — past, present and future. More speeches followed until finally the Walter's band (which had come all the way from Los Angeles) led the crowd down to the tracks. Here a typical miner, dressed in slouch hat and blue flannel shirt carelessly open in the front, stood like a statue for a full 10 minutes holding up the golden spike so that all could see it; following which M. M. (Old Man) Beatty, the pioneer rancher, drove the gold spike into place in a carefully selected tie. That evening localities and visitors from far and near mixed together at a big dance arranged in honor of the occasion.

The celebration was more noteworthy than might first appear. Not only did it mark the completion of a local line of railroad, but in the broader aspect it honored the occasion of completion of the first north-south railroad route within the state of Nevada — a previously unrealized dream of numerous men over the period of the past 35 years. Within a week the first through service was inaugurated via connections with the LV&T on May 3, 1907, although any hopes for traffic of typical bridge route volume were doomed to eternal disappointment.

Diametric to the views on page 493, the panorama (*overleaf*) was taken from Columbia Mountain looking southeast into BG Railroad territory. From the outskirts of Goldfield (upper right) are the Combination Mill and the famous Mohawk Mine with its distinctive headframe, large trestle and ore bins (right center). Just upper left of center is the Florence Mine and Hill, while to the left of that and partially hidden by the hummock is Milltown where the BG's branch to its Goldfield Freight Station left the main. From there BG track extended directly left up the hill to the notch. In the hollow (immediate foreground) at the foot of the mountain is the LV&T main line, while just above it the Jumbotown spur curves into a lumber yard. (*Sewell Thomas Collection.*)

WELCH & TUNE
GOLDFIELD NEV.

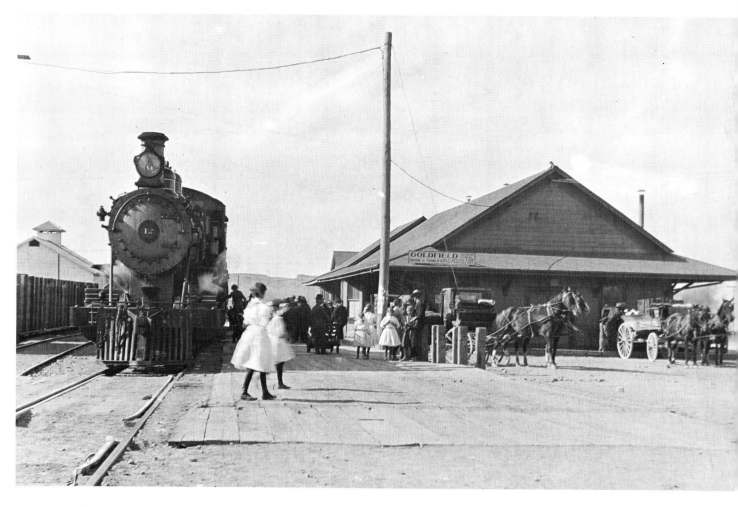

BG passenger trains used the Tonopah & Goldfield Railroad's Goldfield (Columbia) depot. Here BG No. 12 stands ready to leave on the advertised with the morning local south, while passengers say their final adieus before the conductor shouts his familiar "All aboard." *(Hendrick Collection.)*

Cuprite *(below)* was the BG station and transfer point for passengers and freight destined for Lida and Gold Point to which, at one time, a connecting Lida Valley Railroad was projected. *(Nevada State Library.)*

North of Rhyolite the Pioneer Mine *(top, right)* showed considerable promise around 1910, and a town developed on the slopes below the shafts. For a time the BG Railroad considered building a branch to Pioneer from Springdale, and the LV&T entertained thoughts of reaching it from the west. Before either road took action, however, Pioneer's boom collapsed and the town disappeared in a column of flames, ashes and soot. *(Top: H. K. Hall Collection; bottom: Barton Collection.)*

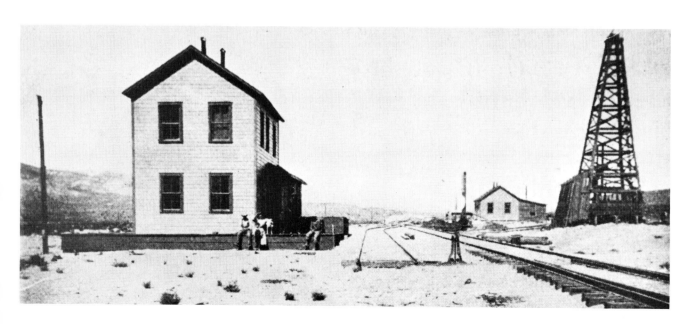

PIONEER MINE
JUNE 1910

Nevada

J. E. Horton

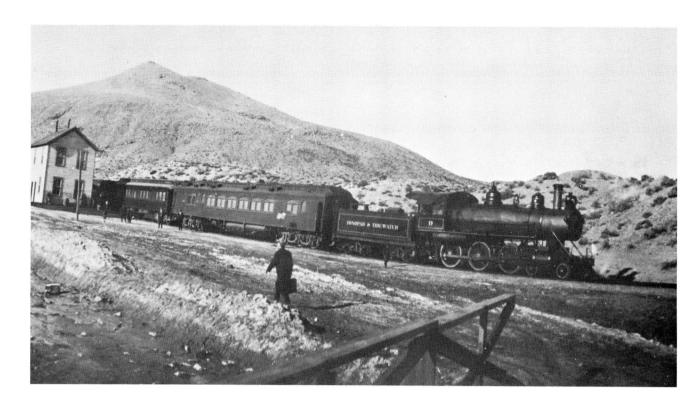

The picture of Springdale station *(above)* was probably taken about 1912, long after operation of the Bullfrog Goldfield had been assumed by the Tonopah & Tidewater and the route was known as "T&T all the way." *(H. P. Gower Collection.)*

The view of the upper reaches of the Amargosa River *(below)* looks northerly and shows the town of Springdale, shipping point for ore from the Pioneer Mine in the hills out of picture to the left. *(A. B. Perkins Collection.)*

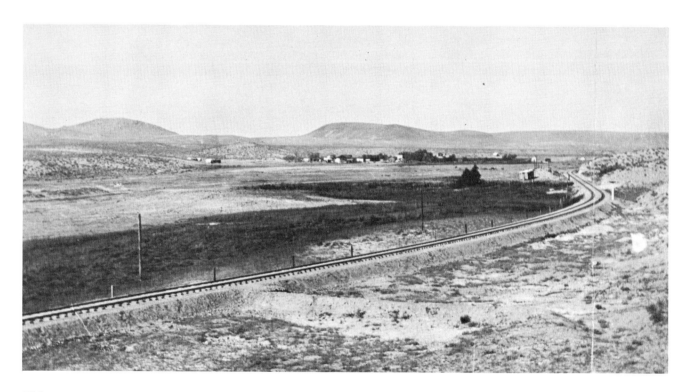

During May 1907 the graders finished their work, and by the end of the month the rails stretched all the way to the old Senator Stewart residence and were being pushed northward past the wye at Bullfrog, the tail track of which extended westward almost to the ice plant. On June 18, 1907, regular passenger train service through to the (first) Rhyolite depot at the bottom of the hill commenced, and the BG was considered to be officially completed.

At that time Rhyolite was a busy place. Pride of the town was centered in the newly completed, three-story John T. Overberry Building on Golden Street (in service by the end of May 1907). The mines were still very active, as were the miners, although it was becoming more and more obvious that the peak of the bonanza had been passed. The I.W.W. (Industrial Workers of the World) labor organization was so strong and self-sufficient the members could behave about as they pleased,

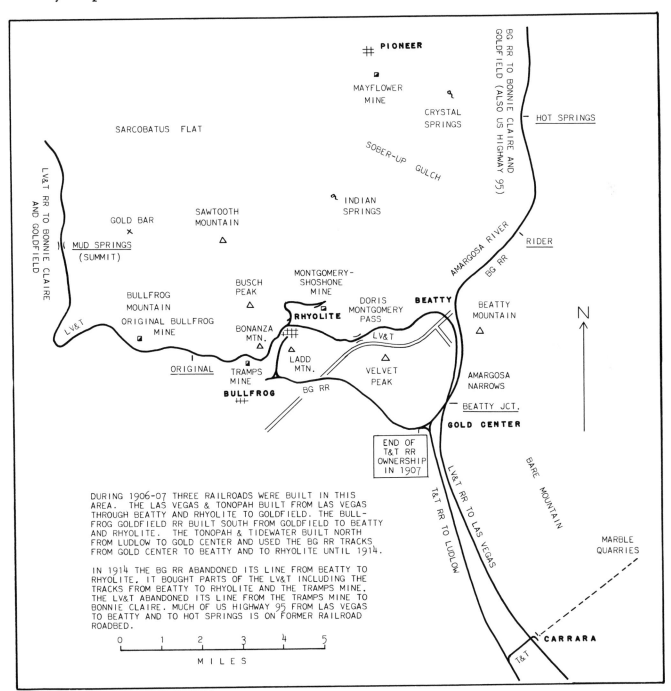

DURING 1906-07 THREE RAILROADS WERE BUILT IN THIS AREA. THE LAS VEGAS & TONOPAH BUILT FROM LAS VEGAS THROUGH BEATTY AND RHYOLITE TO GOLDFIELD. THE BULLFROG GOLDFIELD RR BUILT SOUTH FROM GOLDFIELD TO BEATTY AND RHYOLITE. THE TONOPAH & TIDEWATER BUILT NORTH FROM LUDLOW TO GOLD CENTER AND USED THE BG RR TRACKS FROM GOLD CENTER TO BEATTY AND TO RHYOLITE UNTIL 1914.

IN 1914 THE BG RR ABANDONED ITS LINE FROM BEATTY TO RHYOLITE. IT BOUGHT PARTS OF THE LV&T INCLUDING THE TRACKS FROM BEATTY TO RHYOLITE AND THE TRAMPS MINE. THE LV&T ABANDONED ITS LINE FROM THE TRAMPS MINE TO BONNIE CLAIRE. MUCH OF US HIGHWAY 95 FROM LAS VEGAS TO BEATTY AND TO HOT SPRINGS IS ON FORMER RAILROAD ROADBED.

whether at work or on strike. The same privilege did not extend to the town's dance hall girls; when they went out on strike, they were hauled into court.

When the Rhyolite Foundry & Machine Supply Company announced on June 21, 1907, that they were going to manufacture automobiles, Rhyolite seemed to be on the threshold of becoming an industrial city. Although enough parts for eight autos were gathered together, there is no record that these parts were ever assembled into workable transportation machines. Perhaps the distinction is irrelevant, for the record does show that in the following month the thresholds of saloons in both Beatty and Rhyolite were crossed by automobiles of other manufacture as their owners enjoyed a new version of an old equestrian sport.

From May to December 1907 the Bullfrog Goldfield Railroad was operated by its builders, the Amargosa Construction Co. The reasons were as diverse as they were abundant. Primarily, the Construction Co. was to be paid in bonds and

stock, and the bond issue was still tied up in Louis Teller's legal wranglings in court, which did not reach the point of decision until August 30, 1907. Then, even though the verdict was favorable, the Philadelphians (who had hoped to sell the road at a profit) found themselves saddled with a load of unsaleable bonds of a money-losing railroad. Members of the Bullfrog Syndicate were called upon to make good their pledges — not an easy thing to do in those times of economic adversity brought on by the Panic of 1907 with its consequent closing of the banks.

For the Bullfrog Goldfield was a flop. Not only did it fail to forestall the construction of another railroad to Goldfield (the LV&T was to finish laying its rails to Goldfield on October 24, 1907), but it also failed to discourage Borax Smith's T&T from building through to Gold Center (on October 30, 1907) from the south. Virtually all of the rosy traffic prospects were vanishing into thin air with the immient collapse of the mining bonanza, and the mine profits were turning into dreams.

COLUMBIA JUNCTION TO RHYOLITE

Trains Going East 4

FIRST CLASS

Capacity of Tracks In Cars					4 T. & T. PASSENGER Leave Daily	2 PASSENGER Leave Daily	6 T. & T. PASSENGER Leave Daily	24 PASSENGER Leave Daily	Station Numbers	Distance from Columbia Jct.	TIME TABLE No. IN EFFECT DEC. 5, 19— STATIONS
						12.55 PM		9.40 AM	66		DEPART B-R..... **COLUMBIA JCT** ...
						s 1.05		s 9.50	C 5	5.2	R.....**McSWEENEY JCT** ..
31						f 1.07		f 9.51	C 5½	5.6	0.4**McSWEENEY**
34						f 1.27		f10.15	C 16	16.3	10.7 B........ **KLONDIKE**
Yard						1.55 / 2.05 M 9		10.40 AM	C 28	27.8	L.V. & T. XING 11.5 DN-R **GOLDFIELD**
P 9						2.20			A 3	30.3	2.5MILLTOWN SIDIN—
P 30						f 2.43			A 15	42.5	L.V. & T. XING 12.2 5 M ECUPRITE
0						f 3.03			A 24	51.9	9.4WAGNER
P 26 L 8						s 3.25			A 36	63.9	12.0 D.....BONNIE CLAIRE
0						f 3.52			A 50	77.3	12.4JACKSONVILLE
P 30						f 4.01			A 55	81.9	4.6ANCRAM
P 30						f 4.22			A 63	91.1	9.2SPRINGDALE ..
P 22						f 4.33			A 68	96.0	4.9HOT SPRINGS.
P 30 L 14					s10.57 M9 AM	s 4.45 / 4.55	s 5.00 PM		A 74	102.0	L.V. & T. XING 6.0 1.4 M. EAST-DR **BEATTY**
P 30					s11.02	f 5.00	s 5.05 PM		A 76	103.8	1.8 DR......GOLD CENTER ..
P 35					f11.12	f 5.10			A 80	107.9	4.1BULLFROG
Yard					11.17 AM	5.15 PM			A 81	109.3	ARRIVE 1.4 D-R..... **RHYOLITE**. ...
					Arrive Daily	Arrive Daily	Arrive Daily	Arrive Daily			STATIONS
					4 T. & T.	2	6 T. & T.	24		 TRAIN NO.
					20 min.	4 hr. 30 m.	5 min.	55 min.		 TIME OVER DIST—
					25 M	24 M	24 M	31 M		 AVERAGE SPEED PER H—

EASTBOUND TRAINS HAVE RIGHT OVER WESTBOUND TRAINS OF THE SAME CLASS.

Las Vegas and Tonopah trains have right over trains of the same class of Bullfrog-Goldfield Railroad at Beatty Wye Crossing and crossing three-quarters mile west of Gold Center.
Trains of Bullfrog-Goldfield Railroad have right over trains of the same class of Las Vegas and Tonopah Railroad at crossing five miles east of Cuprite.
All trains will stop within 300 feet of all crossings and sound one long blast of the engine whistle before proceeding.

One important mine at Rhyolite in particular, the Tramps Consolidated, was not showing up as well as Brock, Schwab and others had anticipated and its stock was falling sharply. Moreover, the cost of the Bullfrog Goldfield Railroad had been considerably greater than expected, partly because of the slightly longer route and also because of the full rates charged by the (affiliated) T&G for hauling construction materials. Disappointments were piling up one on top of the other, contributing to the gathering storm clouds of rumors that the BG was about to be sold. And undoubtedly the line would have been sold — gladly, and on the easiest and friendliest of terms — if a buyer could have been found.

In spite of all the vicissitudes, there was a brighter side to the picture for those that sought to find one. For example, there was the growing town of Springdale, located 11 miles north of Beatty. The railroad demonstrated its confidence in the area's future importance through erection of a two-story station building, one of the few along the line to be so built. However, one early arrival

in town had failed to await construction of the edifice or even the advent of regular train service. Instead he had detrained at full speed through the medium of jumping from a coach window, and the momentum of his passing left little opportunity to observe the possible beneficial effects of settling in that remote desert vastness to await the coming population explosion. Of more immediate concern to him was escape from an imminent rifle explosion at the hands of a deputy marshal of Goldfield's Police Chief Inman, toward whose offices he had been unhappily en route.

Possibly the gayest, greatest and most notorious event to stir the citizens of Springdale concerned the case of the mail-order bride. An uncouth (local) chicken rancher initiated the chain of circumstances. Following a series of correspondence, he finally sent the "bride" the necessary funds for her railroad ticket. The word got around town, as usually happens in small, closely knit communities, and all Springdale was down at the station at train time to witness her arrival. Both the train and the bride pulled in on schedule, all right, but

Discovery of this Original Bullfrog Mine by Shorty Harris and Ed Cross in August 1904 started a chain of events which altered a state and rocked the nation. *(U. S. Geological Survey.)*

after one quick look at the "lucky man," the bride climbed back on board the same train and continued on to Goldfield, explaining to the conductor she "had another prospect in Austin." The erstwhile groom, now having lost both his cash and his woman, felt done in and telegraphed the sheriff in Goldfield to arrest her on arrival in that town. The sheriff performed his duty but, as the jail was already full, he locked her in a room in the Goldfield Hotel for safekeeping. Sitting by the window, the bride soon attracted a curious crowd of lonesome men. Suddenly one man stepped forward and proposed to her; she accepted; and a deal was made. Through the medium of the sheriff's good offices, the Goldfield man reimbursed the Springdale man for his expenses, and the marriage took place with the sheriff's blessings. As most stories go, the couple lived happily ever after.

The town of Springdale's importance was augmented by the fact that it was also the railhead for the boom town of Pioneer, a few miles to the west. In actuality, the BG surveyed a branch line between the two points, and the LV&T also contemplated a branch from its main line to the west, but Pioneer's boom faded long before serious consideration could be given to construction of either of the lines. As a matter of expediency, the people of Pioneer looked to Rhyolite for the majority of their supplies, necessities and amusements, in spite of the 6½-mile, mountainous dirt road which connected the two centers. Rhyolite reciprocated these friendly gestures by sending their older buildings and houses to the outpost, and when communications became threatened through deterioration of the condition of the only artery of commerce between the two centers, a road building holiday was declared on December 22, 1908. All business, even including the publication of the diminutive *Rhyolite Daily Bulletin*, was suspended so that every able-bodied man in the area could spend the day improving the "highway."

Although the BG never directly helped the citizenry of Pioneer, the railroad did bring its proportionate shares of joy and sorrow to other residents of the area. A monster picnic was held by the Western Federation of Miners (I.W.W.) at Howell's Ranch, a few miles north of Beatty, on Labor Day 1907. Over 1,000 people jammed the special train which hauled the revelers to the site Then, several weeks later, the whole town of Rhyolite was stimulated with enthusiasm when J. F. Hedden (Supt.) stepped off his private car (the T&G's *Mizpah*) to announce a new location for the

BG's Rhyolite depot. Whereas the older site had been located about a mile away at the bottom of the hill (necessitating that passengers walk up the 4% grade to reach town), the new location would be near the northern end of the extension at the east end of Broadway, a far more convenient spot.

Two, double-header events on October 1, 1907, were far less pleasing. In the first place, the northbound train ran into an open switch (with which someone might have tampered) at Bonnie Claire, and the entire train was ditched. Some of the passengers were shaken and one baggageman was injured, but it was considered a miracle that people were not killed. Then, before the accident could be reported and a relief train sent out, a six-day strike of both T&G and BG enginemen and trainmen was called to enforce demands that one trainman be reinstated following discharge for a violation of "Rule G" concerning intoxicants. The strikers offered to man a relief train to be sent to the scene of the wreck, but refused to accede to the company's insistence that a wrecker be included in the consist. The ensuing discussion delayed the departure of the train for one whole day with the result that 107 passengers (including 35 women and 20 children) were obliged to spend the night on the wrecked train. Although the cars were fairly warm, "there was mighty little to eat." It was late the following day when the relief train finally brought in the "bedraggled lot of indignant passengers."

The fourth quarter of the year 1907 was one of great toil and trouble for virtually all of the major participants in the bonanza legend. The Panic of 1907 with its attendant financial and banking crises hung like a pall over everything. The BG's entire line was completed between Goldfield and Rhyolite, but its efficacy had been dissipated by the LV&T's construction through to Goldfield and the final arrival of the T&T. With three separate railroads now reaching the gold fields, the problems were to become ones of strategy instead of logistics.

The BG (through its quasi-parent, the T&G) took the initiative. When C. K. Lord succeeded to the presidency of the T&G on November 1, tripartite negotiations were immediately started among the BG, the T&G and the Bullfrog Syndicate to resolve the complex financial problems with which they had been encumbered. In virtually the same breath other arrangements were consummated with the T&T for use by the latter road of BG tracks in the Beatty-Rhyolite area and

ultimately, on November 25, 1907, for the inauguration of through merchandise car service (via BG-T&T-Santa Fe) from Goldfield to Los Angeles and San Francisco.

The financial arrangements took longer to settle, being the more involved. Finally, on December 16, 1907, an agreement was reached whereby the earlier arrangement for guaranteeing the BG RR bonds (actually never placed in effect) was cancelled. The T&G accepted a cash payment of $250,000 in settlement of all claims against the Syndicate, and as part of the package deal the two roads (T&G-BG) entered into a traffic agreement whereby the T&G would operate the BG under contract and grant certain trackage rights over T&G rails in Goldfield. On January 1, 1908, the new plan went into effect, and the Amargosa Construction Co. ceased to operate the line.

Physical changes were also involved. In line with the close ties set up between the BG and the T&T, the BG's division headquarters were moved to Beatty in December 1907, furnishing new, even if slight, stimulus to that town's economy. In Rhy-

olite, the outlook was gloomy indeed. The banks were substituting script for money, and passenger traffic was heavy in one direction only—people were leaving town by the hundreds. In spite of this prevalent situation, Harry App of the *Daily Bulletin* found spirit enough to complain that Rhyolite was the only station on the BG "with a dry goods box for an office building." Apparently the BG concurred, for in March 1908 work was begun on a new depot building (24' x 72') and a month later Agent Goodwin moved into his new quarters. Perhaps in jeering triumph over the protracted incompleteness of the LV&T station of the time, he even talked of holding a dance in the waiting room.

Early in 1908 a reduction in section men's wages resulted in a strike of several weeks' duration on both the T&G and the BG. At one point, to the north of Beatty, three strikers were arrested for disturbing the peace when they attempted to intimidate some newly hired replacements. Upon apprehension, one man with a gun insisted that he was hunting jackrabbits. Judge Brissell of Tono-

Capacity of Engines in Addition to Weight of Engines, Tenders and Cabooses

9

EASTBOUND ON ALL DISTRICTS					WESTBOUND ON ALL DISTRICTS				
STATIONS EAST	Class "A" Engine No. 1 to 4 Tons	Class "B" Engine No. 10 to 14 Tons	Class "C" Engine No. 50 to 55 Tons	Class "D" Engine No. 100 to 102 Tons	STATIONS WEST	Class "A" Engine No. 1 to 4 Tons	Class "B" Engine No. 10 to 14 Tons	Class "C" Engine No. 50 to 55 Tons	Class "D" Engine No. 100 to 102 Tons
NA TO REDLICH	320	405	425		RHYOLITE TO SPRINGDALE		600	750	780
DLICH TO COALDALE	2000	2000	2000		SPRINGDALE TO ANCRAM		680	860	900
ALDALE TO BLAIR JUNCTION	430	540	570		ANCRAM TO BONNIE CLAIRE		1800	2000	2000
AIR JUNCTION TO MILLERS	960	1030	1140		BONNIE CLAIRE TO CUPRITE		430	560	590
LLERS TO GOLDFIELD JCT	730	920	950		CUPRITE TO MILLTOWN SIDING		300	390	400
LDFIELD JCT. TO TONOPAH	230	290	300		MILLTOWN SIDING TO GOLDFIELD		230	290	300
LDFIELD JCT. TO McSWEENEY	620	760	800		GOLDFIELD TO KLONDIKE		1800	1800	1800
SWEENEY JCT. TO KLONDIKE	2500	2500	2500		KLONDIKE TO McSWEENEY		600	750	770
ONDIKE TO GOLDFIELD	600	750	770		McSWEENEY TO GOLDFIELD JCT		1800	1800	1800
LDFIELD TO MILLTOWN SIDING	235	295	310		TONOPAH TO MILLERS		900	900	900
LLTOWN SIDING TO CUPRITE	1000	1000	1000		MILLERS TO BLAIR JUNCTION		930	1100	1200
PRITE TO GOLD CENTER	1800	2000	2000		BLAIR JUNCTION TO COALDALE		680	860	900
LD CENTER TO BULLFROG	320	405	425		COALDALE TO ROCK HILL		1800	2000	2000
LLFROG TO RHYOLITE	160	210	220		ROCK HILL TO REDLICH		350	430	450
					REDLICH TO TONOPAH JUNCTION		1800	2000	2000
					TONOPAH JUNCTION TO MINA		640	800	840

Weather Rating { 1—When temperature is 25 degrees above zero or over.
2—Very frosty or wet. 5 to 25 above zero.
3—Five degrees above to 10 below zero.
4—Ten below zero and colder.

Chief train dispatcher may increase or decrease above rating as it may be found necessary.
The following will govern when handling empty cars: With ten or less empty cars in a train no allowance will be made for wheel friction; with 10 to 20 empty cars in a train add to actual weight 5 tons for each empty car for wheel friction; with more than 20 empty cars in a train add 6 tons per car for wheel friction. When no water car is used, rating between Bonnie Claire and Milltown Siding is to be the same as rating between Cuprite and Milltown Siding.

AVERAGE WEIGHTS OF EMPTY CARS WILL BE ESTIMATED AS FOLLOWS WHEN NOT MARKED:

x Cars, 28 to 30 foot11 Tons	Flat Cars, 28 to 30 foot9 Tons	Small Mogul Engine and Tank102 Tons
x Cars, 33 foot12 Tons	Flat Cars, 33 and 34 foot11 Tons	Large Mogul Engine and Tank102 Tons
x Cars, 34 foot13 Tons	Flat Cars, 40 foot12 Tons	Consolidation Engine and Tank111 Tons
x Cars, 56 foot16 Tons	Coal Cars12 Tons	Mail25 Tons
Cars, 40 foot15 Tons	Gondola Cars13 Tons	Baggage30 Tons
frigerators20 Tons	Oil Tanks15 Tons	Coaches, 8 wheel30 Tons
rniture, 30 to 40 foot17 Tons	Ballast Cars12 Tons	Coaches, 12 wheel35 Tons
rniture, 40 to 50 foot19 Tons	Steam Wreckers75 Tons	Dining Car40 Tons
booses, 8 wheel17 Tons	Engine Tank (empty)30 Tons	Sleeping Cars41 Tons
booses, 4 wheel10 Tons	Standard Engine and Tank81 Tons	Ore Cars—wood, 12 tons—steel15 Tons

Yardmasters will at all times make up trains in accordance with the above instructions.

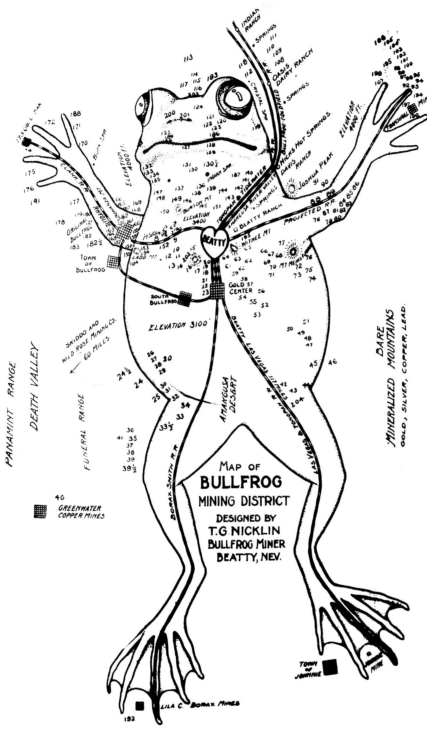

The figures on above map mark the location of mines and prospects.

Although without major mining *per se*, Beatty is depicted as the heart of the Bullfrog District in this hopefully futuristic map of the region. The Borax Smith R.R. (T&T) never progressed beyond Gold Center; instead it connected with the BG's rails from that point north. The projected railroad to Transvaal likewise never materialized. In spite of this optimism, artist T. G. Nicklin composed a most logical, intriguing piece which, being frequently reproduced, did much to popularize the area. *(From the Las Vegas Age, Nevada Historical Society.)*

A year after the T&T ceased operations, but a year before the road was dismantled, the Beatty yards, engine house and station stood in suspended animation on this June 1941 day. *(Top and center: Guy L. Dunscomb photos; bottom: Louis L. Stein, Jr. Collection.)*

THE BULLFROG MAP

The figures on above map mark the location of mines and prospects. A copyright has been applied for and an index will be added when copyright is granted.

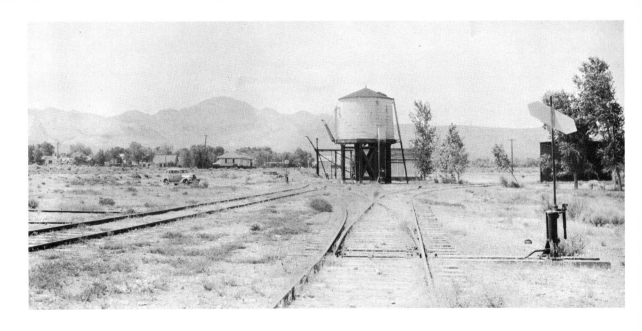

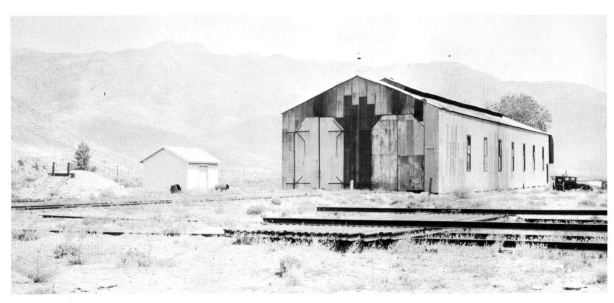

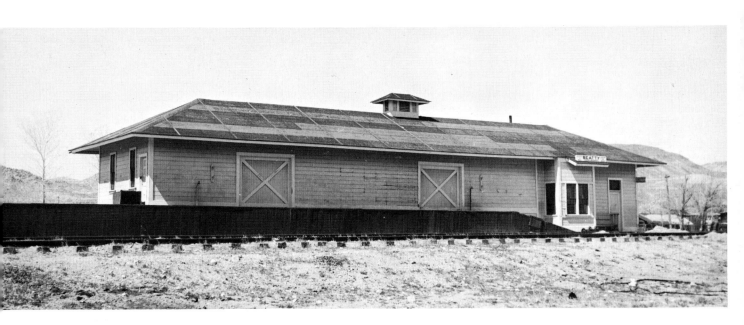

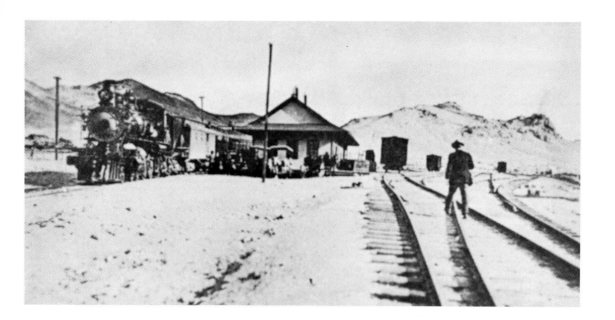

The BG's Rhyolite station and freight yard *(above)* was established on the hill at the east end of Broadway near the main part of town. Incoming passenger trains turned on the wye in Bullfrog and backed up the hill to the stub-end terminus so they were properly positioned with the locomotive in front. The reason for such movements was the safety factor of keeping the locomotive on the downhill end of the train as a precaution against runaways. *(Top: Mrs. Earle Clemens; bottom: Nevada Historical Society.)*

The two views of Rhyolite *(page opposite)* are almost identically positioned with the jail in the left foreground and the LV&T station at center, right. The upper was probably taken about August 1908 as Rhyolite was beginning to decline from its peak population of approximately 8,000 people; the lower was taken in August 1960 when the two inhabitants of the station building (Mr. and Mrs. H. H. Heisler) were among the handfull of Rhyolite's permanent residents. *(Top: Mrs. Gladys Wells)*

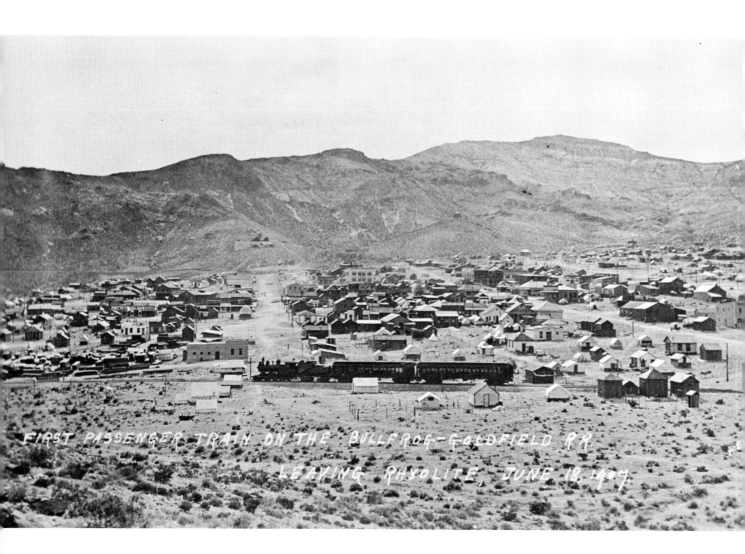

FIRST PASSENGER TRAIN ON THE BULLFROG-GOLDFIELD R.R. LEAVING RHYOLITE, JUNE 18, 1907

pah dismissed the case after giving a severe warning and telling the parties involved that if they did not want to work, they were to allow others to do so.

The general situation continued to deteriorate rapidly. In contrast with the heavy mass emigration from Rhyolite in December 1907 which kept outbound trains filled to near capacity, L. D. Porter observed an entirely different status quo when he left for a visit in Rawhide in February 1908. On that trip he reported that he was the only passenger on the train from Rhyolite to Beatty.

In the final analysis, the trend of the times became perfectly obvious from the financial reports. For the six-month period to June 30, 1908, the BG took in total revenues of $92,000, but not one penny was carried through to income. Instead the road suffered a staggering net loss of $79,000. The holders of the First Mortgage Bonds virtually acknowledged defeat and exchanged most of their bonds for General Mortgage Income Bonds on which interest was payable only if earned. Had these people been able to look ahead, they might have seen that there wasn't a prayer of this ever happening. During the next 6½ years to June 1914, their unwanted railroad took in $782,000 of revenues but failed to cover even the operating expenses and taxes by some $117,000, let alone provide anything for rents or interest.

The T&G wanted no more of the operations of its spendthrift bedfellow. From the northern viewpoint, the Bullfrog Goldfield Railroad not only ran nowhere, but once it arrived there was no business to be had. On the other hand, from the southern viewpoint, the Tonopah & Tidewater Railroad had built to nowhere (Ludlow to Gold Center), and it needed the rails of the BG to reach the northern sources of traffic at Goldfield. Thus it was only natural that the T&T and the BG get together and inaugurate a plan, formalized in an agreement of June 15, 1908, whereby the T&T took over formal operations of the BG RR. The stock of both companies was exchanged for that of the Tonopah and Tidewater Company, a new holding company specifically organized for that purpose. One part of the joint operating contract called for the utilization of the profits of one road to offset the losses of the other, as neither road of itself could accomplish the objective of them both together.

For the next six years to 1914, the T&T operated the BG Railroad as part of its line. In fact, the operations became so ingrained on the local citizenry that the complete route was referred to as T&T all the way (see T&T). But even Goldfield was not immune to the generic cancer of mining operations — exhaustion of the ore bodies — and by 1913 the end was beginning to come in sight. The effect was woefully felt in the volume of traffic being originated, which was hardly sufficient for the support of one railroad, let alone three. Both the LV&T and the BG wanted to improve the situation or else get out of business.

In June 1913 Chris Zabriskie, then president of the BG, made the first overture. Going to Philadelphia, he offered to lease his road to the T&G, possibly with the thought that the T&G might wish to protect its territory. Under the terms of the proposal, the lease would extend for a period of three to five years, while the annual rental would constitute payment of the interest on the small amount of remaining First Mortgage Bonds outstanding. Also included was a stipulation not to run up any further bills or debt during the term of the lease. Just as the deal appeared to be about to be consummated, the T&T's traffic manager, W. R. Alberger, suddenly called off all negotiations. At first he refused to give any explanations for his actions, but later he indicated that he was dissatisfied with the proposed traffic agreement between the BG (under T&G control) and his (T&T) road.

By this time Senator Clark and his brother, J. Ross Clark, began having thoughts on the matter. In November 1913 they approached the BG with a plan of operation which would combine the two railroads between Goldfield and Rhyolite, yet each would benefit through the combination. The idea was to eliminate one of the two duplicate routes by combining the better features and most favorable grade of each, thus eliminating the weaker sections of either line. The revised railroad would then consist of the following:

	Old BG Route Mileage	New Line	
		Mileage	Former Ownership
Goldfield to point just south of Bonnie Claire ..	36.65	42.12	LV&T
South of Bonnie Claire to Beatty .	37.49	36.83	BG
Beatty to Rhyolite	7.79	5.83	LV&T
TOTAL	81.93	84.78	

Under the plan of action, which became part of an agreement dated June 26, 1914, those portions of the LV&T to be used in the combined system were sold to the BG, and those portions of the BG which were to be abandoned were conveyed to the LV&T. The LV&T then abandoned its (revised) line between Beatty and Goldfield, leaving only the new, revised BG route extant. The BG's corporate identity was to remain, but the LV&T would take over the operation of and financial responsibility for the road, agreeing to pay the principal and interest on the remaining $182,000 of First Mortgage Bonds outstanding. The original BG stock would be wiped out in this reorganization, but new stock would be issued in exchange for the income bonds, and (as part of the deal) 51% of this new stock would be given to the LV&T. Only one factor remained — to get the T&T off the hook. To accomplish this, W. A. Clark reimbursed the T&T for some $50,000 of moneys that road advanced to the BG for taxes, while the T&T (now glad to be let out of its older arrangement) agreed to waive a balance of some additional $280,000 due them. Possibly it wasn't the best deal in the world, but it solved a problem.

When the matter of the consolidation of the two lines came before the Railroad Commission of Nevada in February 1914, there were no protestants. The Commission recognized the fact that the two lines had ". . . for a long period . . . constituted a wasteful and unprofitable procedure on the part of both roads by reason of the extraordinary and unanticipated diminution of traffic . . ." Thus, with the informal blessing of the Commission, the consolidation became a matter of record, effective July 1, 1914.

As an implicit part of the new arrangement, there was an understanding that all points should continue to receive rail service, whether previously served by the LV&T or the BG. Since the BG was to be operated as a separate entity from the LV&T (even though under its domination), and since that segment of the old LV&T main line from Beatty to Rhyolite was to be used for servicing the mines to the north and west of the latter town, Rhyolite became situated at the end of an adverse branch of the BG, and trains were obliged to back up the line from Beatty.

In the lexicon of earlier days this would have been an ignominy unworthy of the town of Rhyolite. At its peak the bonanza settlement had boasted a population of 8,000 people (somewhat of a standard figure given out as the population of many a ghost town), but undoubtedly there were over 7,000 souls in the area in December 1906 at the time the LV&T first rolled into town, head on as steam locomotives and trains were intended to run. Equal honors were accorded by the BG on its initial entry in May 1907 when trains were run through to the end of its line in true ferroequinological fashion. It was not until the belated T&T arrived at Gold Center in October 1907 (with continuing trackage rights over the BG to Beatty) that the first of the ignoble shuttle trains was instituted over the BG between Beatty and Rhyolite, a situation which was mildly corrected in June of the ensuing year following assumption by the T&T of BG operations and the institution of the procedure of backing all main-line trains from the junction at Gold Center to Rhyolite. The population was declining, however. By July 1909 the number of inhabitants was down to 800; and by June 1912 the last of the three newspapers, which had so assiduously recorded the functionings and malfunctionings of the citizens, closed its doors and suspended publication, while the former editor, Earle Clemens, determined to try a theatrical career in preference to a play on words. At that, Rhyolite was still a two-railroad town with the LV&T performing main-line service in the best of head-end tradition. But now the distinction was being taken away, there was but one railroad left and, even more demeaning, there were few people left to care.

During the first half of 1914 (prior to the amalgamation), an average of only two patrons per day utilized the services of the trains to Rhyolite. After the consolidation, no service at all was provided for a period of a few weeks. Protests of the citizens and of the Nye County Grand Jury were countered by an offer of weekly service, but this was refused. Finally J. Ross Clark personally came to town to meet with the people, and a twice-weekly (Tuesday and Friday) service was decided upon, to become effective July 31, 1914. The protests were quieted, and serenity prevailed.

Under the over-all revised plan of BG-LV&T operation, the BG at last began to make money. No longer was the trickle of business from Goldfield, Beatty and Rhyolite being shared with a competing line, but the very cannibalization of the unwanted parts of the former parallel lines produced burgeoning revenues from the hauling of the scrap ties and rails and helped to contribute to the road's only three profitable years from 1915 to 1917. The results might have been even more encourag-

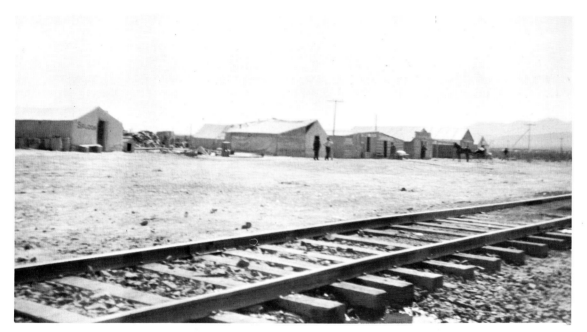

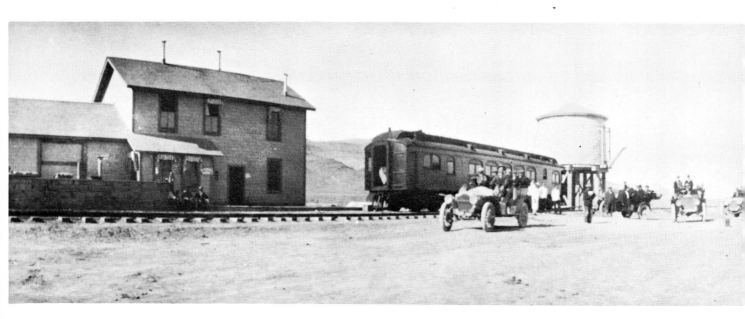

The panorama *(above)* was taken in 1907 as the spur to the Bonnie Claire Mill was under construction. Track ends at the group of buildings in the center, and graders can be seen preparing the right of way at left, center. The 23-mule team with its train of wagons has just brought a load of ore from the mine on Gold Mountain, while a second, similar "train" can be seen at the upper level unloading bins of the mill on the mountainside.

The impermanence of Bonnie Claire is attested to by the tent city which arose along the railroad *(center, left)*, prominent feature of which was the saloon. Even after the railroad built its more commodious two-story depot *(left, below)*, passengers forsook its creature comforts as well as those of their non-air conditioned coach (probably set out by the *Alkali Limited*) to ride roughshod in early vintage, high-wheeled autos to the mountain vastnesses of the mines on Gold Mountain or down tortuous Grapevine Canyon and through Racetrack Valley to far distant Ubehebe.

Although the last train left Bonnie Claire in 1928, the town managed to limp along through several revivals, the most recent of which was occasioned by erection of the J. Lippincott Mill *(below)* on the same site, shown here in 1957. *(Top and center, left: Nevada Historical Society; bottom, left: Don Ashbaugh Collection.)*

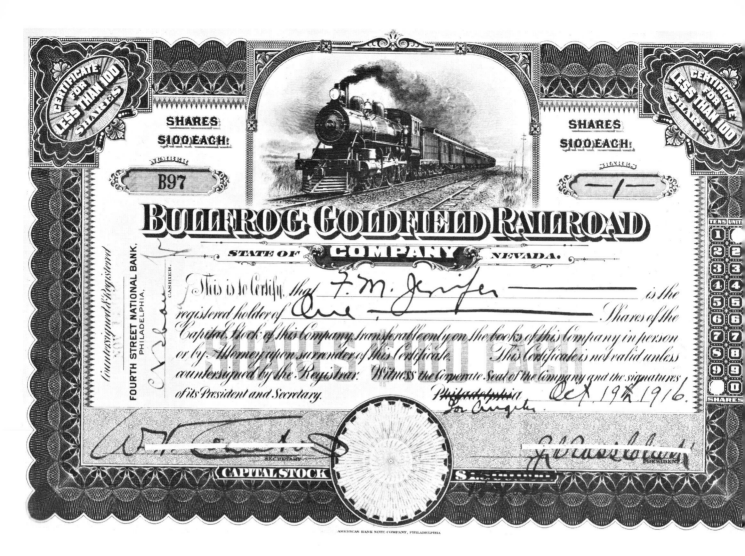

CERTIFICATE FOR LESS THAN 100 SHARES

SHARES $100 EACH.

SHARES $100 EACH.

NUMBER
B97

SHARES
—1—

BULLFROG GOLDFIELD RAILROAD COMPANY

STATE OF COMPANY NEVADA.

This is to Certify that F. M. Jenifer is the registered holder of One, Shares of the Capital Stock of this Company, transferable only on the books of this Company in person or by Attorney upon surrender of this Certificate. This Certificate is not valid unless countersigned by the Registrar. Witness the Corporate Seal of the Company and the signatures of its President and Secretary.

Philadelphia
Los Angeles
Oct. 19th 1916.

Countersigned & Registered

FOURTH STREET NATIONAL BANK,
PHILADELPHIA.

CASHIER.

SECRETARY

PRESIDENT

CAPITAL STOCK $.

TENS UNIT
1 1
2 2
3 3
4 4
5 5
6 6
7 7
8 8
9 9
0 0
SHARES

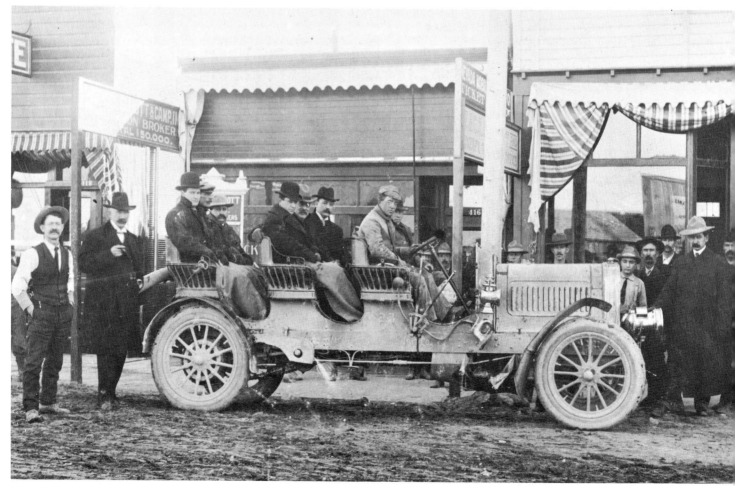

BG fireman, Frank Green (posed above), took a number of splendid photographs of Bullfrog Goldfield trains and equipment, among which is the classic photo of No. 12 and train stopped on the desert to accommodate his slow lens and film of the era. Aside from the normal, 3-car consist, Vanderbilt tenders on the locomotives, and a single-track, desert right of way, BG trains strongly resembled those in the classic engraving on the road's stock certificates. (F. M. Jenifer was T&T Traffic Manager.)

Railroad travel of the day was far preferable to the earlier rough and tumble transportation provided by the 50 H. P. Pope-Toledo touring cars of the Nevada Mobile Transit Company *(below, left),* in spite of that company's advertised "Specially Built Toll Road" along the route from Goldfield to Bullfrog, Rhyolite and Beatty. *(Top, left: Harry Gower Collection; bottom, left: Oro Parker; both photos this page: Hendrick Collection.)*

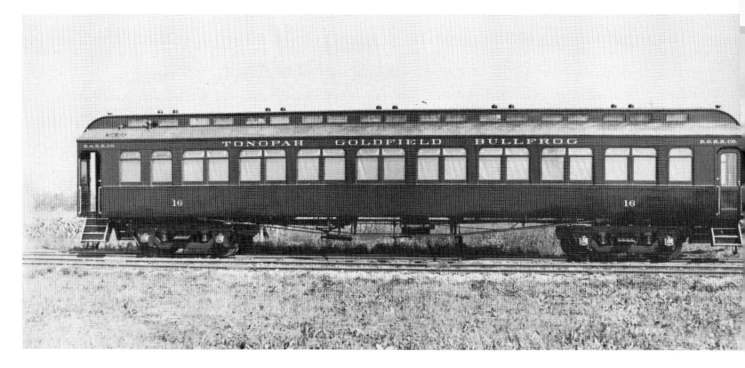

Bullfrog Goldfield Railroad equipment was picturesque as well as useful. Coaches ran from Mina (on the N&C) via Tonopah and Goldfield (T&G) to Bullfrog and Rhyolite in the road's earliest days. Later they were used on the Goldfield Las Vegas (LV&T) and Goldfield-Ludlow (T&T) runs as operations of the BG were assumed by others. Of the locomotives, the switchers were the least essential and saw but light service. BG equipment was maintained in sparkling condition under early T&T domination presided over by Supt. Wash Cahill. The immaculate running gear *(below)* is in distinct contrast to the unkempt overalls of "Red" Meehan, night hostler, and "Slim" Warner, engineer (left to right, respectively). *(Above: Pullman-Standard Car Mfg. Company; below: Hendrick Collection; top right: Baldwin-Lima-Hamilton photo; center and bottom: H. L. Broadbelt Collection.)*

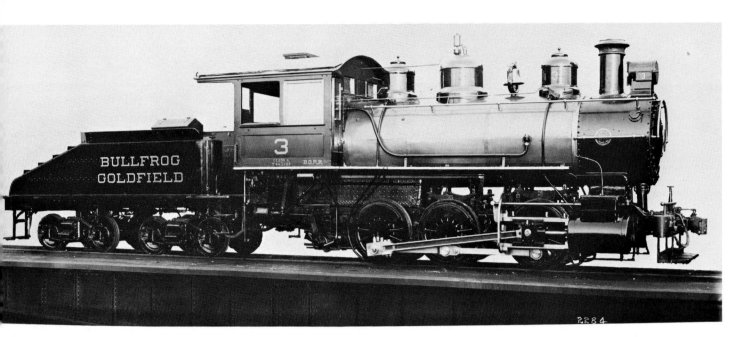

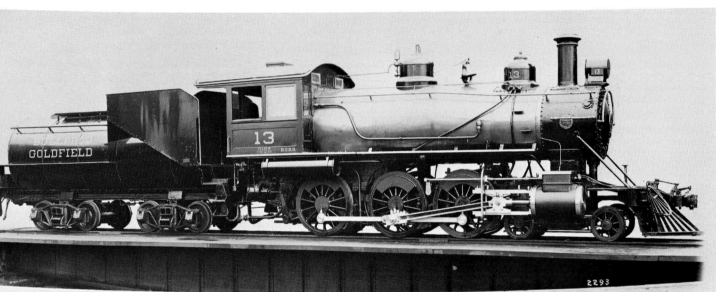

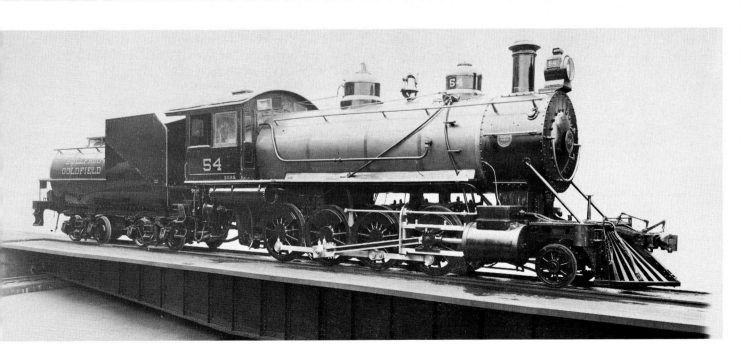

ing had it not been for the high wage rates paid to BG engineers and firemen which, in some cases, were almost double the daily rates paid by other short-line railroads in Nevada.

Before a year and a half were up, efforts were made to abandon the Rhyolite branch. Only one mine was operating in the area — the old Tramps Consolidated which had been reorganized just three years previously into the Sunset Mining & Development Co. — and in spite of merchant H. D. Porter's disagreement, the railroad contended that no carload business had been originated. Average monthly earnings for the Rhyolite branch for the period from June to November 1915 amounted to $143.71, while expenses in the same period averaged $160. Protestants to the railroad's petition for abandonment arose like phantoms out of the desert. Aside from Porter, there were E. D. Van Dyke of the Sunset Mining & Development Co., and F. N. Fletcher of the Keane Wonder mine over in Death Valley. In view of the unexpected developments, just before the hearing in May 1916, C. O. Whittemore, attorney for the BG RR, asked that the hearings be postponed for a few months in the hope that business would improve. Unfortunately it did not.

In August 1916 both mines were closed and only three miners were working in the entire area. In September, Whittemore requested that the hearing be held shortly as the condition of the track in the branch would shortly demand that repairs be made for safe operation. Porter retaliated with a request that the hearing be postponed from September 1, 1916, until December, contending that most of the Rhyolite businessmen were away on vacation. Sunset Mining's E. D. Van Dyke supported the request for postponement, stating that he was the only person qualified to testify for his company (the principal shipper) and that he could not then attend any hearings as he had broken his leg in an auto accident.

The hearing was finally held in Rhyolite on October 25, 1916. In the interim business had fallen off even further as exemplified by the tally of gross revenues of only $23.76 for the first 27 days of October. On December 30, 1916, the Commission conceded to the railroad's request and authorized discontinuance of service, although one qualification of the decision required that the track be left in place for a period of at least one year following which a request for dismantling would be considered.

It made but little difference, for Rhyolite was through. In the first half of 1917 the BG issued a number of special freight tariffs providing for the movement of second-hand mining machinery, store and bar fixtures, corrugated iron, lumber and junk from Rhyolite to Beatty. The deserted rails then lay in the desert sun for approximately another year. Just when physical abandonment took place has not been definitely determined, but it appears that the last freight train to Rhyolite operated on August 17, 1918, while the last work train burnished the rusting rails on October 31, of the same year.

During World War I the BG and its foster parent, the LV&T, came under control of the United States Railroad Administration. Then, six months before the control period ended, the U.S.R.A. threw out the LV&T part of the combination as being "not essential" and ground the latter road into the dirt through denial of use of the UP's repair facilities at Las Vegas. By the latter part of 1918, the LV&T was seeking abandonment as it could no longer keep its equipment in repair and operate on a self-sufficient basis. All of which placed the BG in a difficult position for it, too, could not support itself.

To circumvent the situation the BG looked to its old friend and former ally, the T&T. In September 1918 a five-year agreement was signed whereby the T&T again assumed operation of the BG in spite of the fact that the nearly defunct LV&T still held its 51% ownership of BG stock. To the citizenry the surface indications were perfectly normal — the route to Goldfield was still "T&T all the way."

For a period of a little over a year this strange combination of bedfellows continued searching for a solution to their problems. In December 1919 the deadlock appeared to be broken with the announcement that the LV&T had sold its 51% holding of BG stock to the firm of Althouse & La Grande of New York City. Mr. Althouse, being of inquiring mind, made an inspection trip over the BG early in February 1919 accompanied by Whittemore, the LV&T attorney then currently president of the BG, Cahill, BG supt., and Jennifer (traffic manager of the T&T. One look prompted Althouse to declare that he was not in the railroad business and it was his plan to scrap the BG, pay off the bondholders and divide the remaining proceeds among the stockholders.

As president of the BG, Whittemore felt that the road had a definite value as a going concern and that it served a useful purpose in the region which

it had helped to develop, in spite of the fact that losses had been running around $1,000 a month. He urged that the stock be offered to Esmeralda and Nye Counties to let the people decide whether they wished to assume responsibility for its continued operation. The idea was well received, and at a joint meeting with the Board of County Commissioners the 51% stock interest was offered for sale for $125,000 cash plus the assumption of the $160,000 of debt.

The Board appointed Uri Curtis of Tonopah, W. J. Tobin of Pioneer and L. L. Patrick of Goldfield to confer with the Mine Operators Association in Tonopah. Tobin also attended a mass meeting of the citizens of Tonopah held at the Tonopah-Divide Stock Exchange on February 10, 1920, and introduced a resolution proclaiming that the Bullfrog Goldfield Railroad was essential to the development of Tonopah and southern Nevada and therefore that steps should be taken by the citizens individually or else by both counties to purchase the stock as offered. A committee of five was formed to confer with the Commissioners in the attainment of the objective, and a plan was evolved whereby local subscriptions would be solicited for the purchase of Althouse's 8,359 shares of BG stock at $15 per share (a total of $125,385). All of the stock would have to be subscribed for in order to bind the deal; payment could be spread over a two-year period — one-fifth cash down payment, and the balance carried at 6% interest until paid; all stock would be held in a voting trust, the Nevada First National Bank of Tonopah to act as Trustee. In addition, subscribers would have pro rata rights to purchase any of the (minority) 49% remaining outstanding stock held by the members of the old Bullfrog Syndicate or their successors.

At another mass meeting held at the Elks Club in Goldfield the sentiments previously expressed at Tonopah were reiterated. However, the over-all public enthusiasm for the project was subsiding and, with the waning interest, the plan was never consumated.

Once again, the T&T ultimately provided the solution to the problem of continued BG existence. Even though the current operating agreement had another three years to run, and in spite of the fact that BG operations were only conducted at small annual deficits, the T&T volunteered to take the road over providing that satisfactory arrangements could be made with Senator W. A. Clark, the bondholder. The proposal called for a new issue of bonds (due date October 1, 1928) to be exchanged for the old bonds on which all unpaid interest would be waived. Clark agreed to the plan; the I. C. C. approved the refunding bonds; and on September 20, 1920 the T&T acquired the majority stock interest. The BG was saved; its corporate identity was still intact; its accounts were maintained separately; but its public recognition and acceptance were unimproved — the line was still considered to be T&T all the way to Goldfield.

The entire 10 years following World War I could hardly be classified as anything more than the "decadent decade" for the BG. The road owned but one locomotive and that was unserviceable, so T&T locomotives were used. Also, having disposed of its "fleet" of 29 freight cars as far back as 1915-16, the line was dependent upon the T&T for all of its equipment. Any repairs were made at the T&T shops at Ludlow except for such minor adjustments as could be performed by hand at the roundhouse at Goldfield. Train operations were confined to tri-weekly service in both directions with the exception of a brief period during 1919 when a booming Divide District (near Tonopah) justified sufficient business to warrant six-times-a-week service. It was hardly a stimulating situation.

Areawise the picture was no brighter. Goldfield, which had had 792 men employed in the mines in 1915, now (in 1927) could record but 36 men so employed. In July 1923 the town had suffered its worst fire (see T&G), yet hardly had the after effects worn off than a second conflagration occurred on the evening of September 29, 1924, in which the Elks Club, the News Building (which housed the *Goldfield Tribune*), the third floor of the J. S. Cook Bank Building, the Post Office, the T&T offices, the T&G offices and the Goldfield Consolidated Mining Co.'s offices received varying degrees of burns, smoke and water damage. According to accounts in the *San Francisco Chronicle*, the damage amounted to some $250,000, a modest sum considering the number of buildings involved but rather a staggering loss to a city already on its economic uppers.

Aside from Goldfield, the BG territory had but little to recommend itself. If one were to take the entire BG "sphere of influence" (a pathway 80 miles wide, extending for 40 miles on either side of the BG tracks) one could count but about 250 people in the area. Yet surprisingly, BG local passengers numbered 300-500 annually, while interline passengers ranged in the 1,200-2,000 bracket. Industry was relatively non-existent. Bonnie Claire had had its ups and downs, but by and large it was

quite disappointing. Mining activity was spotty, and any encouraging developments were but short-lived. Two small silica operations contributed but mildly to ton-mile statistics; the one near Ralston managed to ship 40 carloads in the year 1926, but in the first 10 months of the following year it could only muster 16 cars. Coal traffic, once an important commodity, had virtually vanished. The decline in traffic can best be illustrated by the fact that in 1916 the BG managed to originate some 14,789 tons for line haul, whereas in 1926 (10 years later) it could only scrape together 2,910 tons. No self-respecting 80-mile railroad could operate on such a meager diet.

As was to be expected, the reflection of conditions on net operating railway income was disasterous. During the 1920's deficits of approximately $40,000 annually were encountered. Commencing on January 1, 1922, in an effort to help forestall abandonment, both the Santa Fe and the Union Pacific (southern connecting lines) assumed a portion of the deficit by granting an extra 5% arbitrary allowance of revenues on all through freight received via T&T. Even with this boost, losses continued to mount and the interest on the bonds falling due August 1, 1927 was defaulted. Taxes also were in default, those for the last half of the 1926 county taxes being paid by the bondholder (the estate of W. A. Clark). Inevitably only one solution to the problem remained.

In June 1927 an application was filed to abandon operations. The usual hearing was held in Goldfield in October of that year, during the course of which it was demonstrated that mining activity had continued to diminish drastically. As was to be expected, the mining interests protested, holding out distant hopes of good discoveries and subsequent volume shipments. One individual, A. M. Johnson of Chicago, had a short-term project of BG revenue interest — a variety of building materials were to be shipped to Bonnie Claire before the end of the year, from which place they would be transported to Death Valley for fabrication into what is now known as Death Valley Scotty's Castle. Johnson, in fact, not only hauled away the last incoming material at Bonnie Claire, but he also took a sizeable portion of the railroad with him besides. Much of the current firewood at Scotty's Castle consists of pieces of crossties from the BG RR, so many ties being obtained and stored in a nearby gulch that the location is now called "Tie Canyon."

Continued operation of the BG was found to be hopeless, and abandonment was authorized. On Friday, January 6, 1928, the last northbound train ran through to Goldfield and the following morning, Saturday, January 7, the last BG train departed for Beatty. It was a sad occasion which was duly recorded for posterity in the *Goldfield Daily Tribune* whose owners by then no doubt were regretting their earlier decision so unwittingly eulogized in their slogan "If you stick, you'll win in Goldfield."

A tri-weekly bus service was instituted by the Tonopah-Goldfield Stage the following week, but M. Machado's machines held none of the romantic appeal that had characterized the BG's trains — even if they were "T&T all the way." Nevada's "most unwanted railroad" had finally become a thing of the past.

Lida Valley Railroad

South and west of Goldfield, Nevada, lie the Lida and Gold Mountain mining districts, among the oldest in the state. In early times, due to the remoteness from any forms of human habitation or transportation, shipments of only the richest of ores could be made on a profitable basis. By 1871-72 the majority of the ores were being treated at Hiskey & Walker's Mill, located some 35 miles west of Lida in the Deep Springs Valley of California (about 55 miles south of Candelaria and 25 miles east of Bishop as the crow flies, but not according to the crude and inefficient roads of the period).

The building of the Carson & Colorado Railroad from Mound House south to Sodaville and Candelaria during the early part of 1882 alleviated the isolation of the district to some extent. Had the line been continued south to Silver Peak, Lida and Gold Mountain, as originally proposed, the district's problems would have been solved. As it was, the C&C headed west over Mt. Montgomery, and it was not until the early 1900's that relief was accorded following the discoveries of silver at Tonopah and gold at Goldfield with the resultant concentration of all manner of transportation and facilities in the area immediately to the north of Lida.

The boost to the marginal productivity of the mines was notable, and by 1906 Lida could boast

Tom Jone Green

Major hub of activity in the Lida of 1906 was the combination Assay, Exchange Office and Stage Station for Goldfield stages. Sidelines of the business comprised the servicing of automobiles and the dispensing of good, 5-cent cigars. Another, more permanent business was that of the Lida Restaurant, which might have been obliged to expand its facilities had the town grown to the expansive platting indicated in the view below. The large proportion of tents to permanent structures might signify that residents were insecure concerning their future and were ready to move along to the next big strike without unnecessary delays. More logically, it was the result of a stringency of building materials which had to be carted from Goldfield until the Bullfrog Goldfield Railroad reached Cuprite in September 1906. *(All photos: Robinson Collection, Nevada Historical Society.)*

Lida 1906

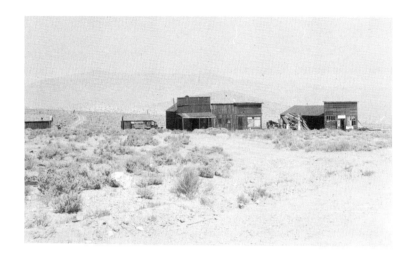

Hornsilver (later Gold Point) was another active mining camp, on the opposite side of Lida Valley, which might have been served by the BG or the LV&T had rumored branches materialized. As late as 1910, the camp was enjoying a revival and was included in projections of the still-born Lida Valley Railroad. Hornsilver's housing still stood when these pictures were taken in 1957, but only the gasoline station and store showed evidences of human habitation.

of approximately half a hundred permanent or semi-permanent dwellings, together with an even greater number of tent dwellers representing the more transient trade. It was a far cry from the time of the original claim filed by an early prospector, Col. Buel, and named for his wife, Alida; for the now modern town had its own local assay office which not only served as terminus for the Goldfield and Lida Stage line but even dealt in that nebulous new contraption, the automobile.

Other districts were enjoying a revival as well. Tule Canyon to the southwest, Gold Mountain to the southeast, even little Hornsilver (later Gold Point) were all participating in the mineral excitements of that decade. Mining claims were being filed and sold with the greatest of rapidity and the utmost of ease. In fact, one auto carrying a load of ore became stuck in the muddy street of Hornsilver for a few days, and when the owner returned with the advent of clearer weather he found that someone had filed a location notice on it.

In 1907, as the Las Vegas & Tonopah Railroad was building northward from Rhyolite to Goldfield, and the Bullfrog Goldfield Railroad was rushing southward in the opposite direction between the same two points, it was rumored that both railroads were contemplating branches to Lida. Later, in May 1910, A. D. Goodenough was busying himself checking all possible tonnage for a railroad to the Lida area, and the results of his tabulations appeared so flattering that surveys were made for construction of such a line. In November 1910 an announcement was made that the railway would be built, to be called the Lida Valley Railroad, and to run from Stonewall (a station three miles south of Cuprite on the BG RR) for a distance of 25 miles southwest and west to Lida, including a branch (near the mid-point) to continue southwest to Hornsilver (Gold Point). Financing was to be arranged by a group of San Antonio, Texas, people.

When the necessary $250,000 for construction was considered to have been raised, the *Goldfield News* proudly headlined a news article, "All Aboard Cuprite to Lida." In February 1911 the company was formally incorporated and S. W. Connelly, who had worked on the T&T, the LV&T and even the proposed Ely-Goldfield Railroad (see "Projected Railroads"), began actual surveys for line location, marking the path of the road with his survey stakes.

Unfortunately no actual construction ever took place, in spite of optimistic talk at the time of extending the tracks all the way to Bishop, California (near Laws, on the SP narrow gauge). The entire project became dormant and eventually faded away altogether, in spite of a flurry of corporate paper activity in 1916. Lida and Gold Point (Hornsilver) can be reached today over "improved roads" out of Stonewall, generally following the route of the original survey for the Lida Valley Railroad, but at the end of the line will be found only small settlements, occasional ruins, and sandy roads leading to abandoned ghost mining camps.

Bonnie Claire and Ubehebe

Bonnie Claire — the name has a placidity and resonance implying almost extreme quietude and sereneness; the surname denotes "beautiful, healthy, plump." Yet the combination of syllables and their implications are probably as misleading as men, mines and milling can make them.

For Bonnie Claire was a most unplacid milling town. Its original name was Thorp's Wells, or Thorp Post Office. When the Bullfrog Goldfield Railroad built through the area in October 1906, the designation of Montana Station was bestowed upon the locality by that corporate body, but the name did not stick. Custom and usage dictated that the more euphonious Bonnie Claire should supersede, and that is the name which has predominated to today.

Bonnie Claire is located to the south of Goldfield, practically equidistant between that terminus and Beatty, Nevada. Primal stimulant to the town's economy was the 1905-07 promotional era of mining speculation, this in spite of the fact that but little actual mining was performed in the immediate vicinity of the town proper. Most ores were derived from the Rattlesnake, the Courbet and the Hard Luck mines, located some six miles to the west in the shadows of Gold Mountain, and transportation of the ores to the mills at Bonnie Claire was accomplished through the usual rough and cumbersome method of teaming.

Bonnie Claire might have become an important railroad terminal as well as center if promoters of the era had had the intestinal fortitude and financial backing to support their propaganda. Multifarious and precarious were the railroad schemes which reached the ears of editors of the local newspapers of the period in secondhand manner; yet because of the enormity of the projects in the

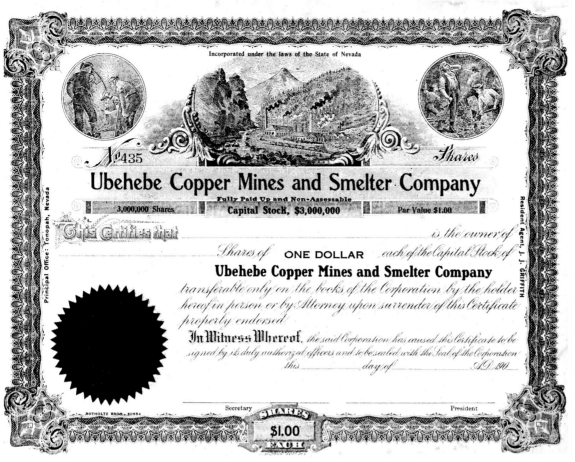

Incorporated under the laws of the State of Nevada

Nº 435 *Shares*

Ubehebe Copper Mines and Smelter Company

Fully Paid Up and Non-Assessable

3,000,000 Shares | Capital Stock, $3,000,000 | Par Value $1.00

Principal Office: Tonopah, Nevada

Resident Agent, J. J. GRIFFITH

This Certifies that _____ is the owner of _____ *Shares of* **ONE DOLLAR** *each of the Capital Stock of*

Ubehebe Copper Mines and Smelter Company

transferable only on the books of the Corporation by the holder hereof in person or by Attorney upon surrender of this Certificate properly endorsed

In Witness Whereof, *the said Corporation has caused this Certificate to be signed by its duly authorized officers, and to be sealed with the Seal of the Corporation this _____ day of _____ A.D. 190_*

ROTHOLTZ BROS., 60554

Secretary | SHARES $1.00 | President

Had the railroad been built from Bonnie Claire, down Grapevine Canyon to Death Valley, around Ubehebe Crater and through Racetrack Valley to the copper mine at Ubehebe, rails would have passed the location of Death Valley Scotty's Castle which was erected about 1927. Nearby is "Tie Canyon", last resting place of hundreds of Bullfrog Goldfield ties when that railroad ceased operating in January 1928. Today thousands of visitors are welcomed annually at Scotty's Castle. *(Top: Tolford Collection; bottom: Barton Collection.)*

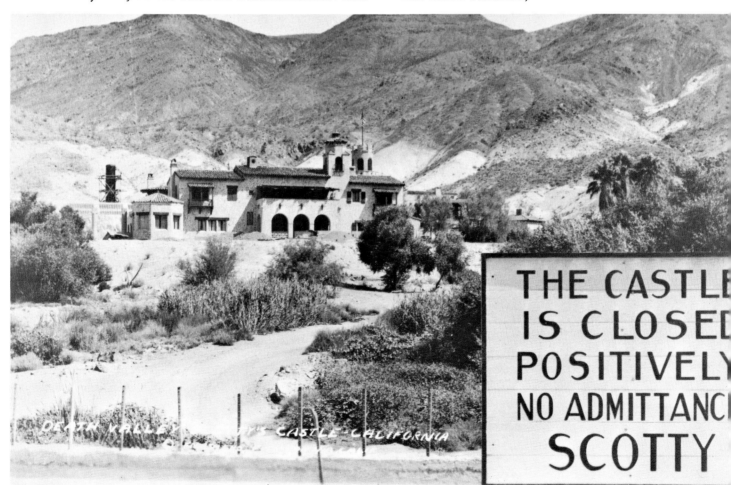

THE CASTLE IS CLOSED POSITIVELY NO ADMITTANCE SCOTTY

regional economic picture, such reports were humanely and wishfully editorialized as current fact — not fiction. Thus the records of the period became unconscionably distorted from the true facts, and accurate history today is difficult to decipher.

For example, it was in August 1906 that Fred H. Vahrenkamp, general manager of the Bonnie Claire Bullfrog Mining Co. and a promoter of the first water, delighted the populace with the news that his company would build a five-mile railroad from his company's mines in the Gold Mountain region to the mill in Bonnie Claire. At the time, the Bullfrog Goldfield Railroad was just pushing its rails southward over the pass out of Goldfield, and construction as far as Bonnie Claire would not be accomplished until the following October. The only other railroad to the area, the Las Vegas & Tonopah, had not reached Rhyolite from Las Vegas and ultimately did not arrive in Bonnie Claire until a year later. Thus any railroad news in Bonnie Claire which contemplated an immediate connection with a main-line railroad constituted a full measure of wishful thinking and hoping.

In spite of this, a month later (in September 1906) additional reports were circulated that a group of mining men and people connected with the LV&T railroad had incorporated a separate company to construct the Gold Mountain line. At the same time the same group commenced promoting the sale of town lots through the medium of their Bonnie Claire Townsite Co. By November 1906 Vahrenkamp was telling newsmen in Rhyolite that the Bullfrog Goldfield Railroad had already laid four miles of track on its Bonnie Claire spur [presumably the route to the mines at Gold Mountain] and had sufficient materials on hand to complete the remaining three miles. No explanation was offered for the sudden lengthening of the road by two additional miles, nor for the benevolent affluence of the BG which was suffering extreme contractions of the pocketbook about this time and could ill afford to finish its own main line to Bullfrog, let alone build a seven-mile branch to mines of dubious productivity.

In those days, however, railroad fever was contagious, and Vahrenkamp was not to be the sole propounder of iron rails to Gold Mountain. In the same month of November 1906 a Mr. Norrington, secretary of the Nevada Goldfield Mining Co., was reported as saying that the BG RR had laid three miles of track and would reach his company's property in two weeks. Moreover, to make matters more

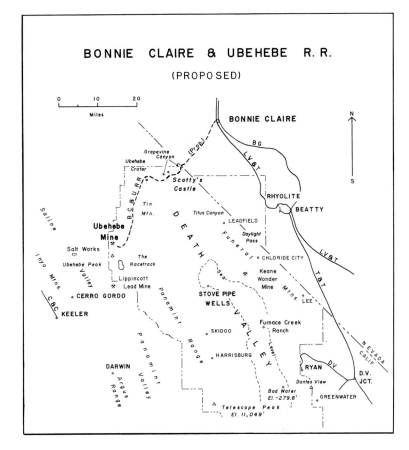

personal and more pertinent, a special train would be chartered to take Goldfield men to the area just as soon as the spur was completed. It is to be hoped that not many people took the account seriously, for the following month a newspaper reported that the BG's spur had shrunk to two miles in length, being finished to the reduction works near town. By June 1907 a further erosion had occurred, for *The Rhyolite Herald* tendered the news that the BG had built a one-mile line to the mill.

In view of the conflicting nature of these reports, it has been difficult to make an accurate determination of the situation. The files of the BG RR are scattered, but reports on record with the I. C. C. indicate that the BG considered the spur line too short to be reported. Some maps published by the T&T (subsequent operator of the BG) showed a short spur in that locality, and it probably was used to reach the mill, either directly or by LV&T tracks. It is known that the LV&T did construct a branch in 1907 which was .79 of a mile long and which was subsequently lengthened by a full mile in 1910. This short branch was transferred to the BG at the time of the LV&T-BG (1914) consolidation in which the better portions of the lines of each of the two roads were combined into one railroad and all excess trackage abandoned. Apparently the line lasted until 1918 when the LV&T ceased operations and was abandoned.

Still another abortive attempt was made to organize a railroad from Bonnie Claire to Gold Mountain during the early part of 1907. Men associated with the Tonopah Mining Company formed the Gold Mountain Railroad to build from Bonnie Claire over approximately the same route the predecessors had selected; but every indication points to the fact that, in line with the success the predecessors had obtained, no physical work of any description was ever accomplished on the project. The mines in the mountains did not develop properly, and financial problems forced the mill in Bonnie Claire into the hands of receivers before the end of the year.

Had plans materialized, Bonnie Claire might have become the terminus of still another railroad — this time to Ubehebe along the northwestern edge of Death Valley in California. Although copper had been known to exist in the area, it was not until June 1907 that the Ubehebe Mining District was organized, and John Salsberry and Ray T. Baker became the principals in a newly formed Ubehebe Copper Mines & Smelter Co. Salsberry had already realized paper profits on investments at Greenwater, a situation which may or may not have served to cool the ardor of prospectors even more than the tropical summer heat of the desert, for there was not one case of claim jumping recorded — a situation unique in the annals of western mining.

With cogent reasoning, the firm of Peard, Hill & Co. of Baltimore, Maryland, was persuaded to promise to take up $1,000,000 of bonds before November 15, 1907, the proceeds of which would be used to develop the mine, erect a smelter (in Bonnie Claire) and construct 48 miles of standard-gauge railroad to span the distance between the two. Salsberry went over the railroad route with Neil McLean (the T&G's former contractor). Starting from Bonnie Claire, it headed southwesterly down Grapevine Canyon, past the present site of Scotty's Castle, circled around the Ubehebe Crater, then turned south down a long valley to a point near the foot of Ubehebe Peak near a dry lake called "The Racetrack." Optimistically, Salsberry anticipated that the bonds would be "placed easily" so that grading could be started in short order, and there was even some talk of using electric power due to the proximity of the power line from Bishop to Goldfield. Stockholders were taken over the proposed route in October, following which it was reported that engineers were in the field and that work would commence soon. Another report

stated that the Ubehebe Townsite Co. was sinking a well on Main Street, but the Panic of 1907 struck and put an end to all work. With the closing of the banks and the shutting off of the available money supply, all further work was curtailed and the project capsized of its own accord.

For the next two years the town of Bonnie Claire limped along in an economic vacuum, there being but little activity to support its population. Then news was made again in February 1910 when the New Bonnie Claire Mining and Milling Co. took over certain of the properties and started restoration. Manager Andrew J. Trumbo hired a crew of workers to commence renovation of the mill and at the same time announced plans for a railroad to connect with the Rattlesnake and the Courbet mines in the Gold Mountain area. Just what prompted the shift in nomenclature is not known, but the Bonnie Clare and Gold Mountain Railroad was unusual in more than name — it was planned to utilize 8% grades to be negotiated by Shay-geared locomotives, while two small tramways — one ¾ of a mile long from the Rattlesnake mine and one two miles long from the Courbet mine — would feed the ores to a central loading point. By June 1910 Trumbo was reportedly in Needles, California, inspecting the scrapping of a nine-mile narrow-gauge railroad which had served the smelter in that locality, and was determining the suitability of the materials for incorporation in his new, projected line.

Whatever the reasons for delay, Trumbo's work was far from complete after a year of spasmodic efforts. Reconditioning of the mill had not been finished, although the LV&T had laid a short spur to serve the unit, and, except for a small amount of surveying, nothing had been done on the railroad project (other than the reported purchase of materials at Needles). Trumbo was playing with the idea of using a trackless trolley arrangement to bring the ore from the mines. Then new management was instituted to replace Trumbo, the job on the mill was finished, and the unit was placed in operation, stamping out ores from the Great Western mine near Gold Point and, for a time, even some ores from the Jumbo Extension mine near Goldfield which were brought down to Bonnie Claire over the BG. The results of these sporadic operations, however, were disheartening.

In 1913 another mill was built on the site of the former Thorp property, immediately south of Bonnie Claire. Here J. P. Williams worked ores from the Happy Kelly mine. However, this unit failed

as well as its predecessors, and eventually both mills were dismantled. For years Bonnie Claire remained stagnant without any facilities whatsoever. Ultimately Lippincott built a mill to work ores from his mine near Ubehebe which were hauled in by truck, but even this revitalization failed to last.

Today Bonnie Claire belies the healthy robustness of its name. But one house still stands near the old LV&T grade, the rest of the town and both of the railroads have disappeared, although the crisscross of grades can still be seen. In time, even this last remnant will shortly follow the same pathway to oblivion, and the desert will have reclaimed all vestiges of this once important town and prospective railroad center.

In distinct contrast to the deep, wooded valley, flowing stream and large, active mills of the Ubehebe Copper Mines and Smelter Company (as depicted on their stock certificate, page 540), Ubehebe is more noted for its neighboring valley, barren of trees, vegetation or water, and containing the famous dry lake which Indians called "The Race Track" *(above)*. The 73-foot high cluster of rocks which rise out of the lake bed are called "The Grandstand." The Ubehebe mine *(below)* was approached from two entrances, one near the buildings at the bottom of the sidewall; the other, at the top of the canyon wall, was dependent on a bucket and cable arrangement to bring its ore down. The only water locally available would be that from an occasional cloudburst in season.

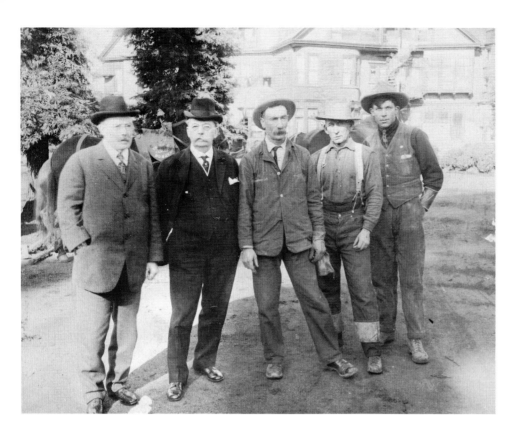

Francis Marion "Borax" Smith (second from left in the photo *above*) was the instigator and guiding genius behind the Tonopah & Tidewater Railroad. At his left stands John Ryan, general manager of PCBCo, while to his immediate right is a man named Wilson, driver of the 20-mule team at the 1915 Exposition in San Francisco. The identities of the two men on the left are not known, although the end man is believed to have carried the nickname of "Tarantula Pete." The picture appears to have been taken at Smith's Oakland, California, estate about the time of the Exposition. *(Bancroft Library.)*

When Smith bowed to the will of Senator Clark and abandoned his attempt to build the Tonopah & Tidewater Railroad north from Las Vegas, it became John Ryan's problem to move as much of the equipment and supplies as possible to Ludlow, on the Santa Fe. The view *(below)* adequately portrays the motley assortment of teams, wagons, Fresno scrapers and other paraphernalia of railroad construction which paused at the Harsha White ranch at Manse, Nevada, in the Pahrump Valley west of Las Vegas, as John Ryan paused to visit with his friend. Harsha White was O. J. Fisk's father-in-law. *(O. J. Fisk photo.)*

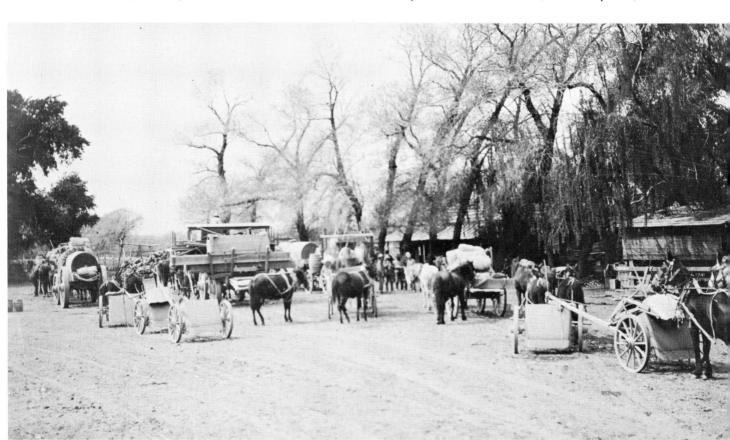

TONOPAH & TIDEWATER RAILROAD

Death Valley is a legendary, desolate stretch of wasteland extending from the California-Nevada state line in southern Nevada south into the lower reaches of California along the northern border of the Mojave Desert. Near its center lies the lowest point in the United States (282 feet below sea level) which, from Dante's View (near Greenwater) may be compared with the former highest point in the United States — Mount Whitney (el. 14,495). As early as 1849 the terrors of Death Valley were being widely circulated by the survivors of the Bennett-Manley party who gave the valley its name, and in the succeeding years additional tales of terror became tantalizingly mixed with frustrating tales of fabulous mineral riches discovered by hardy prospectors who visited the area.

Unfortunately for those who listened to these tales of wealth, the landmarks were vague and difficult of discernment, and subsequent investigation of the area by the hardy few who dared to follow usually ended in disappointment and all too frequently in death beneath the merciless rays of the hot desert sun. Thus the list of "lost mines" grew longer and longer. Jacob Breyfogle was one of the more fortunate prospectors who lived to return to Austin, Nevada, with fabulous samples of rich gold ore in his hand, but his mind had become so confused and crazed by the heat he was unable to fix the location of his discovery. Time and again over the years the Breyfogle mine, object of intensive searching, has been reported as having been discovered, but who is there to say which, if any, of the locations made corresponds to that of the original find?

Oddly enough it was borax, rather than gold or silver, which attracted settlers to Death Valley. William T. Coleman of San Francisco was among the first to develop deposits of the newly discovered mineral. His Harmony Borax Works mined the ores while 20-mule teams were used to haul the product across the wastelands to Mojave for shipment over the Southern Pacific Railroad. Those same mule teams were to become famous in later years as part of a brand name which is known the world over.

In 1888 Coleman suffered tremendous financial reverses, and his properties passed into the hands of Francis Marion Smith. Smith was no newcomer to borax operations — in 1872 he had found the ore at Teel's Marsh (northwest of Belleville, Nevada) near Candelaria. His business had prospered, and when Coleman failed, Smith added to his holdings both the Lila C. mine in Death Valley, which Coleman had named for his daughter, as well as Coleman's mines at Borate (Calico), California, to the south. In September 1890 Smith combined all three properies to form the Pacific Coast Borax Co., and nine years later merged this company into Borax Consolidated, Limited, an international organization with headquarters in London, England.

When the Teel's Marsh resources became exhausted, Smith concentrated on the Calico deposits which were nearer to existing methods of transportation. After 1900, however, even the Calico ores began to give out and "Borax" Smith (as he was then called) was forced to turn to the Death Valley deposits at the Lila C. mine. The location made access difficult, being situated in the Funeral Mountains on the eastern edge of Death Valley approximately 100 miles north of Ivanpah, California, the last outpost to which the California Eastern Railway (Santa Fe) was planning to extend its line.

To solve the problem, Smith constructed a rock-base wagon road between the Lila C. mine and Ivanpah at the railhead. In lieu of the 20-mule teams of yesteryear, he envisioned trains of wagons hauled by steam traction engines. Although he might have learned from his previous futile efforts at that mode of transportation in 1894 at Calico, apparently Smith was a determined man. In April 1904 his traction engine started out successfully enough from Ivanpah on its initial trip, but it quit operating quite completely after covering the first 14 miles of travel. The lesson was pounded home, albeit expensively, and a railroad was decided upon as the only practical alternative. The arguments in its favor were probably considerably strengthened by the silver and gold discoveries to the north — first at Tonopah (1900) and then at

Goldfield (1902) — but to what extent they influenced Smith's thinking of the moment is difficult to determine in retrospect.

Certain it is, no time was wasted. On July 19, 1904, the Tonopah and Tidewater Railroad Company was incorporated in New Jersey where the Borax Company maintained offices and a refinery at Bayonne. The expansive name of the railroad implied dreams of vast conquest, although immediate actions ostensibly were concentrated on completing a line of railroad to the Lila C. mine. To this end the first step of the new company was to take title to the wagon road, for which Smith received all of the stock of the T&T with the exception of the directors' qualifying shares.

Over the period of the next nine months, surveys were made and contracts arranged. Various routes for the railroad were publicized. One ran northward from Ivanpah, situated at the end of the recent (1902) northern extension of The California Eastern (Nevada Southern) Railway which was the only operating line in the area at that moment. The ultimate T&T route utilized the old wagon road as a base for the railroad grade for virtually the entire distance. Another projected line commenced at Soda Spring (15 miles west of Crucero on the then-building SP, LA&SL between Los Angeles and Salt Lake City) and proceeded northeasterly to the Kingston Mountains, then turned to the north to follow the wagon road to the mine. Thus the mine was emphasized as the focal point of the railroad — not the gold centers of Tonopah or Goldfield, even though later surveys were extended to encompass these points.

It was only natural that Smith should discuss his proposed railroad with Senator Clark (the Montana copper multimillionaire) who was just then joining the rails of his SP, LA&SL on January 30, 1905. Under Clark's considered advice, Smith selected Las Vegas as the starting point for his railroad. Not only was Las Vegas the promotional by-product of Clark's townsite company, but the distance from there to the Lila C. would be shorter than by any other route.

In late spring in 1905 Smith's new superintendent, John Ryan, his assistant Wash Cahill (who had been a faithful employee at Borate) and engineer Clarence Rasor established a tent headquarters at Las Vegas and began to assemble grading equipment for the project. Bright and early on Monday morning, May 29, 1905, the first spadeful of earth was turned. A gratifying response to Cahill's call for men for construction facilitated organ-ization of that phase of the work, and by the end of the first two weeks of effort some four miles of completed grade were reported. A blacksmith shop was set up on the Buol tract in Las Vegas, while the first shipload of ties reportedly had arrived in San Pedro Harbor, California. Although hot weather set in to slow construction, by the end of the following month some 40 men and 50 horses had carried the grade a good nine miles toward its destination.

Meanwhile Senator Clark had been having some serious second thoughts. Perhaps he had already been watching the continuing rapid rise of Tonopah and Goldfield as bonanza towns; perhaps he was influenced by Cross' new discovery of the Bullfrog claim in August 1904, or by the rapid development of additional claims in the Rhyolite area in November of that year; perhaps he had been too preoccupied with completion of his own SP, LA&SL; or perhaps his discussion with Borax Smith over the Tonopah & Tidewater had ignited a spark. Whatever the cause in February 1905, Clark sent his own surveyors into the field to plot a railroad between Las Vegas and Tonopah and a digest of their reports evidently convinced him he had made a mistake in allowing Smith to be the first in the field with his T&T. Now that the step had been taken, how best could it be corrected?

Smith was entirely unaware of the change of feasance. Close cooperation with Senator Clark's SP, LA&SL had been anticipated from the beginning, but by the early part of August 1905 it became obvious that all was not well. For one thing, F. M. Grace was busy grading an auto road parallel to the railroad for use by the Nevada Transit Company, a Clark organization. For another, the SP, LA&SL (according to Ryan) was charging the T&T a prohibitive rate of 45-cents-freight per tie on each of the 12,000 redwood ties then arriving in Las Vegas. As a crowning blow, when the T&T attempted to form a rail connection with the Clark road at Las Vegas, it was flatly denied permission. Telegrams dispatched to Clark's office in New York received bland replies that Clark was in Europe and could not be reached. The decidedly uncooperative attitude could only be attributed to one thing — Senator Clark had changed his mind and had decided to build his own railroad to the Tonopah-Goldfield area, including a stopover at the new bonanzas of Bullfrog and Rhyolite along the way. With the problem thus oriented, Smith ordered all work on the T&T halted while a readjustment of plans was made.

Finding that the Santa Fe would turn an attentive ear to his proposals, and with proper assurances of their continued backing, Smith quickly shifted his T&T's base of operations from Las Vegas, Nevada, to Ludlow, California. (Although the general impression is gained that Smith received financial backing from the Santa Fe, this cannot be substantiated; it is certain, however, that he did receive cooperation in numerous other ways.) To complete the move, Ryan brought the grading outfits overland to Ludlow, stopping at Manse on the way to visit at the ranch of his old friend, Harsha White. By the latter part of August 1905 the job had been accomplished; a tent city for construction workers had been set up at Ludlow, and a brand new grade was started northward for the second time. Unfortunately for Smith, he now had 167 miles of line to build to reach Gold Center as against a previous 118 miles along the path of the original survey. These extra miles, in conjunction with the delay in moving the base of operations, were to work to the detriment of the T&T, to make it the last railroad to reach the gold fields from the south. Strangely enough, however, the road was to survive the longest — proof of that venerable adage, "And the last shall be first."

With the setback in his plans still rankling, and with developments in the gold fields increasing in tempo, Smith reoriented his thinking and set his sights higher. The Tonopah & Tidewater no longer would start as a local road to service the Lila C. mine, but would revert to the original cherished dream incorporated in the title and head directly for the obviously substantial bonanzas of lasting portent along the upper Amargosa River. A branch to the Lila C. would suffice to service that facility. As though to remind himself constantly of that intent, Smith had large wall maps made depicting the entire proposed T&T route from Tonopah, Nevada to tidewater at San Diego, California. One of these maps is remembered fondly as having hung on the wall in the Ludlow office for many years.

Financing of any new railroad is an eternal problem, for the T&T it became increasingly difficult due to the initial false start. To salvage what he could, Smith sold the T&T's Las Vegas terminal lands together with the first 12 miles of completed grade to his despised rival in October 1905 thus recovering a portion of his wasted dollars for the new construction fund. The proceeds were immediately put to use, and on November 19, 1905, first rails were laid on the T&T's new balloon track at Ludlow. In short sequence tracks were pushed on around the big loop, then started downgrade to the floor of the valley which the railroad was to follow for the next 50 miles northward to Silver Lake. Between Ludlow and Crucero the roadbed

Railroad surveying parties, such as this T&T group on location, were a heterogeneous admixture of people, nationalities and trades. Privations and hardships were their common bond in the performance of numerous seemingly insuperable tasks. (*Carl R. Rankin.*)

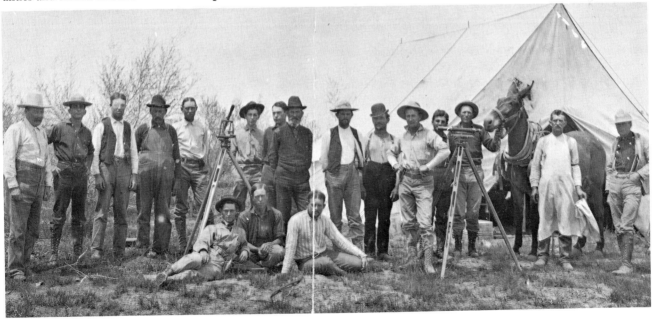

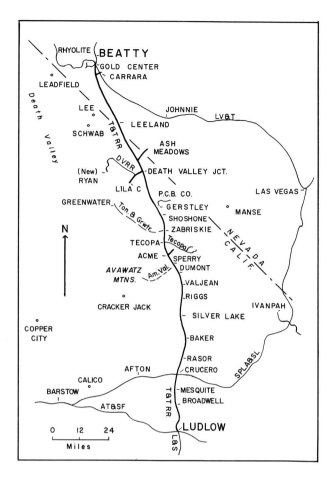

MAP LABELS (within image):

RHYOLITE BEATTY
GOLD CENTER
CARRARA
LEADFIELD
Death Valley
LEE
JOHNNIE
LV&T
LEELAND
SCHWAB
ASH MEADOWS
(New) RYAN
DEATH VALLEY JCT.
LILA C
P.C.B. CO.
LAS VEGAS
GREENWATER
GERSTLEY
MANSE
Ton. & Grnft.
SHOSHONE
N
ZABRISKIE
TECOPA
Tecopa
ACME
SPERRY
AVAWATZ MTNS.
Am. Val.
DUMONT
VALJEAN
RIGGS
CRACKER JACK
IVANPAH
SILVER LAKE
COPPER CITY
BAKER
RASOR
AFTON
CRUCERO
CALICO
BARSTOW
MESQUITE
BROADWELL
AT&SF
ATSF
T&TRR
LUDLOW
LB&SL
SPLA&SL
NEVADA CALIF.
T&T RR
DVRR
0 12 24
Miles

was laid on the floor of Broadwell Lake which normally and usually (but not quite always) was dry. The point where the T&T crossed the tracks of the Salt Lake Route was designated as Crucero, the Spanish word for crossing: Both roads maintained their own limited station facilities adjacent to each other, but no trains were scheduled to meet in the vastness of the desert wasteland.

From Crucero north past Soda Lake, Rasor, and on to Silver Lake the line was pushed. At that time Silver Lake was quite an active community, the store of Rose Heath Fisk Co. alone doing an annual business of nearly $150,000. O. J. Fisk, one of the partners in the enterprise, also developed a stage line to the then booming Crackerjack, a tent town complete with tent saloons and tent stores lying westward over the desert near Avawatz Pass. Mr. Fisk demonstrated his business flexibility at the time that Crackerjack's boom collapsed with astonishing rapidity, for his stage line was closed down in less than three days. Notwithstanding the actual circumstances, certain Santa Fe timetables of the period showed a railroad between Silver Lake and Crackerjack. The closest any such project ever

came to realization occurred in March 1908 when the Rasor brothers surveyed a 12-mile line from the T&T to within two miles of the Crackerjack mine. No construction work of any kind was ever performed on the project.

Silver Lake was crossed in March 1906 in much the same manner as Broadwell Lake — by laying the tracks on the bed of the dry lake floor. By April the rails were continuing northward over the desert plain, while surveying crews worked far in advance to close the gap in their final locations between Ash Meadows (near Death Valley Jct.) and Gold Center. Although Borax Smith was proclaiming at the time that the railroad would continue north to Tonopah, a change of plans must have been encountered for actual surveying was halted at Goldfield and the surveying crews were disbanded. Talk still persisted, however, and some people contended that a route would be staked out all the way north to Manhattan, Round Mountain and Austin. That such discussions were obviously wishful thinking was evident, for no work of any kind was ever done on the project.

The first 75 miles of track to a point just beyond Dumont were completed and ready by May 1906; then difficulties were encountered. For the next 12 miles to Tecopa the railroad had to descend from the plateau into the Amargosa River Canyon and traverse its length along the sidewalls of the gorge. Involved in the construction were large cuts and long fills, while three major trestles of up to 500 feet in length were necessary to cross and recross the river at strategic points. One contractor went bankrupt, and litigation ensued; for patently over all hung the torrid heat of the Death Valley area and the unwillingness or inability of men to withstand the rigors of such abnormal working conditions.

The contemporary reports were terrifying, even though perhaps a bit wild, but to the laboring man any reports that "many were dying in Death Valley" or "the T&T has suspended work" made him think twice before signing on. In June 1906 a brief but disappointing experiment was made with Japanese laborers. A total of 100 men were brought out from Los Angeles, each with his enormous bedroll, and sent to the work site. Subsequent investigation a few days later revealed that of the 100 men on the job, only 17 were working and (to use the words of Wash Cahill) "out of those 17, only 8 were handling picks and shovels. The other 9 were spraying them with water, using that precise, skilled and unlovely method that old-time Chinese laun-

TONOPAH & TIDEWATER RAILROAD

drymen used on clothes for ironing — a mouthful of water and a well aimed 'whoosh' sprinkled each coolie as fast as human spray could operate." The large individual bedrolls were also discovered to have their purpose. When the Fourth of July rolled around, the bedrolls suddenly shrank as each member of the crew extracted his own individual jug of saki and proceeded to devour the contents. Hours later the drunken crew tied the guy ropes of their dining tent to the track and were resting comfortably when a passing construction train severed the ropes. With the breeze of the train's passing, the ceiling closed in on the inebriates leaving them to struggle beneath the weight of the canvas. With tolerant kindness and understanding, the boss sent them all home on the next available train.

Still, somehow the work continued. In July 1906 *The Goldfield News* reported on the difficulties Smith was facing in the Amargosa Canyon and commented, "he could not get his men to work at this time of year because of the insufferable heat. Men died off like flies, and the rest fled from the death pit." Another attempt was made to import laborers from Los Angeles. This time Mexicans were selected, but they quickly developed an unorganized system of rotation. For each 15 days at work, they spent the next 15 days on siesta in Los Angeles in luxury, then back to the job again. The net effect of the program was a constant daily arrival and departure of workers with which it was almost impossible to cope.

In desperation, Smith asked for outside bids for construction of the 13 miles of canyon roadbed (estimated to cost $30,000 per mile). No bids were received, for no one could get men to work in the summer heat of the desert. As a consequence, T&T construction bogged down until the cooler winter weather arrived.

Idleness brought on speculation. There was some talk of building a temporary track right down the normally dry Amargosa River bed while work continued on the canyon walls, but this was not done. Perhaps the railroad should have detoured a few miles to the east and built over Tecopa Pass in the Kingston Mountains, thence down a declining grade to the Amargosa River. (The Tecopa Railroad was built along a substantial portion of this same route a number of years later.) Undoubtedly the total construction time (and cost) would have been reduced materially, but operations of such a line indubitably would have required helper locomotives on both sides of the pass.

With the advent of cooler weather, men returned to the job and construction got under way again. Even unsolicited help began arriving on the scene in search of work. One young man, E. L. Orr, discovered that desert railroading could provide plenty of unexpected excitement in spite of its dull monotony. Arriving in Ludlow just before Christmas 1906, he took a job unloading ties. It wasn't long before he was firing for an engineer named McClure on T&T No. 3, an ancient and honorable second-hand, cross-compound locomotive used on construction trains. Toward the close of one working day, while the locomotive was pushing two flat cars of Mexican laborers back to camp for the night, McClure instructed Orr to climb out on the front of the engine and kick a Mexican laborer off of the pilot. Orr did as he was told but met with stiff opposition from the Mexican who felt that his rights were being pre-empted. Words followed, to the disadvantage of the Mexican whose English vocabulary was obviously limited to a constantly repeated "Me God damn you." A scuffle ensued on the pilot of the moving engine, during the course of which the Mexican lost his sombrero beneath the wheels and ultimately retreated over the coupler to the flat car loaded with other Mexican laborers. Orr returned to the cab and forgot the incident, not so the defeated Mexican.

That night when Orr joined his friends for supper in the dining tent, the Mexicans were eating in an adjoining tent. When the vanquished laborer poked his head around the tent flap and saw Orr inside, he retreated. Then some white men finished their meal and left, but one returned with the warning that 200 Mexicans were waiting outside for the fireman to appear. Since Orr was only 17 years old at the time, McClure volunteered to stand by his fireman. When it came time for them to leave, McClure borrowed two butcher knives from the cook. Thus armed, the railroaders left the tent. Outside no Mexicans were in sight, so the two men went quietly to their locomotive where they remained until train time without any further disturbance. Subsequently they learned that the Mexicans had expected that they would sneak out the back of the tent, and had waited there to greet them. In the ensuing delay, emotions subsided, and ultimately the entire incident blew over and was forgotten.

Construction began moving along faster during the early part of 1907, and traffic started to trickle to the new line. People in large numbers suddenly boomed the passenger traffic to Silver Lake as part

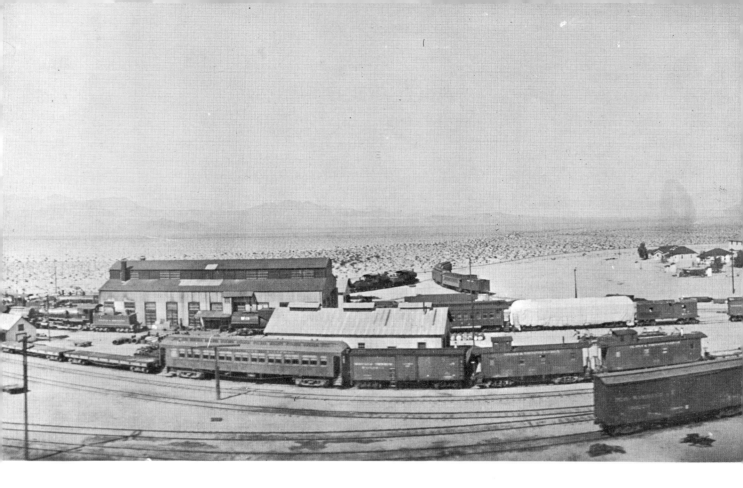

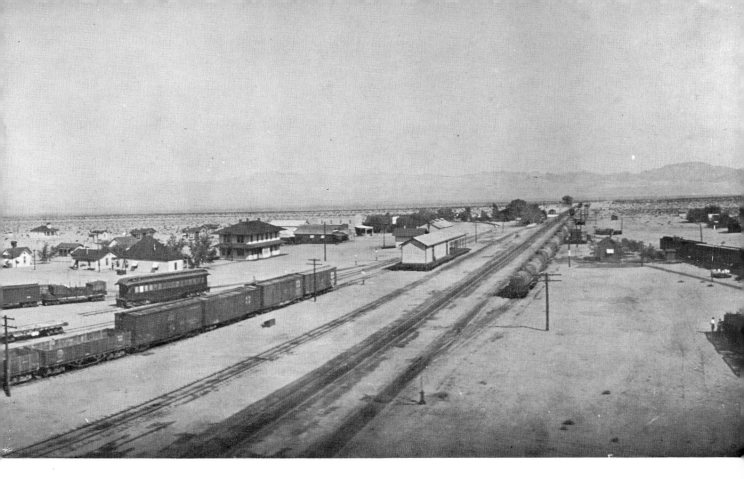

Ludlow, California (*above*) in striking panorama facing north. At left is the engine house and shop of the T&T, behind which and to the right locomotives and cars stand on the wye. The balloon loop line which circumscribes the majority of the town is evident along the back edge of the premises near the desert, and can be seen again in the center right portion beyond the freight house where the rails swing back in to the yard tracks. The three tracks (siding with tank cars) which start near the center foreground and run diagonally to center right comprise the Santa Fe yard, while at the extreme right the Ludlow & Southern (cars on track) swings in from the south. The large two-story building (center, right) houses the T&T's station and general offices. (*David Painter Collection.*)

The overall view (*bottom, right*) looks west along the T&T tracks at Ludlow with the freight warehouse in foreground and shops in center, between which on a siding stands the *Boron* under a shelter to protect it from the sun. Incoming ties for T&T construction, loaded on flat cars in foreground and stacked the length of the wye in right background, indicates that this is an early photo (probably about 1906 and a year before locomotives Nos. 7 and 8 (*bottom, left*) were being assembled on location. The Santa Fe freight, heading west in the extreme background may have been headed by a tandem compound such as the No. 840 (*center, right*). (*Bottom, left: Hendrick Collection; center, left: H. P. Gower Collection; bottom, left: C. R. Ferguson Collection.*)

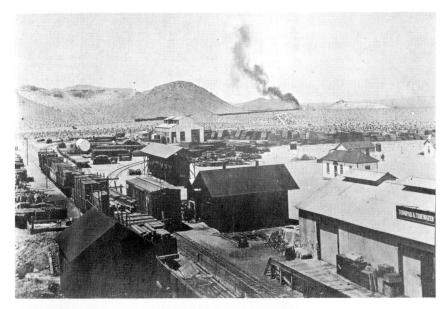

— 551

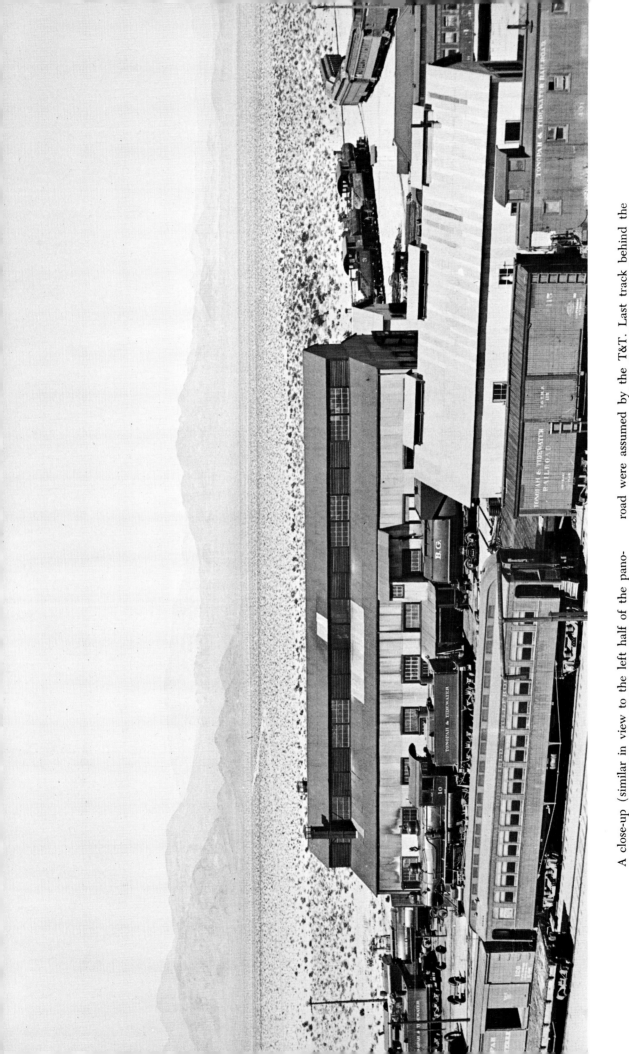

A close-up (similar in view to the left half of the pano-rama on the preceding page) shows the galaxy of equip-ment and variety of ownership which glutted the yards and side tracks of the T&T at Ludlow around 1910. BG switch-ers Nos. 3 and 4, on the west leg of the wye behind the engine house, were seldom used after operations of that road were assumed by the T&T. Last track behind the engine house is part of the balloon loop, while the pathway of white zigzagging across the desert background from left to right represents the grade of the main line heading north for Tecopa and Beatty. (Hendrick Collection.)

552 —

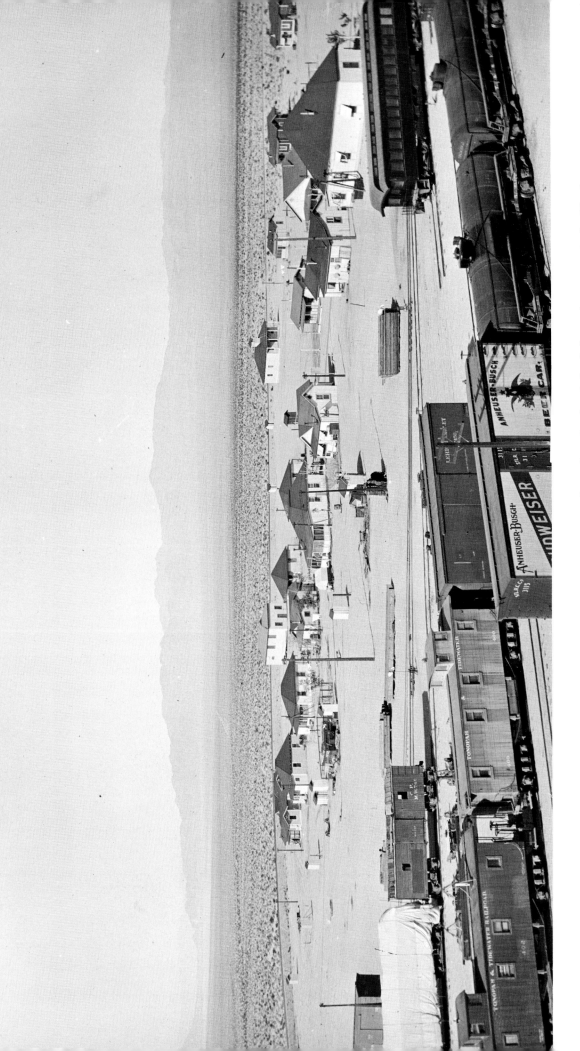

Carloads of cool beer brought welcome relief from the hot desert sun to residents of Ludlow as well as to T&T employees (during their hours off duty). The railroad's company housing (inside the loop track) was substantial but never air conditioned against the searing desert heat. On the stub end siding behind the tank cars stands the *No. 1* with the residence of the superintendent just beyond. Broadwell Lake and the vanishing T&T grade to the north may be seen at upper left. *(Hendrick Collection.)*

A succession of almost continuous cloudbursts in March 1938 wreaked all manner of havoc throughout Southern California and Nevada. This aerial view of Crucero with the crossing of the Salt Lake Route (left to right) with the Tonopah & Tidewater shows the vast amount of damage to the latter's roadbed across the Mojave River basin. In this area alone, over five miles of track were washed out, not to mention the extensive damage incurred farther north. Fortunately T&T Motor Car No. 99 was held at Crucero on a convenient spot of "high ground" not engulfed by the swirling waters. (Union Pacific photo.)

554 –

of their westward trek to Copper City. Although reportedly "The new camp is said to be a marvel," the real marvel ultimately appeared to be that so many people could concentrate in one spot yet produce nothing of consequence.

Regular trains began operating to Sperry in the southern end of Amargosa Canyon on February 10, 1907. By May, approximately one year from the start of the 12-mile canyon section, trains were operating all the way through to Tecopa at the northern end, and the seemingly impossible task had been accomplished. Tecopa came under consideration as the terminus of a branch line eastward to the Gunsight and the Noonday mines which were then in production on the adjacent hillside, but the projected line languished for another two years before an independent Tecopa Railroad was finally constructed (q.v.).

In 1906-07 another potential source of traffic appeared to lie in the undeveloped copper deposits in the area surrounding Greenwater, California, to the northwest. For a time the T&T opened an office in Greenwater, and a separate (though owned by the same interests) Tonopah & Greenwater Railroad was incorporated to build a line to connect with the T&T at Zabriskie. For a variety of reasons these plans did not materialize, and the railroad was never constructed. (See Greenwater chapter.)

By now Smith's dream of transportation for his Lila C. mine was rapidly approaching realization. In June 1907 the ore was being teamed from the mine to the railhead at Zabriskie, 91 miles north of the terminus at Ludlow. (Christian Brevoort Zabriskie, a Candelaria, Nevada banker, was selected by Smith to be his New York fiscal representative. Later he was vice president of the Borax Co., as well as the T&T and DV RR.) By the middle of July "the front" had been extended another 18 miles to Evelyn (named by Smith for his wife), and roughly only 60 more unglamorous miles of construction were left to traverse the great, flat plain of the Amargosa Desert to Gold Center in the Bullfrog District. Death Valley Junction (122 miles) was the point of connection for the Lila C. branch. Rails to the mine were obliged to follow a southwesterly course, and the seven-mile branch was completed on August 16, 1907. As considerable time had already been spent re-establishing the mine, borax shipments were moved out over the new line the same day it was opened.

During the month of August some 700 men were working on the railroad, largely from two basic camps — Lee's Wells and Golden Center. Autos stranded on the desert were being rescued by the railroad workers, but construction crews, were an independent lot and developed a habit of going

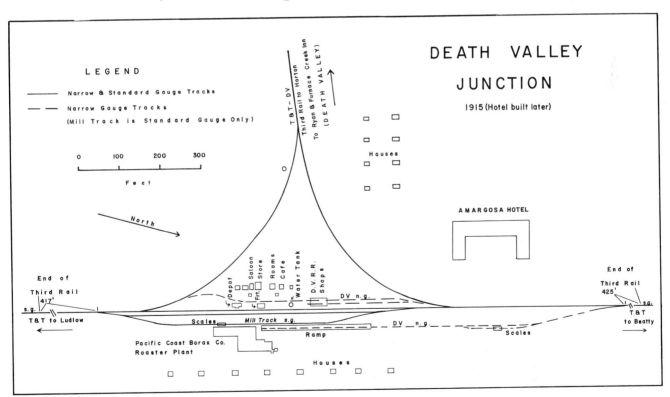

on strike over individual grievances. In the exaggerated recollections of one man, "they were going on strike every 15 minutes."

By September 27 the grading job was done, and only 15 miles of track remained to be laid. Then a shortage of rail halted the work for a few days with the result that regular service to Scranton and Leeland did not commence until October 15. Leeland (144 miles) was developed in substantial manner, replete with a three-room station and an agent, because for a time it was considered to be the candidate for a junction with a branch line to run westward for 3½ miles to service Lee, California, and its neighboring settlement of Schwab on the other side of the hill.

On Wednesday morning, October 30, 1907, only 600 yards of rails remained to be laid. That afternoon at three o'clock the last spike was driven at Gold Center. There was no celebration—the Panic of 1907 was in full force and effect, banks had been closed, the country was thoroughly depressed both physically and financially. Senator Clark's Las Vegas & Tonopah Railroad (which had started out from Las Vegas over Smith's original grade) had reached Gold Center over a year previous and had gone on through to Rhyolite and continued all the way to Goldfield. Another upstart — John Brock's Bullfrog Goldfield Railroad — had been pressed south from Goldfield to Beatty, Bullfrog and Rhyolite. To cap the climax, the bonanzas at Rhyolite were disintegrating, and even the previously exciting booms at Tonopah and Goldfield were showing signs of wearying. The whole railroad situation had become completely demoralized during the year the T&T had been stuck trying to get through the 12 miles of Amargosa Canyon.

There was little to be done except to make the best of a bad situation. Announcements were made that the T&T would not build any further north, and arrangements were made to connect with the Bullfrog Goldfield and use its tracks from Gold Center northward to Beatty and westward to Bullfrog and Rhyolite. With natural local pride, the Rhyolite Board of Trade protested the T&T plan to terminate its main line at the junction of the two roads at Gold Center and use the BG tracks as a branch to town. Rhyolite, they contended, should be on the main line. But the T&T was adamant and strictly unimpressed — at least to the point of performing any new construction. Instead, trains were run through Gold Center to terminate at Beatty on the BG, while a stub train was operated from Beatty to Bullfrog and Rhyolite under a trackage agreement.

Of most immediate necessity to the new line was the establishment of regular service to the West Coast. On November 25, 1907, through merchandise cars via T&T-AT&SF were inaugurated to Los Angeles and San Francisco. Passenger service commenced on December 5 when 30 people took the inaugural Pullman to Los Angeles over the same routing. Because the T&T-AT&SF combination provided the shortest and fastest service as against that via the LV&T-Salt Lake Route, the majority of passengers and mail utilized the new connections. Even more welcome than the improvement in speed and distance was the reduction in fares — the one-way ticket from Beatty to Los Angeles was dropped in price from $20.75 to $16.25, while the round-trip fare was cut from $34.65 to $26.00.

Being the newest and nearest railroad to Death Valley, it seemed only natural that "Death Valley Scotty" should attempt additional notoriety through exploited use of its services. Scotty, it may be recalled, was the reputed owner of an exceedingly rich mine in Death Valley whose resources had been called upon to finance the famous fast "Coyote Special" run over the Santa Fe from Los Angeles to Chicago in 1905. The resultant fame and publicity impressed Scotty with the inviolability of large amounts of money recklessly spent in the pursuit of his own desires. Thus, when he strode into the T&T's Rhyolite office in January 1908, he was convinced that immediate obeisance would attend his request for a special train to be run to Vallejo Junction (about 30 miles from San Francisco). His surprise was genuine when the offer was refused for reasons of insufficient equipment, but the ensuing discussions brought on resentment causing him to rant that all railroads were outlaws for he "had the cold, hard simoleons in his mitt, but there was nothing doing." A few weeks later he tried again, spending an unsuccessful two days in Rhyolite attempting to arrange for a special train to haul his ore to San Francisco via the T&T and the Santa Fe. Just why he wanted a special train of his own he would not reveal, but the following morning he handed the *Daily Bulletin* the following statement:

"Where and who's the nigger?

"I've made my bet for one of these railroads to cover and they haven't called the bet yet. Therefore I don't have to show my hand unless called. If they knew positively I had the money in my pocket the train would be here

in a few hours, and that's what I want, and they take the dough.

"I want to start from Rhyolite — this place and no other. I'm not boosting, but start from where I live, and I think the people here should understand that."

Just what happened from this point on, the record does not disclose, but Scotty continued his forays on railroads elsewhere, arranging for many further special trains and special runs. None were recorded on T&T rails, however.

The depressing conditions following the Panic of 1907 deepened as time went on, to be further aggravated by the general collapse of the mining boom. When the Los Angeles Chamber of Commerce sponsored an excursion to Rhyolite over the newly completed T&T in April 1908, so little interest was evoked the trip was almost cancelled. However, 80 people finally were found to make the trip and were duly greeted by the Rhyolite Board of Trade on arrival at the town on a Sunday. Although the mining prospects failed to arouse any noticeable interest, "many of the visitors were openly 'impressed' with the wide-open town on Sunday, and also with the price at which beer sold per glass."

In the spring of 1908 the new roaster at the Lila C. mine at (old) Ryan was completed, and the Pacific Coast Borax Co. began moving its men, their cabins, bunkhouses and equipment from Borate (Calico) to the new location. Operations at Borate were suspended, and all efforts were concentrated at the Lila C. where borax in the form of colemanite was plentiful. Treatment of the ore consisted of crushing it in a mill, then passing the granules through a rotary kiln heated to a temperature of 1200 degrees, at which point the colemanite precipitated, passed through a screen and fell in the form of a fine white flour. The bulk of the borax was then shipped to the Company's refinery at Alameda, California, or to Bayonne, New Jersey.

That summer people took to the T&T cars in droves to ride to Los Angeles to see the U. S. Fleet arrive at San Pedro. Perhaps the majority were sincerely interested in the spectacle (the benefit of the doubt will be bestowed) but perhaps, too, it was one way of escaping the summer heat or a discreet method of avoiding the obvious fact that they were escaping from Rhyolite forever. Undoubtedly certain railroad magnates would have been equally happy if, in some obscure manner, they could have escaped and taken with them the value of their investments in Rhyolite's railroads or

mines. For Rhyolite was crumbling in the dust of the ores which had given her sustenance.

By June 1908 the Bullfrog Goldfield, the T&T's northern connection to Goldfield and its supplier of trackage rights locally in Beatty, Bullfrog and Rhyolite, was in serious difficulties. For the past six months it had been operated under contract by the Tonopah & Goldfield, had lost a sizeable amount of money, and had failed to pay one cent of interest to its bondholders. The T&G (operator of the BG) wanted to be relieved of its contract operation on the other hand, the T&T needed the facility of BG rails for the servicing of local industries in the Bullfrog-Rhyolite area as well as for its Goldfield connections.

But the T&T was hardly in much better shape itself. It had not been able to meet its operating expenses for the first fiscal year (ending June 30, 1908), and the immediate prospects for profits looked very vague indeed. However, the railroad did have a purpose — to serve its parent, Borax Consolidated, Ltd., which also owned the Pacific Coast Borax Company, producer of the borax being shipped over the line. To this end, the parent company had guaranteed the bonds of the T&T, and as long as the parent did not run into financial difficulties, there was no danger of forefeiture of bond interest.

Finally a plan of operation for both the BG and the T&T was evolved and a formal written agreement was drawn up under the date of June 15, 1908, whereby the stock of each of the two railroads (the BG being closely controlled by the Bullfrog Syndicate and the T&T by Borax Consolidated, Ltd.) was placed with a holding company (the Tonopah and Tidewater Company) specifically organized for this purpose. The T&T (holding company) then took over formal operation of both railroads as one, continuing to use the name Tonopah & Tidewater for the entire route from Ludlow to Goldfield even though separate accounts were maintained for each of the constituent companies. The thought was that each company could help the other out financially, and that the profits, of one road could be used to offset the losses of the other — a wonderfully idealistic theory.

On July 1, 1908, combined operation started, and the people liked what they saw. The new route was referred to as T&T all the way, and the citizens of Rhyolite were particularly overjoyed when, on July 19, through trains entered town for the first time. It was virtually the same operation as before — each train had to back in to Bullfrog and Rhyo-

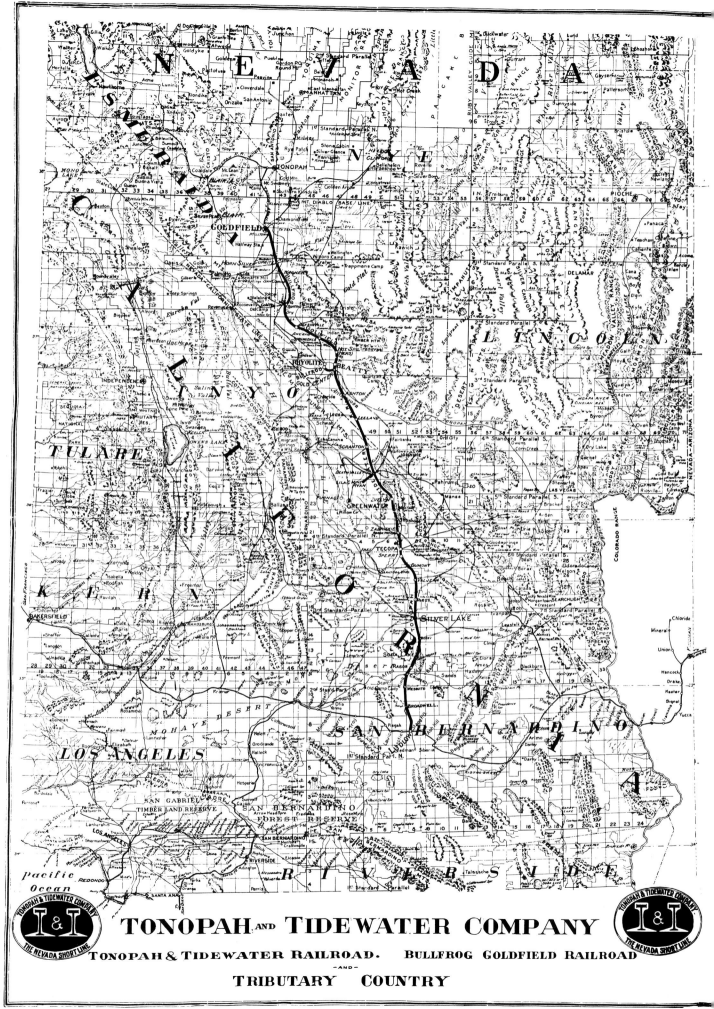

TONOPAH AND TIDEWATER COMPANY

TONOPAH & TIDEWATER RAILROAD. BULLFROG GOLDFIELD RAILROAD

—AND—

TRIBUTARY COUNTRY

POINTS OMITTED FROM MAP; PIONEER, 2½ WEST OF SPRINGDALE; ELLENDALE, 45 MILES NORTHEAST OF GOLDFIELD, 30 MILES EAST OF TONOPAH; ANTELOPE SPRINGS, 30 MILES EAST OF GOLDFIELD

lite from the junction — but they were the regular trains, not just a shuttle, and the people could rightfully consider themselves to be on the main line of the Ludlow-Goldfield trains.

For the next six years to 1914 the line was relatively active, even though not overly prosperous. Products of the mines were the principal commodities handled, and of these borax (and later clay) were the most important items. The branch to the Lila C. mine (primary objective of the railroad from the beginning) carried thousands of tons of borax ore, as was to be anticipated. Other branches were proposed though never constructed. A 40-mile branch eastward from the main line to Potosi (Goodsprings) was a projected thorn in the side of Senator Clark against whom resentment still stirred and retaliation was desired. There was also talk of building a branch westward across Death Valley to Skidoo if the Santa Fe failed to extend its line northward from Johannesburg to Ballarat and Skidoo. Flourine, not far from Beatty, was another likely candidate for a branch line which failed of realization, while the Greenwater line (as previously related) probably came the closest to becoming an actuality. One independent line, the Tecopa Railroad (q.v.) was completed in 1910 to connect the Noonday and Gunsight mines with a concentration mill at the south end of Tecopa on the T&T.

The rivalry with Senator Clark's LV&T did not end with the defeat of being the last to reach Gold Center, if anything, it might be said to have increased. With both lines now operating to Goldfield, the T&T had the edge through possession of the more direct route to the coast, and it made the most of its advantage both in publicity and in operations. Both lines had northbound passenger trains scheduled to arrive at Beatty (where the tracks crossed) at about the same time. As the main lines on the southerly approach to town were not too far apart, it was a common practice when the train of the other road was in sight to race in to the terminal to command the crossing first.

Other (defensive) activity was stimulated by the usual desert problem of water. Not only was it difficult to find good or even passable water in sufficient quantities for the locomotive boilers, but there was also the eternal problem of how to handle the unwanted and unusual volume of surface water which poured down the gullies and through the canyons with destructive results as an aftermath of so-called flash floods. One cloudburst over Eagle Mountain during the early part of August 1908

sent a column of water rushing down the Amargosa River bed which undermined the track near Shoshone and caused a wreck in which three men were killed. At various other times the Amargosa Canyon sustained its share of flood waters with equally devastating results. In the spring of 1910, near the southern end of the line, the Mojave River rose to its highest flood stage since 1862 and overflowed its banks. Water poured into the dry bed of Silver Lake and refused to evaporate. At first trains were able to creep slowly through the water on the tracks laid on the floor of the lake, but as the level of the water rose, the matter of flooded fireboxes became more serious. Ultimately the problem was solved by raising the track six inches above the lake bed.

Liquids of a different kind frequently brought unexpected results. Because the T&T was a desert road, it was difficult to get (let alone keep) the engine crews, and the men knew it well. Consequently the train and engine crews became an independent lot and virtually ran the road to suit themselves. "Rule G" was frequently violated, and many stories have circulated of engine crews famous for bringing their train into Beatty purely because the flanged wheel followed the steel rail. One such crew "landed" its train without too much difficulty at the Beatty station, but then ran into some very "heavy seas." Following usual procedure, the engine was uncoupled from its train and run to the water tank to replenish the tender supply. By some strange coincidence, the end of track came too soon and the engine landed on the ground. Rerailing was accomplished only after the application of superhuman efforts (accompanied by additional liquid refreshments), following which the lomomotive was finally spotted with difficulty beneath the tank. In the act of wildly groping for the elusive spout, the fireman managed to fall off the tender; but apparently his internal liquids helped to absorb the shock, for he recovered sufficiently to clamber back up on the tender and complete the chore. The taking of water accomplished, the next project was to back the locomotive to the waiting train, standing at the station with its brakes tied down. Even in this simple movement, alcoholic confusion prevailed; and an empty flat car was inadvertently picked up along the way and rammed so hard against the standing train that it buckled to form a giant, inverted "V." The passenger train was a "little late" leaving town, but for the passengers standing

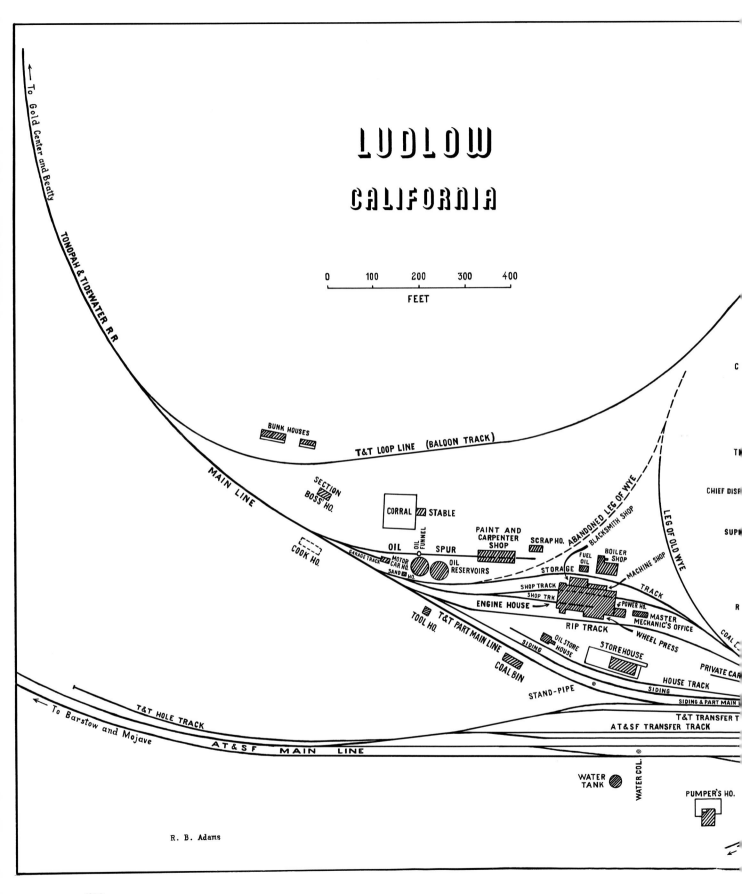

LUDLOW
CALIFORNIA

0 100 200 300 400
FEET

To Gold Center and Beatty

TONOPAH & TIDEWATER R.R.

MAIN LINE

BUNK HOUSES

T&T LOOP LINE (BALOON TRACK)

SECTION
BOSS HO.

COOK HO.

CORRAL STABLE

OIL

OIL
FUNNEL

SPUR

GARAGE TRACK

MOTOR
CAR HO.

SAND HO.

OIL
RESERVOIRS

PAINT AND
CARPENTER
SHOP

SCRAP HO.

ABANDONED LEG OF WYE

BLACKSMITH SHOP

LEG OF OLD WYE

CHIEF DISP

SUP

T

C

STORAGE

FUEL
OIL

BOILER
SHOP

MACHINE SHOP

TRACK

SHOP TRACK

SHOP TRK

ENGINE HOUSE

POWER HO.

MASTER
MECHANIC'S OFFICE

RIP TRACK

WHEEL PRESS

R

COAL

TOOL HO.

T&T PART MAIN LINE

SIDING

OIL STORE
HOUSE

STOREHOUSE

PRIVATE CAR

COAL BIN

STAND-PIPE

HOUSE TRACK

SIDING

SIDING & PART MAIN

To Barstow and Mojave

T&T HOLE TRACK

AT&SF MAIN LINE

T&T TRANSFER T

AT&SF TRANSFER TRACK

WATER
TANK

WATER COL.

PUMPER'S HO.

R. B. Adams

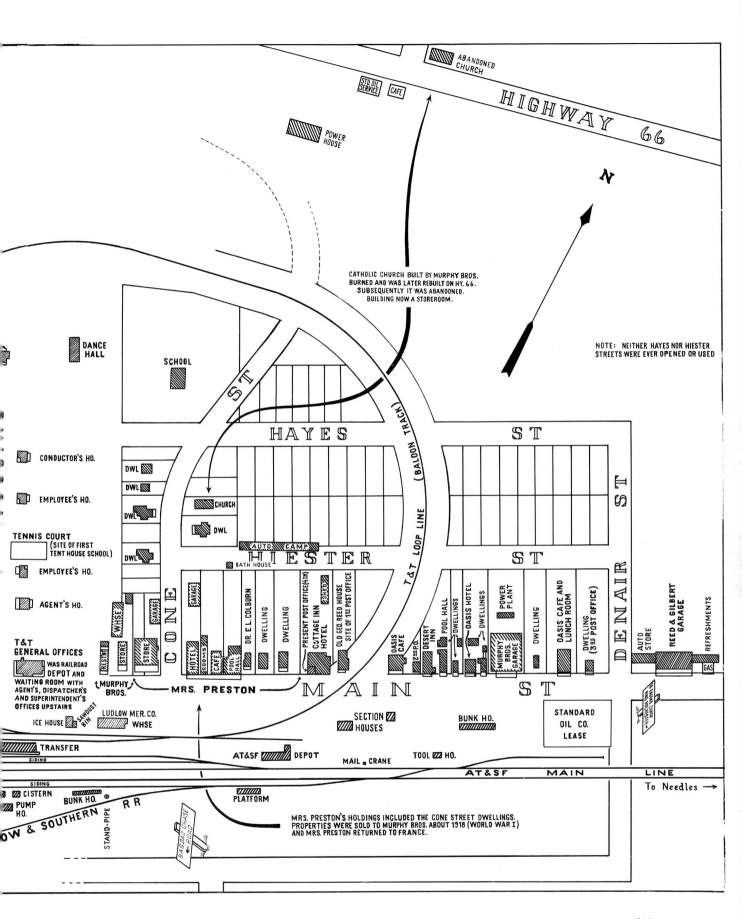

ABANDONED CHURCH

HIGHWAY 66

STD. OIL SERVICE CAFE

POWER HOUSE

N

CATHOLIC CHURCH BUILT BY MURPHY BROS.
BURNED AND WAS LATER REBUILT ON HY. 66.
SUBSEQUENTLY IT WAS ABANDONED.
BUILDING NOW A STOREROOM.

NOTE: NEITHER HAYES NOR HIESTER
STREETS WERE EVER OPENED OR USED

DANCE HALL

SCHOOL

HAYES ST ST

CONDUCTOR'S HO.

DWL

DWL

DWL

CHURCH

EMPLOYEE'S HO.

DWL

DWL

TENNIS COURT
(SITE OF FIRST
TENT HOUSE SCHOOL)

AUTO CAMP

HIESTER ST ST

EMPLOYEE'S HO.

BATH HOUSE

DENAIR ST

AGENT'S HO.

GARAGE

CONE

T&T LOOP LINE (BALOON TRACK)

POOL HALL

OASIS HOTEL

DWELLINGS

POWER PLANT

REED & GILBERT GARAGE

WHSE

GARAGE

HOTEL ROOMS

CAFE

POOL HALL

DR. E. L. COLBURN

DWELLING

DWELLING

COTTAGE INN HOTEL

PRESENT POST OFFICE (4TH)

SHED

OLD GEO. REED HOUSE
SITE OF 1ST POST OFFICE

OASIS CAFE

2ND P.O.

DESERT INN

DWELLINGS

DWELLINGS

MURPHY BROS. GARAGE

DWELLING

OASIS CAFE AND LUNCH ROOM

DWELLING (3RD POST OFFICE)

AUTO STORE

REFRESHMENTS

T&T
GENERAL OFFICES

WAS RAILROAD
DEPOT AND
WAITING ROOM WITH
AGENT'S, DISPATCHER'S
AND SUPERINTENDENT'S
OFFICES UPSTAIRS

REST.

STORE

STORE

MURPHY BROS.

MRS. PRESTON

MAIN ST GAS

ICE HOUSE SANDUST BIN

LUDLOW MER. CO. WHSE

SECTION HOUSES

BUNK HO.

STANDARD OIL CO. LEASE

TRANSFER

SIDING

AT&SF DEPOT

MAIL CRANE

TOOL HO.

AT&SF MAIN LINE

SIDING

To Needles →

CISTERN

PUMP HO.

BUNK HO.

LOW & SOUTHERN RR

STAND-PIPE

PLATFORM

BAGDAD CHASE ROAD

MRS. PRESTON'S HOLDINGS INCLUDED THE CONE STREET DWELLINGS.
PROPERTIES WERE SOLD TO MURPHY BROS. ABOUT 1918 (WORLD WAR I)
AND MRS. PRESTON RETURNED TO FRANCE.

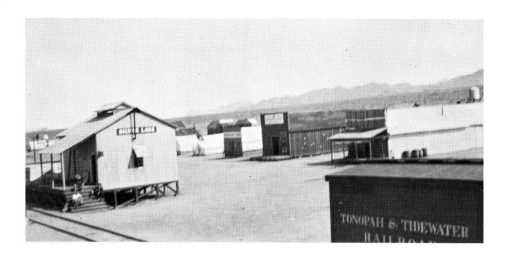

Because the floor of the T&T's Silver Lake freight house was built at a level corresponding with that of the standard railroad box car, the building *(above)* seemed incongruous when compared with those of the rest of the town. In January 1916, however, when heavy rains spread all over Southern California, the normally dry bed of Silver Lake filled with water for the second time in T&T history, and the little freight house-on-stilts became one of the few dry places in town. As the waters rose and took her track, the T&T was obliged to suspend operations completely. *(Top: H. P. Gower Collection; bottom two: W. C. Hendrick Collection.)*

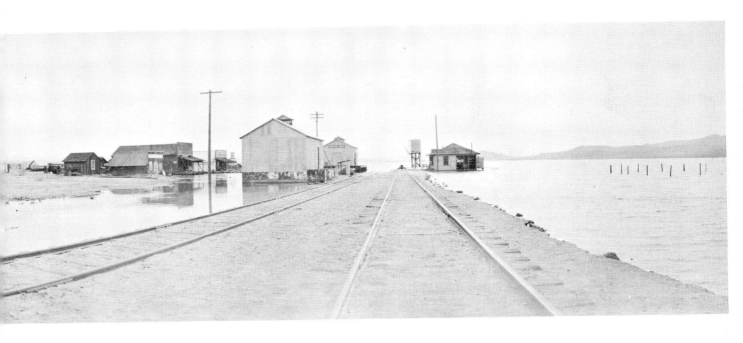

The waters evaporated very slowly, and months went by before the T&T could resume regular operations without recourse to a lengthy detour. During the intervening period a new, 7½-mile line was constructed along the eastern shore of the lake, and the station was dragged to a new location on higher ground along the revised right of way. Note that flood photos this page face south; those on page opposite, to the north. (*Top two photos: W. C. Hendrick Collection.*)

— 563

Considerable track repairs were required after each flood, and those of 1916 were no exception. A work train near Tecopa included in its gang Bill and Ralph Parkinson, Andy Tier (first, third and fourth men from the left) and Ben Horton, later roadmaster (black sleeves). Silver Lake station *(top, right)* was an improvisation of a later date after the water soaked station had been discarded. *(Top, right: R. P. Middlebrook photo; all others: Hendrick Collection.)*

564 —

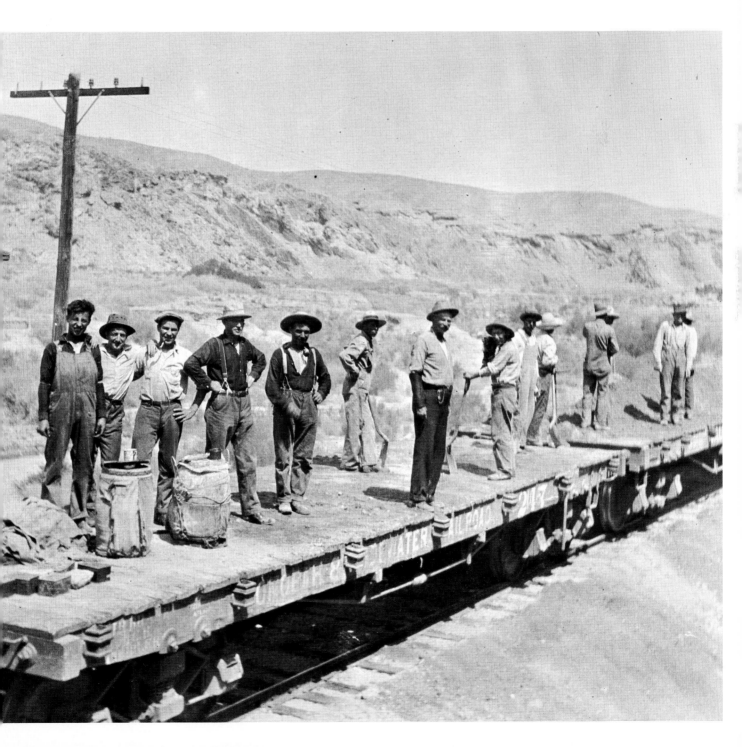

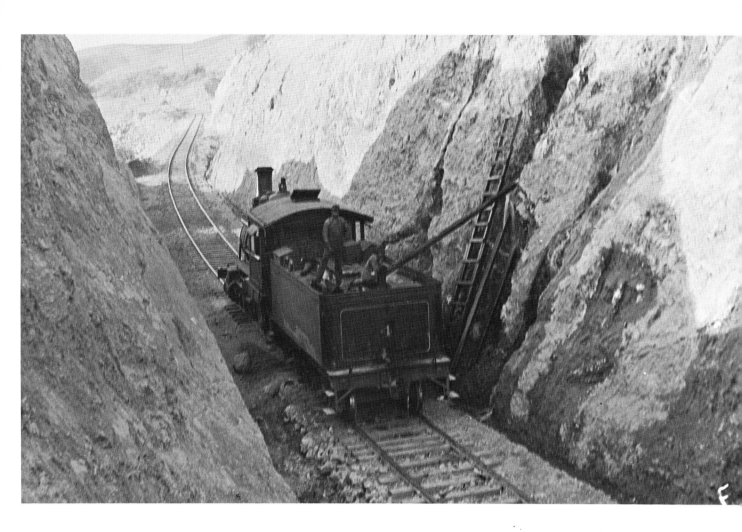

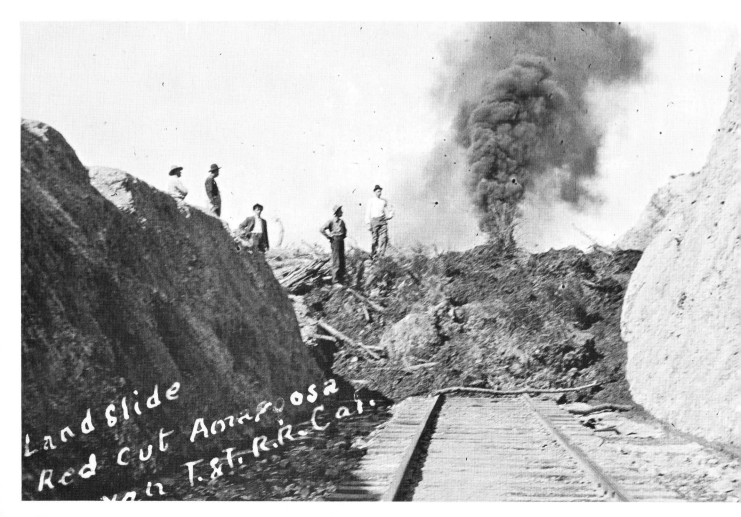

Landslide
Red Cut Amargosa
Cyon T. &T. R.R. Cal.

South of Tecopa along the Amargosa River Canyon one of those rare miracles of nature in desert country appear — a spring of free flowing water. T&T railroad men were not long in discovering it, and temporary facilities for taking emergency supplies of water at Red Cut were quickly improvised. The moisture in the bank proved to be dangerous as it made the ground unstable, and a landslide eventually ensued at the north end of the cut. Although modern bulldozers would make short work of such a relatively small slide today, the ridge of earth at that time presented a problem of no mean dimensions for pick and shovel artists. The dirt on the near side had to be shoveled onto push cars and rolled to the south end of the cut for dumping. Trains from the north and the south met at opposite ends of the slide, and passengers walked to their connecting carrier as workmen transferred the more bulky, less-than-carload freight. To prevent a recurrence of the difficulty, Chief Engineer Rasor was obliged to install a large drainage tunnel some 300 feet back of the hill. (All photos: Hendrick Collection.)

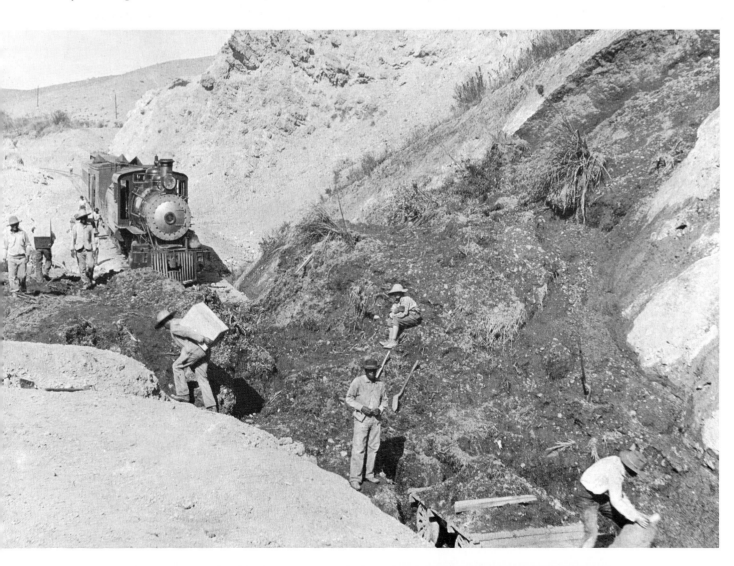

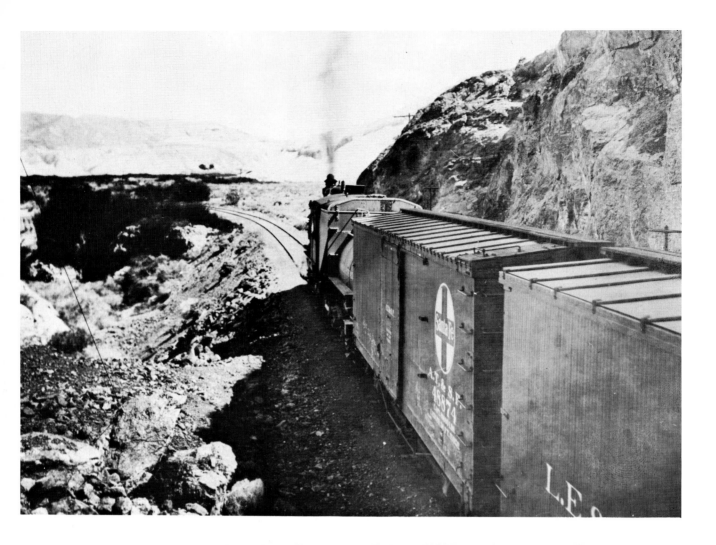

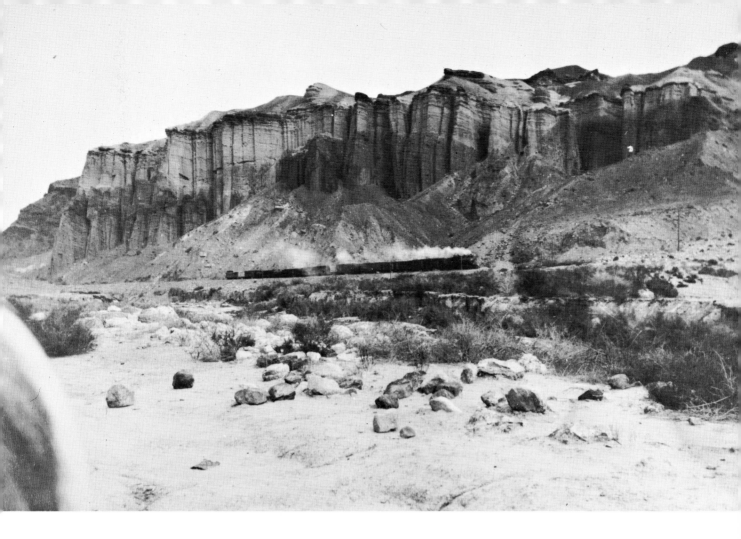

South of Tecopa *(top, left)*, the T&T dove into the rugged Amargosa River Canyon *(top, left)* along the Palisades *(above)*, which was about as desolate and hot a stretch of railroad as could be found. One day in 1915 the daily mixed train left town and proceeded down the canyon to Morrison (later Acme), where the passenger car was set out while the crew took the balance of the train up the Acme branch for some switching. On the return trip down the hill the brakes failed, and the runaway train gathered speed as it raced to the main line. There the waiting passengers were treated to the spectacular climax *(left, center and bottom)* as the cars and locomotive left the rails and overturned directly in front of them. Several days of hard labor plus the "big hook" borrowed from the Santa Fe were required to clear up the mess. *(Left, top: U. S. Borax & Chemical Co.; center and bottom: Hendrick Collection; top, right: U. S. National Park Collection.)*

Conductor Elmer French, shown *(left)* with his wife, Clara Bell, at their T&T home in Tecopa in 1912, normally made the southbound, 2-day run to Ludlow and return. Andy Tier shared equal honors on the northbound turn-around run to Beatty. Tecopa then served as the railroad's division point, being 87 miles from Ludlow and 82 miles from Beatty. *(Hendrick Collection.)*

— 569

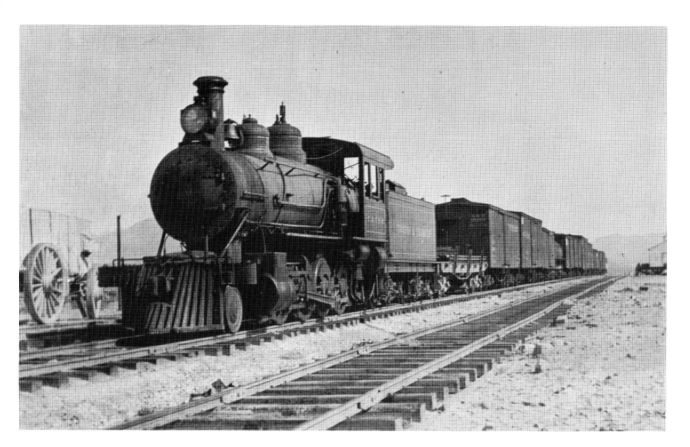

Zabriskie *(above)* became the 91-mile northern terminus of the T&T when the rails reached that point in June 1907. Borax from Smith's Lila C mine to the north was teamed to this newest and nearest railhead. So great was the excitement at Greenwater that a separate Tonopah & Greenwater Railroad was incorporated by T&T interests to be extended northwesterly from Zabriskie to the mining camp, but Greenwater expired too quickly to realize the dream. In this view, a symbolic ore wagon awaits the arrival of T&T No. 6 with the local freight not long after the railroad had been completed. *(Hendrick Collection).*

On August 9, 1908, a desert cloudburst brought death to two enginemen and a hobo, and destruction to the T&T. Heavy rains struck Eagle Mountain (north of Zabriskie), and the run-off of waters swelled the usually dry Amargosa River to flood stage, undermining the track about 11 miles to the south. A southbound T&T train with BG locomotive No. 13 at the head end unwittingly hit the washout and landed in the dirt *(top, right)*. The following day a relief train pushed by T&T No. 10 *(below)* arrived on the scene, while still later No. 13 was righted and brought back to Ludlow *(bottom, left)* for repairs. *(All photos: Hendrick Collection.)*

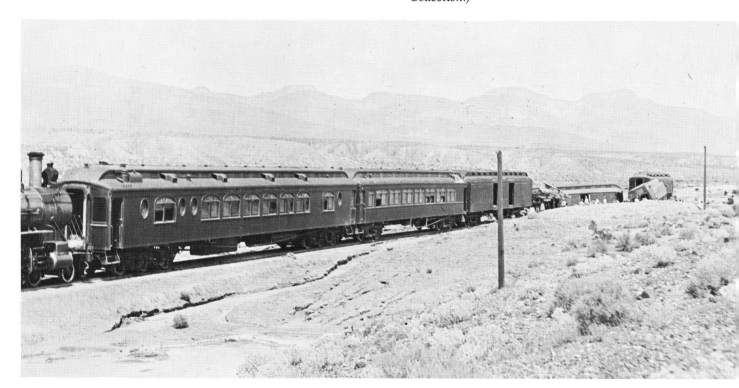

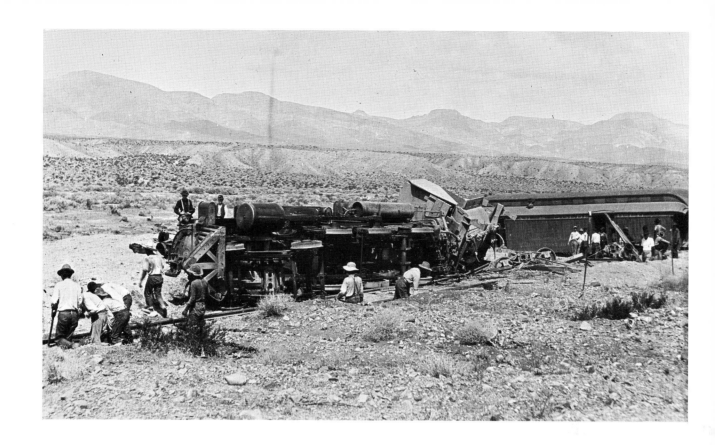

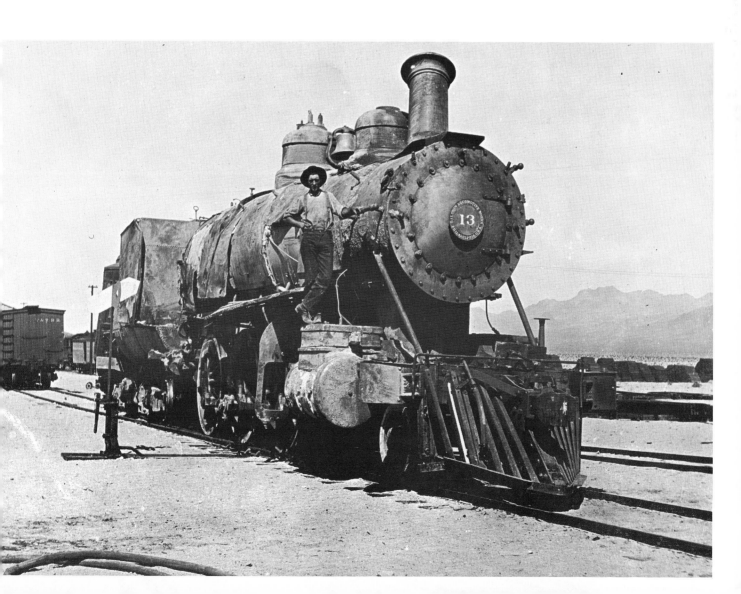

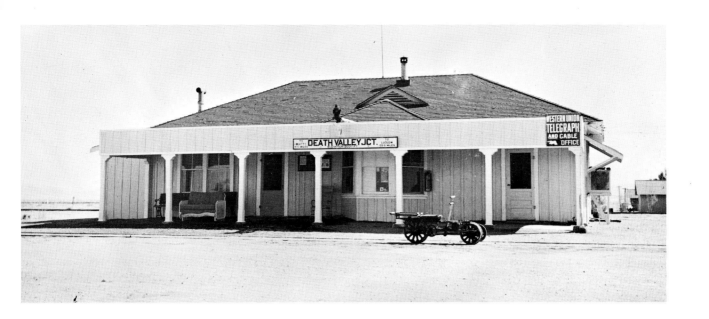

Death Valley Junction on the T&T was an oasis along the western edge of the Amargosa Desert, 47 miles south of Beatty and 122 miles north of Ludlow. Here the original (standard gauge) branch to the Lila C mine swung to the west and south, its easterly portion (as far as Horton) later became part of the narrow (3-foot) gauge Death Valley Railroad. The Amargosa Hotel (below) was built on the northwest side of the junction to accommodate the tourist business in the Death Valley area, which was heavily promoted during the late 1920's. The Funeral Mountains loom in the background, while Furnace Creek Wash creases the range out of the picture to the left. (Top: Louis L. Stein Jr. Collection; bottom: Barton Collection.)

T&T No. 6 in capped stack, original paint and striped drivers, was still relatively new when the portrait (top, right) was snapped at the end of the original Lila C branch. The position of the sun and the blocking under the wheels indicate that the crew had made up the train the night before and had taken precautions against any unscheduled departure downhill toward the junction during the night. (Hendrick Collection.)

T&T No. 1 (bottom, right) was a hand-me-down of several owners and a variety of numberings before being acquired in 1905. Although largely used in passenger service, No. 1 is shown here doing switching service at Death Valley Junction. (R. P. Middlebrook photo.)

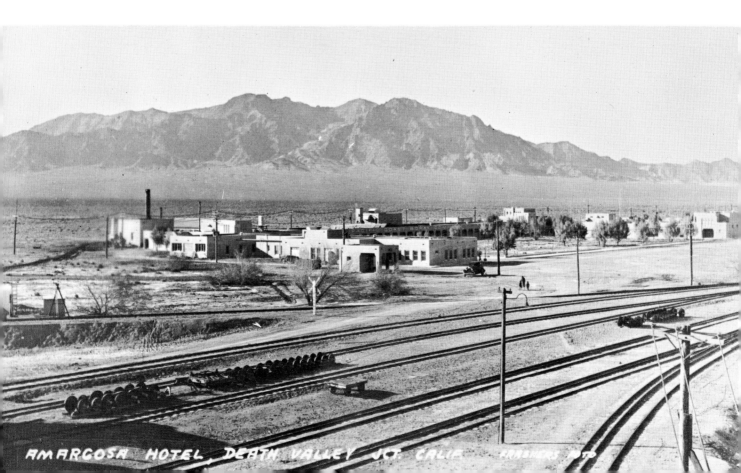

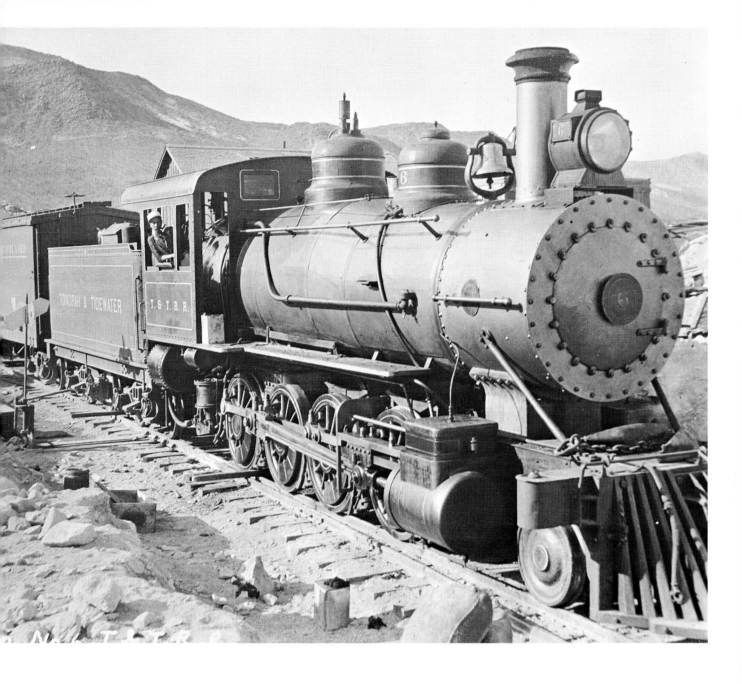

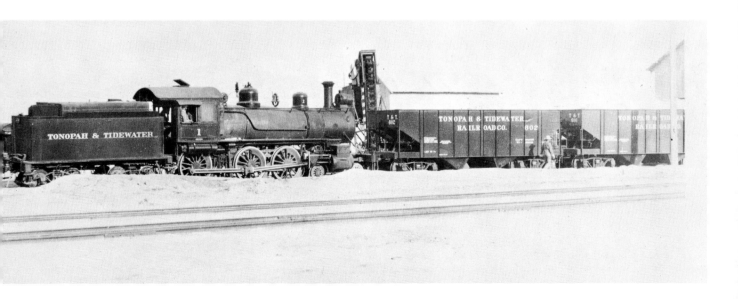

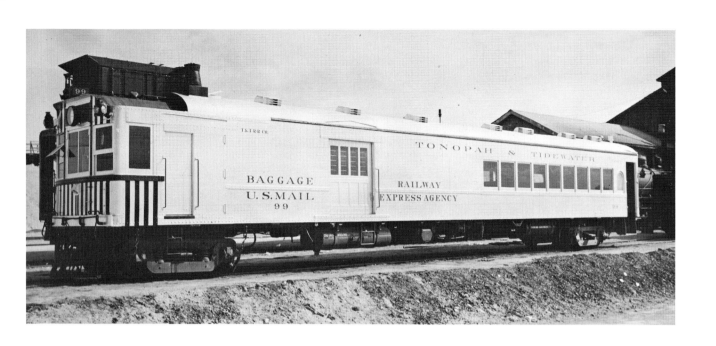

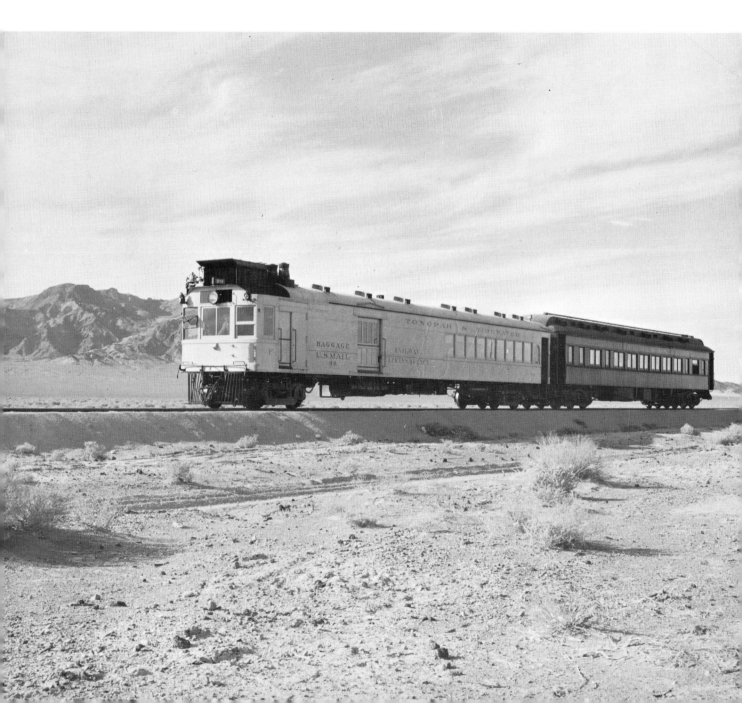

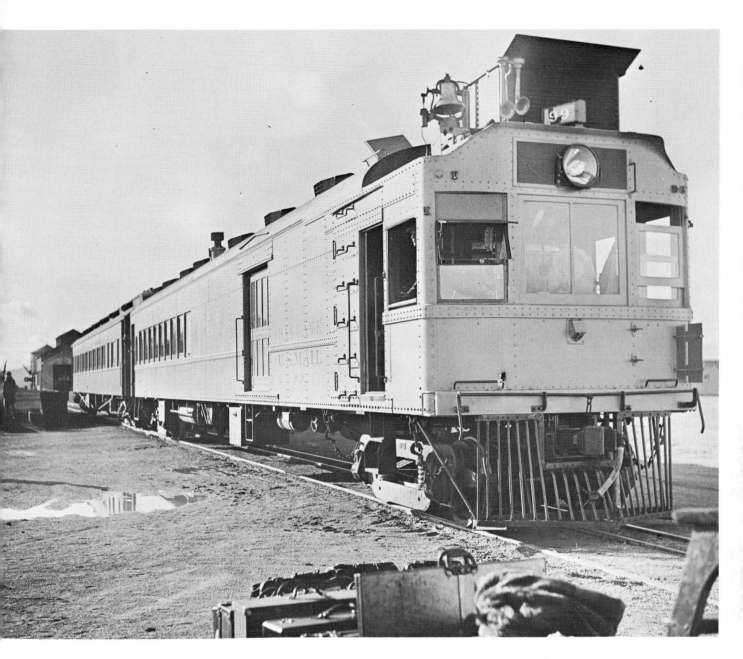

In December 1928, the T&T took delivery of a brand new gas-electric combine as part of the Pacific Coast Borax Company's program to develop Death Valley as a winter tourist resort. The 225 H. P. Winton engine managed to develop sufficient current for the traction motors to pull a standard "heavy" sleeper on the carded runs between Ludlow and Death Valley Junction. In 1929, the timid stayed at the Amargosa Hotel; the more venturesome transferred to companion equipment on the narrow gauge Death Valley Railroad for the final leg to Ryan or the brand new Furnace Creek Inn on the floor of the valley. "Starlets" Alma Kelly and Betty Gilles *(near, left)* were welcome companions to engineer Mickey Devine and conductor Wm. M. "Blackie" Mayer on their visit in February 1929 to popularize the route. *(Top, left: Fred Stindt photo; bottom, left: Frasher photo, Pomona, California; two photos this page: Union Pacific Railroad Collection.)*

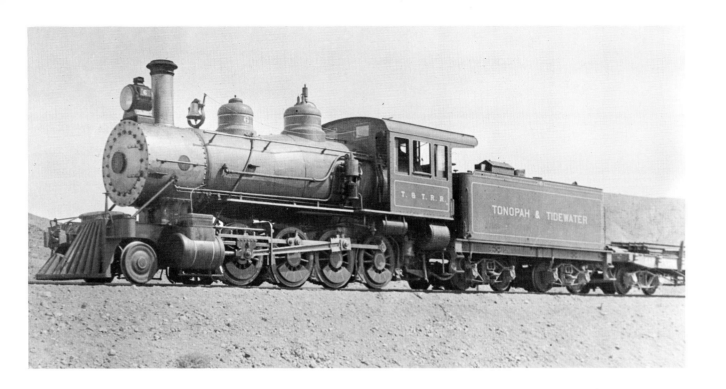

Representative motive power on the T&T are exemplified by Consolidation No. 6 (2-8-0) *(above)*, 10-wheeler (4-6-0) No. 1 taken with the original cab and tender as received from the Santa Fe (compare with later photo), *(upper right)* and the road's only (2-6-0) Mogul, No. 4 *(lower right)*. Of the rolling stock on parade in the view of the Ludlow shops *(below)*, probably the most interesting and most exclusive item is the former Bullfrog Goldfield, Wells Fargo-RPO car in foreground. *(Top, right: Phillips C. Kauke Collection, courtesy of Gerald M. Best; all others: Hendrick Collection.)*

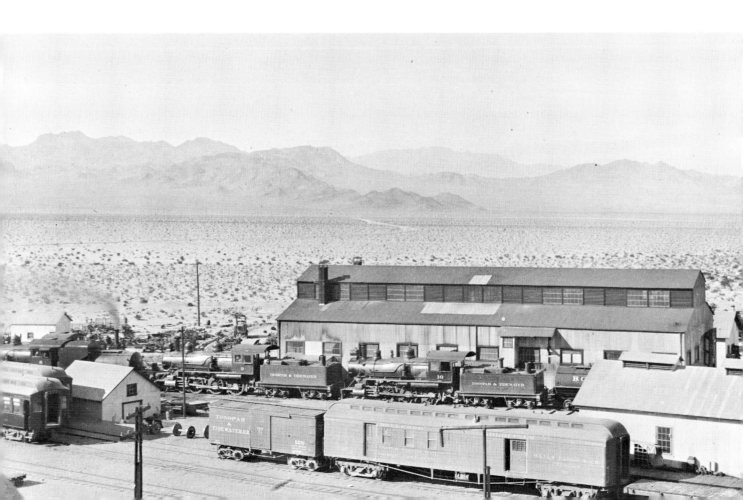

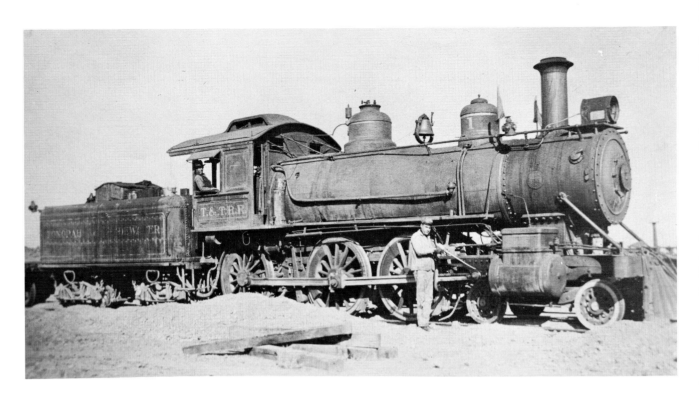

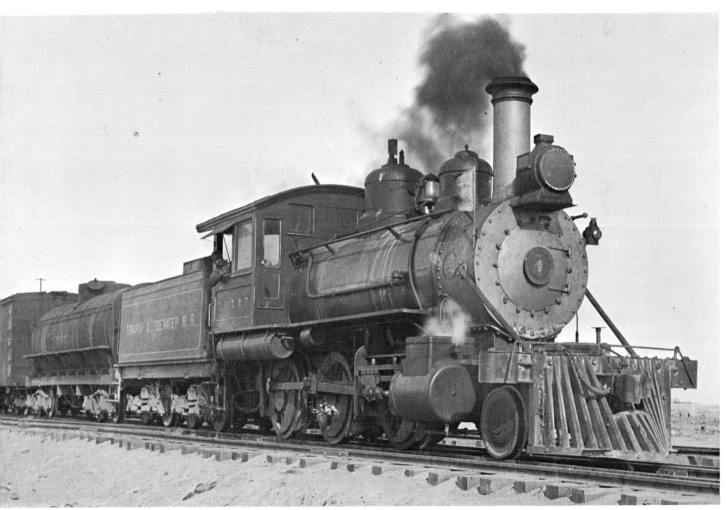

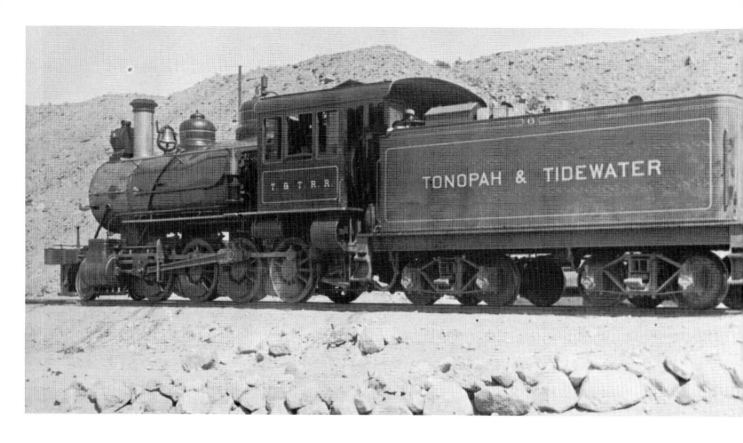

T&T No. 6 (above) looked handsome from most any angle, as did 10-wheeler No. 9 shown in mint condition (below) following assembly at the Ludlow shops in 1907 and (top, right) at the Santa Fe roundhouse in Barstow in 1945 following abandonment of the T&T. Of the T&T group (bottom, right) at the Ludlow shops, some are road men and others are shop employees. Perhaps all were anxious to finish the job of putting new flues in the locomotive and getting her back in service on the road. (Top, right: Phillips C. Kauke; all others: Hendrick Collection.)

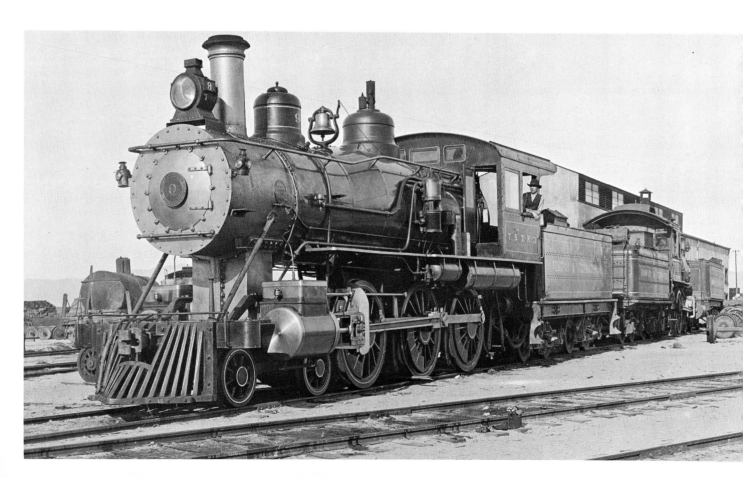

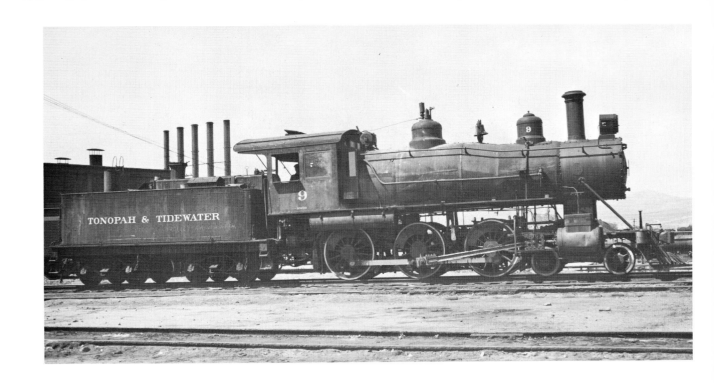

T&T No. 1 *(top)* was the *Good News* in its grander days before becoming an official car on the T&T. Following standard operating practice, cars were stepped down, eventually relegated to work train service. Bunk car No. 508 and Dining Car No. 506 are typical of this reassignment. *(Top: Walter Averett; center and bottom: Gerald M. Best photos.)*

The *Hauoli (top, right)* was Borax Smith's private car which, although shown here at the Key System's shops in Oakland, California, about 1910, was frequently to be found on T&T rails. The *Boron,* Supt. Wash Cahill's private car, was later used as sleeping quarters for crew men at Death Valley Junction. Here the wives of two employees demonstrate the early-day practice of "riding the rods," an inglorious and highly dangerous practice of bums and vagrants. *(Top: Louis L. Stein, Jr. Collection; center: Hendrick Collection.)*

T&T No. 11 *(bottom, right)* originally was purchased by the Bullfrog Goldfield Railroad from the San Francisco, Oakland & San Jose R.R. Co. (Key System) in 1913 for use as a crew bunk car at Goldfield. *(Hendrick Collection.)*

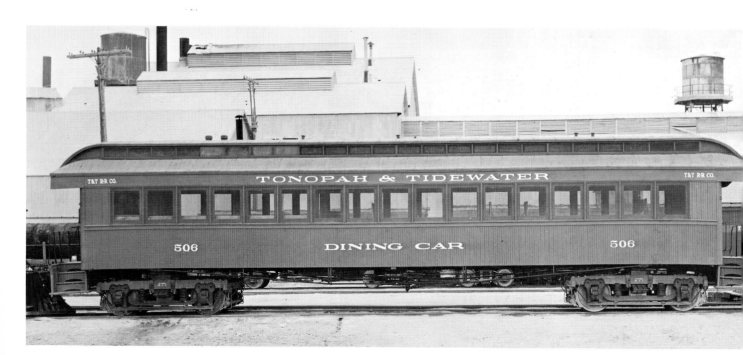

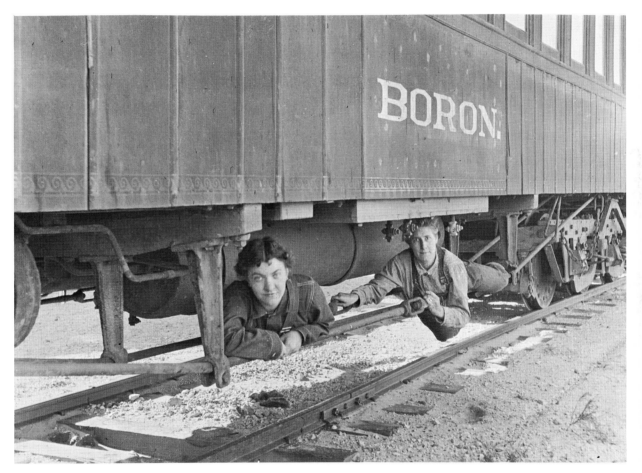

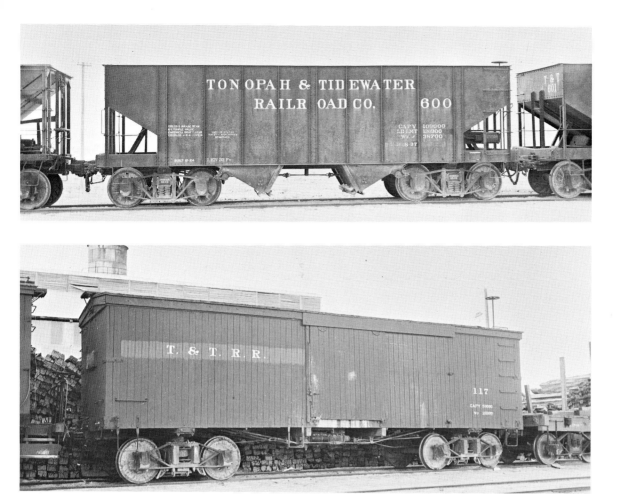

Freight equipment on the T&T developed into a motley assortment of new equipment and hand-me-downs. Of the more modern cars, the hopper and water tank *(top, left and right)* are typical. Older box car No. 117 and tank-on-a-flat car No. 302 *(center, left and right)* and caboose *(bottom, right)* are most interesting for their early arch bar trucks with wooden center sills. Box car No. 130 *(below)* is unusual in that it carries the full name and emblem of the T&T, a combination not often used. *(All photos: Gerald M. Best.)*

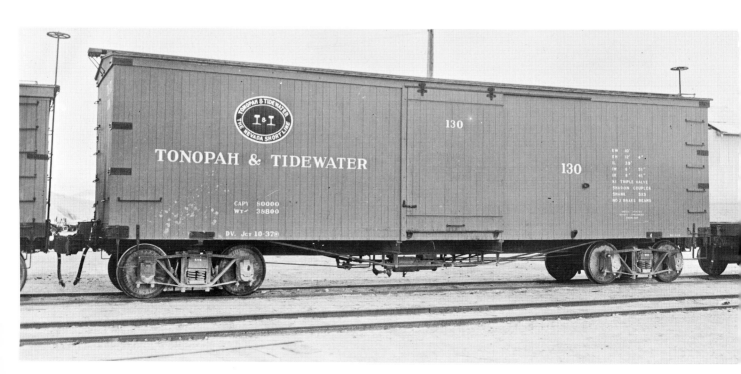

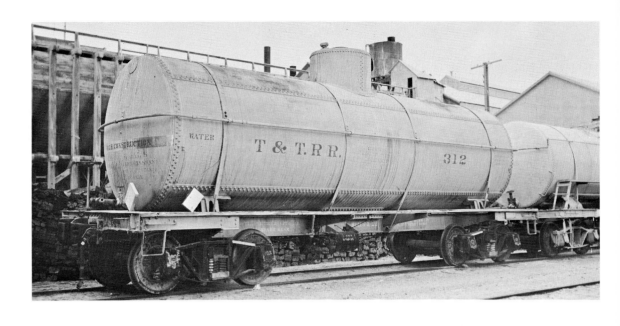

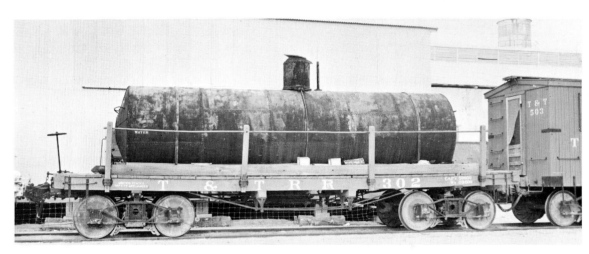

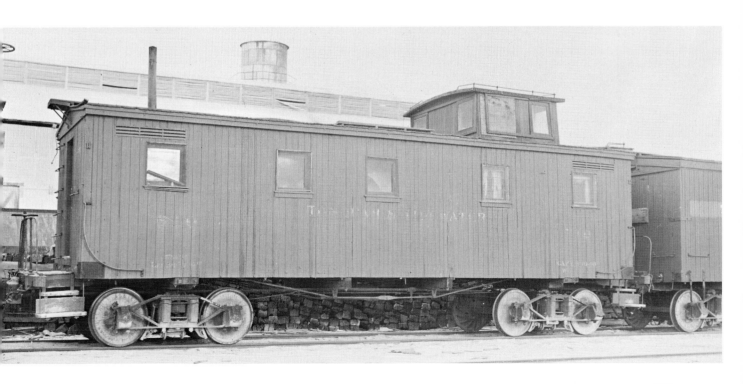

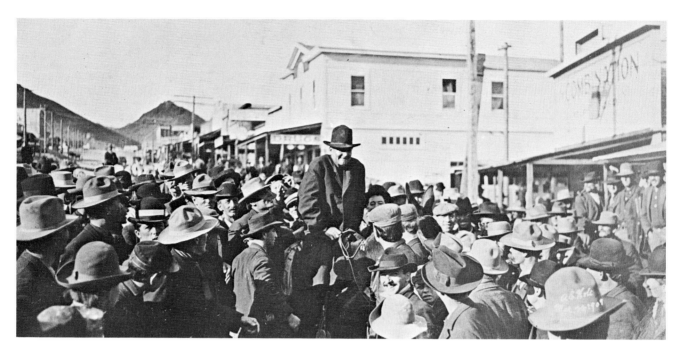

Following completion of the T&T to Gold Center and a union with the BG to Beatty and Rhyolite in October 1907, it was a natural supposition that Death Valley Scotty would take an interest in the new road which passed near his reputedly fabulous mine. In March 1909 Scotty again visited Rhyolite (shown *above* on Golden Street surrounded by a well-hatted, curious crowd). The year before, in a previous visit, he attempted in vain to arrange for a special train from Rhyolite in the direction of San Francisco. Surly when rebuffed, Scotty wasn't the least bit interested in riding the regular trains which sped across the desert in spontaneously picturesque motion such as this passenger carrier *(below)* which approaches Death Valley Jct. from the south with Brown Mountain in the background. *(Top: Nevada Historical Society; bottom: Hendrick Collection.)*

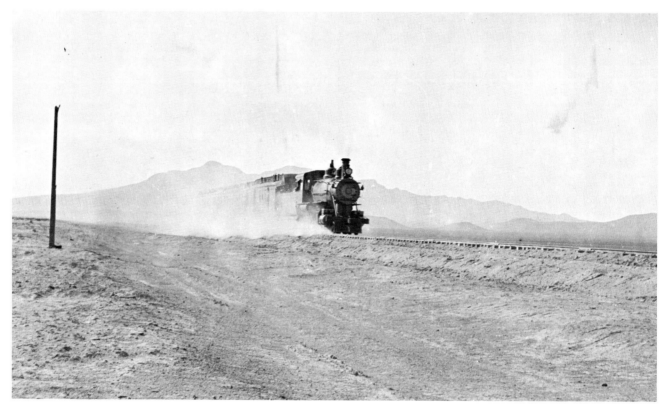

TONOPAH & TIDEWATER RAILROAD

on the station platform, the free show had been ample recompense for the delay.

From the beginning of construction and all during the early years of T&T operations, the road's headquarters were established at Ludlow at the Santa Fe connection. Here Wash Cahill maintained his residence and office in the private car, "Boron," conveniently parked on a siding adjacent to the road's shops and facilities. In spite of its many conveniences, the car was considered to be a good place not to be obliged to visit — although in later years the stigma was eradicated when Cahill released it for relocation at Death Valley Junction to serve as an overnight stopping place for crews tying up for the night at that division point. Another official car was acquired in October 1908. Originally the "Good News" of the National Florence Crittenden Mission, it was promptly adopted to the Spartan simplicity of railroad usage through eradication of the name and substitution of the simple designation "No. 1."

In the memory of former employees there appears to be some disagreement as to the managerial ability of Wash Cahill, but on one point there is an obviously complete unanimity — Cahill enjoyed a good time. What is more, he wanted his employees to share in the fun, which, in the Ludlow circa 1910, was of necessity, self-generated. To this extent, dancing became one of the most important forms of diversion. In turn, it decided Cahill upon the necessity of hiring a Negro cook — not that he really needed a cook on his car, but Jean Lucas not only could cook if the occasion required; what was more important, he could play the piano.

The dancing was not confined to employees only; everyone joined in the fun. In fact the T&T benefited considerably from increased passenger revenues as it brought people in from far and wide to share in the amusement. Complications were bound to arise, and did; but solutions to the problems were usually found. When one dancing party was scheduled to start at 9:00 P.M. and it was discovered that the train was not due to arrive until almost midnight, Cahill was petitioned to try to improve upon the situation. Much to everyone's surprise there was not only an improvement — the train arrived at nine on the dot and the costume dance was a tremendous success. In fact, people were enjoying themselves so greatly it seemed a shame to break up the party, and Cahill was approached again — could not the northbound departure be delayed a bit so that all could have breakfast together? Again the T&T obliged with a custom scheduling to suit the friskiest celebrant.

Some problems were solved a bit more inadvertently though nonetheless effectively. When one scheduled dance was threatened by a drought of whiskey causing the male dancers to assume long and woebegone faces, it was determined that an express shipment of a barrel of the desired liquid would be en route from Goldfield to Los Angeles on the southbound train that very evening. By strange coincidence, as the train lurched around the curve into the Ludlow station, the barrel rolled right out of the baggage car door into the arms of a group of members of the dance committee who just happened to be standing at that particular spot to watch the train come in. The dance that evening was a great success, and future dance committees found it advantageous to visit the same spot on the same curve on a number of other occasions.

"Lost shipments" might almost be said to be a Ludlow specialty. In the early days when Goldfield was booming, the more exalted of the mining fraternity developed a substantial appetite for frogs' legs as a delicacy. Shipped from the Gulf Coast by railway express, they arrived in Ludlow on the Santa Fe and were transferred immediately to the waiting T&T train. One day a Santa Fe shipment arrived in town just too late to make the connection, and with no ice available locally for their preservation, the express agent was faced with a dilemma. If the shipment were held until the next train to Goldfield, the frogs' legs would spoil; so how best to handle the situation? The agent put on a sale and peddled the frogs' legs at three for one dollar; Ludlow citizens loved it. In fact, so well was the new diet received, quite a number of subsequent shipments failed to make the connection. Unfortunately the express company became curious over the frequency of missed connections and investigated, putting an end to Ludlow's gourmet diet by diverting the frogs' legs traffic to another route with more assured connections.

The year 1914 was one of many major changes for the T&T both physically and economically. As a matter of internal economy, the more productive ores at the Lila C. mine had become exhausted and the seven-mile branch from Death Valley Junction, although it had carried thousands of tons of borax over its seven years of operations, was now a useless appendage. To compensate for the loss of production, the Pacific Coast Borax Com-

pany developed the Biddy McCarty mine, approximately 12 miles north and west of the old location, on the very fringes of Death Valley proper. Transportation was provided with the inauguration, in 1914, of the narrow-gauge Death Valley Railroad (q.v.), consisting of all new railroad construction from the mine eastward to Horton (on the T&T's Lila C. branch) and the installation of a third rail from there to Death Valley Junction. Since the Death Valley Railroad was a separate corporation, operations over the 3-rail portion of the line were conducted under a trackage rights agreement with the T&T. Ultimately, after all details of the mining shift were accomplished, that portion of the T&T's Lila C. branch from the mine to Horton was abandoned and the tracks taken up; between Horton and Death Valley Junction the third (standard gauge) rail was removed, following which the narrow-gauge tracks and roadbed were sold (in 1916) by the T&T to the Death Valley Railroad, giving the latter an exclusively narrow-gauge property all the way from Death Valley Junction through Horton to the mine at (new) Ryan. Although the DV was a separate railroad corporation, control was vested in the same basic parental management and operations were conducted as though the line were a branch of the T&T.

Although there had been a major shift of operations from the Lila C. to the Biddy McCarty mine, the Pacific Coast Borax Company never completely abandoned operations at the former unit. In order to hold good title to the property, some ore was produced each year; but since the rails had been torn up on the branch line to the mine, the ore was merely stockpiled above ground and allowed to accumulate.

The year 1914 was notable for another major change in the T&T when it lost the northern (BG) segment of its line from Beatty to Goldfield. Times were rough in the bonanza districts — Bullfrog and Rhyolite were about extinct as gold producing areas; Goldfield, to the north, was wobbling rather pitifully; railroad revenues for the T&T-BG combination had dropped to an abysmal low; and the BG needed some form of revitalization. Since the BG and Senator Clark's LV&T roughly paralleled each other for the entire distance from Beatty to Goldfield, an agreement was drawn up between the two roads whereby the best segments of each line would be combined into a new routing, and the less desirable portions of either route would be abandoned. The resulting railroad corporately was

still called the Bullfrog Goldfield Railroad, but it was operated by the LV&T. Thus the T&T lost its identity in Goldfield but maintained trackage rights over the BG from Gold Center to Beatty.

As though to compensate for this closeout of Goldfield business, some new traffic was generated through construction of the so-called Acme spur from Morrison (later Acme) to the main line in Amargosa Canyon eastward up the north side of Willow Creek for 1.3 miles. The tracks ran past China Ranch and through a picturesque canyon to a gypsum deposit at Acme. No particular importance attaches to the line, unless it be recalled that it was on this branch that two cars got away from an engineer and coasted all the way to the junction, resulting in a bad wreck.

Over the next few years the road experienced varying fortunes and misfortunes. In January 1916 heavy rains spread over all of Southern California creating many unusual situations. Silver Lake again filled with water, inundating seven miles of T&T tracks, while washouts at various other points completely disrupted service. To bridge the gap between Crucero (at the crossing of the Salt Lake Route) and Tecopa (at the northern end of Amargosa Canyon) a giant detour was necessary — via the Salt Lake Route from Crucero to Las Vegas, thence northward over the rival LV&T to Beatty, then southward on T&T rails to Tecopa. Months went by before service could be resumed. A new, 7½-mile rail line along the eastern edge of Silver Lake had to be built with materials salvaged from the recently abandoned Lila C. branch. In March the Silver Lake depot and warehouse collapsed with the result that the railroad station and the balance of the small town were re-established along the eastern shore of the lake next to the new rail line.

In 1917-18 (during World War I) the United States Railroad Administration (USRA) took over operation of all of the country's railroads, including both the T&T, the LV&T and the latter's operation of the BG. As a weak and unnecessary duplicate facility, the LV&T was ostracized by the USRA and virtually forced into abandonment. The impoverishment of the LV&T left the BG without an operator, and in September 1918 the T&T once again picked up the loose ends of the old BG Railroad and tied them to its apron strings under a five-year operating agreement. Mining might stage a comeback, and the T&T thought it could continue to operate the road at a small loss pending determination of the outcome. To the local

citizens, it seemed as though nothing had happened, for they still continued to regard the entire route to Goldfield as T&T.

Changes came slowly in the postwar years. Around 1919 the two sons of the owner of the Acme mine were killed by a cave-in while eating lunch, and all activity at that location ceased forthwith. The Acme branch relapsed into quiescence, although the rails were not physically removed from the grade until 1927 when the Carrara spur was built.

About 1920 the old Lila C. branch was rejuvenated — in a manner of speaking. The token annual production of ore from the mine which had been stockpiled on the premises had increased to a quantity which was too large to ignore, and some means of removing the excess needed to be provided. Stopgap but effective results were obtained by the Borax Company through construction of a light, narrow gauge railroad over the old right-of-way from a junction with the Death Valley Railroad at Horton to the Lila C. Light mining railroad rails were used, and a narrow gauge Milwaukee gas engine with P.C.B. Co. markings inched its way over the temporary trackage. Ore cars were loaded at the Lila C. stockpile and hauled to Horton over this "Lila C. Railroad", then the trains continued under informal trackage rights over the DV for the balance of the distance to Death Valley Jct. on the T&T. Official recognition was accorded the line in the T&T Timetable No. 26 of May 13, 1923, in which Rule No. 14 provided that all Lila C. trains were inferior to those of the Death Valley Railroad and to all T&T trains at Death Valley Jct. The rejuvenated Lila C. Railroad lasted but a few years, then was removed. Except for a few memories, a reference in an operating timetable, plus a scattering of small, 3-inch spikes along the right-of-way, there is little to recall the existence of this brief but purposeful operation.

As though to demonstrate its complete versatility in railroading, the Pacific Coast Borax Company built a 2-foot, narrow gauge railroad to serve its new borax mining operation north and east of Shoshone about 1921. To provide accommodations, the T&T installed a siding and an elevated ore bin at a point approximately four miles north of Shoshone designated as Gerstley in official operating timetables. Tracks of the narrow gauge ran to the bin for dumping of ores, while one paralleled the T&T siding at grade to facilitate the transfer of drinking water for the miners from T&T tank cars to a miniature tank car on the little railroad. The main line of the narrow gauge extended three miles eastward to the mine, over which a solitary Milwaukee gasoline locomotive trundled its varying consists compiled from the approximately eight, three-ton ore cars available. The carting of ore from the mine to the bin and the return of the empties to the mine constituted the road's entire operations over the five years of its existence. Service ceased in 1926, although the unused tracks remained in place for a longer period of time before they were finally removed for transfer to the Company's new, open-pit mine at Boron, California (between Barstow and Mojave).

Additional T&T business was proposed in 1921 when a standard-gauge railroad was projected to run from Dumont (at the southern end of the Amargosa Canyon) westward for approximately 16 miles across the desert to some gypsum deposits near Salt Basin in the Avawatz Mountains. Called the Amargosa Valley Railroad by its proponents, the projected road failed to interest the T&T to the point of construction. Although the backers still planned to construct their own independent line, some second thoughts were apparently entertained as the idea ultimately was discarded.

When the Death Valley Railroad was abandoned in 1931, the T&T acquired an additional source of sporadic business. Clay pits to the northeast of Death Valley Jct. had been served by the narrow gauge through the medium of a third rail laid in the T&T's tracks for six miles north to Bradford siding, from which point the narrow gauge's private right-of-way was resumed. With the demise of the narrow gauge, the third rail was removed from the T&T's tracks, and the grade of the narrow gauge from Bradford Siding to the clay pits was widened to support standard-gauge rails. T&T locomotives then serviced the clay pits for whatever traffic pertained.

South of Gold Center along the hillside on the eastern edge of the Amargosa Desert lay the area known as Carrara (q.v.). During the peak years of 1915-16, a sizeable town and marble quarry had existed, suitably served by Senator Clark's LV&T Railroad. The quarry, however, had ceased operations and the town had folded even before the hasty exit of the LV&T from the scene. For years the area lay deserted. Then, during the latter half of the 1920's, quarrying was briefly revived, and transportation for the bulky blocks of marble was required. The T&T, being the only surviving

railroad in the area in 1927 built a short ¾-mile spur from its main line across the valley to the old LV&T grade and siding location, using rails and ties removed from its extinct Acme branch to outfit the line. The revival was short-lived; the quarry was again abandoned; and the branch was torn up in 1932 when it became necessary to replace some worn-out 52-lb. rail on the T&T's main line. Although the tracks of the branch are gone, the paved-over rails of the highway crossing were still evident as late as 1960.

Operating as it did over some 250 miles of desert country railroad, the T&T became a lifeline for the scattered people living in the area. Over the course of the decades, the railroad men and the townspeople came to know each other well, no doubt far better than those along larger railroads of similar circumstance. In talking with people today — whether they be former employees, former patrons, or merely neighbors — thoughts of the T&T bring back many friendly recollections.

Passenger traffic was handled in a somewhat informal manner. In the early days, the fares were high — frequently beyond the cash resources of the prospective traveler. Fortunately most engine crews were sympathetically understanding and would permit a man to ride on the tender for the small payment of 50¢ or $1.00. Later, as this informal business increased in volume, trainmen got into the act, boosting their already higher-than-average take-home pay by permitting the riders to decorate the tops of the cars in Indian style. When the boss came around strict measures were taken, and crews instructed their "passengers" to get off at stations and walk around the platform as though they were prospective patrons. On one occasion Wash Cahill, the superintendent, got off the train first on arrival at Goldfield and observed the car roofs covered with people. To the trainmen's relief, his only comment was that "no wonder no one was inside the train, they were scattered all over the outside!"

Not always did crews welcome passengers, even those with full fares. During one strike of the operating men, it was agreed that the mail train would be allowed to operate — provided it carried no passengers. However, at train time a smooth-talking salesman, sporting a top hat, could not be convinced and tried to inveigle his way aboard. The gesture was useless — the trainmen would not let him on. Doing a quick double-take, the salesman made a hurried trip to the post office and pastered his top hat with stamps; then demanded

that he be allowed to go out with the other U. S. Mail. Still the crew kept him arguing until train time; whereupon a stone found its target and the top hat was observed rolling rapidly down the station platform. While the salesman scampered after his evidence of postage paid, the train rapidly left town.

The care and feeding of passengers at that time (even as today) presented its problems. During the first few years of the road's operations (to 1910) a diner was provided on the through trains, but as the volume of passenger traffic rapidly dwindled to a thin trickle, the diner was dropped and an eating house was established at Shoshone. "Dad" Fairbanks came down from Greenwater to take charge of this pioneer operation, and having pioneered at most everything else in the territory it was not considered unusual that the project should succeed. For Fairbanks' career had started with the freighting of construction supplies for the building of that portion of the original SP, LA&SL between Caliente (near Pioche) to Las Vegas. When the Salt Lake Route was opened for traffic, Fairbanks moved his teams over to the Las Vegas-Beatty run, and it was he who established the original tent city at Ash Meadows. Aside from tents for hotels and residences, there were a tent restaurant and a ten saloon. It was the memory of the ten saloon which stuck most forcibly in the minds of some of Fairbanks' eight children, not by reason of the nature of its dispensations, but more the nature of its habitues. For they still remember Tiger Lil emerge and smile, a subject of intense curiosity, as Tiger Lil was also known as Diamond Tooth Lil (she later ran a sporting house in Greenwater), and no such elegant "lady" ever visited a saloon in those days — at least not in Ash Meadows!

The Shoshone eatery prospered and grew, becoming the center of interest for people in that area. In 1919 "Dad" Fairbanks retired from the picture and turned the operation over to his daughter and son-in-law, Mr. and Mrs. Charles Brown. Success continued to crown their efforts, and gradually the station expanded into an important settlement with a store (the original building was moved from Zabriskie in 1921), a restaurant and two motels. Charles Brown increased in stature as well, becoming for a number of years the representative in the California Senate from Inyo, Mono and Alpine Counties.

March 1926 was the month of the big excitement, for the T&T was called upon to operate per-

haps the largest passenger train in its history. This was the "Julian Special," a 15-car, double-header, hired by C. C. Julian, the famed Southern California oil promoter, in an effort to talk people out of thousands of dollars for a new lead development not far from Beatty. The prospective investors were taken to see the location of the newly projected flourishing camp of Leadfield, and those who left their money behind saw it vanish in the desert air. For one year later there was no camp and there were no mines — just a few empty houses in a narrow canyon. Leadfield's post office was closed December 31, 1926 probably establishing a record for the shortest life span of a "permanent" post office — it had been opened only the previous June 25th.

In 1927-28 the big shift started that represented the beginning of the end for the T&T. Borax mining in the Death Valley area was coming to a close as the mines were becoming exhausted. The Pacific Coast Borax Company years before had located large new deposits at Boron, in the Mojave Desert area of California between Barstow and Mojave, and as the new property was developed the older mines were scavenged of their equipment and facilities. The Death Valley Railroad was the first to take the full brunt of the move. Because virtually all of its traffic was obtained from the mine at

	NORTHWARD				DISTANCE FROM LUDLOW	**Time Table No. 62**	DISTANCE FROM BEATTY	SOUTHWARD					CAR CAPACITY OF SIDING
	SECOND CLASS		FIRST CLASS			December 27, 1939		FIRST CLASS			SECOND CLASS		
	25 MIXED	11 MOTOR	9 MOTOR	7 MOTOR				6 MOTOR	8 MOTOR	10 MOTOR	24 MIXED	26 MIXED	
	LEAVE Fridays Only	LEAVE Sundays Only	LEAVE Wednesday Only	LEAVE Tuesdays Only		STATIONS		ARRIVE Mondays Only	ARRIVE Tuesdays Only	ARRIVE Wed. and Sat. Only	ARRIVE Thursdays Only	ARRIVE Fridays Only	
Y					0.	LUDLOW	169.07						
					12.53	—12.53— BROADWELL	156.54						
					21.08	—8.55— MESQUITE	147.99						
	A.M. 4.45	A.M. 4.30	P.M. 2.55	A.M. 4.45	25.68	—4.60— Union Pacific Crossing CRUCERO N	143.39	P.M. 1.40		P.M. 2.14	P.M. 1.40		Yard
	f 4.57	f 4.40	f 3.05	f 4.57	29.40	—3.72— RASOR	139.67	f 1.20		f 2.04	f 1.20		24
	f 5.06	f 4.47	f 3.12	f 5.06	33.34	—3.94— SODA	135.73	f 1.05		f 1.54	f 1.05		8 Spur
	s 5.30	s 5.04	s 3.29	s 5.30	41.82	—8.48— BAKER	127.25	s12.40		s 1.34	s12.40		20
S	s 6.00	s 5.20	s 3.45	s 6.00	50.03	—8.21— SILVER LAKE D	119.04	s12.10 P.M.		s 1.19	s12.10 P.M.		24
	f 6.30	f 5.38	f 4.03	f 6.30	59.47	—9.44— RIGGS	109.60	f11.39 A.M.		f12.59	f11.39 A.M.		22
	f 6.47	f 5.49	f 4.14	f 6.47	65.11	—5.64— VALJEAN	103.96	f11.23		f12.48	f11.23		6 Spur
	f 7.09	f 6.07	f 4.32	f 7.09	74.40	—9.29— DUMONT	94.67	f10.59		f12.29	f10.59		25
	f 7.21	f 6.17	f 4.42	f 7.21	78.84	—4.44— SPERRY	90.23	f10.44		f12.20	f10.44		24
	f 7.41	f 6.29	f 4.54	f 7.41	82.97	—4.13— ACME	86.10	f10.30		f12.08 P.M.	f10.30		Yard
	s 8.03	s 6.41	s 5.06	s 8.03	87.67	—4.70— TECOPA	81.40	s10.16		s11.57 A.M.	s10.16		24
	f 8.20	f 6.49	f 5.14	f 8.20	91.74	—4.07— ZABRISKIE	77.33	f 9.57		f11.49	f 9.57		40
	s 8.37	s 7.02	s 5.27	s 8.37	96.95	—5.21— SHOSHONE D	72.12	s 9.45		s11.40	s 9.45		Yard
	f 8.52	f 7.11	f 5.36	f 8.52	101.26	—4.31— GERSTLEY	67.81	f 9.29		f11.30	f 9.29		15
	f 9.12	f 7.27	f 5.52	f 9.12	109.62	—8.36— EVELYN	59.45	f 9.12		f11.16	f 9.12		28
Y S	9.45 10.30	7.50 A.M.	6.15 P.M.	9.45 10.30	122.23	—12.61— DEATH VALLEY JCT. N	46.84	8.45 A.M.	P.M. 1.55	10.55 A.M.	8.45 A.M.	P.M. 3.05	Yard
	f 10.43			f 10.40	128.01	—5.78— BRADFORD	41.06		1.45			2.52	24
	f 11.00			f 10.52	133.96	—5.95— SCRANTON	35.11		1.34			f 2.40	20
	f 11.17			f 11.03	139.44	—5.48— JENIFER	29.63		1.24			f 2.23	3 Spur
	f 11.32			f 11.12	144.51	—5.07— LEELAND	24.56		1.15			f 2.07	25
	f11.53 A.M.			f 11.32	154.98	—10.47— ASHTON	14.09		12.56			f 1.45	25
	f12.10 P.M.			f11.43 A.M.	160.55	—5.57— CARRARA	8.52		12.45			f 1.33	Yard
Y	12.30 P.M.			12.01 P.M.	169.07	—8.52— BEATTY D	0		12.30 P.M.			1.15 P.M.	Yard
	ARRIVE Fridays Only	ARRIVE Sundays Only	ARRIVE Wednesday Only	ARRIVE Tuesdays Only				LEAVE Mondays Only	LEAVE Tuesdays Only	LEAVE Wed. and Sat. Only	LEAVE Thursdays Only	LEAVE Fridays Only	
	18.5	29.0	29.0	19.7		Average Miles Per Hour		29.1	33.2	29.1	18.3	25.6	
	7.45	3.20	3.20	7.16		Time Over District		3.19	1.25	3.19	4.55	1.50	

D. Day Telegraph Station.
N. Day and Night Telegraph Station.

The signboard still bore the legend, "Goldfield, 78 miles; Ludlow, 169 miles," when this picture of the Beatty station *(top)* was taken in June 1941. Actually, BG rails from there to Goldfield had been removed 13 years previously. Operations over the T&T had been totally suspended the year before and rails were removed the following year. *(Guy L. Dunscomb photo.)*

Nostalgic mementos of an era long gone are the section crew's hand pumper *(left, center)* and the T&T's "Emergency Car" *(below)*. With brass, acetylene headlamps up front, carriage lights at the dash and marker lamps to the rear, this Acme Auto touring car with monster two-panel windshield, right-hand drive, outboard gearshift, French horn, flared fenders and chain drive was an ideal way to see the line. The driver appears to be enjoying a conversation with Mrs. Gower, while T&T Supt. W. W. Cahill rides in official dignity to the rear. *(Center: R. P. Middlebrook photo; bottom: H. P. Gower photo.)*

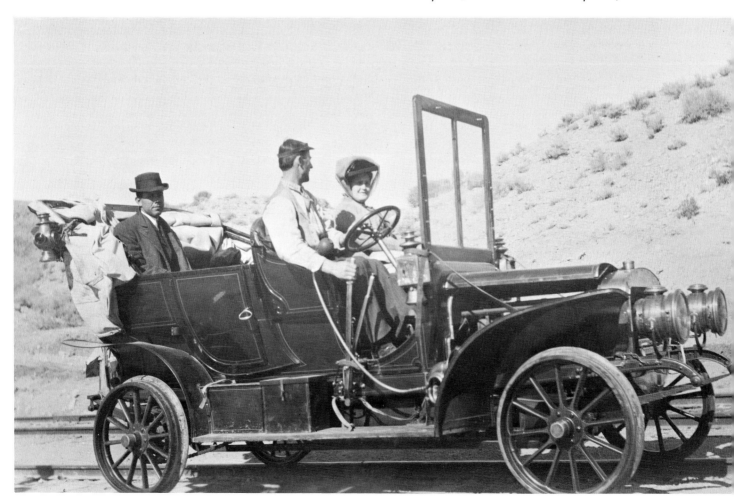

Ryan for haulage to the junction with a trickle of supplies going in the reverse direction, the road came to a standstill when the mine ceased production. Efforts were made to develop a winter tourist resort in the area, but after a few years defeat was acknowledged and in 1931 the DV Railroad closed down for good.

On the heels of the closing of the Ryan mine, the Bullfrog Goldfield Railroad gave up the ghost in January 1928. Because a large share of that road's interline business left the area northbound over the Tonopah & Goldfield Railroad, the loss to the T&T was not quite so severe. Still it was a sad day when the last T&T trains operated — northbound to Goldfield on January 6 and southbound to Beatty on January 7.

There was not very much passenger business at best, and as mining activity declined, the traffic in humans followed the same downward pattern. During the late 1920's Pullman service from Los Angeles to Beatty was operated on a tri-weekly basis in conjunction with the Santa Fe; by 1930 there was only one train a week which went up on Thursdays and returned on Saturdays.

The depression of the early 1930's certainly did not improve matters for the T&T. Still it struggled on in the hope that something might develop. Almost every year the management would be on the verge of filing a petition for abandonment when someone would rush into the office with a story of a big development which would involve the movement of millions of tons of ore. As each such prospect failed to materialize and faded into oblivion, another would appear on the horizon and the process would repeat itself all over again.

Finally, in an economy move, the 25.68-mile section of line between Ludlow (on the Santa Fe) and Crucero (on the Salt Lake Route) was abandoned. The long feud with the SP, LA&SL had become a thing of the past with the demise of the LV&T, and economy at whatever the cost was most paramount. The shops at Ludlow were picked up and moved to Death Valley Junction, and on October 8, 1933 operations between Ludlow and Crucero ceased. The tracks were allowed to remain in place to meet the mortgage requirements and were ready for operation should the necessity arise. It never did.

Traffic during the 1930's was sparse indeed. Local tonnage consisted of small amounts of ore shipped sporadically from Beatty, a short-haul movement of clay from Bradford Spur to the Pacific Coast Borax Co. roaster at Death Valley Junction, some

quantities of bentonite originating at Muck Siding (not far from Bradford), plus varying movements of talc originating at Tecopa and Acme. In satisfaction of the human element of desert existence, occasional drinking water was hauled from Rasor to the 58 people living in Baker which had several gasoline stations and a hotel.

In the six years from 1933 to 1938 the T&T reported revenues ranging from $76,000 to $124,000 (as contrasted with the $600,000 taken in in 1920), while expenses always exceeded (and in some years were almost double) that meager income. Net losses, after interest, were approximately a quarter of a million dollars annually. It was the amount, not the frequency, of the losses that was staggering, for the record shows that the number of profitable years in the road's 33-year history could be counted on one hand.

Borax Consolidated was still picking up the tab. Even after the borax operations were discontinued at Ryan and the move completed to Boron, that company was still fulfilling its obligations as guarantor of the railroad's bonds and paying the interest. In later years it shouldered the additional burden of making up the operating deficits, so that by the end of 1938 over $5,000,000 had been paid out to keep the T&T an operating railroad. Still ahead was the obligation for repayment of the principal of the bonds due in 1960 and totaling $3,285,344 plus the continuing annual interest.

Flood damage in March 1938 brought matters to a head. In December an application was filed with the I. C. C. to cease operations. In accordance with the terms of the mortgage indenture, it was proposed that the track be left in place and that the equipment be maintained in good order so that operations could be resumed should conditions warrant. The implied expenditure was nowhere near as great as might be assumed, for the entire 1939 roster of T&T equipment listed only four locomotives, one motor car, 29 freight cars and four passenger cars, none of which were used in interchange. Service was provided from Crucero by a weekly motor during the summer months (tri-weekly during the winter), usually running only as far as Death Valley Junction. Twice a week a mixed train ran all the way through to Beatty.

Protests to the application were heard, largely from the talc miners who contended that truck hauls would add substantially to their costs. The California Railroad Commission made a suggestion that the Union Pacific (Salt Lake Route) take the road over and operate it, but the UP considered

Dismemberment of the T&T was sporadic, pieces being scattered to the four winds. At top T&T locomotives Nos. 9 and 10 "went to sea" on the Sacramento Northern's train ferry RAMON near Pittsburg, California, in February 1947 enroute to a date with the torch at Oakland. The shops and yards at Ludlow (center) were dismantled, sold or scrapped. Motor Car No. 99 (bottom) became a pay and supply car on the Sonora-Baja California Railroad in Mexico. (Top: Ted Wurm Collection; center: D. A. Painter; bottom: Roy B. Miller Collection.)

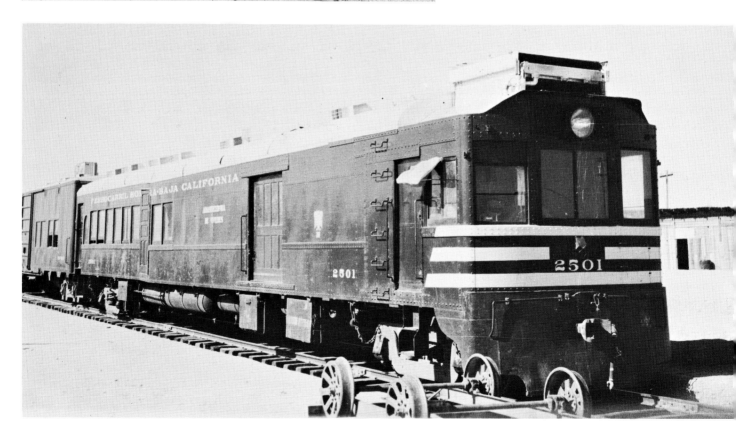

the matter impractical. Ultimately abandonment was authorized, to become effective December 31, 1939. Before the order could be executed, a postponement of the effective date to April 1 (later April 15, 1940) was obtained on the basis that truck transportation could not be arranged in time.

On April 1 a new delay was imposed. Two individuals were allowed to intervene on behalf of the employees and residents along the line, and the case was reopened. Technical objections to the previous hearing were considered and were found to be without merit. Alleged new evidence failed to materialize, so the Commission reaffirmed its previous order. A month later, on June 14, 1940, all operations over the railroad ceased.

As proposed, the track and equipment were placed under maintenance. Harry Rosenberg, the last roadmaster, made regular inspection trips over the line on a gasoline speeder. But World War II was looming on the horizon, and within two years the War Department had requisitioned the line. On July 18, 1942, contractors Sharp and Fellows began tearing up the rails at Beatty and, working southward, the job was completed all the way to Ludlow by July 25, 1943. Of the residue, a quantity of bridge timbers ended up as part of the Apple Valley Inn at Apple Valley, while the ties became scattered all over, a large number being used in the building of the El Rancho Motel in Barstow. Two of the locomotives went to the Kaiser Steel Plant at Fontana, California, while a third went to the San Bernardino Air Base.

In spite of the railroad's requisition by the War Department, the property had never been legally abandoned. Consequently the matter was brought up before the I. C. C. in 1946, and on December 3 of that year authorization was granted. Like the proverbial cart before the horse, the T&T mistakenly had started to build without expressed authorization for a railroad connection with the Salt Lake Route, and it died without expressed authorization for its abandonment. The only real satisfaction should have been that of Borax Smith, for the T&T outlasted its rival (Clark's LV&T) by a span of over 20 years. But Borax Smith, unfortunately, did not live long enough to see the full justification of his dreams.

A highway parallels the old T&T right-of-way today, and the prominent grade with a scattering of ties is easily followed. Talk with the natives, and you will find that people remember the railroad with nostalgia; a number of its former employees still live in the area.

Tecopa Railroad Company

Resting Springs was the euphoniously titled location, first noted by Frémont in 1844, which served as a stopping place for Mormons bound from Utah to San Bernardino, California, via the Old Spanish Trail. The earliest mining in the area took place approximately a century ago when the Gunsight mine was first worked in 1865. Over the ensuing 15 years production improved sufficiently so as to warrant J. B. Osborne's efforts in erecting and operating a 10-stamp mill and three water-jacket furnaces a few years prior to 1882. Around this time also, for reasons undiscovered, the area was given the name of a friendly Piute Indian Chief, Tecopa — a name that has survived to the present day.

But little is known about the district over the intervening years to the early 1900's. There were no settlements to speak of, there were no newspapers, and but little information is recorded specifically. Apparently the early boom subsided, and for a time the district remained quiet as Osborne's production at the Gunsight mine was of modest proportion and did not attract much outside attention.

At just what point the renaissance began is difficult to determine. It is certain that by 1907, when "All of Nevada is Digging Treasure," the optimism had already spread to California and the Tecopa region in particular. It was in May 1907 that the Tonopah & Tidewater Railroad finally reached Tecopa station following a full year of efforts at trying to penetrate the difficult Amargosa River Canyon, and by then machinery was being installed at the Gunsight mine as well as at the Noonday, a little farther to the south. Both mines were owned by the Tecopa Consolidated Mining Co. at that time, and apparently the prospects were most gratifying. Two men reportedly took out so much ore in three days that the manager was obliged to stop them until teams could be located with which to haul the ore to the new railroad. Publicity given out in Rhyolite stated that the company would ship a solid 30-car train of ore valued at $38 to $40 a ton. A railroad spur direct to the mines was being planned, but construction was postponed indefinitely.

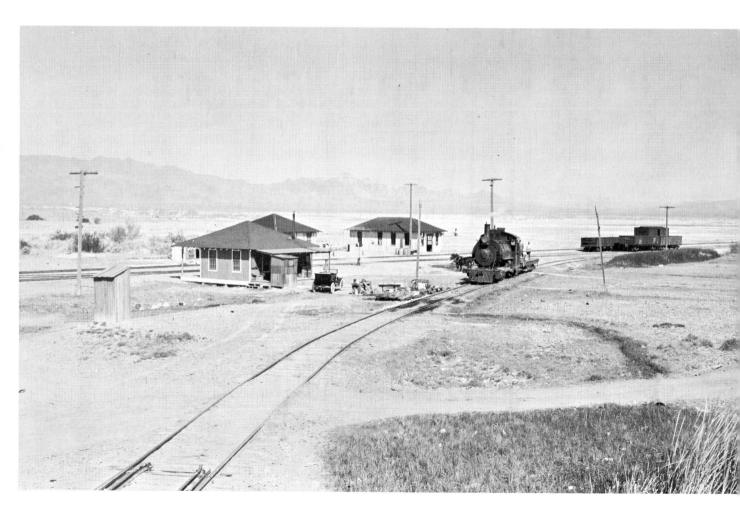

The Noonday Mine *(top, left)* was the primary objective of the 9½-mile Tecopa Railroad; in 1957 the grade was still visible at the loading bins and tramway on the hillside. Above the tunnel of this typical mine *(left)* in the "stope," an area where the vein has been removed. Sturdy timbers have been installed to hold up loose portions of the roof for the protection of the miners. Connection was made with the Tonopah & Tidewater at Tecopa *(bottom, left)* where (house nearest camera) fireman and photographer Frank Green resided. Behind it and across the tracks is the T&T agent's residence with the station building standing in the clear to its right. The Tecopa's tank locomotive No. 1 was actually the second locomotive on the line but adapted itself better to the heavy grade near the upper end of the line. *(Top right: Sewell Thomas photo; bottom, left and right: Hendrick Collection.)*

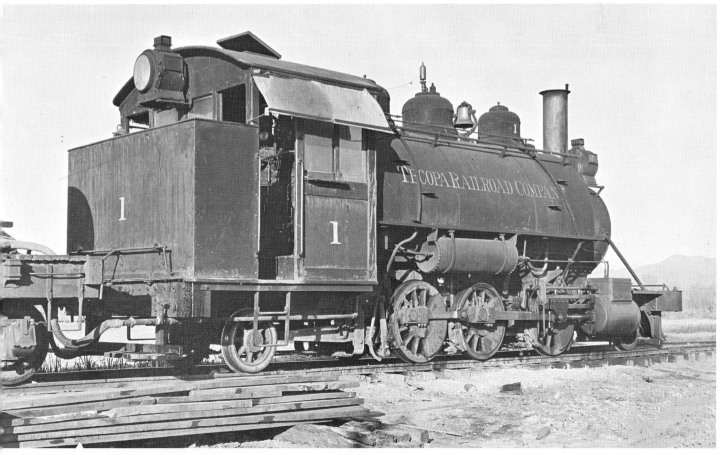

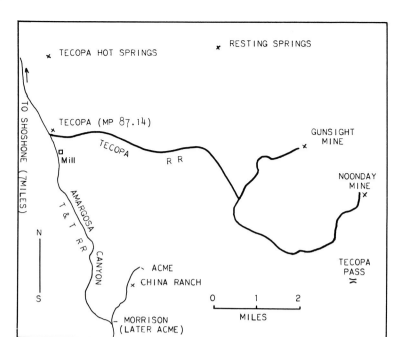

The subject of the spur track was brought up again in November 1907 when John Brock, an early president of the Tonopah & Goldfield Railroad, bought into the mines, but again the project was shelved. At the annual stockholders' meeting in January 1908 the Company reported that their mines were shut down due to the closing of the Utah smelters. That this was not the reason for the lack of railroad construction was evident from the Company's further comment that negotiations were being conducted for the acquisition of some Best traction engines and an aerial tramway.

In April 1908 the mines were reopened and production resumed. Another year passed by before, in May 1909, the Tecopa Railroad Company was finally incorporated in California (for some unexplained reason it was also incorporated in New Jersey a mere six months later). In July the company released an announcement that construction would begin, and in October 1909 the work finally got under way with Supt. Ellis in charge of 80 men and 115 mules.

The Tecopa Railroad was to be of standard gauge, privately owned and operated, and the main line would be approximately 9½ miles long running from Tecopa to the Noonday Mine. A two-mile branch would serve the Gunsight Mine. Grades would be steep — the last two miles of main line to the Noonday climbed nearly 700 feet of elevation (an average grade of 6.6%) while one stretch of railroad was claimed to be on a 13% grade.

Early in 1910 the railroad was ready and in good operating order. Equipment consisted of one "ancient but regular" steam engine (later replaced by a saddle-tank locomotive) plus six or eight ore cars. Assuming that two loaded ore cars comprised the maximum train to be handled down the steep grades at any one time, the little locomotive probably made two round trips per day to handle the 116 carloads of ore recorded as shipped during June 1910. Then something happened: everyone was amazed when the mine suddenly closed down in August, not the least of whom were the investors. Tecopa had become "one of the bitterest of pills which local mining investors have swallowed in the past couple of years."

Dr. L. D. Godshall was hired in January 1911 by the Tecopa Consolidated Mining Co. to manage its property. He had obtained his mining degree at Lafayette College (during which time he established a world pole-vault record which remained unbeaten for 13 full years), and since 1904 had been operating the Needles smelter of the Arizona-Mexican Mining and Smelting Co. Under his ministrations the Tecopa property began to improve. From 1913 to 1918 the mines did quite well, turning out one or two cars of ore every day, consisting primarily of lead and silver with a little gold blended in. The ore went down the hill over the subsidiary Tecopa Railroad to a concentration mill at the south end of Tecopa, while ores with higher values continued on out over the T&T to the smelter at Murray, Utah.

As with any mountainous railroad, operations were not always placid. Runaways, though infrequent, were not uncommon, and several men were killed at one time or another. It is the recollection of one (possibly prejudiced) individual that the Tecopa Railroad locomotive was usually on its side, undoubtedly a contributory factor in the conversion to truck haulage in later years. Until that time, the railroad had a bit of a personnel problem in obtaining employees, let alone keeping them once they were on the job. An outstanding example was a man named Despain who hired on as engineer on July 11, 1913. During his interview with Supt. Gottschalk, he firmly stated he could manage the engine, although it developed that he had had but little experience. Once out on the Noonday grade, he lost control of the locomotive and asked the fireman what to do. "Jump," said the fireman, who did so himself to the accompaniment of a broken ankle. The engineer dallied too long and was forced to stick with the locomotive which jumped the rails on the first curve, rolled over three times, and killed him instantly.

After 1918 production at both mines dwindled, by 1922 they were virtually closed, and remained dormant for the next decade. During the depths of the depression in 1933, many of the mines in the area were being sold at tax sales, and Dr. Godshall (then known as a regular weekly patron of the T&T sleeper) purchased the mine and the railroad for $10,000. The rails were taken up for scrap about 1938 (possibly not until 1942 when the T&T rails were pulled), and still later the mine was sold, eventually winding up as another property of the Anaconda Copper Mining Company.

Greenwater

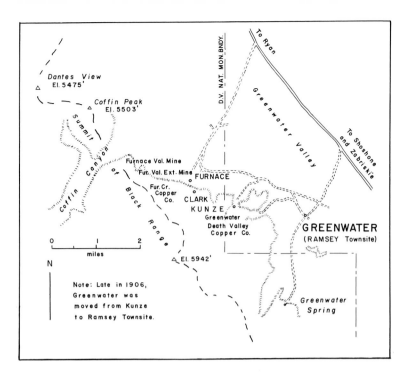

Greenwater *might* have become a great copper development — *if* all the statements and claims of promoters and stock brokers had been true.

In actuality, the values of initial discoveries in the area were fantastic. Some ores assayed up to 18% copper; even more normal run-of-the-mill assays indicated a moderately high 3-4% copper — and right at the surface, too. In fact, the last mentioned detail was the primary factor in the ultimate undoing of Greenwater.

The more modern discoveries which led to the boom commenced in 1904. Within two years nationally known and wealthy men had made substantial investments in various properties. The list of names read like a *Who's Who* of money and industry — Charlie Schwab (Carnegie Steel), John Hays Hammond (renowned mining engineer), John Brock and his associates (Tonopah Mining Co. and the T&G Railroad), Senator William A. Clark and F. Augustus Heinze (copper millionaires from Montana), Tasked Oddie (attorney and associate of Jim Butler at the Mizpah Mine in Tonopah) and Patrick "Patsy" Clark (another successful copper mining man from Spokane, Washington). With the boom coming as it did at the time of great, general excitement generated by such neighboring camps as Tonopah, Goldfield and Rhyolite, it was easy for the public to be duped into believing that wealth could be contagious and that one's few dollars could magically be transformed into a fortune if invested in the same or adjoining mining properties in which these influential men had placed their bets.

With such an impressive list of names of men investing in Greenwater, the logical thing for the public to do was to join in the bonanza. That they did, plunging heavily into the wide-open arms of the mining promoters. The situation was made to order for unscrupulous mining men, and many of that ilk eagerly grasped at the opportunity. The legitimate copper prospects were in sufficient number to lend credence to the seductive literature disseminated by these shysters, and hundreds of thousands of dollars were lured from the pockets of the gullible and greedy public. The procedure was simple in the extreme — find a claim (most any old claim would do), incorporate a company, then promote the stock. With some 2,500 claims located in an area three miles wide and 20 miles long, the problem of selection was not difficult. The payment of a few insignificant fees in proper places was all that was required to incorporate a company, making the selection of the name the most important item on that agenda. The company's title should be one to inspire confidence and exude affluence, factors attained in many instances by using adaptations of the names of the better known and more respected companies already operating in the area. Pièce de résistance of the whole program was the proper development of tantalizing promotional material. To generate confidence, the future of Greenwater inevitably was likened to that of the copper kingdom of Butte, Montana, while the property under discussion never failed to be located near, or even adjoining, that of a Schwab, or a Patsy Clark, or some other person of influence and prestige. The final

clincher of the carefully contrived sales pitch was the appeal to snobbishness and greed — surely, with such wealthy and upstanding neighbors as were just previously outlined, success and prosperity were certain to attend an investment in this outstanding company.

From a practical standpoint, a more desolate spot than Greenwater could hardly have been found for the location of a mine or a town. To the west the Black Mountains rose abruptly in a towering wall from the floor of Death Valley to elevations ranging from 4,500 to 5,800 feet. Extending eastward from their crest for approximately two miles was a relatively gentle slope which eased down to the upper reaches of Furnace Creek Wash, along the east flank of which lay the rugged Greenwater Range of hills. The Biddy McCarty and the (new) Ryan borax mines were located on the northwest slope of this range overlooking the wash, while on the far side (over the crest to the east) the sister Lida C. mine was being worked.

Near the crest of the Black Mountains to the west, was Greenwater Springs. Its name was derived from the greenish tint of the water as observed by the early prospectors who had been attracted to the area by findings of gold and silver as early as 1884. Ten years later others visited the location, but it was not until 1898 that H. G. Betts discovered the first copper showings in the valley. Following the rule that every good Nevada prospector must have a nickname, fellow members of the profession tagged Betts with the somewhat dubious moniker of "Stingy Bill." The derivation of the peculiar name has been lost in obscurity but, to all accounts, Betts actions belied his new title.

In that remote day and age, transportation was virtually an unknown luxury. The nearest railroad, the narrow-gauge Carson & Colorado, only reached to within 130 miles of Greenwater, and at that it stopped at Keeler in the Owens Valley to the west, leaving two mountain ranges, Death Valley and Panamint Valley to be crossed to reach it. The isolation, the vast distances, and the lack of interest in copper development in remote reaches caused Betts to discard the idea of working his find. Later, however, when Greenwater finally did boom, he went back, perfected his claims, then sold them for cash and stock in a mining company. Theoretically he had realized a successful culmination to his efforts; practically, however, he had been unwittingly duped by a well-known swindler, Dr. J. Grant Lyman, the stock of whose company he had received.

The basic sparks of Greenwater's big boom were ignited in 1904, about the time the Tonopah Railroad was rapidly stretching its ties south from a connection with the Carson & Colorado toward Tonopah, and the new camp of Goldfield was about to blossom as "the greatest gold camp ever known." In Tonopah, Arthur Kunze had become so thoroughly imbued with the pioneering spirit, as demonstrated by the many strikes and occasional bonanzas discovered, that he sent two prospectors out into the remote country to search for wealth. The effort was successful. On May 22, 1904, the men found traces of copper near Greenwater Spring, staked their claims and returned to report the good news.

On December 13 of the same year two other men, Phil Creasor and Fred Birney set out from Goldfield to try their luck in unchartered regions. Heading south to Ash Meadows, they came across an Indian named Bob Black who was able to tell them of an area to the west which had never before been penetrated by white men. Perhaps Birney (who later related the story) did not fully comprehend Indian Bob Black's very limited English vocabulary, or perhaps the Indian was uninformed, but white men actually had been to Greenwater Valley a number of times before. It was hardly necessary to recheck the Indian's statement, however, and certainly it would have been most unwise, for two days later Indian Bob Black was reported to have murdered his squaw, her brother and two other white men.

Instead, the two men headed for the "unexplored" region, taking with them four large burros, each carrying 160 pounds of water plus other supplies. After working their way slowly along the dry valleys and rationing their water (two gallons daily per burro), Birney finally noticed some tiny pieces of copper stained ore which had been brought down the slope by cloudbursts. Leaving his partner to follow with the burros, he traced the float up a dry wash, becoming more excited with each mile traversed, for the colored stones became larger and larger. Suddenly, after five or six miles of tracking, the colored stones stopped — there were no more.

More steps took Birney over a small hogback and down into a little draw. Suddenly there it was — a beautiful ledge of copper ore! Hastening back to get his partner, Birney with the help of Creasor staked out six claims, then the two men set out on the long trek across Death Valley to record their claims in Keeler. Believing that this

was the first discovery of copper at Greenwater, the partners lingered in Keeler for several days enjoying such pleasures of civilization as were available, then they sauntered back to locate 16 additional claims. Apparently they were so engrossed in their own discoveries they were completely unaware of the location monuments which Kuntz's men had made just over the hill.

Patsy Clark of Spokane, Washington, was always interested in new copper deposits. Consequently, when Birney and Creasor forwarded samples of their newly found ore with the inquiry: "Would he be interested?", Clark promptly dispatched his brother and another man to examine the claims. Deciding upon a southern approach to the district, the two men journeyed to Daggett, California, (near Calico) before venturing out upon the desert. Their first expedition never reached its objective as the entire outfit was lost in a desert cloudburst. Their second attempt was even more frustrating when, in spite of the long trek, they failed to find the location of the claims due to the inaccuracies of Birney's rough map. Following the second defeat, the two men decided to let the entire matter drop, and they returned to their former pursuits.

With no practical means of quick communication, Birney and Creasor were left in the dark as to what had transpired. Thinking that Clark had lost interest, the partners decided to do some development work of their own. It was a fortunate decision, for it placed the men on their property the day the sovereignty of their claims was challenged, and a quick grasp of firearms protected their interests. The following eyewitness account was related by Birney some time after the encounter!

"One day when my partner had gone out for mail and I was left alone in the camp, three adventurers came upon the ground and declared their purpose to stake some of it. They undoubtedly thought in this way when the surveys were made some fractions would be revealed and they would get them. But I was determined to prevent any clouding of our well-earned title. We had worked three months in that terrible desert and I felt that we were entitled to all we had discovered.

"The men had laid down their arms preparatory to staking a claim, and I was desperate enough to grab my revolver, get a drop on them and tell them I would die right there rather than let them steal our property. That evidently took them by surprise, and they promptly acquiesced in the justice of my position. I then told them I had no objection to telling them where they could stake some ground that might be available. I guided them to a point five or six miles away which afterward was found to be quite valuable."

Following a hunch that Patsy Clark, in spite of his silence, might still be interested, partners Birney and Creasor wrote him again. This time Clark took no chances. Personally leaving Spokane, Washington, he journeyed to Rhyolite to direct an examination of the prospects, particularly the Copper Blue Claim. A deal was made, and the Furnace Creek Copper Company, formed in June 1905, was soon to start development of the property.

In the meantime, neighbor Arthur Kunze had not been idle. With the backing of John Salsberry, he had organized the Greenwater Copper Company and was developing his claims which were located in a narrow little canyon at a camp colloquially known as Kunze but which, to the world at large, was Greenwater. The man behind the throne, John Salsberry, was an early mining figure in Tonopah, a heavy investor in the Bullfrog District, and head of the Tonopah Lumber Company. He was occasionally referred to as "the copper king of Nevada," although several of his copper mine promotions were located in California, first at Greenwater and later at Ubehebe (see Bonnie Claire and Ubehebe).

In June 1906 Charles Schwab, the wonder boy of steel, sent agents Donald Gillis and Malcolm Macdonald to Greenwater to look at the claims of Kunze, Salsberry and others. Schwab was so favorably impressed with Gillis' report, so the story goes, that he gave Gillis carte blanche to draw on him for required funds in any amount. The properties definitely looked good enough to purchase, so another sale was placed on record, title being vested in the Greenwater and Death Valley Copper Company, generally referred to in promotional material as the "Schwab Company." Development work began in September 1906.

The promotional boom was under way. Several townsites had been platted—Ramsey, Kunze, Clark, and later Furnace. Wonderful reports of rich copper deposits were broadcast far and wide in the most glowing terms, the sales material being liberally sprinkled with the names of the wealthy and the influential who had already invested. People began to pour into the area, and there was room for them all — speculators, promoters, prostitutes and the general riffraff normally associated with new, young, high-pitched mining camps. There were serious miners, too, perhaps as many as sev-

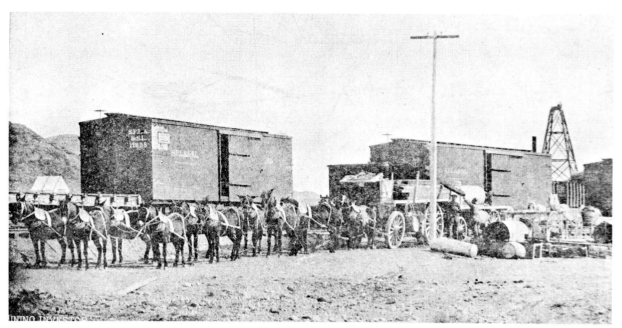

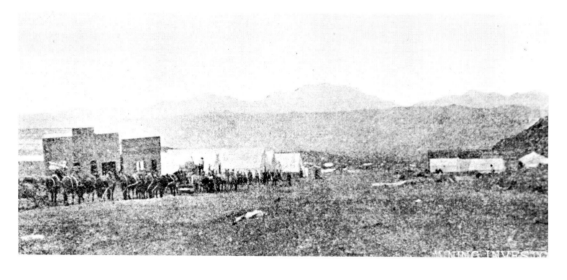

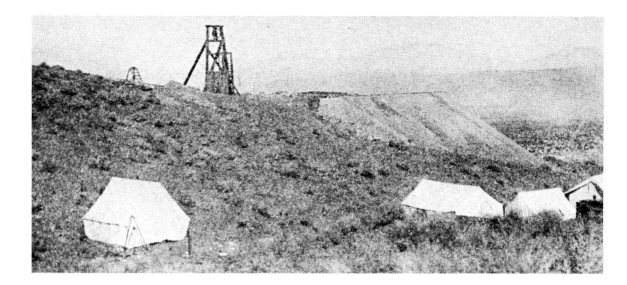

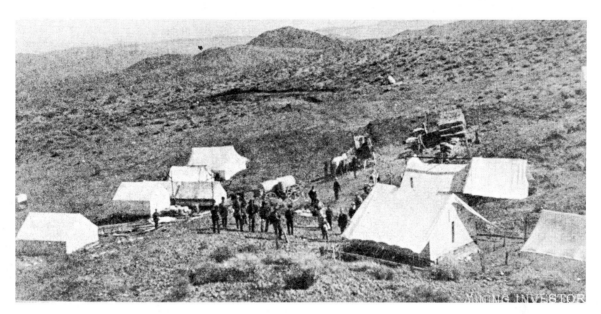

Because Greenwater's boom lasted less than a year, actual photos of this mining camp are virtually non-existent. The views presented here have been culled from ancient copies of the *Mining Investor* and show *(top, right)* the loading of chattels and supplies from railroad cars at the LV&T station of Amargosa preparatory to the long trek to Greenwater. The lumber on the wagon will bring a terrific price at camp *(center, left)* where Greenwater's Main Street (90 feet wide) is lined with canvas tents and only two false fronts. For those who wished to venture to prospective mines, auto transportation was available, but at high prices; such service was somewhat dominated by W. F.

"Alkali Bill" Brong and his $100-a-day chauffeured automobile *(bottom, left)* A pioneer and one of the more exploited properties at Greenwater was the Copper Blue Shaft *(above, top)* of the Furnace Creek Copper Company whose camp *(above, center)* was luxurious compared with others in the vicinity, such as that of the Pittsburg and Greenwater Copper Company, located several miles south of Greenwater *(below).* Greenwater today is represented by a lonely highway marker plus a few rusting tin cans. *(All except center insert: Western Historical Collection, University of Colorado Library.)*

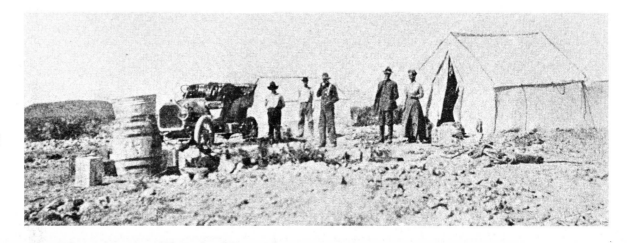

eral hundred, who were employed by the major companies to dig shafts and drifts in an effort to locate the extensive ore bodies which surface indications led many to believe existed below the ground.

All arteries of travel, however far removed, were crowded to overcapacity with the influx of people to Greenwater's remote location. The best and quickest route from the nearest point of civilization was via Las Vegas, Nevada, and the newly laid rails of the LV&T to Johnnie station. From that point, if you were fortunate enough to obtain space on the stage, it was only a jolting 46-mile ride to Kunze which was then the central camp of Greenwater. Kimball's six-mule stages left Johnnie late in the afternoon for a short 12-mile jog over the desert to Dad Fairbanks' comfortable ranch at Ash Meadows or to Longstreet's, a mile and a half farther on, where passengers spent the night. Some of the desert was crossed in the relative coolness of early morning before the Lila C. borax mine was passed (two miles to the south) as the stage started its lumbering climb up Dead Horse Canyon (later the approximate route of the Death Valley Railroad). Once over the crest and part way down the wash, a swing to the left headed the traveler south up the final climb to Greenwater Valley.

The next closest route was via the T&T from Ludlow, California. The railroad was then completed to a point about 70 miles south of Greenwater, but travelers were warned that they might be obliged to wait for days at the railhead before finding a conveyance to take them over the last short leg of the trip. There were no regular auto or connecting stages and, as one scribe wrote: "A friendly automobile might happen along, however, which might land him in Greenwater for from $100 to $200." Lest those rates seem unreasonable for a 70-mile ride to the voyager of today, it might be pointed out that W. F. Brong charged a flat $100-per-day fee for the use of his car, including his services as chauffeur. Many people thought the excitement of his auto ride, whizzing over the dry lake beds at 50 miles per hour, was well worth the price, and their experiences earned for Brong the title of "Alkalai Bill."

A full-fledged railroad directly into Greenwater undoubtedly was of urgent necessity, and railroad talk was prevalent in the early fall of 1906. Looking to the future when steam trains would be working up the slope to the camps, the more stalwart citizens of the area decided that Kunze, situated in its narrow canyon, would be in an undesirable and disadvantageous location as a commercial center of the district. Not only was there insufficient space for the anticipated 75,000 residents, but the area was relatively inaccessible to teams and would be an even more impossible approach for any future railroad. The town of Ramsey, on the other hand, had been staked out on a gently sloping plain about two miles to the east and possessed none of these handicaps. Ramsey, moreover, only had about 75 to 100 people scattered over its 2,200 townsite lots.

Around November 1906 Salsberry decided to take matters into his own hands. As an initial step, he acquired control of the sparsely settled Ramsey townsite, but at first the people in Kunze showed no inclination to budge from their present housing in the canyon. Salsberry, however, was undaunted. In a determined effort to re-establish the town of Greenwater in the improved location, he offered all the property owners in Kunze an equally attractive lot in the new location, and to clinch the deal he offered to pay all moving costs for the owners. The people became convinced, they moved en masse, and the official Greenwater post office was established at the new townsite.

Greenwater now became quite an impressive town. Main Street was a full 90 feet wide while the lesser side streets spread out to an imposing 60 feet in width. The aesthetics of the situation did not enter into consideration, the widths were determined by the plain, plebeian precaution against fire sweeping the community. Lots on Main Street sold for prices as high as $500 (one report states $2,000), but there were ample lots on back streets available for as little as $50. The types of housing erected were proportionally as erratic as the prices. Most people lived in tents to which were added the luxury of a plank floor with a few boards on the sides to keep out the scorpions and rattlesnakes. Scattered among the tents were occasional frame buildings and some business establishments, among the latter being a bank, a brokerage house, a few stores and the usual number of saloons. Any wooden frame buildings were either a luxury item or a necessity, for lumber prices skyrocketed due to the long haul from the railroads.

Water was another luxury item which presented an eternal problem in Greenwater. In an effort to promote the mining camp, John Salsberry hired teams to haul water which he sold "as cheaply as possible." Although $7.50 per barrel might seem like a high price to pay, Salsberry claimed that he lost $600 a month on the business. Once, in Novem-

ber 1906, when a water wagon broke down, panic swept the camp and water briefly commanded a price of $20 per barrel.

Estimates of the population of Greenwater were as varied and conflicting as was the life of the camp itself. No civil authority existed for a long time; trouble makers were simply advised to leave by the townspeople, and most of them did without much hesitation. Some people attempted to judge the camp by the number of miners actually employed, but here again the figures were confusing. Some reports stated that several hundred were working, others placed the number at a fraction of that figure. Judging by the small size of the mine dumps in evidence today, the conservative estimate would appear to be the more nearly correct.

By December 1906 the majority of activity had become concentrated in the hands of a few. To the north, Patsy Clark's Furnace Creek Copper Co. still operated at the townsite of Furnace, just north, down the slope from the original (but never formally settled) location of Clark. Nearer to town, the United Greenwater Copper Mining Co. and Schwab's Greenwater and Death Valley Copper Co. were just being placed under the control of the Greenwater Copper Mines & Smelter Co., a holding company combining the interests of Brock, Schwab and others. In almost the same breath the GCM&SCo. announced plans for the formation of a subsidiary company to erect a smelter at Ash Meadows where adequate water would be available. A 30-mile railroad was surveyed between Greenwater and the smelter, and a news item in late December 1906 stated: "Work is to begin next week." In actuality, no work on the railroad was ever begun, either the next week or any other week, but for many years one of the items listed on the asset side of the GCM&SCo.'s balance sheet read: "Railroad survey contract . . . $11,073."

Criticism began to be directed against Greenwater as early as December 1906. The *Mining & Scientific Press* of San Francisco carried a letter from a correspondent in Greenwater which stated that no commercial shipments of any size had been made from the entire district, and that as far as he could learn, "the only so-called 'shipments' consisted of a few burro-loads of samples to beguile speculators."

In February 1907 the same publication felt compelled to editorialize on the subject of Greenwater. Pointing out that although some $3,000,000 had been taken from the public in the name of Green-

water, and that although there were good showings of oxidized ore on the surface at several places, the editorial flatly stated that there was no ore in the camp that would pay to ship — a rather stinging denunciation for such a highly touted copper camp of the future. Undoubtedly the comments represented a refutation of statements made in the galaxy of prolific promotions disseminated by the speculators as well as articles and advertisements published in the local press.

For Greenwater had three newspapers in the course of its history. The first two were the *Greenwater Times* (published, according to one report, by James Brown from the copper city of Butte, Montana) and the more famous *Death Valley Chuckwalla*. The latter was published by Carl B. Glascock and C. E. Kunze (Arthur Kunze's brother) and was an exhuberant booster for the great copper camp, readily accepting all advertising, however lurid, touting mining stocks for distribution in every state of the union. Of the third, the *Miner*, but little is known except that it appeared to be only slightly more sedate.

In spite of the planned precautions in laying out the town of Greenwater, early on Saturday morning, June 22, 1907, the inevitable happened — the Smith and Owsley Building was consumed by fire. With it, in flaming inferno, went the printing plant of the *Chuckwalla*, the *Miner*, and an adjoining saloon. In reporting the fire, the *Las Vegas Age* ad-libbed the following comments to its news story:

"The *Chuck Walla* was roasted alive by the Angel of Fire because of the many unholy things it has printed.

"The destruction of the *Miner* (whose sins are less notorious) and the saloon only proves that chastisement, like rain, falls 'alike upon the just and the unjust'."

When rails of the Tonopah & Tidewater Railroad reached Zabriskie (to the south of Greenwater along the Amargosa River) on May 22, 1907, that road's management was eager to capture the prospective Greenwater trade. As a first aproach, an office was opened in town to serve as the terminal of the T&T's own auto service (which began May 25) directly connecting with the trains at Zabriskie. Through rates via the auto connection were offered to passengers from San Francisco, Los Angeles or Ludlow. Even at that late date the prospects must have appeared to be enticing, for the same interests actually incorporated a Tonopah & Greenwater Railroad to build from the camp southeastward to a connection with the

T&T's main line at Zabriskie. Possibly the instigation stemmed from a late arrival's desire to be first in the field, for the LV&T had taken a moment in November 1906 (as its rails were nearing Rhyolite) to amend its incorporation papers to permit construction of a 49-mile branch from Amargosa (on its main line) through Ash Meadows to Greenwater. The Brock interests (T&G-BG) also had had their eye on this potentially profitable pie, and had even gone so far as to run a preliminary survey southwestward from Beatty to Greenwater. None of these projects ever reached the point of actual construction as the development of Greenwater's mines was still too nebulous to warrant the outlay.

Of them all, Brock's interests apparently were the most active. In February 1907 their surveying party of 12 men was camped at the foot of Main Street in Greenwater ready to start work, using the old preliminary survey Brock had made the year before. At least that was the report of the *Reno Evening Gazette* of March 4, 1907, detailed under the heading: "Brock Scored on Borax Smith." The story then went on to say that Brock had sent a force of graders to Greenwater under the direction of Capt. Geppert. Apparently a moderate amount of "lip service" went into the reporting, for John Lansdale, who was with Geppert in Greenwater, states unequivocally that an instrumental survey never was made between Greenwater and Gold Center (Beatty). Admittedly a preliminary "looking-over or inspection" had been accomplished, but no further work or grading was ever done pending the complete report of a competent geologist. When the geological report on Greenwater's copper was finally rendered, it proved to be adverse, and the railroad project was dropped.

By September 1907, following 10 months of exploration work in search of Greenwater's elusive copper, a number of shafts had been sunk, some as deep as 600 feet; crosscuts and drifts had been executed; but still no large bodies of pay ore had been encountered. Many of the smaller companies had ceased work entirely, and even the larger companies had reduced their employment to a few men at best. Where, a few months previously, 100 men had been laboring underground; now there were only 20. Total mineral production for the entire camp had narrowed down to the equivalent of only a few carloads of ore and the majority of the people had drifted away.

The Panic of 1907 (starting the end of October) finished Greenwater. By May 31, 1908, even the post office was discontinued. The following year (on November 26, 1909) stockholders of the Greenwater Copper Mines & Smelter Co. voted to discontinue all operations at Greenwater. They did agree, however to continue mining activities at other locations, and the company maintained its existence for approximately another decade.

Gradually the buildings of Greenwater were moved away. Dad Fairbanks moved his store and other buildings to Shoshone to start life anew (see T&T). By April 1916 only one deserted cabin remained of the once rollicking town of Greenwater, while the visitor of today will find but a few boards and the crumbling remains of an assortment of scattered excavations.

Probably the most fitting epitaph for Greenwater is to be found in the 1910 edition of Stevens' *Copper Handbook*. A number of Greenwater companies were still listed at that late date, although the majority were classified as either "idle" or "dead." Several were described as stockjobbing enterprises while one, the Greenwater Furnace Creek Copper Co., bore the most appropriately illuminating comment: "Dead. Was a fake, promoted by some of the most talented liars ever in the crooked mining game."

American Carrara Marble Company

Carrara marble, undoubtedly one of the finest in the world for quality, color and texture, originated in the mountains of Carrara, Italy, located along the western shores of that country not far from the leaning tower of Pisa. For centuries Carrara marble was supplied for the great temples and statues of both the Greeks and the Romans, and down through the ages its name has become a symbol of the finest of polished stone.

When a combination of twenty color varieties were discovered in a marble deposit a few miles south of Rhyolite, Nevada, around the turn of the first decade of the twentieth century, it was hoped that a real find had been made. A whole year was consumed in drilling for samples, and although the deposit proved to be unlike its namesake either in size or in history, a successful enterprise was indicated. Thus in the year 1912 the American Carrara Marble Company was formed, backed by stock-

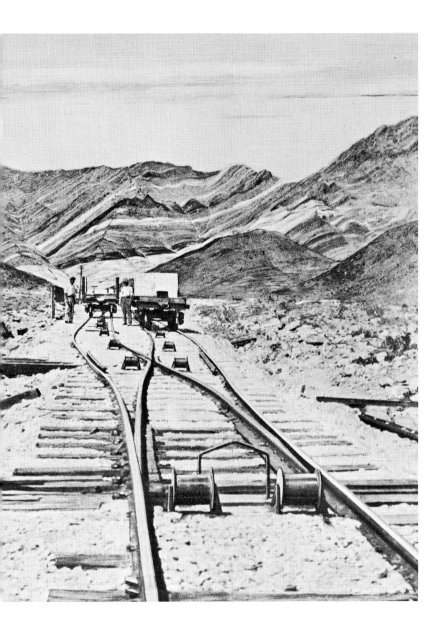

Not many people remember Carrara, Nevada, the town with a 3-mile railway which existed (basically) for but three short years from 1913-1916. At its peak Carrara consisted of some 40 buildings of which *(top, left)* are visible a corner of the general store, the American Carrara Marble Company's office and the two-story hotel replete with porch from which visitors could look easterly toward the quarry.

Two flat cars, operated on the Lidgerwood cable system *(left)* counterbalanced each other going up and down the mountain, a turnout at mid-point enabling the cars to pass each other automatically as wheel flanges actuated the spring switches. This reproduction of a painting portrays the action, the loaded car at right descending (toward the bottom) to Carrara. When the quarry ceased operations, the cable railway was dismantled, leaving but a faint scar on the mountainside *(top, right)*. *(Left, top and bottom: A. B. Perkins Collection.)*

— 605

holders in Columbus, Cincinnati, Marion and Toledo, Ohio.

Development of the property was really two jobs in one—a whole town had to be created along the eastern edge of the valley near the Las Vegas & Tonopah Railroad, and a quarry had to be developed in the mountain overlooking the valley. Additionally, a direct means of communication and transport between the two had to be arranged. Chief promoter of the project was a man named P. V. Perkins — handsome, a good dancer and a good mixer. As a young man he had come to Nevada with his parents from Rutland, Vermont, and after making the usual rounds of the mining camps of Goldfield, Bullfrog and Greenwater, he had settled down at Bare Mountain (between Rhyolite and Carrara) where his family had an interest in a gold mine.

Perkins lost no time in getting started. Marble quarrying, at best, was a slow process, and the bed of the quarry had to be stripped of its top soil and initial cuts made to reach the hard core of pure rock underneath. A derrick was also installed — a 65-foot mast which was 32 inches thick at the base, supported by ⅝-inch cables each 400 to 600 feet long. From this a huge 60-foot boom, 28 inches in diameter, was swung. In working order, the derrick could handle blocks of stone weighing up to 15 tons each.

To take men and materials to the quarry site, as well as to provide for removal of the blocks of marble after quarrying, a railroad was needed. In 1913 surveys were made for a private, three-mile cable railway to run in a perfectly straight line from a point near the LV&T tracks, up the hill to the quarry. Due to the quirks of the desert, the instrument work could only be performed between 4:30 and 6:00 o'clock each morning; after that time the air became too warm and hazy to permit the running of levels.

The Carrara townsite was laid out in the valley near the terminus of the railway alongside the LV&T. The eternal desert problem of an adequate water supply was solved through construction of a nine-mile water pipeline from Gold Center. In flagrant disregard of the value of water to a desert community, a large town fountain, 18 feet across and three feet deep became the central feature of Carrara. Although the town fathers of Gold Center might have been incensed to witness their water rights thus being abused, it was reportedly a refreshing sight to see the six-foot column of water

sprayed into the atmosphere while one columnist (perhaps affected by the desert heat) exaggeratedly described a 30-foot spout.

P. V. Perkins was also in charge of development of the Carrara Townsite Company's property, and he met the challenge head on. May 8, 1913, was announced as "Townsite Day," and a big celebration was planned. Announcements were sent broadcast throughout the area, and publicity was developed. In anticipation of the event, some buildings were moved over from Beatty and Rhyolite. George Dimmick sent over a saloon which was so eagerly received it had an unofficial opening and was doing a rushing business before it could be removed from its wheels and established on a more permanent foundation. Hastily constructed step ladders enabled the thirsty to climb aboard and enjoy the refreshments, while those who overimbibed experienced no difficulty in locating the "big step" back to terra firma.

"Meet me at the fountain" became the password for the gala event (although "Meet me in the fountain" might well have been more appropriate for this and all subsequent special days which reportedly resulted in rather grandiose drunken orgies). In compliance with the theme, some 82 people left Goldfield on the morning of the big event via an LV&T train which picked up 10 more at Rhyolite and an equal number at Beatty on the way down. Autos brought other people over shorter distances to the townsite where the Goldfield Moose Band, wearing red uniforms in the hot desert sun, played with an almost too great constancy in an effort to maintain a favorable atmosphere. A baseball game (staged later in the day) was won by Tonopah, and that evening the Hippodrome Orchestra developed music for the dance. It was early morning when the northbound LV&T train finally picked up the band and the guests to take them back to Goldfield, its warning whistle officially terminating the dance.

With the impetus gained from "Townsite Day," Carrara grew rapidly. A weekly newspaper was soon established. Although it carried the formalized local title of *Carrara Obelisk*, a more heterogeneous admixture of typography, advertising and editorial material is difficult to imagine. Printing was performed in Salt Lake City; the major advertising support was derived from Goldfield; and aside from the nominal number of local subscribers, circulation was enhanced through the

inclusion of all of the stockholders of the Marble Company. On its first six months' birthday, the newspaper proudly reported that all houses were filled and that there was no unemployment in Carrara. Possibly this was intended to indicate that there was a shortage of reporters as well, for residents of the town were obliged to read the *Randsburg Miner* in December 1913 to learn that P. V. Perkins had made the news when his auto became stuck in deep snow after crossing Death Valley. Perkins was forced to abandon his car in Emigrant Canyon, following which he walked almost 40 miles through snowdrifts two and three feet deep before finally being rescued near Ballarat.

A. B. Perkins, a brother, came to Carrara to assist in the various enterprises, and proved himself to be almost as versatile and capable as the founder of Carrara. A. B. ran the newspaper, an engineering office, a boarding house accommodating 80 people for meals, and the Marble Company's office. In addition, he owned the Hotel Carrara which offered rooms at 50¢, 75¢ and $1.00, plus additional desert luxury of a bath at 25¢ extra charge. Another man of local distinction was Fred Bovberg, postmaster and restaurant operator, being renowned in large part for the unusual variety of caviare, pâté de foie-gras, and other delicacies kept on hand which he advertised profusely.

By the spring of 1914 the railroad was finished. Two flat cars, operated on the Lidgerwood cable system, counterbalanced each other on every trip, the loaded (down) car helping to pull the empty (up) car to the quarry at the top of the hill. A turnout at mid-point enabled the cars to pass each other automatically, wheel flanges actuating the spring switches. The powerhouse was located at the top, purposely buried in the hillside to protect the electrically driven machinery from possible landslides. Reportedly the machinery was considered to be so expensive that any replacement was to be avoided if at all possible. At the valley end of the line where the rails approached the LV&T, a sharp turn was provided to reach the marble saw tables and the LV&T siding. An electric-storage-battery locomotive (recharged each night) switched the cars on this short section of the line.

On April 7, 1914, the first shipment was made, almost a year after the initial cuttings were instituted. Most of the town was on hand to witness the event as six blocks of blue-white marble were sent on their way to Los Angeles. Many other shipments followed over the years, including one which was politically expedient in that it was installed as a marble counter in the *Marion (Ohio) Tribune* offices frequented by a number of resident stockholders.

The "Golden Age" of Carrara arrived with a rush during the years 1915-16 and departed equally as expeditiously. Some 40 buildings comprised the town; about 60 men were on the Marble Company's payroll, including 20 Greeks who labored on (or about) the railroad. The loaded cars sometimes ran away and jumped the tracks, whereupon the car would be rerailed but the marble would be left where it fell as there was no convenient method of lifting it back on the car. Even in those early days the quarrying, finishing and sale of Carrara marble faced increasing competition from Vermont marble as well as from the newer and cheaper artificial marble tiles, so just what precipitated the climax is difficult to determine. Suffice it to say, the death knell came suddenly and vitally in December 1916 when electrical service was abruptly terminated. The quarry ground to a halt; the railroad stopped dead in its tracks; the newspaper suspended publication; and the town quickly folded.

The years of World War I came and passed; and with their going came the demise of the LV&T Railroad which had served the town of Carrara in its time. It was not until years later, during the 1920's, that activity at Carrara was revived for a while. In 1927 the Tonopah & Tidewater Railroad (the only surviving road in the area) built a short ¾-mile spur to service the town and quarry, but the effort was hardly a lucrative investment. Within a very short time the attempted revival was abandoned, and today nothing remains at the site of Carrara except the old foundations, the road and an abandoned quarry.

For the edification of the curious, the ruins to be found about a mile north of the old location of Carrara are those of the buildings of the Elizalde Company, a cement operation of Philippine ownership of the 1930's, which was abandoned even before production began. In the Amargosa Desert of today, life begins at 58 — that is, where Highway 58 joins Highway 95 at the former gold town of Beatty — and few old-time residents remain who can recall a town south of Beatty called Carrara or its once familiar slogan: "Meet me at the fountain."

Death Valley Railroad Company

%%%

It all happened in a span of less than 20 years; it concerned a mere 20 miles of transportation; but because a major railroad lacked the earning power with which to extend its lines, a new and profitable private railroad came into being. And if this appears to be a strange anachronism, then just consider that that was the way of life in Death Valley.

The story began at the Pacific Coast Borax Company's Lila C. mine at Ryan, California, which was served by the Tonopah & Tidewater Railroad via its Lila C. branch. When it became apparent that the ore reserves would became exhausted about 1913, plans were made to develop a new property at the Biddy McCarty mine, approximately 12 miles to the north and west in the direction of Death Valley. Transportation obviously would be required to bring the ore from the mine to existing facilities, and a railroad was the only logical solution to the problem.

Since both the Pacific Coast Borax Company and the Tonopah & Tidewater Railroad were owned by the same parent Borax Consolidated, Ltd., and since the T&T already served the Lila C. with a branch line, the logical solution was to have the T&T build a new branch (even though it be of narrow gauge) from the nearest convenient point on its existing lines to the new mine. As a consequence, surveys were made and a 16.95-mile line was projected from Horton on the Lila C. branch to the Biddy McCarty mine. Construction was to be financed through the issuance of $364,000 of additional T&T bonds, and to this end a routine application for authority to issue the bonds was filed with the California Railroad Commission. Then, with the stage all set and the actors ready to play their parts, the Commission suddenly turned out the footlights.

With the specious reasoning that the T&T's earning power was so poor that any additional bonds would create an undue financial burden on the road resulting in abnormally high rates to the shippers, on December 13, 1913, the Commission denied the T&T's application. A new approach became necessary; so heads were put together and a plan was formulated whereby the parent Borax

Consolidated, Ltd., would form a new and separate railroad company to build and operate the proposed line. Thus in January 1914 the Death Valley Railroad Company was incorporated to carry the project through to fruition.

New construction began at Horton on March 1, 1914, and the work proceeded westwardly with reasonable despatch. Additionally, a third rail was laid between the standard-gauge rails of the T&T's Lila C. branch from Horton to Death Valley Jct., at which latter point the concentrator from the Lila C. was relocated. A second-hand, 3-foot gauge Heisler named "Francis" served as initial power during construction. The locomotive had come from the Borate & Daggett Railroad of the PCBCo.'s previous operations at Calico (q.v.) and, though slow, was reasonably reliable in service — at least until delivery was obtained in June 1914 of the first of two new, heavy-duty Consolidation locomotives from Baldwin.

By Thanksgiving Day the rails stretched all the way to the new townsite of Devair at the far end of the line, and all hands joined in for a big turkey feed. On December 1, 1914, the road was formally opened for traffic over its full extent. Starting at Death Valley Jct. a trackage rights agreement permitted operation over the T&T's Lila C. branch three-rail roadbed for the first 3.19 miles to Horton (named for Ben Horton, T&T gang foreman and later roadmaster). At this point the three-foot gauge DV tracks diverged to head northwesterly up and around the end of the Greenwater Range, high above Furnace Creek Wash, then turned south to Devair and the Biddy McCarty mine. Near the western extremity, extensive heavy grading and several high trestles were necessary, leaving scars on the mountainside which are still visible today. Along this portion of the route maximum grades of 3.5% were encountered, while the sharpest curves were 24°. It is interesting to note that the name of the new townsite of Devair was subsequently changed to Ryan (same name as the town at the Lila C. mine), although the advance whistle board for the station retained the earlier name for many years, thereby provoking considerable curiosity and confusion among visitors.

As soon as the Death Valley Railroad was completed, arrangements were made to abandon the Lila C. mine and move the town of Ryan to the new location. The concentrator, on the other hand, was dismantled and reassembled at Death Valley Jct. on the T&T's standard-gauge main line, yet accessible by the narrow-gauge DV for delivery of

ores. By 1916 the changes were completed, and the T&T removed its standard-gauge rails from the entire Lila C. branch. Between Horton and Death Valley Jct. the narrow-gauge rails were allowed to remain, and the T&T sold that part of its property to the DV; the balance of the branch from Horton to the Lila C. (old Ryan) was abandoned.

The Death Valley was never a high-speed railroad, except possibly when an unexpected runaway broke loose on the grades. Its 1917 schedule offered a slow (average of 15 m.p.h.), daily-except-Monday train, undoubtedly a mixed but still a decided improvement over walking in the desert sun.

No. 1	Miles		No. 2
11:15 AM	0.0	D. V. Jct.	3:15 PM
11:30 "	3.5	Horton	3:00 "
12:30 PM	18.0	Colmanite	1:50 "
12:40 "	20.0	Ryan	1:40 "

Mining officials who accompanied F. M. Borax Smith on an inspection trip over the line shortly after it opened might have questioned the use of the term "improvement." A special train had been readied for Mr. and Mrs. Smith and their party which included, at the rear end, an impromptu observation-flat car which had been used in the building of the railroad. The floor had been swept clean; hand-rails had been installed; and folding chairs had been provided for the distinguished guests and company officials who flocked to the car to ride with Smith. As the train left Death Valley Jct. and proceeded over the three-rail trackage to Horton, the car began to flex and loosen the dirt between the floorboards. By the time the DV's new roadbed was reached and the train had picked up speed over the freshly graded right-of-way, the loose dirt from the floorboards began to fly, engulfing the party in dust. Finally Smith could stand it no longer. "Stop the train!" he demanded, as he stood up clenching his hands. A halt was called, and the train was backed to the terminal where the car was thoroughly hosed down. But the mining company officials had had enough. When the trip was resumed, the majority of the party took the safe course and rode farther ahead on the train, leaving the Smiths and young Harry Gower as the only occupants of the dubiously distinguished "observation car." Gower was one of the engineers who had helped to build the railroad, and he and Smith had a fine chat all the way to the end of the line, whereupon Smith paid Gower the supreme com-

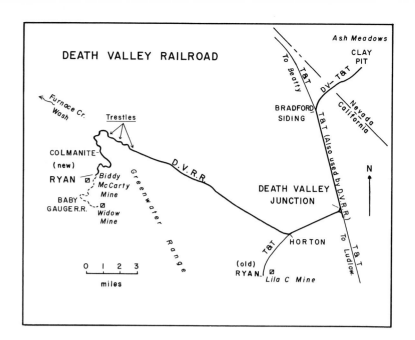

The T&T built the standard gauge line from Death Valley Junction to (old) Ryan in 1907. When the D.V.R.R. was built in 1914, a third rail was added from Horton to Death Valley Junction, thus permitting narrow gauge operation to the latter point. Later, when the T&T was abandoned from Horton to (old) Ryan, the Horton-Death Valley Junction became exclusively narrow gauge.

pliment of borrowing Gower's horse for a tour of Ryan and its facilities. Gower was elated with his fine new relations with the boss; but his ego was quickly and disappointingly deflated at the end of the day when Smith returned the horse, thanked Gower, and gave him a dollar tip!

With the Biddy McCarty mine in production and the Death Valley Railroad operating full blast, a number of satellite projects were proposed and some executed. One projected extension of the railroad which failed to materialize would have carried the DV's rails four miles to the Widow Mine and thence down the Furnace Creek Wash to some borax mines at Mount Blanco which were also owned by the Pacific Coast Borax Company. Another extension, approximately a mile long, was actually constructed around the hill to the Lower Biddy Mine.

Eventually the neglected Widow Mine did receive railroad service, but of a nature and to an extent not originally contemplated. A two-foot-gauge railroad (dubbed the "Baby Gauge") was curved sharply around the cliffs, eventually extending five miles in length between Ryan and the Widow Mine. Gasoline locomotives pulled the little ore cars over the 24-inch-gauge tracks, and shift trains took the miners to and from their jobs.

By 1916 the Death Valley Railroad was really in its stride. The transfers of mining equipment had

been completed; the Biddy McCarty, the Lower Biddy and the Widow mines were all contributing productive tonnage to the rails for haulage to the junction; gross revenues for that one year alone were $121,000 of which a handsome 54.5% (or $66,000) was carried through to net income. In retrospect, the results were rather a sad commentary on the earlier rebuff the T&T had received to its application for authorization for bonds with which to finance the road.

One final expansion of the Death Valley Railroad occurred when clay deposits were located near Ash Meadows, Nevada, just over the state line to the north and east of the T&T's main line. In the early developmental stages of operations, the clay was removed from the pits of the Death Valley Clay Company and processed near the mine in a small mill powered by an ex-submarine engine — a constant source of grief. When one mechanic attempted to install a little life into the reluctant motor through injection of a sniff of ether, there was a very definite response — the injector was blown through the roof of the machinery house and the flywheel was broken. At such times as the mill could be coaxed into operation, the resulting production was loaded into ore wagons which were hauled in cumbersome fashion behind Johnnie Bradford's Holt tractor over four miles of country roads to Bradford Siding on the T&T where empty ore cars waited to receive the mix. Local T&T way freights then hauled the loads over the six miles of railroad to Death Valley Jct., returning the empties to Bradford Siding.

Around 1926 it was decided to improve the transportation facilities, so the Holt tractor operation was replaced by a four-mile narrow gauge (3-foot) railroad. Small Plymouth or Milwaukee gasoline locomotives trundled miniature ore cars back and forth between the mill and the siding with such noticeable improvement in operating efficiency that it was decided to eliminate the last remaining bottleneck. To this end a third rail was laid in the tracks of the T&T's main line over the six miles between Bradford Siding and Death Valley Jct., and DV trains commenced operating directly to the clay pits. No interchange was necessary over the revised route, and no transshipping of ores were required.

Death came to the Death Valley Railroad in 1927 and 1928 (although the railroad continued to writhe spasmodically for another three years). Actually, to those who could recognize it, the spector of disenfranchisement was visible back in 1913

at the time the DV was being born. In the fall of that year John K. Suckow, a Hungarian doctor, filed a desert agricultural claim on some land in the vicinity of what is now Boron, California, on the north side of the Santa Fe Railroad between Barstow and Mojave. In drilling for water on the property, Suckow hit a crystal formation at the forty-foot level and, thinking it was gypsum, took samples to Los Angeles where they were identified as borax in the form of colemanite. When John Ryan heard the news, he dashed down from Oakland and bought the lands from Suckow on behalf of the Pacific Coast Borax Company. Although every effort was made to keep the discovery a secret and avoid a "rush" to the area, the local papers did carry the story but without disastrous consequences.

Over the ensuing years discoveries were made of new forms of borax called rasorite or kernite. Development of the properties was delayed until the resources at Death Valley had been more completely and economically exploited. Finally in 1925-26 preparations were started for a new form of open-pit mine which would be in close proximity to natural markets, and by 1927-28 the general closing of the Ryan mines and the shifting of equipment was started. A new 3-mile Santa Fe branch north from Boron to the new Baker mine was installed in 1928 to handle the bulk of incoming materiel. (In 1957 this spur was extended westward for two additional miles to a new mill.)

With the cessation of mining activity at Ryan, the Pacific Coast Borax Company instituted efforts to develop Death Valley as a winter tourist resort (from October to May of each year). A new luxurious hotel, the Furnace Creek Inn, was erected on the edge of the valley northwest of Ryan to develop appeal, while additional accommodations were also provided in the corrugated, sheet-iron buildings of the Death Valley View Hotel at nearby Ryan. An impressive novelty of a visit was the warning not to waste water as it had to be brought in from the Junction by railroad tank car. For those less venturesome or more timid, accommodations were available at the rambling Amargosa Hotel at Death Valley Junction, from which daily trips could be taken to see the sights of the region. Later, additional accommodations became available at the Furnace Creek Ranch as well as at the unaffiliated Stove Pipe Wells Hotel which expanded its facilities.

During the early developmental stages, the paved highway from Los Angeles ended abruptly

at San Bernardino, and the auto roads to Ryan and Death Valley were so lonely and marked so vaguely that motorists were well advised to telephone ahead to some responsible party at their point of destination advising of their anticipated time of arrival. The railroads hoped to benefit from this lack of travel facility. Both the standard-gauge T&T and the narrow-gauge DV railroads put on broad new motor cars to handle the anticipated rail traffic, while the T&T, in conjunction with the UP (Salt Lake Route), offered through Pullman service between Los Angeles and Beatty on an every-other-day basis in either direction. Tour buses of the Utah Parks Co. (a UP subsidiary) were used to circulate patrons among the various points of interest, one of which was the Baby-Gauge Railroad at Ryan.

After mining had ceased in 1927, considerable tourist interest centered about the abandoned borax mining properties. The Baby-Gauge Railroad was a most opportune method of reaching them, being both interesting and at times spectacular. Passengers were carried on open-air cars and the novel, narrow-gauge trains made frequent trips over the line, passing through tunnels and the interiors of the mines themselves, then emerging along a precipitous mountainside. It all added up to a very scenic trip which was further enhanced by the running commentary of tour directors Ben Barlow and later Bob Gardiner with his wonderful Irish brogue. One of their favorite jokes, as the little train wound its way along the cliffs, was to announce that a large tin deposit would hove into view around the next curve. With craning necks the timid tourists would stretch to see over the edge of the precipice; and sure enough, there it was — a tin can dump of many years' accumulation.

Lack of patronage caused abandonment of the hotel project at Ryan in January 1930. The buildings are still there under the watchful eye of a caretaker, and occasionally they are used to handle the overflow crowds from the Furnace Creek Ranch. The town of Ryan, which had boasted a population of 150 people only a few years earlier, became virtually uninhabited. The Baby-Gauge Railroad, however, continued to haul its trainloads of passengers for another two decades, trips finally being discontinued about 1950 following settlement of an expensive injury claim, although it was recently reported that operations would be recommenced.

For the Death Valley Railroad, the tourist traffic was woefully insufficient to bolster the declining mining revenues. In 1926 gross revenues were down to $64,000; the following year they shrank to $16,500; by the time the first nine months of 1930 had rolled around, only $1,389 had been taken in. In its last years, the railroad's equipment only consisted of one motor passenger car plus 27 miscellaneous freight cars.

On December 1, 1930, an application to abandon the line was filed with the I.C.C. There were no protests; nobody was left who cared. Operations ceased on March 15, 1931. The locomotives were sent to an affiliated potash mine at Carlsbad, New Mexico, while other disposition was made of the miscellaneous items of equipment. When the tracks were taken up, one of the large trestles on the shoulder of the Greenwater Range was dismantled, and the timbers were used for beams in the bar at the Furnace Creek Inn. The six miles of third (narrow gauge) rail in the main line of the T&T northward from Death Valley Jct. were removed, and the four-mile balance of narrow-gauge trackage from Bradford Siding to the clay pits was widened to standard gauge for operation by the T&T.

Thus the Death Valley Railroad died, leaving scant traces of its remains. In later years Locomotive No. 2 was returned to its native habitat and stands on display today at the Furnace Creek Ranch museum.

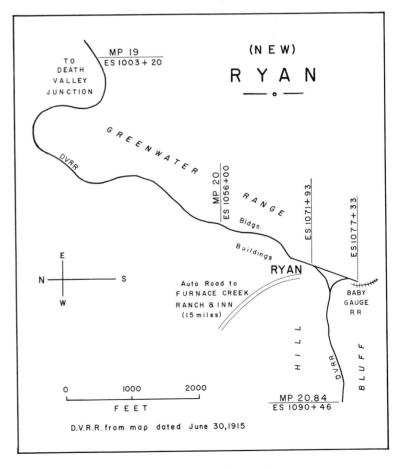

D.V.R.R. from map dated June 30, 1915

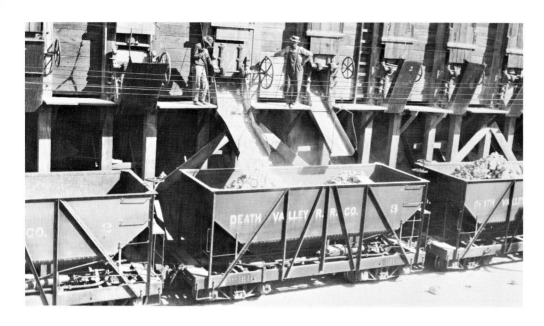

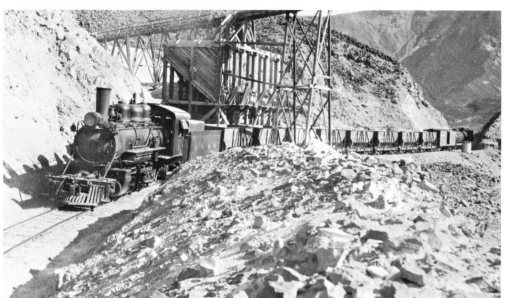

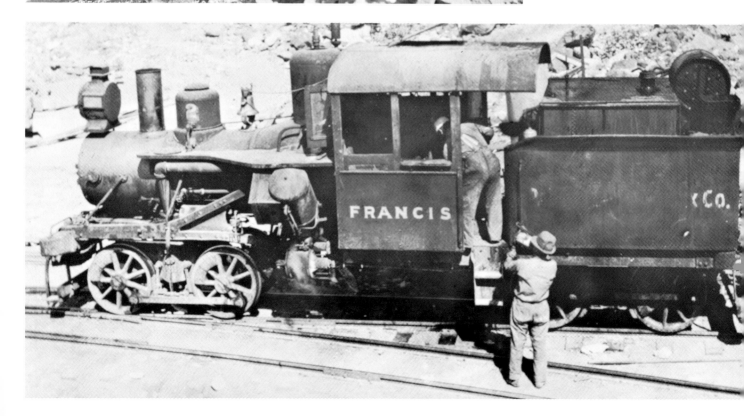

Ores from the Biddy McCarty, the Lower Biddy and the Widow mines went to loading bins on the narrow gauge Death Valley Roalroad at Ryan, California *(left, top)*. Other loading bins were maintained at Colemanite (two miles from Ryan) where DV No. 1 stands ready to take its train down the Furnace Creek Wash, around the end of the Greenwater Range and through Dead Horse Canyon to Death Valley Junction. Inbound trains, one shown *(below)* behind No. 2 near the Played Out (Colemanite) mine,

brought empties back to the loading bins, box cars of supplies, flat cars of lumber and tank cars of water for domestic use. The narrow gauge Heisler named FRANCIS, depicted *(bottom, left)* on the wye at Ryan, came from the Pacific Coast Borax Company's Borate & Daggett Railroad near Calico and was used in construction of the Death Valley Railroad. *(Left, top and center: Joe Horton Collection; bottom, left and right: H. P. Gower Collection.)*

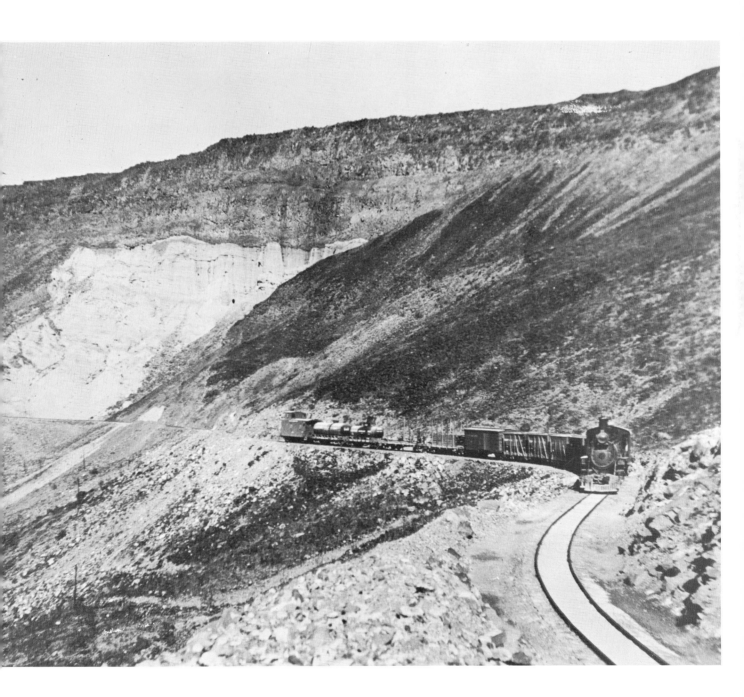

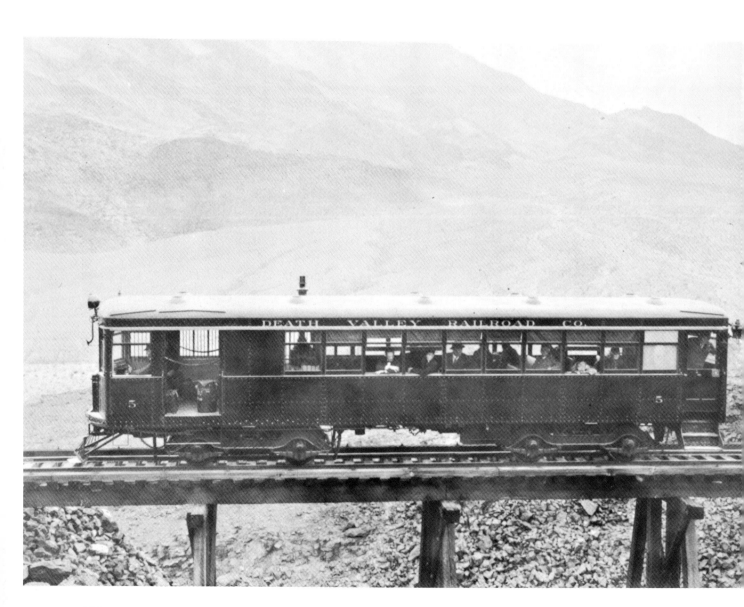

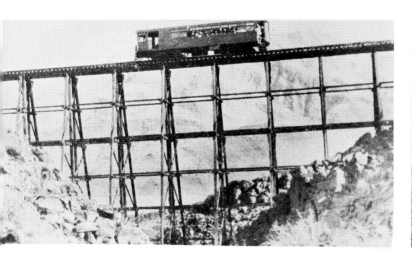

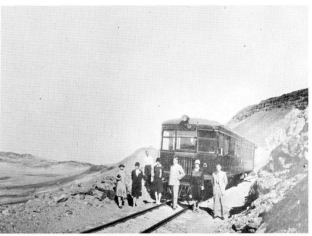

Along the northern end of the Greenwater Range, the Death Valley Railroad traversed some rugged terrain by means of a number of trestles which became favorite locations for posed photographs. The "Emergency Car" *(top, left)* was a 1912 Cadillac with its tread altered to accommodate the narrow gauge rails. Rail motor car No. 5, in spite of its number, was the only one of its breed on the DV. Built by Brill in 1928, it was part of the program to popularize Ryan, the Furnace Creek Inn and the Death Valley Region following cessation of mining at Ryan. "Starlets" Alma Kelly, Winnefred Jacobs and Betty Gilles *(below)* pose with the new arrival on a publicity trip. *(Left, top and bottom: H. P. Gower Collection; above, left: Ted Wurm Collection; above right, and below: Union Pacific Collection.)*

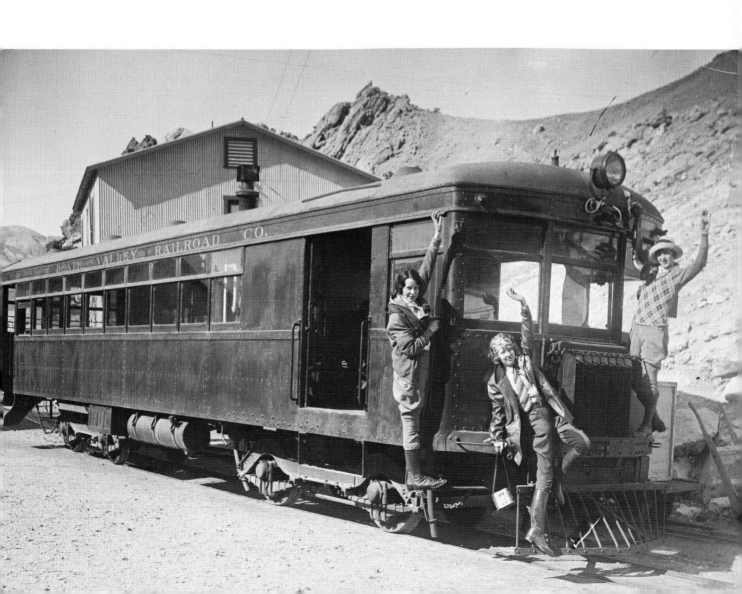

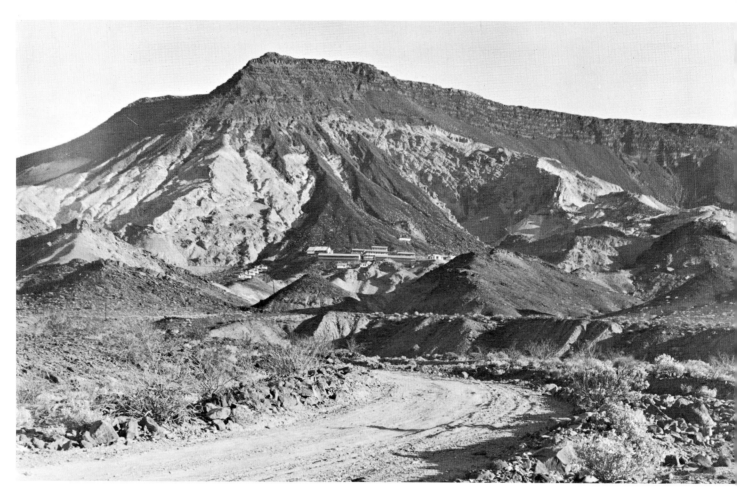

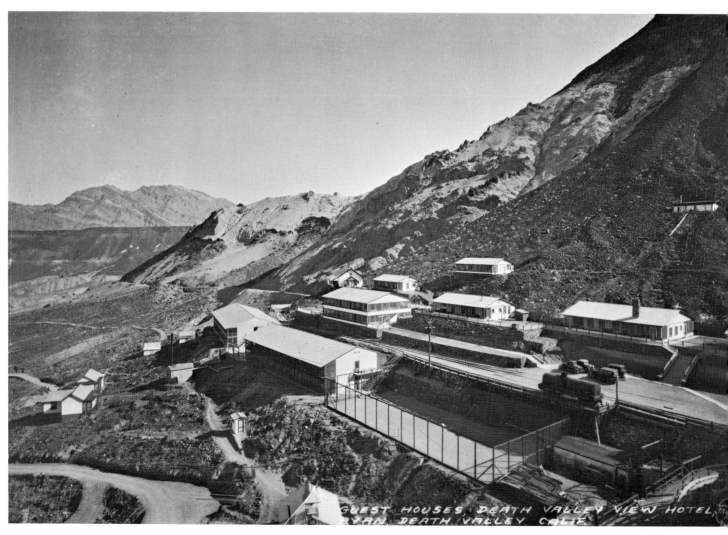

GUEST HOUSES DEATH VALLEY VIEW HOTEL
RYAN DEATH VALLEY CALIF

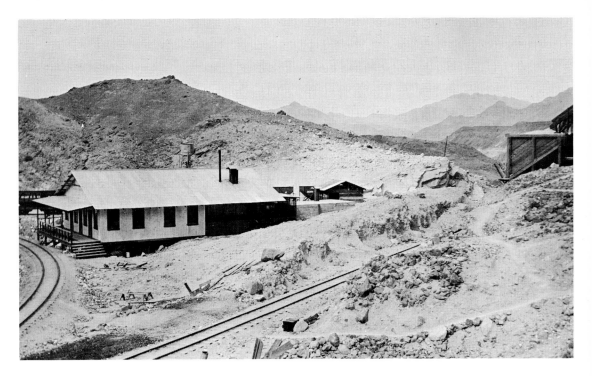

Ryan changed rapidly over the years from its original development as a mining center in 1914 to its conversion into a tourist attraction about 1927. Most people remember the later glamorized version, seen *(top, left)* from the approach in the Furnace Creek Wash and *(bottom, left)* looking along the Greenwater Range with the DV's roadbed vanishing in the distance. Note the perennial water car on the siding in the foreground, probably the town's most essential item, for Ryan had no water of its own. *(Both photos: Frasher Photo, Pomona, California.)*

Few are left who remember Ryan as a mining community. The building *(above)* stood inside the west leg of the wye with ore cars visible on the north leg and the loading bins at right along the east leg. The same landmarks are easily spotted in the view *(below)* taken from the westerly extension (see map, page 611). *(Both photos: D. A. Painter.)*

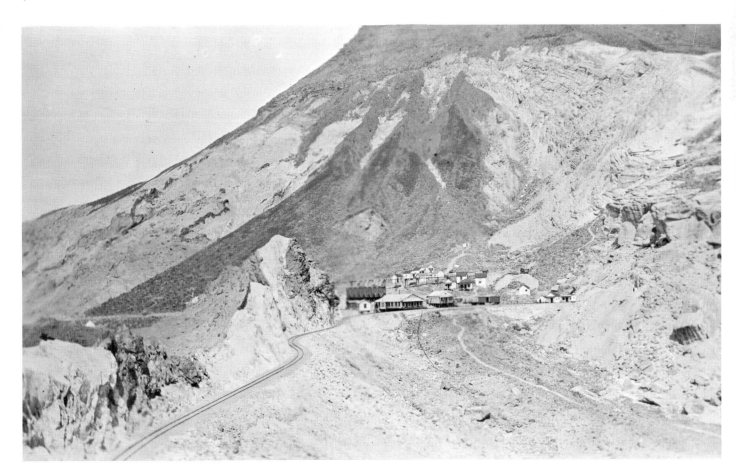

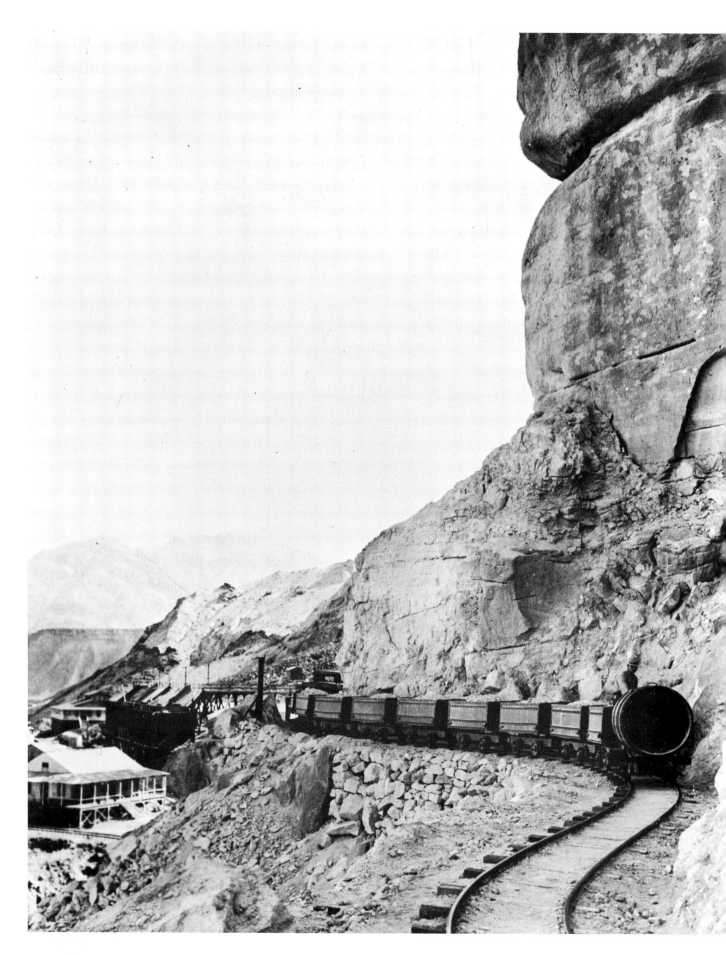

The nickname, "Baby Gauge Railroad," carried with it a rather misleading and innocuous connotation of placid simplicity which publicity photos, such as the one *(above)* with the tourists sitting on the battery-powered, electric mine locomotive, did little to dispel. In reality, the previously highly industrialized, miniature road was a winding, twisting cliff hanger on its approach to Ryan *(left)* as well as out near the Widow mine *(below)* where the several levels of its convolutions are plainly evident in panorama. One of the numerous borax mine portals can be seen behind the last car of the loaded ore train in siding on the middle level. Note the heavy stone embankments along the intermediate and upper levels. *(Left: U. S. Borax & Chemical Corp.; both photos this page: Union Pacific Railroad.)*

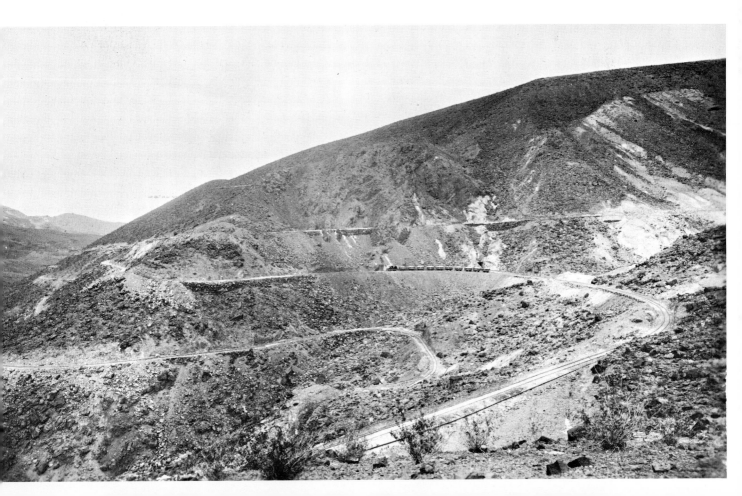

After the Baby Gauge went public, and following the demise of the Death Valley Railroad in 1931, the two-foot gauge rails were relaid to reach Ryan at the former level of the DV. In 1963 one of the former mine cars was still sitting on the track in Ryan where tiny trains were turned on the wye. In the road's later years of operations a gaso-line locomotive was the motive power. Note the varying levels of the Widow mine in the background, ample reason for the divergent trackage of the once extensive Baby Gauge Railroad. (Bottom: Frasher Photo, Pomona, California.)

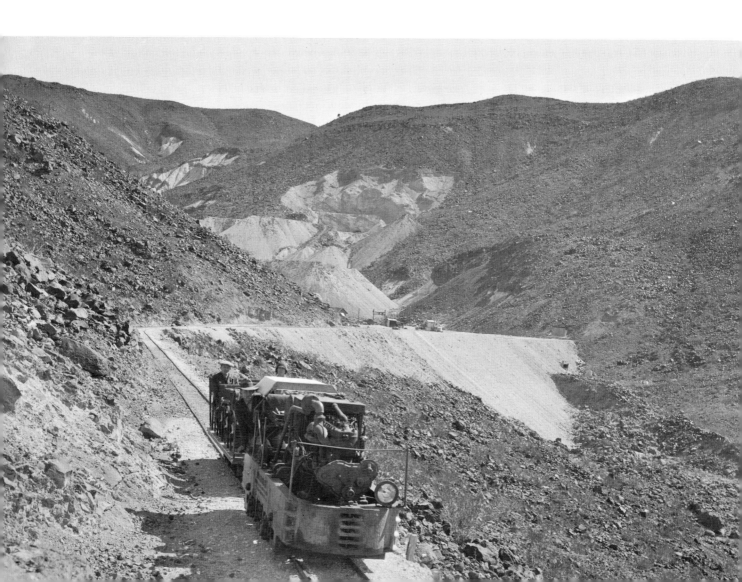

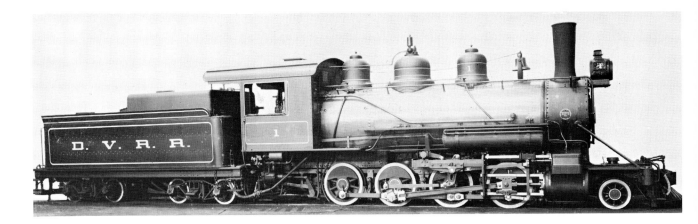

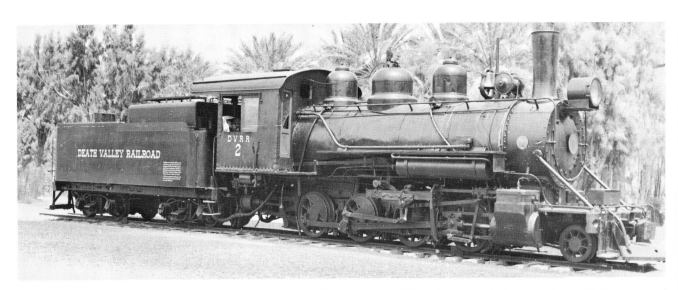

Above are the handsome, little, 3-foot gauge (2-8-0) Consolidations Nos. 1 and 2 of the Death Valley Railroad. The latter is now on permanent exhibition at the Furnace Creek Ranch museum. *(Top: H. L. Broadbelt Collection; bottom: R. P. Middlebrook photo.)*

Below is the world's only open pit borate mine and the processing plants of the U. S. Borax & Chemical Corp. at Boron, California, which seuperseded the former mining operation at Ryan. In May 1959 when this picture was taken, the pit was 275 feet deep and 2,000 feet long, comprising an integral part of the 80-acre, $20,000,000 development. *(U. S. Borax & Chemical Corp. photo.)*

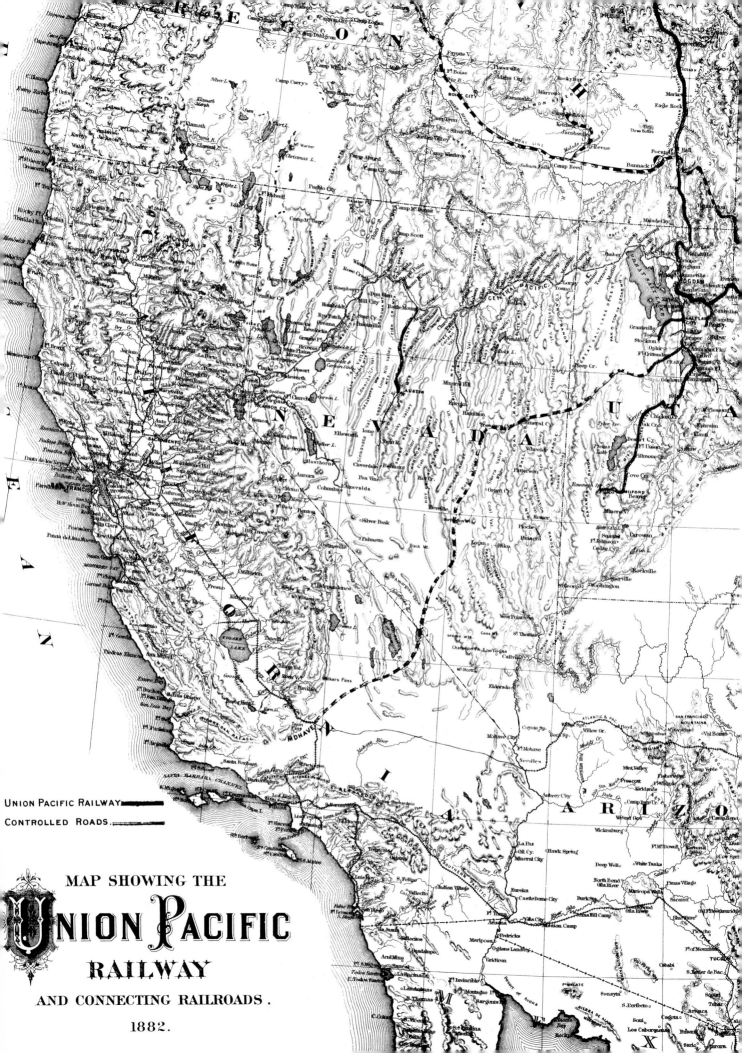

UNION PACIFIC RAILWAY.
CONTROLLED ROADS.

MAP SHOWING THE

UNION PACIFIC

RAILWAY

AND CONNECTING RAILROADS.

1882.

THE SALT LAKE ROUTE

ⅩⅩⅩ

Union Pacific officials long had entertained thoughts of southwestern expansion from their major terminal at Salt Lake City, Utah. The first concrete evidence of this thinking took form in 1880 when the Utah Southern was pushed southwesterly from Salt Lake City to Milford, Utah, with an extension to the neighboring silver mines at Frisco immediately to the west, a total distance of some 240 miles. The effort could be considered to be somewhat of a major accomplishment considering the sparseness of the territory and the fact that the famous union of the rails at Promontory (May 10, 1869) had taken place only a short 11 years previously. Undoubtedly consideration had also been influenced to some extent by the big silver bonanza at Pioche, Nevada, which had reached its peak just eight years earlier in 1872. Although Pioche had quieted down considerably, its tentative prospects were not being overlooked. In fact, the map in the UP's Report to Stockholders for the year 1880 indicated a proposed extension of the Milford line southwesterly to Pioche.

Other UP dreams were also being shaped. For the next two years maps in the company's various reports to the stockholders indicated (but without comment in the text) a projected route from Lehi, Utah, all the way southwest to Mojave, California, on the SP. The line headed west from Lehi to Mineral City (near the present Ely), Nevada, thence southwesterly through Railroad Valley to pass Treasure City (Hamilton) and Reveille. It passed through the area which became the future site of Beatty (Rhyolite), crossed the state line into California, then headed for Mojave. The route represented a most ambitious undertaking, the demise of which undoubtedly was influenced by the depressed times and delicate finances of the period. The enigma of the Mojave, California, terminus might be reasoned logically from the fact that it was in 1882-83 that the SP constructed its line across the Mojave Desert to Needles, trackage which later became part of the main line of the Santa Fe (see A&P).

In 1887 the UP resumed discussions for new lines in Utah, but a slump in the company's earnings halted any real work with the exception of some preliminary surveys. During most of the year 1888 two UP engineering parties were in the field surveying between Milford, Utah, and Barstow, California — a proposed railroad to Los Angeles being the prime objective. Early in 1889 a mass meeting in Salt Lake City, attended by 600 citizens, gave strengthened support for the project. A few days later, in February, the stockholders of the Utah Central (successor to the Utah Southern) voted to build the first section, an extension of the rails from Milford to the Nevada line at Desert Springs. Additional branches were authorized to Kanarrah and to the coal mines in Castle Valley, both in southern Utah. Three months later, as part of this effort, the same Union Pacific interests organized the Nevada Pacific Railway, to build a continuing section of road from the Utah line across the state of Nevada, and eventually to Daggett, California (near Barstow).

The year 1889 was rife with other new and disturbingly exciting events. The Union Pacific had become the principal owner in a number of short-line railways (including the Utah Central) radiating out of Ogden and Salt Lake City and was determined to gather these together under the aegis of the Oregon Short Line & Utah Northern Railway (most commonly referred to as the Oregon Short Line). John Sharp, who doubled as a Mormon Bishop, was placed in charge of the combined operation, and his eagerness and resourcefulness immediately became apparent. In October 1889 he announced that the line would be built to Pioche just as fast as graders could be obtained and that it was planned to make a start on the next section of road to Barstow as soon thereafter as possible. He declared that there would be no let-up until California was reached as "they could not afford a 200-mile stub-end track ending up in the desert."

Virgil Bogue, chief engineer of the UP, who had already run surveys from Pioche northward through White Pine County to Eureka and westward over Beckwourth Pass to California, now turned his attentiton to the southern route. Various surveys were made into Southern California — one

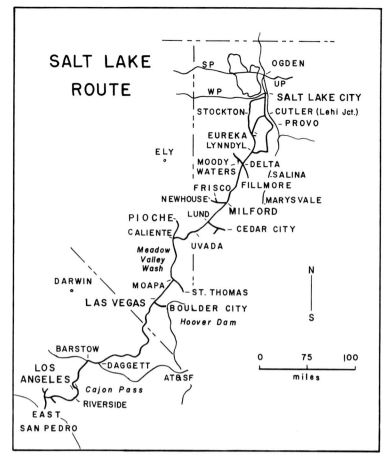

SALT LAKE ROUTE

running to Homer and another to Ludlow (both on the Atlantic & Pacific R.R.), while a "third survey runs to a point on the Southern Pacific road that I do not care to mention."

Meanwhile Sharp was pressing the OSL extension. The new year (1890) started with men and teams dotting the Escalante Desert south of the end of track at Milford. Supplies were arriving in Milford in large quantities and the contractors, Kilpatrick Bros. & Collins, planned to put 2,500 teams on the job. By February, at Clover Valley, Nevada (just west of the Utah-Nevada line), an important supply camp had been established replete with a hospital (40¢ per month payroll deduction) and a boarding house which provided all the wants of the normal laboring man except "fusil oil." As one reporter expressed it, however, "the thirsty navvy is not long to suffer. Several unselfish and generous hearted individuals have already opened 'saloons' at various points along the line of work. These places possess none of the elegant refinements conveyed by the word 'Saloon' ordinarily, but consist of dug-outs in the steep hillsides, large enough to turn around in, and must remind old-timers forcibly of '49!"

The resident engineer, H. M. McCartney, a principal figure in the extension, was always a good source of news. He reported that 2,000 men were on the job and, although unwilling to discuss routes, he admitted that four parties were out hunting passes through the mountains. "It is much cheaper to run surveys than it is to build railroads," he said, adding: "We have a survey that would take the line through White Pine, Eureka, and Beckwourth Pass. We also have a line south from Pioche, tapping the A&P at Ludlow. But no building will be done south of Pioche this year." Apparently Pioche was to be the immediate objective, perhaps in the hope that a mining revival might result from the introduction of the economies of rail connections with the outside world.

In spite of John Sharp's avowed intentions of pressing completion of the line, a number of problems arose to delay the work and throw it far behind the original schedules. Wages were low and men were scarce. Mule skinners, for example, received but $30 a month and rock work commanded $2.00 a day, although some subcontractors were paring this rate to $1.75. Board cost the worker $5.00 per week so that, after liquids, there was a sorry amount left out of his wages. When the glorious Fourth of July rolled around, some bosses kept their men on the job to keep them from getting drunk. The more popular bosses suspended work and generously furnished refreshments so that everyone was properly and celebratingly full — then tapered the diet down with beer as work was resumed the following morning.

On July 7, 1890, the Milford depot caught fire. A supply of giant powder, received that very morning for intended use in cuts and tunnels, exploded prematurely to help spread the flames. In short order the entire structure was consumed as well as the adjoining railroad office building.

Other catastrophies took their toll. A tunnel cave-in plus a bit of careless blasting caused a number of injuries among the men. One man was killed by a falling rock, and the workers around him left that job in a panic. Only about half of the required number of men were actually on the job because "the hogging system of discounts and low pay used by the original contractors is such that most of the men employed leave the job as soon as they get 'out of the hole,' by which is meant 'get out of debt to the contractors' (for transportation). It is somewhat dangerous to leave before 'getting out of soak,' and a number of personal encounters have occurred between the contractors and the men at different times from this cause." In fact, one contractor settled a "deductions" argument with a

worker through forcible means and nearly killed the laborer with a whippletree in the process.

In July 1890 the mushroom town and supply camp of Clover Valley reverted to its former ignominious status as grading operations were moved and centered at Dutch Flat as well as at Condor Canyon, just south of Pioche. It was planned to pierce the canyon, then circle northwest to a terminus on the flat just three miles from Pioche. As the grading came nearer to completion, a stockpile of second-hand rails from the UP's main line east of Ogden was created at Milford in preparation for the start of track laying.

By the first of August, 110 of the 145 miles of grade had been completed, accomplished in spite of such difficulties as stolen contractor's checks and the slitting of a drunken grader's throat by an angry saloon keeper. Little favor was likewise accorded any attempts to levy a $3 poll tax at the grading camp, particularly when efforts were made to collect from those workers who had had only 10 days of residence in the county.

In September 1890 the grade, together with its six tunnels, was completed and ready for the track laying machine. The job of rail laying was started early in October, but hardly had it been begun (about eight miles of track southwest from Milford were laid) than orders were issued from Omaha to halt all work immediately. Various were the reasons proffered in explanation of the cessation of activities, but the basic underlying cause lay in the UP's serious financial difficulties and the fact that control had passed back into the hands of Jay Gould. On November 24, 1890, Charles Francis Adams resigned the presidency, and Sidney Dillon once again assumed that position. The floating debt at the end of the year was $21,418,000, largely due to the tremendous expenditures for extensions which had not yet been permanently financed, and with unprofitable operations it was imperative that the UP cease all work in an effort to strengthen its treasury. At this time, Gould was reported to have made the quotable quote that the West had had all the railroad building it needed for some years to come.

For approximately five months reports continued to circulate that work would be resumed. Finally, in February 1891, H. M. McCartney, the resident engineer, returned from Omaha and stated that the construction department had been abolished and that 228 men had been laid off, including Virgil Bogue, the UP's chief engineer. Thus some $17,-000,000 of construction projects were halted in

mid-stream, including the $10,000,000 Seattle extension of the UP as well as the $2,500,000 Milford extension. When the *Salt Lake Tribune* questioned McCartney about the resumption of construction, his reply was blunt and to the point. "Well, that is something about which you know as much as I do. You newspaper fellows have been decrying Adams and calling for a change; you wanted a man who knew how to run a railroad; now you have got him. The proposition is that there shall be no more construction, the corollary to which is that there is no need of a construction force. Hence the bouncing of the entire department." McCartney had already made plans to work elsewhere, while Bogue eventually built a different west coast railroad — the Western Pacific.

With construction halted and the UP desperately trying to straighten out its financial problems, the topic of a railroad to link to Los Angeles with Salt Lake City became a frequent newspaper football to be kicked about at will. Some attention was paid to the little Los Angeles Terminal Railway which was doing a nice quiet business down in Southern California. William Workman, the mayor of Los Angeles, and R. C. Kerens of St. Louis were among its principals, and as early as 1891 they were thinking of building a railroad to Salt Lake City. W. S. Godbe of Pioche was also agitating for a revival of the project, and in October 1891 was reported to have promised sufficient ore tonnage or direct aid to persuade UP's president Dillon to build the line. But the answer was still "no."

Then, with the Panic of 1893 coming on, the Union Pacific went into receivership. The OSL&UN, which had constructed the grade out of Milford, became divorced. The eight miles of rail west from Milford were taken up, and that portion of the old grade in Lincoln County, Nevada, (assessed at $100,025) was sold to Lincoln County for taxes. It was not until five years later that the UP emerged from bankruptcy under an aggressive leader, E. H. Harriman, and shortly afterward succeeded in getting the Oregon Short Line back into its fold. Thus the stage was set for the next round in the attempt to link Salt Lake City with Los Angeles via a ribbon of rails.

For unexplained reasons a seemingly unrelated Utah and Pacific Railroad was incorporated in August 1898 to complete the first (75-mile) section of line from Milford to Uvada, near the State Line Mining District. The company was headed by A. W. McCune of Salt Lake City (owner of the Payne Mine, the "greatest dividend paying mine in

British Columbia") and by David Eccles of Ogden. The approach was precautionary. As a safeguard before incorporation, McCune of the U&P signed an agreement with W. H. Bancroft, general manager of the OSL, which provided that the OSL supply the rails and ties for the line and which permitted the U&P to use the old (OSL) grade in exchange for U&P bonds. More importantly, Bancroft arranged for his OSL to have a five-year option on the rejuvenated property.

The Utah & Pacific's organization for construction did not take very long, and on October 11, 1898, the first spike was driven to the accompaniment of President McCune's words that the road would never be stopped until it reached the Pacific. If there was any doubt that McCune was thinking of his U&P as part of a larger OSL route, those doubts were dispelled on February 2, 1899, when the OSL formed a Utah, Nevada & California Railroad to build a line of road across Nevada from Uvada (terminus of the U&P) to the California state line. Maps of the route, including a branch to Pioche, were filed the same year but were returned for correction. The OSL's inattention to this detail was to prove costly within a very short time.

Meanwhile U&P construction continued apace. Before the end of October 1898, nine miles of track had been spiked in place, and work continued all during the winter months. On April 30, 1899, Timetable No. 1 was issued to become effective for the regular operation of trains to Modena. Service was extended to McCune on June 1, and to Uvada commencing July 24, 1899. Since there was no wye or other facility for turning trains at Uvada, equipment was backed down from Modena, eight miles away. This operation was the cause of at least one wreck for, just a year after the line was opened, a backing train hit a cow resulting in derailment of the coach and a baggage car plus injury to several of the passengers.

Up to this time, although many transcontinental railroads had been plotted on paper (see Projected Railroads), Harriman's Union Pacific had been alone in the field with any tangible efforts to construct a line between Salt Lake City and Los Angeles. However, with the turn of the century, a new and ruthless competitor entered the field, a man who was to generate more than his share of rough and tough competition and create many sleepless nights. That man was Senator William A. Clark (the Butte, Montana, copper king). The event was to become known as the two-year "Clark-Harriman War." The time was August 1900.

In that month the newspapers announced that Clark had bought the Los Angeles Terminal Railway and had started surveys under Henry Hawgood for an independent railroad to Salt Lake City. Not as generally known and relatively unannounced was the fact that Clark had earlier acquired the Utah and California Railroad, a "paper railroad" originally incorporated in 1896 to build from Salt Lake City to the Nevada state line. Location maps had been filed with the Land Office (Interior Department) in 1896, but approval had never been obtained and the matter had been allowed to lapse, possibly largely because it was a Utah corporation which, under the terms of its charter, could not operate outside the state. Thus, in effect, Clark had acquired the "extremes" of a Los Angeles to Salt Lake route and merely needed the "means" to connect the two.

August 1900 was a month notable for another circumstance of importance in railroad circles, for in it Huntington of the Southern Pacific passed away. Huntington had frustrated Harriman (Union Pacific) a few years previously by securely gathering into the SP fold the vital Central Pacific, which Harriman had wanted as an outlet for the Union Pacific to the Pacific Coast. With Huntington's passing, Harriman grabbed the opportunity to acquire the large block of SP stock from the Huntington estate and thus acquire control not only of the Central Pacific but the Southern Pacific as well (see Central Pacific.) With control of the Pacific Coast now in Harriman's hands, he was more determined than ever that other railroads should not penetrate his sphere of influence. These would include not only Senator Clark's Salt Lake Route, but also George Gould's Rio Grande, which previously had been running surveys through the territory, and the Burlington which was poised at Cheyenne, Wyoming, ready to leap westward.

Of them all, the Salt Lake Route posed the most immediate, most positive threat, for Clark was actively moving to consolidate his gains and develop new strategies. On January 2, 1901, the necessary changes to the charter of the Utah & California Railroad were made to enable it to operate outside the state of Utah. At the same time a bill was introduced in the Nevada Legislature by Senator Freudenthal of Lincoln County (for the benefit of Clark's road) which placed out-of-state railroad corporations on an equal footing with those formed in the state. The *Reno Evening Gazette* of March 8 devoted considerable space to a discussion of the bill and was observed to com-

ment: "There was a red hot time in the Assembly over S.B. 38, giving certain rights to the Los Angeles and Salt Lake R.R. There was not much in the bill but the suspicion of a colored gentleman being in the wood pile . . . but he was so elusive that no one could find him. There was a disagreement in the Lincoln delegation and Mr. Paul, Mr. Conway and Allen had a lively time. Conway made his maiden speech. Mr. Conway is a man of sterling character, and no man in the legislature more fully had the confidence of his colleagues." The bill ultimately came to a vote and was defeated. However, on reconsideration the next day, it passed with 25 votes and became law on March 11 with the affixing of Governor Sadler's signature.

While the Nevada legislature waged its debate over S.B. 38, Clark carefully and meticulously carried on a campaign of public relations designed to build confidence and sympathy for his project. On February 21, 1901, he expressed great surprise over the announcement of the Harriman purchase of Southern Pacific stock and told the *San Francisco Examiner* with much reticence: "My company is not for sale. It was organized in good faith by myself and my associates. The Union Pacific's purchase of the Southern Pacific is not going to interfere with our plans. Within 16 days we will begin active construction of the first 71 miles of road from Los Angeles to Redlands.

"The company has come into possession of two surveys between Salt Lake and Los Angeles. Engineers will carefully go over both of them, selecting such parts of each as best suits the company's purposes. Will we make a connection with the Burlington at Salt Lake? That is something which the future will tell. As to our company connecting with the Oregon Short Line at Uvada . . . I can only say that our company plans to have its own line all the way from Salt Lake to Los Angeles . . . The story that I am using the proposed road as a club over the Santa Fe, the Southern Pacific and the Union Pacific people in order to get concessions in the way of freight rates on shipments to and from my [copper] mine is as untrue as it is unjust . . . I am not losing any sleep about being shut out of an eastern outlet at Salt Lake by the railway purchases and consolidations going on in the West."

March 1901 was a busy month for the Clark interests as their various projects began to gel. On March 4, for example, the Lincoln County Commissioners, in meeting at Pioche, acted upon the request of Clark's attorney, C. O. Whittemore, and agreed to transfer the County's ownership of the old OSL&UN (UP) grade to Clark's U&C RR in consideration of a payment of $5,083 and provided a broad-gauge railroad was built over the Uvada-Culverwell part of the route within six months. In effect, this gave Clark tentative ownership of his competitor's grade (including six tunnels) extending westward from the Utah-Nevada line (near Uvada) through the confines of Clover Valley to Culverwell (later Caliente) in the Meadow Valley Wash as well as the partially graded road bed to Pioche. (Subsequently this was modified.) Days later the Nevada Legislature passed S.B. 38, giving the U&C the right to build in the state of Nevada. Then on March 20, Senator Clark — in conjunction with his brother, J. Ross Clark, and others including R. C. Kerens of St. Louis, Thomas Kearns and Reed Smoot of Salt Lake — formed the San Pedro, Los Angeles and Salt Lake Railroad Co. (the name was shortened to Los Angles and Salt Lake Railroad Co. in 1916) which became commonly known as the Salt Lake Route. This was to become the parent company for all the constituent parts of the Clark railroad realm.

The combination of these factors placed Clark very solidly in the driver's seat. He had a railroad in Los Angeles, he had a paper railroad in Utah, he tentatively owned a very vital segment of his rival's nearly completed grade through a strategic area, and he had the legal authority to build a railroad in Nevada. With all the necessary maps now on file with the Land Office, he was set for action.

Harriman, on the other hand, was caught strictly on the defensive. The (still independent) Utah and Pacific Railroad was completed and an operating institution, but only as far as Uvada (almost to the state line); his OSL had formed the Utah, Nevada & California Railroad to build across Nevada, but no work had been done; tentatively (at least) he had lost control of that most vital segment of grade through the Clover Valley which should have been the continuing extension of the U&P; and he had (at the moment) no provision for entry into California in general and Los Angeles in particular. To counteract the deficiencies of his position, Harriman decided that the best defense would be a good offense. However, before he could get his program under way, further set-backs were in order.

Both parties claimed the right to build through the Clover Valley from Uvada to Culverwell on the basis of survey maps filed with the U.S. Land Office. Clark's U&C maps had been filed in 1896, while Harriman's UN&C maps were not filed until

Many early roads in the Salt Lake area became part of the Union Pacific System. The Utah Central train *(above)* stands at the American Fork station (south of Salt Lake City) about 1885. Tracks were originally built by the Utah Southern and extended as far as Milford and Frisco. *(Robert Edwards Collection.)*

One of the railroads in Utah which became part of the Union Pacific was called the Utah Western. Equipment is shown *(below)* in narrow gauge days on the desert near Garfield, Utah. Today a large smelter occupies the area. *(Arthur Peterson Collection.)*

The OSL&UN was an impressive property in the early 1890's when handsome No. 368 *(bottom, right)* headed a freight train between Juab and Milford, Utah. Although UP lettering predominated, the initials of the owning subsidiary (OSL&UN) still appeared individually on the locomotive. *(Robert Edwards Collection.)*

SPLA&SL No. 26 was a former Los Angeles Terminal Railway locomotive, posed *(top, right)* with a Salt Lake Route train at the Los Angeles terminal. The details of the occasion of the private gathering have been lost to posterity, but the whip in the hands of the man at right was never intended as a goad for the iron horse behind him. *(Louis L. Stein, Jr. Collection.)*

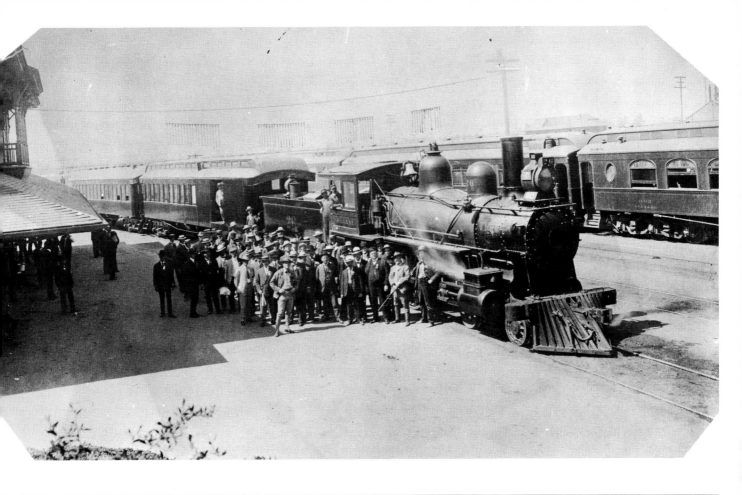

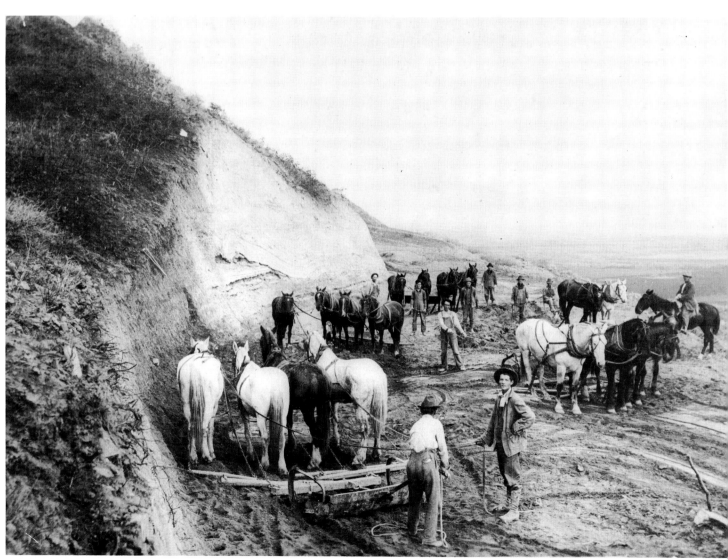

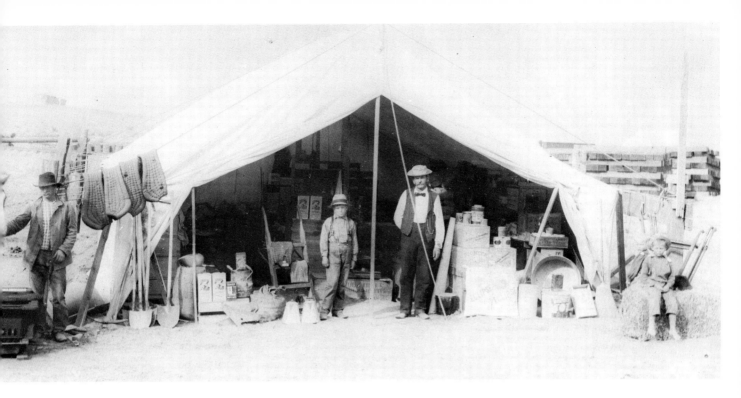

Supply trains, such as this one *(left)* posed at Milford, Utah, on a sunny morning in 1901, brought all manner of materiel in support of construction forces at and beyond the railhead of advancing railroad trackage. Supply tents were established at each construction camp in support of the men, teams and Fresno graders who wore away the side-hill excavations through expeditious application of horse power. It was always a happy day when finished trackage reached a major point where more permanent quarters could be established. Though primitive by today's standards, the floored tents and false-front shacks *(below)* at Las Vegas in 1905 represented as palatial an assortment of housing as could be found on the desert. *(Top, left and bottom, right: Union Pacific Collection; bottom, left and top, right: Miss Arlene Mendenhall.)*

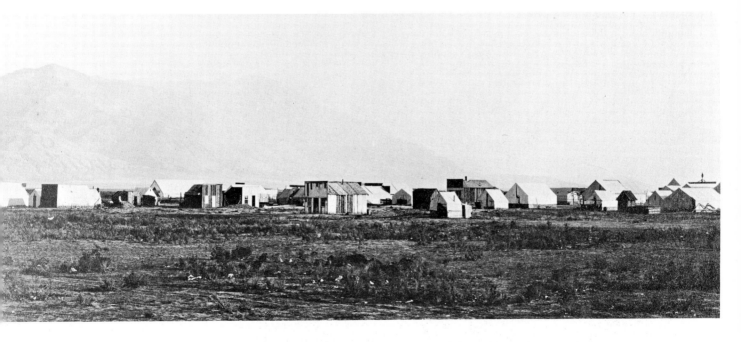

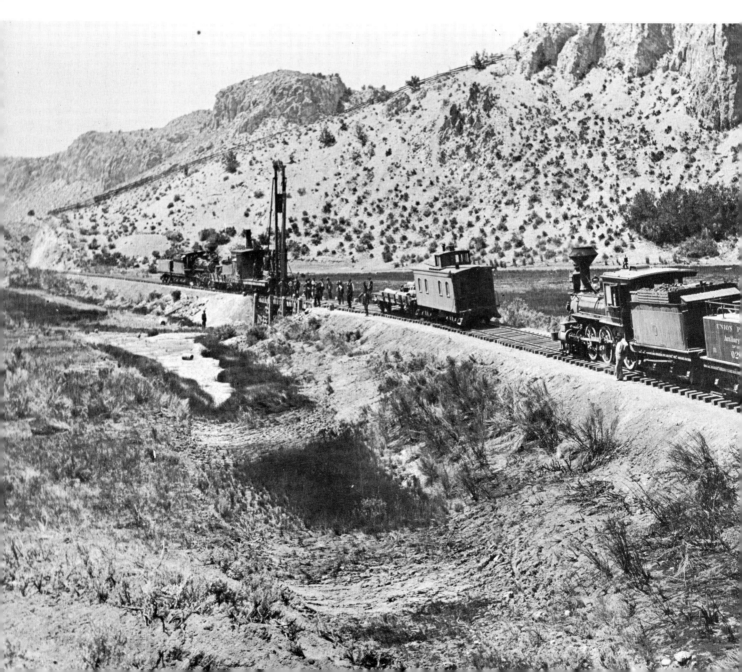

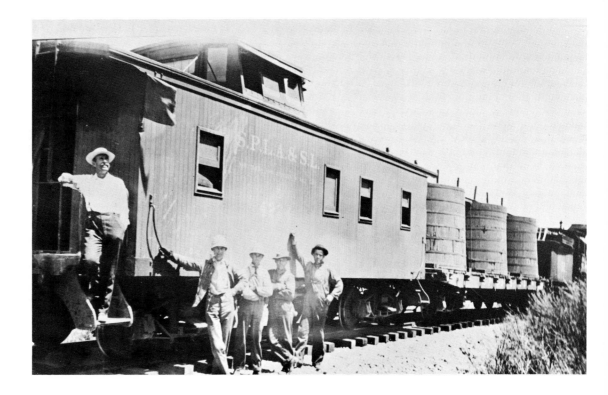

Indicative of turn-of-the-century equipment used in construction of the Salt Lake Route are *(top, left)* SPLA&SL locomotive No. 52 with narrow firebox forcing erratic spacing between the middle and rear drivers, and *(above)* the perennial desert water car, this time composed of three vertical vats mounted in tandem on a flat car. Union Pacific equipment was typified by ex-OSL locomotive No. 502 with auxiliary tender (foreground, *below left*) while a companion locomotive in background ministers to the needs of the pile driver putting finishing touches to a bridge over Clover Creek, near Islen, in the Clover Valley. Railroad ties were one of the most essential ingredients of construction—some 2,600 per mile were needed—and this UP tie yard was a busy spot. The man resting must be the boss. *(Bottom left: Arthur Peterson Collection; all others: L. Burr Belden Collection.)*

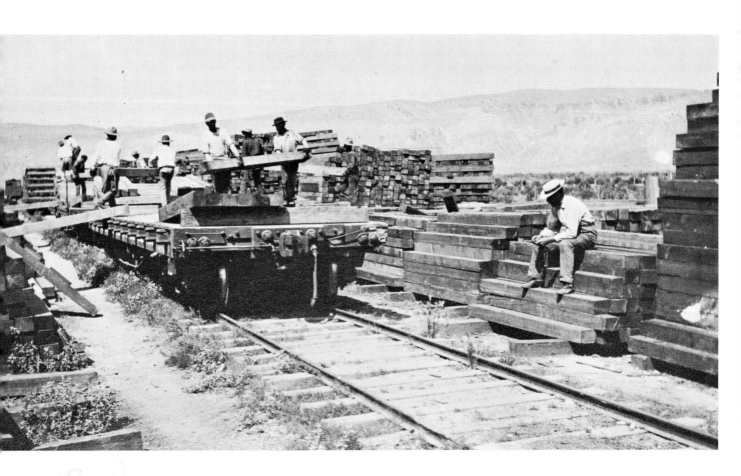

121. Las Vegas Rancho. R.r.P. Photo Co.

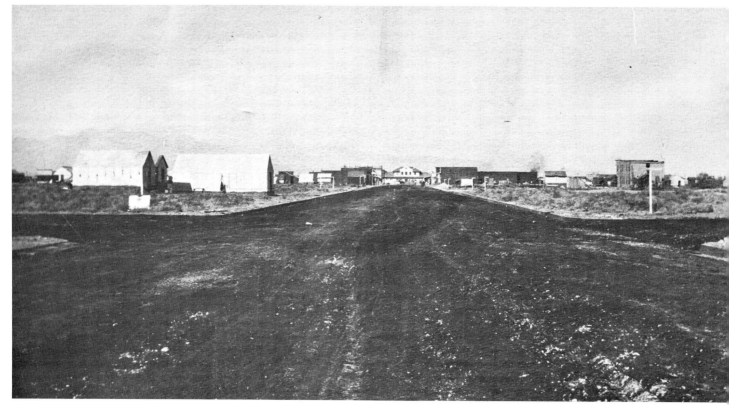

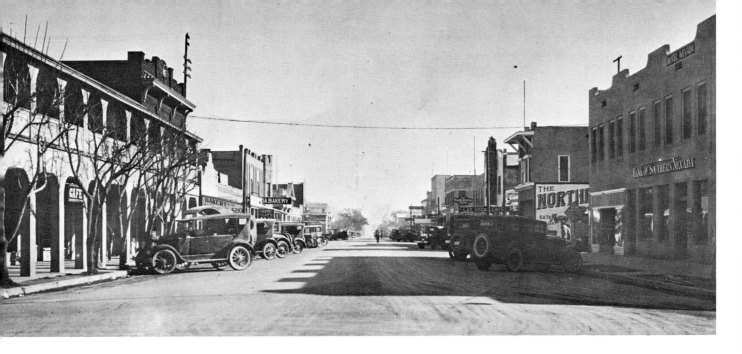

Surprising to many is the fact that Las Vegas was nothing more than a ranch on a desert oasis until the railroad arrived in 1904. Las Vegas Rancho *(above, left)* possessed the distinctive asset of its flowing water from springs. *(Mrs. Frank M. Grace Collection.)*

Arrival of the railroad brought development to the desert. After a few years, Fremont Street's *(below, left)* tent structures had given way to more permanent and durable build-ings. The Salt Lake Depot highlights the background. A decade later the improvement was significant. Fremont Street *(above and below)* had been paved, sidewalks installed, and the town was booming with Hudson-Essex autos exploding Red Crown gasoline in their cylinders, while Ward's Cash and Carry catered to all manner of needs of the increasing populace. *(Bottom left and top right: Las Vegas News Bureau; bottom, right: Union Pacific photo.)*

In the early 1930's Las Vegas boomed again as the gateway to the country's newest and greatest marvel—Hoover Dam. Fremont Street took on added new life as flags and bunting brought a contrastingly festive touch to the gloom pervading the majority of the country. Top view looks toward the railroad station while view *(below)* looks southerly through the park from the station plaza. At right is the Fremont Street of the 1960's, as gay a "white way" as in any of the largest cities of the world. *(Above, and at right: Las Vegas News Bureau; below: Union Pacific photo.)*

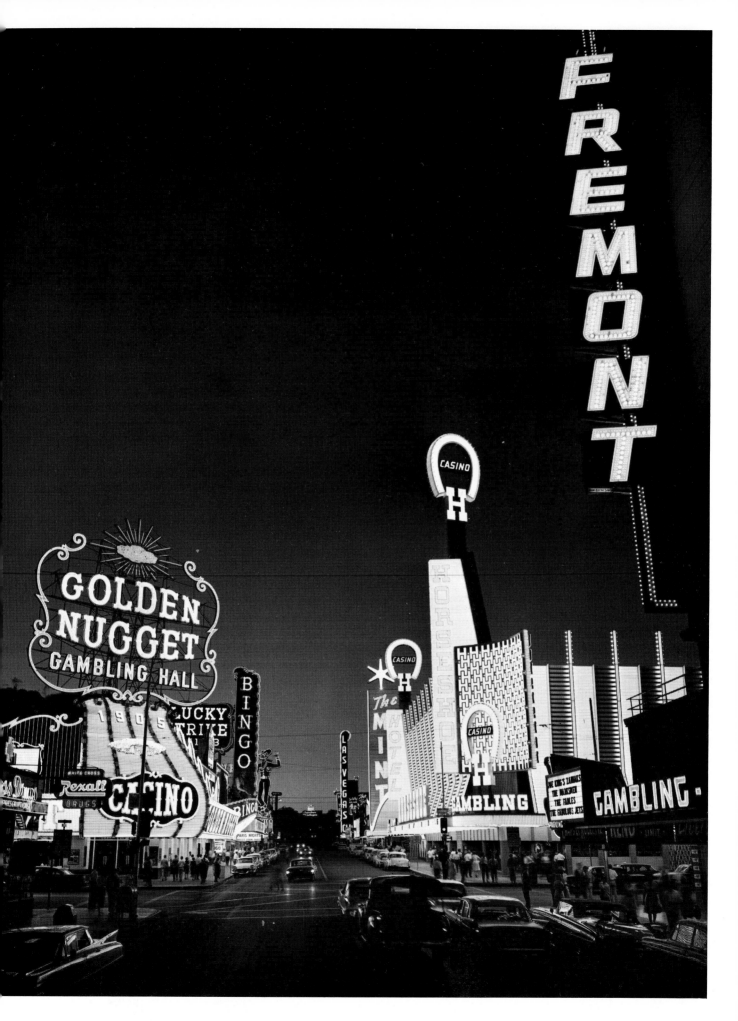

Modern Las Vegas is indeed "The Streamlined City of the West." Fremont Street *(right)* is still the heart, with the station at the northwesterly end. The railroad yards and facilities lie to the northwest, and beyond one of the residential areas is Mount Charleston where winter skiing is enjoyed.

As epitomized by the map, Las Vegas' greatest expansion in the entertainment field, has been to the south along the area known as "The Strip." There, lavish new hotels, such as that of The Dunes *(below)*, cater to every need of the traveling and vacationing American public. *(Above: Union Pacific photo; bottom left and right: Las Vegas News Bureau.)*

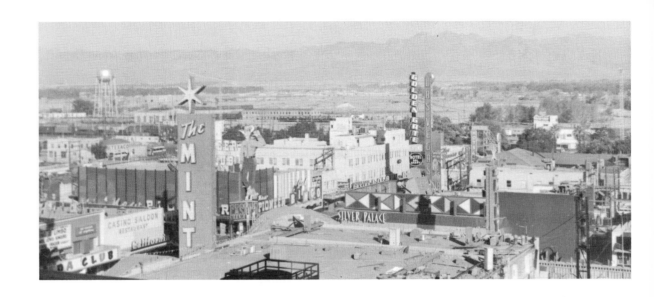

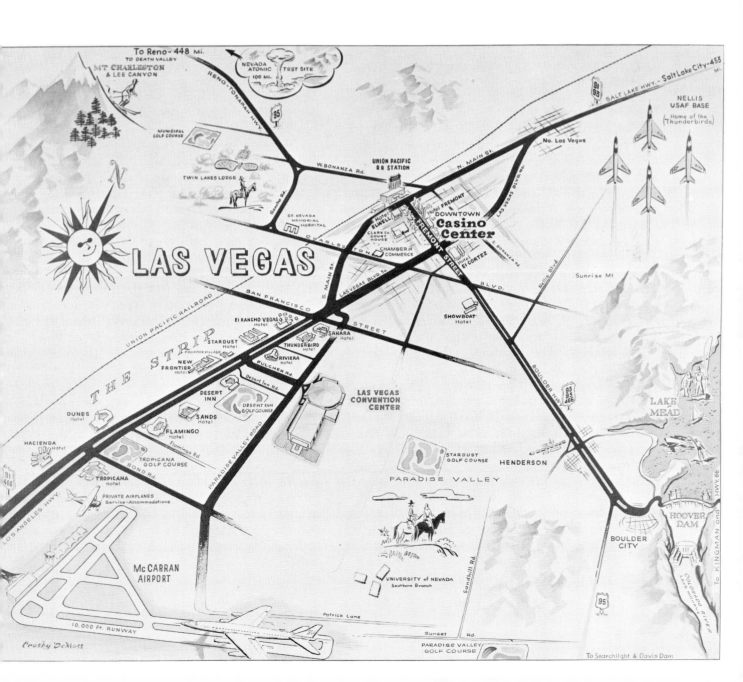

after that road had been formed in 1899. At that, they had been returned for correction, thereby casting a cloud on their acceptance as valid.

In view of the intense dispute, the maps were removed from the files in Washington, D.C., and forwarded to the Registrar of the U.S. Land Office in Carson City, Nevada. Following a four-day hearing in the early part of April 1901, it was decided that the Clark claim should be upheld as the SP, LA&SL maps had been the first to be filed. The diplomatic defeat only angered Harriman the more; he attacked on two fronts. A strong appeal was drafted and sent posthaste to the Secretary of the Interior in Washington, D. C. At the same time, men were assembled and sent to Uvada to hold and repair the railroad grade.

On Sunday, April 7, the first group under OSL Superintendent Joe Young arrived and were put to work restoring the old grade. Whittemore, Clark's attorney, got wind of the movement and hurried to the site. Arriving on the noon train that same Sunday, he rounded up a working force to hold the Salt Lake Route's claim to the grade on the Nevada side of the state line. Apparently the OSL effort, being premeditated, was the better organized. By offering fantastic rates of from $10 to $20 a day, the OSL was able to induce some of Whittemore's teams to transfer their allegiance to the other side, and by 4 o'clock in the afternoon the restored OSL grade had been advanced to the state line.

Here positive resistance was encountered. With uplifted shovel, Whittemore and his small force attempted to hold the grade against the advancing OSL teams being urged forward by Supt. Joe Young, also armed with a waving shovel. For almost 20 minutes the seesaw action prevailed; then 100 OSL men rushed forward and swept the Whittemore men off the grade. Temporarily defeated, Whittemore fell back to reform his lines at a more strategic position farther down the grade.

The next day both sides were busy in nearby Panaca trying to hire every man and team that could be found in the area, offering most generous wages. The OSL was rushing materials to Uvada, and a temporary track was being laid on the restored grade with ties four feet apart. W. H. Bancroft of the OSL, following a conference with Harriman in New York, stated explicitly that construction on the line would not stop until tracks had reached Los Angeles. Prevailing local opinion differed, however, for the citizens felt that the OSL would only build to Culverwell and that, had it not been for Clark's competition, the OSL would

never have scratched the surface of the roadbed. In fact, had Clark given in and ceased his efforts, the local people would not have been surprised to see the rails immediately taken up as had happened at Milford in the 1890's.

Possibly their feelings were right; possibly they were wrong — conjecture can lead to a variety of justifiable conclusions. It would appear, however, that Harriman really was ready to build all the way to California. During the early part of April the OSL formed the Utah, Nevada & California Railroad (of California) to build the extension from the Nevada-California line to Los Angeles, and on April 16, 1901, the OSL exercised its long dormant option to purchase the Utah & Pacific. Obviously, this time, no loose pieces were going to be allowed to get away.

By April 17 the OSL had laid five miles of track as far as the big gully at Horse Shoe Curve, and five more miles were ready to be laid just as soon as a bridge over the gully was finished. Crestline was to be the first station in Nevada. Men were pouring into the area to work for both sides — some were armed, a fact not welcomed by the local people. The Clark forces were the more unpopular, being criticized for destroying the grade in places and filling the cuts with trees as they retreated. No credit was given for the fact that these were merely short-lived efforts to hamper the "enemy's" progress, and that immediately after establishing their new camp at the first cut on the north side of Tunnel No. 1, their work could be confined to repairing the grade to the west.

J. W. Bracken, in charge of the Clark forces, had an advance group working in Condor Canyon (near Pioche) repairing the old 1890 grade. The following week the situation was the same except that OSL surveyors were running lines through Condor Canyon in an attempt to head over Bristol Pass, 17 miles northwest of Pioche near Jackrabbit. By utilizing this route, the Meadow Valley Wash, long considered a treacherous location for a railroad, could be avoided.

Finally, on April 24, 1901, a telegram was received announcing that Secretary of the Interior Hitchcock had reversed the ruling of the Land Office in Carson City and awarded the right-of-way to Harriman and his OSL. Hitchcock found that the four maps filed by the OSL-UN were the earliest to be approved (May 3 and June 7, 1890) and, in spite of the fact that it had been 11 years since their filing as against only five years since the filing of the U&C maps, the OSL's failure to operate a

railroad within five years of filing did not necessarily forfeit their rights. A long list of court decisions was cited in support of this contention. Hitchcock also found that, in contrast to the amount of work actually performed by the OSL-UN in 1890, the little effort put forth by (Clark's) U&C was "not enough to amount to more than a colorable attempt to construct a railroad."

The decision bolstered the confidence of the OSL men. Technically they had the right to build a railroad in accordance with the route maps previously filed; legally they had no right to the grade which (tentatively at least) was still owned by Clark's U&C. And the Clark people were in no mood to surrender.

Two days later, on Friday afternoon, OSL Supt. Young tried to rush the 70 Clark men off the grade with a frontal attack consisting of 32 wagons loaded with ties. When the head team tried to cross the line, Clark's Virgil Kelly stopped it. Supt. Young then called on Sheriff Johnson (who "just happened" to be among a group of spectators) to arrest Kelly. Kelly asserted that he was on his own property and had a right to keep anyone off, but that he would submit to Johnson's arrest providing proper service was made. Even as the two men were talking, an attempt was made to drive a team over Kelly, but other Clark men came to his aid. The sheriff then produced a dispatch from the District Attorney at Delamar dated the preceding day (April 25) advising that Clark forces had no right to the grade and that Sheriff Johnson should appoint as many deputies as were necessary to see that the work was not impeded. Kelly objected that the dispatch was not in legal form and therefore not enforceable. Meanwhile, during this discussion, OSL teamsters were rushing down the hillside for the grade, while Kelly's men were stopping them as fast as they appeared. In the words of one reporter, "One of the best stops was made by Lafayette Woods who caught a team, was lifted in the air, carried downhill for 20 feet, when rescue came." Ultimately, after about two hours of effort, a mule team finally got on the grade and carried the Clark men away so that the spot was defenseless, and two OSL teams rushed in and took possession.

In the aftermath of battle, an agreement was reached whereby the Clark forces were to withdraw two miles down the grade, at which point they were not to be disturbed until removed by civil process. Notwithstanding the claims of certain Salt Lake papers that the fight was a fake, witnesses at the local scene assured one and all that the affray was most genuine. In fact, a week later there was another vague news dispatch of a terrible fight; but the basic, physical "war" for the right-of way" was over by the middle of May, and the OSL forces continued to repair the grade and lay their track toward Culverwell (Caliente).

Although beaten in the field, the Clark forces still held tax title to the property, and the OSL made every effort to have the Commissioners reverse their previous decision. On May 5, 1901, a

meeting was held before a capacity audience which carried over the afternoon hours and continued, following a pause for supper, until 10:00 P.M. An agreement was reached which confirmed the sale of that portion of the old right-of-way between Culverwell and Pioche to Clark's U&C, but which postponed any decision with respect to the most disputed portion of the route from Uvada to Culverwell pending a court decision concerning the validity of its title. Should the latter segment be sold privately, the Clark interests would be given first preference at the time of sale. Quite naturally the OSL was most displeased with the arrangement and immediately filed suit against Lincoln County in an attempt to regain its former title to the property.

Even though the contest had boiled down largely to a legal battle, the struggle was definitely not yet over. As one reporter expressed it: "Both sides are active, and when they go to sleep they keep both eyes open." OSL forces continued diligently to restore the grade, and both sides were buying rights of way from the ranchers in the area. By early July Harriman's OSL tracks were within 15 miles of Caliente (as Culverwell was now being called), and the legal controversy still raged. Clark's attorney, Whittemore, charged that the OSL maps were fraudulent; a hearing was ordered; but no decision could be expected before September. Conversely, the OSL was suing the Clark organization and obtained an injunction to keep them off the Uvada-Caliente grade and prevent them from interfering with the work. Such progress as was being made was accomplished slowly, so a night shift was instituted in one place to help speed it up. When the section of road was finally opened for the 42 miles from Uvada to Caliente in August 1901, Whittemore (Clark's attorney) immediately obtained a court order restraining the OSL from entering on the next portion of its right-of-way from Caliente to the California state line.

In spite of earlier objections to constructing down the Meadow Valley Wash (Caliente south to Moapa) as a treacherous place to build a railroad, it became equally obvious to both the OSL and the SP, LA&SL after careful surveys and study that it might be the best of the possible routes. Any trackage out of Caliente northwest through Pioche would encounter difficult grades over Bristol Pass before turning south again, grades which would bring with them incessant operating problems. The treacherousness of the Wash might be the lesser of the two evils as well as a more direct route.

Clark was the first to act on this theory. In July 1901, while the battle was still raging over the Clover Valley line to Caliente, he awarded a grading contract to Deal Bros. & Mendenhall for the construction of 60 miles of line down the Meadow Valley Wash from Caliente to Rox. Placards were posted all around the area for "Men Wanted" at $2.25 a day less 75¢ for board, and over 100 men and many teams were signed for the job, such force being augmented with as many additional men and teams as could be procured. By August the force had been increased to 300.

The OSL, on the other hand, was in a difficult position. It needed all the men it could find to work on the Uvada-Caliente line to finish that section of track, so only a token force of about 30 men could be spared to work in the Wash. At that, the injunction was against them. While it was relatively easy to ignore the U.S. Marshal and keep on working, it was quite a different matter to deal with "Mayor" Culverwell. When the OSL commenced laying rails on his land without permission, the "Mayor," backed with a broad-gauge shotgun, quickly put a stop to all that nonsense. He told the men they could have all the land they needed, but that he wanted his money *first* before they tore up his land.

By September 1901 both groups were grading down the Meadow Valley Wash with a vengeance, the OSL (Harriman) line following the west bank. When Bancroft, boss of the OSL, arrived in Caliente on a three-hour mystery trip one Sunday, rumors circulated that work was to be suspended. Others contended that more men would be put on. Still another story circulated that Clark had bought the OSL from Salt Lake to Caliente. Everyone was guessing; no one really knew.

In actuality, both railroads brought in more men to work on their respective lines. Then in October the OSL sent 200 men north to another construction job in Idaho. Suddenly, in the middle of November 1901, both sides halted work. The SP, LA&SL had almost completed its grade from Caliente south to Kiernan's Ranch, 25 miles, while the Harriman forces (OSL) had four grading camps stretched over the next 40 miles south of the Ranch.

Obviously, something was going on behind the scenes, and the public was not being informed. What was more, they would not know the full story until 1907. All that could be said definitely was that things were very quiet in Nevada; aside from

a moderate amount of surveying, there was no activity of any nature. Moreover, there would be none until construction was resumed in July, 1903, some 19 months later.

For the privileged few who could look behind the scenes, the situation had a lot more meaning. Work had been halted due to the declaration of a truce, during the course of which arrangements were made for parallel surveys to be performed by both roads. Through an odd quirk of fate, H. M. McCartney, (the engineer who had performed a large part of the UP's early survey work on the OSL&UN's projected southern extension to Los Angeles and the man who had been so summarily discharged by the UP at the time of its financial difficulties in 1891) was the engineer selected by the SP,LA&SL to complete its surveys. In a letter dated November 7, 1901, T. E. Gibbon, vice-president of the SP,LA&SL instructed McCartney to commence a survey starting from a point four miles south of Caliente and running southwestward for 115 miles to the vicinity of Las Vegas, thence onward through Bird Springs Pass (the approximate Salt Lake Route of today). Gibbon also directed McCartney to work with the UP engineers who would be locating their parallel Utah, Nevada & California grade to the east of McCartney's location, neither line to cross the other (a stipulation which appears oddly at variance with the earlier newspaper report that the OSL grade followed the west side of the Meadow Valley Wash). The two roadbeds were not to approach closer than 20 feet from each other, and at any point where they were less than 50 feet apart, they were to be at the same elevation.

For the best part of a year the locating engineers of both roads remained in the field, and until late in 1902 all appearances indicated so little activity that some people were convinced that the Milford story would be repeated all over again and the project abandoned. Such, however, was not the case.

In the offices of the two railroads, considerable activity was being stimulated. Following the truce, negotiations had led to a compromise agreement dated July 9, 1902, calling for the sale of pertinent portions of the OSL to the SP,LA&SL including the main line of the former from a point near Salt Lake City to Caliente plus certain branch lines and even including the old Pioche grade which had never been completed. In exchange for these properties, Clark agreed to turn over one-half of his stock in the SP,LA&SL to the OSL (Union Pacific), resulting in

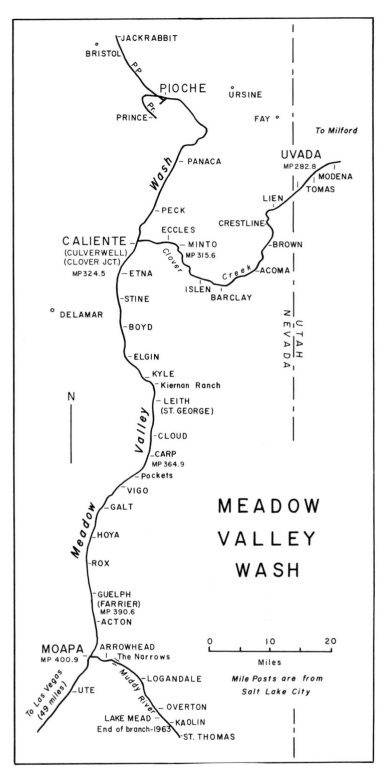

a joint Harriman-Clark ownership of the Salt Lake Route. Both parties placed their stock in a voting trust. The several railroad law suits, which had been postponed a number of times over the years, were finally settled without adjudication in June 1903, while in the same month four separate agreements were signed to complete the effective transfers contemplated by the original (July 1902) agreement. The extensive (and expensive) legal

maneuverings thus came to an end to clear the way for the more positive work of construction.

On July 8, 1903 work was resumed, starting at Caliente but rapidly spreading to both ends of the unfinished portion of the line through Nevada and California. Although the route as previously projected was to have extended all the way to the Southern Pacific at Banning (near Riverside), California, the later revisions contemplated a connection with the Santa Fe at Daggett and the use of that road's facilities from there to Barstow and thence over Cajon Summit to Colton and later to Riverside. Considerable construction was saved through the utilization of this routing with a consequent reduction in time as well.

Grading equipment began arriving in Caliente in August and the town took on a very cosmopolitan appearance with the arrival of crews of Greeks, Syrians, Austrians and Italians. Each nationality strove to live within its own group, speaking the jargon of its own particular language, and boarding one another in efforts to save the maximum amount of money possible. The Irish were the most ubiquitous, being engaged in virtually every occupation from bartending to shoveling. Tent cities arose around the headquarters of the various contractors, ranging in size and volume from the large tents for dining rooms, storehouses and stables to the smaller ones for bunkhouses and lesser facilities to the smallest type of individual habitation. With such a heterogeneous admixture of humanities and facilities crowded together within the narrow confines of a remote Nevada canyon, it was not surprising that a series of battles erupted among the Austrians and Italians, and likely most fortunate the strife did not spread to involve the other indigenes.

Rains hampered the work, yet water was scarce and had to be hauled in. (A few years later it was to become far too plentiful in this same location.) In spite of the 1,000 men on the job, there was a surfeit of saloons to slake the local thirst, resulting in such a disparity of business that some establishments voluntarily retired from the scene. "Ten day men" were very much in evidence, the turnover making it difficult for the contractors to keep a steady supply of experienced men on the job. The situation was definitely not improved when 23 Mexican workmen, sleeping in a boxcar at Caliente, were held up one night by two men. The fugitives were caught and taken to Delamar, but they escaped and boarded a northbound train out of Caliente. They were caught again at Milford,

but once more escaped, only to be recaptured for a third time still later.

By November 1903 the rails reached five miles south of Caliente, and late in the same month the track was at the Delamar pumping plant at Stine where a tramway was built to handle the coal for the steam power plant. Shortly after the beginning of 1904, the rails reached Kiernan's Ranch, but John Kiernan, who had settled there in 1876, failed to witness the event — he had died just a few weeks before. At the southwestern end of the line, 23 miles of railroad had been completed during the last few months of the year with the tracks stretching from Daggett all the way to Field, California.

The year 1904 was one full of construction for the Salt Lake Route in which its line was almost completed. Certainly no records were set, and there appears to be no particular explanation for the relatively easy progress maintained. At the southwestern end, 114 miles of rails were laid eastward as far as Borax, Nevada, with no particular obstacles of any major nature to overcome. When contrasted with the 500 plus miles of track laid in less than 10 months by the Central Pacific crews over 30 years earlier, the accomplishment loses all significance. At the eastern end, rails were finished all the way down the Meadow Valley Wash to Moapa in May, and trains began operating to that point. Work continued through the hot summer months on the remaining 49 miles to Las Vegas, although several weeks of time were lost while Utah Construction Co. gangs completed a large cut about 30 miles to the north of that point. In the middle of October rails finally reached town and the future metropolis was connected (to the east) with the rest of the world by rail.

It may come as a distinct surprise to some to realize that the city of Las Vegas (as we know it today) has been in existence a mere matter of decades, although the general area was known by the earliest settlers. Even before the Mormons established a short-lived settlement in 1855, the location had become a stopping place on the Old Spanish Trail from Santa Fe, New Mexico, to Southern California. After the Mormons departed, the place became little more than a ranch for almost 50 years, concerning which one visitor in the spring of 1877 was moved to comment that the almond and peach trees were very much in bloom. It was not until the coming of the railroad during the latter part of 1904 that the pastoral scene began to give way before the advent of workers and the

establishment of a bustling construction camp complete with 15 saloons. Evidence of the changing character of the times can be found in the warning issued to the citizenry to watch out for the large number of rounders and garroters prevalent in the area.

The next three months (November 1904 through January 1905) were busy ones as the rail heads neared each other and interest, tension and excitement increased. Gangs of men were busy at Caliente installing side tracks and creating an engine terminal. Another force of 100 was busy along the Meadow Valley Wash installing riprap to protect the tracks, an effort which was to prove futile in the war against the elements in the years to come. Trains passed back and forth over the line to Las Vegas carrying rails to "the front" and returning loaded with laborers, horses, Fresno scrapers, soiled tents and other paraphernalia being transferred to far away places as the contractors finished the various sections of their work.

Where heavy rock work impeded progress, temporary by-passes were built to permit traffic to flow around the point of difficulty. A five-mile, temporary shoo-fly had been built some 20 miles north of Las Vegas on the north side of the then incompleted permanent grade in the Garnet-Dry

Lake area (the tie-marks of the installation can still be seen today). Longest of these impermanent permanent ways was the 12-mile section extending from Arden to Erie to circumvent the blasting and drilling required to complete the lower grade, main line down the hill. Track laying on the shoo-fly began November 18, 1904, and a point just west of the present west switch of the Arden siding, and followed the progress of the graders until it reached the end of the temporary line at Erie (between the two switches of the siding) on January 11, 1905. Much of the right-of-way of this former by-pass, located to the south of the present main line, has been obliterated by latter day highway construction.

About the middle of January, a man sitting high on the frame of the track laying machine gave a yell as he spotted smoke in the direction of California, and the men knew the opposing track gang was not too far away. Excitement took over and helped to push the work two days ahead of schedule. Finally, in the afternoon of January 30, 1905, an unidentified Greek laborer drove the last spike as the rails were joined at the entrance to a deep cut near Siding No. 31.

Although there was no official, public ceremony attending the joining of the rails, Harry C. Carr,

then a staff correspondent for the *Los Angeles Daily Times,* was on hand at the event to note such recognition as was accorded the incident — including a touch of feminine frivolity. For Mrs. Wells, wife of the general manager, had been disappointed. There had been talk of a full-fledged, gold spike to be made in traditional manner from ore found in the grade of the railroad in the Meadow Valley (one sample assayed $17 a ton), but the plans had been discarded as superfluous. The last official spike was to be no different from any of the others, much to Mrs. Wells' disgust, so she took matters into her own hands and had a tiny gold spike fashioned in regulation shape and form. At the ceremony, after the last regular spike had been driven, Chief Engineer Tilton rather sheepishly fished Mrs. Wells' miniature spike from his vest pocket and, according to her instructions, pushed it into the last tie with his thumb. A cheer arose from the engineers on the job which was echoed in five different languages by the track workers who had done the back-breaking work on the line. Then, climbing aboard the engine held in readiness, the engineers rode the first locomotive to cross the finish line.

The exact location of the incident has been lost over the years. Regrettably no one had the foresight to erect a marker at the time of the joining of the rails. Careful analysis has narrowed the location down to two points in close proximity to each other, and both are described in detail for the benefit of future researchers.

The first report (passed on by old-timers) places the meeting of the rails at Engineer Station 7954 + 00, the site being confirmed by old Salt Lake Route maps and profiles as well as by the personal knowledge of a roadmaster who pointed out to an I. C. C. inspector in 1914 that cross ties of California redwood had been used by the track forces working eastward from Daggett, while ties of Oregon pine had been used by the track gangs heading west from Las Vegas. The line of demarcation between the two kinds of ties coincided with this Engineer Station, which is located 1,654 feet east of the backwall of the present culvert No. 305.98 and is just a short distance east of the east switch

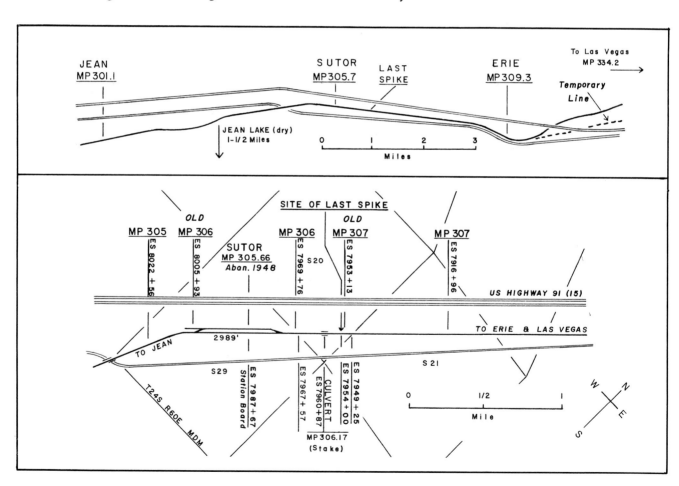

of siding No. 31 (undoubtedly the former Sutor siding, abandoned in 1948).

The second report places the point of connection at Mile Post 309.50 (measured from Los Angeles) which is situated near Erie, about 3.6 miles east of Sutor. This point of connection has also been described as 21.55 miles from the California-Nevada line (at Mile Post 287.95).

In spite of the fact that the rails now were joined connecting the two ends of the system, there was still a great deal left to be done to finish the roadbed and equip the line for operation. On February 9, 1905, the first through train was operated from Salt Lake south to Los Angeles under the scrutinous eyes and personal supervision of both Senator Clark and General Manager R. E. Wells, each in his own private car. Two months later, on April 15, the first through excursion was run for the benefit of the Woodmen of the World, to be followed a few days later by the inauguration of regular train service south from Caliente to Las Vegas and Los Angeles. On May 1, 1905, the line was considered to be formally opened for business, and solicitation of traffic was begun in spite of the fact that the new railroad was somewhat incomplete.

Track laying on the permanent main line between Arden and Erie began on April 11, 1905, at Arden. A 304-foot tunnel near Sloan impeded the progress of the work, so to move the job along as fast as possible the contractor built a spur from the shoo-fly track in a northwesterly direction to his supply camp and on to connection with the permanent grade at a point between Sloan and Erie. By May 26, 1905, the entire project — tunnel, grade and track — was completed all the way to Erie, and the temporary shoo-fly was abandoned. (In 1944 a moderate line change circumvented the tunnel, permitting its abandonment.)

Las Vegas, too, was having its growing pains right along with the railroad, so much so that the distant *Pioche Record* noted in February 1905 that "there appears to be unhappiness down at Las Vegas." The biggest trouble stemmed from the fact that even before the last spike had been driven on the railroad, a townsite had been surveyed and lots ranging in price from $60 to $300 had been sold to eager purchasers. Their eagerness, unfortunately, turned to disappointment and then to disgust when the buyers discovered that their properties were not part of the Stewart Ranch (then owned by the railroad) and therefore were not part of "official" Las Vegas at all. Some sympathetic understanding was generated a month later

when still a third townsite was developed, and for a time the suggestion gained favor that all the surveys be combined into one "Greater Las Vegas." Ultimately the "early birds" were given a second opportunity to participate, for a big auction of "official" Clark townsite properties was held under a spreading mesquite tree on May 15 and 16, 1905. C. O. Whittemore outlined the terms of the sale to the several thousand people gathered, among whom were a goodly number of purchasers. This auction is considered by many to be the beginning of the present-day Las Vegas.

The first newspaper, the *Las Vegas Times,* appeared in March 1905, and it was followed within a week or two by the *Advance.* Still a third paper, the *Las Vegas Age,* appeared in April and, possibly to its financial chagrin, admonished in an early issue: "The press throughout the country should warn persons of scant means against coming to Las Vegas at the present time . . ." Apparently there were sufficient residents of substantial means to support the town's first dance, for all papers declared it an unqualified success attested to by the fact that 100 people from Pioche came down on a special train out of Caliente to enjoy the music of a band especially "imported" from Los Angeles.

Hardly had the Salt Lake Route been completed than it began to be plagued by a series of increasingly disastrous washouts. In July 1905 a storm-weakened bridge 30 miles north of Las Vegas was responsible for a train wreck. Over the following two months a sequence of minor flood ravages occurred.

The next year on March 24, 1906, a four-day storm commenced that took out entire sections of the line in Meadow Valley between Hoya and Minto. Even Superitendent Van Hansen's car was lost, and Van Hansen was obliged to walk back to Caliente in the best manner possible over the soggy ground. For more than three weeks the line was inoperative, and it was not until April 15 that traffic was resumed.

In 1907 the havoc was even worse. Toward the end of February one of the worst storms yet to strike sent a five-foot wall of water down the Meadow Valley Wash taking out bridges, ties and rails and scattering timbers all along the right-of-way. A work train was wrecked and four men were killed. Nor was the damage localized. The storm extended over several states; and at the western end of the line, between Otis and Daggett in California, the grade was completely washed out leav-

Modena and Uvada *(left, top and center, respectively)* were the immediate objectives of the Utah & Pacific (OSL) in 1898. Uvada was virtually astride the Utah-Nevada state line and was the gateway to the Clover Valley, down which the railroad ran *(below)* to reach Caliente and the Meadow Valley Wash. Also down the valley flowed Clover Creek which *(right)* occasionally reached flood stage with disastrous consequences to the railroad as was demonstrated between Eccles and Minto in 1907. In the panorama, note the smoke of a SPLA&SL train behind the ridge. *(Bottom, left: Sewell Thomas Collection; right: A. Chesson photo, W. B. Groome Collection.)*

Clover Valley, Nev.

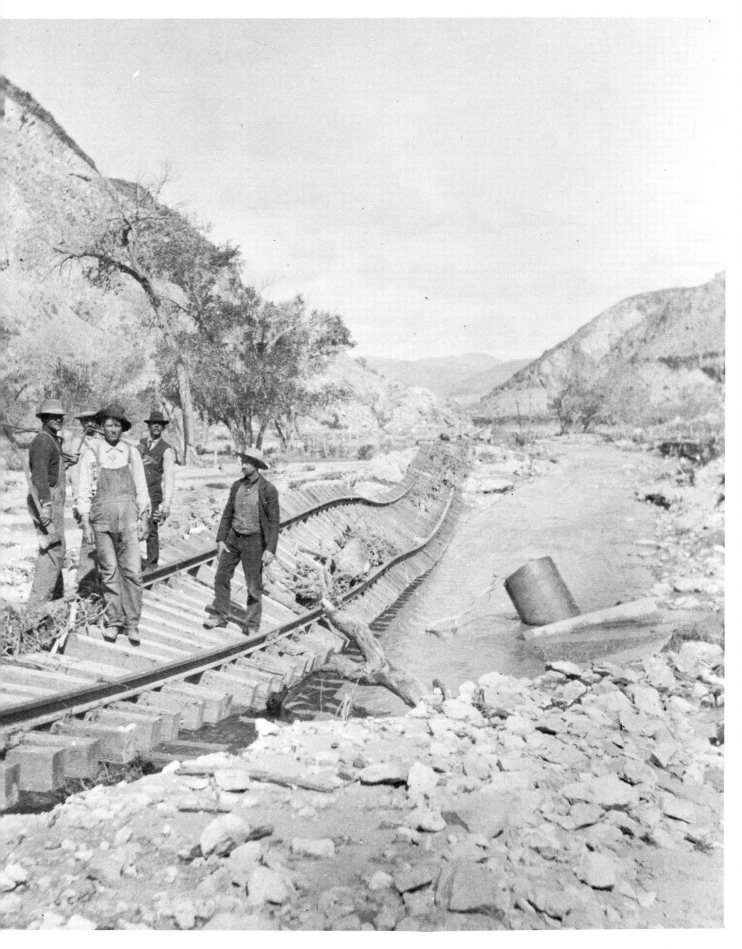

Caliente, Nevada, was located at the junction of Clover Creek and the Meadow Valley Wash, an updating and railroadization of the former hamlet of Culverwell. Even after 60 years of changes and improvements, the original station (top, left) still stands in testimony to its sound construction although now used as a hospital. The more glamorous station-hotel (above) replaced it many years ago. The latter may easily be spotted along the Salt Lake Route's main line to the left of center in the panorama (bottom, left). The view looks south down the Meadow Valley Wash. Clover Valley adjoins it to the east (rear left from camera). The branch from Pioche may be seen entering from bottom right with the switch for the wye with the main line at bottom left.

In an almost diametric view (below), the camera points toward the northern reaches of Meadow Valley extending behind the ridge at center, right. The cut of cars beyond the roundhouse stand on one leg of the wye, while the southern leg passes just in front of the nearest white roofed house at center left. Main line crosses in foreground—left to Caliente station and on to Los Angeles, right to Clover Valley, Uvada and Salt Lake City. Branch up Meadow Valley in center background extends to Pioche. (Bottom, left and right: Frank M. Scott.)

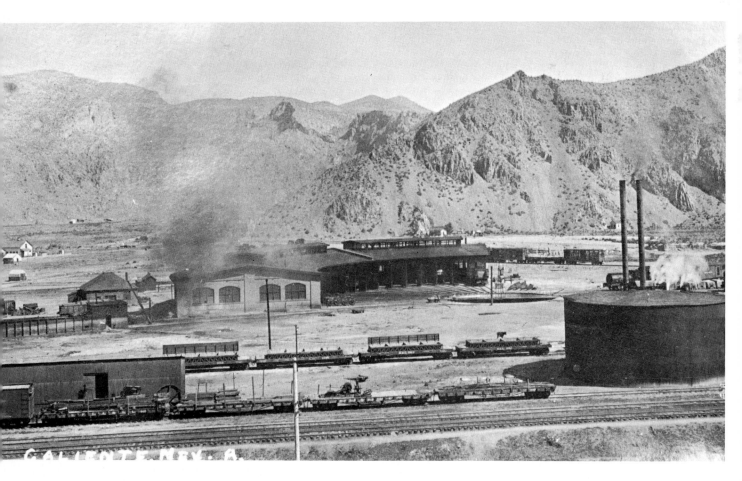

Elgin Nevada

Elgin, Nevada *(top, left)*, was an important water stop on the Salt Lake Route, situated 19 miles south of Caliente in the Meadow Valley Wash. Note the shallow elevation of the original roadbed above the stream, a costly error in judgement as evidenced by the roadbed in the contra view *(bottom, left)* of the same location following the 1910 floods. The Wash was an ideal spot for train watchers and photographers, as witness the spectacular early view of the *Los Angeles Limited (above)* with No. 412 on the head end, or the mid-century (1947) action portrait of Train No. 38, the *Pony Express*, with UP 4-6-6-4 articulated No. 3981 at the head end of 15 cars of mixed consist. *(Top, left and right: Sewell Thomas Collection; bottom, left: J. Lee Rauch photo; bottom, right: R. H. Kindig photo.)*

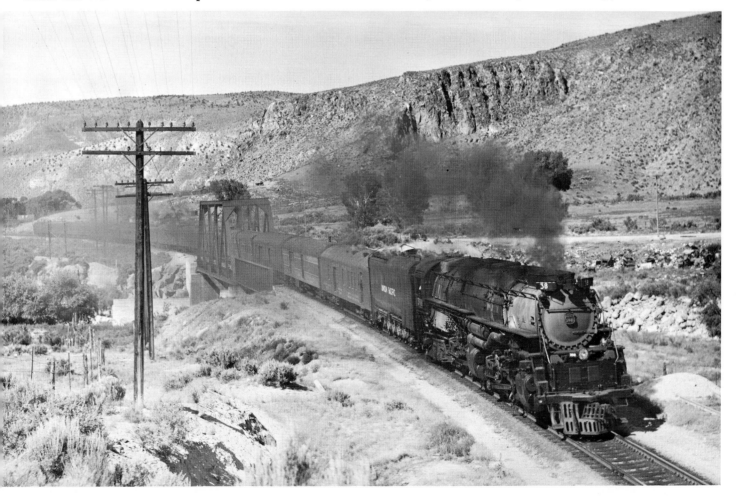

Between Elgin and Carp the ruggedness of the Meadow Valley Wash abated somewhat, and the railroad was largely able to get a dry foothold on the valley floor. The eastbound passenger train (top, left) is shown near Leith and heading toward Caliente over the old, original alignment, while the freight (top, right) has spliced in a helper five cars behind the lead engine to combat the grades. Four-man section crews (bottom, left) regularly inspected the track for possible deficiencies, the abundance of muscle power being most helpful on the eastbound climb. Carp (bottom, right) was a coal and water stop as well as a station and section headquarters, and was particularly important at the time of this 1925 photo due to the presence of the boss' business car which is parked on the siding. (Bottom, right: H. Bennett photo, W. B. Groome Collection; all others: A. Chesson photos, W. B. Groome Collection.)

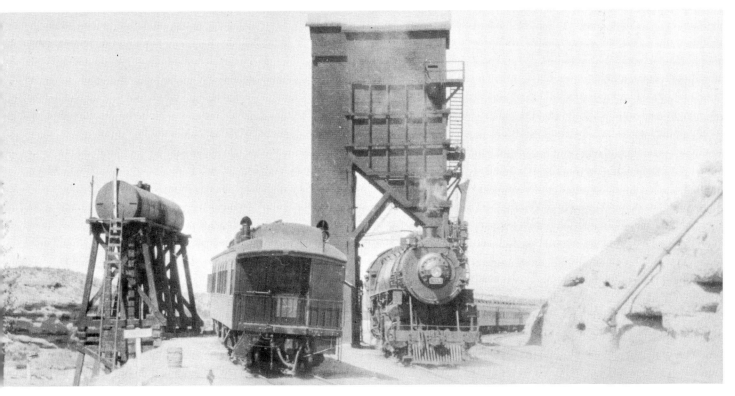

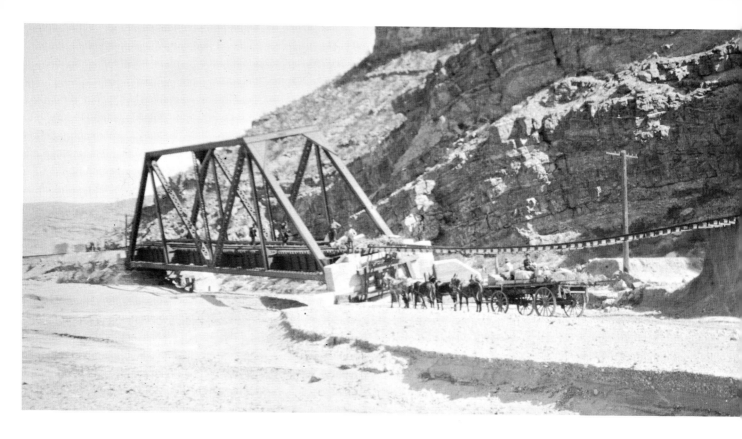

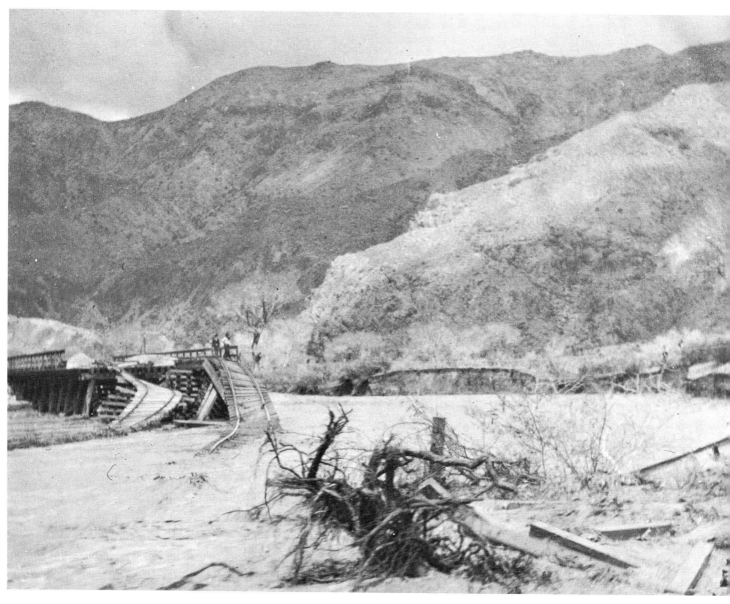

Although the Salt Lake Route built its original line through the Meadow Valley Wash as high as appeared to be necessary, Mother Nature quickly proved the fallacy of taking matters at their face value. A series of disastrous floods during the early years of operations brought devastation and hardship, while the prolonged interruptions to traffic made the financial burden doubly difficult to bear. Bridges and embankments and trestles were washed out or carried away. The softened roadbed caused several wrecks. Here the crew escaped injury, but had to walk home. Even little Clover Creek demonstrated its ferocity *(left)* under the stimulation of desert cloudbursts. *(Top, left and bottom, right: J. Lee Rauch photos; bottom, left and top, right: A. Chesson photos, W. B. Groome Collection.)*

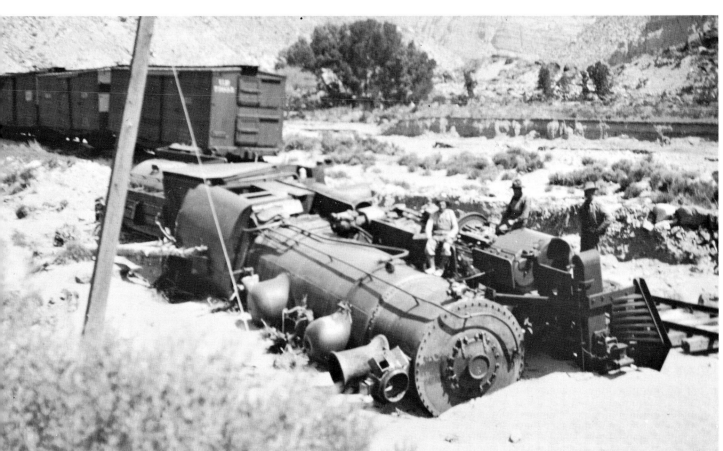

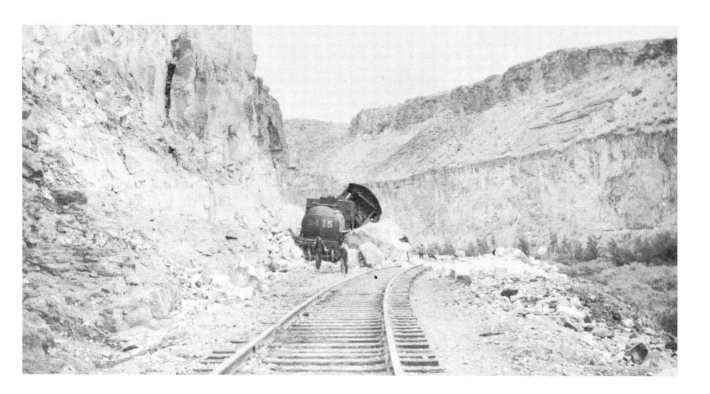

Other types of calamity also took their toll. On this page, engine No. 3415 tried to climb over a rock slide at the west end of Huntsman Canyon just west of MP 395 without success. To get traffic moving as quickly as possible, crews leveled the outer edge of the slide, cut the rails behind the locomotive and swung the track outward for the start of a shoofly around the obstruction. Later, cranes lifted the engine back on the rails to be towed to the shops for repairs. (Both: L. C. Williams photos, W. B. Groome Collection.)

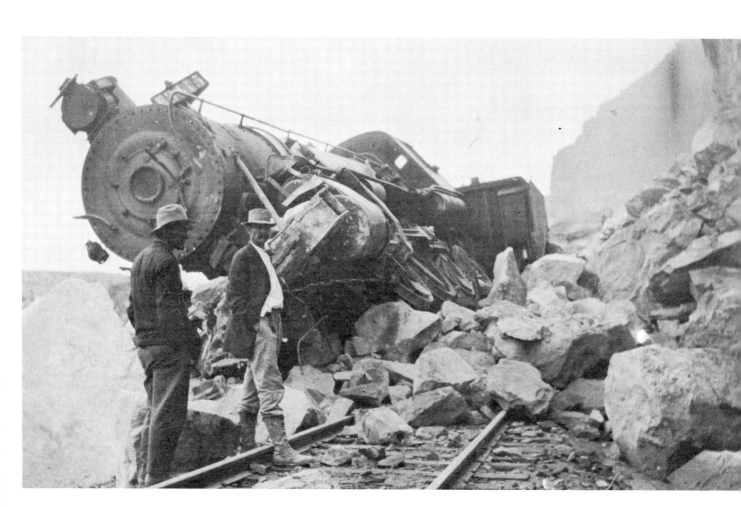

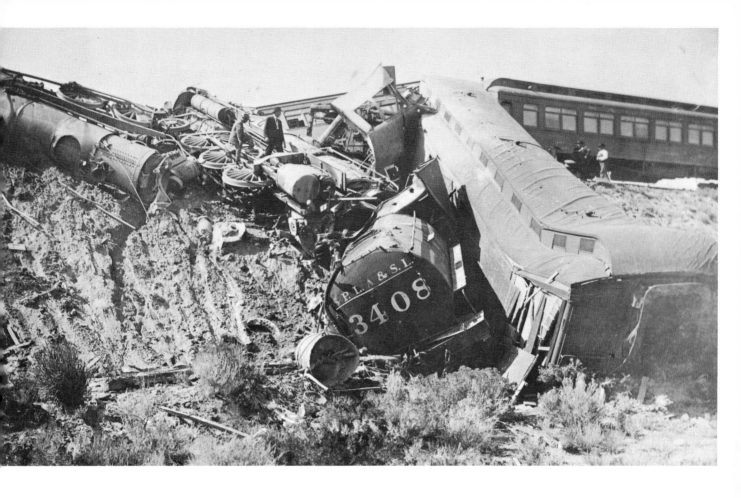

In 1909 two opposing trains disputed the single track right of way on the Utah end of the Salt Lake Route to create these scenes of destruction and ruin as a result of their "cornfield meet." Modern signalling and safety appliances have virtually eliminated such happenstances today. *(Both photos: Robert Edwards Collection.)*

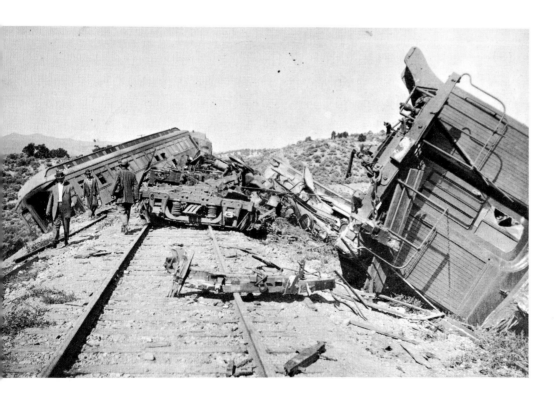

ing Las Vegas marooned until a detour could be arranged over the Santa Fe from Daggett to Ludlow and thence via T&T north to Crucero where home rails were once again reached. The tie-up lasted for six weeks, during which time the *Las Vegas Age* almost continually harrassed the railroad by contending that the Moapa (lower Meadow Valley) farmers had lost fortunes because the washed out railroad did "not fulfill the purposes of a common carrier." It failed to commend the over 1,000 men working to restore the flood damage, and never mentioned the risks of restoration, such as the time two men were killed when a railroad crane fell at Afton, California, or the feeling of discouragement when another rain fell so hard it washed the tracks out and they had to be repaired again.

Finally, on April 12, 1907, service was restored, and during the ensuing first week of operations 44 trains, averaging 30 freight cars each, passed through Las Vegas. A corps of 20 civil engineers was sent out to look for a new route, while Senator Clark personally inspected the Meadow Valley Wash and the damage wrought. In May he pronounced his judgment — the railroad would remain in Meadow Valley, but by raising the grade in some places and by diverting the channel of the stream in others, the railroad's problems should be over.

"Big Jim" Shanahan was the engineer placed in charge of reconstruction. After checking with a number of old-timers who had been living near the Wash for 40 years, he determined to raise the new grade a full four feet above the 1907 high-water mark. "I'll build you a road which the old Wash will not carry away," he declared, "and I'll build it in the valley." Unfortunately he failed to heed the words of one aged Indian. "Water up here," said the Indian pointing high up the side of the canyon. The engineer laughed and pointed to a lower line saying, "No, no, high water here."

By the fall of 1907 eight new, steel bridges had been ordered and an army of 700 men were busy rebuilding the railroad through the Meadow Valley Wash. The grade was realigned in several places; the river channel was changed through the use of riprapping. Total cost of the project was $769,572. It was no small wonder that Caliente boomed with the proceeds of the worker's paychecks.

For two years it appeared as though "Big Jim" had fulfilled his promise and that the Salt Lake Route's water troubles in the Meadow Valley were over. Then came the big flood of 1910. The *Los Angeles Limited*, eastbound to Salt Lake City, paused at Las Vegas on New Year's Eve, December 31, 1909, and never went any farther. It did not reach its destination until 6 months later in June 1910. As in 1907, the storm was widespread and caused considerable damage over a broad area. At the western end, the joint trackage (Santa Fe-Salt Lake Route) over Cajon Pass in California became blocked by a landslide; at Afton (west of Crucero) the SP, LA&SL was washed out necessitating use of the previous detour via Ludlow (SF) and Crucero (T&T) for a period of several weeks. Fortunately for the Salt Lake Route, the T&T's damage was largely confined to the more northerly areas around Silver Lake and the Amargosa Canyon at Tecopa; the detour route was relatively untouched. As was to be expected, the heaviest Salt Lake Route damage was suffered in Clover Valley and down the Meadow Valley Wash. In this area the flood topped its 1907 crest by eight feet, and all of the extensive repair work accomplished in 1907 was wiped out. Thousands of ties, bridge timbers, parts of houses and every conceivable kind of wreckage went hurtling down the Wash. From Crestline (in Clover Valley) all the way to Guelph (10 miles north of Moapa) the railroad was almost completely washed out for a distance of 100 miles. The damage was staggering.

One 30-car freight train had left Caliente that night and had been overtaken by the flood at Boyd, 15 miles to the south. The engine and 22 cars of the train were lost in the flood, while the crew narrowly escaped by taking to the hills. Ultimately they made their way to Guelph two days later, having been thoroughly soaked and without any food or sleep in all that time. A relief train, started northward toward the Wash, became marooned for several days above Moapa. Agent Butterfield at Rox was almost drowned while attempting to rescue the body of a man. At Leith and Elgin the agents' families were only rescued with great difficulty (the wife of the agent at Elgin gave birth to her baby the day after the rescue). At Caliente the depot was undermined and the roundhouse was flooded to a depth of four feet. Up the grade toward Pioche, two feet of ice and water covered sections of the line.

Immediately following the debacle Senator Clark took positive action to reassure the people that the railroad would continue without change of management. "I undertook this project with the intention of giving Southern California a first-class rail-

road over a short, natural and practical route," he said, "and I intend to stay with it." The problems were many, difficult and protracted, but solutions were reached.

Primary consideration was given to possible alternate routes outside of Clover Valley and the Meadow Valley Wash, and surveys were made. One line to the north and west would leave the old main at Tomas, five miles east of Uvada, Utah, and head due west to the Pioche branch, thus avoiding the previously bitterly contested Clover Creek section entirely. Then, branching off again near Panaca (just below Condor Canyon) it would head for Delamar and follow the Pahranagat Valley south to Dry Lake to rejoin the old main. The corresponding east-south alternate was plotted to leave the old main at Modena, Utah, head south to the Virgin River on the Utah side of the border, thence follow the Virgin River to the vicinity of St. Thomas before circling back northward to rejoin the old main near Moapa. By the middle of February, however, when all of the reports were in, it was still obvious that the quickest way to restore service would be to repair the old line down the Meadow Valley Wash; then later, if deemed necessary, a new line could be built.

As a consequence of the decision, five work trains were set to work tackling the lower end of the Wash, while the Utah Construction Co. was called back to work at the upper end near Caliente. For a month all work was concentrated in Meadow Valley to the exclusion of Clover Valley, as there was still a possibility that the northern connection to Pioche might be built. Ultimately it was decided to maintain the old alignment and the Clover Valley line was replaced.

On April 1, 1910, the 20-mile section between Moapa and Hoya was reopened, and that month the forces under W. C. Fraizer, supt. of construction, were doubled to 3,000 men. Two SP pile drivers were conscripted into service, and the Santa Fe sent up an entire Bridge & Building gang from San Bernardino. Six months and $658,407 later, the line was finally reopened early in June 1910, and on June 11 the entire populace of Las Vegas turned out to watch the first *Overland* pass through on its way to Salt Lake City. The Salt Lake Route was back in operation.

Once again Clark was faced with a momentous decision. Which, if either, of the two alternate routes should be selected for a final permanent route, or should the railroad remain in the Meadow Valley Wash? It was a difficult conclusion to reach,

but finally the die was cast — the railroad would remain in the Wash, but it would rebuild on higher and safer ground.

Two more months were all that were required to organize the preliminary details, and in August 1910 contracts were let for a brand new High Line. Involved in the project were 10 new tunnels, 24 steel bridges, and the complete rebuilding of 74 of the 86 miles of line from Barclay in the (Clover Valley) to Guelph (near Moapa). Caliente once again enjoyed a boom for its 21 saloons due to the stimulation of outside payrolls, while five contractors' camps were located in the vicinity of Elgin in the Meadow Valley Wash. Aside from a tunnel cave-in which killed one man, construction proceeded relatively smoothly on the slopes of the canyon.

The basic problem still centered on keeping the old line on the floor of the Wash in operation. Minor washouts in January 1911 provided some interruptions in service, but starting March 8 floods raised such havoc in the vicinity of Caliente and Boyd that the *Overland* was marooned for 10 days. When the new High Line was finally placed in service in April 1912 at a cost of $4,448,681, the days of dramatic washouts became a thing of the past, although nature had one last major fling in March 1938 when floods tied up the line for three weeks, trapping a freight train near Carp. The big battle, however, had been won.

Appearances to the contrary, the story of the Salt Lake Route is not altogether one of legal and physical battles and of floods; it is also one of development and expansion, of services and of service. A separate chapter in this book has been devoted to the story of another Clark project, the Las Vegas & Tonopah Railroad, which stretched its rails northward from a connection at Las Vegas in 1905 to reach the developing gold bonanzas at Bullfrog and Rhyolite and the slightly older camp at Goldfield. A section of the chapter on Pioche delineates the story of the Salt Lake Route's subsidiary Caliente & Pioche, which built north from Caliente in 1907 to connect the centers of its corporate title. The coming of the Salt Lake Route stimulated the development of innumerable mining efforts in Southern Nevada which frequently resulted in the organization of small, independent connecting railroads such as the one to Yellow Pine (q.v.) or those others garnered under the chapter entitled "Salt Lake Supplemental."

The Salt Lake Route's influence also extended to the communities it served, and particularly to

that largest one in Southern Nevada which it virtually created — Las Vegas. In 1909 extensive yards and shops were installed, which were expected eventually to employ 400 or more people. To house that many employees and their families, the railroad organized a subsidiary Las Vegas Land & Water Co. in the same year to commence construction of 40 of an estimated 120 concrete block houses. A spur line was run from the old ice plant directly up Bonneville Street with tracks extending down each alley in order to bring material to the job. At the same time this subsidiary began supplying water to the community it was creating, a service which it continued until the property was sold in 1954.

The St. Thomas branch was another innovation long awaited by the residents of that area. Work began in the summer of 1911 at Moapa on the Salt Lake's main line. The first five miles of grading to The Narrows was a relatively easy task, but at that point heavy rock work was encountered which delayed construction appreciably. In spite of this, rails were laid as far as The Narrows to permit the operation of trains in time for the annual cantaloupe crop in August. Grading continued over the remaining 15 miles to St. Thomas, but further track laying was deferred until the High Line (up the Meadow Valley Wash) was completed. By the middle of March 1912 the last rail was spiked in place so service could commence, and June 7 was scheduled as the day for a full-scale railroad day celebration.

Even Las Vegas took due note of the event — the mayor declared the day a legal holiday so that all could attend. In spite of the fact that not everyone availed himself of the opportunity, at least 200 people boarded the special train which left Las Vegas at 6:15 A.M. Moapa was more enthusiastic as virtually the entire population joined the special on arrival, and still more squeezed aboard at Overton on the way down the branch. The arrival at St. Thomas was enthusiastic. The whole crowd watched admiringly as a special copper spike was driven which had been donated by the Grand Gulch Copper Co. Miss Mildred Anderson of Overton was crowned Queen of the celebration, the program for which included the usual rodeos, baseball game, and a "real old Southern barbeque." For a change of venue, the evening's dance was held in Overton (6½ miles to the north), following which the celebrants poured themselves back onto the special for the return to Las Vegas which was finally reached at 2:30 the next morning.

The following year (in 1913) a spur track was extended westward from The Narrows (St. Thomas branch) to serve the Moapa Gypsum Co. The event is noted for its chronological connection with the story, not because it played any vitally important role in the fact that 1913 was the year in which gross revenues of the Salt Lake Route exceeded $10 million and the road was able to show a profit for the first time. In fact it looked as though the company was about to come of age, a turning point which was further stressed in 1916 when the SP,LA&SL abbreviated its name to (simply) Los Angeles and Salt Lake Railroad. In 1919 another spur was added to the St. Thomas branch extending from Arrowhead eastward to the White Star Plaster Mill.

Two years later Senator Clark turned 82 years of age and was persuaded to sell his half interest in the LA&SL to the Union Pacific. This gave the UP complete ownership of a line which had not been especially profitable, although it did hold promise for the future. Included in the assets was the ownership of what was known as Terminal Island on the western end at the bay in East San Pedro, California. In exchange for the half-interest, Clark and his associates received 20¢ on the dollar for their LA&SL stock (or $2.5 million), and for their $29.5 million of Salt Lake Route bonds they received the equivalent in other bonds of like value.

Although Clark may have derived his satisfactions from the physical accomplishments of building and developing the Salt Lake Route, it is unfortunate he did not live to enjoy the financial fruits of this particular effort. In 1930-31 the Boulder City branch was constructed for the primary purpose of hauling building materials and supplies to the site of construction of the Hoover Dam (see Six Companies, Inc.), and for the next five years the line was a very lucrative source of traffic.

In exchange, however, the railroad lost the extreme, six-mile segment of its St. Thomas branch, for when the impounding of the waters in Lake Mead began, the days of St. Thomas as a community and a source of revenue became threatened. In 1938 and 1939 the six miles of track from St. Thomas back to Overton were abandoned and removed, and the area comprising the former town is inundated today during those periods when the reservoir is full.

From a financial standpoint, one of the most lucrative parts of the Salt Lake Route's economy has been a surprisingly non-railroad operation. At the far western end of the system, little "Rattlesnake

Island" had been developed into the railroad's terminal property at East San Pedro, California, and renamed "Terminal Island." In 1936 oil was discovered far beneath the layer of ballast, rails and ties and subsequent production yielded an income probably far in excess of the entire cost of the LA&SL Railroad.

As with any undertaking, the human element played an important part in the Salt Lake Route's development. The coming of the railroad made the vast area of Southern Nevada far more accessible to miners, although virtually no new, important mineral discoveries have resulted directly along the railroad's line. Undoubtedly the life of more than one desert prospector was saved during the early days of operations through the unofficial hailing of trains for unscheduled stops for water in the desert, but these humanitarian aspects of a mechanical operation were part and parcel of the railroading of that time and circumstance.

The human element frequently became humorous as well, particularly during the earlier days of the road. Take the instance of the passenger train which approached one of the stations on the line, only to jerk to a halt and back up before the platform was reached. Investigation revealed that the engineer had spotted his lost false teeth on the ground and had gone back to retrieve them. On another occasion an angry bull caused a series of reports by knocking a whole string of cars off the track east of Caliente. The *Los Angeles Limited* was the star of another incident when the engineer kept making unscheduled stops in response to the train signal. The conductor maintained he had no part in any pulling of the signal chord and berated the engineer for having all kinds of delusions. As the incidents continued to happen, the conductor began a car by car investigation to determine the cause but was unable to locate any source of trouble until the baggage car at the head end was reached. There, in strictly unauthorized fashion, was Jocko, a monkey, out of his cage and giving the professional sounding signals to the engineer, having previously observed the conductor making use of the signal rope.

Over the years the Salt Lake Route has refined its procedures, and the individuality of many of its practices have disappeared as the area has developed. Today it is the strong southwestern arm of the Union Pacific, and many branches have been added in Utah. The route was used in October 1934 for the initial part of the transcontinental scheduling of the UP's pioneer streamlined train which broke the Los Angeles-Chicago speed record previously established by Death Valley Scotty in 1905. Less than two years later (1936), regular streamlined train service was inaugurated on a weekly schedule which was faster by hours than the record set by Scotty. In recent years Centralized Traffic Control has been installed over the entire line, starting from Daggett in 1942 and reaching Salt Lake City in 1948.

Thus Clark's original objective to build a first-class railroad has been achieved in spite of difficulties, and the Salt Lake Route is now an important part of one of this country's great transcontinental railroads.

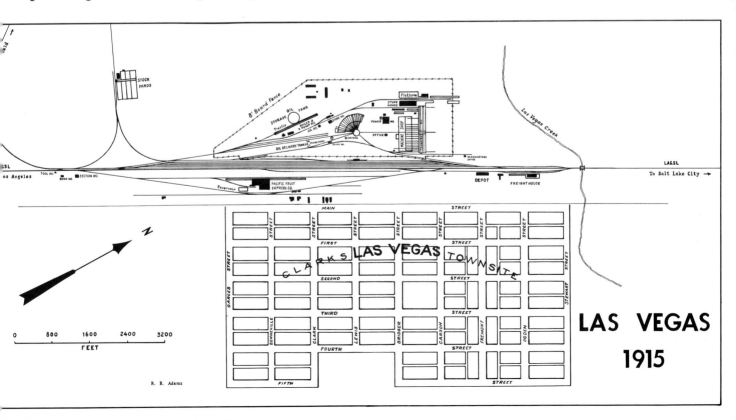

LAS VEGAS
1915

R. B. Adams

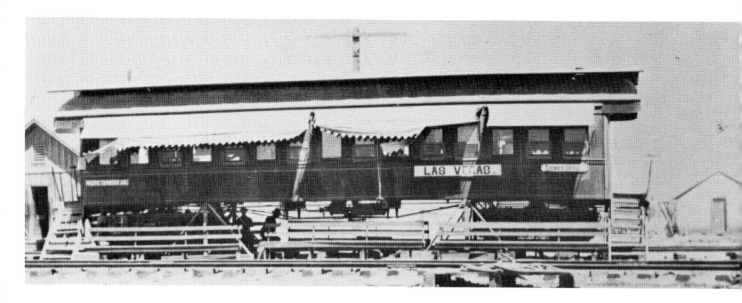

Regardless of the temporary crudeness of Las Vegas' first (1905) passenger station spotted on a side track just south of the location of the present station, the town has inevitably bulked large in the Salt Lake Route's economy both as a division point and as a formerly important junction with the Las Vegas & Tonopah Railroad extending to the gold fields to the north. The coach was quickly replaced by the large, two-story, combination station and headquarters building *(center, right)* which in 1910 appeared large in comparison with the town it served but entirely adequate for the two railroads which utilized its facilities. Upstairs in the building was the joint dispatcher's office *(top, right)*. The freight yards and other facilities *(bottom right)* included the engine terminal and extensive shops *(below)* seen in the process of construction. *(Top, left: Union Pacific photo; bottom, right: from* The Arrowhead, *California State Library; all others: Don Ashbaugh Collection.)*

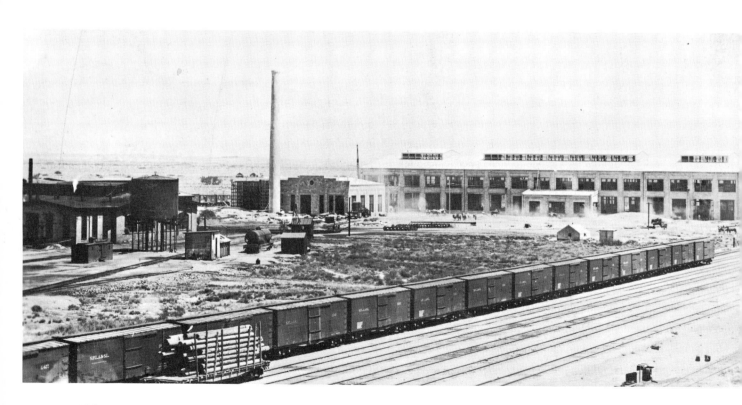

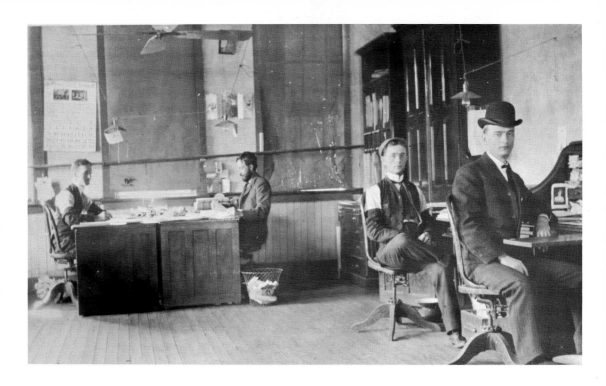

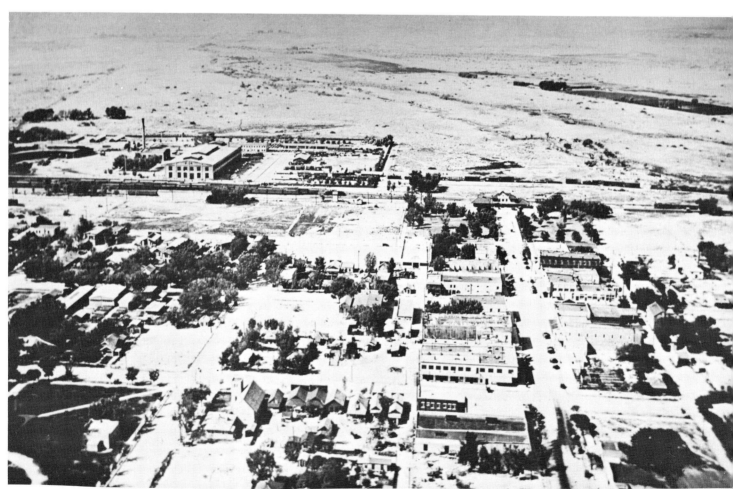

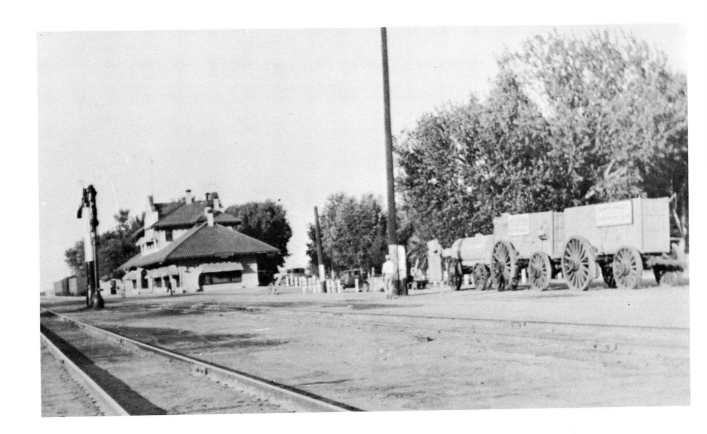

The architectural style of the second Las Vegas station was called Neo-Mission, having been borrowed from that of the early California Missions. At top left it is seen in gala dress to welcome participants for an early convention. In the earlier view (above) a borax wagon train from Death Valley is on display. The location of the station at the head of Fremont Street is plainly evident in the aerial view (left, below) which faces to the northwest. On the far side of the tracks toward left lie the extensive shop and engine terminal facilities. Coaling up (below) appears to have been a hand operation from this bin on the north side of the shops on the far side of the transfer table. (Top, left: Union Pacific photo; bottom, left: Las Vegas News Bureau; top, right: A. Chesson photo, W. B. Groome Collection; bottom, right: Don Ashbaugh Collection.)

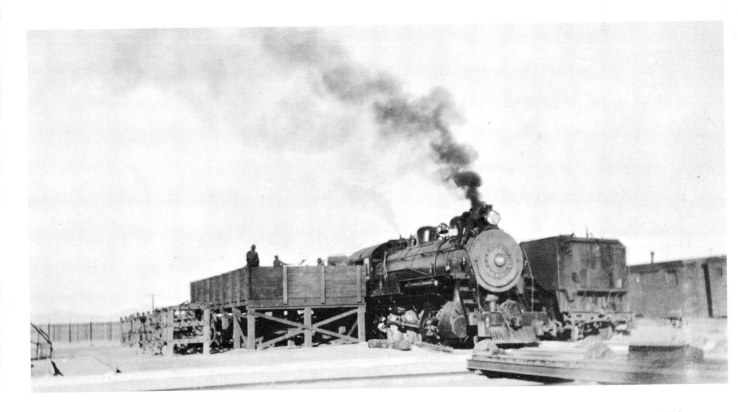

Las Vegas delights in the new, the old, and the unexpected. Dedicated in 1940, the UP's third Las Vegas depot was described as "typical modernistic western motif" and was billed as "the first streamlined, completely air conditioned railroad passenger station anywhere." By contrast, the station platform has been host to such oldsters as ex-Virginia & Truckee No. 18, the DAYTON (*below, right*) which was renumbered 58 by Paramount Pictures and used in the filming of *Union Pacific*. It is shown here on the occasion of a publicity trip for Cecil B. DeMille's then latest movie in 1939. Note the America La France fire engine and the "Desert Love Buggy" with the outboard tiller for steering. (*Bottom, left and right: Union Pacific photos.*)

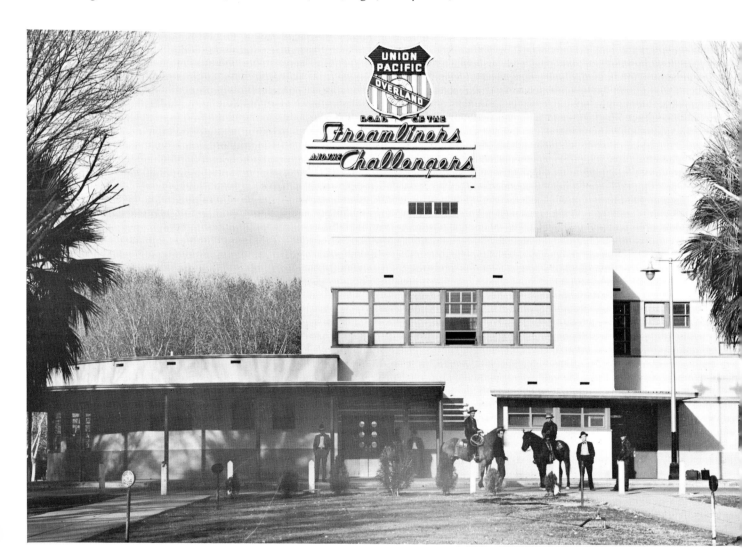

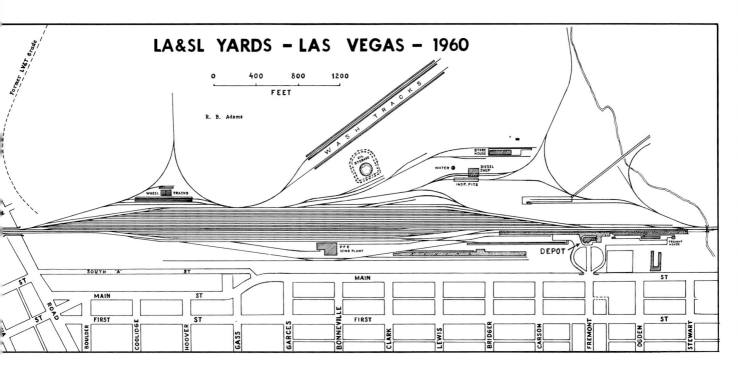

LA&SL YARDS – LAS VEGAS – 1960

R. B. Adams

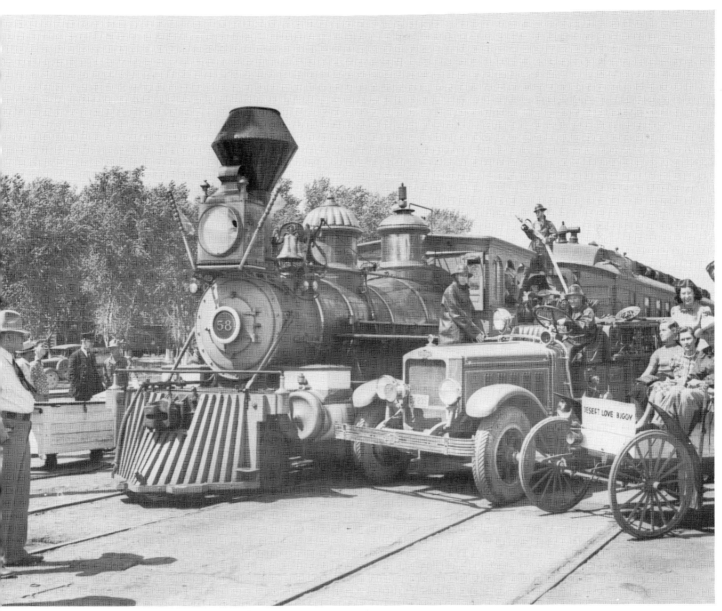

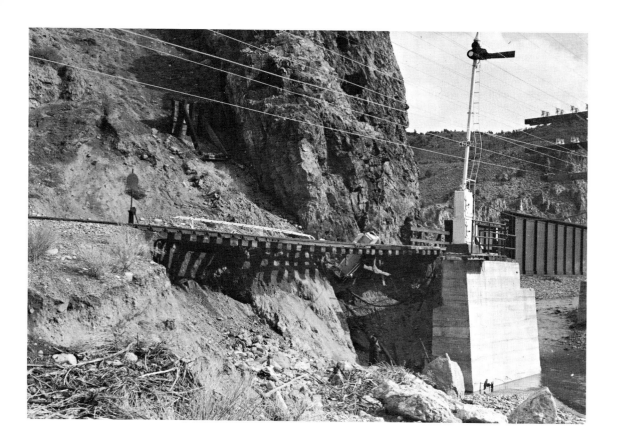

In 1938 Mother Nature went on another mad rampage and poured billions of gallons of water on Nevada and Southern California. Although the Salt Lake Route's revised Hi Line of 1912 had withstood flood damage for a quarter of a century, portions still were no match for the swirling waters. The track behind the bridge abutment *(above)* was left suspended in the air by swollen Clover Creek, while the semaphore base of the signal on the far side became wedged between the rails and the cliff. One span of the Mojave River bridge *(below)* was swept away to leave a solitary rail as a memento of the continuity that once prevailed. Other major areas fared much better. At Rox, Nevada *(above, right)* and again near Moapa *(below, right)* the roadbed was able to withstand the ravages of the flood waters. *(All photos: Union Pacific.)*

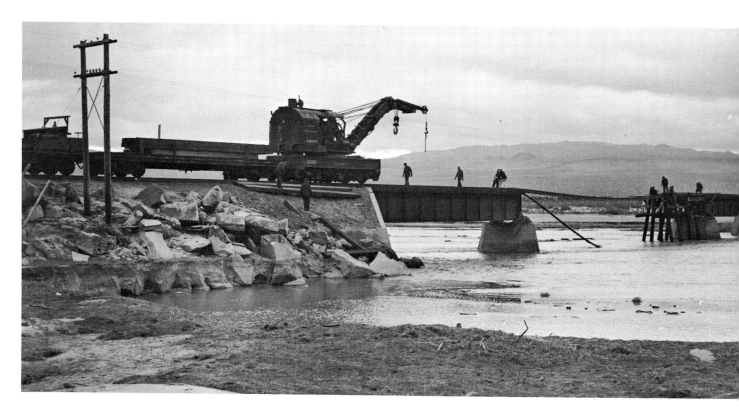

The deluge of 1938 swelled the normally placid Mojave River to peak flood proportions. The Salt Lake Route suffered considerable damage along Afton Canyon where high waters took out long sections of grade. Twisted rails on the bluff (*left*) mark the break in the main line; its continuation at the far right of the picture is marked by the signals. Baxter (now Basin), at the eastern end of Afton Canyon, suffered extensive damage. Flowing from the mouth of the canyon (center background in photo *below*), river waters inundated the entire area including the ballast quarry tracks at the left. The light grey stretches of trackage in the photo indicate where rails have been washed out or undermined; only the dark areas represent substantial, solid roadbed. A cut of cars stands on the spur to the lime rock quarries across the river to the north, while a second string stands isolated on the far bank following obliteration of the trestle by the flood. (*Both photos: Union Pacific.*)

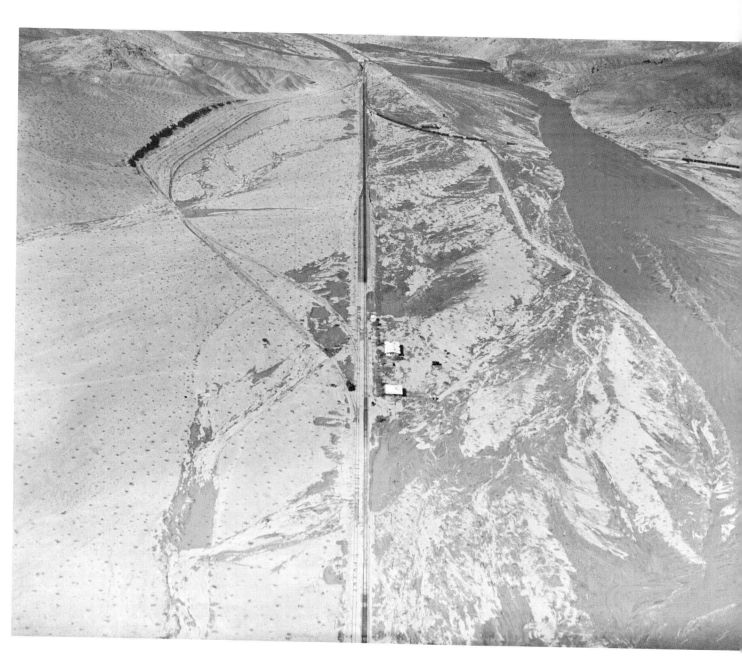

At Afton Canyon swirling waters removed both bridges from the ends of the 542-foot Tunnel No. 1 (center of photo) and created an aqueduct out of that bore. Afton lies in the background to the west, the Mojave River snakes downstream toward the camera, and the white dike (top left) diverts water from the side canyon to flow under the railroad bridge at the beginning of the main canyon. (Union Pacific photo.)

— 673

Deterioration of the timber lining of Tunnel No. 1 in Afton Canyon forced the railroad to decide between enlarging the bore and lining it with concrete or "daylighting" the 542 feet of trackage through removal of the overburden extending to a height of 170 feet. Since the ridge was composed of a loose material which would have made any tunnel relining a prolonged and costly job accompanied by a perpetual maintenance problem, huge earth-moving machines were brought to the site on May 1, 1957, and work on an open cut commenced. Since Afton lies in desert territory where daytime temperatures reach as high as 118°, the work was done in shifts between 4:00 P.M. of one day and ending at 10:00 A.M. the next. Removal of the approximately 330,000 cubic yards of rock was accomplished in 100 working days without interruption to normal traffic over the line. The views of the work shown here face the western portal, while passage of the *City of Las Vegas* in streamlined dress *(top, right)* signalled removal of the last remaining timber portal. Evolution of steam had come full cycle on the Salt Lake Route with monster locomotives such as UP 5519, shown *(bottom, right)* at the Lower Narrows of the Mojave River near Victorville, California, in 1940. *(Bottom, right: Allan Youell photo; all others: Union Pacific.)*

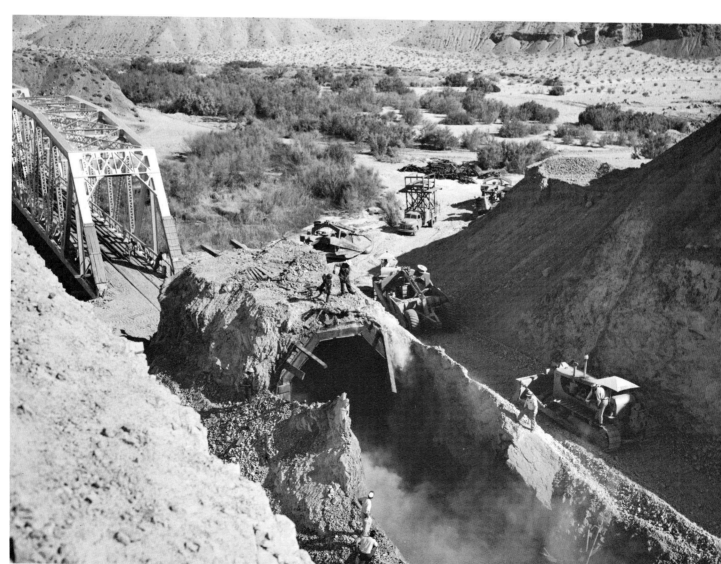

One of the early name trains to use the Salt Lake Route was the daily *Los Angeles Limited*, replete with electric lights, de luxe drawing room and compartment sleepers, tourist sleeper, an observation-buffet-library car, and diner providing a-la-carte service. After the 1910 flood-damaged line was restored, promotional activities were stepped up, as is shown by the advertisement from *The Arrowhead*, the magazine put out by the Salt Lake Route to extol the scenic beauty of the newest way to Southern California. Running between Chicago and Los Angeles, the train was routed via Chicago & Northwestern-Union Pacific to Salt Lake City where, at the Union Depot (shown *below* in 1912), it was turned over to the Salt Lake Route for the final leg to Los Angeles. The inaugural run was carefully catalogued with fine photographic glass plate mementos such as the train paused in the Mojave Desert by the Joshua trees and in Utah's Weber Canyon. (*Top, left: California State Library; bottom, left: Robert Edwards Collection; both photos, right: Wyoming State Historical Department.*)

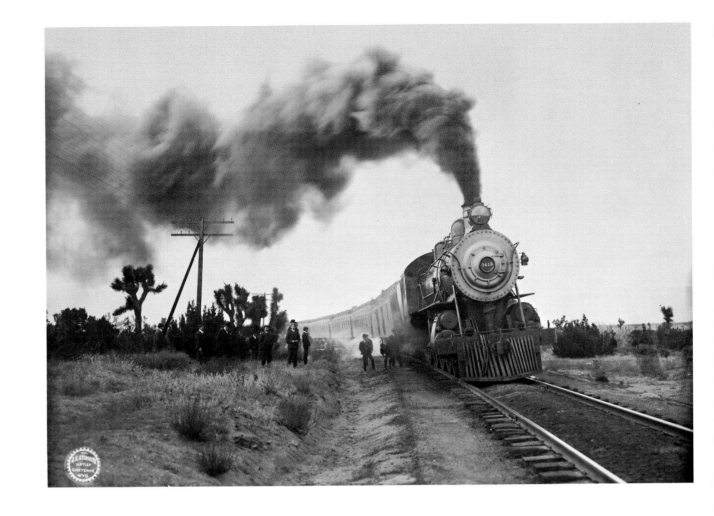

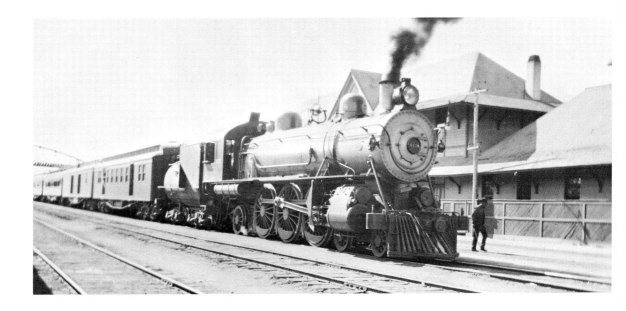

Changes are inevitable in railroading as well as other industries. Diesel locomotives, photographed near Sloan, Nevada *(top, left)* now haul freight formerly handled by steam. The heavy Pacifics of earlier days *(above)* gave way to the ponderous 4-8-4's *(bottom, left)* shown pulling the famed *Challenger* near Barstow in 1948, have been superseded by lightweight trains, such as the *Challenger-Domeliner* with its diesel power along the Meadow Valley Wash. *(Top left, and below, right: Union Pacific photos; above: Charles P. Atherton Collection; bottom, left: Pacific Railway Journal.)*

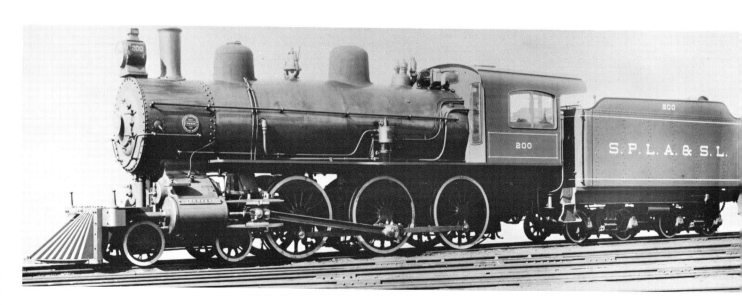

680 —

Representative steam locomotives of the Salt Lake Route's stable of iron horses are shown on these pages. No. 412 *(below, center)* has been shown elsewhere at the head of the *Los Angeles Limited.* All were fine machines well able to perform their assigned tasks. *(Top, left and below, center and bottom: H. L. Broadbelt Collection; left, center: Union Pacific photo; left, bottom: Pacific Railway Journal.)*

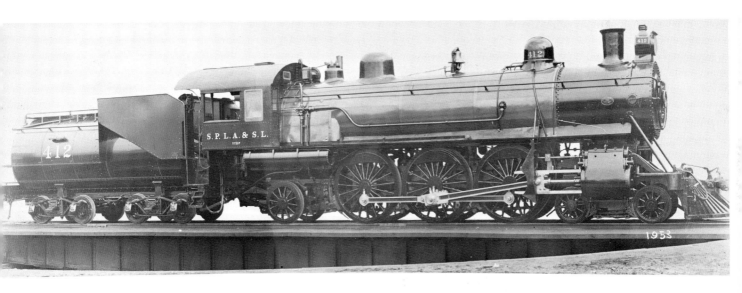

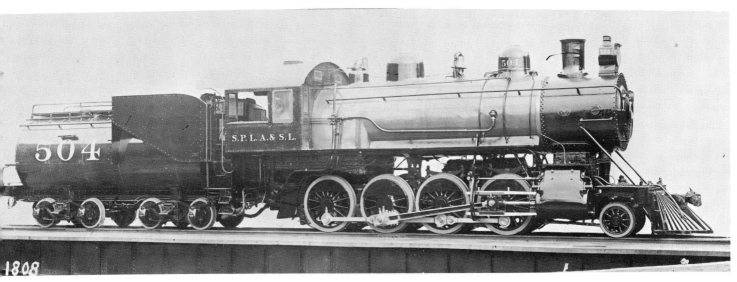

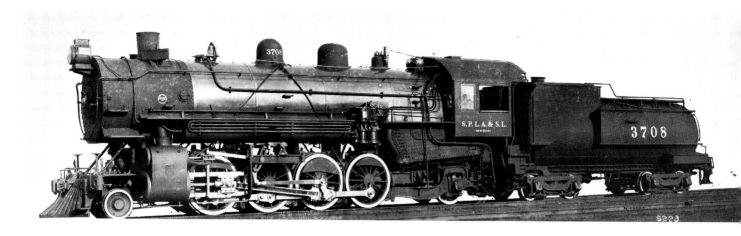

Characteristics of the heavier Salt Lake Route power of later years were the extended smokeboxes and the Vanderbilt tenders. Caught at the Yermo, California, engine house in 1935, No. 8807 (bottom), was an unusual three-cylinder giant with power lubricators, dual air pumps and feed-water pump externally mounted along the left side. Note head of third cylinder beneath smokebox. (Top and center: H. L. Broadbelt Collection; bottom: M. A. Lowry photo.)

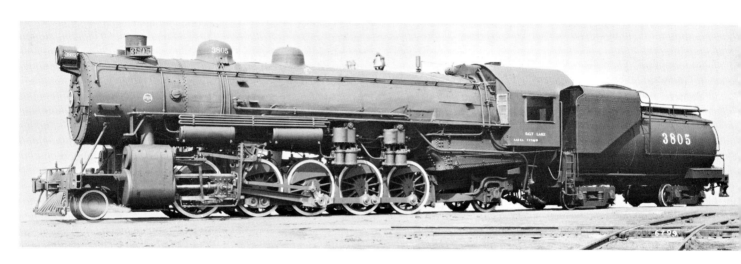

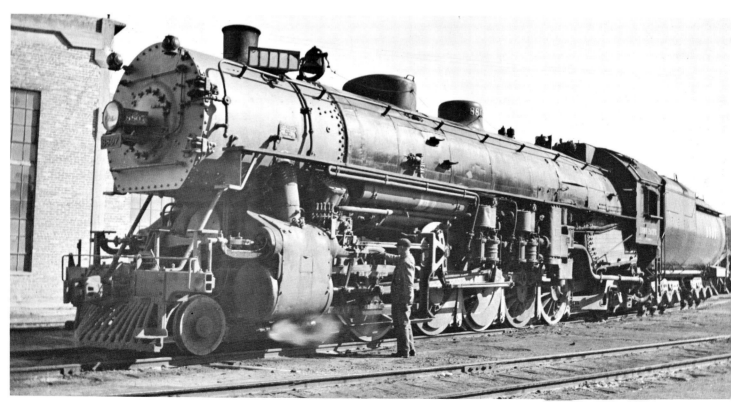

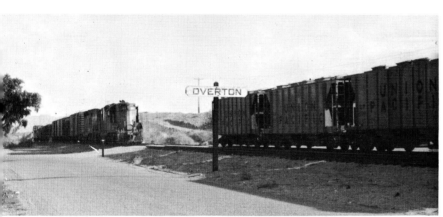

Mead Lake is the present end, and Overton the principal station, on the Salt Lake Route's former branch to St. Thomas. Silica is a major traffic item on this branch. Backwaters of Lake Mead, created by erection of the Hoover Dam, have covered the latter's townsite, forcing partial abandonment of the branch. In 1938 floodwaters of the Muddy River isolated a sizeable segment, but the bridge was replaced and service resumed. Note that the roadbed bears right at the far end of the tangent and extends along the foot of the escarpment up the valley toward top right of picture. (Bottom: Union Pacific photo.)

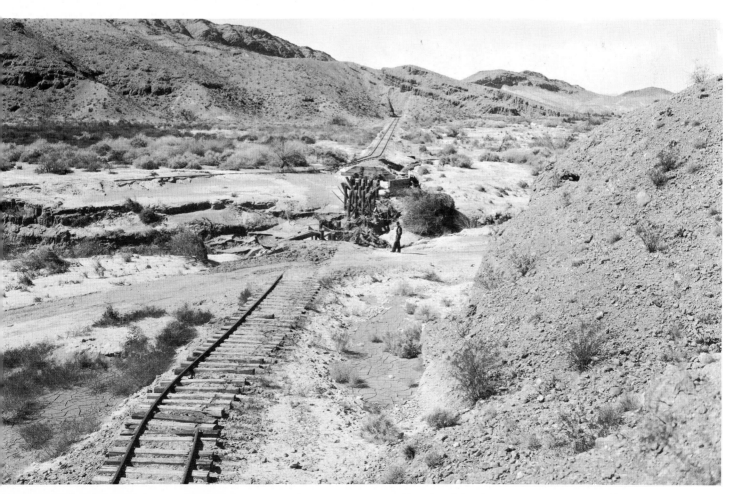

PIOCHE AND ITS RAILROADS

Anyone visiting the canyon city of Pioche today would find it difficult to realize that here was once a boom town replete with all of the varied activities normally associated with the Wild West of the 1870's. Mining had zoomed until, in 1872, the area's mineral production was exceeded only by that of the Comstock itself; the population had exploded to the extent that available housing had been pre-empted and undue hardships were being imposed upon all latecomers; even the multifarious saloons and gregarious flesh pots were in insufficient quantity to satiate the demands of the ever-increasing throngs.

Basically it all started in the fall of 1863 when knowledgeable but hungry Indians visited William Hamblin, one of Brigham Young's missionaries then residing in St. George, Utah. The Indians brought with them some "panacare" (Indian word for silver ore), and offered to disclose the location of the source for a price. A bargain was made, following which Hamblin went to the spot and located the Panacker Lode. The town of Panaca was settled the following spring. However, development of the claims was delayed both by Indian hostilities in 1865 and by Brigham Young's disapproval of mining (for that area was still part of Utah in those days).

But others drifted into the region, exploring up the canyons and staking out numerous claims. In 1868 Charles E. Hoffman (with the backing of a French banker named F. L. A. Pioche then living in San Francisco) purchased many of these claims, the combination of which later formed the nucleus of the famous Meadow Valley Mining Company located to the north of Panaca near the newly established mining camp of Pioche. Shortly afterward Hoffman had company in the form of William H. Raymond and John H. Ely, who came over from their unsuccessful operations in the Pahranagat Valley to the southwest and acquired the Burke claim which became the core of Pioche's Raymond & Ely Mining Company, an enterprise that developed into the greatest nineteenth century producer in southern Nevada. In fact, for a time the mining area came to be known as the Ely District, and care should be taken not to confuse early references to this district with those of Ely city and its copper mines 100 miles to the north which were developed after the turn of the century.

Any expansion of productive facilities in that remote wilderness was a long and arduous task. Parts for the early furnaces were shipped around the Horn to San Francisco, thence by Central Pacific rails (completed in 1869) to Elko, Nevada, and finally by wagon over difficult trails for 273 miles to the southern outpost. Fire bricks were imported all the way from Scotland at a reported cost of $1 per brick. Only the crudest of smelters could be erected; and with the low lead sulphide content of the ores, successful results were almost impossible to achieve.

A supply of water was another very real problem until General Patrick Edward Connor (a former Brig. General of the mountain territory and operator of the first steamer on Great Salt Lake) built a nine-mile pipeline from mountain springs to the west. While this satisfied the needs of the people, it was insufficient for milling purposes. The demands of commercial requirements dictated that the mills be located about 10 miles to the south at a place which later became known as Bullionville (not far from Panaca). Pioneer of such enterprises was the Raymond & Ely five-stamp mill, brought over from the partners' previous mining operation at Pahranagat and reinstalled in the new location. In spite of its diminutive size and insignificant capacity of but 10 tons of ore from the Burke claim each day, and irrespective of the fact that half of the values were lost in the tailings, the crude mill could still bring the owners up to $900 profit per day, a not inconsiderable and promising result.

Such good news traveled swiftly, and Pioche began to boom. Many San Franciscans spent $93 of hard-earned money and over three days of strenuous travel to reach the new camp. In company with the miners came other souls, intent upon relieving the lonely miners of their earnings whether by fair means or foul. Visitors to the area found no hotels; accommodations were provided at lodging houses where large flies with a slightly toxic bite discouraged dawdling. Yet crimes increased in spite of the erection of a substantial two-story county court

house which was to plague the county financially for generations. One observer in this city of 7,500 people cited some 72 saloons, 3 hurdy-gurdys (dance halls with entertainment) — two white and one "variegated" — and 32 maison de joie; then he went on to attempt to relate the quantity of these establishments with a number of occupants (78) of Boot Hill — all reportedly having died a violent death.

Disputes among the mine operators were sometimes settled by shootings between armed guards; at other times the lawyers were given a primal opportunity to ply their trade. One lawsuit between the Raymond & Ely and the Hermes over a disputed area split the town into such hostile groups that local opinion expressed itself in street fighting. Ultimately the court house had to be guarded by volunteers from both sides to see that justice was accomplished, while the jury required greater protection than the regular prisoners. Claim jumping increased and so many problems arose from "soldier's titles" that no U.S. patents in the area were issued for many years.

Fire swept the town in 1871, leaving many people homeless and decreasing the population by 13 when 300 kegs of powder in the basement of the local hardware store exploded. Being on the ascendency, the town was immediately rebuilt, only to suffer from recurrent fires in the subsequent years to come.

The expenses of local as well as interstate transportation were both costly and burdensome to the mine owners. All supplies had to be brought from the outside by wagon teams. If one wished to travel, the only available facilities were provided by the Gilmer & Salisbury stages. The latter partnership was not unaware of the problems besetting the mine owners, and the two men proposed to relieve Pioche's isolated status through construction of a railroad southward from Elko (on the CP) to Pioche by way of Hamilton. Undaunted by these prospects, General Connor was boosting his Salt Lake, Sevier Valley and Pioche Railroad on a largely Utah routing, while D. O. Mills (of V&T fame) made plans for a line from Palisade, Nevada to Eureka and Pioche. Unfortunately, Pioche's boom burst long before any of these lines could attain fruition, although the Eureka & Palisade Railroad did reach as far southward as Eureka and served Pioche by means of its freight wagons a few years later.

The crest of Pioche's boom came in 1872 when $5,462,000 of recorded production was tallied. The

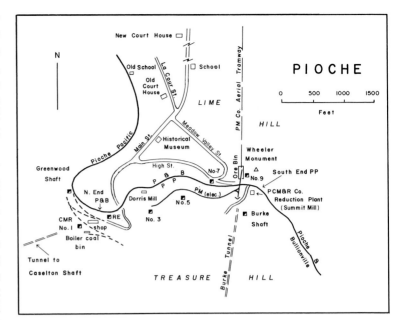

The Raymond & Ely Mining Co. and the Meadow Valley Mining Co. dominated mining activities at Pioche during the early 1870's. Principal hoist of the R&E was the Lightner, indicated by RE on the map. Other outlets were the Burke Shaft and the Page & Panaca Hoist, the latter now the No. 1 Shaft of the Combined Metals Reduction Co. The Lightner Hoist caved and in later years was covered by the mine dump of the CMR No. 1 Shaft. Shafts Nos. 3, 5, 7 and 9 were the property of the Meadow Valley Mining Co. The Hermes mine, a local battleground during the boom days of Pioche, was located between the Lightner and Page & Panaca Hoists, directly under the present shop building as shown on the map.

The Pioche & Bullionville Railroad was built from the Lightner Hoist easterly through the pass near the Wheeler Monument at the head of Meadow Valley Street on its way to Bullionville. It was abandoned about 1881 after less than ten years' operations.

The Pioche Pacific was built from the PCM&R Summit Mill westerly over the abandoned P&B grade to the Lightner Hoist, thence northerly over a new grade to the PCM&R smelter at West Point. It was soon extended to Jackrabbit.

After 1900 the Pioche Pacific track between the former Summit Mill and the Dorris Mill was abandoned. About 1922 a series of switchbacks (dotted lines on map) were built to reach CMR No. 1 Shaft and coal bin for the boilers serving the mine, and the old track between the Greenwood Shaft and the Dorris Mill (including the trestle over the wagon road) was abandoned. In 1942, the remainder of the Hill Line ceased operations.

The Pioche Mines Co. built an electric (storage battery) railroad from their main hoist (No. 3) and from the mines served by the Burke Tunnel to the ore bins connecting with the aerial tramway to their mill at West Point. The line crossed over the highway near the ore bins on a viaduct (part of the steel spans have been removed for use in the Ely Valley Mine).

year before, and the year after as well, over $3,500,-000 was taken from the ground, no modest figure for a camp that was only about four years old at best. In 1872, the Raymond & Ely property alone produced $3,700,000, enabling that concern to pay dividends aggregating $2,070,000 (a considerable increase over the $615,000 paid the previous year). However, when an analysis of the expenses incident to operations revealed an item of $153,000 solely for the teaming of ores from the mines in Pioche to the mills at Bullionville, the firm became quite amenable to newly propounded propositions for a railroad between those two points and advanced $100,000 toward its accomplishment.

Bullionville (in 1872) had 450 inhabitants, many of whom were employed in the five quartz mills and one Stetefeldt roasting furnace in the area. Two steam operated, wet-process mills, one with 20 stamps and the other (originally a dry-process) with 30 stamps, were part of the Raymond & Ely combine; others were the 15-stamp American Flag, the Bowery Mill with 10 stamps, the five-stamp Pioneer, and a new Magnet Mill with 10 stamps just being erected by W. H. Raymond. North of Bullionville, beyond Panaca and Condor Canyon, was the 30-stamp Meadow Valley mill near the mouth of Dry Valley which, although it would be about a mile from any railroad construction, could easily utilize such facilities by teaming to the railhead.

Pioche & Bullionville Railroad
Central Nevada — Nevada Central

General Page and his associates initiated the first concrete railroad effort early in 1872 with incorporation of the Pioche & Bullionville Railroad. Apparently these efforts were somewhat misguided, for the same group of men reincorporated the same railroad somewhat later in the same year. Also in the same year, General Page joined with W. H. Raymond in the incorporation of a Central Nevada Railroad Company to accomplish virtually identical objectives to those of the P&B. And if this should not appear to be sufficiently confusing, then consider that the railroad as finally built was called (inversely) the Nevada Central Railroad, although it had no connection with the later (1880) line between Battle Mountain and Austin, Nevada, to the northwest of Pioche.

Actual work on the Nevada Central began in the summer of 1872. A scheme to issue county bonds as a construction subsidy was defeated at the last minute by quick work in the courts. In spite of this, grading was completed by the following February and operation was eagerly awaited, for the combination of impassable winter roads and an epizootic boom among the animals (which soon spread to most of the teams in Nevada) virtually suspended ore shipments to the mills for weeks.

Most welcome to the mine operators was the news that the first locomotive had been shipped from Lehi, Utah, in February 1873, for which considerable altering of grades and curves became necessary. On April 11, 1873, the *Pioche Daily Record* flatly declared that "there is no use in longer trying to deny the fact that the narrow gauge railroad between here and Bullionville is a failure. The rails are too frail, and the grading, in places, is not safe." The newspaper then noted that the original plans only contemplated light, 20-pound rail; then it went on to say that a new survey was being made and that the work of building a good and serviceable road was "being prosecuted sensibly and in earnest."

In May 1873 a brief hurricane swept down upon the railroad camp in Dry Valley "capsizing tents, prostrating railroad workmen and sweeping everything before it of less specific gravity than solid rock." Apparently this did not materially retard the work for two days later, on May 5, the new locomotive was fired up for the first time in Bullionville. Mr. Barber pulled the whistle cord, and as the echoes of the whistle's blast reverberated through the hills, everyone felt they were the harbinger of better days to come. Work on the line continued, and finally on June 8, 1873, the road was placed in operation.

The *Daily Record* took full cognizance of the occasion and recorded it thus:

"At Bullionville, day before yesterday, between one and two o'clock in the afternoon, the last spike — a silver spike — was driven into the rails of the Nevada Central Narrow-gauge Railroad, and it is now completed between Pioche and Bullionville. A large concourse witnessed and participated in the ceremony, much enthusiasm being manifested. At three o'clock a fire was kindled in the furnace of the fine new locomotive COLONEL J. F. CARTER, and half an hour later steam was up and it was snorting for its first trial trip. The J. F. CARTER has an 11-inch stroke, 3 drivers and single 'pony,' and weighs 36,000 pounds. At half-past 3 o'clock it was put in motion towards Pioche — traveling slowly, of course, as

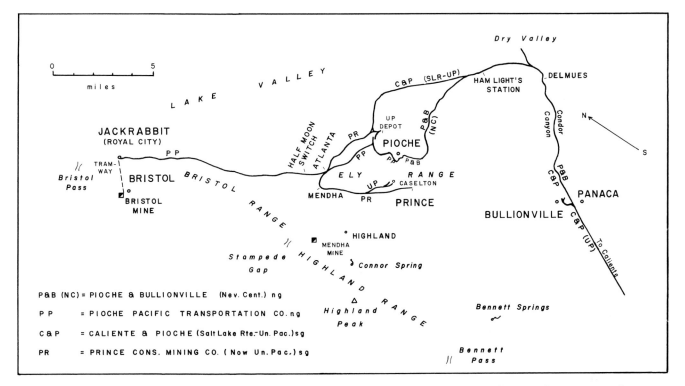

the principal object was to test the track. At Ham Light's Station, 6 miles from Pioche, a train was attached, when it came on up into the city to the turntable at the head of Meadow Valley street. The time from Bullionville to Pioche, including the time spent at Light's Station was just two hours, the distance traveled being 20 miles. Nicholas Remfry, the engineer, long experienced on railroads in that position, said he never knew a more successful trial trip over a new track. An immense crowd of people, ladies and gentlemen, had gathered at the head of Meadow Valley street, to greet the first train from Bullionville, and it was welcomed on its arrival with loud and long-continued applause — General Page, the chief director of the road, being heartily congratulated on the success of the enterprise. From the turntable, the locomotive leisurely steamed around on the track to the Raymond & Ely dump, where the engine was reversed and it moved back to the turntable. The narrow gauge is a practical success. The Raymond & Ely Company, for whose especial benefit it was constructed, are heavily interested in it . . . The other locomotive, the first one received, is now in the Company's machine shops at Bullionville, being remodeled under the supervision of Ney Churchmen, Superintendent of

the iron works, and will soon be put on the track."

Two days later the first ore train left the Raymond & Ely mine for Bullionville, and on June 23, 1873, a regular schedule was instituted with one passenger and one freight train each making a daily round trip. The first complete, published timetable of the Nevada Central became effective on Monday, December 1, 1873, and read as follows:

Lv.	Bullionville	7.30 A.M.	1.10 P.M.
Ar.	Amador Mill	7.45 "	1.25 "
"	Head of Canon	8.00 "	1.40 "
"	Dry Valley Station	8.20 "	2.00 "
Ar.	Pioche	9.15 "	3.00 "

Lv.	Pioche	10.00 A.M.	4.00 P.M.
Ar.	Dry Valley Station	10.45 "	4.45 "
"	Head of Canon	11.00 "	5.00 "
"	Amador Mill	11.15 "	5.15 "
"	Bullionville	11.45 "	5.45 "

The average speed apparently was about 10 miles per hour, while a reassuring footnote for the benefit of passengers stated that "A passenger car will accompany each train."

The following year (1874) the mines ran into trouble with excess water at the 1,200-foot level, and disputes arose among the companies over

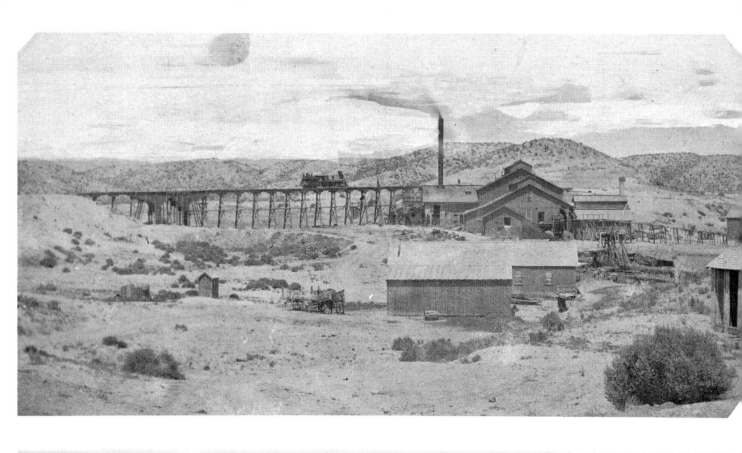

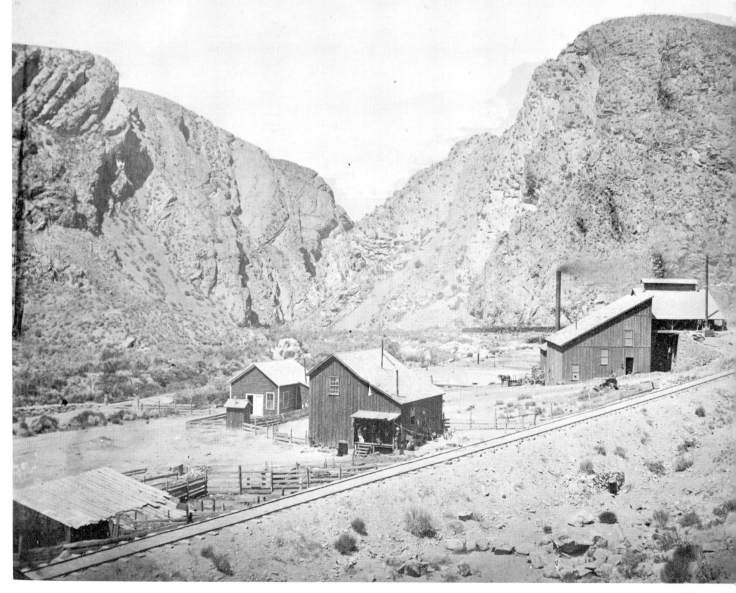

Rare indeed are these early views of the first Nevada Central Railroad, more commonly called the Pioche & Bullionville. Developed for the transportation of ore from the mines at Pioche to the mills at Bullionville, the narrow gauge was operated spasmodically by a succession of owners. One of the road's two locomotives is seen on the trestle to a mill unloading bin at Bullionville in the 1870's. Way stop along the route *(bottom, left)* was the Condor mill located at the north end of Condor Canyon. The track in the foreground is a siding extending to the small trestle behind the mill at far right; the main line passes behind the houses before entering the canyon proper where the hand-hewn ties and light rails of the narrow gauge appear in insignificant contrast to the towering cliffs. *(Joe Delmue photos, courtesy of James G. Hulse.)*

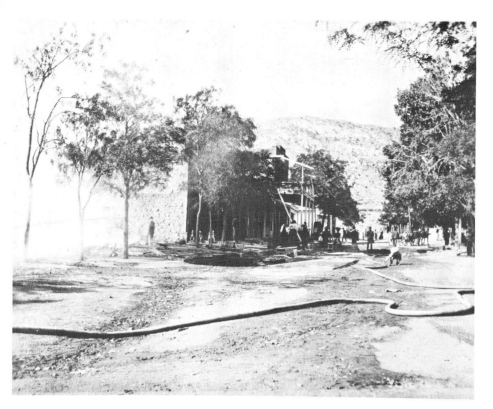

Fire, such as the conflagration *(left)* in Pioche in 1905, was the scourge of Nevada mining towns. The hazard of closely packed, dry, wooden buildings as seen *(below)* at Pioche in the spring of 1871 is obvious, and the town's citizens suffered from widespread conflagration later that same year. The four stacks on the hillside above town mark the Raymond & Ely's Lightner shaft.

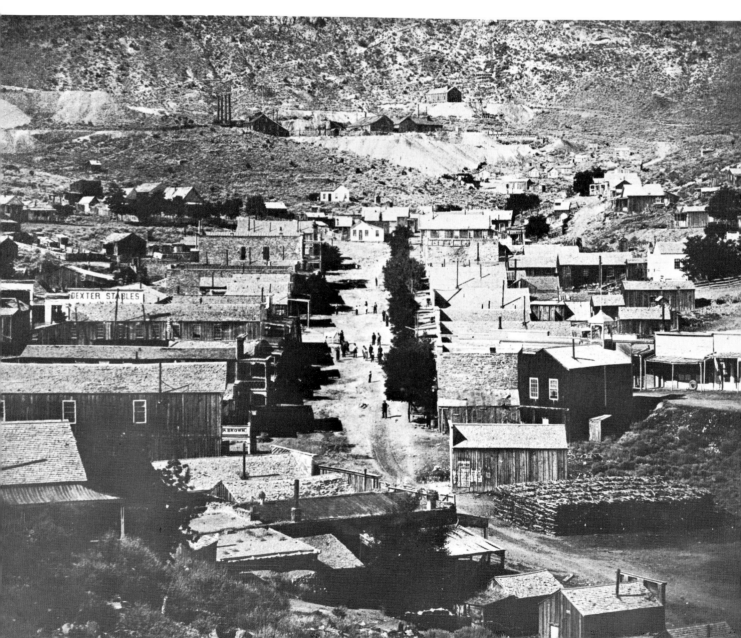

The face of Pioche's Main Street had changed considerably by the late 1930's *(below)*, but the original court house which overtaxed the town financially for generations still stands today. *(Top, left: Grace R. Bowman Collection; bottom, left: Nevada Historical Society; below, right: Sewell Thomas photo.)*

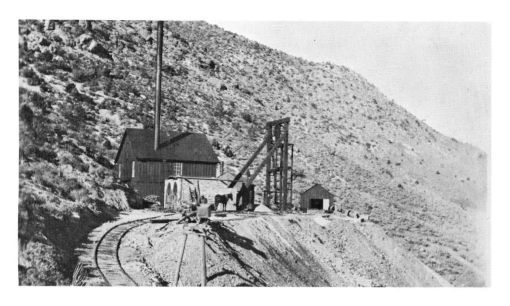

The No. 1 Shaft proved to be the mainstay and most productive of the Pioche mines. In its simple beginnings around 1890 *(left)* the surface works consisted of a small hoist house and head frame while the earliest trackage of a forthcoming Pioche & Pacific Railroad, utilizing rails and other appurtenances from the former Pioche & Bullionville, extended from here to the PCM&R Co.'s Summit Mill on the eastern slope of Lime Hill. *(Grace R. Bowman Collection.)*

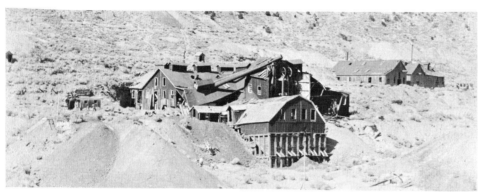

The 1905 view *(left)* shows the Raymond & Ely Shaft with its toppled stacks in the decadent condition prevailing following the slump in mining at Pioche around the turn of the century. *(Grace R. Bowman Collection.)*

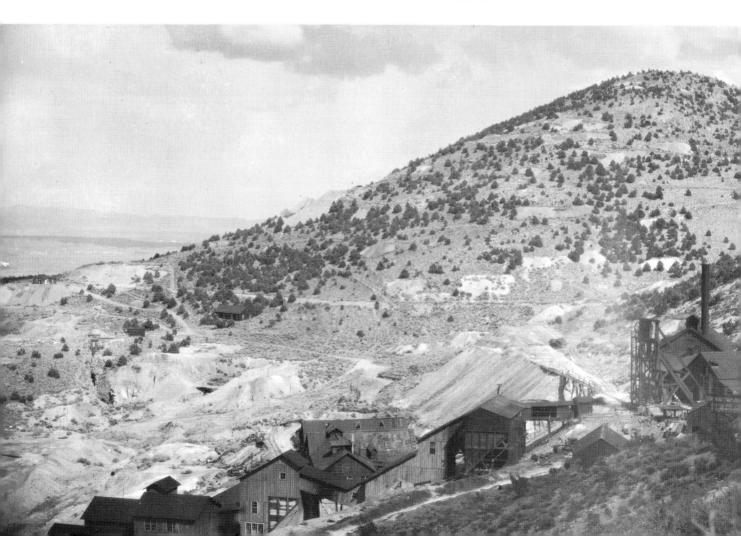

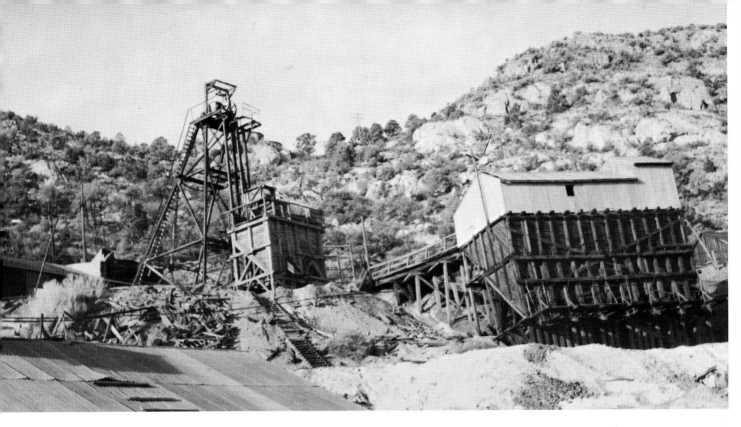

These views of the No. 1 Shaft were taken at different times and from divergent angles. The wooden head frame *(bottom, left)* is indicative of an earlier photo than the two on this page. Note the engine house of the Pioche Pacific along the grade behind the stacks in the view *(below)*. View *above* shows bins after the mill had been dismantled. Ore was loaded directly to the railroad cars until the railroad was abandoned. Trucks used the same spot when the Caselton Mill began operation. Later ore was hauled underground through an 8,000-foot tunnel to the Caselton Shaft and the No. 1 was only used for handling men and materials. *(Bottom, left: U. S. Geological Survey; below: James G. Hulse.)*

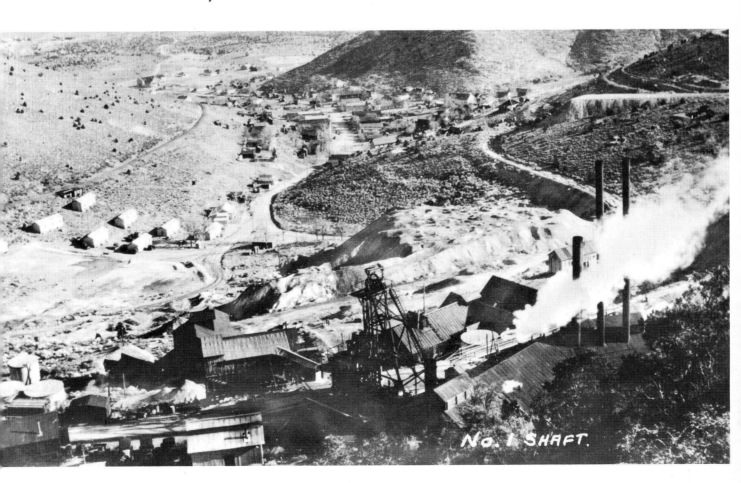

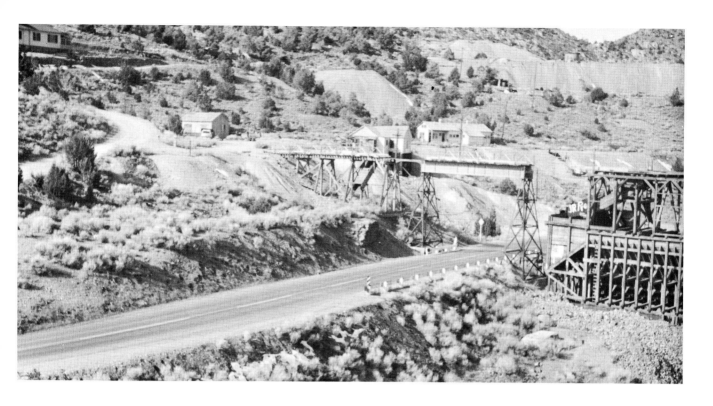

Second largest of Pioche combines in the late 1920's was that of John Janney's Pioche Mines Consolidated, Inc. Ores from the mines were brought by a short surface electric tram to loading bins of an aerial tramway *(top, left)*, carried down the hill and across the flat *(left, center)* to a new flotation mill *(bottom, left)* near the UP's station. The stack in the distance in the panorama *(above)* indicates its location in relation to the town. In later years, two steel trusses were removed from the surface tram's bridge over the highway for use in Janney's other Pioche area operation, the Ely Valley Mines, whose headframes stand against the sky *(below)*. *(Bottom, left: Sewell Thomas photo.)*

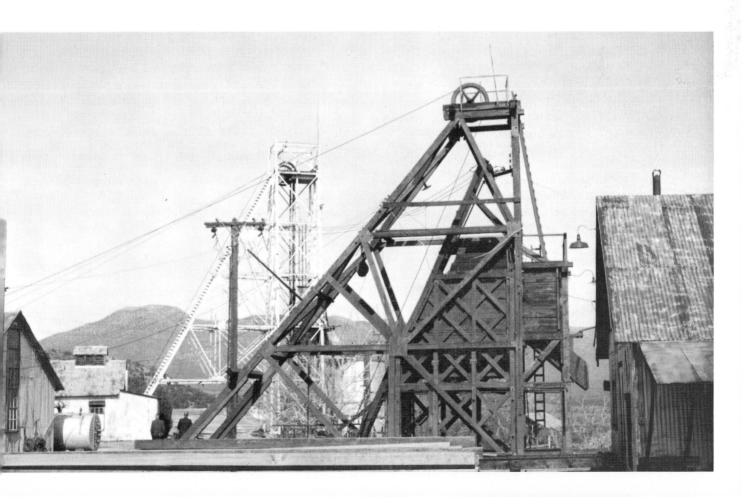

pumping operations. As the rich ores played out, the boom collapsed, and people began leaving Pioche by the thousands.

W. H. "Uncle Billy" Raymond was among them. He had come to Pioche some $75,000 in debt; his participation in operations of the Burke claim had made (and lost) him a fortune; and he left town a sadder but wiser man. It was said that during the peak of operations, the Bank of California offered him $3,200,000 for his 16,000 shares of Raymond & Ely stock (out of a total of 30,000 shares outstanding), but he refused the offer. At the time, the stock was paying dividends of $7.00 *a month* and was selling as high as $180 a share on the San Francisco Stock Exchange. Uncle Billy also was president of the Central Nevada Railroad (Pioche & Bullionville) stimulated by General Page in 1873, although his remuneration from that source was hardly as beneficently bountiful as that from the mining operations. Amazing but true, when Uncle Billy left town a short while later, he "packed his blankets" out of camp just as he had packed them in, and headed for Arizona to try his luck again.

Train service on the railroad ceased as the ore movements vanished, but early in 1877 several trains of 10 cars each were operated to the mills weekly. A general rehabilitation of the road and equipment took place, and even the "large locomotive" became the recipient of not one, but two separate paint jobs. The first was applied by a skilled craftsman; the second the work of a rank amateur who ran rampant with a can of red paint, completely desecrating the work of his predecessor with huge splotches of red. The result was a locomotive which, when seen passing through the sagebrush, might easily have been mistaken for a spotted cow. The craftsman was reportedly "out of his right mind" for weeks.

Railroad "fan" trips were not unknown, even in that early day and age, as witness this report by a local scribe:

"By invitation of Capt. H. H. Day we made a trip last Thursday on the Nevada Central R.R. to Condor Canyon and Bullionville. The Captain ordered the caboose and also a platform car to be hitched to the train to accommodate the numerous ladies and gentlemen to whom invitations were extended to make the trip. We found the caboose car filled with ladies, amongst whom were . . .

"The train was to have started about half-past nine, but owing to the difficulty of making it up did not get off from the summit until a quarter after 11. Previous to the start Jimmy Douglass, brakesman of the train, whilst coupling two ore-cars had his hand caught between them, but luckily he only suffered a little squeeze, he being promptly released from his unpleasant predicament. Considering the heavy load, the train made fair time to Condor Canyon, arriving there about one o'clock, and leaving the ore-cars filled with ore from the Meadow Valley mine to be worked at that mill . . . On the way to Bullionville the train was stopped twice to replace rails that had become displaced during the recent heavy storms, this being the first trip that any train has made over the lower portion of the road for nearly a month. The engineer, Sam Stoddard, had to keep a sharp look-out for such things, so as to prevent accidents.

"The train reached Bullionville at 3 o'clock, and many of the passengers were pretty hungry. Some of the ladies had stopped at Mrs. Lehigh's, at the Canyon, preferring to have a good dinner there to going on to Bullionville, and in this action we think they showed their good sense, for when the hungry passengers did arrive at Bullionville, no restaurant could be found where anything to eat could be obtained, and they had to content themselves with soda crackers and cheese obtained at a grocery store. Bullionville looks very slim . . . On the return trip much better time was made, it taking only twenty minutes from Bullionville to Condor Mill, and the entire train and party reached Pioche at quarter after six, pretty well tired out, but well pleased with the trip and the attention bestowed upon them by the employees of the road.

"Several carloads of ore were also carried to the mill at Bullionville, also a carload of lumber and supplies. Two ladies and gentlemen rode in front of the locomotive both going and returning, and a couple also (rode) inside of the engine with the good-looking engineer. The last we observed of the locomotive was a young lady seated in front with her head leaning on the rim of a gentleman's ear whispering something, but not being close enough, we could not catch the sweetly whispered words."

Regular Nevada Central ore trains continued to be operated through the year 1878 as the mines sent their ores to the Dry Valley, the R&E or the Condor mills. The latter was located four miles north of Bullionville and used rollers to crush the

ore in lieu of stamps, a feature which caused considerable comment in 1872 when the mill was built. On May Day (1878) a picnic special was run, hauling almost 500 people to the event. The train proceeded on to Bullionville where it tied up until the return trip.

The economy of Pioche degenerated, however, and by the early part of 1881 the situation had become critical. The R&E property had been shut down and foreclosure was anticipated momentarily. Chloriders (independent leasers) were working the Meadow Valley Mines, which provided scant hope for work for the miners. In fact, about the only people who could look forward to a regular paycheck were those few still on the county payroll. The reduction in the laboring force was reflected in reduced business for the railroad, a situation which generated heavy financial problems resulting in a sheriff's sale of the little road on March 3, 1881. With people leaving town in droves, the *Pioche Record* could hardly be blamed for its caustic comment: "The general outlook is blue."

Even the chloriders were having bad luck. In the cold winter months, ores loaded on the railroad's little cars were delivered to the Dry Valley Mill (of the Meadow Valley Mining Co.) only to find the mill frozen solidly and the operators spreading the discouraging news that a wait of several weeks would be necessary before the machinery could be thawed. Since the chloriders' shipments were virtually the only traffic for the railroad, operations under the new management became sporadic. In April, after two trains of ores had been delivered to the mill, the balance of the mine production was accumulated at the chutes and loading platforms of the No. 3 Works, while the railroad personnel utilized the waiting time in effecting track repairs. A week later one train was operated through to Bullionville, hauling all the ore awaiting shipment. The railroad then noted that "the cars will probably not make another trip for another week or two."

Reports are vague, but possibly these few, occasional revenue trips were the last to be made over the little line. In 1883 — the property — consisting of 21 miles of narrow-gauge railroad, two locomotives, 15 five-ton, ore dump cars, four side-dump cars, two turntables and a roundhouse — was sold again. Eventually on January 1, 1884, much of the removable property passed into the hands of Thomas Taylor of Cedar City, Utah, who in turn sold the components to various mines and mills in

the Pioche area over a period of the next five years. W. T. Godbe, a Salt Lake mining man, became the principal purchaser of the various units.

The Pioche Pacific Transportation Company "The Jackrabbit Road"

For approximately five years Pioche languished in a railroadless decadence. Then in 1889-90 there was a notable quickening of the pulse and a stimulation of excitement — the Union Pacific was grading a line from Milford, Utah to Panaca and Pioche. Unfortunately, financial difficulties halted the work before the project could be realized, and it was to be many years before railroad connections between Pioche and the outside world were to be established. (See Salt Lake Route.)

Meanwhile, however, a less exalted work of more commercial dimensions got under way in September 1889. A three-mile "narrow track" tramway was projected from the existing roadbed of the former P&B (Nevada Central) trackage between the old Raymond & Ely Lightner Shaft and the Reduction Works (Summit Mill) to run up and over the Ely Range to the west side of Mount Ely where the Half Moon Mine was located. A more thorough examination of the steep terrain to be negotiated undoubtedly dampened enthusiasm, for when actual construction began in November 1889 the plans had been curtailed and revised to a half-mile line down the side of the hillside west of Pioche to a point near the school house along the Half Moon Mine Road. Teaming of ores to the mills would be less difficult from this location.

To carve the grade in the hillside, 10 men and 20 teams were brought in from Nephi, Utah, undoubtedly an indication of the shortage of local manual and animal resources. Reportedly the grade to the schoolhouse was completed before Christmas with some rails spiked in place on their cedar ties. In order to utilize the available narrow-gauge ore cars from the former Pioche & Bullionville line, the track gauge was made the same as that of the former road — thus establishing a precedent which was to be sustained for virtually 60 years.

In January 1890 the balance of the track was laid on the grade, and operations commenced. Although talk persisted that the tram line would be finished all the way to the Half Moon Mine, this was never accomplished.

Of even greater importance than inauguration of tramway service in the year 1890 was the merger of the Pioche Consolidated Mining Co. (combina-

tion of the R&E and Meadow Valley mines) with the Yuba Mining & Reduction Co. to form the Pioche Consolidated Mining & Reduction Co. with W. S. Godbe as chief benefactor of the area. Godbe's moves were not without repercussions and involved the usual litigation attending all mining developments. Thomas Taylor, the previous vendor of the railroad, charged that Godbe had "wrongfully and unlawfully with force and arms" entered into the former P&B property, causing damage to Mr. Taylor's interests. To set these wrongs to rights, Mr. Taylor felt that a payment of $25,000 would not be unreasonable to assuage his discomfort. Godbe's attorney countered this attack with a demurrer saying that the complaint was "ambiguous, uncertain and unintelligible." Furthermore, his client had bought and paid for most of the railroad material some years before.

The District Court, after weighing the evidence, found on December 27, 1890, that Taylor had purchased only the *removable* items from the agent of Lazard Freres, the New York bankers who had control of the former R&E properties, including the railroad. Godbe, in two separate deeds, had purchased the R&E properties and the railroad *grade*. Consequently Taylor's claim for damages was denied.

When the word went around that the Union Pacific had halted all work on the extension of its line from Milford, Utah, to Pioche, consternation was uppermost in everyone's thoughts. Now there would be no rail connection with the outside world. The disappointment was allayed to a great extent in January 1891, however, when Godbe's Pioche Consolidated Mining & Reduction Co. announced that it would build a new smelter on the little bench in the flat about a mile north of Pioche, a location then known as West Point. In conjunction with this improvement, an extension of the tramway was in order so that it would connect all of the mines on the hillside above town with the new smelting facility on the flat, some three miles distant. No time was lost in getting the project going, but hardly had grading on the extension been started in April than plans were expanded again.

To the north and west of Pioche, along the Bristol Range of hills, lay two other silver producing areas of lesser caliber. Bristol City (then called National City), on the west side of the range, had burst into mining bloom in 1871. Within a short time a small furnace had been built to handle the smelting of the ores, but it had rapidly become idle as the mines gave out. Then in 1878 new discoveries had brought about a revival, and for some time Bristol was rated as an important silver producer. On the east side of the range, a counterpart had sprung up when ore was discovered at the Day (or Jackrabbit) mine in 1876, giving rise to the locality known as Royal City.

To reach these two producing areas and furnish additional business for the budding new smelter, Godbe decided to build a 15-mile addition to his railroad to extend northwest from Pioche up the valley to the Jackrabbit mine at Royal City. Although the formal incorporation papers of the Godbe interests to cover this new construction utilized the title of The Pioche Pacific Transportation Company, inevitably a colloquialism quickly abbreviated this verbose name to the "Jackrabbit Road."

Rails for the (short) hill line extension of the narrow gauge began arriving in Pioche in July 1891. Some came from the old, abandoned road to Bullionville, but the majority were brought in by teams from Milford, Utah, on the Union Pacific (OSL). For some unexplained reason, the Shay locomotive destined for the road and originally scheduled to be delivered in the same manner as the rails, ultimately found its way to Salina, Utah, on the Marysvale branch of the Rio Grande and was teamed overland from that point to Pioche. This development prompted local expectations that that railroad might construct a line of road from Salina to Pioche, a speculation to which credence was lent when, a few weeks later, Rio Grande surveyors were sighted at work not too many miles away. Hopes quickly died when nothing came of the effort.

Summer rains in Pioche turned the new grade of the narrow gauge into a sea of mud, delaying the track work. Then a severe thunder storm "shocked" the men at work, and although no physical evidence of damage was apparent, the crews were nervous for the balance of the day.

Grading continued, and by mid-August 1891 the toot-toot of the new Shay locomotive from the hillside west of town brought crowds of curiosity seekers to witness the event. The sight of the locomotive prompted the local scribe to report: "It is smaller than the engines formerly used on the Bullionville line, but fully as strong, and climbs the grade in great shape." By the end of another week he was prompted to the further comment that the whistle, at 6:30 A.M. when the train took 100 men to work at the PCM&R's Summit Works each morning, was always on time — a claim no other local whistle could make.

With the three-mile main line now in operation, graders were urgently needed for the 15-mile Jackrabbit extension. Those who did apply for work under the hot August sun became a thirsty lot, making the owners of the Highland Brewery most satisfied with their progress. By early October the new smelter at West Point was ready for trial runs; some 60 teams and 170 men were putting the finishing touches to the Jackrabbit grade; and trains were already operating to Mendha station. In short order all was completed, the commencement of operations being almost immediately immortalized by a derailment of 14 cars of a 25-car train near Mendha, resulting in a magnitudinous smash-up which required a full night's work to clear.

In December 1891 a larger locomotive, which had formerly seen service on the D&RG, was acquired and placed in operation, thus permitting the Shay to be temporarily retired for installation of new flues and a general overhauling. In addition, a number of larger cars were assembled in which to haul firewood for the new smelter, then in regular operation. Some talk was entertained of operating the newly completed Jackrabbit grade as a gravity road to the smelter. As a consequence, just before Christmas experiments were made with at least one surprising result. Three loaded ore cars, started down the grade out of Royal City, did very nicely until they quietly glided up on some empties which had been overlooked by the brakeman at the Mendha switch. Although the resulting damage was not too severe, the lesson caused cessation of the experiments.

Snow blockaded the Jackrabbit extension for several weeks during the latter part of January 1892, the line not being cleared and reopened until early in February. The incident was typical of Pioche Pacific operations, for no matter what the cause, the road passed through constantly recurring periods of relatively intense activity followed by other periods of complete inactivity during its entire career.

Godbe was considered by some people to be the savior of Pioche. In the short span of approximately two years (1891-92) he had not only acquired the dormant, litigation-torn properties of the Meadow Valley and the Raymond & Ely and reincarnated them in the form of his Pioche Consolidated Mining & Reduction Company, but he had spent virtually $200,000 on the erection of a new smelter plus the rejuvenation and major extension of a narrow-gauge railroad. Everything considered, it was a most impressive performance.

Unfortunately for Godbe, the price of silver slumped steadily on the market without surcease, and costs of operations just could not be trimmed as quickly. Even a 10% cut in wages did not alleviate the situation, and further curtailments were necessary. The decline in production reflected itself in the quantity of shipments of available ore, and soon the night train was suspended. Still the people were looking hopefully ahead. One smelter crew, leaving at the end of the 3:00 A.M. shift, insisted that they saw a ghost train operating, complete with engine and cars, which paused in languid fashion for the customary meal stop. By the end of February 1892, the smelter closed for two months of idleness while the railroad, following two weeks of desultory operations, also closed down.

It was a discouraging spring; but by May, when the smelter was again blown in, Pioche began to pick up its heels. Roadmaster Mace Dixon went over the line of railroad, and the outshopped locomotives were put back on the job. A little motor car, described as more ornamental than useful, was converted to a passenger conveyance of sorts and utilized to haul the men to Jackrabbit and return. Surveyor F. P. Swindler made a number of changes in grade on the line and eliminated several more acute curves so that the larger locomotive could be used on the Jackrabbit run while the Shay worked the shorter (old) main line between the furnace and the mines above town.

Aside from the normal complement of irksome derailments, the Pioche Pacific developed considerable trouble with sparks from the locomotives setting the cars of wood on fire. One particular carload in a moving train caught fire and burned so vigorously it was necessary to summon Hose Company No. 2 to extinguish the blaze. Thinking the fire was out, the men set the car aside on a siding; but a week later it again burst into flame and Hose Company No. 1 had to be called. In a similar circumstance just three weeks later, two cars of wood burst into brilliant flame from the same cause. In spite of these vicissitudes, the wood trains continued to run until February 1893, by which time 150 cords of wood were stacked and ready for the ravenous furnaces.

Fire continued to plague Godbe's operations. An investment in a new mill down at Bullionville had started a revival in that area, ores being teamed from the Yuba mine (formerly the American Flag). Suddenly on July 6, 1893, a blaze broke out in the wood yard and shortly spread to consume the en-

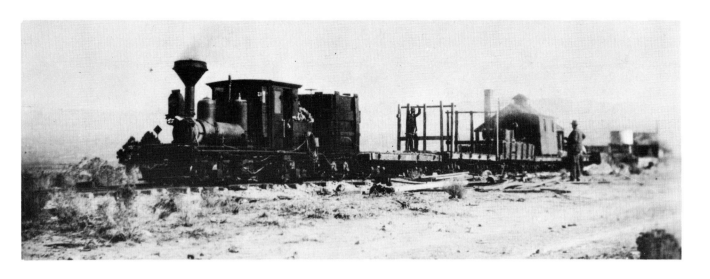

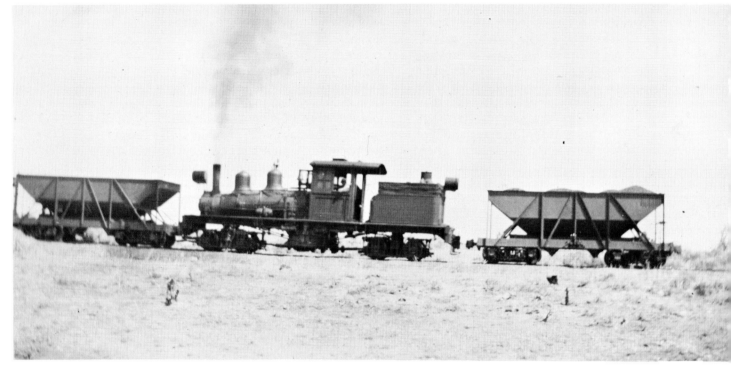

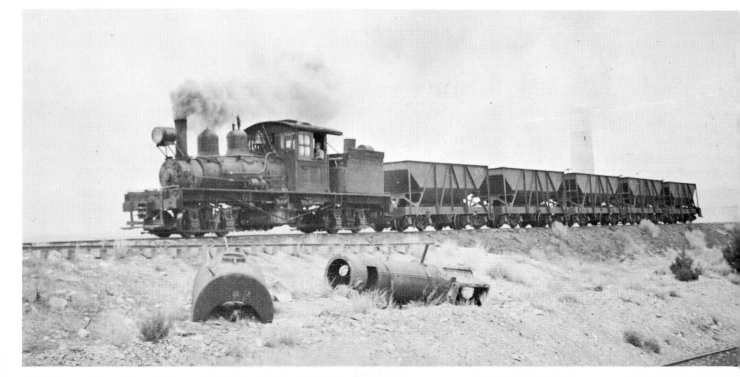

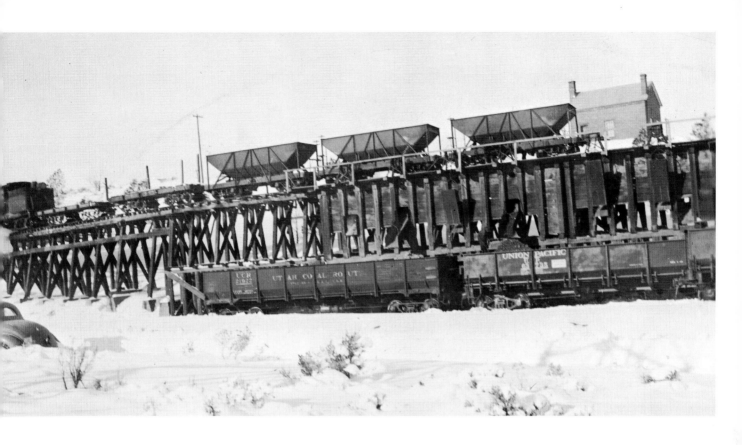

Narrow gauge Shays were the lifeblood of the Pioche Pacific's Hill Line, and the road acquired several during its years of operations. One of the earliest *(top, left)* was equipped with the customary diamond stack of the period. Note the homemade, rectangular water car mounted on a 4-wheel chassis behind the locomotive, and the end-frames on the flatcar to adapt it to the carrying of mine timbers. The engine house and the stack of the early smelter appear behind the train. The trestle facilitated the transfer of ore from the narrow gauge to the standard gauge gondolas seen on the lower track. Note the car of the Utah Coal Route. One of the Pioche Pacific's Shays still stands on display at the Last Frontier Village in Las Vegas. *(Top, left: Grace R. Bowman Collection; center, left: photo by A. L. Rowe, collection of Bert H. Ward; bottom, left: R. L. Searle Collection; above: William H. Roberts.)*

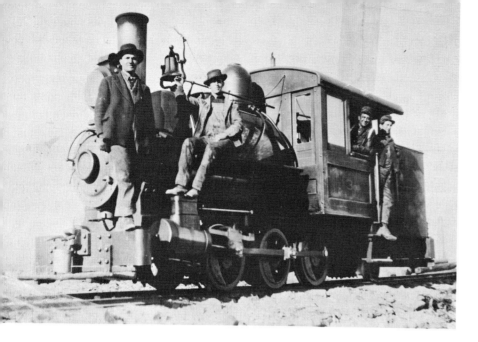

Rod locomotives were less prevalent on Pioche Pacific rails and normally were confined to service on the Jackrabbit line. The 6-wheel saddle-tanker No. 3 *(left, top center)*, was acquired by the Nevada-Utah Mines & Smelting Corp. in 1907 at the time that organization succeeded to Godbe's various properties, including his Pioche Pacific. Note the older form of wooden hopper car coupled to loco, as contrasted with the more recent, metal hoppers in background. The two tank cars at the end of the train were for carrying water to the dry camp at Jackrabbit. *(Both photos: Mrs. Roy Orr, Sr. Collection.)*

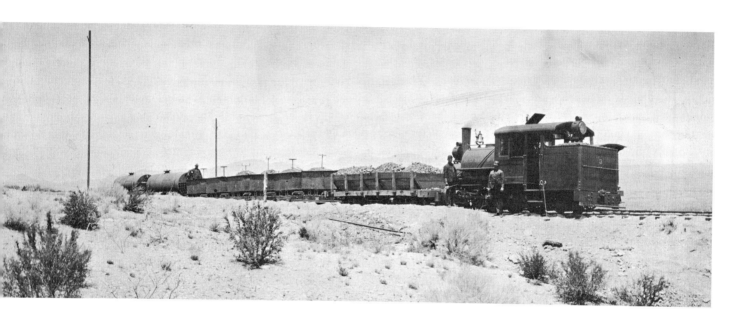

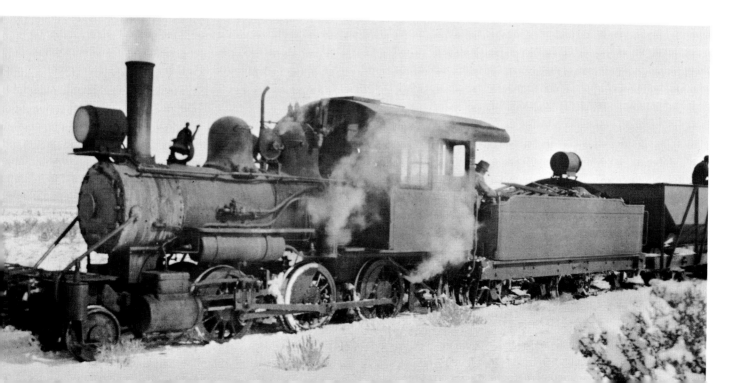

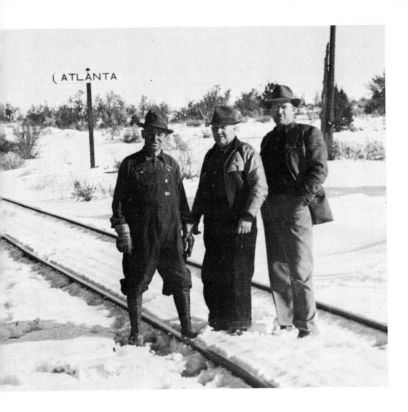

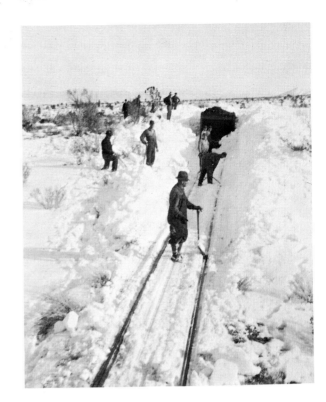

By 1939 the Bristol Silver Mines Company was operating the Jackrabbit line of the Pioche Pacific with narrow gauge (2-6-0) Mogul, No. 279, an ex-C&NW engine *(bottom, left).* In the late winter of 1937 *(this page)* heavily drifted snow tied up the railroad for almost six weeks while cuts were bucked free with a loaded hopper or shoveled clear by hand. The station of Atlanta marked the crossing point with the rails of the Prince Consolidated Railroad. *(Bottom, left: D. S. Richter photo; this page above, left: Mrs. J. H. Buehler; three right photos: Paul Gemmill Collection.)*

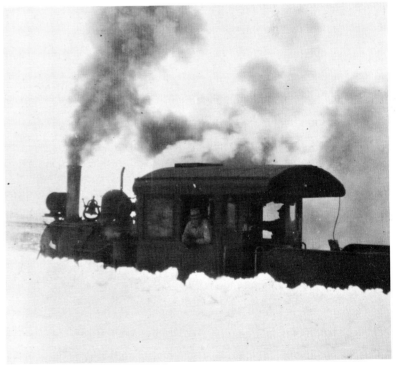

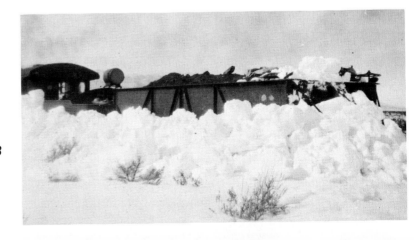

These two splendid panoramas of Pioche are about as opposite in season as they are in point of view. Townsend Smith, a Pioche Mines stockholder from Virginia, waited all day to take this winter picture. Posed in the left foreground is the electric tram of Pioche Mines Co. while in the background the Shay locomotive is hauling four empty cars back up the hill to the No. 1 Shaft, seen at the center left where a rising cloud of smoke is indicative of the activity then prevalent. This scene looks to the northeast along the Ely Range with the crest of Mount Ely at left, top center, behind which lies the Half Moon Mine, once an objective of the Pioche Pacific. The town of Pioche lies in the right foreground. (*Owen Walker Collection.*)

The summer view looks southeast from the railroad grade, over the town of Pioche toward Treasure Hill in center of picture. The narrow gauge tracks curve gently upgrade toward the No. 1 Shaft which stands atop the farthest waste dump at the foot of the mountain, originally con-tinuing on around the hollow, back across the face of Treasure Hill at center, and on over the notch at center left to the PCM&R Summit Mill. Lime Hill lies to the far left. *(Mrs. J. L. Underhill Collection.)*

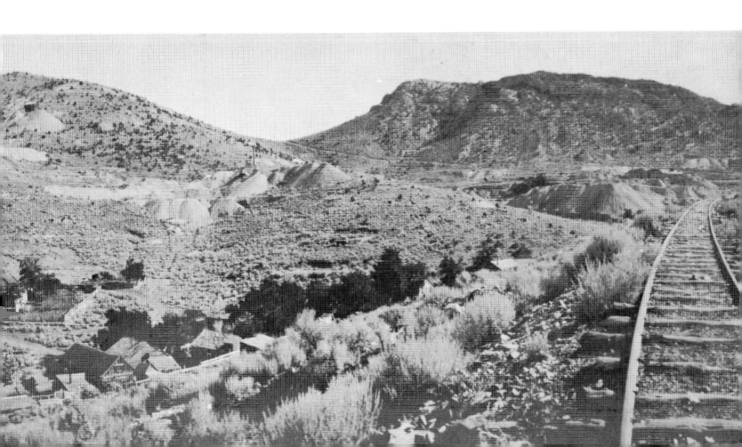

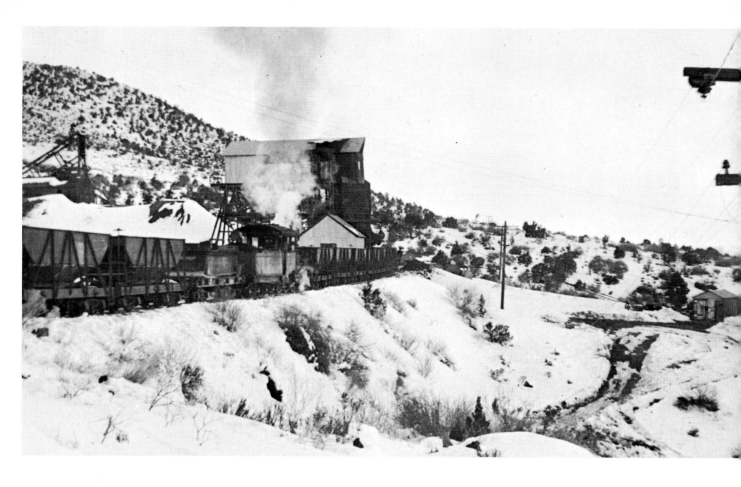

End of the Pioche Pacific's longest line was at Jackrabbit where ore cars were loaded from bins at the end of the Bristol Silver Mines Co. aerial tramway (above). Here too was the line's engine house (below) in which the rod loco- motive was usually kept. Note the harp-type switch stands and stub switches, characteristics of early day railroading. (Top: Mrs. J. H. Buehler; mottom: L. J. Ciapponi.)

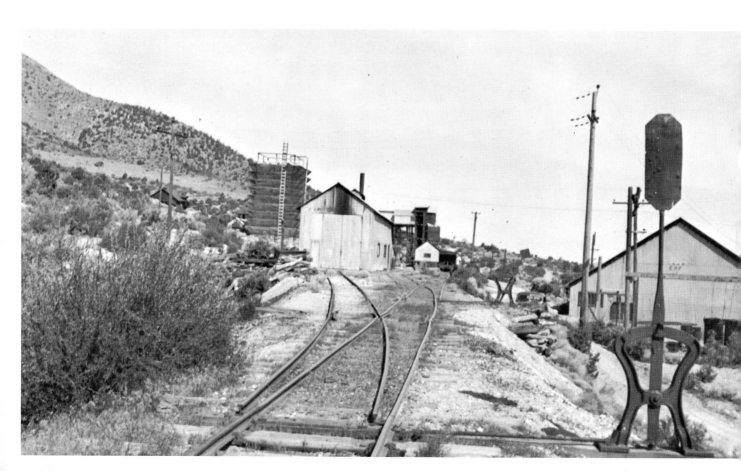

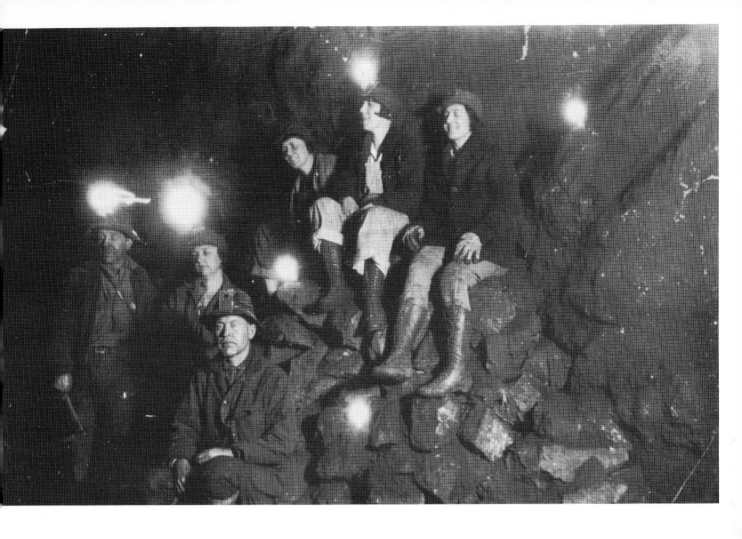

The ladies in the inspection party (*above*) seemed to be enjoying their worm's eye view of the Bristol Silver Mine. The ore on which they are sitting will be shipped out over the tramway and thence via the narrow gauge to Pioche for shipment to the smelter. (*Above: Mrs. J. H. Buehler; below: William F. Roberts Collection.*)

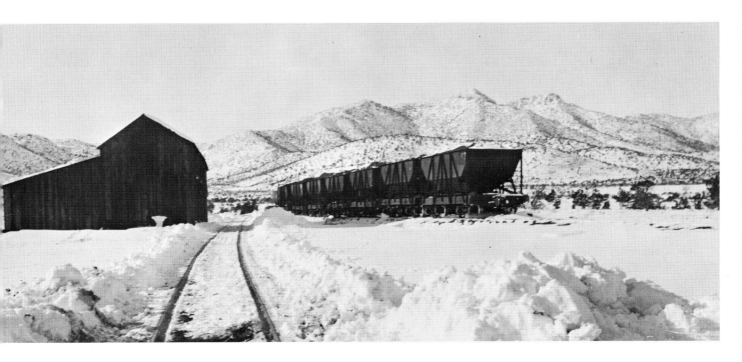

tire $250,000 mill on which there was but $40,000 of insurance. Godbe was undaunted; he immediately formed the Phoenix Reduction Company, and six months later a brand new mill was in operation as before.

Unfortunately, the vote of confidence expressed by Godbe's actions was not to be sustained. The price of silver, which had declined almost constantly from its high of around $1.32 an ounce in the early 1870's to $1.05 in the mild 1890 recovery, continued to plummet to a low of 52 cents which was reached in 1909. A local concern leased the Yuba mine and mill of the PCM&RCo., but even they could not meet expenses at the low rate of return. In July 1898, two miners brought suit for back wages, and the only settlement which could be offered — and was accepted — was to allow the men to work the mine for themselves until they recovered their wages.

Except for a brief interlude, the Pioche smelter was closed down for a long period, and the railroad suspended operations coincidentally. To cap the climax, early one morning as the town was enjoying an extenuated dance in a spirit of revelry, fire broke out at 1:30 A.M., April 20, 1899, to consume the Summit Mill of the PCM&RCo.

It was not until 1901, when new discoveries of *copper* ores were made at Bristol, that activity in the region became stimulated. In October 1901 the Pioche smelter once again was reactivated and the narrow gauge placed in condition for operations. The old order was about to change.

Delamar,
Gold Star for Lincoln County

Although Pioche, silver center and county seat of Lincoln County, was going through the doldrums in the decade of the 1890's, the town's idle miners and prospectors never gave up their search for gold which still commanded a good price. The fitful trail led to many strange places, not the least of which was Monkey Wrench, ultimately part of the area called Delamar, which for a time eclipsed Pioche as the most important mining district in Nevada.

Two prospectors, John E. Ferguson and Joseph Sharp, inaugurated the procession back in the summer of 1889 when they set out from Hiko, about 50 miles southwest of Pioche, on one of their ever-hopeful prospecting trips. After several days of travel, they became aware of the absence of one of their most essential pieces of equipment — a

hammer. Having proceeded too far to warrant turning back, they decided the most expedient solution to the problem was to find some substitute which might have been cast aside by a preceeding prospector. Ironically, the first and only item to be spotted was the main (handle) portion of a monkey wrench which they kept for lack of anything better. Not surprisingly then, when they did discover gold ore in the Bennett Spring Range, they named their claim after the primitive implement they had used.

Prospecting in the vicinity of Monkey Wrench continued in the summer of 1891 as others joined in the search for riches, but the real development started during the early part of January 1892. Encouragement was stimulated by the news that assays had been made showing 1,716 ounces of silver and five dollars of gold per ton of ore. This represented real riches, and miners from other places hastily pointed their burros' noses in the direction of the prevailing finds.

The influx of people demanded attention and accordingly, on February 20, 1892, the Ferguson Mining District was formed. In a March letter to the *White Pine News* of Ely, Nevada, one correspondent noted that in all six of the claims then being worked, rich horn-silver and yellow chloride had been found in veins reaching from two to six feet wide, and that "every man here is excited to the highest pitch." Small wonder they were jubilant!

The next logical development was the platting of a townsite, to which the optimistic title of Golden City was accorded. The over-optimism was demonstrated by the almost immediate suspension of development when a new town was started barely a half mile to the south near the Magnolia claim. The new upstart was called Helene in honor of Mrs. H. A. Cohn, wife of one of the Fergusons' early partners. Tents quickly dotted its streets and avenues, while a saw mill six miles away was kept busy turning out lumber for the four frame buildings placed under construction. Within a matter of months, the urgency and excitement had died down, and that summer the earlier town of Golden City was revived — this time under the founder's name of Ferguson.

For the moment the Magnolia claim was the only real mine in the new district. The owners — the Cohns, the Fergusons and another partner, Jerry J. Manning (later Lincoln County assemblyman) — sported satisfied looks on their faces as the property turned out gold ore worth $500-600 to

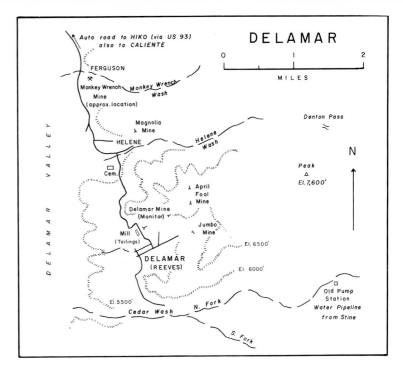

the ton. Their satisfaction turned to amazement, however, when two miles farther south another group of men — D. A. Reeves, A. C. Ellis and Frank Wilson — startled everyone with a new discovery of gold quartz on the first of April. The success of their find was quickly indicated in the name selected — the April Fool. A small camp called Reeves was started immediately below the mine, the location of which in later years became the site of Delamar.

The glowing reports from the Ferguson District created feverish excitement in Pioche. The unemployed and many of those eeking out a marginal existence in the town's depressed economy determined to try their luck in the new bonanza. Even S. T. Godbe, another esteemed member of the prominent mining family of Salt Lake City, Pioche, etc., when asked for his opinion, replied: "Ferguson is all right. I have seen a good many camps that have been blown up a great deal, and when you went to them, you didn't find what you expected to find, and would come away disappointed; but here in Ferguson I was agreeably surprised and that is saying considerable."

There was no doubt; the Ferguson District was riding high. J. M. Denton's stage made round trips twice a week from Pioche. A weekly paper, *The Ferguson Lode*, appeared on the scene in August. One sample of ore from the April Fool caused terrific excitement by assaying at $24,000 per ton. The big fallacy with any figure of that kind was that it was based upon one sample and did not necessarily mean that a whole ton of ore of that value could be found. The results, however, made nice reading for prospectors and mining promoters alike.

In July 1892, a Mr. John Sevenoaks appeared in the Ferguson District, liked what he saw, and took an option on a two-thirds interest in the Magnolia at a purchase price of $50,000. Two months later another group of buyers contracted to purchase the April Fool group of claims, $50,000 to be paid within 60 days from September 6 and the balance of $100,000 within another four months. More good mining news continued to be reported that fall as additional rich ore samples were uncovered. Prosperity was everywhere in the towns of Ferguson, Helene and Reeves, to the detriment of Pioche from which there was a steady exodus to the booming area.

The meteoric rise, however, was too good to last. First the option on the April Fool was forefeited; then while people were striving to recover from

that disappointment, the same thing happened with the Magnolia. Work on both mines momentarily came to a standstill. "Everything is dull in the extreme," wrote an unhappy correspondent in February 1893, although he might have countered his despondency with the good news that the Nevada Southern Railway had begun construction northward from Goffs, California, with the visionary aim of tapping the various mining districts across the southern part of Nevada.

The next month, however, the news began to improve as additional explorations yielded new finds in the mines. Seven men went back to work at the Magnolia, and thought was being given to starting up the old 20-stamp mill at Hiko, some 30 miles to the west. A. H. Godbe (still another of that famous mining fraternity) told the *Salt Lake Mining Journal* that he had great faith in Ferguson and expected that within two years it would have a railroad to its door.

Happy faces appeared around the Magnolia that spring when the men welcomed their first payday following several months of work. The cash payment was made possible through the recent sale of ore in Salt Lake City. Not so fortunate were the workers at the April Fool. Bad air in the mine caused suspension of the work for three weeks but finally, in June, four teams were dispatched to the railhead at Milford, Utah, with ore for the Salt Lake refineries.

By the close of 1893 the economy of the gold camp was on its ascendancy in the manner of a prelude to the major events forthcoming in the

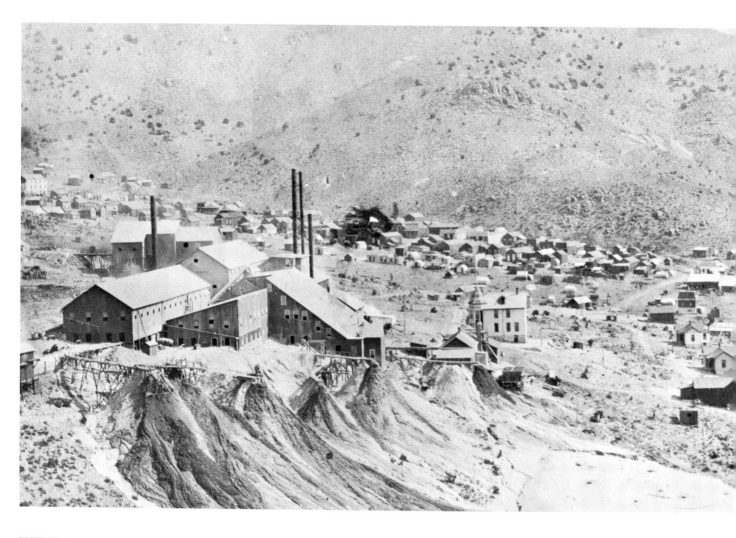

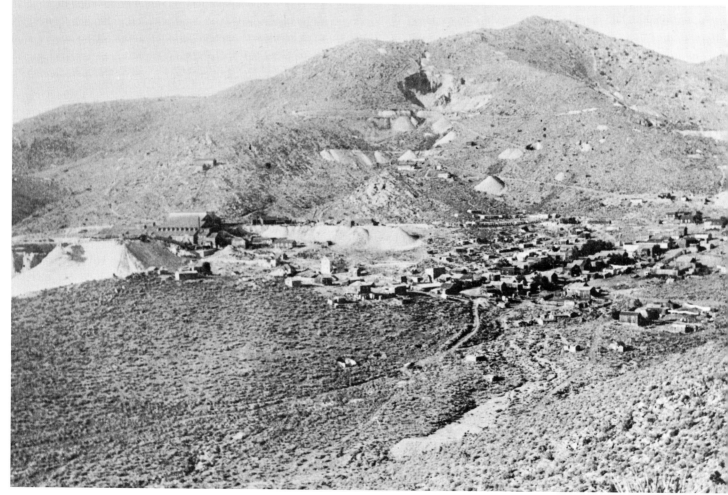

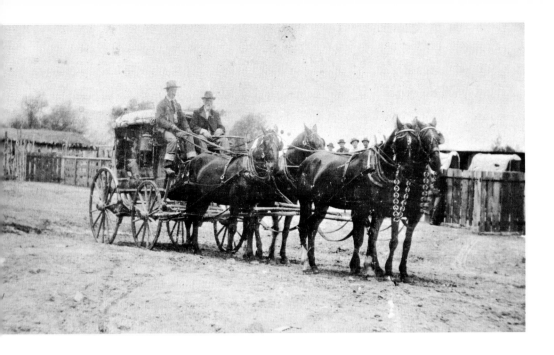

The site of the town of Delamar was bleak and uninviting, abominably dry and completely unsheltered from the desert winds. Three pumping stations lifted an insufficient quantity of water over 12 mountainous miles from the Meadow Valley Wash, while deadly silica dust from the dry-process Griffin mills pervaded the atmosphere. None of the tentatively proposed railroads was ever built, and all metal produced was shipped in bullion wagons *(above)* to the nearest railhead. The low buildings in the background of the picture *(below)* were the comfortable weather-proof stone houses provided by the Company but were scorned by the miners in favor of the flimsy dwellings along the more exciting main street. *(Left, top and bottom: Frank M. Scott Collection; above: James G. Hulse (Delmue Collection); below: Nevada Historical Society.)*

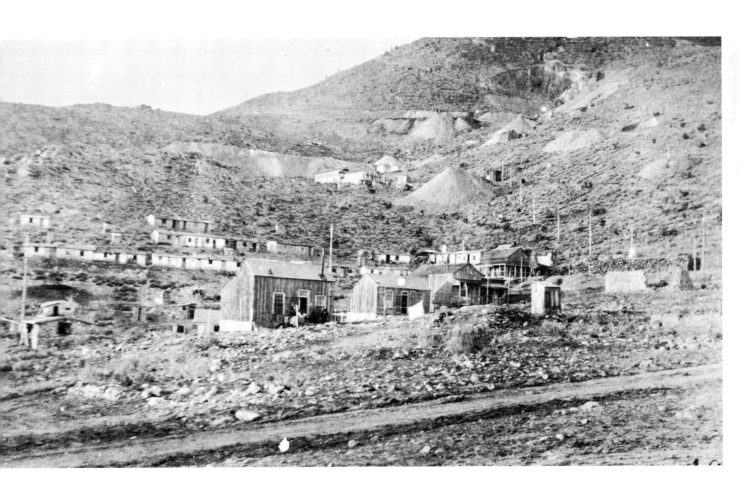

spring. Magnolia ores were being worked on a regular basis at the Hiko mill under the watchful eye of Johnny Ferguson. The more recent Jim Crow mine, owned by the Nesbitt brothers and a Mrs. McFadden, was developing good news. The April Fool and the then still unspectacular Monitor, both of which were held by the Reeves-Ellis-Wilson combine, were forwarding ores to W. S. Godbe's recently renovated Bullionville Mining and Reduction Company mill to the south of Pioche below Condor Canyon.

It was in April 1894 that S. T. Godbe, Isaac Blake (of the Nevada Southern Railway) and Joseph Raphael De Lamar journeyed to Ferguson together, a visit which was to have profound repercussions for the gold camp. Just what course of conversation was pursued is not known, but apparently it was sufficiently convincing for De Lamar to return to Pioche with deeds to the Monitor and the Jim Crow claims in his pocket. Later he also acquired title to various selected neighboring claims.

Captain De Lamar (as he was usually called) was a notably successful mining man. Born in Amsterdam, Holland, he spent his early years at sea, and it was not until later that he became identified with western mining activity. One of the more notable of his earlier ventures was his purchase of the Wilson Mine at Wagontown in southwestern Idaho in 1888. Ultimately the town was renamed De Lamar, and the captain profited handsomely when he sold his mine to a British company in 1891. The Britishers also congratulated themselves on their fortunate purchase, for over the next three depression-ridden years the mine succeeded in paying out $1,000,000 in dividends.

Now, embarking on his new venture in Nevada, the captain planned to develop his property. Lack of water had been the most vexing problem ever since the camp had been founded. De Lamar proposed to solve it by tapping an artesian well, a project which was eagerly watched both by neighboring miners as well as ranchers. If successful, the new well would set a precedent for many similar projects. Unfortunately, the efforts were unrewarding, but little water was found in spite of 900 feet of drilling.

Still, water in reasonable quantities had to be provided in some way, not only for operation of his proposed mill but primarily to satisfy the needs of the enlarged population anticipated as a result of the opening of the mines on a large scale. De Lamar met this challenge by going east about 12 miles to the Meadow Valley (south of Bullionville)

where ample water was available close to the surface of the ground. A pipeline was run over the mountains to a series of tanks located in the hills above the camp, but it was found that three pumping stations would be required to lift the water over the ranges for a net vertical rise of 1,500 feet. The basic unit in this complex system was located in the Meadow Valley at Pump Station (sometimes called Power Plant, later Kershaw Post Office, also Stine). Here coal-fed steam boilers furnished the power for generation of electricity with which to operate the pumps. When the system was finally placed in operation it was found that, after domestic requirements had been met (250 people were listed on the mine payroll alone), but little water was left for use in the milling operations.

The mill was constructed in the fall of 1894. Prior to its completion, the gold ores from the Delamar Mine (formerly the Monitor) were teamed to the mill in Condor Canyon, south of Pioche. Along with the change in the name of the mine, it was axiomatic that the camp of Reeves should become the town of Delamar. In spite of the honors bestowed through use of the captain's name, the implications became derogatory over the course of time as word spread that "Delamar was a widow-maker."

The site of the town was bleak and uninviting, abominably dry and completely unsheltered from the desert winds. Thus control of the fine silica dust which was always prevalent both in the mines and in the mill presented an eternal problem. The dry-process Griffin mills, in particular, with their terrible silica dust was "said to be responsible for the deaths of more than 500 men." Perhaps this was an exaggeration, but there is no question that silicosis struck down and took the lives of many men until a more effective method of dust control was instituted in the mill in 1899.

Well-built frame houses near the mill were provided by the company for married men, while single men were offered the facilities of stone bunk houses at a low monthly rental of $2. In spite of this, most employees found that higher priced, though inferior, living quarters in town were more to their liking. The primary reason given for the change in fealty was the proximity to such diversions as the saloons, the "stockade" and the Schaffer Grand Opera House. It was in the "stockade" that a fire commenced on May 29, 1900, which rapidly spread to the opera house, the Episcopal Church, the schoolhouse, the office of the *Messenger* and to many other buildings. The flames

could not be brought under control until a fire-break had been cleared with the assistance of a liberal sprinkling of giant powder.

By 1902, when De Lamar decided to sell out to Simon Bamberger, the District's production record had become most impressive. With the majority of Nevada's silver mines closed down due to the low prices of the 1895-1900 era, Delamar's gold mines alone accounted for half of the State's total mining production. The Delamar Nevada Gold Mining Company turned out $8,500,000 in ores to make Lincoln County the principal mining county in the state of Nevada. Even the April Fool turned out $877,000 in the same period (1894-1902), but the much heralded Magnolia managed to produce only $37,694.07 in the same years. Since no mention of the Monkey Wrench is made, undoubtedly its production was even smaller.

Simon Bamberger was joined by others (including Marcus Stine and two famous New York bankers — Philip Lehman and Henry Morganthau) in the purchase of the mines and the formation of the Bamberger Delamar Gold Mining Company. In addition to the purchase of the former De Lamar properties in June 1902, other claims were acquired including the Magnolia and the April Fool. Extensive improvements were made to the properties, including the addition of a 400-ton cyanide plant and more modern milling machinery. The new mill was started in operation in June 1903, and the following month electricity was inaugurated for town lighting, thereby reducing the hazard of fire. At the same time electric mine locomotives were inaugurated to bring ore trains out through the No. 10 tunnel, replacing the mule power which had prevailed through the years. Over at the Power Plant in the Meadow Valley Wash, a more dependable coal supply could now be assured with the arrival of the tracks of the Salt Lake Route in November 1903. A new tramway from the main line tracks to the Power Plant obviated the maintenance of teams at this point for the haulage of fuel, and it was reliably estimated that the days of forced shut-downs for lack of power were now a thing of the past.

Under the new management, the mines continued to be among the most important gold producers in Nevada. Even in 1905-06, when the Florence Goldfield and the Tonopah Mining Company were enjoying the peak of their frenzied booms, the Bamberger-Delamar still ranked third in output of gold in the state.

That a railroad never was built to Delamar was a disappointment to many people. Had the Salt Lake Route been placed in operation 10 years earlier than its ultimate completion, a branch line to Delamar might well have been an economic possibility. However, by the time that railroad was finished in 1905, Delamar's days were numbered. By 1908 the end was in sight, and on September 1, 1909, the mill was permanently closed, having produced the handsome sum of $3,400,000 for its new owners. Abandonment of the mine and dismantlement of the mill were natural eventualities. The useful parts of the mill were removed for ultimate re-use at other locations, while the tailings continued to be worked by lessees for a few years longer. Another fire occurred in 1910, but this time the purpose was useful — by burning the old woodwork in the precipitation department of the mill, considerable hidden gold was yielded.

In postscript it might be mentioned that sporadic production of the tailings took place in a limited way over the period of the next two decades. The population shrank from a recorded 904 in 1900 to a mere 17 by 1920. Then in 1932 the Caliente Cyaniding Company began to treat the tailings of the former Delamar Mill, utilizing new techniques developed over the intervening period. Additionally, new but small discoveries of ore in 1932 and 1933 brought people back to the once deserted camp until the population grew to 100 people, necessitating re-establishment of a school and a post office. Today the camp is again deserted, and only the stone walls of abandoned cabins and the ruins of an ore bin mark the site of once frenzied activity.

Caliente & Pioche Railroad (OSL-UP)

The Union Pacific long had had its eye on Pioche as a lucrative source of railroad business. As early as 1880 that road's Utah Southern had penetrated southwest as far as Milford, Utah, but there the project had halted for a full decade. Although the next extension in 1890 carried the grade to within a few miles of Pioche, financial difficulties suspended the work and no track was laid for another decade. By the turn of the century, Harriman (of the UP) became engaged in a bitter struggle with Senator Clark (SP, LA&SL) over the right-of-way through Clover Valley and Meadow Valley for a Los Angeles-Salt Lake City route, and once again the Condor Canyon approach to Pioche came back into the limelight. Completion of the UP's grade

as originally surveyed would effectively block any SP, LA&SL construction.

In the middle of August 1901 it was reliably reported that the Oregon Short Line (successor UP operating subsidiary to the Utah Southern and other roads west of Salt Lake City) would lay rails on the old Pioche grade at once. Physical confirmation of the pending struggle was obvious by October, for both Harriman and Senator Clark had men surveying separate lines to Pioche. The OSL (UP) had the upper hand for their grade was already partially worked. Ties, timbers and rails began arriving daily for the Harriman forces. Construction was started, and the people in Panaca, Bullionville and Pioche eagerly expected to hear the whistle of a locomotive about the end of the year. Grading was pushed. In November 1901 a trainload of Italian construction workers arrived to bolster the forces. Then suddenly all efforts were suspended, both on the main line and on the branch. Harriman and Clark had called a truce, and time was required to settle the details.

Pioche waited, as did all the other people in the area, to learn the outcome. It was not until the summer of 1903 that workers again began to toil on the main line, now an (undisclosed) joint Clark-Harriman project. Nothing was said or done about branch line rails to Pioche. The people still waited — and wondered.

From out of the wilderness to the south and west of Caliente came the next news of a railroad to Pioche. In November 1904 *The De Lamar Lode* carried an announcement that work would begin on a branch line to serve its neighboring city to the north within three months after the SP, LA&SL had completed its main line between Los Angeles and Salt Lake City. What was more, the tracks would not just end at Pioche, but would be continued on northward all the way to Ely, Cherry Creek and Wells, Nevada (on the SP). Even after the Nevada Northern was built to Ely and McGill from the north (1905-06), persistent references to the proposed branch indicated its terminus would be at Ely where Pioche ores could utilize the facilities of the McGill smelter. As so frequently happened, talk proved to be cheaper than action, and no actual construction was ever undertaken.

It was not until June 1906 that the SP, LA&SL finally commenced work on a line to Pioche. Using the facility of a subsidiary company, the Caliente & Pioche Railroad, the old (UP) grade was once again gone over, revised in some places, and restored in others. Early in 1907 a contract was let

to Deal Brothers & Mendenhall, and construction seemed to be assured at last. August 5 was set for a completion date, and supplies and men began to arrive in Caliente. The big push was about to start.

Suddenly, without warning, one of the major floods in the Meadow Valley area occurred. The men, forces and supplies were immediately diverted to repair the damage to the main line, while the branch construction was necessarily suspended. Hardly had main line service been restored and the men returned to their original project than another interruption intervened. It was now July 1907, and 25 men in the steel gang quit because of poor food. Delays were piling up, and it was obvious the completion date could not be met. Pioche anticipated the problem and moved the date of its proposed celebration forward from October 15 to November 11, 1907. Thus, when the track laying was completed at the end of October, the railroad was greeted quietly and the formal celebration was postponed until the following spring. By the time spring arrived, Pioche was enjoying a revival (due in large measure to its new connection with the outside world) and the celebration was forgotten.

Changing Times

The first outbound ore shipment over the Caliente & Pioche was made on November 18, 1907, approximately one week after J. Ross Clark of the SP, LA&SL had paid a surprise 15-minute visit to Pioche one Sunday morning. The shipper was the Nevada-Utah Mines & Smelting Corporation, a recent (inc. 1904) successor to various properties in the Pioche area, including Godbe's Pioche Consolidated Mining & Reduction Company and his Pioche Pacific railroad.

In anticipation of the changing pattern of transportation, the Nevada-Utah M&SCo. had extended the narrow-gauge tracks of the Pioche Pacific the short distance from the roundhouse to the new C&P depot and (transfer) ore bins. Likewise, orders had been placed for some new equipment — a narrow-gauge locomotive, 30 ore cars, plus some heavier rail with which to strengthen and improve the roadbed. By 1908, with the improvements placed in effect, the Pioche Pacific commenced operations as a common carrier railroad.

The changes outlined served in part — at least around Pioche — to counteract some of the extreme ill will which had been generated (inadvertently on the new Utah company's part) by the "notorious Thos. W. Lawson" during the early months of

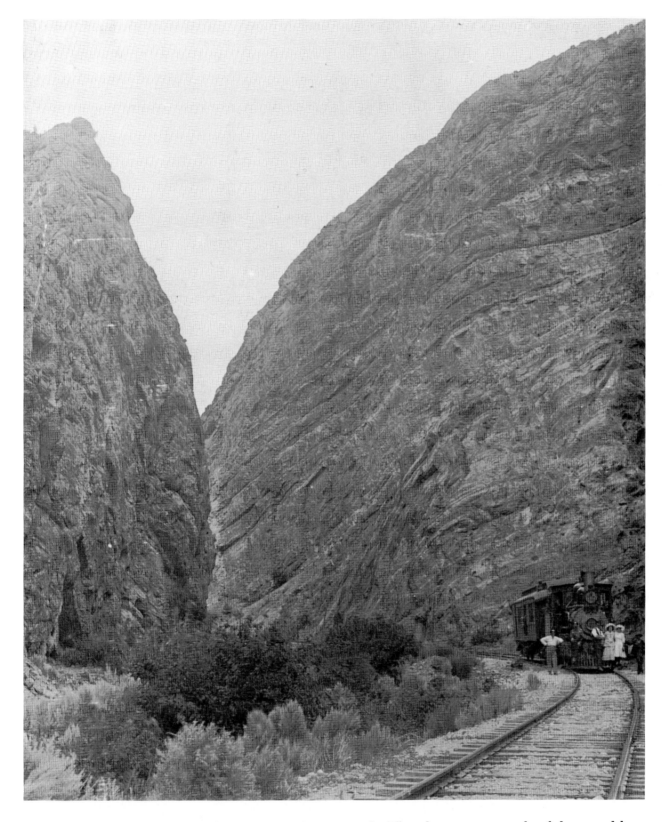

Condor Canyon, passage for the pioneer, narrow gauge Pioche & Bullionville, was the logical choice of route for the succeeding Caliente & Pioche. The spectacularly high rock cliffs and narrow passage dwarfed men and locomotives to Lilliputian proportions. (*Don Ashbaugh Collection.*)

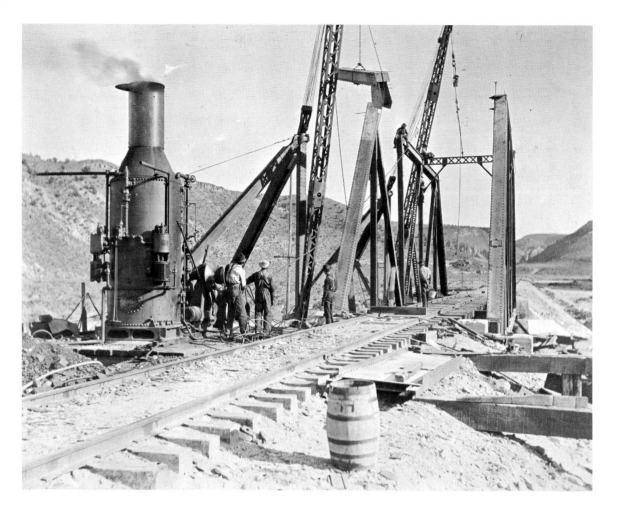

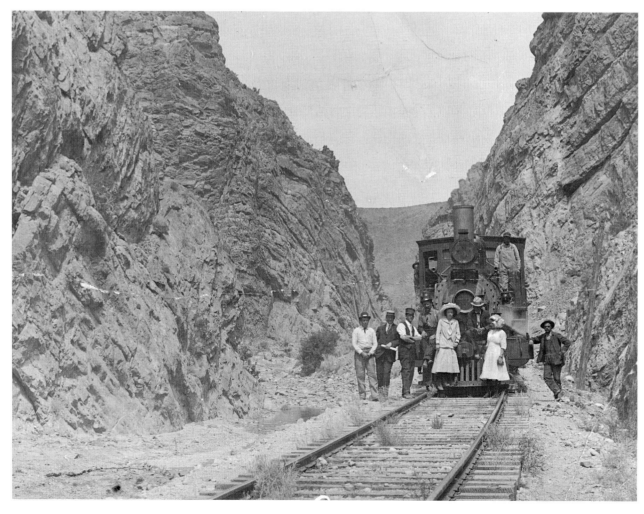

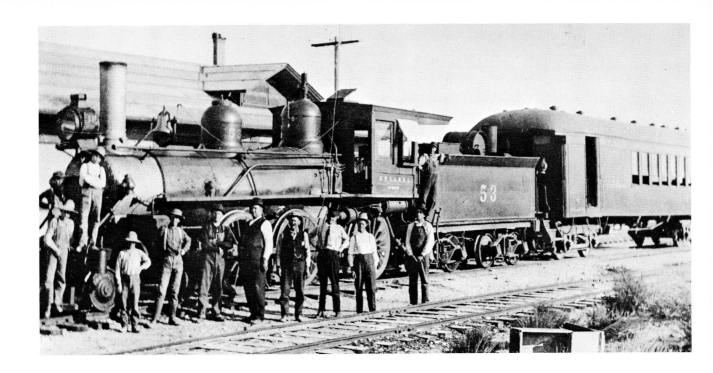

In building the Caliente & Pioche, the necessity for installation of such heavy steel bridges such as this *(left)* appeared incongruous when compared with the shallow roadbed virtually laid in the stream bed of the important Meadow Valley River *(bottom, left)* through Condor Canyon. Essential construction supplies by the thousands were piled up at Panaca in preparation for the project, as witness the fence posts and rolls of barbed wire in foreground *(below)*, the heaps of tie plates and rail joiners across the track, and the stack after stack of ties in the background. When the railroad was completed, locomotives of the Salt Lake Route were utilized to handle the trains, such as No. 53 of the SPLA&SL *(above)*, photographed at Panaca. *(Above: Arthur Petersen photo; all others: courtesy James G. Hulse.)*

1907. Lawson had successfully rigged the market price of Nevada-Utah stock on February 28, 1907, by extensively advertising that he was anxious to purchase control of the company. Over the next two weeks, as the gullible public scrambled to buy shares of stock with which to meet this unexpected demand, Lawson apparently disposed of his holdings. Then on March 13 Lawson announced that he was through with the property — that it was not as it had been represented to him. In the public's ensuing scramble to unload the stock so hastily bought, Lawson probably repurchased his shares at a much lower figure. Then he magnanimously announced that, because so many small speculators — street hawkers, newsboys, bar porters, scrubwomen, and the like — had become so intricately involved in the speculation to their detriment, he would pay double the price of the stock "to help them out." And that he did. The price soared as the people attempted to buy back in for a quick profit, and Lawson unloaded again for the last time at a most satisfactory figure. He had kept his word and helped the unfortunates out — out of whatever meager savings they might have had.

The combination of this taint together with various difficulties over the next few years (including some questionable titles to properties at Pioche) cast a stigma upon the company, and its operations fell into disrepute. An adjustment of its affairs definitely became in order. As a result, in 1911 the Nevada-Utah turned over some of its claims in Pioche to the Amalgamated Pioche Mines & Smelters Corporation in exchange for a stock interest. Apparently the integrity of this transaction was somewhat questionable in the eyes of at least one contemporary critic, for he expressed dissatisfaction with its secrecy contending "the exact deal being about as hazy in outline as most of the previous financing of the company." Perhaps his diatribe was justified, for the Nevada-Utah went into bankruptcy the following year (1912), dragging the Pioche Pacific along with it. In 1913 a new Consolidated Nevada-Utah Corporation emerged and, thanks to the financial backing of the shareholders of the old company, it limped along in active mining operations through its subsidiary, the Amalgamated Pioche, until 1917. The latter company also directed the operations of the Pioche Pacific Railroad and the Pioche Water Works.

Not all business affairs in the area were conducted in such a clandestine manner, however, and a newcomer to the fold was beginning to loom large on the horizon. Two miles southwest of Pioche on the far side of the Ely Range lay the Prince Mine, originally small and relatively undeveloped — that is, until the Godbes took it over.

Prince Consolidated Railroad

Because the Prince Mine lay on the opposite (south) side of the Ely Range from Pioche, it enjoyed none of the benefits of the early transportation developed in the area and was unable to utilize the same facilities. As a consequence, Prince ores were hauled by teams in a southeasterly direction toward Bullionville. Supplies were brought to camp in the opposite routine. The Prince was an outpost operation depending solely upon itself for sustenance and production.

In 1907, as the Caliente & Pioche Railroad finally started its climb northward from Caliente through Condor Canyon, the Godbe Brothers and James Hackett acquired the Prince Mine and formed the Prince Consolidated Mining & Smelting Company to operate the property. Ores continued to be teamed southeasterly to the new railroad at Panaca pending some better method of transportation. In August 1909 relief appeared to be in sight, for the Salt Lake Route became sufficiently interested to send surveyors into the field to locate a favorable railroad grade to the Prince Mine. Hopes faded, however, when nothing in the way of railroad construction developed.

Meanwhile the Godbe Brothers were finding revenues in the discarded tailings of the early, inefficient mills at Bullionville. A ¾-mile standard-gauge spur was built from a connection with the Caliente & Pioche Railroad to the Bullionville mill site in November 1911 over which many thousands of tons of ore for reclamation were shipped to the Salt Lake City smelters. (A visit to the former site of Bullionville today will still reveal the foundations of several of the mills as well as traces of the grades and cuts for both railroad lines — the standard-gauge spur and the earlier narrow-gauge Pioche & Bullionville.)

The owners of the Prince Mine could not afford to be patient with the transportation problem to their isolated location. Late in 1911 they decided to build their own standard-gauge railroad to run from the mine in a northwesterly direction up behind the Ely Range, then circle the end of the range at The Point (near Mendha) to swing back down the valley, cross the narrow-gauge Pioche Pacific at a station point known as Atlanta, and continue to a connection with the UP's Caliente & Pioche at its terminus near the Pioche mill and

depot. Although the roundabout route would form a gigantic, inverted letter "U," the difficulties of construction and operation would be negligible as compared with those of any other approach.

The George C. Thompson Construction Co. was awarded the grading contract in January 1912, and the following month 80 men and 50 teams were on the job, the first earth being turned on February 9. Work was started simultaneously from Pioche and at The Point (near Mendha) where a large cut 22 feet deep and 250 feet long was required. Except for the rock work at the cut, no particular physical difficulties were encountered. The weather, however, presented a different problem. Heavy snows in March hampered all progress. Even the neighboring Pioche Pacific suffered ignominies when a locomotive stalled in a snow-filled cut and the crew was obliged to struggle six miles back to town on foot.

In spite of these minor set-backs, track laying was begun by the first of May and on June 12, 1912, the last rail was spiked in place. Three days later service was inaugurated when an initial ore train traversed the entire 8.7-mile route to the junction with the C&P. On Sunday afternoon, June 30, a gala celebration was held. A special train brought 50 people from Salt Lake City, largely members of the Commercial Club. In honor of the occasion, they distinguished themselves by wearing badges reading "Jones Club, Pioche-Salt Lake, June 1912." The *Pioche Record* patronizingly explained that the members were Utah people "who recognized that Pioche had a wonderfully bright future." Henry Sadler drove the traditional Gold Spike; speeches followed; then a banquet; and finally a grand dance in the opera hall climaxed the entertainment for the week-end visitors. It was a heartening occasion for the townspeople as well, for the advent of the railroad was the first concrete evidence of real progress in the region in a number of years.

Varying Fortunes

Fire came to Pioche on a Sunday in October 1913. It quickly got out of hand, and the day being on a weekend, there was no concentration of people to fight it. As a last resort, a hasty telephone call was made to the manager of the Prince Mine for all the help he could muster. Men were gathered together; a special train was readied; and after a fast run they arrived in Pioche just 18 minutes after notification in time to help curb the blaze.

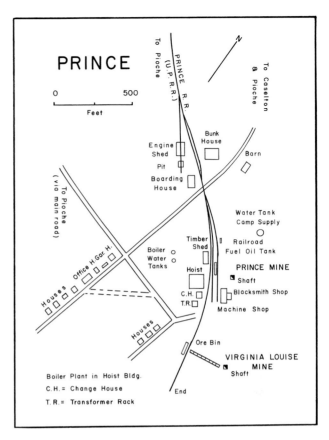

The year 1913 might best be remembered for the constructive action on the part of E. H. Snyder and some partners in the formation of the Greenwood Leasing Company, an act which presaged one of the largest developments in the Pioche area. Exploration of the Greenwood property led to the discovery of large, lead-zinc, sulphide bedded ores plus a vein of high-grade fissure ore, the latter yielding $70,000 worth of metal in a six-week period.

Snyder had arrived in Pioche just two years previous in 1911, having been promised a job surveying with the Pioche Pacific Railroad at $5 per day. As he discovered, the timing was most inappropriate. Although the arrival of the Caliente & Pioche Railroad late in 1907 had stimulated a number of the mines to start up in 1908, the revival had been short-lived. Production was dependent upon a demand for base ores, for which there was no satisfactory treatment. Gradually, one by one, the mines closed down; the Pioche Pacific had gone into receivership; only the Jackrabbit and Bristol mines remained open. With the Pioche Pacific in such difficult circumstances, Snyder's job had failed to materialize, and he accepted work as a mucker at the Jackrabbit mine. Before going on shift, how-

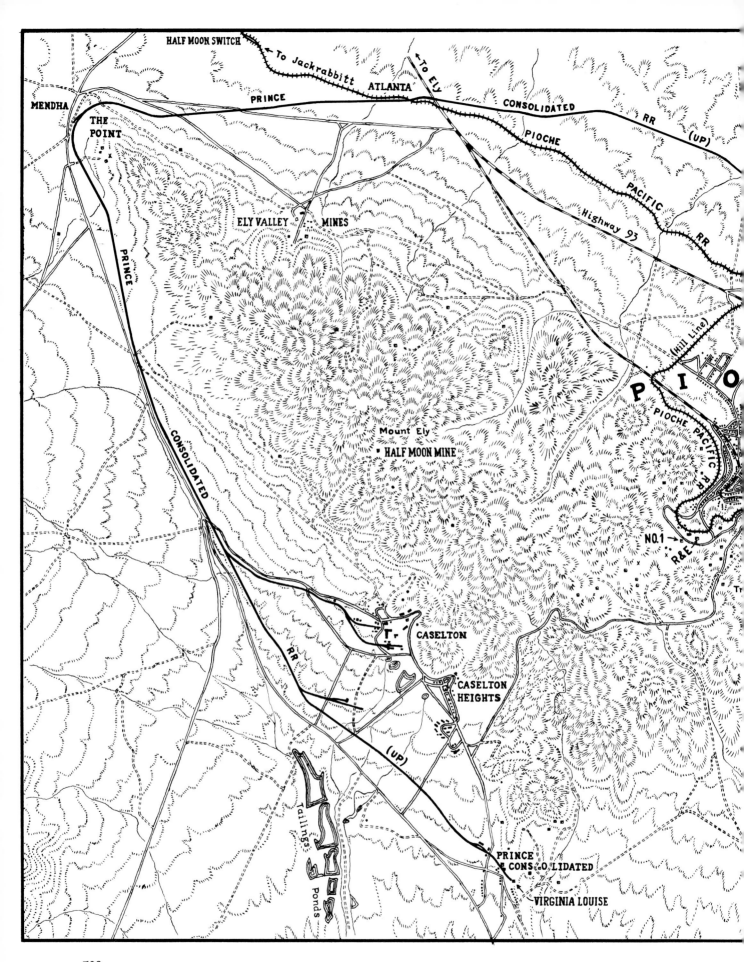

HALF MOON SWITCH

← To Jackrabbitt ATLANTA ← To Ely

MENDHA

PRINCE CONSOLIDATED RR

THE
POINT PIOCHE

PRINCE PACIFIC

Highway 93 RR

(UP)

ELY VALLEY — MINES

P I O

(Mill Line)

PIOCHE PACIFIC RR

PRINCE

Mount Ely
HALF MOON MINE

CONSOLIDATED

NO.1 →
R&E

RR

Tr

CASELTON

CASELTON
HEIGHTS

(UP)

Tailings

Ponds

PRINCE
CONSOLIDATED

VIRGINIA LOUISE

720 —

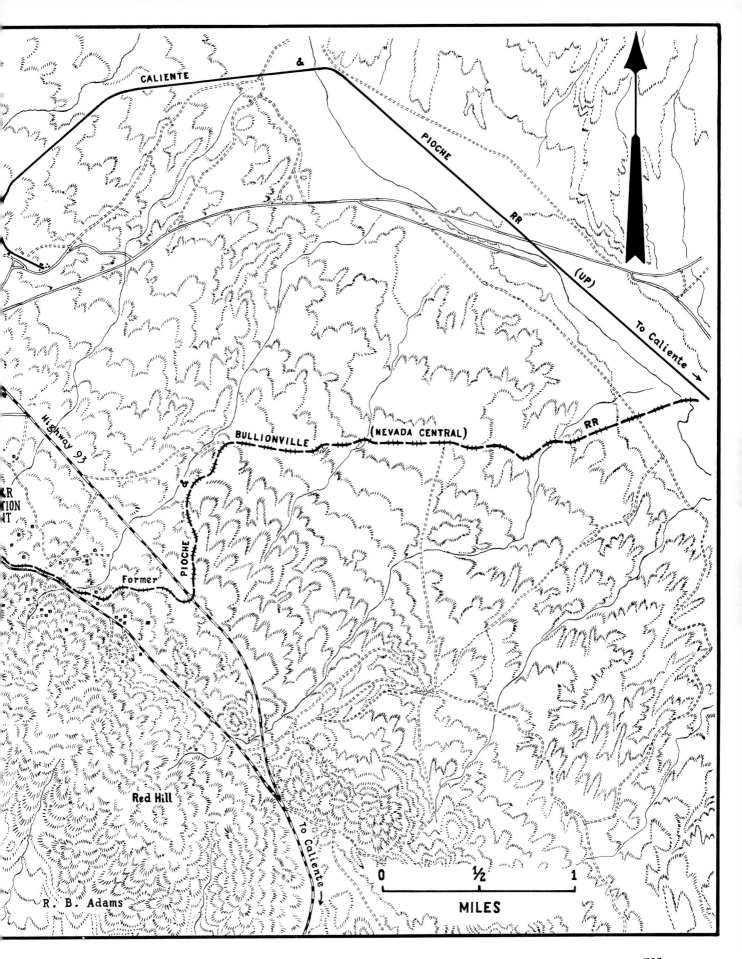

CALIENTE

& PIOCHE RR (UP)

To Caliente →

Highway 93

BULLIONVILLE (NEVADA CENTRAL) RR

& PIOCHE

Former

Red Hill

To Caliente →

R. B. Adams

0 ½ 1
MILES

—721

ever, he found out about and took a different job as a surveyor's helper at $3 a day at the Bristol mine. Unfortunately the position only lasted for three months before the mine went into the hands of a receiver, but during the tenure of his stay Snyder managed to get a good look at the Bristol mine — one which ultimately led to his acquiring control of the property some nine years later.

Upon severance of employment, Snyder took a contract with a partner, Mart Empy, to sink the Virginia Louise shaft (near the Prince Consolidated) — a job which was accomplished through the application of a primitive hoist and some hand tools. Money was made, and with the proceeds the Pioche assay office was purchased. Additional leasing at Jackrabbit and on the Telephone claim brought further good results. In 1913 Snyder built a small mill to treat the old dumps on Treasure Hill, but a tornado blew the mill down the canyon and into the cemetery. The project was abandoned with the formation of the Greenwood Leasing Company.

Still not solved was the metallurgical research problem of separating the lead and zinc in the sulphide ores with which the Greenwood property (as well as the adjoining properties) were richly endowed. Unless and until a practical method was evolved, it would be useless to mine any of those ores at Pioche. Credit for solving this knotty problem must largely go to Mr. Snyder who spent the eight years from 1915 to 1923 in constant research which culminated in development of the flotation process. Such developments, however, were slow in arriving and extended far into the future.

Meanwhile, near the northern end of the Bristol Range a metamorphosis was in progress. On the north side of the range at the end of the Pioche Pacific's branch line lay the Jackrabbit (Day) Mine, the rich producer of some decades before. On the south side of the range, and many hundreds of feet higher, were the mines of the Bristol Consolidated Mining and Smelting Co. and the accompanying town of Bristol. In 1911 the two mining properties were merged into the Day Bristol Consolidated Mining and Smelting Co., and the development of copper ores sparked new interest in the area.

Although the Jackrabbit mine became quiet, the Bristol area began humming with renewed activity. Achilles Heel to the successful and profitable exploitation of the operation lay in finding a practical solution to the problem of transporting the ores to the railroad, only 2 miles distant as the crow flies but nine miles via the mountainous, semi-circular

roadway northward from Bristol to and through the Bristol Pass before descending southward down the mountain to Jackrabbit. The cost of teaming was exhorbitant — for every ton of ore hauled a "tribute" of $6.00 was exacted for transportation. Undoubtedly this was a major factor in the early financial distress of the Day Bristol organization, in not long after its formation receivers moved in, in spite of the fact that leasers were actively supplying sufficient tonnage at the railhead to keep the Pioche Pacific operating steadily.

In 1914, to obviate this costly method of transport, a two-mile aerial tramway was installed, extending from the mine directly over the mountain and down to the loading bins along the railroad at the foot of the east slope. Mining supplies, plus water both for domestic use and for the compressor, were transported in over the wires, while ores (in varying values of silver, copper, lead and zinc) were easily carried in the reverse direction to the narrow gauge for haulage to the smelter. Occasionally, during winter snow blockades, passengers were permitted to ride over the hill on the tramway.

New life for the operation began in 1915 following transfer of the properties to the California-Nevada Mining Company, but even with the added shipments of copper, the venture was short lived. Following a brief struggle, receivers again took over, the property ultimately emerging as the Uvada Copper Company.

It was in July 1917, during the period of Uvada control, that lightning struck the cables in a summer storm, the bolt grounding near some oil tanks at the hoisting works. The tramway was disabled, and the hoisting works were consumed in the resulting conflagration. Reconstruction was effected and operations continued for many more years, excluding a period of a few months in the early part of 1924 when fire again ravaged the tramway.

The year 1917 was notable for several other major changes in the Pioche District. On the north side of Treasure Hill, the Amalgamated Pioche Mines & Smelter Corp. proved to be no better able to manage its affairs than its predecessor, the Nevada-Utah. Active mining operations ceased, and the property was leased to Snyder's Greenwood Leasing Co. which in turn released it to Combined Metals, Inc., a corporation organized by Snyder interests in 1917 specifically for that purpose. Title to the Pioche Pacific Railroad was not transferred, the railroad continuing to be operated as a captive line.

On the south side of the Ely Range, the Prince Mine was booming. In fact, during the years 1915-16-17 it declared annual dividends totaling $124,-924, $250,000 and $200,000, respectively, and became the leading producer of the region. Godbe was delighted with the results and encouraged to attempt to repeat an earlier success at reworking some old mill tailings. Under the aegis of the Prince Consolidated, a flotation plant was erected on the site of the old Bullionville smelter for the purpose of recovering values from the old Bullionville and Dry Valley tailings. Unlike the results of the earlier efforts, failure attended the project due to the complex nature of the tailings. Modifications of the recovery process was tried to no avail, and in 1918 the mill was abandoned.

This setback was to be but the first of several reverses in its normally good fortunes. During the earlier days of the Prince Consolidated, while it was concentrating on building its private railroad between the mine and Pioche, but scant attention was paid to an upstart little neighboring mine immediately to the south — the Virginia Louise. Though beneath official recognition, the Virginia Louise Mining Company started to dig a shaft to an extension of the Prince Mine's ore in 1912. Before the close of 1913 the VL's shaft and various levels of tunneling had been completed and the ore blocked out. There was no way to ship the ores to market. The Prince was not kindly disposed toward overtures for use of its railroad, so patience and the waiting game were inculcated. Then depressed metal prices at the start of World War I forced a closing of the mine, and the premises became idle.

Toward the end of 1917 the time apparently had come to act. The Virginia Louise entered into litigation with the Prince Mine over ore rights, and a legal struggle ensued which did not end until 1918 with a favorable decision for the Virginia Louise in which it was granted a judgment against the Prince Mine in the amount of $27,334 for trespass. As a compromise settlement for release of the judgment, the Prince Mine agreed to grant the Virginia Louise the right to ship ores at 50¢ a ton over the Prince Consolidated's railroad provided the Virginia Louise dismissed its apex suit against the Prince.

Thus the Virginia Louise won the basic essential to its successful operation — transportation. The Prince Consolidated Railroad's tracks were extended some 500 feet beyond the Prince Mine to the VL. A small tramway was installed, about 200 feet long with a 30° incline, up which mine ore cars were pulled to dump their loads in the waiting standard-gauge cars. The arrangement sufficed as long as production from the Virginia Louise obtained (1927), following which the tracks were taken up back to the original Prince Mine (the present terminus in 1963).

The woes of the Prince Consolidated became multiplied in 1918 when an epidemic of influenza invaded the labor force and disrupted production. Then floods, in September, washed out four of the railroad's bridges. Both factors seriously affected the Prince's financial position.

Nor was that all. As though to thwart the new arrangement so forcibly impressed upon the Prince Mine as owner of the railroad, nature again went on a rampage in the spring of 1919, almost completely washing out a trestle of the Prince Consolidated Railroad and leaving the locomotive stranded at the end of the line near Prince. With only a small supply of light mine timbers available with which to bridge the gap, the skimpiest of flimsy trestlework was set in place and the rails joined. Water was drained from the boiler of the engine; the fire in the firebox was killed; coal was removed from the tender and the water drained; then, using the remaining steam still under pressure in the boiler, the lightened engine was edged onto the straining structure. Beams groaned and sagged under the increasing load, but fortunately they held together until the locomotive was safely across. Refueling was then quickly accomplished, and the engine despatched to Pioche for a load of more substantial materials.

With the acquisition of shipping rights over the Prince Consolidated Railroad, the Virginia Louise became a very active mine. Ore shipments to the Midvale, Utah, smelter began in September 1918 at the rate of 50 tons per day and were gradually increased until, by October 1919, daily shipments of 100 tons or more were the rule. Most productive were the three years from 1919 to 1921 following which, in 1922, the mine was shut down and the word began to circulate that it was available for lease.

Two widely experienced mining men, David B. Gemmill and Howard W. Squires, found the proposition to their liking. Together they formed the Virginia Louise Development Company to lease and operate the mine. They also leased the Prince Consolidated Railroad, and in April 1923 the first shipments of daily tonnages of fluxing ore (varying from 75-200 tons per day) were hauled to the Junction for forwarding to the Midvale smelter.

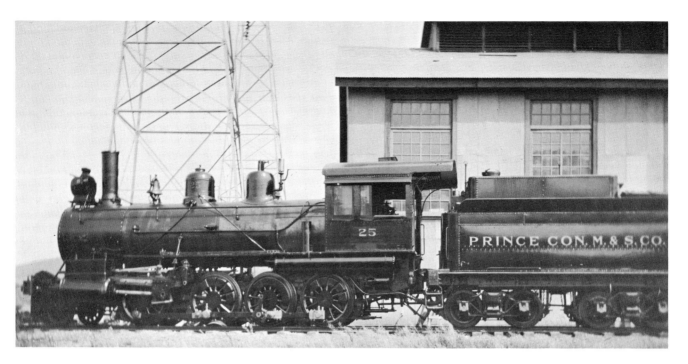

Pristine paint and the lack of a main rod indicate this portrait of Prince Consolidated's No. 25 was taken around the time of delivery by the Southern Pacific. A sister engine, No. 2511, is shown *(top, right)* in the nadir of its usefulness in 1938. Of particular interest are the unusual valve chests mounted on the inclined cylinders of both locomotives. *(Above: Louis L. Stein, Jr. Collection; top, right: L. J. Ciapponi photo.)*

The ore cars *(below, center)* failed to stop when they reached the end of the line at the Virginia Louise mine, nearer of the two mines in the view *(bottom)* facing west. Extension of the railroad approximately 500 feet from the Prince Mine (right, background) was part of the compromise settlement of a law suit in the 1920's. In 1942, after the Union Pacific took over the Prince Consolidated, the headframe was turned to face easterly across the several railroad tracks and is seen in its new position in the diametric view *(bottom, right)* which also shows the Prince's elevated, locomotive fuel oil storage tank, subsequently discarded. *(Left, center: David L. Gemmill photo; bottom, left and right: Paul Gemmill photos.)*

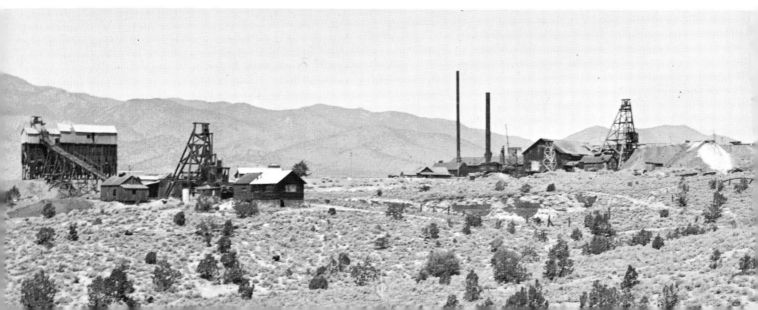

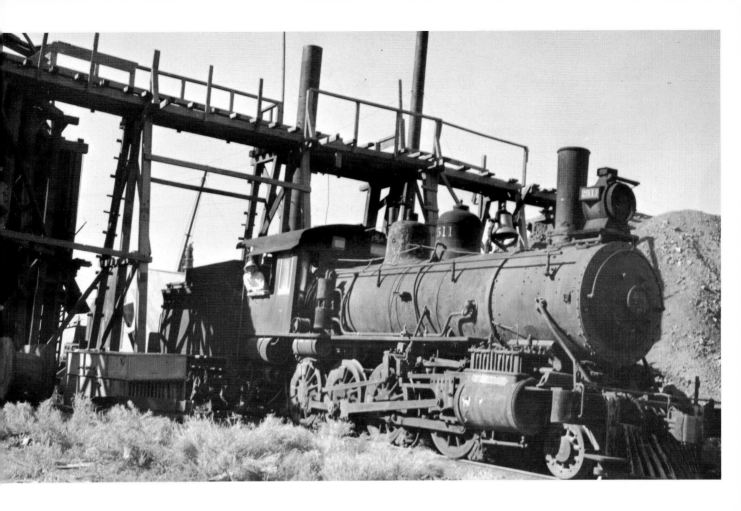

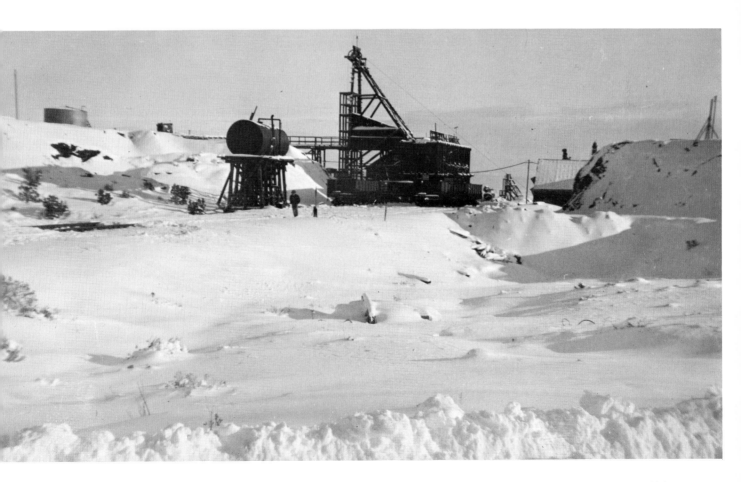

This time there were no objections to the shipment of "foreign" ores over the private railroad. For the Prince Consolidated Mining & Smelting Company had been experiencing operating difficulties which led the owners into deeper financial difficulties. In June 1920 the Prince Mine became idle, although ore shipments were continued until the following March. To finance a search for new ore bodies to replace the exhausted ones, additional stock had been sold, but the proceeds were insufficient to support the expansive cost of the search. Additionally, a large flow of water in the existing mine overtaxed the capacity of the pumps and generators, and in 1923 all work ceased.

With the cessation of activity Gemmill and Squires became interested. Utilizing the financial backing of one R. P. Sherman, control of the Prince was acquired, and in August 1923 reorganization was effected with the formation of a new Prince Consolidated Mining Company. The former Godbe interests retired into the background, and the operations of the Prince Mine were dovetailed with those of the Virginia Louise as far as was practical. A second generating plant of greater capacity was purchased in Utah; the pumps were reactivated; and with the water level receding, the sulphide ores were reached and tapped. Shipments from the Prince Mine were resumed in the fall of 1923, and with the combined production of both properties now being forwarded to the reduction mills, the Prince Consolidated became the dominant producer in the Pioche area.

During this period the Prince Consolidated Railroad had two ex-Southern Pacific locomotives on its roster, although only one was operating. The older of the two (No. 2511) was drafted into stationary boiler service at the Prince Mine about 1923, and never ran again. Gone was the old familiar, but peculiar, "chug, chug-chug" sound which resulted from the "monkey-motion" valve arrangement under the tutelage of engineer Jim Wheeler at the throttle. People living along the line could identify the engine by its distinctive exhaust, whether running forward down the line or returning backward with tender first. For Prince Consolidated locomotives were seldom turned. There was no wye or turntable at Prince; whatever turning was necessary was accomplished on the wye of the UP tracks at Pioche. Equally enigmatical was the double-ended engine house at Prince, only one of the approach tracks connected with the main line. The other lead merely extended to an engine pit just south of the house.

In spite of the best efforts of Gemmill and Squires, the Prince and the Virginia Louise mines were living on borrowed time. In 1927 the last of the manganese ores were shipped; the mines were closed; and operations over the Prince Consolidated Railroad ceased. In spite of this, the tracks of the railroad remained in position (except for removal of the short extension to the Virginia Louise, as previously noted), but no regular traffic burnished the rusting rails (other than occasional sporadic trips) for a period of over a dozen years.

The Snyder Era

Following the war, the Pioche mines (on the north side of the Ely Range) had their share of mixed problems as well. The newly formed (1917) Combined Metals, Inc. was headed by E. H. Snyder, who had about perfected his selective flotation method of processing the complex sulphide (bedded) ore. The greatest difficulty for Snyder lay in finding a market for such production. Some ores were shipped to the River Smelting & Refining Co., a National Lead affiliate, at Florence, Colorado; but the total potential mining output of Pioche far exceeded the capacity of this one outlet.

A fortunate combination of several favorable factors entered the picture in the next few years. One of the first and more important was the reduction by the Union Pacific of its freight rate on low-grade ores which became effective on August 30, 1922. Ore valued at $10 a ton or less could now be sent from Pioche or Caliente to Salt Lake smelters for $1.80 a ton, while for ores of greater values, the rate advanced 20¢ a ton for each additional $1 per ton of value.

Encouraged by this development, as well as by the completion of Snyder's metallurgical process, the National Lead Company joined with Snyder's Combined Metals Co. interests to form a new Combined Metals Reduction Co. in 1923. Immediately a lease was taken on the old Honerine (Bullion Coalition) Mill in the Rush Valley District at Bauer, Utah. Following extensive remodeling, the flotation mill was made ready for full production in 1924. Inauguration of the facility meant the beginning of a whole new era for Pioche. Shipments totaling well in excess of a million tons of ore were made to the Bauer mill during the succeeding years to 1941, following which a new mill in the Pioche area obviated the lengthy haul. The changes wrought by this large-scale production were many and varied.

In preparation for the expansion of operations Combined Metals Reduction Co., following its formation in 1923, began to acquire ownership of large numbers of mining claims in the Pioche area. In addition it also leased part of the Amalgamated Pioche Mines & Smelter Corporation's property (already under lease to Snyder's Combined Metals, Inc.). Of the prime, selected units encompassed in the program, the most important was the old No. 1 Shaft (formerly the Panaca Shaft of the Raymond & Ely mine), then being served by that portion of the Pioche Pacific Railroad previously referred to as the "old main line" and now known as the "Hill Line," which extended from the No. 1 Shaft (on the hillside above Pioche) down the slope and across the flats to the (UP's) Caliente & Pioche Railroad terminal some 2½ miles distant. Although title to this portion of the railroad remained with the owner, Amalgamated Pioche, operations were independently conducted under a private contract between Combined Metals and the Pioche Pacific Railroad.

A second large-scale operation on "the hill" was that originally conducted by the Pioche Mines Company, utilizing other portions of property belonging to the Amalgamated Pioche. Among these were the former Meadow Valley Mine, extending from the No. 9 Shaft to the No. 3 Shaft, plus various portions of the former R&E property, including the Lightner Shaft and the Burke and Yuba Dikes. The new unit began operations in 1922 under the direction of John Janney, but its production never amounted to more than a fraction of that of the Combined Metals group. In 1923 Janney erected a cyanide plant to bolster output, but the big development was made six years later following reincorporation of the properties as Pioche Mines Consolidated, Inc., with Janney still in control.

Primary step in the expansion program was the erection in 1929, on the site of the old Godbe smelter to the north of town, of a new 250-ton flotation concentrator. Disaster visited the project that same year when fire razed the building, but reconstruction was effected immediately and the finished mill was placed in operation in 1930. To reach the mill, Pioche Mines constructed a surface tramway eastward along the hill from the mines to carry the ores to the head of an aerial tramway which, in turn, stretched northward over the valley in which Pioche lay, to terminate at the concentrator on the flat to the north of town.

Traces of the mining railroad are still visible today as a shelf between the old wagon road along Treasure Hill and the abandoned grade of the former Pioche & Bullionville which lies on the downhill side toward Pioche. Starting from the ore bins of the tramway (near the old No. 9 Shaft), the tracks crossed the road on a bridge of steel girders, then turned sharply to the right along the face of the hill for a few hundred feet to a wye, one leg of which entered the Burke Tunnel and pierced Treasure Hill for approximately 1,000 feet to reach the Yuba Dike. The other leg continued along the side of the hill for another 1,500 feet to the No. 3 Shaft, the second of the two mine entrances. Motive power for the little line consisted of two small electric (storage battery) locomotives. In 1963, the aerial tramway and its cables were still in place, though not operating. The continuity of the rail tramway's over-the-highway approach to the terminal had been broken with the removal of two steel trusses from the overhead bridge for use in the Ely Valley Mines, another John Janney operation near Mendha.

If the mines in the Pioche area during the late 1920's were becoming more and more consolidated into single larger units, the railroad operations were becoming more diverse. The Prince Consolidated Mining Company's standard-gauge railroad had been deactivated following the closing of the mines in 1927. The Pioche Pacific's Hill Line (the short 2½-mile leg) was humming merrily under the large bulk of business from the Combined Metals operations. Although the line was owned by Amalgamated Pioche, small profit accrued due to the nature of the company's contract with Combined Metals. On the other hand, Amalgamated Pioche still owned and operated the longer (15-mile) branch from the Junction up the long hillside to the Jackrabbit mine and the loading bins of the Bristol Mines' tramway connection. Ores continued to flow in from this northern extremity. Leasers and small operators contributed a portion of the tonnage, but the preponderance was supplied by the Bristol Silver Mines Co. (formed by the Snyder interests in 1919) which had taken over the old Uvada properties in 1921-22 and re-equipped the plant in 1926, thereby boosting its output considerably. In the period 1927-28 BSMCo. was the largest producer of lead in Nevada, and employed 150 men in the mines.

Although Amalgamated Pioche may have been pleased with the tonnage flowing over its Jackrabbit line, Snyder (the shipper) was somewhat less than happy with the high cost of local transportation. To him it seemed unreasonable that the costs

of shipping his ores 15 narrow-gauge miles from Jackrabbit to the UP rails at Pioche should virtually equal the costs of shipping those same ores the balance of the 300-odd miles via UP to Bauer, Utah. The result was an ultimatum directed to the Pioche Pacific — either sell him the railroad, or he would parallel their line with another railroad. Still nothing happened. It was not until UP surveyors were observed running lines parallel to the Pioche Pacific grade that the narrow gauge's owners began to see the light. On June 5, 1930, a sale was consummated — for a consideration of $30,000 the Jackrabbit branch of the Pioche Pacific became the property of the Bristol Silver Mines Company, excluding the trestles, culverts and right-of-way on which a 20-year lease from the Pioche Pacific assured continued operation. With the sale of the Jackrabbit line to private interests, and with operations of the Hill Line under contract, the Pioche Pacific (unofficially, at least) ceased to be a common carrier.

During the depression following the market crash of 1929, mining was largely suspended throughout the west. Mineral prices fell; the mines at Pioche became adversely affected and generally closed down. As early as 1929 the Combined Metals Reduction Co. had analyzed its ore beds under Treasure Hill and decided to open the seams from the south side of the Ely Range (near the Prince Mine) for greater facility. To this end, a new shaft was sunk at Caselton (northwest from the Prince Mine), and tunneling was started toward the old Raymond & Ely beds on the north side of the Ely Range at Pioche.

By 1933, with metal prices rising, Combined Metals Reduction reopened its No. 1 Shaft (the old R&E Panaca Shaft) and started shipping high-grade lead-zinc-silver ore over the narrow-gauge Hill Line. On the other side of the Ely Range, leasers were turning out ore from the Prince Mine and, although the quantities were small, the accumulation was sufficient to warrant reactivation of the Prince railroad for the first time since 1927. The tonnage was hardly impressive — contrasting with the earlier daily movements of 100 tons or more, now a "train was called" about once every three or four weeks after the leasers had filled the four gondolas spotted on the Prince Mine's siding.

To get the wheels rolling again, a locomotive was necessary, and the Prince Consolidated Railroad's locomotives were in deplorable condition after six years of dead storage. The only engine remotely serviceable was No. 25, and its boiler hardly seemed capable of holding a pound of steam. Nev-

ertheless, the UP was called upon, and boiler repairmen from the roundhouse at Caliente were sent up to look the situation over. Their opinions, following inspection of the engine, were optimistic; the recommended repairs were made; and tests proved the soundness of their judgment — old No. 25 could run again.

The inconstancy of the railroad's prospective traffic prohibited the hiring of a regular railroad crew. Instead, the Prince Consolidated Mining Co. compromised the situation by utilizing personnel from the ranks of the company on those occasions on which the train ran. David L. Gemmill, son of the president of the company, was assigned the temporary job of engineer; another son, Paul (nominally a geologist), served as conductor; Stewart Mahaffie became the fireman. Major mechanical difficulties or problems were usually solved with the assistance of Jim Wheeler, the locomotive's former engineer, or (in later days) his son. Mahaffie apparently was the most colorful character of the crew. Uncertainty appeared to be his forte, even at the expense of confidence. Frequently, on leaving Pioche for the return trip over the line, he would screw down the pop-valve (which controlled the boiler's pressure), and then comment to fellow crew members that he hoped they would get home all right before the boiler exploded. Perhaps inwardly he knew all along that the leaky, old locomotive could never attain a full head of steam.

Undoubtedly the improved mining outlook in Pioche in 1933 was the primary instigation behind the report that the Union Pacific was considering taking over and rebuilding the Prince Consolidated Railroad. Certain it is no covetous eyes would have been cast at old No. 2511 with its leaky seams, nor would the spasmodic voyagings of the line's four-car trains have inspired confidence in the future growth of the line. In actuality, the railroad's brief, irregular operations came to a halt the following year (1934), and it was not until several years later that the UP made more positive, open advances toward acquisition of the property.

Irrespective of the decadence of the Prince Consolidated's operations, the Bristol Silver Mines near Jackrabbit were coming alive and pouring out increasing amounts of silver-lead-copper ores for the Utah smelters. The aerial tramway over the hill from the mines to Jackrabbit was carrying ever-greater quantities of ore, as was the connecting narrow gauge to Pioche. By 1934 the Bristol mine was one of the largest silver producers in Nevada with an output of some 12,700 tons of lead and

silver being routed to the International Smelting Company at Toole, Utah. The following year the ante was upped to 15,000 tons.

By the mid-1930's, management of the Pioche Pacific Railroad was taking a good, hard look at its own peculiar situation. Its Jackrabbit line, although weighted down with the booming traffic from Bristol, was providing only a frustratingly fixed revenue from the 20-year lease of the sub-grade and supports for the roadbed. The Bristol Silver Mines Company, as owner and operator of the movable equipment, was the beneficiary of savings accruing from the increased traffic. The shorter "Hill Line" was the mainstay of the railroad and a lucrative proposition at that. Combined Metals Reduction, as lessee, was setting a production (and transportation) pace proportionately corresponding to that of the Bristol Silver Mines, the increase in traffic redounding to the railroad's benefit. In 1935, for example, Combined Metals employed 200 men and produced some 92,000 tons of ore from its No. 1 mine, all of which tonnage was shipped out over the "Hill Line."

Revenues from the increases in tonnage were reflected all too obviously in the financial statements of the little road. Back in the peak year of 1929, the Pioche Pacific's gross revenues were $126,000 (greater than those of the Nevada Central and the Eureka-Nevada Railroads combined), while the operating profit (net profit would be smaller) was a rather lush $43,000, a very comfortable showing for an ultra-short line in Nevada. Naturally, in the early, depression-ridden 1930's, there was a slump, but nothing like the terrific decline which brought red ink to the statements of the other short-line railroads of the period. Then, during the revival 1934-37 era, Pioche Pacific's gross incomes climbed back to around $50-60,000 annually with operating profits at a most respectable $25-29,000 figure.

Although the profits were a comfort to management of the Pioche Pacific, the publicity attending their publication was most undesirable. Mine operators and the world at large were free to read the results in the biennial reports of the Public Service Commission of Nevada, with which august body earnings statements were obliged to be filed as a common carrier. To avoid such embarrassing disclosures, as well as to be able to bargain in the matter of rates or to abandon the railroad or any portions of it at will, management decided to remove the line from its status as a common carrier operating under a Certificate of Public Convenience and Necessity (the Certificate had been

granted in November 1931, along with those of other existing utilities, in compliance with the statutes of the time to confirm largely the individual statutes which had prevailed for many years.) Perhaps, too, management was viewing with uneasiness the progress of Combined Metals Reduction in boring its tunnel from Caselton to the No. 1 Shaft, realizing that ores could then be removed from the Caselton outlet near the mill which would render the Pioche Pacific's "Hill Line" superfluous and unnecessary. Another potentiality threatening the line was the possibility of inauguration of a truck haul between the No. 1 Shaft and the UP's terminal which would parallel the Pioche Pacific's road and render it useless.

In a breezy, informal letter to the Commission on March 13, 1936, Joe G. Martin, Pioche attorney for the railroad, requested relief from the burdensome classification, pointing out that in actuality the railroad had not been a common carrier since 1930 when the removable properties of the Jackrabbit line had been sold to the Bristol Silver Mines Company. Conveniently, his letter made no reference to the 1931 application for a Certificate of Public Convenience and Necessity then currently in the files of the Commission.

Informality was not a forte of the state body and, in lieu of cancelling the railroad's common carrier status, the Public Service Commission of Nevada ruled that a formal application would be necessary. The railroad studied the situation. Though traffic was still high at the beginning of 1937, indications were that a decline was about to set in. As a consequence, the railroad returned to the Commission with a formal application for abandonment, and a public hearing was then ordered to be held in Pioche on the following April 22, 1937. Although virtually no public interest was expressed at the meeting, still it took the Commission a full two years to decide the case, and then it dismissed the railroad's application "for want of jurisdiction." The contention was that the ore shipments from the mines were sent to Utah for reduction; therefore the situation was a matter of *interstate* commerce.

While the Pioche Pacific continued to pursue its elusive abandonment authority, other events were taking place on the south side of the Ely Range which ultimately were to mean rejuvenation of the Prince Consolidated Railroad. The Combined Metals Reduction Co. had continued to develop its property served by the Caselton Shaft (near the Prince Mine). The shaft, named for James A. Casel-

ton (secretary-treasurer of CMR and an officer or a director in various National Lead Company affiliates), was used to tunnel beneath the Ely Range at the 1,400-foot level. Physical connection through the mountain was made possible by a raise to the 1,200-foot tunnel of the No. 1 Shaft on the Pioche side of the hill, out of which portal ores continued to be removed for the time being. An ultimate, long-range program envisioned a new mill to be erected at Caselton, but currently the low freight rate for the Utah smelters and the limited availability of electricity at the new site encouraged maintenance of the present status quo. Adequate electricity to operate the pumps and keep the Caselton Shaft clear of water was obtained from the diesel powered generators at the Bristol Mine, but the tremendous requirements of a new mill would have completely overtaxed the capabilities of this source. The volume of power required had to depend upon completion of the Hoover Dam facilities (1930-36, see Six Companies, Inc.), and construction of a proper transmission line to Lincoln County.

Meanwhile consideration was given to the problem of developing adequate transportation to the new mill site. The UP indicated a willingness to take over the Prince Consolidated Railroad, and to this end it went before the Interstate Commerce Commission early in 1938 to seek authority to acquire and expand that 8.69-mile line. The arrangements were not easy ones to explain or to make, for the situation was complicated by a whole series of intricate transactions which clouded the issue.

Basically involved was the UP itself (or its affiliated LA&SL). Back in 1925 the Salt Lake Route had furnished materials for an earlier rehabilitation of the Prince railroad, payment for which had been deferred and then found to be impossible. In satisfaction of the claim, the LA&SL had taken the note of the Prince Consolidated Mining Co. ($8,627 dated September 16, 1931) which had been secured by a mortgage on the railroad. In 1938 the note was still outstanding and unpaid.

Combined Metals (developers of the Caselton mill) and International Smelting were also involved. In 1934, when Prince Consolidated Mining needed to finance some development work, a total of 1,600,000 shares of Prince stock had been sold, one-half going to Combined Metals Reduction and the other half to International Smelting. Since the Prince had a total of 3,000,000 shares outstanding this meant that each of the companies (CMR and IS) held slightly more than 25% of the total stock,

thereby controlling the Prince Consolidated and through it the railroad. The CMR now was happy to approve an agreement whereby the Prince Consolidated Mining conveyed the railroad to the Union Pacific in return for cancellation by the UP of the note it held against the railroad property plus UP rehabilitation and expansion of the railroad. The rehabilitation work on the existing trackage alone was estimated to cost $60,000, while another $52,000 would be required to construct new track facilities, the longest segment of which would be a 6,812-foot spur to the Caselton Shaft.

I.C.C. approval was granted on April 21, 1938, following a minimum period of deliberation by that body. William M. Jeffers, then UP president (and later the nation's "rubber Czar" during World War II), made a personal inspection of the line with his division superintendent. In deference to the condition of the roadbed, his special train — replete with business cars, staff assistants and general lackies — was parked on a siding at the junction, and the trip was ignominiously accomplished on a "speeder." In spite of the lack of accommodations, general approval for acquisition of the line was signified.

Then further complications arose. A search of the railroad's title revealed that the majority of the right-of-way had been granted under a government permit in accordance with regulations pertaining to local mining or logging railroads, which left an obviously moot question as to whether such authority would be valid for the railroad's use in common-carrier operations. Moreover, reciprocal trade tariffs then under negotiation might seriously affect the price of zinc, and any fluctuations in the zinc price pattern could seriously affect the economic advisability of constructing the new Caselton mill. UP's president Jeffers was ready to drop the whole railroad acquisition project on the assumption that the mining companies had lost interest, but his traffic department convinced him that the large potential ore tonnages made the rehabilitation of the railroad a worthwhile venture. Ultimately the indecisions were resolved and culminated in an agreement between the UP and the CMR which was signed on May 27, 1940. In addition, approval for the use of the right-of-way for common-carrier purposes was obtained from the Secretary of the Interior.

Work on the rehabilitation of the Prince Consolidated Railroad commenced Monday noon, June 10, 1940. W. McKee, Union Pacific engineer, was in charge of the project; J. A. Tippets was the foreman of UP extra gang No. 6, consisting of 60 men,

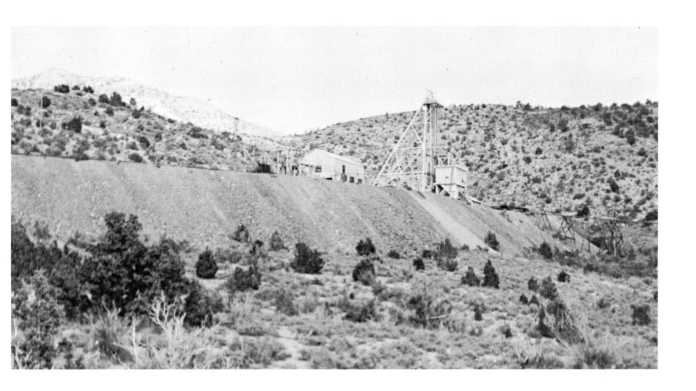

The Caselton Shaft *(above)* and mill *(below)* handled virtually all of the ore mined in recent years in the Pioche area. A long tunnel connects through the hill with the No. 1 Shaft on the north side so that all ore can now be removed at Caselton to eliminate the haul 'round the hill to the mill. *(Above: Sewell Thomas photo.)*

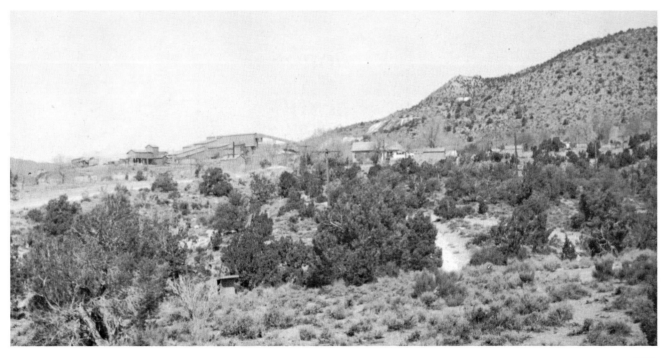

which performed the work. Fear and trepidation must have crept into the hearts of the mechanical officers when they examined the existing roadbed, for they deemed it to be too light to stand up under the weight of the heavy UP engines. Instead, old No. 25, the scorned and forgotten locomotive with the funny "monkey-motion" valve action, was again called back into service to handle the work trains. Apparently it gave a good account of itself, for the engine continued to be used for several months after the UP had completed the job.

By far the greater portion of the work consisted of substituting second-hand, 90-lb. rail for the old 54-lb. rail of the original line, plus a general re-working and strengthening of the roadbed. Additionally, 2.49 miles of new spurs and side tracks were constructed to service the Caselton location (two miles north of the Prince Mine). At the time the track crews reached Atlanta station and the junction with the Jackrabbit line of the Pioche Pacific, the crossing diamond was removed and never replaced. The Bristol Silver Mines Co. owned the railroad (except for the sub-grade) and was only interested in transferring its ores to the UP cars for transshipment to Utah. Since the UP now owned the former Prince Consolidated Railroad, Atlanta became the new terminus of the narrow gauge, and sidings plus a mechanical conveyor were installed for transfer of the ore to UP gondolas and hoppers. The approximately two miles of surplus narrow-gauge trackage between Atlanta and the UP's Pioche depot were abandoned as a useless, duplicate facility.

Late that summer (1940) the job was done, and supplies for erection of the Caselton mill started rolling over the new line. In September 1941 the new mill of the Combined Metals Reduction Co. was completed, and just in time. The advent of World War II created a demand for minerals, and the value of the Pioche area's hidden treasures zoomed.

The new mill not only treated ores from the Caselton Shaft but those from the CMR's No. 1 Shaft above Pioche as well. To avoid loading the narrow-gauge cars for the trip down the hill, then reloading the ores to the UP's standard-gauge cars for forwarding to the Utah mill, trucks were employed to haul the ore direct to Caselton. Added to the volume of business handled by the new enterprise were some 600,000 tons of additional ore trucked in from John Janney's Ely Valley Mines near Atlanta.

The demands of World War II also boomed business for the Bristol mines, keeping the Jackrabbit railroad busy hauling ores to the new UP ore transfer at Atlanta. Trips from the mines down to the bins were made cautiously, the problem being to keep the trains under control as they descended the grade on the deteriorated track. On the return trips to the mines, empties were hauled back up the hill together with occasional loads of timber, coal or other supplies. For a brief period the Shay locomotive from the Hill Line (made available when that operation ceased) was tested on the longer run. After several trips to the mine and return, its slower speed was deemed to be inefficient for the operation and the locomotive was relegated to stand-by service.

Although the mines were busy during the war years, the Pioche Pacific (as an operating entity) was not. Efforts were continued to accomplish official abandonment of the "paper" railroad. Formal application was filed with the Interstate Commerce Commission following the turndown by the state, but on February 25, 1942, the I.C.C. also dismissed the application on the basis that the traffic was *intra*state (not *inter*state). With no regulatory body interested in ruling on the matter of abandonment, and with the output of the No. 1 mine now moving by truck, the Pioche Pacific took matters into its own hands and removed the tracks from the Hill Line which were no longer used.

Following World War II, when mine production at the Jackrabbit and the Bristol mines diminished, the little 12-car, 20-ton trains only operated once or twice a week. Under such sporadic conditions, the overhead costs of transportation became relatively high, and in 1947 a truck operation was substituted for haulage of ore by train. In October 1948 the railroad was closed down completely, and the last segment of the former Pioche Pacific ground to a halt. The tramway over the hill from the Bristol mine, being more essential, was continued until July 1955 before it, too, was shut down.

The Caselton operation proved to be the most enduring. In 1946, following the end of World War II, a tunnel was driven at the 1,200-foot level from the Caselton Shaft to connect with the same level tunnel of the No. 1 mine on the other side of the range at Pioche, a distance of approximately 8,000 feet. During the 1950's, truck haulage from the No. 1 mine portal, down the hill and around The Point, was discontinued. All ores were hauled underground through the tunnel at the 1,200-foot

level and taken out of the Caselton Shaft to the mill.

The decline of metal prices in 1957 forced the closing of many mines in the Western United States. Among those adversely affected have been the CMR and others at Pioche. Mining in the area, per se, has virtually ceased; but the Caselton mill has been continued in operation to process perlite, a volcanic glass substance used in the building trades.

Not long ago the Union Pacific began eyeing the unproductive tail track of the former Prince Consolidated, extending two miles from the Caselton switch to the old Prince mine, with the thought in mind of tearing up the rails. Before any action was taken, R. J. Dalton & Son stepped into the picture to take over part of the former Prince mine plant. Following alterations, a new process was started for the roasting of pyrites gathered from the mill tailings to form a chemical fertilizer, thus creating a new source of traffic for the Union Pacific and preserving the old railroad line.

Pioche today is a quiet, picturesque, little mining town nestled in the hills of the Ely Range. Its storied past will never be repeated, but it can be remembered. The famed "million dollar" courthouse still stands where erected in 1870; visitors can view with awe the "boot hill" of earlier times; and one of the Pioche Pacific's old narrow gauge rod locomotives is on display down by the ball park. The narrow gauge Shay has been removed for display in the museum at the Frontier Hotel in Las Vegas.

Great tonnages of lead, zinc and silver ore still abound in the Pioche area, merely awaiting the economically opportune moment for their removal. Bristol Silver Mines Co. reportedly still sends out

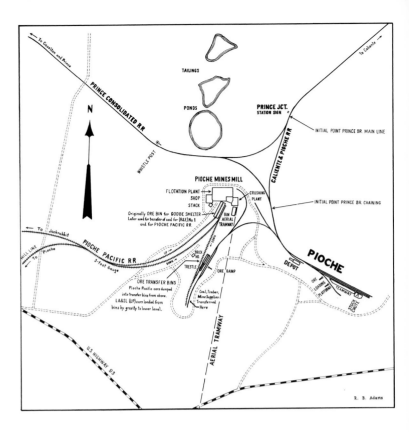

a car or two of copper or of lead ore from time to time. Meanwhile, production of perlite and the Dalton's agricultural mineral keep the Caselton area busy, while UP trains roll occasional rust from the rails along the old Prince Consolidated Railroad's right-of-way. A change toward more attractive market prices for ores, a new metallurgy, or a combination of both factors could bring about a revival of the mines; and Pioche some day may become again the center of a beehive of mining activity.

(R. H. Kindig photo.)

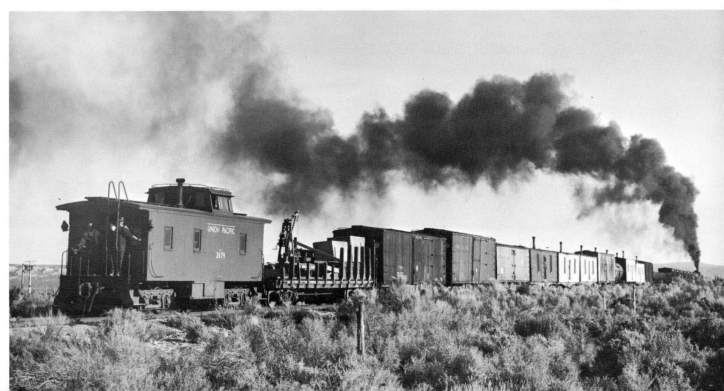

SIX COMPANIES, INC.

The Six Companies, Inc. Railroad has vanished. It wasn't consumed in a fire; it wasn't washed away in a flood; it wasn't rebuilt into a highway; it merely was submerged beneath the waters of the very project it helped to create. That project was the famous Hoover Dam (at one time called the Boulder Dam), located in the Black Canyon of the Colorado River.

Certainly it wasn't always thus. For centuries the right of the Colorado River to behave as it pleased went unchallenged. In late spring the river was apt to overflow its banks with a superabundance of water resulting from the melting of accumulated mountain snows; yet during the dry part of the seasonal cycle (in late summer and fall) this aqueous torrent would diminish to a narrow trickling stream, perhaps following a channel which had not existed the previous year.

Farmers discovered that the water could be useful — that a Southern California desert could be made to turn out abundant crops with its aid — sufficiently so as to justify the majestic name of Imperial Valley. They also learned that tapping the river water for irrigational purposes could lead to catastrophic results. One outstanding example was the Colorado River's breakthrough in November 1905 when its waters rushed into the neighboring, below-sea-level basin to form the Salton Sea — a gigantic lake 45 miles in length and up to 17 miles in width. The dry basin had had water before — a smaller version of the Salton Sea had been formed as far back as 1891, but that was before the valley had been cultivated extensively and only moderate damage had resulted. In this instance 15 months (to February 1907) and several attempts were required before Harriman and his Southern Pacific forces successfully and permanently could close the break, and then only after a terrific struggle.

As a matter of practicality, the U. S. Bureau of Reclamation had been studying the flood problem since 1904. Ultimately plans were evolved for a large dam to be located either in Boulder Canyon or in Black Canyon. A total of some 70 sites were taken under consideration; then the number was narrowed down to five sites in Boulder Canyon

and two in Black Canyon; then to one in each canyon; and finally the Black Canyon location was selected as being most suitable for the project.

Although the Black Canyon's favorable width ranged from a minimum of 260 feet to 500 feet at the normal river level, and although the abrupt walls of the gorge rose from 1,000 to 1,500 feet in height, canted almost vertically for the first 450 feet before sloping outward more gradually toward the higher elevations, still the advantageousness of the rugged profile was not the deciding factor in the selection of the location. Instead, the criterion for construction lay in the fact that any dam built in Boulder Canyon would require a service railroad 53 miles in length reaching from a connection with the UP at Moapa (north of Las Vegas), whereas the Black Canyon location could be reached by a relatively short, 23-mile line from Boulder Junction to Boulder City with additional feeder lines from there to the river canyon.

On December 21, 1928, construction was authorized with the signing of the Boulder Canyon Project Act by President Coolidge. A terrific amount of advance, detailed planning was required, not only for the dam itself, but for such innumerable ancillary facilities as railroads, highways, and even an entire new community to be called Boulder City.

Railroad transportation to the area was most essential in order to bring in the huge volume of equipment and supplies required for a project of such magnitude. Construction of the necessary trackage was broken down into three segments, each handled by a separate organization:

UNION PACIFIC RAILROAD (LA&SL) — from Boulder Junction (near Las Vegas) to an interchange yard and wye at a point designated as Summit (Boulder City) 22.71 miles

U. S. GOVERNMENT CONSTRUCTION RAILROAD—from Summit down the hill to the Himix (High Level Concrete Mixing) Plant on the bluff overlooking the dam site, 6.7 air-line miles but by railroad 10.00 miles

SIX COMPANIES, INC. RAILROAD — to branch off the Government Railroad at Govt. Junction

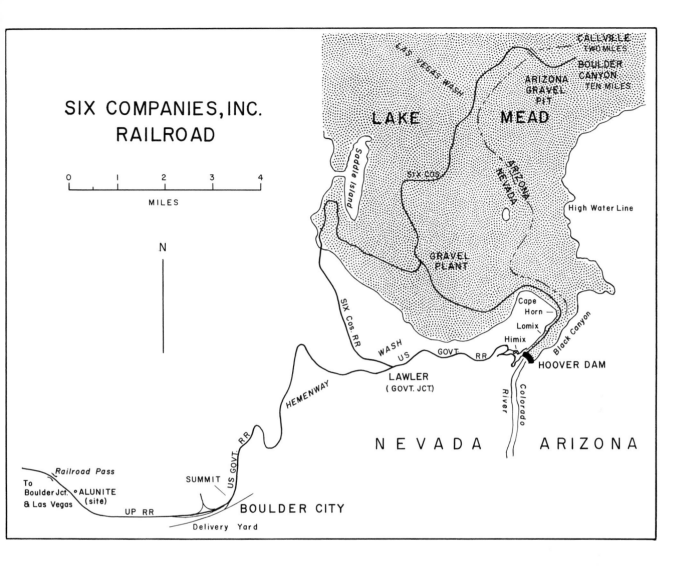

SIX COMPANIES, INC. RAILROAD

0 1 2 3 4

MILES

N

(Lawler), run 7 miles north and then east to Gravel Plant (Three-Way Jct.), there splitting into two branches — one up river to the source of supplies at the Arizona Gravel Deposits (7.3 miles), and the other to the Lomix (Low Level Concrete Mixing) Plant and the dam face, down-river to the southeast (4.8 miles), a total distance of19.10 miles

51.81 miles

The projects were developed in successive steps, each step depending upon the one preceding it for completion.

Union Pacific Railroad — Boulder City Branch

John Paul Elliott, the same UP engineer who had laid out the OSL (Idaho Central) line, was called upon to locate the new railroad to service the Boulder Dam project. No particular difficulties were encountered in the 22.7 miles of rolling coun-

try traversed. Starting from a point on the main line 7.17 miles south of Las Vegas, the road gradually dropped 390 feet in elevation over the first 11 miles, then climbed 605 feet in the next 11.7 miles to go through Railroad Pass to the delivery yard and wye at Summit (Boulder City). From here to the dam site the continuation of the line was to be constructed by a contractor of the U. S. Government.

Construction of the railroad through the pass made this Railroad Pass unique in the annals of Nevada's numerous notches so named, for it became the first and only such defile ever to achieve an operating railroad through its confines. Like the others, its appellation had been derived from a prior railroad survey, undoubtedly that of an 1890 short line contemplated to run from El Dorado Canyon (a mining community to the south of Boulder City), northward to meet the then ex-

pected Union Pacific (OSL&UN) building south from Milford, Utah.

In July 1929 the I.C.C. bestowed its approval on the UP's Summit (Boulder City) project, whereupon the basic job of organizing the work began. In August 1930 the final surveys were run, and the following month the grading contract was awarded to Merritt, Chapman and Scott for their bid of $115,000. Under the terms of the offer and acceptance, the roadbed was to be completed in 90 days, following which the UP forces would lay the ties and rails.

To mark the beginning of construction, a celebration was held on September 17, 1930. As a fitting part of the ceremonies, and in front of a large crowd gathered to witness the event, Dr. Ray Lyman Wilbur, Secretary of the Interior, drove home a silver spike. Most unpremeditated was the highlight of the incident when Wilbur made a wild swing with the spike maul and completely missed his target. A second swing proved equally ineffectual, as did a third. To compose his embarrassment, Wilbur next tested his range before the fourth try, tapping the spike gently with the head of the maul. To his utter consternation the spike sank gently into the tie — the hole had been predrilled to make the job easy and a light tap was all that was required! In spite of the anticlimactic nature of his ensuing speech, Wilbur paid due compliments to President Herbert Hoover and named the great undertaking Hoover Dam in his honor.

Immediately following the ceremonies, grading for the railroad began. As fast as the roadbed was completed, the UP forces followed behind with ties and rails. The first track was spiked in place on November 20, 1930, and by January of the following year the job was completed. A group of UP officials then formally inspected the branch and on February 5, 1931, the line was officially opened for traffic.

Passenger service was inaugurated on April 26 utilizing a regulation steam train consisting of Consolidation (2-8-0) No. 6002, one of the first locomotives from the LA&SL, a baggage car and a coach. Harry Baldwin was the engineer; Freeman Smith, the fireman; Charles G. Duff, conductor; and D. M. Reeves, the brakeman. If other "firsts" are to be recorded, possibly Elton Garrett should receive due mention as purchaser of the first ticket for a ride over the new line.

Later the steam train was replaced by one of the M-151 gas-electric cars brought down from the OSL. In this unit, power was supplied by a spark-fired, internal combustion engine, started with gasoline fuel, then switched to distillate by means of valves when the engine temperature reached 140°. The internal combustion engine drove an electric generator which, in turn, fed electricity to the traction motors.

The opening of the Boulder City branch enabled supplies to be brought near to the base of operations for the tremendous undertaking that lay ahead. The project was ready for its second major step in development. To help comprehend it, a few quick statistics are appended.

Hoover Dam

Visualize (if you can) a gigantic, solid, reinforced concrete block, formed in an arc of 1,244 feet, which is 726 feet high, 660 feet thick at the bottom and tapers to a 45-foot thickness at the top. If distances in large numbers of feet lose significance for you, think of it in terms of being ¼-mile long, ⅐-mile high and ⅛-mile thick. To pour such a monstrosity required 3,250,000 cubic yards of concrete, entailing equivalently proportional quantities of sand, gravel, cement and water. That was Hoover Dam proper.

To anchor this monolith in position across the Colorado River within the narrow confines of the Black Canyon required the excavation of the sides and bottom of the river to bed rock. In turn, this meant that the waters of the river had to be diverted around the construction site to enable the men to work. As a consequence, four diversion tunnels had to be bored through the solid rock walls of the canyon — two on each side of the river — each tunnel a full 50 feet in diameter and approximately 4,000 feet (⅘ of a mile) long.

That was only the nub of the problem. Included in this vast combination of dam, tunnels and water, an entirely new complex of turbines, generators and electrical power transmission had to be superimposed to utilize the energy of the waters to be stored behind the dam. To carry out the massive project, an army of men and their equipment had to be provided, including all arrangements for new facilities for housing, shopping, schools and recreation in an area previously uninhabited. In general, that is a brief picture of the problems involved in developing what is casually indicated on most maps today as the Lake Mead National Recreation Area.

As a government project, bids for the work were solicited from private contractors. When the call was issued in December 1930, only three responses

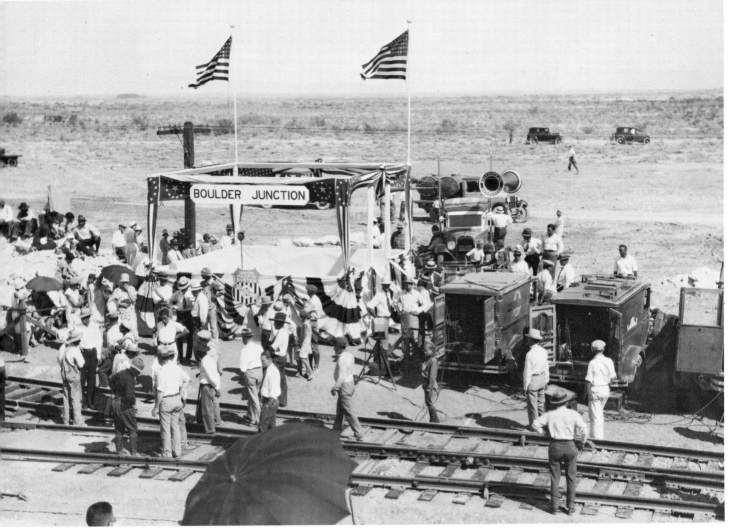

On September 17, 1930, seven miles southwest of Las Vegas on the sagebrush flat, the Union Pacific set up a gaily decorated speaker's box alongside the railroad. Movietone News Reel sound and camera trucks rolled in with customary paraphenalia; Standard Oil's portable announcer system was placed in position and people began to gather, using umbrellas to protect against the sun. Secretary of the Interior, Dr. Ray Lyman Wilbur was about to inaugurate and name one of the nation's greatest projects, the building of Hoover Dam, which would commence with construction of the Union Pacific's branch to Boulder City to be signified by the driving of a spike of Nevada silver. (*Above: Union Pacific photo; below: Don Ashbaugh Collection.*)

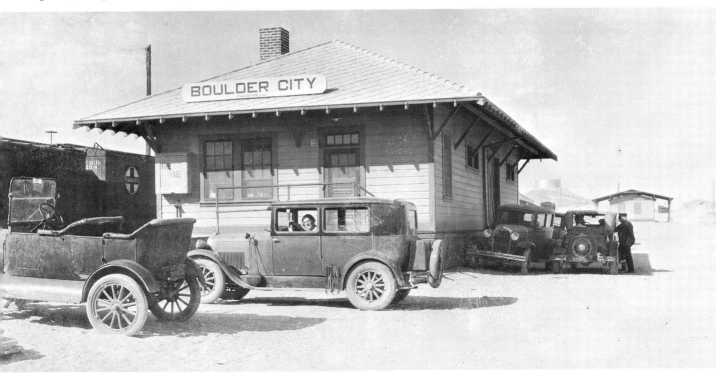

were received due to the enormity of the project. On March 11, 1931, the contract was awarded to a corporation known as Six Companies, Inc.; their bid of $48,890,995 was $5,000,000 under the next lower bid. Six Companies, Inc. was a combination of six different organizations: W. A. Bechtel, San Francisco, and Henry J. Kaiser, Oakland, California, (Bechtel-Kaiser) participated to the extent of 30%; Utah Construction Co., Ogden, Utah — 20%; MacDonald & Kahn Co., Los Angeles, California — 20%; Morrison-Knudsen Co., Boise, Idaho — 10%; Pacific Bridge Co., Portland, Oregon — 10%; and the J. F. Shea Co., Portland, Oregon — 10%. It was indeed a big undertaking.

Over a month was required to draw up the final contract which was signed by all participating parties on April 20, 1931. By that time the UP's line to Summit had been completed and was ready for full-scale operations — a most welcome assistance in the early stages of development. Not so welcome were the large number of premature job seekers; for the depression was under way and great hordes of people — cowboys, prospectors, families in old cars with all their possessions — began arriving as early as 1930 to seek work on the project — long months before the contracts were awarded. It fell to the lot of Frank T. Crowe, an expert on dam building and general superintendent of construction, to find work for the hungry men, even though his position was still tentative pending the contract signatures.

Housing became a matter of most immediate consideration, so Boulder City was created at the top of the hill, approximately eight miles above the dam site. Being at an altitude about 2,000 feet higher than the Colorado River, the temperature was 10° cooler, a most important consideration when it is realized that temperatures in the Black Canyon frequently registered 119° for weeks at a time. Moreover, the UP's branch line ended at Summit, a point just west of Boulder City, and the 500-car interchange yard was a handy, logical supplement to the location.

U. S. Government Construction Railroad

Between the end of the UP branch at Summit (elevation above sea level 2,497 ft.) and Himix, the end of track at the top of the bluff overlooking the dam site (1,094 ft. lower), is an air-line distance of 6.7 miles. Were one to connect the two with a straight line, the calculated grade would be only 3.2%, hardly a staggering obstacle for a railroad.

However, no engineer in his right mind would build a 6-mile tangent for an adhesion railroad down a 3% grade, particularly when the bottom of that grade ended abruptly on the brink of a high bluff overlooking a deep canyon. Moreover, the topography of the region was such that a direct route was quite impractical.

Instead, taking all factors into consideration, the U. S. Government Railroad utilized 10 miles of track carefully wrapped around the hills and washes to accomplish the same objective. On the hill proper the maximum grade was 4%, and the sharpest curve was 10°. The first six miles of line out of Boulder City presented no particularly unusual physical problems, but the remainder of the route traversed some very rough terrain. Five tunnels aggregating 1,500 feet had to be drilled; many rock cuts and heavy fills (some over 100 feet high) were required. To reach the area, seven miles of truck roads with grades up to 15% were necessary to bring men, machines and materials to the site.

Remembered as the biggest, single obstacle to be overcome was the logistical problem of supplying water to the workers — an absolute necessity in the extreme summer heat. Railroad tank cars brought the liquid from Las Vegas to Summit; trucks took it the rest of the way. When a flash flood damaged the truck roads so that water deliveries became impossible, construction was halted for three whole days.

The railroad approach to Himix, site of the high-level mixing and cement blending plants, necessitated both a loop and a switchback to avoid excessive excavation work. The switchback had two "tails." One led to Himix and the loading bins; the other wormed its way down and along the wall of the canyon to terminate under the big cableway near the present parking area on the Nevada approach to the dam. The last portion of this latter route was shared with U. S. Highway Nos. 93-466, but the infrequent use of the railroad by the U. S. Bureau of Reclamation after completion of the dam did not constitute a serious hazard to motorists.

The big cableway with its substantial towers was designed to carry burdens of up to 150 tons and was used to pick up loaded freight cars from the end of track at elevation 1,262 feet, move them to points over either the Nevada or Arizona sides of the river, and lower them approximately 700 feet to tracks adjoining the power houses below the base of the dam along the Colorado River. In this way even the heaviest electric generators could be installed with the minimum amount of handling.

A separate U. S. Government Construction Railroad was organized to build from Boulder City down the hill to the location of the dam. The upper part of serpentine route was relatively easy to construct, but near the lower end a series of five tunnels was required to pierce the backbone of a rocky ridge. *(Below: U. S. Bureau of Reclamation.)*

The contract to build the U. S. Government Construction Railroad was awarded to the Lewis Construction Company, based upon their bid of $455,509. Although the contract was dated January 28, 1931, work was not scheduled to start until February 13. Due to various other delays, actual construction did not start until March 1. With all the difficulties encountered on the rugged project, the railroad was completed and ready for operation by the first week of September 1931.

Why did the government wish to own this section of line? A number of reasons can be hypothesized. The contract was let almost 3 months before the Six Companies' contract was signed, as the road was essential to reach the base of operations. The UP's branch to Summit (Boulder City) had been completed in January 1931 so that work on the U. S. Government Construction Railroad (second step in the sequence) could proceed immediately, regardless of the signing of the Six Companies' contract. Possibly most important of all considerations was the fact that, although the road would be used heavily during the course of construction of the dam (actually operated under lease by Six Companies, Inc.), it would remain long after construction had ceased, and the trickle of anticipated later-day traffic would not be sufficient to justify its maintenance and operation by a private, tax-paying railroad corporation.

The facts were to substantiate these conclusions. Immediately upon completion of construction, the railroad was leased to the Six Companies, Inc., which organization furnished all of the rolling stock and personnel for the railroad's operations all during the period of construction of the dam.

Six Companies, Inc. Railroad

By the middle of June 1931, the Six Companies, Inc. was ready to start work in earnest. The contract had been signed two months earlier; supplies were rolling in over the UP's completed branch to Summit; and the U. S. Government Construction Railroad was largely completed for the easier, first six miles down the hill. It was time for the next stage of development.

John Phillips of San Francisco was given the contract for construction of the third and final section of railroad known as the Six Companies, Inc. Railroad. Branching off from the hill line at a place known as Government Junction (later Lawler), it headed northward on a winding course across Hemenway Wash and down the face of the bluffs, then looped back south and eastward to the Colorado

River basin, on the edge of which a large water treating plant and gravel plant were to be installed. The distance to Gravel Plant (as this point became called) was 7 miles; the maximum grade on the hill was 1.75%.

To obtain gravel in million-ton quantities, all possible sources within a radius of 50 miles of the dam were carefully investigated. Through a process of elimination, it was finally determined to use what were known as the Arizona Gravel Deposits located along the east bank of the Colorado River about six miles north of the dam. To reach the gravel beds from Gravel Plant required a line of railroad 7.3 miles long, 4.7 miles of which were on the west bank of the river in Nevada and 2.6 miles on the east bank in Arizona. From Gravel Plant to the river crossing a descending 1.75% grade was adverse to the return movement of loaded trains but this could not be helped. Grading for the line was rushed and the laying of rail was started in September 1931.

The crossing of the Colorado River, with its surging high waters in the spring, became the subject of considerable debate. It was feared that a trestle would be subjected to annual spring washouts, and serious consideration was given to the construction of a suspension-supported conveyor to bring the gravel all the way from the pit directly to the Gravel Plant. Then someone with a sharp pencil calculated that, even were a new 1,120-foot trestle installed each year for the three years the line would be in operation, the total cost would still be comfortably less than the initial cost of a flood-proof conveyor. A trestle was decided upon and duly installed.

The fears for the safety of the trestle proved to be groundless. Although annual spring freshets brought their usual complement of high water, the trestle was never washed out. The only difficulty encountered involved an accumulation of debris on the upstream side of the bents, a problem which was quickly and easily solved by the expedient installation of two cranes with 4-way hooks (made from old rails). During the annual periods of high water, the cranes worked from the trestle, reaching under the debris and lifting it over the track to release it on the downstream side of the structure. When a gravel train approached, the cranes merely retired to nearby sidings at each end of the bridge until the train passed, then they resumed their work once again.

No particular problems were encountered in the erection of the trestle, although old-timers on the

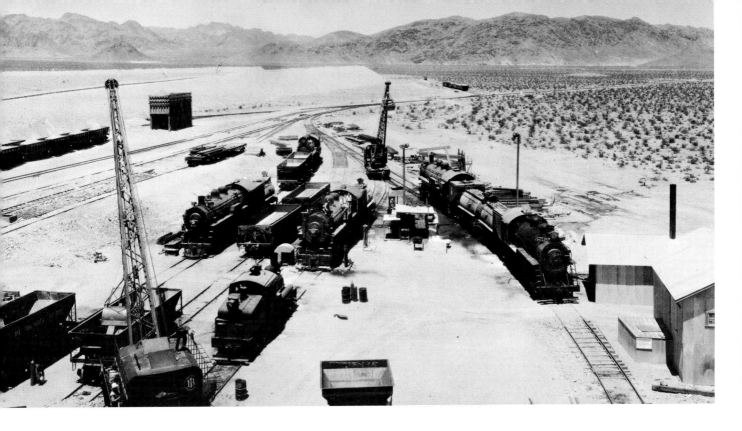

The Six Companies, Inc. built a railroad system from Law-ler on the hill down to the Colorado River. Along the way was the Gravel Plant, where the engine terminal and offices were established. A further extension upstream was re-quired to reach the gravel deposits, crossing the Colorado River to the Arizona side on a pile trestle bridge. *(Both photos: Compressed Air Magazine.)*

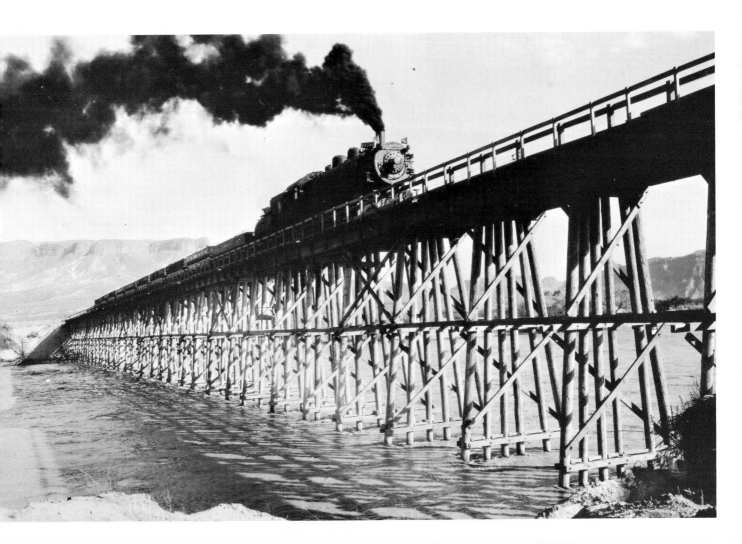

job recall with a chuckle the fateful day of December 16, 1931, and the runaway. A frantic call had come from dispatcher "Red" Allen that a car loaded with bridge timbers had gotten away from the little Plymouth gasoline switcher and was headed in their direction. The men were quickly pulled off the job, and the pile driver was moved off the trestle to a point of safety. Some 50 feet west of the bridge a loaded flat car was blocked in place where it rested on the main line to act as a buffer in stopping the runaway. Then everyone moved to a safe distance to await the inevitable. They waited — and waited — but no car appeared! A telephone call to the dispatcher garnered no additional information or shed any further light on the matter. Finally some brave souls crept toward the blocked, "buffer" car on the main line. Closer examination revealed that the car which the workers had so securely anchored against movement was, in reality, the runaway load of timbers. The load had shifted so that the partially set brake was inoperative and, after running wildly down the grade, the car's speed had been lost as it covered the two-mile stretch of gently rising track to the trestle. Quietly and unnoticed, the car had glided to a halt behind the frenzied activity of the workmen preparing for its arrival. With full realization of the strange sequence of events came deep embarrassment, and for 15 minutes no one would answer the ringing telephone to report to the dispatcher what actually had occurred.

To complete the complex of lines comprising the Six Companies, Inc. Railroad, one more branch — the most costly — was built by the Company itself. The track left the main line near Gravel Plant at a point known as Three-Way Junction and continued downstream on a 3.4% grade along the base of Hemenway Wash for two miles to a point at the upper end of Black Canyon called Shea (named for Charles A. Shea, director of construction for the entire Six Companies job). No unusual troubles were encountered in this section of the line, but south from Shea the railroad entered the Black Canyon proper, the area which involved the most difficult construction of all and earned for the stretch the colloquial title of Canyon Railroad.

"Cape Horn," a particularly sharp rock projection at the mouth of the canyon, was blasted away early in October 1931 under the stimulation of eight tons of dynamite. Removal of the obstacle provided railroad access to the narrow shelf of a truck road along the side wall of the canyon immediately above the waters of the Colorado River. Wherever possible the standard-gauge track was laid on the bed of the truck road, although one jutting escarpment was conquered only by boring a 1,000-foot tunnel through its shoulder. The primary objective in the early stages of development was to reach the diversion tunnels which were being bored to carry the river water around the area of dam construction; later the line was extended all the way to the face of the dam itself so the railroad could be used to assist in the job of pouring concrete.

Work on the diversion tunnels was not delayed pending completion of the railroad, but was started immediately. As soon as a toehold had been secured in the rock, narrow (3-foot) gauge railroad tracks were laid, over which dump cars were pushed to carry the rock and silt outside away from the work. As the tracks became longer, small narrow gauge, 10-ton Baldwin-Westinghouse, battery-electric locomotives were floated in on barges to the tunnel mouths, hoisted to the rails, and used to power the trains of dump cars. By this means a tailings pile was pushed out into the river to provide a working area.

When the standard gauge railroad reached the site, steam locomotives hauling five-car trains of regulation air-dump cars were used to haul the tunnel muck for emptying along the original truck-road fill on the river bank, thus gradually widening the 23-mile embankment between Shea and Lomix until a double-track railroad and a roadway two trucks wide were supported. Loading of the dump cars at the tunnel mouth was performed by 3½-yard Marion Electric shovels.

Meanwhile, as fast as the Canyon Railroad was extended to the diversion tunnels and the line consolidated, work continued on an extension of the trackage for seven-tenths of a mile downstream to the dam proper. This required the boring of a second 1,000-foot tunnel through a projecting escarpment and following that with a substantial timber trestle (generally double-tracked, 100 feet high in places, and 1,600 feet long) which hugged the canyon wall. Subsequently part of the wooden structure was replaced by a steel trestle which extended well into that area which became part of the dam. In fact, as the level of poured concrete rose, the steel trestle bents became imbedded in the concrete, and today they are a hidden part of the finished dam. The entire section of extended Canyon Railroad, thus formed, was characterized as "one of the most interesting and expensive stretches of railroad construction ever built in this country."

Huge penstock pipes (*above*) of 30-foot diameter were fabricated at a special Babcock & Wilcox plant erected part way down the hill along the U. S. Government Railroad. The first Union Pacific streamliner is dwarfed by comparison. End of the line was the Himix concrete mixing plant into which gravel and cement were dumped from above and concrete removed below, to be carried to the dam site in buckets via the separate electric railway to the canyon rim. (*Both photos: U. S. Bureau of Reclamation.*)

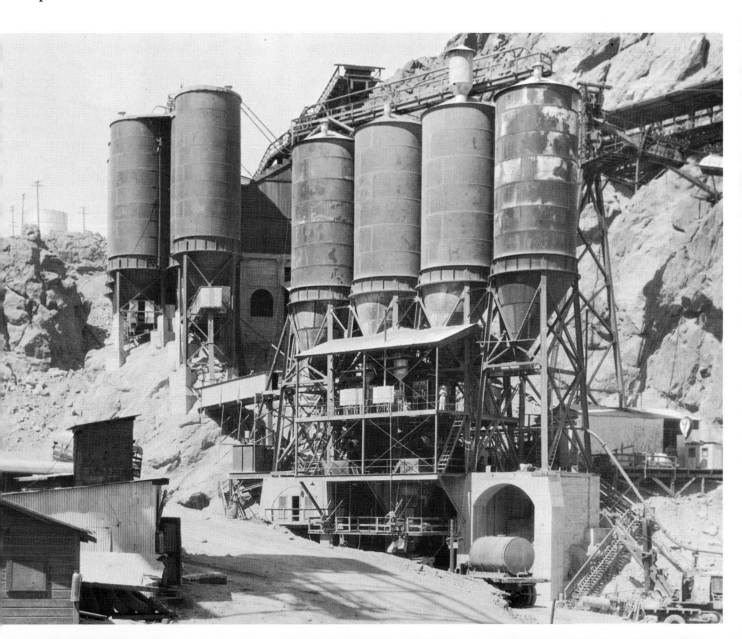

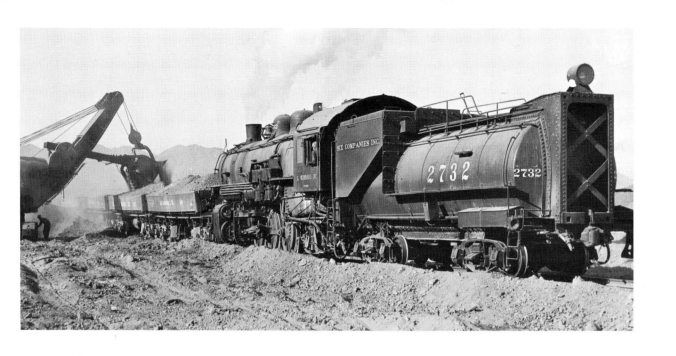

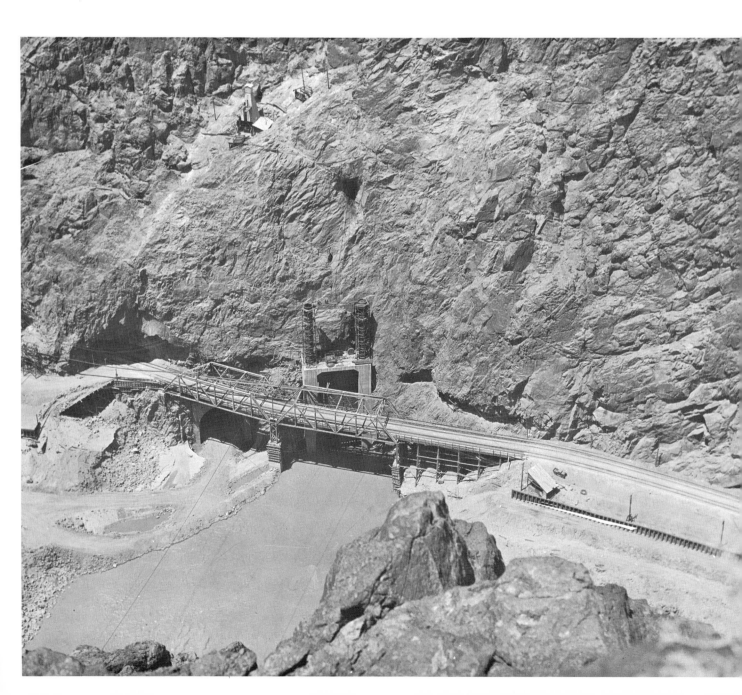

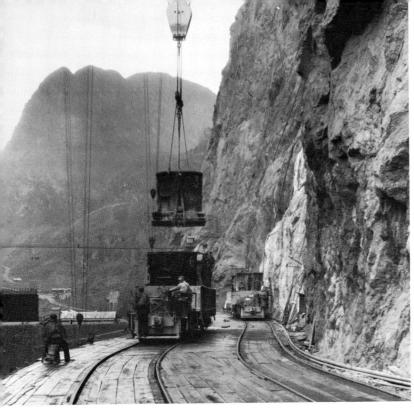

In the early days of construction the ex-Salt Lake Route locomotive *(top, left)* with the passenger diaphragm buffer on the tender hauled fill for the upper cofferdam used to divert Colorado River waters while the main dam was being built. The temporary, two-span bridge was used to carry the railroad across the inlet channel at mouth of diversion tunnel. *(Both photos: U. S. Bureau of Reclamation.)*

Huge, 8-cubic-yard buckets, eight feet tall and six feet in diameter, were wheeled to the dam site on specially constructed cars pushed by battery-electric locomotives. Empty buckets were brought back to Himix or to the Lomix cement plant *(below)* for refilling. This view of the Black Canyon is taken from the Arizona side looking upstream toward Cape Horn; Hoover Dam lies downstream behind camera to left. *(Top: U. S. Bureau of Reclamation; bottom: Compressed Air Magazine.)*

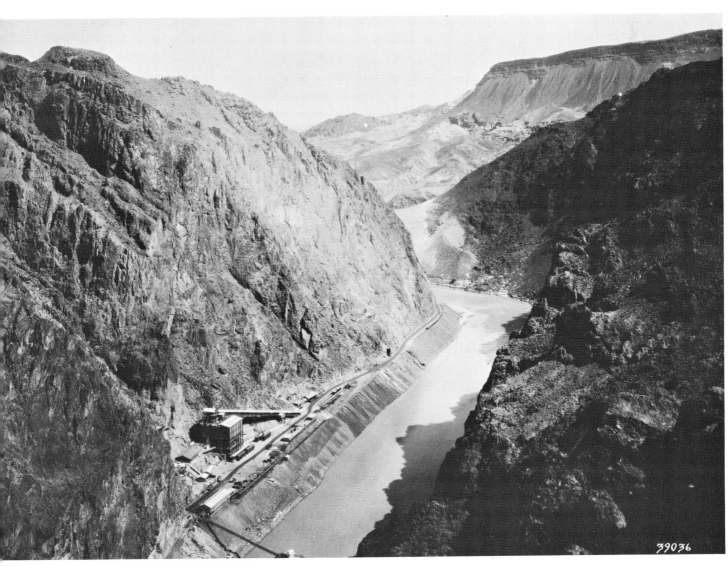

39036

At first the Canyon Railroad was steam operated throughout. When the diversion tunnels were completed, the little battery locomotives were taken to the Gravel Plant shops, where they were altered from 3-foot to standard gauge. Other changes were incorporated, including the installation of air brakes to facilitate control. Then, before pouring started on the base of the dam in June 1933, that portion of the Canyon Railroad from Lomix to the dam site was electrified, using a rather unusual system. D.C. current of 230 volts pressure was brought to trackside through installation of a third rail (except at switches, under cableways, and in the Lomix yards). Shoes on the battery operated locomotives contacted the third rail, and the current was used to recharge the batteries — not to power the locomotives. Thus the gaps in the third rail in no way affected the locomotive or railroad operations.

Taken collectively the Six Companies, Inc. Railroad, including its leased U.S. Government Construction Railroad, comprised over 29 miles of line. (It should be noted that mileages frequently varied at any particular moment, for a construction railroad is constantly in a state of flux.) The main line was delineated as running from Boulder City, down the hill as far as Lawler, thence over the Gravel Plant line to Three-Way Jct. (known as Gravel Plant), then via the right fork downstream to the face of the dam. Using this arrangement as a base, the station list took the following form:

FIRST SUBDIVISION

Mls.		
0.0	Boulder City	
6.0	Lawler	
7.0	Crowe	
9.2	Morrison	
12.0	Sw. to Stock Track	
13.0	Gravel Plant (3-Way Jct.)	
14.8	Shea	
17.1	Lomix	
17.8	Dam (Base)	

SECOND SUBDIVISION

Mls.		
0.0	Gravel Plant (Nev.)	
0.8	Hart	
2.6	Kahn	
4.7	Bridge	
7.3	Gravel Pit (Ariz.)	

THIRD SUBDIVISION

Mls.		
0.0	Lawler	
2.3	Bechtel	
4.0	Himix (Cableway)	

Stations, generally, were named for the directors of the Six Companies, Inc. Supervision of the entire aggregates operation (including the railroad) was placed in the hands of Tom Price, the aggregate engineer who had designed and built the Kaiser Plant at Radum, California. Price, in turn, delegated responsibility for the operation of the railroad to Grant S. "Red" Allen, who had had charge of the work trains that were used in construction of the UP's branch line from Boulder Junction to Boulder City, as well as the yards and facilities at the latter point.

Operation of the Six Companies, Inc. Railroad (and leased line) was not an easy one. Basically, scheduling fell into distinct objectives designed to provide a minimum of shutdown for any part of the entire aggregate operations in the event of difficulties. Primary consideration centered upon a constant flow of sand and gravel from Gravel Pit, Arizona, where the 5-yard electric drag line (shovel) had to be continuously furnished with supplies of empty, 30-yard, air-dump cars as the loaded cars were removed. Trainloads of the composite were then assembled, brought down the river, over the trestle, and up the grade to Gravel Plant, Nevada, where the raw material was cleaned, sorted into sand and aggregates, then stored. The latter received a further grading into four different sizes for discriminating use during the various stages of dam construction.

Gravel Plant, however, could not always keep up with the flow of material from Gravel Pit; yet the trains needed to be kept moving. To this end a regular train order signal was installed on the top of Gravel Plant which was visible to the engineers of approaching trains. If the blade was in clear position, the train would proceed to pull in alongside the plant and dump the gravel into the receiving bins from which a conveyor belt carried the mixture into the plant proper. The procedure only took about 10 minutes to execute, following which the train was turned on the wye and the locomotive spotted at the water tank near the dispatcher's office for refueling while the crew received their train orders for the return trip. If Gravel Plant was unable to accept the trainload of material, the order board was set in stop position, and the train backed out onto one of two stockpile tracks where the cars were dumped so the train could proceed in the usual routine back to the pit to keep the shovel operating.

The stockpiling operation was simple, yet effective. Each of two sidings was fashioned as a skele-

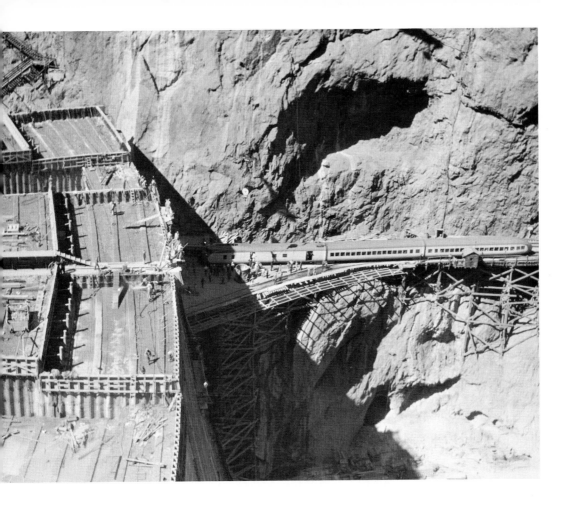

Progress was symbolized on March 9, 1934, when the nation's first streamlined train (Union Pacific) was permitted to go down the hill and over the Canyon Railroad's trestlework to the face of the dam. Symbol of the union was the cement bucket lowered to the platform near the train. Omitted from the ceremony were such iron work horses as the Six Companies, Inc. Shay No. 4002 and (2-8-0) Consolidation No. 6036 which performed the basic dog-work on which the whole operation of construction hinged. *(Both photos: U. S. Bureau of Reclamation.)*

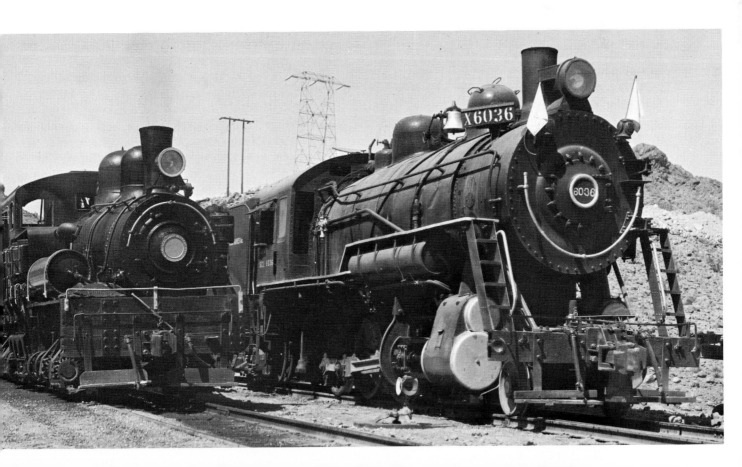

ton track with but eight ties to the rail, laid on top of the ground in simple fashion. As the material was dumped to either side, the track was thrown over onto the higher elevation so the cars could empty onto the former site of the track. In this way the piles were built up in graduated heights, being highest at the far ends of the sidings. Toward the end of the job, when sufficient gravel had been removed from the pit, that operation was closed down and the balance of requirements was met by withdrawals from the stockpiles.

Gravel Plant was in the middle, so to speak. Not only did it have the problem of receiving all material as fast as Gravel Pit could ship it, but it also had to process and produce the finished aggregates as fast or faster than the concrete mixing plants (Himix and Lomix) could use them. In the normal flow of operations, carloads of graded sand and gravel were hauled south along the river bank to Lomix, the low-level concrete mixing plant); or they were hauled up the hill to Lawler and thence down the Himix line to the high-level concrete mixing plant at the top of the bluff overlooking the dam. Any excess production of the aggregates over immediate demand was hauled up the hill to the five stockpiles at Crowe — one of sand and four of rock, each of the latter according to size. If (or when) demand exceeded Gravel Plant's ability to produce, withdrawals from the stockpiles were made to meet the exigencies of the moment. (Remnants of these stockpiles may still be seen along the road from Lawler to the lakeside resorts.)

Lomix and Himix (as their names designated) were the two cement mixing plants. Lomix, being located down in the canyon along the Colorado River (elevation above sea level 720 feet), was the first to go into operation to prepare all the concrete for that portion of the dam from its base at bedrock (elevation 506 feet) to the 720-foot level. Himix, on the other hand, supplied all of the concrete for the dam from the 975-foot level to the top (elevation 1,232 feet). Concrete for the middle portion (elevation 720 to 975 feet) was supplied by both plants interchangeably.

Essentially, both the Lomix and the Himix plants were identical in construction and operation; only the differences in location and terrain forced variations in the methods of loading and unloading. At Himix, for example, the downhill approach of the railroad permitted loaded gravel cars to be nosed into the top of the plant over a trestle so that hoppers could be unloaded directly into the bins. The ground-level approach to Lomix, on the other hand, dictated that loads be discharged into a bin below the track level, from which two 42″ conveyor belts, 519 feet in length, carried the aggregates to the top of the plant, about 150 feet in height. Both plant units were operated on a gravitational feed basis, discharging the mixed concrete from the bottom into large buckets on waiting railroad cars. Electric locomotives then moved the cars into fixed station positions beneath the cableways at the end of their respective runs, where the filled buckets were picked up for pouring and empties returned to the cars. The tracks from Himix, isolated from other parts of the rail system, led 1,500 feet to the top of the bluff overlooking the Nevada spillway; those from Lomix extended nearly a mile to the base of the dam.

Conveying the concrete from the mixing plants to the point of pouring presented terrific problems, for a continuous flow of concrete was essential to successful completion of the entire structure. The special electric trains did the job and did it well. The battery-electric locomotive operation proved to be simple, convenient and quick. Standardization of the other components afforded complete interchangeability. Basic unit of the procedure was a large, circular, 8-cubic-yard bucket, eight feet tall and six feet in diameter. Special railroad cars held four of these buckets in a row, while corresponding special loading hoppers at the plants had four positions exactly matching those of the cars. Similar stations were spaced out beneath each of the seven cableways installed at the dam to facilitate the pouring operation. Trains were confined to one electric locomotive and one car of four bucket positions each, but only two buckets in alternate positions ever were loaded at any one time.

Thus a locomotive engineer would spot his car at the Lomix loading stand and fill (say) buckets 1 and 3 half full of concrete (the normal load). He would then take his train to the dam and spot his car at the designated station beneath one of the seven cableways. The cableway operator would set an empty bucket in one of the empty spaces on the flat car and pick up a loaded one for dumping at the proper location in the dam. The train would then move ahead to the next station where another empty would be left and a loaded bucket removed. Following this, the train would make a return trip to Lomix with its two empties (in positions 2 and 4); the buckets would be refilled; then the sequence of operations would be repeated all over again. To handle expeditiously the dense railroad traffic at the dam, all trains, when they reached the trestle,

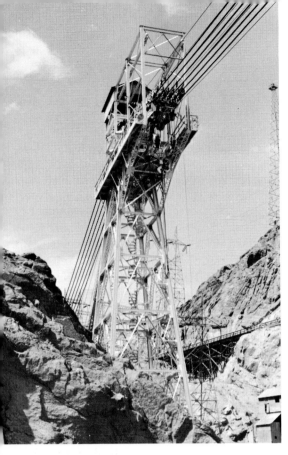

Although the Himix plant had long been removed when this 1959 photo was taken, the cableway remained in position to lower freight cars of equipment and supplies to the power houses on either side of the river at the base of the dam. Today the cableway still remains, but the U. S. Government Railroad's tracks to the dam site were removed in 1962. *(Bottom: Las Vegas News Bureau.)*

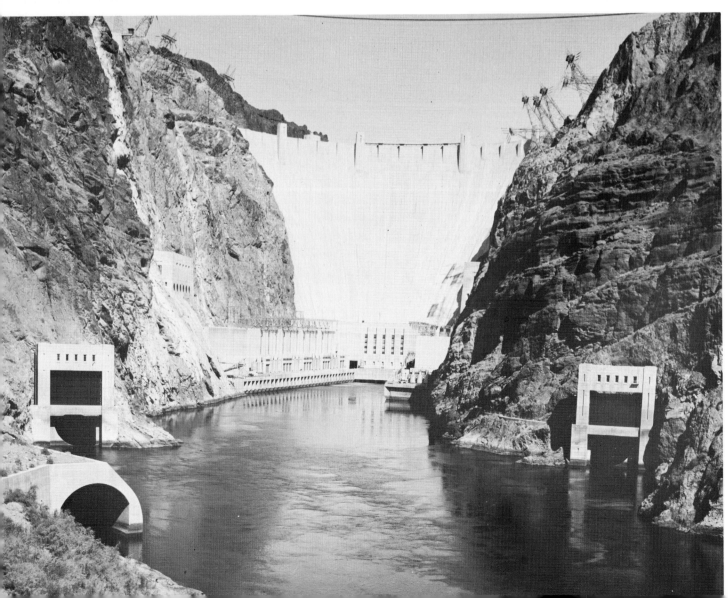

came under the control of a special dispatcher who directed their movements and spotting at loading platforms by means of compressed air, remote-controlled, track switches.

Electrification was also considered for one other segment of the Six Companies, Inc. Railroad. When the engineers contemplated the tonnage of materials to be moved over the 7.3 miles from Gravel *Pit* to Gravel *Plant*, electric operation appeared to be indicated. To this end telephone poles along the line were designed to carry power lines, and arrangements were almost concluded to acquire second-hand locomotives from the Pacific Electric Railway to power the line. Allen recalls pointing out that there would be difficulty in matching electric power with steam power as well as the fact that electric locomotives could not be used in the stockpiling operations due to the constant shifting of the track. In the final analysis the idea was abandoned, and steam operation prevailed during the 2½ years of heavy traffic.

Allen also recalls the unusual bargain in mallet locomotives offered for use on the line. Baldwin had manufactured them for a main line railroad before the order had been cancelled, and the builder was ready to dispose of them for a mere $6,000. While the extra power would have been welcome, Allen voiced two objections — the mallets would not be feasible for operation on the stockpile sidings with their eight ties per rail, and if they ever became

derailed on the somewhat sub-standard trackage of the construction railroad, rerailing the monsters would be far more difficult. After due consideration, the offer was declined.

Commencing February 6, 1932, eight-car trains hauled by (2-8-0) Consolidation locomotives began making continuous round trips over the line, each trip requiring about 2½ hours to complete. Experience quickly indicated that 10-car trains pulled by (2-8-2) Mikado locomotives were equally versatile and more efficient. By using a telephone system of dispatching, around 23 to 25 round trips could be accomplished each 24 hours. In one particular month 8,423 cars of 60-ton capacity were handled, while during the entire period of dam construction the aggregate haul for the 139,952 cars totaled some 9,000,000 tons of gravel.

The over-all statistics for the entire Six Companies, Inc. Railroad operation were even more impressive. Considering the 29 route miles of line, about 60,000,000 ton-miles were hauled, the volume occasionally reaching as high as 7,500,000 in one week. Three dispatchers were required to handle the situation, with "Red" Allen then doubling as chief dispatcher as well as assistant superintendent. (Later, after the job was done, Allen became Supt. of Transportation for the Western Pacific Railroad.) The men were hard pressed to control the large number of train movements, for operations were carried on around the clock with standard 8-

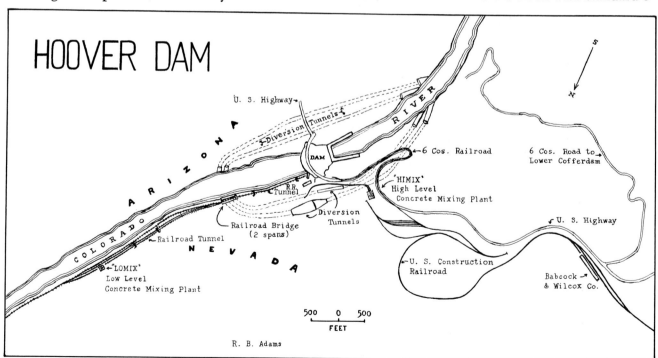

An abundance of land, coupled with an ideal climate, have combined to attract a number of major industries to the Henderson industrial plants at Henderson, Nevada, served by a spur of the UP's Boulder City branch. Over 15,000 residents attest to its growing importance. (*Las Vegas News Bureau.*)

hour shifts for the 7-day work week. Although perhaps an extreme example, the train sheet for March 27, 1933, measures a full seven feet across the face to encompass the activity of the 127 "main line" trains (exclusive of yard engine movements) which constituted the business of that 24-hour period. The engine miles alone for that day totaled 2,166, a not inconsiderable figure for a 29-mile railroad.

The personnel requirements were equally and proportionately staggering. In normal course, 10 to 12 train crews of three or four men per crew were on the line each day, although that number was augmented as the occasion demanded to as many as 17 crews per shift. Engineers and conductors were paid a straight wage of $6.00 a day, while firemen and brakemen received one dollar less. A. H. "Gus" Ayers, the chief engineer, supervised two track gangs of 30 men each to keep the line in condition. Harry Eck, the master mechanic, kept 25 men occupied in the Gravel Plant shops making minor repairs to the rolling stock.

The contingent of locomotives required for such diverse operations were of mixed ancestry and assorted breeds. Steam locomotives provided the preponderance of power, but they were supplemented by the electrics for use at the dam site as well as by a few gasoline engines. The steam locomotives were largely Mikados (2-8-2) or Consolidations (2-8-0)

leased or purchased from the Union Pacific Railroad, although there were occasional mavericks. One such was purchased from the Tonopah & Tidewater Railroad while another, a Shay ordinarily used for switching at the Gravel Plant, was a descendant of the Mount Tamalpais & Muir Woods Railway. The latter met an ignominious fate when it was released from its mundane switching operations and sent out on the main line with 10 cars of aggregates on a rush order for the Lomix Plant. Going down the grade, it ran away, stripped the gears from its side and was wrecked. A replacement from the East Butte Copper Mining Co. behaved in a more staid manner. Of the gasoline engines, four were small Plymouth machines with gear shifts which were used in the initial construction of the railroad.

Major repairs to all locomotives were performed at the shops of the Union Pacific at Las Vegas. To keep the equipment in serviceable condition, a program of rotational servicing was scheduled for all locomotives, at least one engine always undergoing major repairs at any one time.

The rolling stock consisted of 50 hopper cars, 66 side-dump cars and 42 Hart selective hoppers. No passenger cars were required as all of the 5,000 construction workers were hauled to their jobs daily by truck.

Although "freight service only" was indigenous to the Six Companies, Inc. Railroad operations, occasional passengers did ride the line. In the spring of 1934, when the nation's first streamlined train was on exhibition tour, permission was granted the Union Pacific to run the train all the way down the hill and along the Canyon Railroad to the dam face where various publicity photos were taken. On another occasion on the night of October 20, 1934, just before the sluices were closed and impounding of the waters begun, 10 trainloads of Shriners from California and Utah held their ceremonial on the upper coffer dam. Harold Lloyd, movie star and potentate of the Almeleca Shrine Temple of Los Angeles at that time, attended this august solemnity. Under the supervision of Frank Crowe, superintendent of the works, the divans were brought down from the top of the canyon at Himix to the dam face by cableway, floodlights following them the entire 700 feet of their descent. Other railroad excursions were run on virtually a weekly basis as far as Boulder City to bring sightseers to witness the progress of construction.

In spite of the density of traffic on this short-line railroad, serious accidents were relatively few and far between. There were many derailments (as naturally could be expected), but no collisions between trains were ever recorded. One recalcitrant locomotive managed to run off a stub-end track at Gravel Plant and plunged 300 feet into the desert before coming to a halt by digging itself five feet into the ground. Once back on the rails, it was found that damage to the locomotive was slight; not so the damage to the boss' plans for a Sunday family picnic which had to be cancelled.

Washouts were another source of occasional minor trouble. One took out the trestle across the Las Vegas Wash in July 1932, leaving the tracks suspended in mid-air.

The Six Companies, Inc. Railroad (excluding the leased U.S. Government Railroad) died when the purpose for which it had been constructed was accomplished. On September 30, 1935, President Roosevelt dedicated the dam, and on October 26 of the following year the first electric generator went into operation. Although it took five more years for the Colorado River to fill the basin and overflow the spillway to the dam, the railroad (and the area it had served) had long been submerged beneath the waters of Lake Mead to a depth of hundreds of feet.

The U. S. Government Railroad continued in existence (though only sporadically operated) until 1962, a total of 31 years from the time of its initial construction. Altogether, the line had transported approximately 35,000 carloads of construction materials to Hoover Dam which weighed, in the aggregate, about 2,000,000 tons. Installation in late 1961 of the last of the generating units required the transportation of 60 carloads of parts weighing 2,000 tons and signalled completion of the Hoover Dam Power Plant. The last car was hauled over the rusting rails on December 1, 1961. In May 1962 the property was sold. Lipsett Division, Luria Brothers of Los Angeles, California, purchased the 11.32 miles of trackage plus four rail cars for $81,-039.08; National Metals and Steel Company of Terminal Island, California, purchased the 65-ton diesel-electric locomotive for $7,831; Henderson Industrial Park, Henderson, Nevada, bought the 30-ton mechanical-drive locomotive for $1,051.

The Union Pacific continues to serve Boulder City with its 22-mile branch as well as the new industrial center of Henderson, located south of Las Vegas along the same line, but passenger service is non-existent. Rails now end at Boulder City. The lower reaches of Hemenway Wash, which once pulsated with intense activity, have been forever stilled.

No. 4002 was the second and largest of the Six Companies, Inc. Shays. This three-trucker with auxiliary tender replaced the standard, two-truck Shay from the Mt. Tamalpais & Muir Woods Railway when the latter stripped its gears in a runaway. (*Gerald M. Best photo.*)

Yellow Pine Mining Company

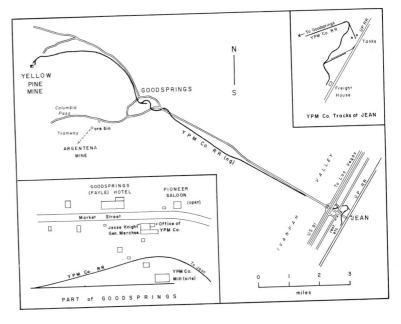

Potosi

Although seldom indicated on early maps, one of the oldest mining developments in the State of Nevada occurred at Potosi, located south and west of Las Vegas near the Goodsprings or Yellow Pine Mining District. Indians first reported finding lead ore in the area on May 9, 1856, and Nathaniel V. Jones, one of the early Mormon settlers at what is now Las Vegas, confirmed the discovery and named the location Potosi. Development followed, and some 9,000 pounds of lead was mined and smelted before the entire Mormon settlement of Las Vegas returned to Utah the following year.

For almost 50 years the property lay isolated and virtually neglected. Other parties attempted working the mine with but desultory success, for the location was remote from civilization, and transportation to markets was arduous, expensive and well nigh impossible.

Real development of the property did not take place until the Mahoney Brothers of San Francisco acquired the facilities and formed the Potosi Zinc and Lead Company to operate it. Since the mine was located high on a mountainside (700 feet above, and a half mile south of the camp of Potosi Springs), a short mule-powered tramway was installed between the mouth of the mine and the upper end of an aerial tramway which dropped the ores down the hillside to the camp below.

In 1914 the Empire Zinc Company purchased the property, and it became an important producer of zinc until 1920. The peak year of operations was reached in 1916 when production of 8,400,000 pounds of zinc rivaled production from the more affluent Yellow Pine Mine to the south. Ore quantities continued to drop and the property was sold to the International Smelting and Refining Company (a subsidiary of Anaconda) in 1926. The following year activities ceased altogether.

Goodsprings
and the
Yellow Pine Mining Company's Railroad

Before man began digging in the ground, he ranged the land with his cattle. One such cattle-man in southern Nevada was Joe Good, and the watering spot for his herds became known as Goodsprings, a name which has survived both the man and the activity which gave him substance.

The basic change in the pattern began in 1882 when S. E. Yount located his Keystone (gold) mine in the mountains west of Goodsprings and selected the Springs as the site for a new mill to process the ores. Ultimately S. T. Godbe, a mining man from Salt Lake City and Pioche, acquired the property and developed it, while the newly formed Nevada Southern Railway (q.v.) planned an 1893 extension of its line from the south to serve the growing area. (It should be noted that the extension did not become a matter of record until 1902, and even then the end of track reached only to Ivanpah station with a hopeful but ineffectual projection to Goodsprings.)

A number of additional important discoveries and developments took place around the turn of the century. Probably the most far-reaching was the founding of the Yellow Pine Mining Co. by J. F. Kent in 1901 as a combination of the majority of claims in the vicinity of Porphyry Gulch, four miles to the northwest of Goodsprings. Kent also acquired the old German-American copper leaching mill (using the ammonia process of extraction) from "Lying-Truthful" Bill Smith, and subsequently had it converted into a gravity concentrator by O. J. Fisk. Further stimulation to these activities was given impetus with the opening (in 1905) of the Salt Lake Route (SP,LA&SL), which removed the blight of isolation from the area and lowered shipping costs for the ores. Kent made his first shipments of copper in 1906, and the following year he commenced on the lead and zinc produc-

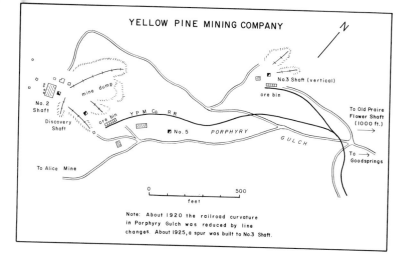

YELLOW PINE MINING COMPANY

Note: About 1920 the railroad curvature in Porphyry Gulch was reduced by line changes. About 1925, a spur was built to No. 3 Shaft.

tion which was to maintain the prosperity of the mine for approximately 20 years.

Better transportation between the Yellow Pine mines and the mill at Goodsprings, and from Goodsprings to the SP,LA&SL Railroad at Jean (33 miles south of Las Vegas) demanded the facilities of a railroad, and Kent decided to build his own. Knowing that the Quartette Mine's narrow-gauge railroad from Searchlight to the old (abandoned) mill on the Colorado River had ceased operations in 1906, Kent scurried over to Searchlight in May 1909 to try to purchase the rails and equipment. Apparently the problems were numerous, for it was not until 1910 that the deal was closed. By March of that year Kent had already completed the grading of the roadbed for his railroad from Jean, and was awaiting deliveries of the rail. Even after the negotiations were consummated, there were further delays, for the rails from Jean to Goodsprings (8 miles) were not spiked in place until June 1911, about the time Kent's new 100-ton lead-zinc mill was placed in operation. Nevertheless, by August the remaining 4½ miles of track to the mines were completed, and O. J. Fisk was appointed the first master mechanic for the new line.

The job was not an easy one. Although the Yellow Pine Mining Company's railroad was only 12½ miles long, there were maximum grades of from 4% to 5% in the easier first section from Jean to Goodsprings, while in the section from Goodsprings to the mines short grades of up to 12% were encountered. At the time of construction the latter had appeared to be the lesser of the two evils of sharp curves or steep grades, but once the line was placed in operation, quite possibly Fisk may have had some emphatic second thoughts on the matter.

The first locomotive was a gasoline engine which, in less than six months of operation, became involved in a wreck at Jean in December 1911. The actual damage to the machinery was moderate, and

the little engine was quickly put back on the job, only to be wrecked twice more on the steeper section of line to the mines. The third wreck was its last, and the incident caused management to follow a more precautionary approach toward its motive power requirements. A Shay was purchased, but this locomotive also was wrecked in November 1914, necessitating the closing down of the mines and the mill while the engine was in the Salt Lake Route's shops in Las Vegas undergoing repairs. During the enforced waiting period another (Shay) locomotive was ordered, and shortly both engines were being operated interchangeably on the single round trip from Goodsprings to Jean or the two trips from Goodsprings to the mines daily.

In operation, the little railroad made a determined effort to avoid any prospects of a common carrier status with its attendant regulatory problems. It not only handled no passengers; but when one man bribed his way aboard, the management worried for months that the Nevada Public Service Commission would hear about it.

From 1915 to 1925 the combination of good production and high metal prices enabled the Yellow Pine Mining Co. to pay dividends totaling $2.5 million. The prosperity overflowed into Goodsprings. In 1916 the population was comprised of some 800 people; the Hotel Fayle was opened with great fanfare and a dance; and the *Goodsprings Gazette* commenced a 5-year tenure of publication. One afternoon in July a cloudburst sent a 15-foot wall of water through the area. Although the town was not severely damaged, the railroad was washed out in several places. The following year nature repeated herself with similarly disastrous consequences to the Yellow Pine's railroad grade.

Following the slump of 1920, mining was resumed, but at a far less spectacular pace than previously. On September 19, 1924, the original mill burned to the ground. Two years later it was replaced, operated for two more years, then again destroyed by fire on June 10, 1928. A small flotation mill was erected in 1929 which served until the cessation of operations.

During the period from 1925 to 1930 the Yellow Pine Mining Company had for its president a man by the name of Jesse Knight, a mining engineer and lawyer from Provo, Utah. In addition, he also personally owned the Goodsprings Hotel plus a general store in town. (Should the name sound familiar, it may be recalled that the Knight Investment Company, headed by his uncle and the man

754—

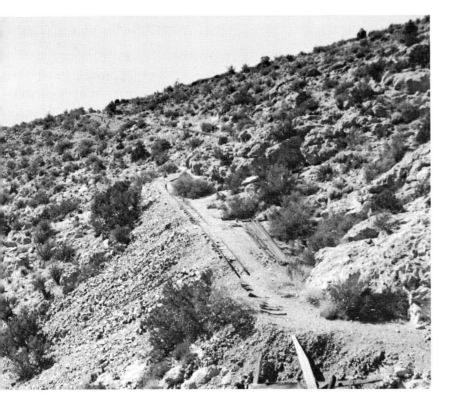

The Potosi Zinc and Lead Company operated this short, mule-powered tramway between the mouth of the mine and the head of an aerial tramway to the camp below. No record has been kept of the number of runaways coming down the hill, nor of the number of rest stops a mule had to make to pull so much as one empty ore car back up that hill. Without equivocation, the mine was in an isolated location. (*Both photos: Walter R. Averett.*)

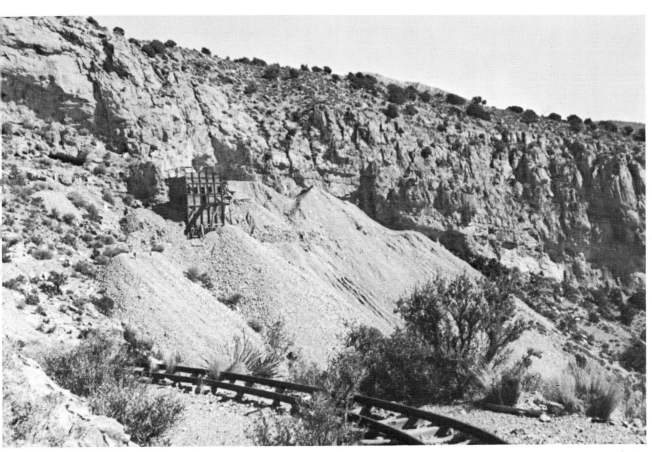

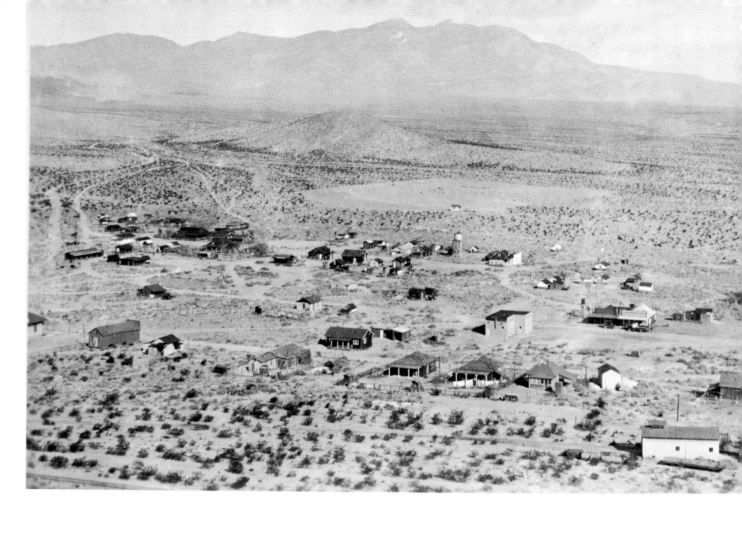

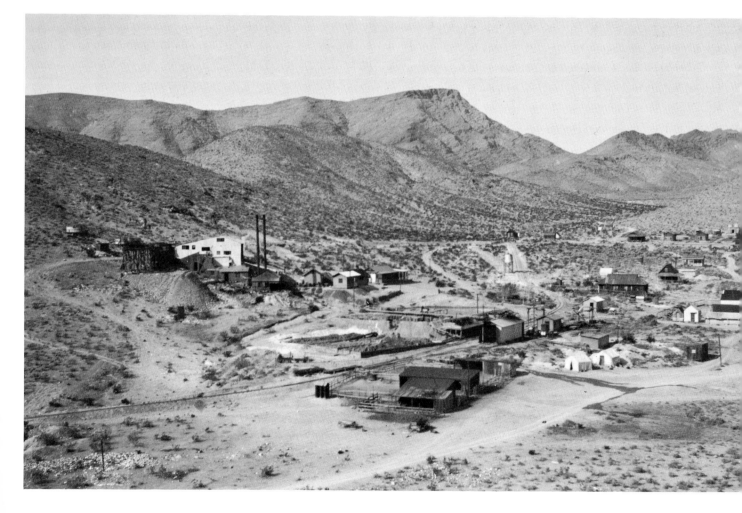

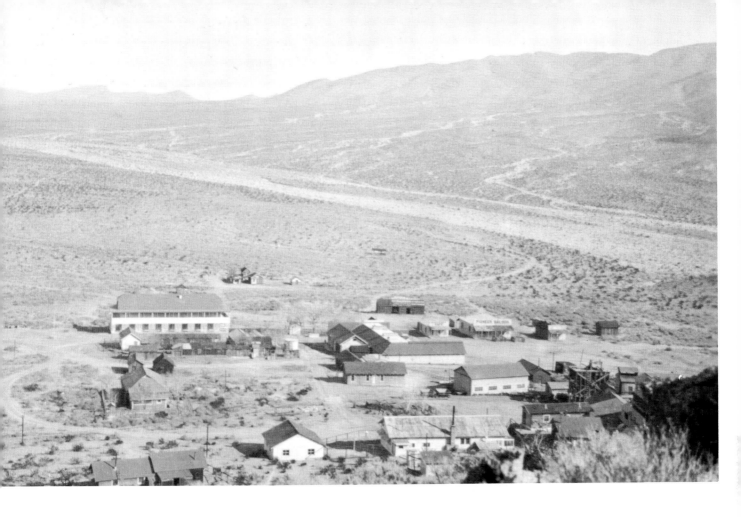

Goodsprings, presented in panorama, was a widely scattered settlement for its 800-odd population. On the main street at right are the Pioneer Saloon, Goodsprings Cafe and the two-story Goodsprings (Fayle) Hotel. Between them (with backs to the camera but connected by a common false front) are the offices of the Yellow Pine Mining Company and the general merchandise store of Jesse Knight. A spur of the narrow gauge leads between the buildings to a loading platform. In the lower right corner are the loading bins, immediately to the right of which is the cupolaed roof of the railroad's original engine house.

Tracks approached the town along the river from the far end of the valley to the south, swung up and in to town from the right, and are seen climbing the rise in the foreground behind a second engine house and water tank. A diametric view, taken at an earlier date from a point near the Pioneer Saloon, appears at *bottom, left*. The Yellow Pine Mine lay up in the hills to right, lending credence to the reports of grades of up to 12 per cent in the upper portions of the line. *(Below: Fred Green photo; all others: U. S. Geological Survey.)*

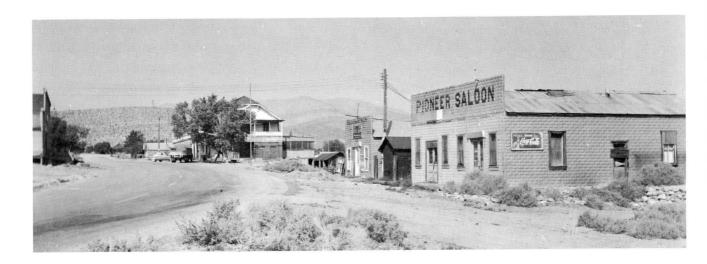

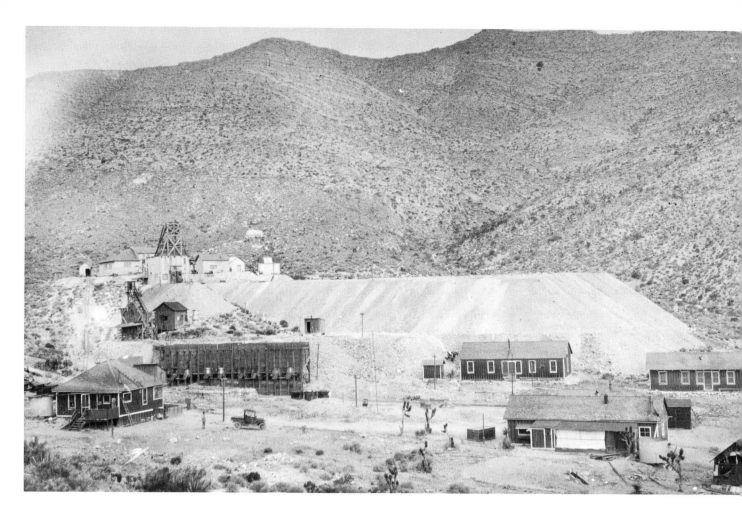

The northern end of the line stopped at the Yellow Pine Mine, shown *(above)* in 1922 with the original Discovery Shaft at the foot of the higher Main No. 2 Shaft sunk at a later date. Ten years earlier *(below)*, the Discovery Shaft was the only one in existence. *(Both photos: U. S. Geological Survey.)*

The Yellow Pine Mining Co.'s Shay locomotives at work eluded railroad photographers. In 1939 the one *(bottom, right)* stood forlornly on a siding near Goodsprings. *(Ted Wurm Collection.)*

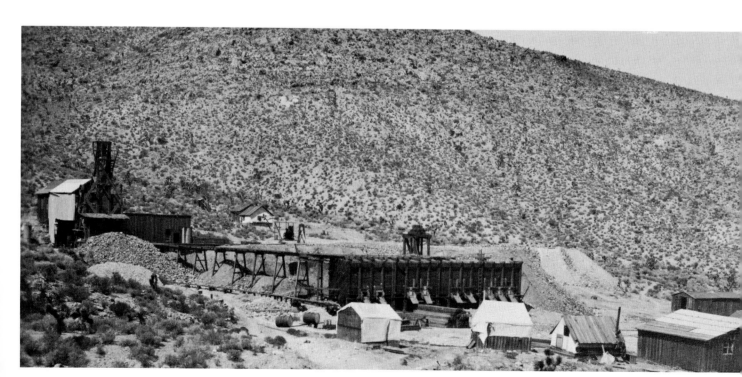

for whom Jesse was named, had been active in Aurora and other mining operations at an earlier date. See Volume I, page 227.) Jesse Knight had also been a familiar figure in Goodsprings in prior years. In 1909 he had been president of the Prairie Flower Mine Company, near the Yellow Pine Mine, and he had continued to take an active interest in the district until 1918. His son, too, had learned the mining business from the practical viewpoint, working as a mucker and hard-rock miner in the Yankee Mine for a short time in 1915 and in the Mohawk Mine two years later. The son continued his education to become a lawyer, later a judge, then lieutenant governor of California and finally still later the state's governor. His name? — Goodwin J. Knight.

Jesse Knight's tenure of office with the Yellow Pine Mining Company was definitely no bed of roses. Aside from the problems resulting from fires (previously outlined), there were more difficulties with floods. One in particular, in the summer of 1927, wreaked havoc with the YP's sub-grade. Repairs were effected, and the Shays with their short trains (there were only 12 ore cars on the entire line) continued to climb the steep grades to the mines with the empties and return downgrade with the loads. As the late Harold Jarman recalled, it took great caution to bring the heavily loaded ore cars down from the mines to the mill, as well as to lower them from the mill to the UP's main line at Jean. That same summer of 1927, one substitute engineer from the UP learned the hard way that an ore train headed by a Shay with only its engine brakes to rely on could not be handled as easily or as well as a "main line" locomotive equipped with both engine and train brakes. Coming down

the mountain, the engineer lost control of his train, but managed to ride with it for two miles before the engine left the rails on a sharp curve and exploded on impact. Fortunately the engineer jumped just before the locomotive did, and so lived to relate the story of his narrow escape from the grim reaper.

Following this incident, the railroad was not operated again until the spring of 1928 when a Whitcomb gasoline locomotive was instituted to haul water and supplies to the mine. In 1929 another (Plymouth) gasoline locomotive was added, with Harold Jarman again at the throttle, and ores were brought down the mountain to the mill. The next year operations ceased. In 1934 the rails were taken up. The locomotives were sold to a Los Angeles junk dealer to end their days on a construction job. Two years later in 1936 the mine was reopened in a limited way for a short time; it was again reopened during the 1940's for a modest production of lead and zinc; then in 1942 the property was transferred to the Coronado Copper and Zinc Company.

A paved highway leads between Jean and Goodsprings today, but sharp eyes can still detect the old railroad grade along the way. Look to the north side of the road near Jean, then watch for the crossing to the south side a short distance out. At this point the railroad traversed the river bed for a distance before swinging back to pass below the mill and enter Goodsprings proper. A number of people still inhabit the town but nearly all the mines are inactive — a far cry from the time when more tonnage was reportedly shipped from Yellow Pine and Jean than from any other point on the Salt Lake Route.

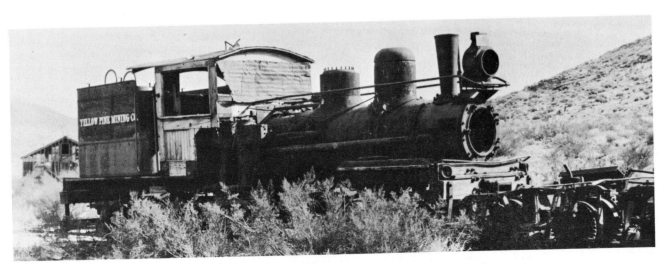

YELLOW PINE MINING COMPANY

— 759

Salt Lake Route — Supplemental Lines
Baxter

Along the Mojave River Wash, 38 miles east of Daggett, California, a station called Baxter (now named Basin) was located on the Salt Lake Route. The name was derived from that of the Baxter and Ballardie Quarry, located on the north side of the river. Around 1910 a 3,574-foot spur track was laid to the premises, crossing the Mojave River on a 503-foot trestle. In 1913-14 the quarry employed some 60 men in the mining of limestone for use in the processing of sugar beets by factories in Southern California. Apparently demand for the product remained high, as additional tracks were added in 1914 and again in 1917 to tap both sides of the White Marble deposit, No. 1, thus bringing the total trackage involved to approximately two miles.

In 1930 the California Portland Cement Company acquired the premises but ironically the property in recent years has commanded more attention as an iron ore deposit.

Arden Plaster

For almost two decades following its completion, the Salt Lake Route was so closely identified with Senator Clark that it was frequently called the "Clark Road." On the other hand, there is possible evidence of an affiliated Harriman influence in the designation of certain of the station names. One of these, an original small station twelve miles south of Las Vegas, was called Arden, possibly in honor of Harriman's luxurious estate in New York. However, lest the thought occur that the physical characteristics or appearances of the two sites were comparable, it should be stated that there was absolutely no resemblance whatever. Arden, Nevada, never could be considered to be splendiferous.

Early in 1907, when a plaster company was formed to work some gypsum deposits in the area, it was not surprising that the station name was borrowed for part of the corporate title — Arden Plaster Company. A gypsum mill was erected near the Salt Lake Route's main line at Arden, and a 5-mile, narrow (3') gauge railroad was laid out north and west to the company's mine at the base of the Spring Mountains from which the gypsum was extracted. A locomotive was purchased from the Quartette Mining Co. at Searchlight, and a number of automatic dumping ore cars were procured. By the summer of 1907 all was in readiness to commence operations.

For about a year the small, isolated company experienced no particular problems; then suddenly it ran into more than its share of difficulties. In December 1908, a runaway ore car glided down the grade and smashed into a train standing at the mill. The train was shoved bodily into the building and one man was killed. Hardly had the excitement died down when, six months later, the Italian workmen gave their wages to Carlo Rossi to deposit in the bank. Rossi, too, ran away (but for a different reason), and that was the last that was seen of the man. Then, a few months later, some Mexicans became engaged in a cutting affray; and finally, in May 1912, the mill and its property were consumed by fire.

Apparently the evil spirits that seemed to have jinxed the company could not withstand the fire, for the mill was subsequently rebuilt and served continuously from that time until the property was purchased by the U.S. Gypsum Company in July 1919. Five years later (in 1924) the original motive power was replaced by two 25-ton Porter saddle-tank locomotives which served successfully until the railroad was abandoned and the equipment sold in 1930.

Blue Diamond Corporation

Not far from the Arden Plaster Company's properties, but farther back in the Spring Mountains, the Blue Diamond Corporation (now part of Flint-

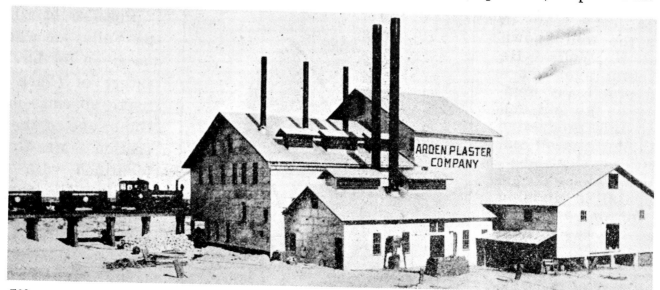

(Nevada Historical Society)

kote) located its gypsum mine and mill. To service the property, in 1925 the LA&SL constructed a line of standard-gauge railroad from a point approximately 3,100 feet south of Arden on its main line and extending northwesterly 10.6 miles to the Blue Diamond Mill.

Almost as though the gremlins from the Arden Railroad had been lying in wait, troubles beset the line before it had been completed. Floods resulting from a summer storm washed out the roadbed in several places. The grade was repaired, and the line completed. In contour, the road rises on a general 1.8% grade over the majority of the distance, with one stretch of 2.35% grade for a distance of two miles. The tracks are in place today and are operated by the Union Pacific.

Las Vegas Spurs

In 1941 the Boulder City branch was expanded by the addition of a two-mile spur which branched from the main and headed southwest to Royson, a new industrial area.

In the same year a three-mile spur was constructed to the north of Las Vegas which branched off the Salt Lake Route's main line at a point known as Valley and headed southeast to Nellis Air Base. A second spur of approximately the same length was constructed to the adjoining Lake Mead Base.

About 50 miles northeast of Las Vegas and just south from Moapa on Overton-St. Thomas branch of the Union Pacific, a short stretch of road known as the Arrowline Spur branched eastward to the mill of the White Star Plaster Co. This was a gypsum operation similar to those at Arden and at Blue Diamond. During the 1920's a short, narrow-gauge railroad was built and operated between the mine and the mill to convey the ore for processing. The line is no longer operating, and the disposition of the property or the equipment is unknown.

Caliente Ballast Pit

A few years ago while driving along the highway from Caliente to Pioche, a motorist was keeping one eye on the road and the other on the Union Pacific's branch to Pioche. When 1.36 miles north of Caliente he was surprised to see a track swinging off from the branch to cross the highway and head westward into a narrow canyon. A railroad crossing sign marked the intersection with the highway while on the far side a locked gate across the track prevented access to the right-of-way. In recent years, removal of the track has only added to the mystery.

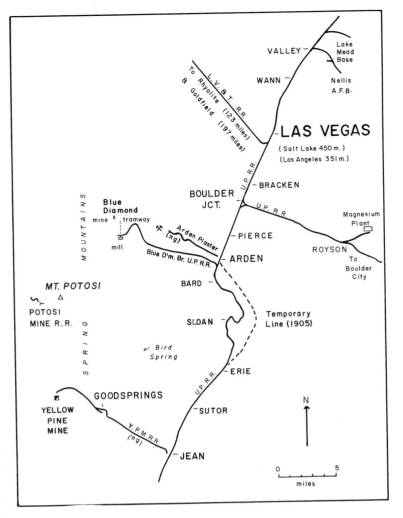

Investigation now reveals that this track was built to serve a ballast quarry operated by the Morrison-Knudsen Company for the benefit of the Union Pacific. In the period from 1955 to 1958 about 72 miles of Union Pacific main line was ballasted with the quartzite rock from this deposit. Since the material did not set firmly and resulted in excessive maintenance costs to keep the desired smooth roadbed, its use for this purpose was discontinued in 1958. Until the supply became exhausted in 1961, the remaining processed ballast was used for fill in washout protection and for the surfacing of sidings.

The main spur to serve the quarry was 3,716 feet long, and toward the end it branched into several ancillary tracks. Included in the installation was a 380-foot (safety) runaway track. Construction work on the facility began in the latter part of October 1954, and the job was completed toward the close of February 1955. The line remained in place until September 5, 1961, when removal of the tracks was effected. Nothing remains today except an abandoned quarry and a section of repaved highway at the former point of crossing.

ATLANTIC & PACIFIC RAILROAD

Behind the coastal region of southern California lies the great Mojave Desert, stretching to its maximum width from the Tehachapi Mountains in the vicinity of Mojave in Kern County for approximately 250 miles eastward across the full width of San Bernardino County to the Colorado River. Some idea of the vastness of this wasteland may be gleaned from the fact that San Bernardino County alone encompasses a territory that is twice the size of the state of Massachusetts, yet only 10% of the land is considered to be useful — 90% representing desert wasteland.

It is a wild and desolate country, treacherous to man or beast. Predominately it is hot, at times terrifically hot; yet it can and does turn bitterly cold. By and large it is dry, so arid only the scantiest of vegetation can survive; yet desert storms occur which engulf the area in cooling moisture, not only saturating the soil, but frequently resulting in treacherous cloudbursts with ensuing and devastating flash floods. It is a country to be treated with respect, for the desert is cruel and unrelenting. Although terror tales are largely things of the past since city conveniences have followed the migrating populations away from the more congested areas of the Los Angeles basin, still tragic events do occur even today as unwary and woefully unprepared wayfarers venture forth on sometimes needless errands. As recently as February 1962 a sudden 20-inch snowfall billowed up into 10-foot drifts, stranding motorists in the desert without sustenance near Mojave.

It was through this forbidding country that the Santa Fe railroad of an earlier day chose to run its surveys for a transcontinental route to the shores of the Pacific Ocean. In time the Santa Fe's rails followed, backed by a cordon of large, black, water tanks — sentinels of security in an otherwise arid desert — to become a prime force in the conquering of that desert wasteland. Between the time of the railroad's conception and its ultimate consummation, many strange things were to happen, not the least of which was the apparent paradox of construction of this desert segment of railroad by the rival Southern Pacific for the express purpose of discouraging the Santa Fe.

Rightfully the story dates back to July 27, 1866, when an Act of Congress chartered construction of the original Atlantic and Pacific (A&P) Railroad. The vision was to construct a line of railroad from Springfield, Missouri, all the way to the Pacific Ocean. With thousands of miles of wild, uncharted Indian country to traverse, quite likely the progenitors of the line paid scant heed to a further section of the same Act which authorized a fledgling Southern Pacific Railroad to build south from San Francisco to a connection with the A&P at a point somewhere along the eastern border of California. If there was any hint of trouble in this apparently innocent circumstance, the owners of neither of the lines were sufficiently astute to raise the issue.

The A&P's immediate problems were how to organize such a vast project and how to determine what route should be followed. Surveys were made and a pathway selected, roughly following the 35th parallel; but a bad start, coupled with a chain of misfortunes, stalled the project after the rails had been stretched some 327 miles from a point near St. Louis, Missouri, westward into the wilds of the Indian Territory in what is now Oklahoma. Shaky finances following the troubled times of the Panic of 1873 forced the company to seek the solace of a receiver, and from the ensuing reorganization a new company arose, the St. Louis and San Francisco Railway Company, to acquire the existing line of railroad plus all of the stock and franchises of the old company together with the supporting Congressional grants of land for each mile of railroad constructed.

Unfortunately the new company had but a modicum of cash with which to meet its obligations, and the possibilities of raising the huge sums necessary for the financing of construction of a major transcontinental line were virtually non-existent. Help would necessarily have to come from some outside source. Thus, when some Boston men identified with the Atchison, Topeka & Santa Fe Railroad made overtures of financial backing, the Frisco was willing to listen.

The reasons for the Santa Fe's paternalistic interest were selfish. Originally starting as the Atchi-

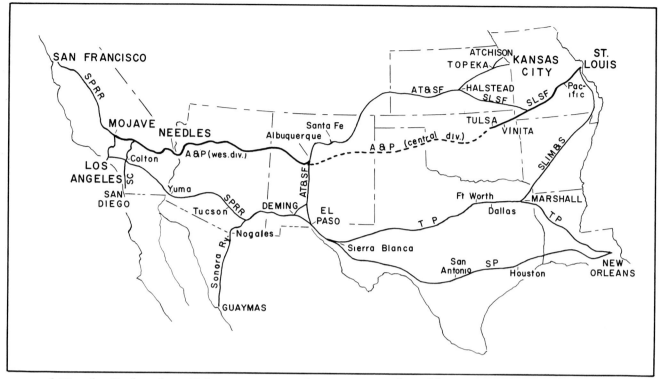

son and Topeka Railroad in 1859 to construct 50 miles of line between the cities of its corporate title, an early adjustment was made in 1863 whereby a new Atchison, Topeka and Santa Fe Railroad more accurately reflected the expanded scope of its forceful management. Westward expansion across Kansas was pushed; then the Boston capitalists raised their sights to the far distant objective of Santa Fe, New Mexico. Long before the rails had been pushed some 900 miles to Las Vegas, New Mexico (just short of Santa Fe), the company had again revised its objective and was reaching for the Pacific Coast. Surveyors were sent out to roam the rugged territory of Arizona and New Mexico in search of favorable routes, only to return with the news that the two best and most logical pathways had already been pre-empted (so to speak) by the A&P in the northern part of those states and the Texas & Pacific (later Southern Pacific) in the southern part. The most immediately feasible alternative was to reach southward from Albuquerque to Guaymas, Mexico, on the Gulf of California, from which harbor all other ports along the Pacific Coast could be reached.

Although the Santa Fe did build to Guaymas (in 1882), it continued to agitate for a direct rail route to California as being most desirable and most important. Rather than buck the powerful T&P-SP combination, an approach to the uncompleted and more vulnerable A&P (Frisco) holdings appeared desirable. Thus the overtures were made.

Santa Fe-Frisco negotiations were carried on during the latter part of 1879 and were culminated by the signing of two agreements on the following January 31 (1880). The first of these split the stock of the A&P right up the middle, giving both the Santa Fe and the Frisco equal and joint control of the former road's rights and privileges. With joint control thus established, a "Tripartite" agreement was entered into among all three railroads (the Santa Fe, the Frisco and their joint subsidiary, the A&P) to provide for the construction and finance of the latter's chartered road, primarily its Western Division from A&P Jct., a point near Albuquerque, New Mexico, west to the Pacific Coast. On the eastern end, the Frisco would provide the important connection to the St. Louis gateway, while the Santa Fe's main line would connect at Wichita, Kansas, and carry through to Albuquerque for the important A&P routing. To eliminate possible misunderstandings, the details were spelled out in the written agreement, including the financing which would be shared equally between the two parents.

Actual work began at A&P Jct. (now Isleta), New Mexico, late in the spring of 1880. In spite of problems with Indians, rough characters and winter weather, the graders and tracklayers pushed westward until, by the close of the following year

(1881), approximately 190 miles of rail had been laid across western New Mexico and into Arizona. Only about 360 miles remained between the railhead and the California border of the Colorado River near Needles.

At this point difficulties were encountered. People interested in California railroads quietly invaded the board of the Frisco and were using their influence to delay construction of the A&P beyond Needles, California. To understand this aspect of the situation, a look at the other side of the coin — from the viewpoint of the westerners — should be made.

Following completion of the Central Pacific Railroad (at Promontory, Utah, May 10, 1869), the road's owners, the "Big Four" (Huntington, Hopkins, Crocker and Stanford), discovered that business was hardly overwhelming and that the cherished railroad for which they had fought so hard amounted, in retrospect, to a proverbial white elephant. For a time it seemed as though all efforts to make the line really pay were fruitless; even later, with high freight rates, only moderate dividends

were possible. In the light of this experience wherein the total California business was hardly enough to support one family of railroads, there was reasonable justification for the attitude that other transcontinental railroads then projected or in process of construction would only dilute an already insufficient California market.

Some people within the state thought otherwise, and several little local lines were started with dreams of major proportions. To save them from the potential heavy losses of such foolhardy construction, the Big Four usually managed to persuade the owners to sell out for one reason or another. Then, to forestall construction of other railroads from points outside the state, a plan was devised to extend the Big Four's existing system to any areas along the California border where encroachments were unavoidably threatened. This became the policy and creed of the Central Pacific (later Southern Pacific), Railroad, and it led to many unusual situations.

Initially the Central Pacific extended its rails southward down the then vacant San Joaquin Valley. Construction was continued by the Southern Pacific (control of that road was acquired in 1868) and gradually the rails were pushed up and over Tehachapi Pass to Mojave, and Los Angeles, California, and Yuma, Arizona. Yuma had been the anticipated meeting point with the Texas and Pacific Railroad, but when the SP reached the border town in 1877 the T&P was nowhere in sight, having been stalled in Eastern Texas. Crocker then decided to press his advantage and take the initiative by extending his rails east of the California border — to El Paso, Texas, thence southeastward for another 90 miles — to a connection with the T&P at Sierra Blanca in 1882. The T&P at that time was under the control of the famous railroad financier, Jay Gould, and an agreement (known as the Huntington-Gould Agreement) was drawn up assuring close cooperation between the SP and the T&P. Thus another transcontinental railroad line became an accomplished fact.

Now, more than ever, with control of both a northern and a southern overland route to California, the Southern Pacific did not want any other railroads diluting its market. Still the erstwhile A&P, for all of its early (1866) start, was just now (in 1881-82) making real, concerted progress. Somehow they must be stopped at the California border to preserve the integrity of the SP's position.

Since the A&P itself was virtually invulnerable (50% of the stock being held by the Santa Fe and

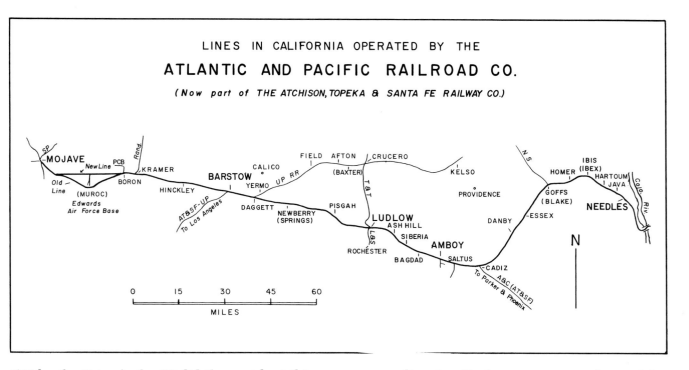

LINES IN CALIFORNIA OPERATED BY THE
ATLANTIC AND PACIFIC RAILROAD CO.
(Now part of THE ATCHISON, TOPEKA & SANTA FE RAILWAY CO.)

50% by the Frisco), the SP did the next best thing and invaded the weaker of the two parents — the Frisco — through the expedient of acquiring sufficient stock to assure Huntington and Gould seats on the Board of Directors. The move was a surprise to the Santa Fe; but even more surprising was the Frisco's sudden inability in January 1882, to sell its half of the next $15,000,000 issue of A&P mortgage and income bonds, the funds from which were essential to successful completion of the A&P's construction. Although shocked and retarded, the Santa Fe was not to give up easily. It sold its half of the bonds and applied the money toward completing the A&P's line on a foreshortened basis — as far as Needles, California, on the western bank of the Colorado River. Completing the balance of the route, the Santa Fe reasoned, would have to await the proper time and circumstance after the immediate problems had been ironed out.

If anything, the Santa Fe's position was more vulnerable than that road realized. Its adversary, the SP, already was starting to use the time gained in the delay to build an SP line east from Mojave to meet the Santa Fe at Needles and block the Santa Fe at the California border. SP's William Hood and a crew of 30 men were placed aboard the river steamer *Mohave* and sent to The Needles to start surveying a line of railroad westward from that point. A similar SP party was taken to Mojave on the SP's main line at the foot of the eastern slopes of Tehachapi Pass and started out in the reverse direction. Each party was to work as quickly as possible until it met the other.

The project did not take unduly long. By early February 1882 actual construction work was started eastward from Mojave. The Bakersfield *Kern Weekly Record* of February 9, 1882, reported that a large force of men and supplies were at Mojave and "a carload of Chinamen, 60 head, arrived at Mojave station Saturday. They are expected to gobble up the Atlantic and Pacific, scales, tails and fins." Obviously, the propaganda picture of an eastern A&P dragon ready to devour all West Coast business had been well implanted in the public mind.

In spite of the lack of time for proper organization, track laying began on February 20, 1882. Five days later 4,200 feet of rail were spiked in place; graders, meanwhile, were working five miles out.

As spring faded into summer, the rails were stretched across the hot desert sands. By October 23, 1882, trains were operating all the way to Waterman's, 70 miles distant. Waterman's was the site of an ore crushing mill, located on the north bank of the Mojave River about a mile west of Barstow, which had been named for Robert W. Waterman, subsequently to become the governor of California. Later, when the Santa Fe's branch southward via Cajon Pass was established on the south bank of the river just east of Waterman's, the junction point was named Barstow in honor of William Barstow Strong, president of the Santa Fe.

Strong's middle name was selected due to the fact that his last name had already been appropriated for a station in Kansas.

Advance crews were strung out along the projected line of road ahead of the rails, and citizens of the thriving silver camp of Calico were being interviewed respecting the location desired for the Calico station. By the close of the year 1882 rails had been extended on into the desert beyond Ludlow, and almost as far as Siberia and Bagdad, for a total of 131 miles of line.

Service to Amboy began on February 12, 1883. From Amboy easterly over the remaining 84 miles of line to The Needles, a precedent was established in the naming of the railroad's stations. As is sometimes done in the naming of city streets, perfect alphabetical order was the rule: Amboy, Bristol, Cadiz, Danby, Edson, Fenner, Goffs, Homer, Ibex and Java. In later years, after the Santa Fe acquired the line and increased traffic necessitated the addition of more passing tracks, the regular pattern of names became lost. The novelty of the euphonious titles was continued with the addition of such places as Siam, Hartoum, Nome and Klondike, while others, such as Edson and Bristol, were changed to Essex and Bengal, respectively.

In March 1883 a correspondent for the *San Francisco Evening Bulletin* made a trip over the line to the end of track at "The Front." In the delineation of his experience, he mentioned the Amboy Crater, the yucca plants, the cottonwoods and willows growing out of a waste of salt grass. He was intrigued with the number of stamp mills and reduction plants at Waterman's and Calico and was gratefully amazed at the array of pioneer drinking establishments available in such desolate outposts. Most impressive was the way the cars "skim rapidly over sandy wastes, barely enlivened by the scant verdure of patches of greasewood or the more lively creosote bush. The few stations passed are generously protected by a double roof, not as a provision against rain (which scarcely averages one or two inches a year), but against the intense heat of the summer sun, in contrast with which the winters are quite severe, and in the clear winter night the frost is often intense."

Whereupon (after pausing for breath) he went on to recount that on leaving Calico station (in the spring of 1883 its name was changed to Daggett in honor of the new lieutenant governor), the line left the Mojave River and crossed the Providence Mountains by a series of steep grades. To the correspondent it seemed enigmatical that for a distance of 100 miles, a daily train of 20 tank cars was necessary to bring water to the stations and construction camps while, by contrast, the ever-present threat of flash floods demanded that every wash be traversed by a substantial trestle. On one sharp curve, 16 such trestles could be counted at one time. Then, 200 miles from Mojave, he reached the isolated but intriguingly named station of Providence which belied the presence of the promising camp of the same name located 20 miles to the north. Finally, a short distance beyond, he reached "The Front," complete with its "bustle and activity of railroad construction, its army of laborers, the omnipresent Chinamen, the bustling temporary camp, the clang of iron rails and the sharp click of the driving spike." A two-day sandstorm had filled up the turntable, obliterated the track and delayed the trains, and all were annoyed "except plodding John Chinaman who, with goggled eyes, tackled the moving mass of sand with scoop shovel."

Operations as far as Goffs commenced on March 19, 1883, and less than a month later on April 11 the graders had completed their job over the balance of the distance to The Needles. Although 10 miles of rails still remained to be laid before trains could roll into that terminus, the race had been won — the A&P tracks were still 40 miles to the east and the Colorado River still remained to be crossed. The last SP rails were spiked in place on April 19, 1883 and The Needles, which had had an informal population of some 600 people for the period of the past six months, suddenly dropped to ghost town status as men, equipment and materiel were returned to San Francisco at the rate of a trainload every day.

Across the border in Arizona, the A&P continued to stretch its rails westward, finally halting in May 1883 on the east bank of the Colorado River. A major bridge would have to be built, and exasperating and disheartening was to be the task.

June is the normal month of high water on the Colorado River in the vicinity of The Needles. Late spring thaws in the Rocky Mountains trickle freshets down the mountainsides into the tributaries and thence into the mother stream, swelling the lower river water to a crest which is full of treacherous, swirling currents and filled with tree stumps and other potentially destructive debris. If the onus of timing rested upon the shoulders of the bridge builders, they could not have selected a more inopportune moment to tackle the stupendous task. To compound the difficulties of rising waters, a bed

American (4-4-0) type locomotives such as No. 14, the SIOUX, predominated the stable of A&P iron horses in the late 1880's, while tickets over the newly opened route via Southern Pacific to The Needles could be purchased at the A&P's offices at No. 4 Montgomery Street in the heart of far-away San Francisco's financial district. Note the similar, but different, insignias for the railroad as distinguished from the "fast freight line." *(Top: Charles Battye Collection; bottom: Louis L. Stein, Jr. Collection.)*

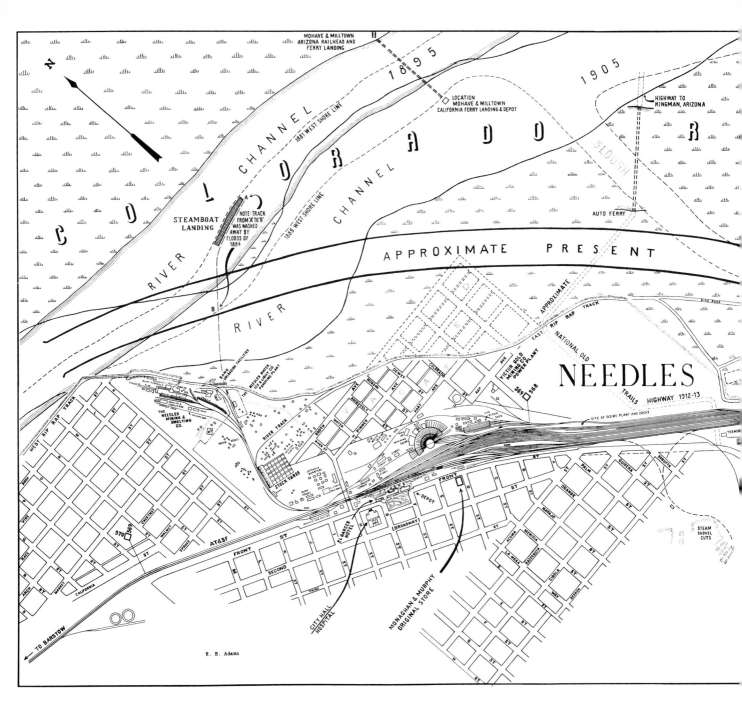

of quicksand at the selected point of crossing furnished a soft and insecure footing from which the pilings were swept away with a constancy almost equal to the speed with which they were driven.

For a time speculation was rife over the possibility of postponing the work until the waters had receded somewhat, but excitement toward the end of June counteracted this tendency when the contractor reported that only a 20-foot gap remained to be closed. The exhileration was short-lived for 280 feet of pile trestle suddenly took off in a surge of high water and once again it was necessary to repeat the same old task.

To obviate some of the delays, a gang of A&P track forces were set to work on the California bank of the river building the intervening piece of road between the west end of the bridge and the point of junction with the SP. (The name of Hood, honoring an SP engineer, was proposed for the connecting point, but there is no record that the cognomen was ever officially adopted.) To service these track gangs and provide a connecting transfer service between the SP and A&P railheads, Capt. W. H. Hardy came down from his settlement of Hardyville and instituted a ferryboat service across the river, by means of which it was possible to route through freight over the new route via

ATLANTIC & PACIFIC RAILROAD

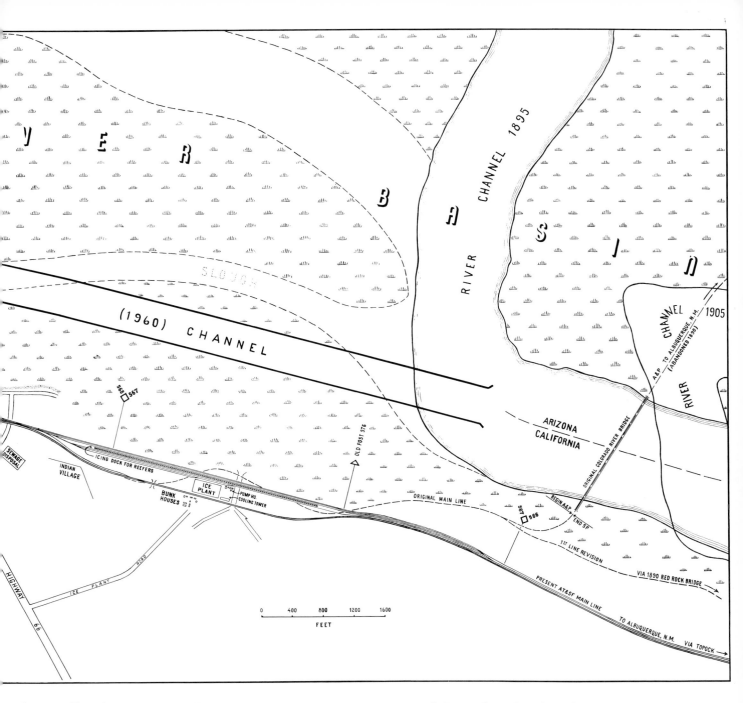

The Needles if consigned to his care. Even Capt. Hardy could not bridge the sudden gap in the A&P's line of supply when a summer cloudburst ripped a hole in the tracks near Yucca, Arizona, 15 miles east of the river.

Other troubles continued to harass the project. A new barge, expressly built for pile driver service, turned out to be too small for the job. A larger barge, generously furnished by the SP, temporarily solved the problem until it was inadvertently wrecked. Even the workers were not immune from the misfortunes, for a large number were seriously incommoded when fire, caused by a drunken cook, consumed a boarding train on Yucca siding.

In spite of these obstacles the job did progress. By late July, with the Colorado River water receding, the pile bents were firmly anchored in solid footing. In early August 1883 the bridge was completed, and on August 8 the last A&P rail was installed. The following day the "Thirty-fifth Parallel Trans-Continental Line" was declared officially open, and for the first few months of operations tri-weekly train service over the A&P from Ash Fork (west of Flagstaff), Arizona, was provided to The Needles. A last-spike ceremony was reported, but the lack of outside newspaper comment tends to indicate that it was one of exceedingly modest proportions.

ATLANTIC & PACIFIC RAILROAD

-769

On July 1, 1883, a month previous to completion of the A&P's line the Pacific Improvement Company (the construction company affiliated with the SP interests) officially turned over the track from Goffs to The Needles to the SP's operating department, and the entire Colorado Division from Mojave to The Needles was considered completed. Tri-weekly train service was inaugurated, although the trip must have been a weary one due to the lack of habitations and greenery along the line. In the entire first 124 miles between Mojave and Ludlow alone, for example, the only station and turntable on the line were at Daggett, while one section house and a tool house comprised the sum total of buildings at the other six carded stops on the timetable. The desolate desert was hardly conducive to comfortable living.

At the eastern end of the Colorado Division, life at The Needles commenced to rebound as SP forces arrived to construct a 14-stall roundhouse and other substantial buildings, including a hotel and a "magnificent" depot capable of accommodating 500 people. Of more concern to the people than the constructors were the standard galvanized iron roofs which topped all structures — undoubtedly compounding the already intense summer heat. Locally, the sheer size and voluminousness of the installation generated sand house speculation that the SP had set its sights on some objective farther east and fully contemplated continuing its rails southeasterly to a junction with its own main line near Benson (east of Tucson), Arizona.

For the physical joining of the rails of the SP and the A&P at The Needles could mean but little to either of the railroads involved without a joining of intent, and the SP obviously had little interest in developing traffic for a (foreign) A&P connection in competition with its own newly opened Sunset Route (via Yuma, Arizona) which used SP rails all the way east to the Mississippi River. Thus, only a modicum of freight drifted eastward over the desert to The Needles interchange; and passenger travel, for all the benefits of the new and more direct "Albuquerque Short Line," was abstemiously light. When the first through passenger trains arrived from San Francisco on October 22, 1883, the SP halted its coaches at the station, and patrons were obliged to transfer their own personal belongings across the long, covered platform to the waiting A&P cars. Only the sleeping cars were interchanged, thus sparing their passengers the physical inconvenience of deberthing while in transit.

In effect, the SP was operating a branch line to (The) Needles, and the A&P was doing much the same, except that the connection at the Needles terminus did permit the A&P to route freight through to the Pacific Coast. Each line developed its own local business, though the volume was far from sufficient to support the expense of either road's operation due to the primitive and sparsely settled territory through which each ran.

The SP's line across the Mojave Desert, for example, opened up a whole new mining territory to easy access. In lieu of anticipated large revenues accruing from the hauling of bulk ore, the railroad largely succeeded in solving the problem of scarcity of water for others. According to the *Calico Print*, water could be "obtained at any point on the railroad for 2 cents a gallon, by applying to the proper railroad officer who will order the car to stop at any convenient point for the benefit of prospectors." Some of the mining areas to benefit from this new and improved services were Calico, Ivanpah and Providence, of which the latter with its Bonanza King Mine had the reputation (in Au-

CENTRAL AND SOUTHERN PACIFIC RAILROADS,
Connecting at Goshen, 241 miles from San Francisco.

770 —

ATLANTIC & PACIFIC RAILROAD

gust 1884) of being the richest silver mine in California. Thomas Ewing ran this mine successfully for a time, but when the "beautiful and thoroughly equipped" 10-stamp mill burned on July 31, 1885, the mines closed down and the owner, after collecting the insurance, went east, probably with a sigh of relief.

In spite of the war of attrition being carried on with polite subterfuge between the two rail carriers, the young town of Needles, California, seemed to thrive in inverse proportion to the paucity of traffic developed by the conflict of interests. Being situated at the junction of the two rail routes, (and hoping to have two more lines connect there), beside serving as a terminus for each as well as an interchange point between the rails and the Colorado River traffic, the new center developed rapidly. Of course, the Colorado River was sometimes detrimental as well as beneficial to the town's welfare. While the river normally provided a means of water access to the numerous mining camps located up and down its banks, there were times over the years when late spring floods rose to abnormal heights to wreak considerable havoc, particularly when the high waters enabled the river suddenly to change its course.

Of particular note in Needles' economy was the enterprise of two merchants who located their main store in town and who, in addition to supplying a majority of the materials to the mines up the river, also arranged a contract to move all freight destined for Ft. Mohave. To reach the river boats from the railroad yard, these two ex-railroad men — Frank Monaghan and Dan Murphy — built a mile-long spur from the A&P down to the bank of the river. The length of the line and density of the traffic over it hardly justified the normal complement of railroad equipment — instead handcars loaded with merchandise were pushed or pulled by Indians up and down the spur to and from the waiting river boats. In the expansive lexicon of Needles' burgeoning society it was only natural that the name, "M&M Pushcar Line," be evolved to designate the spur.

By the close of 1883, with basic operations for both the SP and the A&P roads reasonably well established, the inherent nature of the competitive stalemate could be analyzed more accurately. There was no doubt but that Huntington's (SP) objective had been accomplished — the Santa Fe had been stopped at the border, and momentarily the SP was in the driver's seat. On the other hand, the Santa Fe was faced with some very real and pressing problems. Its A&P Railroad (part of the Santa Fe-Frisco-A&P combine) had been completed for approximately 560 rather desolate miles westward from Albuquerque, New Mexico, to Needles, California, but it still didn't really go anywhere. The local business along the line was, of course, trifling; the SP connection at Needles generated no through eastbound traffic of any consequence for the bulk of such business was routed via the SP's own lines east to Ogden, Utah, or southeast to El Paso, Texas. In its present condition the A&P line was virtually worthless, yet it could become an even more distinct liability were it to fall into hostile hands, particularly those of the SP.

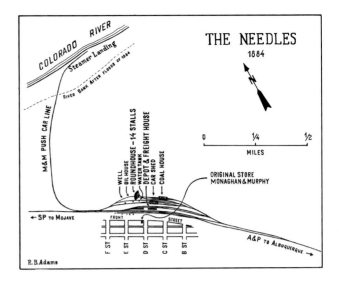

There appeared to be only two possible solutions to the dilemma — either an exhorbitant amount of money must be spent to build a new railroad parallel to the SP's existing line all the way from Needles to San Francisco (600 miles), or else some arrangement would have to be made to purchase the SP's Colorado Division between Needles and Mojave on such terms as would guarantee the A&P (and the Santa Fe and the Frisco, if they so chose) the right of access over the balance of the mileage from Mojave to Oakland and San Francisco. Of the two possibilities, the latter was the more desirable as it would eliminate the need for construction of a second, competing line.

Huntington, however, had different ideas on the matter. In the first place, he was not about to sell to his competitors that obstacle which he had worked so hard to place in their path. Secondly, he did not think that the A&P (with an SP finger in the Frisco partner's pie) was in a financial position to carry out its construction threat. Huntington failed, however, to reckon on the driving force of the Santa

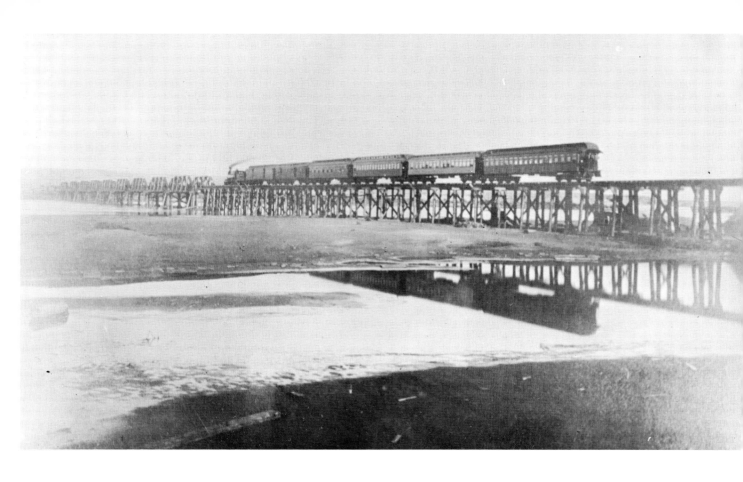

Achilles' heel of early A&P operations was the low-level, wooden, truss-and-trestle crossing of the Colorado River *(above)* which was washed out successively with the seasonal changes of that body of water. For seven years the railroad fought the river at this location until a new canti- lever bridge, shown under construction *(below)* was finally completed in May 1890. Note the river steamer GILA, anchored upstream from the temporary foot bridge, used as a boarding house for workmen during erection of the structure. *(Both photos: Charles Battye Collection.)*

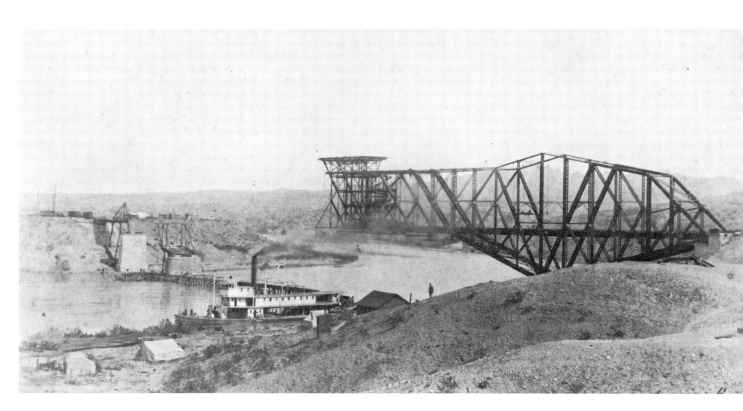

Impressive in portrait was the first station at The Needles which provided hotel facilities for stranded passengers at this junction of the A&P and SP railroads. The slat fencing at right obscures the entrance to the fine bar from more decorous passengers on the platform, a situation which prevailed until Fred Harvey took over operation of the restaurant.

Locomotives of the A&P were turned and serviced at this 14-stall roundhouse where the customary, SP-design, square wooden housing was built around the cylindrical water tank to provide air-space insulation against the extreme desert heat. *(Both photos: Charles Battye Collection.)*

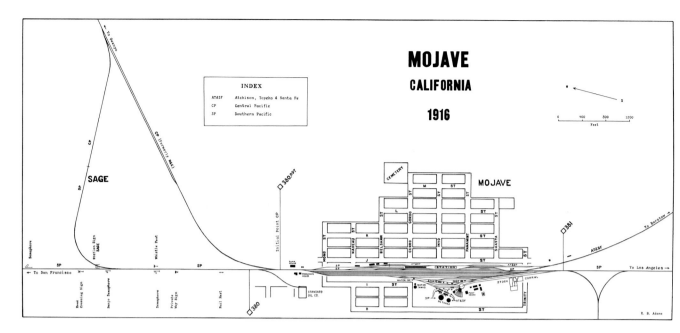

Fe. With only one of the alternatives left — to construct its own line of railroad to the Coast along the lines of the original 1881 A&P surveys — the Santa Fe began to make overtures in that direction. (Some California maps of the nineteenth century anticipatively show two distinct railroad routes in this area.)

Once it became obvious that the Santa Fe was not going to take the situation lying down, Huntington apparently had some second thoughts on the matter and realized that a second (A&P) line would render his SP road as useless as he thought he had made the A&P and that, except for his share of such local traffic as might be created by occasional periods of mining activity — unreliable at best — his competing SP branch through the barren Mojave Desert would have nothing to support it. As a consequence, negotiations were held among the interested parties and ultimately agreement was reached.

Due to the complicated legal aspects of the situation, four separate agreements (all signed on August 20 to become effective October 1, 1884) were required to record the transaction properly. In digest, the basic result was this: The A&P bought the SP's Colorado Division from Needles to Mojave (242.37 miles of road) for $30,000 per mile or $7,271,100, payable when title was given, on the basis of ⅙ in cash and the remainder in cash or in A&P First Mortgage Bonds. Until such time as the SP could give clear title to the property by discharge of the lien of its mortgage, the A&P was permitted to lease the property at an annual rental

of 6% on the purchase price; while to protect the SP, both the annual rental and the A&P bonds (to be given when title was transferred) would be guaranteed ½ each by the Santa Fe and the Frisco. In addition, the A&P secured an option for trackage rights over the SP from Mojave to Oakland and San Francisco, including the use of terminals at the latter points so that, upon 12 months' notice, the A&P might run its trains between Mojave and San Francisco at an annual rental of $1,200 per mile. Additionally, the A&P could also assign its rights to the Frisco or the Santa Fe.

Thus, until October 1, 1884, the A&P as a through line did not really exist. Even after that effective date of contract, it was but an imperfectly organized composite of lines of various ownership plus a leased line and many critical miles of potentially insecure trackage rights. What was needed and desired was an outlet to the California coast over its own, controlled rails as a safeguard to its position. This objective was secured by parent Santa Fe and not the A&P proper.

Local interests had been building a California Southern Rail Road north from San Diego to San Bernardino in the period from 1880 to 1883. Then winter storms in the latter year washed out the line to an extent considered irreparable with the funds available. Under an arrangement providing for Santa Fe backing and control, part of the road was rebuilt and an extension was completed in November 1885 from San Bernardino up and over Cajon Pass to Barstow where a connection was established with the A&P. This gave the latter road

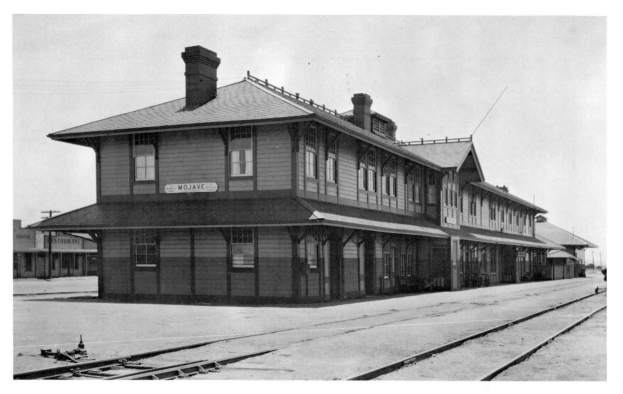

The SP's facilities at Mojave in 1916 accommodated the needs of the joint tenant Santa Fe, junctioning from the south for the climb over joint trackage through tortuous Tehachapi Pass. The station was sandwiched between the SP tracks in the foreground and the Santa Fe's tracks to the rear, beyond which the store fronts along the town's busy J Street are just visible. The steam house and round-house (replaced in 1922) were largely utilized for running repairs of helper engines which boosted trains over the pass. (*Above: Southern Pacific Collection; below: Mrs. Tomaier Collection.*)

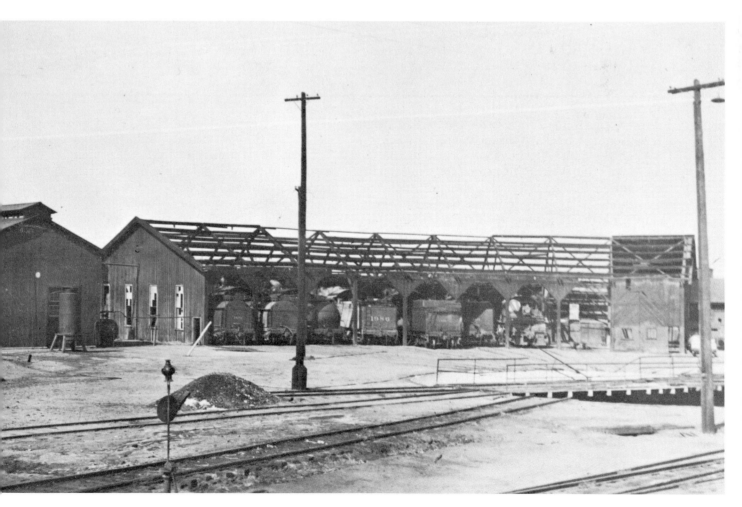

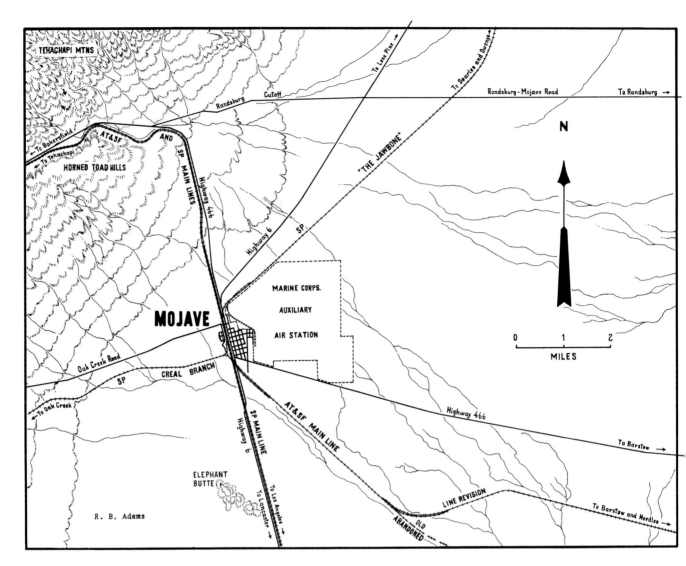

direct access to the Pacific Coast port of San Diego. A subsequent trackage arrangement between the SP and the Santa Fe provided for use of the former road's line west from Colton (three miles south of San Bernardino) to Los Angeles until such time as various little railroads under Santa Fe ownership could be tied together with additional construction to form a parallel, competing route in 1887. Through these expedients the Santa Fe (and indirectly the A&P) succeeded in reaching the major California ports — San Diego, Los Angeles and San Francisco. The primal objectives of the primitive A&P had finally been realized in full.

Not all of the A&P's efforts were quite as beneficent. In particular, the Colorado River was most obstreperous, and the seasonal mutability of that body of water presented no end of problems. The first bridge, built in the summer of 1883, had been located about 2½ miles below (The) Needles, and

hardly a year had gone by before it was washed out. For the two months following the calamity (from May 4 until July 1884) all passengers, baggage and express had to be ferried across the river on flatboats while a new bridge was constructed. The effort was futile. In 1886 and again in 1888 the succeeding bridges were swept away together with hundreds of feet of embankment along the east shore of the river. In 1887 (between the second and third futile attempts at a low-level crossing) the A&P began to tire of maintaining stand-by river boat service during periods of high water and determined to correct the situation. A new location further downstream was selected, and long-range plans for an improved, high-level, single-track cantilever bridge at Red Rock was decided upon, regardless of expense.

Work on the project was begun in September 1888 and continued over the winter. Then the heat

of the following summer forced the contractor, Sooysmith & Co. of New York, to suspend operations from May until September 1889. Ultimately the piers were completed and all the requisite structural iron was assembled on location so that, on February 4, 1890, actual erection of the bridge could begin. Using an average force of 75 men, the contractor assembled the structure (then the largest cantilever bridge in the United States) in 80 working days. Additionally, 13 miles of new railroad construction were necessary from a point near Needles to a point beyond Topock, Arizona, to provide the proper approaches to the new structure. Coincidentally, just two hours after the new route was opened on May 10, 1890, an unexpected washout tore out two miles of the old line. Segments of the original grade, located in a wash, may still be seen in Arizona today. Finally, with finishing touches applied, the 1,100-foot-long bridge was put to the final test on June 14, 1890. A group of 10 large Pittsburg locomotives were run out on the structure and allowed to stand. Later a double-headed trainload of coal was run on the bridge, and when observers found that the framework did not quiver, the test was pronounced satisfactory.

In retrospect, the decade from 1885 to 1895 could probably be called the heyday of the A&P. Stories of the operation of this line are filled with tales of runaway trains, steep grades, water problems and ghosts. As a terminal and later division point at the foot of a long hill, Needles came in for an inordinate share of publicity. One passenger helper locomotive was returning light down the hill from Goffs when a main rod let go and damaged the air compressor, the reservoir and the blow-off cock. Without any air pressure, the locomotive was also devoid of brakes, and down the single track the engine coasted wildly, gaining speed with every turn of the drivers. Engineer W. K. "Dolly" Ackerly and the fireman climbed to the back of the tender, ready to jump to that side of the track which would be opposite from the direction the engine might decide to leave the rails. Hurtling past Ibis, they managed to signal the tower operator with fusees that this was not a normal operation, and in turn the word was relayed down the line to Needles so that trains could clear the yard. Miraculously the engine clung to the rails as it whistled around the curves. With switches all lined for the main route, the locomotive dashed through Needles and on

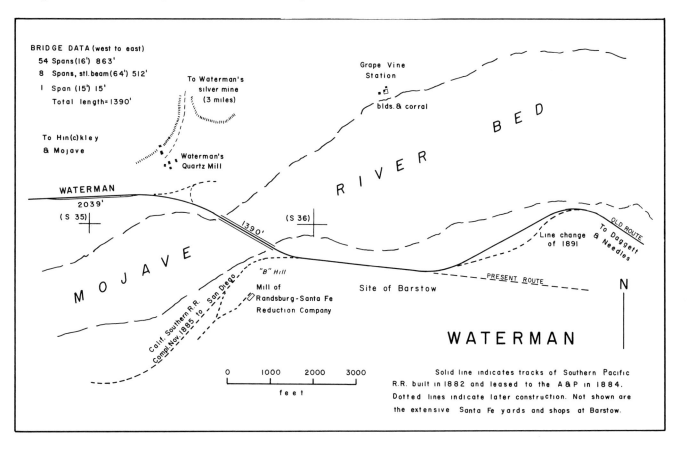

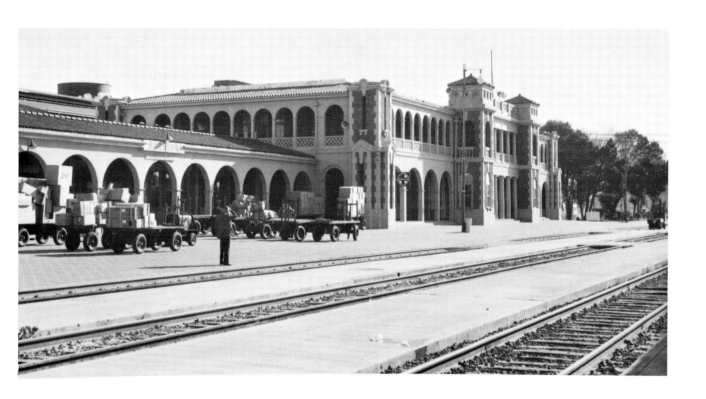

The location of Barstow's modern station and hotel *(top, left)* or diesel locomotive servicing tracks *(below)* may easily be pinpointed in the aerial panorama *(bottom, left)* taken during the days of steam propulsion. Westbound traffic flows in from Needles (near top, right) and departs to Mojave (to left) or to Los Angeles (bottom, right) where side-hill cuts mark the former location of the once busy Randsburg-Santa Fe Reduction Company's mill. Originally the eastbound line followed the river bank and looped around the hills in the background along the shoreline, but sporadic floods of the Mojave River (shown here in aftermath of the March 1938 inundation) dictated the advisability of cutting overland through the background ridges of higher ground. Note the washed-out Las Vegas highway (toward upper left) and the saturated lowland housing on the near bend of the river at center left. *(Bottom, left: Spence Air Photos; below: Santa Fe Railway photo.)*

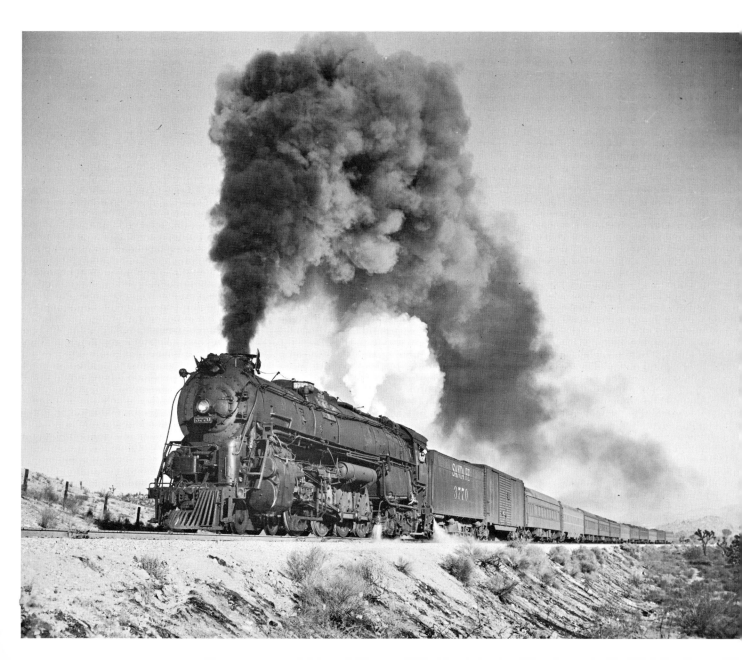

Pride and joy of the Santa Fe in the latter days of steam operations were the 340 well-proportioned 2-10-2 "Santa Fe" type freight locomotives, typified by No. 3854, and the handsome 4-8-4 type such as No. 3770 seen in the summer of 1938 at the head end of the Pullman section of the *Grand Canyon Limited.* With today's diesel, servicing facilities are arranged on a mass production basis, as indicated by the sand towers and the inspection pits which are part of Barstow's pattern for progress. Even these EMD hooded locomotives are slated for replacement by those of different design. *(Top, left: Allan Youell photo; bottom, left: Pacific Railway Journal; both photos this page: Santa Fe Railway.)*

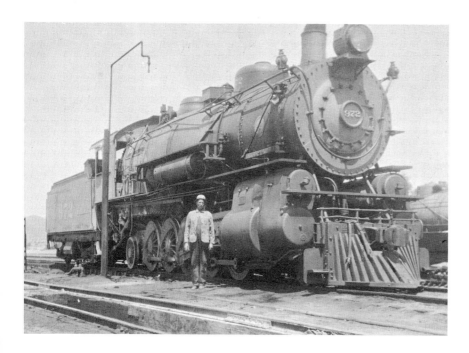

Ludlow, west of Ash Hill, once an important Santa Fe junction with the former Tonopah & Tidewater as well as the erstwhile Ludlow & Southern, is now but a way stop. Bagdad *(left, center)* was situated at the eastern foot of Ash Hill's 1.5%, 1160-foot climb to Squaw Summit and was a most important helper station in 1919 when this picture was taken. While his mother snaps the picture, Ralph Robison holds up the switch stand. Tandem compound 2-10-2's like No. 972 *(below)* occupied the ready track, forerunners of an even more distinctive breed to follow.

The converted box car station and section houses constitute Essex. Little is left at Goffs to remind one of the days when the rambling exhausts of Nevada Southern locomotives signalled the arrival of ore trains from mines in the New York Mountains. Ibis' claim to renown arose from its strategic utility as a water station on the way up to Goffs, the end of the westbound helper district out of Needles. *(Left, center and bottom: W. H. Robison Collection; all others: Phillips C. Kauke photos.)*

782 —

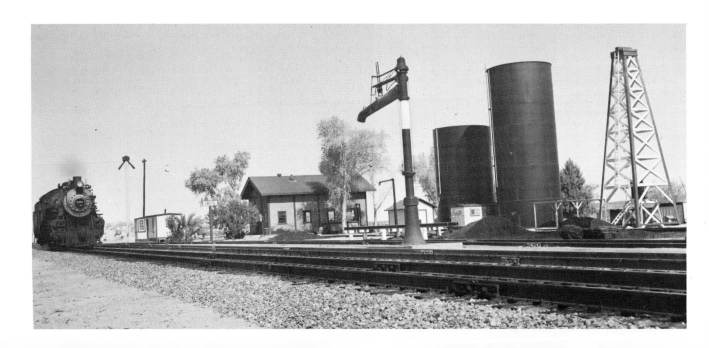

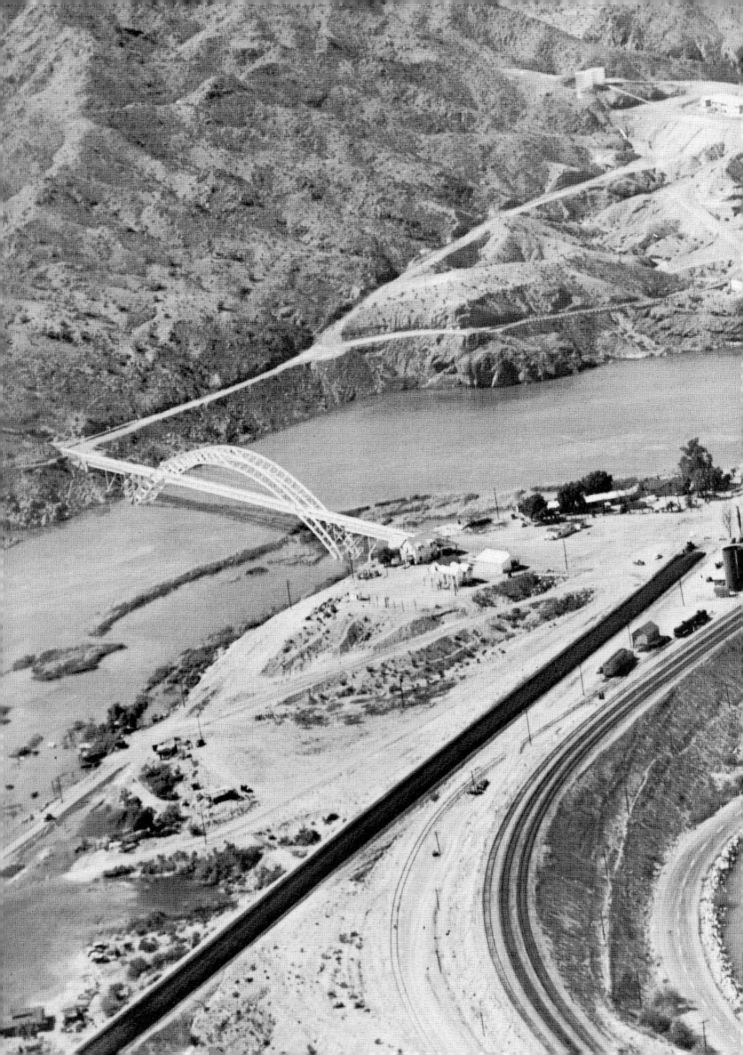

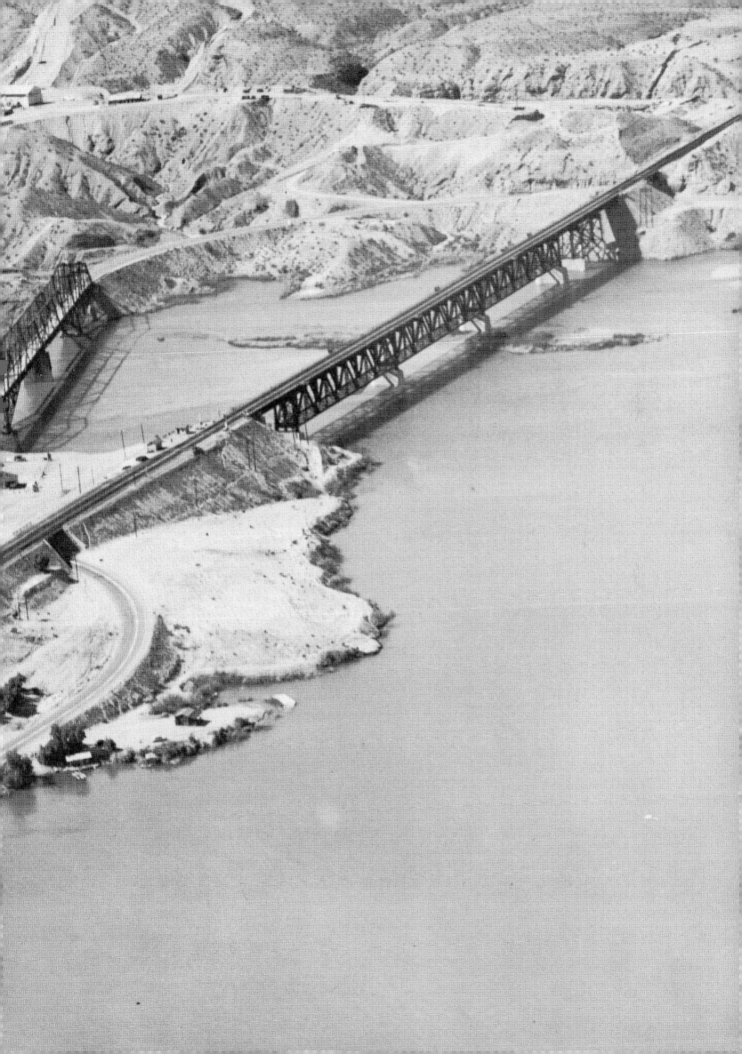

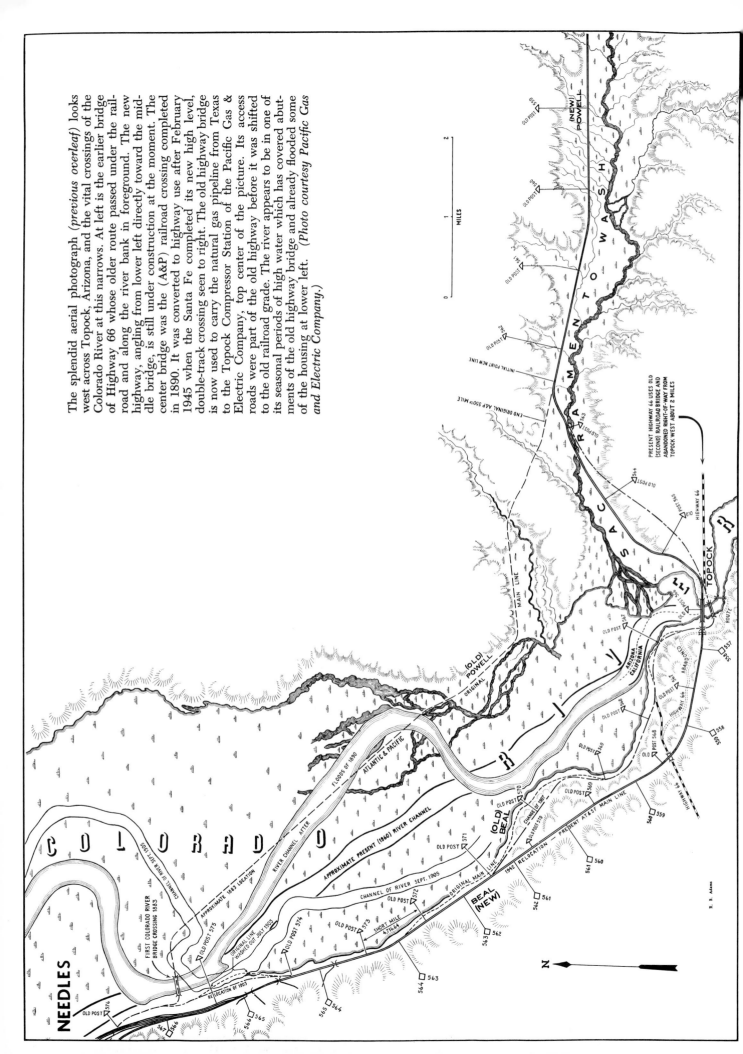

The splendid aerial photograph (*previous overleaf*) looks west across Topock, Arizona, and the vital crossings of the Colorado River at this narrows. At left is the earlier bridge of Highway 66 whose older route passed under the railroad and along the river bank in foreground. The new highway, angling from lower left directly toward the middle bridge, is still under construction at the moment. The center bridge was the (A&P) railroad crossing completed in 1890. It was converted to highway use after February 1945 when the Santa Fe completed its new high level, double-track crossing seen to right. The old highway bridge is now used to carry the natural gas pipeline from Texas to the Topock Compressor Station of the Pacific Gas & Electric Company, top center of the picture. Its access roads were part of the old highway before it was shifted to the old railroad grade. The river appears to be in one of its seasonal periods of high water which has covered abutments of the old highway bridge and already flooded some of the housing at lower left. (*Photo courtesy Pacific Gas and Electric Company.*)

MILES

2 1 0

NEEDLES

COLORADO

COLORADO

R

FLOODS OF 1890

ATLANTIC & PACIFIC

FIRST COLORADO RIVER
BRIDGE CROSSING 1883

CHANNEL OF RIVER SEPT. 1905

APPROXIMATE 1883 LOCATION

RIVER CHANNEL AFTER

OLD POST 576

OLD POST 575

ORIGINAL LINE
WASHED OUT JULY 1903

RELOCATION OF 1903

OLD POST 574

OLD POST 573

SHORT MILE
4.71664

CHANNEL OF RIVER SEPT. 1905

APPROXIMATE PRESENT (1960) RIVER CHANNEL

OLD POST 572

OLD POST 571

OLD POST 570

(OLD) BEAL

(OLD) POWELL

ORIGINAL MAIN LINE

BEAL (NEW)

1942 RELOCATION — PRESENT AT&SF MAIN LINE

MAIN LINE

OLD POST 570

OLD POST 569

OLD POST 569

OLD POST 568

POST 568

OLD POST 567

OLD POST

OLD POST 566

ARIZONA
CALIFORNIA

HIGHWAY 66

HIGHWAY 66

ROUTE

TOPOCK

POST 566

OLD POST 567

OLD POST 565

POST 565

OLD POST 564

OLD POST 563

END ORIGINAL A&P 550TH MILE

INITIAL POINT NEW LINE

OLD POST 562

OLD POST 561

OLD POST 560

(NEW) POWELL

559

560

561

562

563

564

565

566

567

558

559

560

561

562

563

564

557

555

558

559

560

561

562

563

564

S A C R A M E N T O W A S H

PRESENT HIGHWAY 66 USES OLD (SECOND) RAILROAD BRIDGE AND ABANDONED RIGHT-OF-WAY FROM TOPOCK WEST ABOUT 2 MILES

N

R. B. Adams

toward the Colorado River bridge, while a Needles yard switcher set out in hot pursuit, finally catching the errant locomotive as it neared Beal.

The Mohave Indians at Needles were inevitably a wondrous source of entertainment in spite of the problems they created. In the early days, two braves were hired to stoke the standing engines at the roundhouse. Railroad officials condescendingly looked the other way when their squaws dutifully began to pick up coal that fell to the ground and carried it away, ostensibly for home use. The arrangement had to be stopped summarily when it was found that the squaws were selling the coal and that the braves were becoming overly cooperative to the point that too little coal found its way into the fireboxes of the locomotives and too much into the hands of the eager squaws.

The normal costume of the Indian braves, wherever they appeared, ordinarily consisted of the barest essentials — an undershirt and a gee-string. Only on such special occasions as a call for the wrecker would they don their new Levi Strauss overalls and Buckingham and Hecht shoes. Thus when ladies from Boston passed through Needles on their inaugural visits to California via the A&P, they were shocked to distraction at the scanty Indian attire. In righteous indignation, the *Los Angeles Porcupine* fumed editorially that something should be done about the situation, thereby causing the *Redlands Citrograph* to comment caustically:

"The odd spectacle of the *Porcupine* going into spasms of virtuous indignation because the railroad company at Needles does not clothe the Indians before allowing them to come about is one well calculated to make a person ask if the day of miracles is past."

Perhaps some of the Indians learned of the editorial and decided to take matters into their own hands; perhaps other thieves were active in their own behalf. In any event, in 1890 two conductors were robbed of their spare clothes. One of them, while sleeping in his caboose which had been tied up at Needles for the night, had used his pants for a pillow on going to bed, only to awaken later and find them gone. The identity of the culprits was never disclosed, and no record exists of any Indians being apprehended for possession of purloined clothing.

West of Needles, near Danby, an 1891 wreck disappointingly forced cancellation of plans for a Fourth of July celebration by one crew sent out to restore order and operation to the line. The late Charles Battye, a man of remarkable memory, was a member of that gang. He recalled the keen disappointment of the men at missing the organized celebration, but also recounted the unexpected rise in spirits occasioned by the wrecking crew's own impromptu celebration at the wreck site. The work of clearing the line had been moving ahead slowly until suddenly one of the smashed cars was discovered to be loaded with beer. That portion of the car's contents remaining undamaged was dutifully and meticulously inspected by all concerned through intermittent pauses for refreshment as the work of salvage progressed. Harmoniously the job was finished with the men in exceedingly high spirits.

Bagdad, at the foot of the eastern slope of Ash Hill, was once a very busy place as a terminal for helper locomotives, locals and water trains. Here the railroad maintained an eating house for the benefit of the train crews which was staffed by Chinese cooks. Here too, on the slopes of nearby Ash Hill, was a reported Chinese burial ground, unusual in its violation of the normal custom of returning bodies to the Orient for lasting burial. The reported reason for its existence lay in the fact that these were victims of a cholera epidemic which occurred at the time of the building of the railroad. Bagdad's other claim to fame was its importance as a railhead and jumping-off place for travellers to a number of mining properties in the vicinity, probably the most important of which was the Orange Blossom Mine. In fact, during the period from 1907 to 1910, the Orange Blossom was sufficiently active to support a connecting stage line of its own.

Newberry Springs, to the east of Daggett, became a primary source of water for the whole desert division. As a normal procedure, freight trains included an extra water car in every consist, but in spite of this extra protection it was frequently necessary for an engineer to leave his train and head back to Newberry Springs for more water. Other special trains consisting exclusively of tank cars were used to carry water in bulk for such centers as Ludlow and Bagdad, as well as for many a lesser settlement along the way. (A situation which still prevails.)

Mayhap it was the very presence of this priceless desert liquid that attracted such a series of not-so-blythe spirits which plagued the A&P engineers in the performance of their rounds. "Whoop up the romping spooks out east of Barstow," John Carson told a reporter in May 1888. "For eight

months now I have been running the hundred-mile division out east of Barstow. The spooks used to loom up about every other day. Now we have them nearly all the time." The man's broad background and experience became obvious when he likened the sight to that of Dante's Inferno; then he went on to say: "Sol Anderson, our engineer, was the most scared man you ever saw. He put on all the steam he had, and we went tearing over the desert like mad while the spook hovered over the engine for about twenty minutes, then suddenly disappeared."

Spooks or gremlins to the contrary, the demise of the A&P as an operating institution in the 1890's and its gradual absorption by the Santa Fe were not chimerical matters. Actually the deterioration commenced in 1889 when poor crops in the midwest were cited as the reason for the failure of the Frisco (the Santa Fe's partner in the A&P) to pay dividends on its preferred stock. Reportedly, the Frisco had been planning on completing the Central Division of the A&P (from the Frisco's end of line in Oklahoma westward across the Indian Territory to Isleta, New Mexico, and a connection with the Western Division of the A&P) to attain a direct route to the Pacific Coast. When the financial crisis arose, all plans had to be shelved.

In May 1890, through an exchange of stock, the Santa Fe acquired control of the SL&SF, although it was announced that the Frisco would be operated as an independent road. In discussing the sale, the *Commercial & Financial Chronicle* remarked that "a controlling interest in the property was for sale," and that the purchase by the Santa Fe was logical, for in rival hands it could have caused considerable damage to the Santa Fe. At the Frisco's board meeting of November 21, 1890, both Huntington (SP) and his associate, Gates, severed all connections with the road, their positions being filled with representatives from the Santa Fe.

For the next three years the Santa Fe ruled the roost, continuing to operate both the A&P and the Frisco as ostensibly separate entities. The depression of 1893 brought with it a time of crisis. Even Allan Manvel, the new Santa Fe president, could not cut expenses to suit the reduced revenues. Manvel had been a purchasing agent for the Rock Island Railroad, and of him a former associate said, "If another man can get the goods for a dollar, Manvel can get them for 75 cents. That is his forte — to run a railroad closely and cheaply, and hold it well in hand."

Despite Manvel's "75-cent purchases," matters went from bad to worse. The close of the year 1893 found both the Santa Fe and the Frisco in the hands of receivers; and a few days later the A&P followed suit. Various new corporate names clutter the record of the reorganizations, that followed, but in essence the situation was resolved in simple form. The St. Louis & San Francisco wound up with the Eastern Division of the A&P, consisting of only a few physical miles of line, and thus lost for all time its hopes of ever reaching the San Francisco of its corporate title. The Santa Fe, on the other hand, acquired the entire operating Western Division of the A&P including the trackage from Albuquerque, New Mexico to Needles, California, plus the leased line of the SP from Needles across the Mojave Desert to Mojave, California.

Although the ancient and historical name of Atlantic & Pacific Railroad continued to pertain for another few years, the road's potency as a transcontinental carrier had been dissipated. Except for the few miles of trackage from the Colorado River bridge to Needles, no penetration of the state of California was ever accomplished, the trackage from Needles to Mojave being leased from the SP under a contract of sale until long after the A&P ceased to exist. As an operating institution, the A&P was equally unsuccessful. A condensed income account of the A&P (Western Division) encompassing the period from November 1, 1883 to June 30, 1897, showed a deficit of just over $14 million after interest and other charges. Such loss, presumably, was largely made up from the pockets of its former joint parents, the Santa Fe and the Frisco.

On June 30, 1897, the A&P formally ceased to exist. As of that date its property was conveyed to a new Santa Fe subsidiary company which was formed by an Act of Congress under the title of the Santa Fe Pacific Railroad. For the next five years the former A&P property was operated under this name. A new lease of the Mojave-Needles line (effective July 15, 1898) was negotiated with the SP, one clause of which reflected Huntington's precautionary thinking in the new era of railroad development. Although never exercised, this provision reserved to the SP the right to use any portion of the Mojave-Needles lines in connection with "any railroad built or which may be built to or in the direction of Salt Lake City." Concurrent with this lease of Mojave-Needles trackage by the SP to the Santa Fe, the latter, in turn, leased to the SP its properties from Benson to Nogales, Arizona, thence

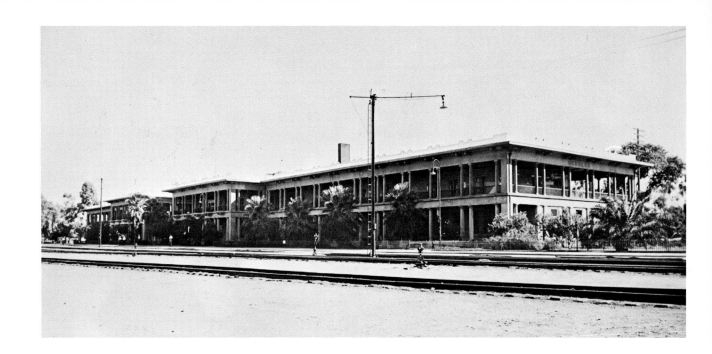

Needles station and roundhouse, shown here in the 1930's, represent a far cry from the earlier units previously shown in these pages. On the main transcontinental line of the Santa Fe Railway, some 1,400 railroad employees were stationed at Needles in 1920 to accomplish the daily chores involved in operation of trains and maintenance of equipment. *(Both photos: Santa Fe Railway.)*

As the modern automobile has succeeded to the railroad's first bridge at Topock, so Santa Fe diesels have succeeded to the jobs formerly handled by steam locomotives. The big search for water on the desert has ended. The Joshua trees, sage and sand alone remain the same, reminder of the burro, the Fresno scraper and the wild goblins which raced with engineers down east of Barstow. *(Both photos: Santa Fe Railway.)*

south of the border to the port of Guaymas, Mexico, on the Gulf of California.

While the Santa Fe Pacific Railroad is still a live subsidiary of the Santa Fe, its current activities are confined to land operations. On July 1, 1902, the title and operations of the former A&P system were transferred to the parent AT&SF, and for many years the route formed a part of a Santa Fe "grand division" called the "Coast Lines." Finally on December 27, 1911, the lease of the Needles-Mojave sector with the SP was amended and title to the property was transferred to the Santa Fe (it was still subject to the lien of an SP mortgage due in 1937) which promptly conveyed it to a newly formed subsidiary, The California, Arizona and Santa Fe Railway Company. At the same time that the Santa Fe gained control of this last remaining segment of the A&P, the SP was given title to the Santa Fe's Benson-Guaymas line. The two properties had close values, even though the Guaymas line was 110 miles longer than the Mojave-Needles line. Although the exchange is commonly referred to as a "swap" or a "trade," it is surprising that, in addition to the excess of mileage gained by the SP, an additional $156,750 of cash was also realized as the Santa Fe made up the difference between the mutually agreed values of the properties, that of the Mojave line being placed at $6,874,750.

Thus, this phase of the corporate struggle between the two titans was resolved; but not so the Santa Fe's continuing problems with operation of the route. By the turn of the century, heavier motive power necessitated the strengthening of the Colorado River bridge. This was accomplished in 1901 and lasted for less than a decade. In 1910, when still heavier power was placed on the line, engine crews began to note a sag in the middle of the main span of the bridge, and a center pier was installed. This sufficed for the next 20 years, but in 1931-37 additional strengthening became necessary. Studies showed that even the reinforced bridge would not support the weight of anticipated future operations nor provide for increased traffic, so in 1941 plans were made for a new, double-track 1506-foot structure of heavier design and unlimited clearances. Construction of the new bridge and its approaches began in September 1942, and 2½ years later, on February 5, 1945, the first passenger train crossed the new facility, headed by 4-8-2 locomotive No. 3734.

Interestingly, the station of Red Rock on the east bank of the river has gone through almost as many transmutations of name as the bridge had of rebuildings. Due to a conflict of title with two other Red Rock stations in Southern Arizona (as well as others scattered throughout the west) the name was changed to Mellen in honor of Capt. Jack Mellen, a steamer captain on the Colorado River. Later, when Mellen (as written in the hasty scrawl of telegraphers and others) became confused with Needles, the need for another change was indicated. This time Topock was selected for its distinctiveness as well as for its significance — it is a contraction of the Mojave Indian word of "a-ha-to-pak," meaning water-bridge.

The building of the Mojave Desert line from Mojave to Needles, California, actually accomplished far more than it was originally designed to do. The primary SP objective — that of blocking the A&P's and Santa Fe's entries to the Pacific Coast — was distinctly a failure. The ultimate real benefits were derived by the Santa Fe from the opening of an isolated desert region to exploration and development with the resulting opportunities for stimulation of individual initiative and enterprise. Many were the projects undertaken which would have been impossible without the services of the railroad, and a dozen additional railroads — some short, some long — were developed to meet the needs of specific industries or districts tributary to the line. Among these, the Nevada Southern and the Randsburg railroads (q.v.) ultimately became branches of the Santa Fe.

Early in 1905 it became the Santa Fe's turn to play host to a foreign road over its own rails on the Mojave Desert. The completion of the San Pedro, Los Angeles & Salt Lake (UP) Railroad required a connecting link between the northern and southern portions of its line via Cajon Pass, and the Santa Fe had pre-empted the easiest and most logical right-of-way. Perhaps the Santa Fe's memory of the battle with the SP over the Mojave-Needles line had had a seasoning effect, for arrangements were made with the Salt Lake Route for trackage rights without ostensible argument. Rails of the SP, LA&SL were allowed to join those of the Santa Fe at Daggett on the Mojave Desert, and trains were permitted to use the Santa Fe's tracks over the intervening 11 miles west to Barstow and 90 miles south via Cajon Pass to Colton and later to Riverside, California, where Salt Lake Route rails were again reached for the balance of the distance to Los Angeles. The arrangement has continued in effect to this day.

The Santa Fe's only major line addition to Mojave Desert trackage started deep in the Salt River Valley near Phoenix, Arizona. During the years from 1905 to 1907 a line was stretched over the 106.84 miles from Arizona & California Junction, Arizona, north and west to Parker, on the Colorado River. For a time the project stopped on the river bank, but ultimately the additional 83 miles from the Arizona-California line to Cadiz, California, were built and a junction with the main line was opened on July 1, 1910.

As the benefit of ownership and control of the full western route became apparent, more and more people started using the Santa Fe to Southern California. The mild winters, plus the personal thrill of picking Valencia oranges in an orchard, attracted thousands of visitors. At the same time, crates of oranges by the carload were being shipped eastward on fast fruit specials, augmenting traffic over the line and sending revenues soaring to new heights. Also soaring to new heights was the public's conception of the speed of transcontinental train travel as foisted upon the imagination by one lonely prospector who tired of travel by muleback.

Walter Scott was the prospector's name. On a hot summer day in 1905 he turned his mule toward Barstow and headed for the railroad station, intent upon getting to Los Angeles as quickly as possible to spend the extra dollars he had in his pocket. Frustrated by the lack of regular service at that hour of the day and impatient to be off, he chartered a special train of his own for the run to Los Angeles. The speed of the special in marked contrast to the sluggish gait of the mule, plus the lack of all normal station stops for the accommodation of passengers, generated intense enthusiasm within Walter Scott's breast. Even more exhilerating was the cluster of reporters awaiting the special at the Los Angeles terminal to determine the important personage aboard. Mr. Scott's rendition of his trip made good news copy, and he suddenly found himself engulfed in bales of welcome publicity plus a new moniker — Death Valley Scotty.

The experience was decidedly pleasant, and Scotty's mind raced to keep ahead of his new-found publicity. Why not, he reasoned, go to Chicago faster than man has ever gone before? It seemed like a good question, so Scotty marched into the local Santa Fe office in Los Angeles to see if he could get an answer. "Could the Santa Fe for a handsome $5,500 take him to Chicago in 46 hours?" It could, and would; and a pact was made. Preparations for the speed run were careful and meticu-

lous. Then on Sunday, July 9, 1905, the *Coyote Special* took off from Los Angeles with crowds lining the tracks to witness its departure. Across the low foothills to San Bernardino the special sped, slowing for the ascent of Cajon Pass, gaining speed on the downgrade. Barstow was passed in a cloud of sand and dust; then the train streaked across the desert lands to Needles, crossed the Colorado, wound through the timberlands of Northern Arizona, traversed New Mexico and climbed over Raton Pass into Colorado. Across the Kansas plains it sped, bridged the Mississippi, and on to Chicago. Scores of press releases daily kept the eager public advised of its progress, recording arrival times at each terminal with calculated time and speed of transit. Less than two days (44 hours and 44 minutes) from the time of leaving Los Angeles, Death Valley Scotty, sombrero and all, was deposited in Chicago — ahead of schedule and a national hero.

The *Coyote Special's* speed record from Los Angeles to Chicago stood for almost three decades. Death Valley Scotty, actually with the financial backing of A. M. Johnson, a rich insurance man from Chicago, went on to capture additional publicity with tales of his hidden gold mines which even the most persistent prospectors could not locate. His palatial home in the desolate northern end of Death Valley became an object of curiosity and, following his death, Scotty's Castle was opened for regular public inspection to allow the interested and the curious to gape, wonder and be satisfied. Equally enduring was his legendary speed run and the fame attending the railroad that gave it sustenance.

Not surprisingly, the capacity of the single-track Mojave Desert line became taxed in relatively short order. Installation of double track became a necessity. In calculated piecemeal fashion, sections of second track were installed in scattered lengths, then connected over the intervening distances. By the end of 1923 double-track operation was complete between Barstow and Needles as well as over many miles of line on either side of this critical section.

Improvements in the basic alignment of the roadbed have also been made — a standard engineering practice of railroads sufficiently affluent to afford such capital outlays. Occasionally they become a matter of necessity, as when the expanding Edwards Air Force Base at Muroc (near Mojave) pushed the Santa Fe's tracks slightly to the north. A 1952-53 line change between Sanborn and Boron

cut 2.63 miles of extra track out of the original 28.47-mile old line through Muroc. At the time of the announcement of a major line change in Northern Arizona in 1958, plans were also revealed for a new line between Goffs and Ash Hill, California, which would save 10 to 12 miles of travel over that of the current 66-mile line. The actual amount of distance saved would vary with the direction of travel, as the new tracks would not always be parallel where improved grades and reduction in maximum curvature could effect distinct savings with one-directional movement. Although the 44-mile Arizona line change was completed in December 1960, thus far no physical work has been started on the Goffs-Ash Hill project.

To the desert dweller living along the Santa Fe's Mojave Desert line between Needles and Barstow, the avocation of train watching could have been interesting, colorful and varied. Many wonderful parades of equipment have streaked across the 167-mile distance. In the lush times of Hollywood's greats, the Santa Fe *Chief* provided the luxury background of an extra fare, de luxe train for traveling movie stars and other Hollywood hopefuls seeking that publicity so requisite to the achievement of their exalted status. For people of lower station, or for families, the *California Limited* or the *Grand Canyon Limited* were eminently respectable and suitable to their needs. Even the slower, less popular trains were glamorized by the addition of western or Indian names — *Navajo*, *Hopi*, *Scout* and *Missionary*. In 1936, after newsworthy trial runs, a brand new *Super Chief* was inaugurated between Los Angeles and Chicago, powered by a new-fangled, blunt-nose diesel to maintain the tightly scheduled 39¾-hour trip. This was followed two years later by a new all-coach train, the *El Capitan*, operating on a once-a-week schedule. Travel increased, new equipment was added, schedules became more frequent; until finally these two trains became a matter of daily routine.

Thus, over the years, the original route of the pioneer Atlantic & Pacific Railroad has grown and prospered. Although the original road's initials have today assumed importance as the connotation of a modern grocery store, and have disappeared from the lexicon of railroading as completely as have the spooks from its desert division, the spirit of the enterprise still flourishes. Diesel powered trains have reduced the water problems, and double track the operational hazards, until today's husky, mature giant of a railroad has completely usurped the weaknesses of an undernourished youth to become the high-traffic main line of the heavily traversed, transcontinental Santa Fe.

Randsburg Railway Company

The discovery of gold in Goler Canyon, 36 miles northeast of Mojave, California, in 1893 attracted many men to the area for further prospecting. The region was wild and desolate, being separated from the A&P (Santa Fe) Railroad 30 miles to the south by the steep slopes of the Rand and Lava Mountains. The Carson & Colorado's narrow gauge railroad had terminated its rails on the shores of Owens Lake, a good 75 airline miles to the north at the far end of the Coso Range. Nevertheless, gold was an ever-alluring metal, and prospectors probed the area in their relentless search, regardless of hardship or location.

The effort was productive. Two years later the Yellow Aster mine was located at Randsburg, nine miles southeast of Goler but 1,200 feet higher on the slopes of the Rand Mountains. Water was scarce at that elevation (a barrel of the liquid cost $3 in 1897 but was happily reduced to 25 cents the following year), so the earliest stamp mills were located along the wash in the valley floor below the site of Goler at a place called Garlock. To take the ores from the mine down to the mill required a long and arduous haul by team; still the cost and prohibitive grades of a railroad could not be justified. (Eventually the SP did build a branch line from Mojave to Owenyo in 1907-10 which passed through both Garlock and Goler, but no rail connection from the valley up the mountain to Randsburg was ever accomplished.)

The initial discoveries led to continued expansion and development of the area until the Rand Mining District encompassed not only Randsburg but also Johannesburg (two miles farther east around the hill) and Red Mountain (another two miles still farther to the southeast). The period of development of the mines was noted for its rough and tough characters, but the mines proved to be sufficiently substantial to attract a number of investors, including some men interested in backing a railroad to the region. In May 1897 three men — J. M. Beckley of Rochester, New York; Albert Smith of New York City; and A. A. Daugherty of Los An-

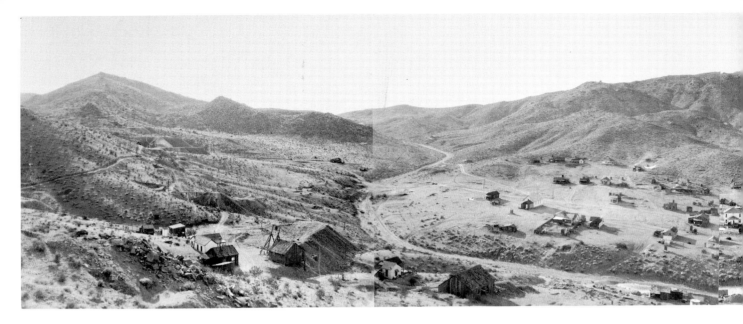

The panorama of Randsburg faces southwest across the town toward the Yellow Aster Mine, high on the hills leading to Government Peak. The road in the foreground from Garlock and Goler (out of the picture, far to the right) winds through the town to mines beyond the notch. The Randsburg Railway, which failed to reach its namesake, terminated at Johannesburg, behind the hills, to the left. One of the Yellow Aster Gold Mining Company's small locomotives with a sheet iron cab of World War I vintage is seen at *left*, while *below* is the Randsburg Railway's terminus at Johannesburg with the train just arriving one September morning in 1914. (*Top: U. S. Geological Survey; left: Kern County Museum; bottom: Trona Railway.*)

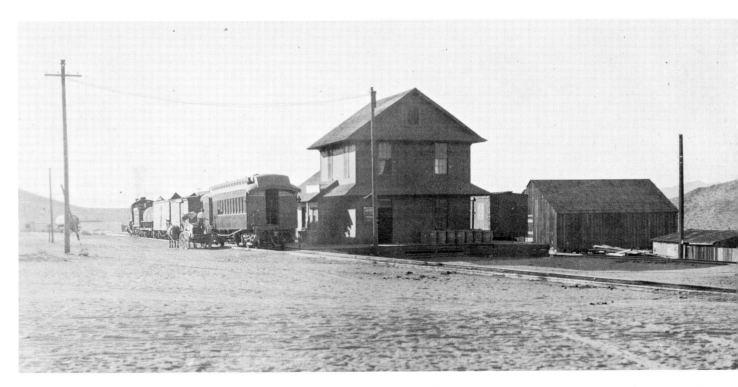

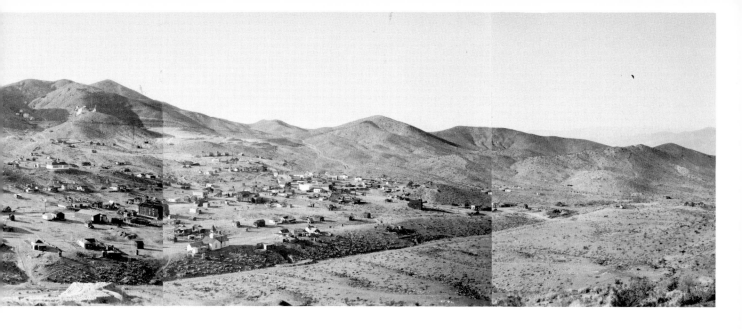

geles — became the principal incorporators in a new Randsburg Railway.

Contrary to usual railroad experience, a nearly straight line proved to be the shortest and best of the surveyed routes to the hilltop mines. Instead of starting from Mojave and building up the valley to the existing mills at Garlock and thence up the mountain to the mines, the engineers recommended that the line commence at a point called Kramer on the A&P (Santa Fe) and approach the mining district from the south. In spite of a report in the *Los Angeles Times* that the railroad "will run over perfectly level country and no blasting or cuts will be necessary," the engineers were inclined to a different opinion. Although the work would not be particularly difficult, there was a very definite increase in elevation of 1,150 feet to be overcome in the 29 miles of route. Thus, with the transit work finished and financing arranged, construction contracts were let to Ramish and Marsh of Los Angeles, and work began on October 2, 1897.

The contractors wasted no time in getting the project under way. A few days later a trainload of laborers was sent out from Los Angeles, and 10 carloads of steel rails were shipped to the starting point of Kramer on the A&P, 33 miles west of Barstow. At San Bernardino, the Santa Fe's shops were busy reconditioning an engine for use in hauling supplies as construction progressed.

Northward from Kramer the grade was pushed, while ties and rails were set in place as fast as each section was completed. Then early in November the work was abruptly halted when a shipment of supplies failed to arrive on schedule. However, with 23 miles of line already graded and 16 miles of track in operation, it was still anticipated that

the 200-man construction force would have the railroad completed by December 5. Unfortunately a shortage of ties postponed the promised opening date, but by the end of November 1897, passengers could ride the construction train over the 22.5 miles to St. Elmo. From there it was but a six-mile stage ride to reach Johannesburg (or Joburg, as the town was sometimes called).

At this point, with the railroad penetrating the mining area proper, troubles began. According to the surveys, the track was to be laid directly over the prospect shaft of a mining claim belonging to partners Webb and Wrem, apparently without their knowledge or consent. Webb and Wrem took umbrage at this high-handed treatment and refused to allow the rails to cross their claim. Contractors Ramish and Marsh were totally unconcerned with the formalities and finesse of the situation; they merely waited until nightfall, then laid the track right over the disputed property and directly across the shaft entrance itself. Quite understandably, Webb and Wrem became wroth with wrath. The next night they organized a gang of men to tear up the track. However, someone slipped the word to the contractors who, with the backing of 12 armed men, succeeded in driving the miners off of their land. Guards were posted to protect the railroad's property; and although more trouble was feared, it failed to materialize.

Completion dates for the railroad were set ahead several times, as were the anticipated dates for the official inspection party trip. By Christmas 1897 the road was virtually finished, only track surfacing and ballasting remained to be done. The contractors already had sent the majority of their tools, wagons and teams back to Los Angeles.

It was obvious that the little construction locomotive would not suffice for the normal traffic of the line, and a second locomotive, this time an oil-burner, was obtained. Incorrect press reports of the time ascribed its origin to the Los Angeles Terminal Railway, thereby creating speculation that the Randsburg Railway might be linked with the Los Angeles Terminal Railway as part of a through route to Salt Lake City. Albert Smith, the Randsburg's general manager, spiked the rumor by announcing to newsmen that his railroad was absolutely independent and that a 25-year traffic agreement with the Santa Fe was the only arrangement or committment that had been made. "Ultimately we expect to extend our road some 60 miles into Amargosa Valley," Smith declared. "That will tap the Death Valley region."

In spite of Smith's allegations, there were others who contended that the builders expected to continue on north to the borax mines at Searles Lake (see Trona Railway) and thence onward to a connection with the Carson & Colorado at Keeler. It was noted that J. M. Beckley and others of the organizers were also associated with the New York Central and the Vanderbilt interests which, in turn, gave them an indirect tie-in with the Chicago & Northwestern and Union Pacific. One sage, in noting all this, put two and two together and came up with an ebullient answer. He theorized that the Vanderbilts might buy the Central Pacific (then in difficult straits) when it came to be sold under foreclosure. In an optimistic forecast of the situation, he went on to say: "The contract for the 110 miles [extension to Keeler] has been virtually let to Ramish & Marsh, the contractors who built the present [Randsburg Railway] line from Kramer." To carry this reasoning to its implied extreme, it is interesting to speculate that, had the contract been let (which it was not) and had the Vanderbilts acquired the CP (which they did not), then by acquisition of the Carson & Colorado a new, through transcontinental railroad route might have been formed — from New York City to Chicago by NYC; to Ogden, Utah, via the C&NW and UP; across Nevada over the CP; south to Keeler, California, via C&C; and on to Los Angeles via the Randsburg and the Santa Fe.

The Randsburg Railway never did build northward, at least not to the major extent anticipated. Even before the line was placed in full operation, Daugherty (one of the principal stockholders) was sued by a promoter named James Campbell who claimed that he was to have received a specific number of shares of stock for his services in arranging certain financing and contracts. Just how the matter was resolved is not known, but it is an established fact that the full 28½ miles of railroad from Kramer all the way to Johannesburg was completed as planned. Due to difficult grades and other considerations, the line never did reach around the hill to Randsburg, the destination of its corporate title, but regular trains began operating to Joburg by January 5, 1898. Five days later the railroad was turned over to its owners, and finally the multi-postponed inspection trip was officially run. Aboard the train on that august occasion were J. N. Beckley, president of the Randsburg (as well as president of the Toronto, Hamilton & Buffalo), stockholder A. A. Daugherty, plus several Santa Fe officials.

The first two weeks of Randsburg Railway operations were frustrating ones for patrons. The one round trip each day did not properly connect with Santa Fe trains at Kramer, so that travel even as far as Barstow was a time-consuming ordeal. The situation was considerably improved on January 17, 1898, when two daily round trips were established, one train of which provided through service via Barstow to Los Angeles. This was even better service than anticipated, and the public teeth gnashing subsided.

The economy of Barstow was given a substantial lift when Beckley and some of his associates erected a 50-stamp mill on a hillside immediately west of town under the name of the Randsburg-Santa Fe Reduction Company. A spur track 2,000 feet long connected the property with the Santa Fe's main line, and when milling operations began in June 1898 ores no longer were teamed from Randsburg to Garlock in the Goler Wash but were routed instead via the Randsburg Railway direct to the ore bins of the new mill.

Unfortunately the big bulk of the ore traffic lasted but a few months. In February 1899 a new 130-stamp Yellow Aster mill, rated as one of the largest stamp mills of its kind in California, was opened not far from the mine at Randsburg. A very short, narrow-gauge railroad connected the mine and the mill, over which ores were hauled behind diminutive saddle-tank locomotives. The Randsburg Railway had lost its biggest and best customer.

In 1901 there was renewed talk that the Randsburg Railway would be extended — first, just a short distance to some newly discovered coal mines nearby; later, a revival of the projected extension to the Carson & Colorado at Keeler in the Owens

Valley. In spite of the discussions and rumors, no physical extension of the rails ever took place. Train service was expanded in the opposite direction — via trackage rights over the Santa Fe for the 33 miles from Kramer east to Barstow. Through this expedient, better connections to and from Los Angeles were assured.

The year 1901 was also the beginning of a boom for the Randsburg-Santa Fe Reduction Company at Barstow, for it was in that year that the first samples of ore from the fabulous Bagdad mine at Rochester, California (south of Ludlow), were processed and the results assayed. The resultant building of the Ludlow & Southern Railway (q.v.) added one more company to the group of which the same men were principals. Edgar Van Etten was a man who was only too acutely aware of this nepotism. For several years he was president of the Randsburg Railway as well as a vice-president of the New York Central and general manager of the Boston & Albany. Eventually, after 1910, he also managed the Ludlow & Southern.

Much to everyone's surprise, in April 1903 the Randsburg Railway was sold. Speculation over the news was rife. It was remarked that the little road had been operated efficiently under E. H. Stagg and that considerable money had been spent on surveys to the north toward Ballarat and the Panamint country. Although the sale price was commonly known to be $300,000 (which was said to have compared favorably with a cost of $180,000), there was a frustrating mystery over the actual name of the real buyer. Subsequently, of course, it was revealed that the Santa Fe was the true purchaser of the road.

Under the new owners, the two daily trains shortly gave way to one mixed train daily, but since it operated all the way through to the junction at Barstow a wider variety of connections was possible. Competition (of sorts) was presented in 1907-10 when the SP constructed its line from Mojave to Owenyo, but the Espee rails followed the valley through Goler and Garlock, and did not attempt to climb the hills to the mines. In May 1913 the Santa Fe commenced a tri-weekly tourist Pullman service direct from Johannesburg to Los Angeles via Barstow. Whether this was because of, or in spite of, the presence of the other line has not been revealed.

Gold mining continued in the Rand District for a number of years longer. Perhaps the *Randsburg Miner* could see the handwriting on the wall in 1915 when it offered the following suggestion,

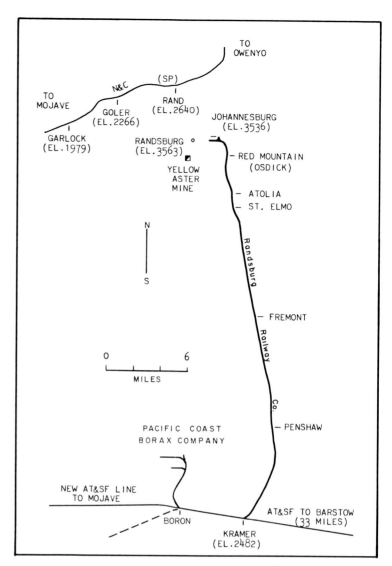

plainly printed in large, black type: "Don't Wait for Prosperity, Come to Randsburg and Find It!" The miners apparently must have been slow readers, or else they were slow to act upon the nature of their readings, but eventually in 1919 two men did discover rich silver ore at what later became the Kelly Mine. Located at Red Mountain, this new discovery gave the whole district a greatly needed boost during the 1920's and (with an output of $16 million) became the largest source of silver in California and, in certain years, for the entire United States.

Ultimately the Kelly Mine became dormant. In 1944 it was purchased by Frank Royer, and there is still hope that new riches may be found. For Royer is an old hand who knows the district well. He can recall the days of 1897 when the rails of the Randsburg Railway were being laid. Ties and rails had been loosely set in place on the new grade, then two men went ahead to set the spikes, and two followed to drive them home. Of the latter, one was Frank Royer.

The mines of the Rand District are relatively quiet today, but the towns are still active. Any pittance of inbound supplies or outbound ores are hand-led by truck, for the railroad was abandoned December 30, 1933 and the tracks were removed the following year. Residential and business buildings still abound and there is a new and interesting historical museum at Randsburg.

Trona
Railway Company

North and east of Johannesburg and the Rand Mining District in Southern California lies the dry bed of Searles Lake, crusted and baking in the desert sun. John W. Searles gave the lake its name a century ago when he located his borax deposits in 1862 and set up a nearby plant to treat the ore. Since there was no rail or other transportation available in the area at that early date, long strings of mules were used to haul wagonloads of borax to Los Angeles for shipment to market.

It was not until 1876 that the first primitive rail line of the Southern Pacific was finally completed south through the San Joaquin Valley and over the Tehachapi Mountains to Mojave on the fringe of the desert. There the rails swung southwestward toward Los Angeles, leaving a gap of almost 80 miles northeasterly to Searles Lake which still had to be bridged by team or on foot. Although the situation was an improvement which reduced the cost of shipping the ore, the respite proved to be relatively short-lived. In 1882-83 the SP built its hotly contested road across the desert from Mojave to Needles (see A&P), and at almost the same instant new deposits of borax were discovered along that right of way near Calico (q.v.) in 1883. The Calico borax, being located almost directly on the new route of rail transportation, rapidly usurped the market, and Searles' production dwindled to a trickle.

Construction of the Randsburg Railway in 1898 alleviated the problem considerably, for the Randsburg's terminus of Johannesburg was only about 30 air-miles south of Searles Lake. Interest in the area began to increase once again, and numerous claims were filed. In 1905 the California Trona Company, using $50,000 of borrowed capital from a subsidiary of Consolidated Gold Fields of South Africa, Ltd., tried to gather a number of the claims together, but its efforts over the succeeding seven years were fraught with "litigation, legal entanglements and delays with wild automobile rides, armed guards and sensational claim-jumping episodes." Cal Trona defaulted on its loan and went into receivership. On June 12, 1913, a new American Trona Corporation was incorporated by interests allied with the creditors to take over the assets of the former California Trona Company.

The use of the more modern word "trona" in the company names was indicative of the progress which had been made in mineralogy, for the term denotes a form of hydrous sodium carbonate which, after proper refining under a process worked out by John W. Hornsey, yields not only borax but also potash, soda ash and salt cake. All of these are useful chemicals which play some part in the production of many of our everyday consumer items.

In November 1912, as matters were approaching a settlement, a young engineer named Raymond Ashton was sent out with a party to locate a railroad to Searles Lake. The selection of a starting point had been made easier when, in 1908-10, the SP had constructed its line from Mojave to Owenyo via El Paso Summit (see Carson & Colorado, Vol. I.). Ashton started from a connection with this SP line at a place named Searles, working east and north along the west shore of the lake to the site of the new potash plant which ultimately was called Trona.

Base camp for the surveying crew was maintained at Garden Station where a temporary tent city clustered in close proximity to the residence of Postmaster Thomas and his wife who fed the men during their entire four months' stay. That the crudeness of the surroundings had no bearing on the quality of the victuals is amply attested by the fact that even today Mrs. Thomas is remembered as a wonderful cook. Possibly her testimonials might be tempered with the knowledge that the crew normally spent a long, hard day on the desert. Transportation to the work site was provided by a right-hand drive, seven-passenger Studebaker Garford touring car which was subject to frequent tire trouble from the sharp stones on the desert floor. Moreover, in the nippy desert winter, the radiator had to be drained each night and refilled each morning with warm water from Mrs. Thomas' kitchen. Cranking of the stiff, cold motor was studiously avoided through judicious parking of the car atop a small hill each night from which vantage it could be coasted into explosive action the following morning.

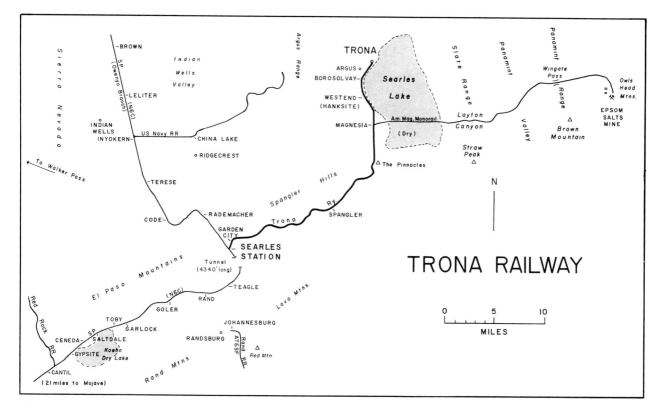

As laid out, the Trona Railway was a 31-mile, standard-gauge railroad designed for maximum speeds of 70 miles per hour. It wasn't anticipated that normal operations would ever require such a burst of speed over so short a course, but concern was evinced that a runaway car out of Searles might reach this speed on the downgrade toward the desert, and proper construction would assure that the car would remain on the track until it could slow down on the long, level stretch near Searles Lake. The first 13 miles of line from Searles to Spangler represented a continuous 1.75% grade, which then tapered off as the rails approached the shores of the dry lake bed. Curves on the line were held to a maximum of 2°, and particular attention was focused on providing large culverts to handle the flash floods resulting from desert cloudbursts.

On September 27, 1913, approximately 10 months after the start of surveys, ground was broken for the Trona Railway. The work of grading was relatively light as no particular difficulties were encountered. By November some 400 men were on the job, and tracks had been laid sufficiently far to warrant placing a construction locomotive (SP No. 2095) on the new, 75-pound rails reaching out from Searles. As the trackwork was extended, a second locomotive (SP No. 2039) joined the first in hauling supplies to the end of track. The smoothness

with which the job progressed was due in some measure to the harmonious relations between the Los Angeles contractors, Robert Sherer & Co., and Raymond Ashton (who had been advanced to construction engineer).

Only one episode occurred to mar an otherwise event-free construction story. In spite of the planned precautions against runaways once the line was completed, nothing could reduce the hazards while the road was in the process of construction. Thus, when an unattended tank car broke loose at Searles and started off down the grade, there just wasn't enough track laid for it to coast to a stop. Moreover, the construction train was occupying the single-track, main line, and there was no siding for a haven of refuge. The speeding tank car struck the rear of the construction train and knocked several cars off the track, but fortunately no one was hurt. Work was delayed while a "big hook" was borrowed from the SP to come in and clear the wreckage from the line.

During the period that the railroad was under construction, work was also continuing on the new potash plant at Trona. Building materials were brought in over the SP as far as Searles, then a Peerless truck and a Renard Road Train (consisting of an engine and three power-driven tractors) hauled them to the plant site.

Breaking ground for the Trona Railway on September 27, 1913 was hardly an impressive ceremony on the barren, sage covered flat. To Raymond Ashton (man in the dark shirt fourth from left), this was the culmination of almost a year of effort in laying out the line, during which time he and his men lived in the survey camp at Garden Station shown (below) in December 1912. Primal transportation for the group was the Studebaker Garford touring car whose tires suffered severely from the sharp stones of the desert.

By November 1913 (top, right) sufficient track had been laid to warrant placing the first train on the rails which was powered by SP (4-6-0) ten-wheeler No. 2095. Two months later (center, right) ballast trains had increased to a respectable length, and the trains were operating to Trona by the end of March 1914. In September 1914 (bottom, right) trains were regularly heading north to Trona along the shore of dry Searles Lake, in this case using SP No. 2039. (All photos: Trona Railway Co. Collection.)

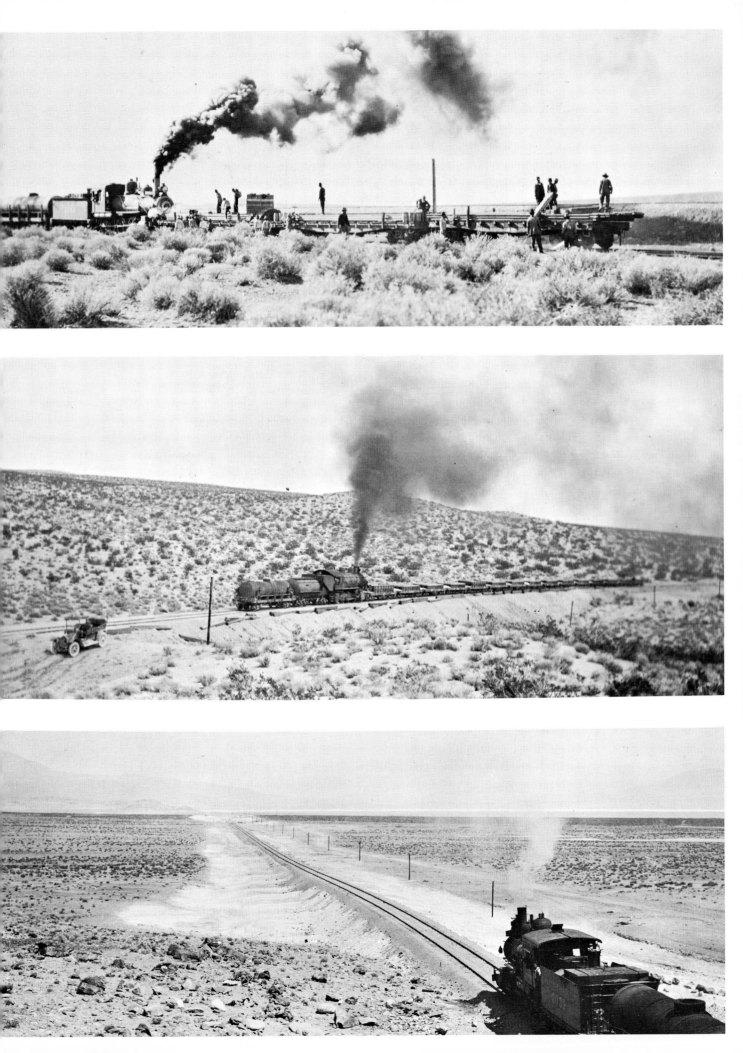

Withal the extensive railroad and new plant preparations for large-scale operation, fighting over the claims on Searles Lake was still continuing both in the courts as well as in the field where armed force sometimes was required. In fact, no loopholes were overlooked in attempts to harry the American Trona Corporation's efforts to get into production. Even the power of the California Railroad Commission was solicited to block the financing of the railroad, but the cause could not be stopped. The railroad was finished about the end of March 1914, and the first excursion over the line took place in May.

Participation in the inaugural started at Randsburg where, amid the waving of handkerchiefs and the clicking of cameras, some 50 joyriders started out in the large auto truck of the American Trona Corporation. The road was rough, the truck was crowded, and "several of the boys got spilled out on the trail which added to the merriment of the party." At Searles, the group transferred to their special train to become the first official passengers on the newly completed railroad. The 31-mile ride must have been a decidedly delightful relief for, in the words of the Randsburg reporter, "This trip, made in open cars, is one not to be missed. Running between mountains and over many miles of salt lake with its water-carved pinnacles throwing their purple shadows over the shimmering desert, the journey is one which will not soon be forgotten." On arrival at Trona, a noonday dinner was held at the company hotel, following which the Randsburg boys distinguished themselves by winning the afternoon's baseball game. Supper was then served to all the celebrants, and an evening ride in the waning hours of daylight by train and then by truck brought the participants back to their Randsburg homes.

Officially the railroad was considered to be completed on September 1, 1914 (some say September 5). Even before that date enthusiasm for the line was bubbling. There was some talk of extending the rails northward via Panamint Valley to tap the local mines along the way, thence to a connection with the SP at Owenyo. Nothing positive ever developed from the idea.

In its early days the railway had, as its president, a baron — a not inconsiderable distinction in American railroad circles. Moreover, since many of the employees were English and had spent a portion of their time in India, they failed to understand the company's historical heritage of long strings of mule teams hauling wagons across the desert. Three elephants, they contended, would have done the job equally as well and at greater efficiency. Out of this expressive thought, the Trona Railway, with its two locomotives, became known as the "Three Elephant Route." In fact, the idea became so firmly implanted that the theme was also carried over to one brand of the corporation's borax products. British thinking and policy also expressed itself in another way. It was their theory that the locomotives of the railway should be bright and sparkling, even if it meant that the firemen would be busy every spare minute of the time polishing them. As far as can be ascertained, Trona Railway locomotives were among the most immaculate desert machines in all the Mojave region.

Considerable difficulty was experienced in processing the salt brine from Searles Lake with the result that the first unit of the American Trona Corporation's commercial plant was not officially completed until October 1916. That the development was costly and slow was evidenced in the fact that the company's refinery at San Pedro, California, did not go into production until March 1918. In spite of the light traffic resulting from these difficulties, the railroad continued to operate. The Official Railway Guide showed the following schedule, effective June 1, 1917:

No. 9	Miles	Station	Miles	No. 10
* 8:30 PM	0.0	Trona	30.7	4:50 AM
8:36	2.2	Borosolvay	28.5	4:37
8:39	2.9	Rock Crusher	27.8	4:35
8:43	4.4	Hanksite	26.3	4:31
9:00	9.9	Pinnacle	20.8	4:13
9:25	17.6	Spangler	13.1	3:50
10:10 PM	30.7	Searles	0.0	#3:10 AM

*Daily except Sunday #Daily except Monday

Although the Trona Railway's schedule undoubtedly was timed to connecting SP trains between Mojave and Searles, the SP's trains in turn were timed to accommodate the desert night runs to its connecting narrow gauge at Owenyo. Thus, although Trona residents may have had good service to Mojave and Los Angeles, the road's daytime service for the local citizenry left a great deal to be desired.

Hanksite (later Westend) marked the spot where the narrow gauge Gravel Bank and Crystal Lake Railroad crossed the Trona Railway in its course between the evaporating ponds on Searles Lake and the chemical plant at Westend. Magnesia, a non-agency station at mile post 24.2 (from Searles) was also a junction point. Here a short spur

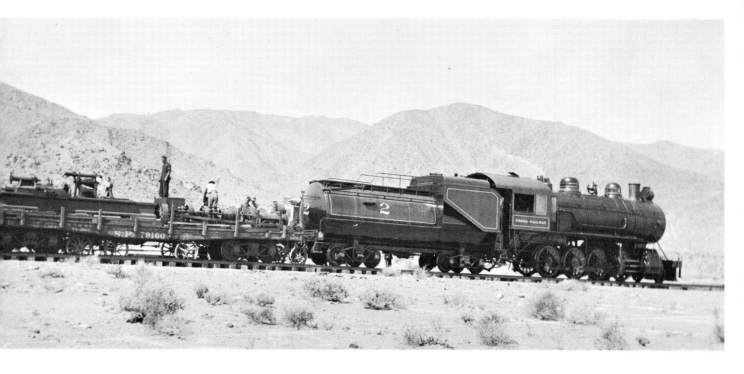

Shown here in the striped paint of builder Baldwin, are Trona Railway's Nos. 1 and 2 when they were placed in operation the latter part of March 1914. Note the galaxy of pulleys and shafts being unloaded on to adjoining wagons for the early drives of mill machinery. *(Both photos: Trona Railway.)*

The narrow gauge locomotive *(above)*, served the Westend Chemical Co. plant at Westend (formerly Hanksite). In spite of its apparent condition in this 1940 view, the engine was placed on exhibit at Knott's Berry Farm in Buena Park, California.

Trona Railway has always been modern and meticulous in its concept and upkeep, from its steam locomotives in use on an excursion train in May 1952 *(below)* to its diesels passing The Pinnacles *(top, right)* to its plant shown *(bot-*

tom, right) at Trona. The buildings of the American Potash & Chemical Corp. lie at center, left; the Trona business district is at center with the residential area to the right, background. At far right are the small ponds on the bed of Searles Lake from which alkaline brine is pumped for extraction of potash, borax, soda ash, salt cake and other industrial and agricultural chemicals. *(Above: Phillips C. Kauke photo; below: Pacific Railway Journal; both photos, right: American Potash & Chemical Corp.)*

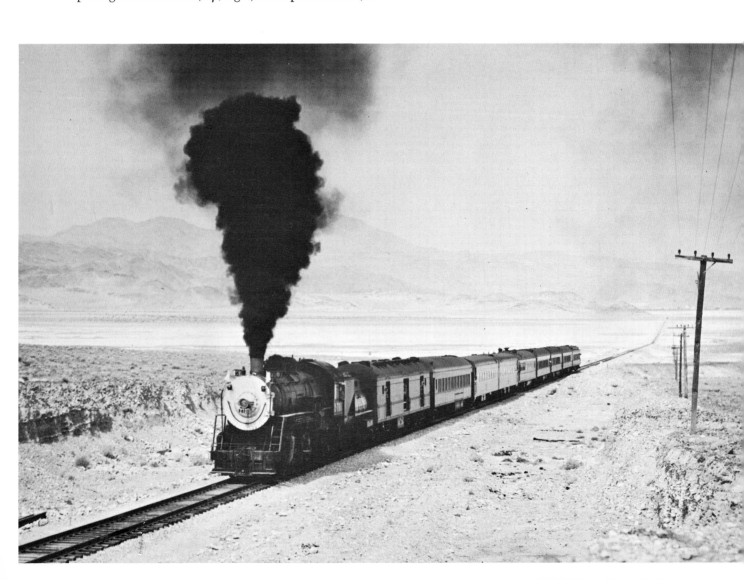

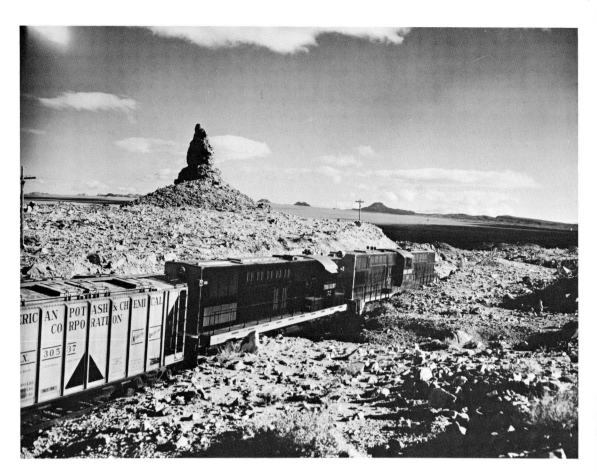

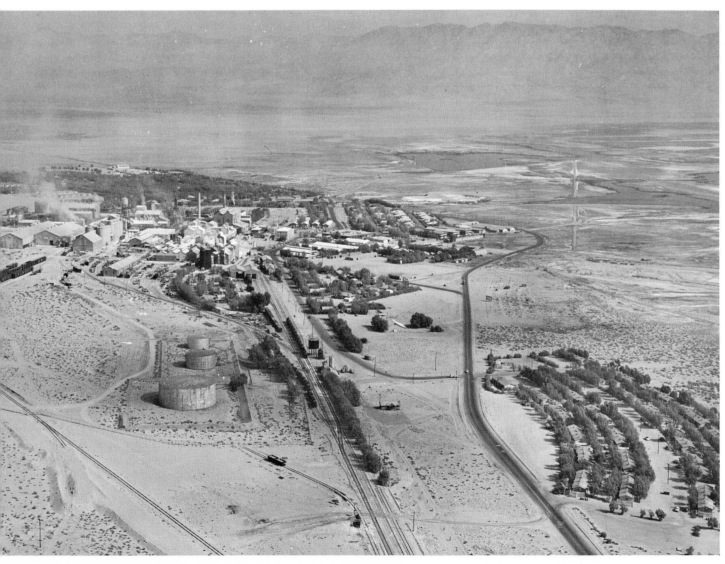

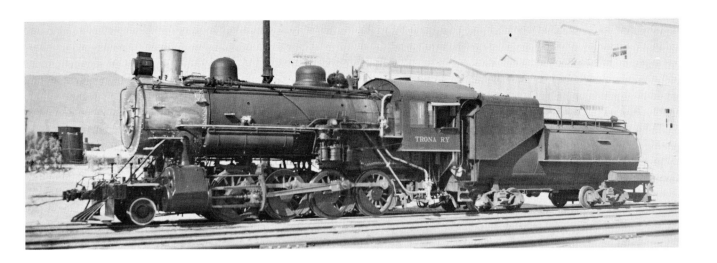

Indicative of the cleanliness of the Trona Railway's good housekeeping is the immaculate condition of its locomotives and equipment shown on these pages. The road only had these three locomotives on its steam roster; at least two *(below)* carried the unusual insignia of "The Three Elephant Route" on their tenders as late as 1948. The rail motor car *(bottom, right)* was a 1926 product of the Skagit Steel Co. and was used for special school train movements during the 1930's. *(Above: R. L. Searle Collection; bottom, right: Louis L. Stein, Jr. Collection; all others: Gerald M. Best photos.)*

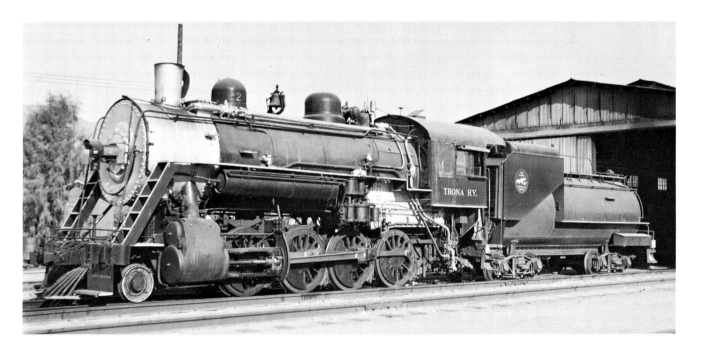

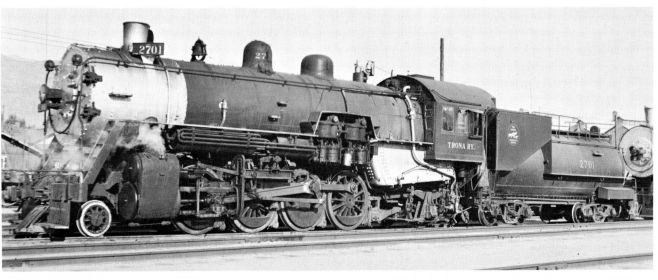

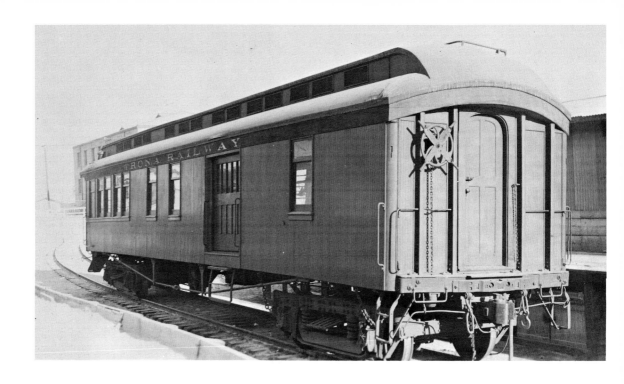

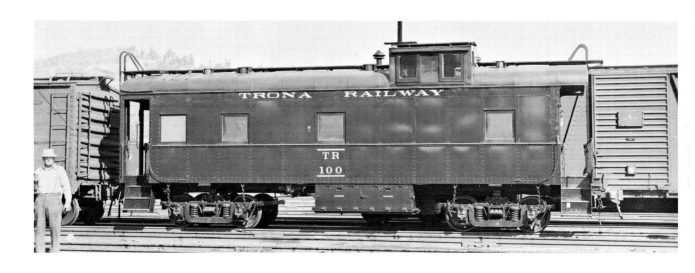

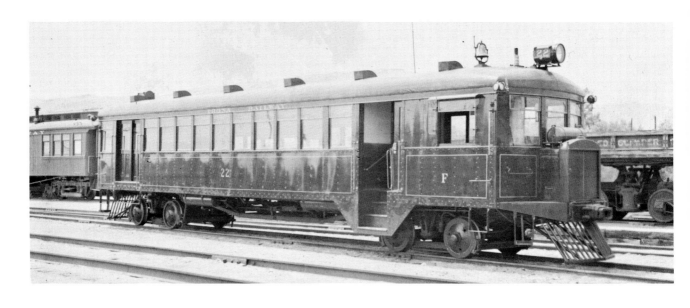

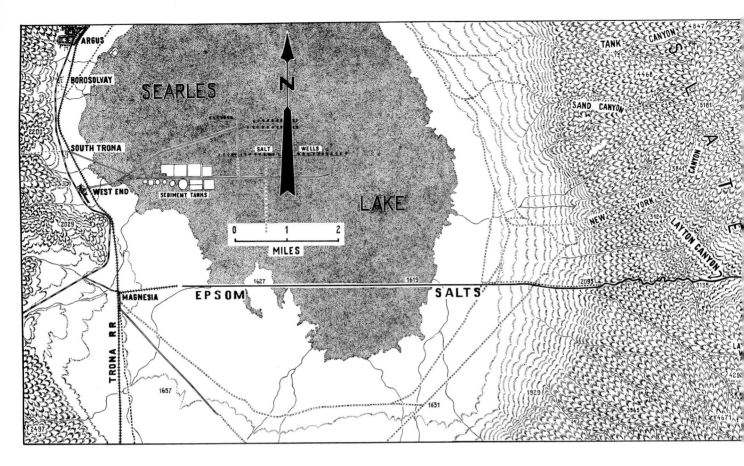

branched off to the east to the rail-head of the American Magnesium Company's monorail (see Epsom Salts) which, in turn, continued for another 28 tortuous miles to the Owlshead Mountains.

Financial problems beset the American Trona Corporation in the early 1920's, and in 1926 the company was reorganized as the American Potash and Chemical Corporation. The rejuvenation was successful, for since that time both the company and the subsidiary Trona Railway have prospered. Unfortunately, changes with the times were essential. In 1937 the railway discontinued all regular passenger service, although a special school train was operated from 1936 to 1941. Students were picked up at Westend, South Trona and Borosolvay and taken to school at Trona in a rail motor car, then returned to their homes in the afternoon. After abandonment of the service, the rail car was sold to the California Western Railroad, on which line it continues to operate between Fort Bragg and Willits, having acquired the now famous nickname of "The Skunk."

With the output of potash and borax constantly on the ascendancy, and with the Searles Lake source of supply considered to be inexhaustible for several generations, the business of the American Potash and Chemical Corporation promises to be active for many more years to come. Barring fur- ther radical innovations which might usurp the business of railway transport, much as diesel locomotives have usurped steam locomotives for motive power, the Trona Railway bids fair to continue piling up the miles on its short-line route. Apparently the early struggles were definitely worthy of the effort, lending credence to the slightly revised adage, "The first 10 years are the hardest."

Epsom Salts Railroad

XXXXXXXXXXXXXXXXXXXXXXXXXXXXXXXXXXXXXXX

What happens when a florist turns amateur prospector and discovers a bed of epsom salts in the California desert? He develops a monorail railroad, of course — at least that is what one desert explorer did to solve his particular problem.

Thomas Wright was the Los Angeles florist; his "find" lay along the ancient road from Barstow to Ballarat west of the Owlshead Mountains not far from one of the routes followed by the famous 20-mule teams of borax history. A more desolate spot in that labyrinth of rocky crags, low ridges and tortuous ravines in the country southwest of Death Valley would be difficult to imagine.

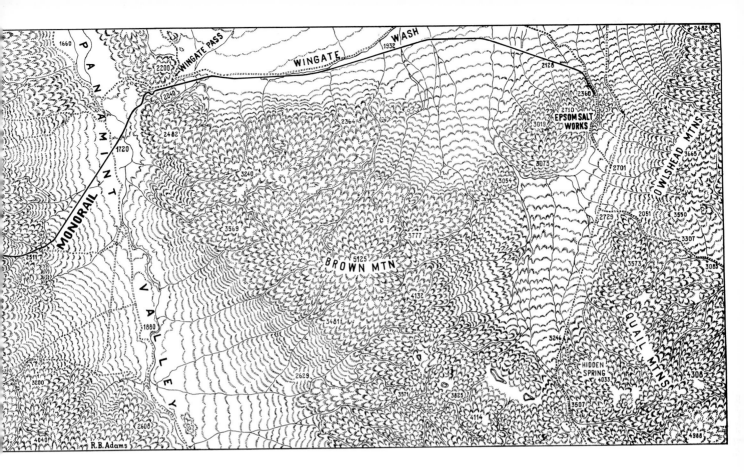

About the time of World War I, Wright and his interested investors were prospecting the body of ore to determine its grade and extent. The deposit apparently was a good one, so work commenced on preparing the ground for mining operations. A temporary camp was established in the adjacent Crystal Hills Wash to which supplies were channeled by a crew of men operating a truck route out of Randsburg, 37 air-miles distant but 63 miles by land excluding the untold jouncings via the sandy tracks and rocky passes of the insufficient roads of the period. Reportedly, one man feelingly wrote of his journey to the deposit as "an interminably long and punishing sentence of bumps and jolts, punctuated now and then by the brisk snap of breaking springs, truculent overtones in the clatter of the badly treated motor, and the sinister hissing of water frying in the radiator."

During the brief post-war depression activities were suspended, but Wright and his associates utilized the period of inactivity to give full consideration to some other means of transportation to the site. A railroad appeared to be the only solution; the big question was what kind, and to where? Some thought was given to a route northeasterly down the Wingate Wash to the floor of Death Valley, thence southeasterly on the gently rising floor of the valley along the banks of the Amargosa River to a junction with the Tonopah & Tidewater

Railroad at a point in the vicinity of Sperry. Although construction of such a line would present far fewer obstacles, possibly respect for the intense heat of Death Valley caused a change of thinking in favor of a shorter but steeper route westward over two summits to a connection with the Trona Railroad somewhere along the southwestern shore of Searles Lake. Surveys were run, and the project was analyzed.

Starting from the Trona Railroad at a point ultimately known as Magnesia (sometimes called Magnesium Siding), two long tangents could carry the road eastward across the relatively flat, salt-encrusted lake bed, following which a series of broad curves would enable the line to climb up Layton Canyon to a crossing of the Slate Range at Layton Pass. From this point considerable hard-rock blasting would be required to permit even the most sharply twisting and winding way down a steep, gash-like canyon to the floor of Panamint Valley. On the far side an equally steep and tortuous climb would be required to accomplish the summit of Wingate Pass. Immediately beyond lay the broad upper slopes of Wingate Wash which the railroad could follow along the southern flank before turning southeasterly up the steep bed of Crystal Hills Wash to the campsite. Aside from the problems of changes in elevation, the total distance would be only 28 miles.

But what kind of a railroad could and should be built over such a difficult terrain? Grading a roadbed for any of the standard types of railroad construction would not be too difficult at either end of the line, but the cost of traversing the Slate Range and climbing to Wingate Pass from the floor of Panamint Valley would be virtually prohibitive. Monorail railroads, then in the public eye, seemed to offer a possible solution. If built of low-trestle design, the need for grading would be eliminated, except in the more difficult canyon stretches where some rock work would be mandatory; the open trestlework would obviate the majority of problems encountered with railroad sub-grade drainage; only half the normal quantity of steel rail would be required; and locomotives and cars would be less expensive to construct and maintain. What, if any, weight was given to the cost of maintenance and replacement of timbers in the trestlework is not known. The idea seemed feasible, and it was adopted.

First a test model of the monorail was constructed to determine its practicality, on the basis of which a patent was obtained on June 23, 1923. Meanwhile, late in 1922, work began in earnest on the actual road. The basic outline was somewhat similar to that of the unsuccessful Sonoma Valley Prismoidal Railway erected on the north shore of San Francisco Bay in 1876. A central "riding beam," six inches by eight inches in size, was supported on a series of A-frames or bents spaced eight feet apart, the central posts of which carried most of the load. The running rail, of standard T-section design and variously reported as being of 50-, 65-, 70- and 80-pounds to the yard, was centered on top of the "riding beam." To the diagonal legs of the A-frames, horizontal crosspieces were affixed extending several inches beyond the legs on either side to enable two-inch by eight-inch side rails to be attached to their ends, parallel to the running rail, to serve as sway stabilizers. Each A-frame was spiked to a broad wooden sill for a base, and the sills were sunk into the ground several inches wherever practical for additional stability. Above ground the structure was laced with supplemental diagonal bracing wherever necessary as a stiffener. The obvious advantage of the monorail's trestle-like construction was the innate flexibility of being able to lengthen or shorten the legs of the A-frames at will to compensate for the unevenness of the terrain and to bridge arroyos or other low areas too narrow to permit dips in the grade.

The Douglas fir used in the road's construction was brought by boat to San Pedro, California, thence by rail to Mojave and up the SP's Owenyo branch to Searles where the Trona Railway picked it up for delivery to the monorail. To service the Epsom Salts Line, the Trona Railway built a spur, at Magnesia, a point about two miles south of Westend. Here the timber was unloaded and stacked on the desert floor for incorporation in the line as it was extended eastward.

The actual work of construction was carried out in the name of the American Magnesium Company (not incorporated until 1924) of which Thomas Wright was the president and chief promoter. Capt. Hollenbeck was awarded the construction contract, and L. Des Granges became the construction engineer on the job. By September 1923 approximately 16 of the 28 miles of road had been completed and construction trains were busily hauling materials to the end of line for further extension.

As was to be expected, the rolling stock of the monorail was unique in appearance and in operation. The basic mobile unit consisted of a rectangular steel frame mounted on two double-flanged wheels, one at either end. To balance this unit on the single rail atop the "riding beam," steel supports angling downward parallel to the slope of the A-frames were affixed on either side to which bottom "steps" or platforms were added on a horizontal plane just above ground level. On these platforms the inbound loads of lumber or supplies and the outbound sacks of epsomite were stacked, balancing each other to a great extent like saddle bags over the bank of a mule. To counteract any inequalities in weight distribution as well as to reduce side sway encountered at speeds over 15 miles per hour, and to furnish lateral support when the equipment was running "light," 8" x 8" steel rollers were mounted on vertical shafts along the bottom inside edges of the four, angled, steel legs of each unit. Tension springs kept the rollers compressed against the wooden side rails of the trestle which in turn helped to hold the two-wheeled vehicle in nearly perfect alignment on the single running rail.

Locomotives were of the same basic format as the cars with the simple addition of a power unit and drive to the main wheels on the running rail. During the initial construction period, the first locomotive to be developed utilized a battery powered electric motor. When this failed to produce sufficient power to haul the heavy loads on anything except the tangent track across the bed of Searles Lake, a Fordson tractor engine was substi-

tuted with a rigid drive shaft to the wheels. The rigid shaft, however, became twisted in negotiating the sharp curves of the line, and a further refinement was made utilizing dual chain drives to each of the two running wheels. In all, eight chain-driven locomotives were used on the line, seven of them powered by Fordson tractor motors. The eighth was an experimental heavier unit mounting a Buda motor, but was never duplicated.

Each locomotive was capable of handling one or two trailers over the road, depending upon the load factor. The system of couplings between units was unimaginatively adapted from salvaged parts of scrapped Los Angeles street cars. Any distance required between cars to compensate for load extensions easily could be accommodated by increasing or decreasing the length of the coupling bar.

Whatever braking system pertained apparently was of crude design, as it was applied only on the locomotives, and was of generally unsatisfactory character and effectiveness on the steep grades. Reportedly one engineer was moved to comment: "I had one ride on the monorail as far as Wingate Pass and was rather relieved to get back with a safe skin, keeping a watchful eye on the braking arrangement all the time."

Naturally, load limits were dictated by the strength of the trestle construction over which they were hauled. In practice each locomotive was restricted to a maximum pay load of approximately 3,400 pounds; trailer carloads were permitted weights up to 8,500 pounds.

Speed was not indigenous to the monorail's operations, but rather surprisingly, 35 miles-per-hour was set as the permissive maximum. In practice, most trains were held to about 30 miles-per-hour along the level stretches, slowed to a crawl on the upgrades, and undoubtedly negotiated the downhill stretches at whatever minimum speed the primitive braking system could maintain in view of the weight of the load involved. After the line was completed, one motorman reportedly made the entire 28-mile trip in one hour flat with a full cargo of Epsom salts. Whether it was his record trip that inspired the colloquialism, "The Epsom Salts Line—Fastest Moving Monorail in the World," or whether it was the speed with which he was fired for having performed the feat, has been lost to posterity.

Construction of the railroad was finished in 1924. From the Trona Railroad's Magnesia siding, the Monorail's trestled roadbed stretched easterly across the lower end of Searles Lake, then climbed

1,850 feet in the next five miles (average 7% grade) to pass through narrow Layton Canyon to the summit of the Slate Range. In places the natural route rose 400 feet to the mile, or approximately 7.6% grade. On the other side of the pass there was a drop of approximately the same magnitude to the floor of Panamint Valley before another, even steeper climb to Wingate Pass on the eastern side of the valley was encountered. It was in this latter rugged area that reported 10 and 12% grades were required to negotiate the terrain.

On the floor of Panamint Valley the only road crossing was encountered. To obviate constructing any movable track sections or installing some form of drawbridge to carry the road across at rail height, the roadway was depressed in a shallow cut and the monorail was raised in a hump to furnish clearance beneath for road traffic. Small wonder, then, that tales were circulated in the area of strange, hump-backed trains which ran down the mountainside with a roar resembling that of a waterfall to race on across the valley floor and leap right over the roadway and anything upon it.

Troubles beset the entire American Magnesium Company's operations almost from the beginning. Epsomite, a hydrated magnesium sulfate, was scraped from the ground at the mine in nearly pure state by men using garden hoes while less useful mixtures of magnesium carbonate, magnesium sulfate and clay were available below the surface. These materials were sacked and stacked aboard the locomotives and cars of the monorail for transportation to Magnesia siding where they were transshipped via the Trona and SP railroads to the company's small plant in Wilmington, California, for refining. For a time in 1924 and 1925 a force of from 12 to 15 men were kept busy at the mine, and trainload after trainload of salts went out over the monorail. However, the high-quality epsomite proved to be limited in quantity, while the flimsy trestle construction of the railroad failed to withstand the swaying impact of even the lightest loads stacked on the spread-eagled locomotives and cars.

For a while, during the early days of the line when it was believed that reasonable quantities of epsomite were available, attempts were made to improve on the transportation problems of the railroad. The heavier locomotive with the Buda engine (mentioned previously) was one attempt to rectify the situation. Greater power, it was reasoned, would permit longer trains and thus more production flowing to the refinery. The experiment failed; the

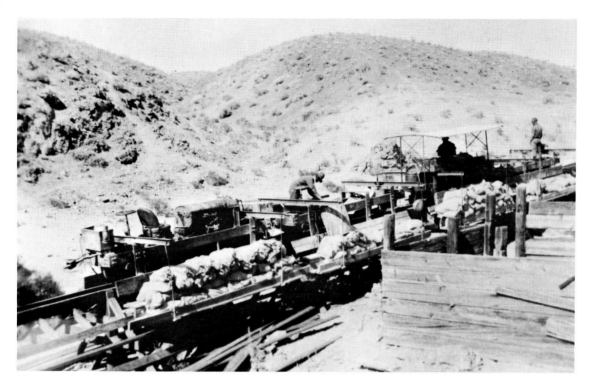

Layton Springs on the Epsom Salt Monorail was located at the head of Layton Canyon. The Monorail's climb up the canyon was long, arduous and grueling, and the respite afforded at The Springs provided welcome relief from the overbearing heat.

The four-unit train *(above)* stands at Layton Springs about ready to depart downhill through the canyon with its loads of salts for the Trona Railway connection. In the reverse view *(below)*, note the water barrels to the right of the track and the primitive piping arrangements for that precious liquid. The smaller, two-unit train is about to enter Layton Canyon. *(Both photos: Richard H. Jahns Collection.)*

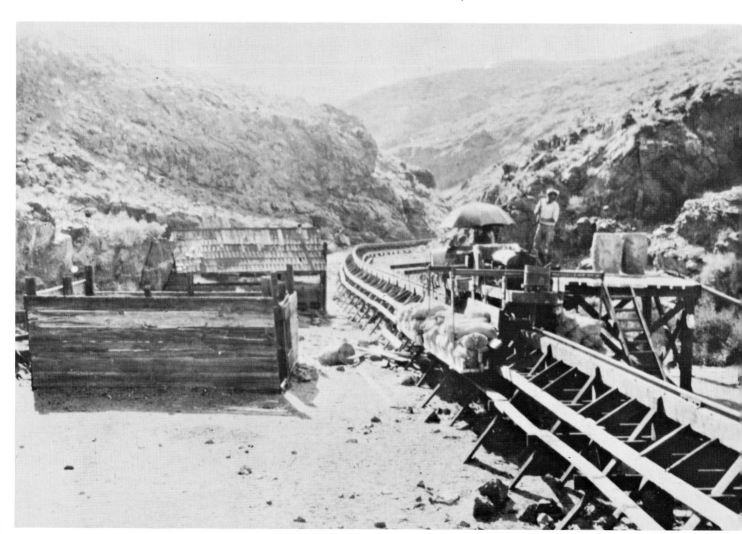

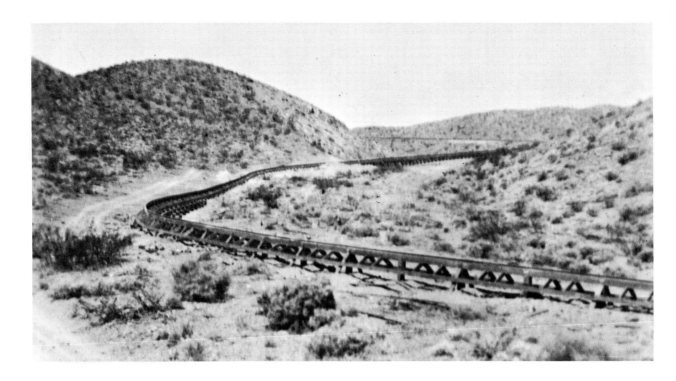

Like a great snake *(above)* the Monorail's trackage winds east up the steep grade toward the summit of Layton Pass. Those barren hillsides and dry washes could be portentous of utmost difficulties in the event of desert cloudbursts, eventualities which could and did occur with disastrous results.

The import of this 1924 visit to the Monorail *(below)* by Norman Ross (man in white shirt), Master Mechanic of the Pacific Coast Borax Mine at Ryan, has been lost in obscurity. Note the revised form of metal, hopper-container bin which has been developed, as well as the angle mounting of the side-sway roller on the near end which bears against the wooden side-rail of the trestlework. The "rear brakeman" rests astride one of the double-flanged driving wheels with the other visible ahead of the radiator of this unit. *(Top: Richard H. Jahns Collection; bottom: H. P. Gower Collection.)*

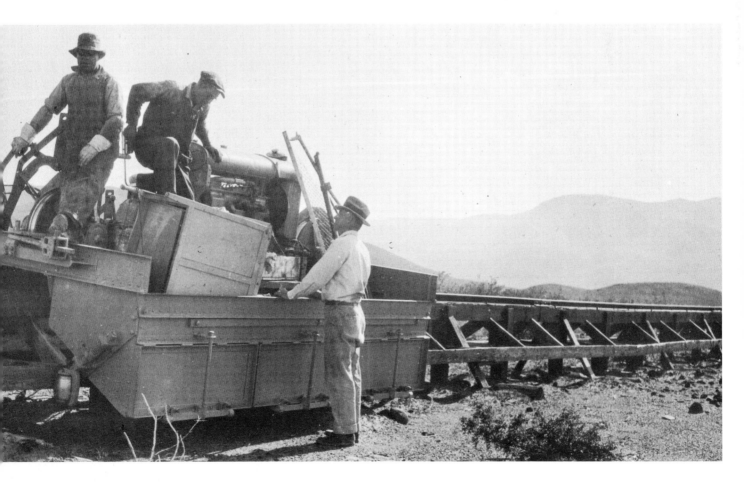

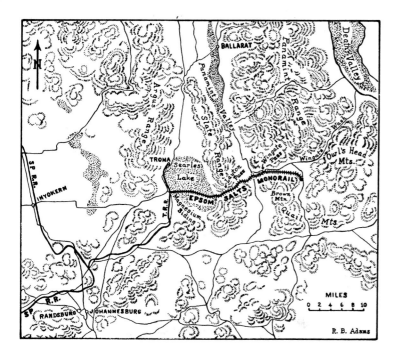

R. B. Adams

extra weight of the locomotive caused the trestlework over Searles Lake to break through the crust and tip, necessitating costly, major repairs.

In a further effort to solve the problem a contract was let with A. W. Harrison of Los Angeles, an automotive engineer, to build a gas-electric train consisting of an engine and generator to supply power for electric motors to drive both the engine and the individual cars. By the time the experimental train had been completed, desert heat had dried and warped the green lumber used in building the road's trestlework and the "track" was completely warped out of shape. Timbers had splintered; nails and screws had become loosened (not enough bolts had been used); and the wooden guide rails had been worn to shreds from the modicum of trains which had passed over the line. Thus the proponents were back where they started — the trestle was not strong enough to carry the weight of the new gas-electric train, and the old locomotives still were unable to haul loads of sufficient quantity to make them a paying proposition.

Other troubles beset the line. In spite of the terrifically arid country traversed, an overabundance of water at certain times caused untold problems. Severe cloudbursts in the Slate Range washed away whole sections of trestlework into the canyons on both sides of the pass. The normally dry bed of Searles Lake became filled with as much as 14 inches of water after general storms in the area finally cleared, softening the lake bottom and causing the trestle to sink through the sediment. Riprap installed during the building of the line was filled and strengthened, but still it was a long time before service could be restored.

Down in Wilmington, the refinery was having its troubles too. The trickle of mine production that found its way out over the monorail was insufficient to keep the plant running at anywhere near capacity. Of the "ore" actually received, approximately 50% was found to be sand, debris and other salts. Waste material began to pile up around the plant. Then the city authorities raised strenuous objections to the accumulation of such waste within the city limits.

After the summer of 1925, mine production was slowed and trips over the monorail became fewer and fewer. In June 1926 the mine was shut down completely and the last load of salts was eased over the creaking trestlework to Magnesia. For over 10 years the bleached timbers disintegrated in the desert sun although the monorail remained in place on its "riding beam."

Behind the cessation of activity lay not only the physical problems of operation, but complicated legal aspects as well. Mineral claims in the mountains had been extended over an area of 1,440 acres, and constant disputes, suits and countersuits were the order of the day. Moreover, slick promoters had managed to obtain control of a sizeable portion of the stock of the company and were using it to further their nefarious ends.

On April 28, 1928, the property was finally offered for bids, although there were no buyers. Over a million dollars had been poured into the operation, but there was little that could be salvaged. In the late 1930's the railroad's single rail was taken up for scrap; the "riding beam" and other horizontal timbers were removed as well, leaving only the line of A-frames still standing in a path across the desert floor. Bit by bit even these mementos of a passing era disappeared, into campfires of sporadic prospectors or the stoves of residents around Searles Lake. The monorail to nowhere evaporated with the times.

Calico and Its Silver Railroad

Ten miles east of Barstow and across the Mojave River from Daggett, California, a broad and seemingly flat plain stretches northward for seven miles to a low range of multi-colored hills where it abruptly ends in a series of small, steep defiles or ravines known by such various and euphonious

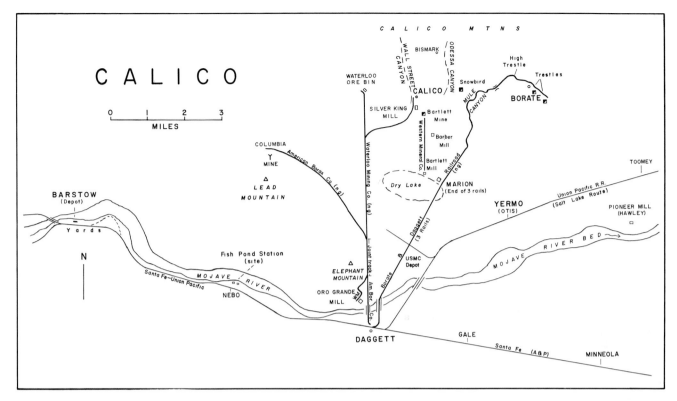

titles as Wall Street Canyon, Garfield Canyon, Odessa Canyon and (more plainly) Mule Canyon. The area is virtually devoid of plant life, unless one wishes to include a few scattered groves of cottonwoods along the Mojave River or a sprinkling of sage brush on the plain. It is not an area of inducement for the wanderer or the curious; yet men came, looked, and settled to endure the searing heat of summer and the biting cold of winter with but one common thought in mind — the avidity of wealth.

Calico was the name of the town that they founded. It was situated high on a narrow little mesa between two gulches formed by the sporadic runoff of waters from the Wall Street Canyon on one side and the combined Garfield and Odessa Canyons on the other. The discovery of rich, silver-bearing ores on the slopes of these canyons provided the initial incentive for the early settlers to stake and work their claims. Over a decade was to pass before borax deposits, far to the east of the narrow confines of Mule Canyon and still later at Bartlett and at the Columbia mine to the west, were to become the more important factors in the economy of the region.

The Calico Railroad

The first discoveries at Calico were of silver ore and have been credited to an eccentric old man

named Lee who, in 1875, found such a rich silver ledge it was at first believed to be quicksilver. Lee wandered off from his findings and probably was killed by Indians near Old Woman Springs.

It was not until the fall of 1880 that a man named Porter, who operated a mill near the site of Barstow in conjunction with R. W. Waterman relocated the claims which had lain idle for so many years. The news spread quickly, and that fall hundreds of new locations were made in the area. The following spring (1881) Lowery Silver made the first discovery on Calico Mountain and on April 6, S. C. Warden, Hues Thomas, John C. King and others located what became the great Silver King mine, subsequently described by E. E. Vincent in the first issue of the *Calico Print* (August 1882) as "the richest and biggest mine in California."

Indicative of the rapid growth of the area was the fact that on the Fourth of July, 1881 only three men were living in Calico. There were no homes whatsoever except the solitary cabin belonging to Allison, one of the discoverers of the Oriental mine. During the month of July, J. B. Whitfield and others staked a claim which later became the Burning Moscow mine. The first actual mining began when Sam James brought men in to work on the Silver King. By the spring of 1882 approximately 100 people were living on the narrow strip of mesa that was Calico. The majority were ranchers turned

miners (not miners by profession), while another enterprising group formed the Calico Townsite Co. and were kept busy over the ensuing year selling lots. There was even talk of building a narrow gauge railroad all the way to Los Angeles, possibly stimulated by the fact that the Southern Pacific had commenced construction in February 1882 of its line from Mojave to Needles, California, via Calico.

The year 1882 was one of varying fortunes. In April, E. Sommers' new five-stamp mill was ready to run on Moscow ore while ore from the King mine was being hauled 40 miles south along the Mojave River to the Oro Grande Mining Company's mill (about 20 miles north of Cajon Pass) which had been built in 1878 to handle the nearby Silver Mountain District ores. The basic problem was one of fuel. The groves of cottonwoods along the Mojave River already were becoming extinct from fueling Calico's 10-stamp mill; greasewood had become the only source of fuel for home use; while living conditions were described as extremely hot and dangerous in the summer, and the winter "puts you in mind of the upper Missouri River and bleak plains."

Sickness during the summer of 1882 turned Calico into a deserted camp; but by fall the feeling was better, and people returned to resume work on nearly all of the claims. Many new strikes were reported, most notable of which was the Snow Bird in the general area of East Calico. Undoubtedly a great deal of interest and excitement was being derived from the fact that rail transportation was rapidly approaching, a circumstance which would be of terrific benefit in the solving of many problems. In actuality, the SP reached out from Mojave to Waterman's on October 23, and trains were running to Calico on November 13, 1882. (It should be noted that Calico station was on the south side of the Mojave River, seven miles from the camp, and that to avoid confusion the station name was changed from Calico to Daggett in the spring of 1883.) Optimism prevailed at the camp. One visitor, on returning to Arizona, told the *Tombstone Epitaph* he thought that the King mine was worth $1,000,000. Unfortunately, news of this kind only served to bring in a glut of miners when there was not enough work for those already there, and the newly arrived surplus population found that Calico winters were difficult to endure.

Garfield Canyon, to the northeast of Calico, was the scene of numerous new developments in 1883 among which was the building, by the Silver

Odessa, of a new road and boarding house. One resident of Goblerville (as the area was called) declared, "The boom has come at last to our little burg." As further evidence of its progressiveness, the Silver Odessa purchased the Pioneer Quartz mill on the north bank of the Mojave River a few miles east of Daggett at Hawley's Station.

May 1883 was also the time of the big borax excitement in the hills to the east of Calico. The town became virtually deserted as the population swarmed up through Mule Canyon in the rush to locate claims. A reporter for the *Calico Print* went along to witness the event and had this to say in the next edition of the paper: "Men start out from town on a 'dog trot,' leaving in their wake rows of monuments (claim markers), and do not slacken their pace until the shades of night prevent further operations. Inside a couple of days two men located 96 claims, and one was lame at that. If the men work the silver mines with the same energy that they cover the country with monuments, the camp would soon be booming." Many of the Borate claims were soon sold; the firm of William T. Coleman & Co. acquired a great number, only to fail in 1888 and be gobbled up by F. M. "Borax" Smith and his Pacific Coast Borax Co. (see chapter on T&T).

Disaster struck Calico in the fall of 1883 when an uncontrollable fire left most of the business section in ashes. With the mines producing well it was not long before as many buildings were erected as before. "The town is now looking substantial, lively and prosperous," declared the *Print*, "and we can safely predict stirring times this fall and winter. Calico's colors are not the kind that easily fade." The veracity of these statements was to be thoroughly tested, for a second fire at a later date failed to affect the increasing population, which reached a maximum of 2,500 people the very next year.

Calico mining took on more of the atmosphere of big business in 1884 when the Oro Grande Mining Company (the second firm with this name) moved in to consolidate a number of holdings. C. M. Sanger, a Milwaukee capitalist, was the principal, D. Bahten was its superintendent; both were aggressive individuals. Early in the year the Oriental mine was acquired, to be followed shortly by the allied Silver King mine and mill. Other properties passed into the combination, and expanded operations were indicated by plans to add another five stamps to the mill. That basic values and sound thinking lay behind these investments was indi-

cated by the fact that in September 1884 the company declared its fourth dividend amounting to $22,000. The Snow Bird (in East Calico) was an 1885 addition, while a short time later the little-worked Waterloo mine in the West Calico District was added.

Of all the properties, the Silver King continued to be the best producer. In a recent 14-month period, over $1,000,000 in silver bars was derived from the ores, thereby supporting the earlier estimate of the mine's potential so blatantly headlined in the *Tombstone Epitaph*. Mining shifts were operated both day and night as well as on Sunday, with wages set at $3.50 for each nine-hour shift. The miners were free to board wherever they pleased; promptness and sobriety were the company's only requirements for employment. Ores were hauled over the seven miles to the company's 15-stamp mill at the Mojave River in 60-ton "train" loads of three wagons each headed by one of two teams of 20 mules each. The cost of this transportation amounted to $2.50 per ton, while total costs (including mining, milling and discount) averaged approximately $18 per ton. Shipments from the mill normally ran around $40,000 to $50,000 per month.

Although the mine owners and the miners appeared to subsist on a reasonably harmonious basis, at least one visitor to Calico in March 1885 found conditions very much *not* to his liking. He condemned the town as having been built on such a narrow ledge the back end of each lot ended on the edge or over a bluff. He decried the galaxy of small, hastily built houses which dominated the scene "with only a few of two stories," and declared that the only thoroughfare in Calico was a long, narrow, serpentine Main Street leading directly to the Silver King mine. He found that saloons were more numerous than the houses; that the only water supply was that which was hauled from Evans' Well at a cost of 3 to 5 cents a gallon; that wood was $10 a cord; and that board was $7 or $8 a week. He declared that "business is generally overdone, the number of blacklegs and tin-horn gamblers that infest the place are remarked by the newcomer"; then he summarized his impressions with these parting comments: "The camp is a good one, but at present is overestimated and overcrowded by men out of money and out of work. Capital, development and a chance is all that this camp needs to be a second edition to the Comstock at no great distant date."

Withal these platitudes, Calico was coming of age. A number of the mines had installed surface tramways extending from the hillside tunnels leading to the mines. The Mammoth had constructed a 600-foot tramway; the Occidental was operating a car track 1,000 feet long running around the west side of the hill facing on Bismark Canyon to its main dump. The Silver Odessa had a 600-foot line which extended from the tunnel to the ore house, running along the ridge on the west; high up in steep Wall Street Canyon, the Sue mine had a total of 300 feet of tramway, one-third of which was nearly perpendicular. A hand windlass was used to operate the inclined portion, as the scarcity of water and wood made "the use of a steam engine a costly and uncertain piece of property."

As yet, there still was no railroad from Calico over the seven barren miles to the mills along the Mojave River or to connect at Daggett with the transcontinental Atlantic & Pacific Railroad which had superseded the original Southern Pacific operation. The need for such a connecting line was readily apparent, and the owners of the Oro Grande Mining Co. resolved to do something about it. In March 1885 they organized the Daggett and Calico Railroad Co. to build a railroad via "the most practicable route from a point to intersect with the Atlantic and Pacific Railroad at the Town of Daggett, thence via the Oro Grande Company's mill to the Town of Calico, with a Branch Road or spur to the Snow Bird Mine via Barber Mill." The total length of the road was to be 10 miles. Surveys were made along a straight-line course from Calico to the mill, following the path of the telephone line, but then no further work was done. William Curry's Concord Coach, operating under the name of the Calico Stage Line, continued to make its two trips daily between the post office in Calico and the Railroad Hotel in Daggett; while Joseph Le Cyr, who doubled as sheriff, continued to specialize in hauling ore to the mills by team.

Calico was slowing down. Chloriders (tribute miners working for proceeds less a royalty to the owner) were leaving town, and although ore continued to flow from the mines, the volume was diminishing. Work on development of the Waterloo mine (West Calico) was continuing, and its production was taking on increasing importance, but progress was slow. By 1887 the Oro Grande Mining Co. started building a new, 60-stamp, $250,000 mill alongside their old mill at the River when suddenly on August 17, just as it was almost finished, the new mill caught fire and burned to

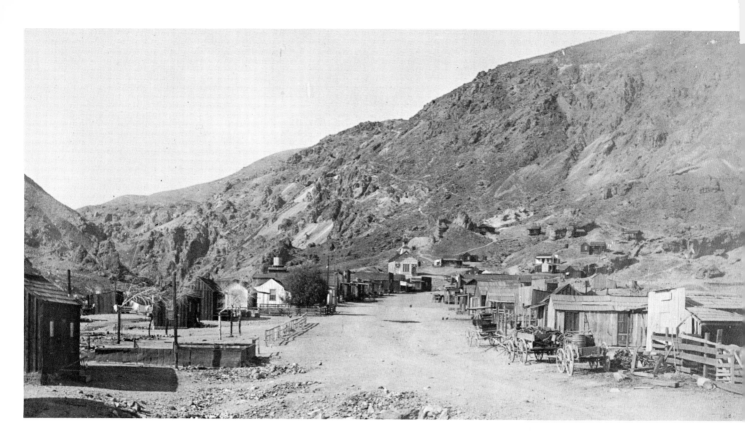

Calico about 1890! The town was condemned as having been built on such a narrow ledge the back end of each lot ended on the edge or over a bluff. Its Main Street was described as a narrow, serpentine thoroughfare leading directly to the Silver King mine, a place where saloons were more numerous than houses and business was generally overdone, being infested with blacklegs and tin-horn gamblers. The continuation of Main Street was a mere trail up the steep bank of rugged, precipitous Wall Street Canyon to the rear where the numerous hillside mines fed their ores to the canyon's floor by means of fragile cableways at seemingly impossible angles.

The Waterloo Mining Company's narrow gauge railroad was constructed *(top, right)* in 1888 and operated between the mouth of Wall Street Canyon and the mill along the Mojave River. Two small, saddle-tank locomotives *(bottom, left and right)* provided the motive power for the line, the mule tram (seen at the top of the loading bin) serving to bring the ore from the mine. *(Above: Henry E. Huntington Library and Art Gallery; all others: Bob Weaver-O. A. Russell Collection.)*

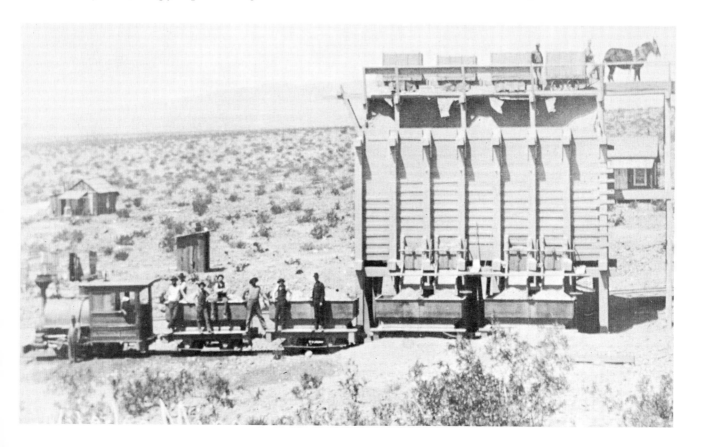

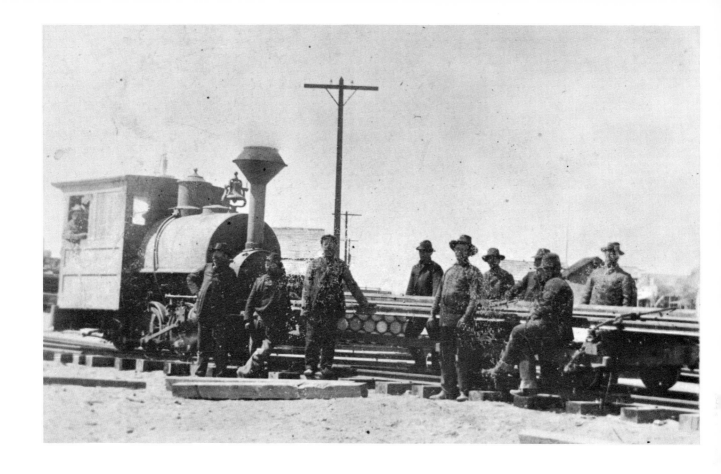

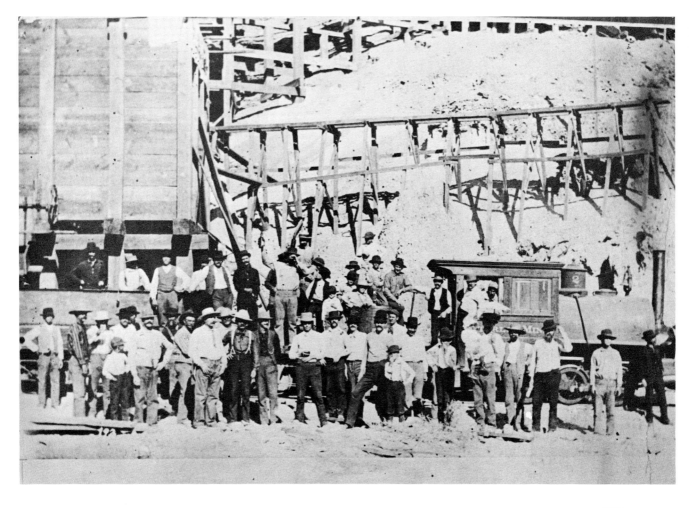

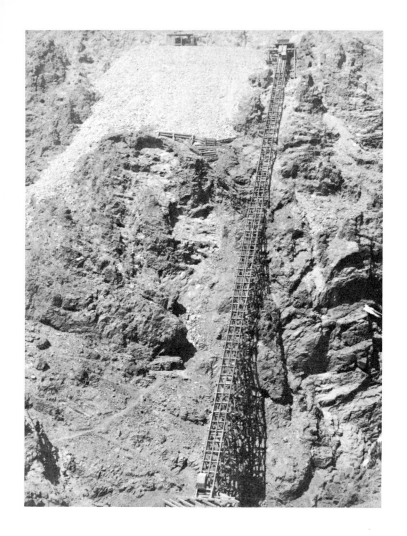

Typical of the more spectacular cableways which lowered ore from the mines to the canyons was that of the Odessa *(left)* located northeast of Calico. *(Grahame Hardy Collection.)*

The Waterloo Mill *(below)* was "end of the line" for the mining company's trains *(top, right)* pulled by their tiny (0-6-0-T) saddle-tank locomotives. Apparently the crew had cached their lunches beneath a home-made shelter from the sun for this unscheduled stop on the desert. *(Both photos: Bob Weaver-O. A. Russell Collection.)*

Trains run again at Calico. The narrow gauge Calico & Odessa Railroad *(bottom, right)* is a 1963 version of a rejuvenated Calico town. Visitors may park at the foot of Wall Street Canyon and ride a substantial cableway to Main Street — not too different in principle from the days of cableways to the mines.

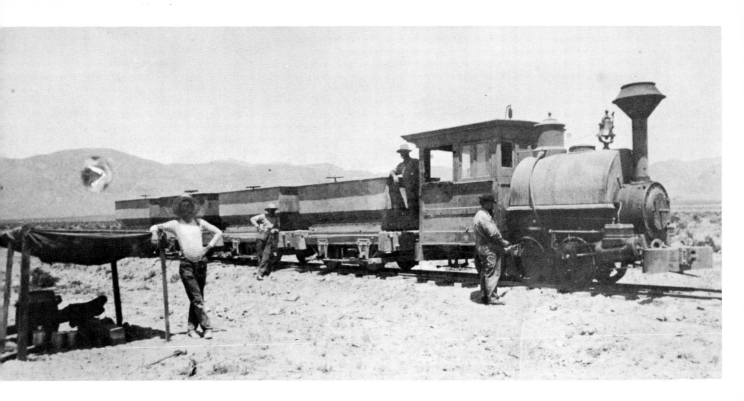

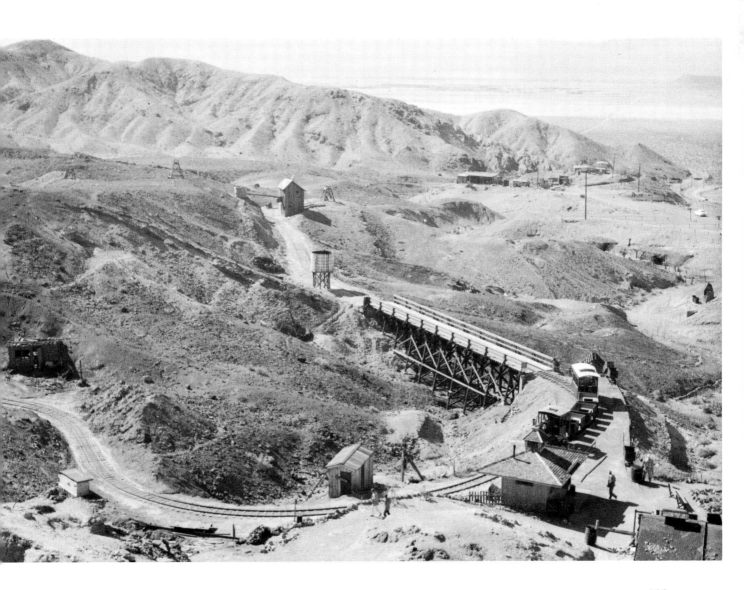

the ground. The incident was most disheartening, but Col. Sanger immediately started upon a second mill on the same site, utilizing the old boilers from the burned out units.

Late in 1888, with the second new mill completed and with the Waterloo mine burgeoning with increased production, the Oro Grande Mining Company built a narrow gauge railroad from the ore bin at the entrance to the Waterloo mine tunnel south to the new 60-stamp mill. Unfortunately the *Calico Print* was not there to record the details of the long-awaited event, for that paper had suspended publication shortly after the destructive mill fire had seemed to put an end to Calico's hopes and aspirations. This much is known about the little line. The motive power was comprised of two small saddle-tank locomotives named Emil and Daniel which served to ease the loaded ore cars down "a pretty steep grade" to the mill while empties, loads of timbers from Flagstaff, Arizona, and other supplies were hauled back to Calico on the return trip. Reportedly transportation costs ran about 7 cents per ton for the seven-mile haul by rail, a rather dramatic contrast to the earlier teaming cost of $2.50 per ton.

Passenger traffic on the narrow gauge was unorthodox, informal and something of a special event. In March 1963 Mrs. Lucy Lane recalled the fun of a delightful trip to the mill made many years ago. Being an irregular operation, there were no conductors to take any tickets, and the young ladies were permitted to stand in the ore cars, holding on to the sides to brace against the rolling of the cars on the uneven, narrow track.

Early in February 1889 the Oro Grande Mining Company sold its mining properties to the Waterloo Mining Co., a Wisconsin corporation owned by the same interests. The railroad, sometimes called the Calico Railroad, was included in the sale and continued to be operated for the owners on a most satisfactory basis. At the northern end a branch was built eastward to the ore bins of the Silver King mine at the foot of Wall Street Canyon, and by September 1891 the railroad was hauling daily loads of 100 tons of ore from the Silver King and 50 tons from the Waterloo to keep the 75 stamps of the mill by the Mojave River working to capacity. In addition, the Silver King Mining Co. of London, England, was working its 20-stamp mill (increased to 30 stamps on December 1) with ores from its Odessa, Oriental and Occidental mines. Calico was still a prosperous and prolific producing area of not inconsiderable reckoning.

The price of silver had been dropping constantly over the years, and in March 1892 the Waterloo no longer could make ends meet. The mine was closed, and 130 men were thrown out of work; the railroad ceased to operate.

Both the Waterloo and the Silver King mining companies had been engaged in litigation for a number of years. After spending $200,000 in attorneys' fees and court costs, the differences were finally compromised in May 1894. It was then expected that the railroad would be extended across the river to Daggett, but the continuing low price of silver forced the Waterloo mine to remain closed. Finally, in 1896, even the Silver King mill hung up its stamps, another victim of the low silver prices.

In May 1899 D. D. Connell and Marcus Pluth leased the Waterloo properties, and once again the narrow gauge was operated for a period of a few years. In fact, the operation was augmented in 1901 by construction of the American Borax Company's railroad (see section, "The Columbia Mine Railroad") from the Columbia mine to its plant in Daggett, which utilized about a mile of the Waterloo Mining Company's rails to join its two segments.

The Waterloo mining operation failed to last and in 1903 the little narrow gauge was taken up, exclusive of the one-mile segment previously used jointly by both lines. Both of the locomotives were sold — one being purchased by the American Borax Company for its Columbia mine operation, the other going to the Mohave & Milltown Railroad (q.v.) for service on the Arizona side of the Colorado River.

In spite of this, Calico did not give up. Leasing of the various properties continued over the years. As late as 1931 the Zenda Gold Mining Company had 47 men working on one of the claims until the price of silver again dropped sharply. Some activity in gold also continued and one mine, the Total Wreck (Burcham), was operated for another 10 years to 1941.

In large measure, Calico (the mining camp) is remembered as one of the major silver districts in California. How much did it produce? Guesses vary. Some are rather generous. The California Division of Mines places the figure at somewhere between $13 and $20 million. Perhaps the name of Wall Street Canyon was more prophetic than its founders realized.

Today a new Calico (a tourist attraction) is arising from the canyons and dumps of the former mines. In 1950 Walter Knott, owner of the famed

Knott's Berry Farm in Buena Park (near Los Angeles), California, purchased the old townsite. With interest sparked by the fact that his uncle, John C. King, played an important part in Calico's early history, Knott has been restoring the town to its former glory.

Included among the attractions is a new, 30-inch gauge, Calico & Odessa Railroad, built and operated by Shafe-Malcom Enterprises, which operates over approximately a mile of track passing through some spectacular mining scenery to the delight of the tourist passengers. To make the Calico area accessible from the parking lot in Wall Street Canyon, the same firm has installed a 450-foot, 36-inch gauge, inclined cable tramway (superseding an earlier installation in a different location by Britt Gray, which has now been abandoned), and visitors may ride to Main Street on the mesa in a style unaccustomed to Calico pioneers.

Visitors now travel to Calico by the thousands each year, making the turn off U. S. Highway 91 just east of Barstow, and sample the atmosphere of life in a formerly great mining town.

Borate & Daggett Railroad

Although the initial borax discoveries northeast of Calico were made in 1883, but little is known of the extent and development of the properties in the early years. William T. Coleman of San Francisco acquired many of the claims to supplement the deposits he was working at his Lila C. mine at Ryan, California, on the eastern edge of Death Valley; but Coleman suffered severe financial reverses in 1888, and his properties were acquired by Francis Marion "Borax" Smith whose mines at Teel's Marsh, Nevada, were nearly exhausted. In 1890 Smith combined all of his holdings in a newly formed Pacific Coast Borax Company, and because transportation (in the form of the Atlantic & Pacific Railroad) was readily available in the Calico area, his operations were centered at that point.

J. W. S. Perry, a pioneer in the borax industry, assumed direction of the Calico properties, and they soon became the principal source of revenues for Smith's company. A settlement called Borate was developed and here the miners lived in close proximity to their work. The mined ore was loaded into wagons which were hauled by 20-mule teams down a steep and tortuous canyon to the A&P Railroad at Daggett, some 12 miles away. The name Mule Canyon immortalizes the significant contribution of their toil.

But faithful as the mule teams were, the costliness of their slow and ponderous transpositions dictated that some better method of conveyance be found. In 1894 "Old Dinah," a steam traction engine, was tested, but it required so much attention both on the road and in the shops that a reversion to mule power became a necessity within a year. Old Dinah was inconsiderately retired without particular honors, but years later she assumed an immortality of sorts by becoming a museum piece at the Furnace Creek Ranch in Death Valley.

The return to mule power did not solve the basic problem of adequate transportation, and finally it was decided that the expense of a railroad was justified to meet the exigencies of the situation. Thus early in 1898 work began on a narrow gauge railway, commonly called the Borate & Daggett Railroad, to span the 11 miles between the termini of its descriptive title. By the end of the year the line was finished — out of Daggett, across the Mojave River, northeastward up the broad expanse of the flat, through the tortuous Mule Canyon and up the hills to Borate and the mines. In the final reaches, the grades were steep and several high trestles were required.

Two narrow gauge Heisler locomotives supplied the motive power, modestly named the FRANCIS and the MARION in honor of Smith himself, and bearing the Pacific Coast Borax Co. lettering on their tenders. The narrow gauge flat cars and their demountable stake-side ore bodies bore the name of the Borate & Daggett R. R. Co. All couplings were accomplished by the then universal, but treacherous, link and pin.

Four miles north of Daggett, at Marion, a calcining plant was erected to treat the ore before forwarding to the refinery at Alameda, California. Between Daggett and Marion a third rail was laid in the track to accommodate the switching of standard gauge cars from the Santa Fe, such operations being performed by the light, narrow gauge locomotives.

The railroad was a decidedly successful improvement over the mule team method of hauling ore and gave a most satisfactory service. By the turn of the century, the borax ore in the mines was being taken from the 600-foot level and production costs were rising. To circumvent this deteriorating situation, Smith's interests were directed toward his

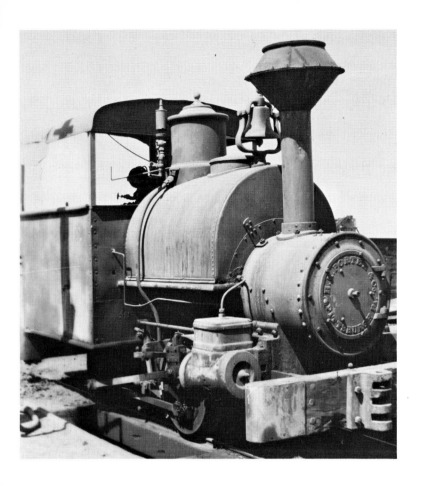

Unusual was this 0-4-0-T saddle-tank locomotive of the Pacific Coast Borax Company depicted at Calico. Reportedly it was for use on some of the company's other properties.

Mainstay of the Borate & Daggett Railroad were the narrow gauge Heislers, FRANCIS and MARION, which could handle the loaded ore cars at slower speeds and with greater safety on the steep grades and light trestles near the upper end of the line. Mining was concentrated in a narrow, twisting canyon, its mouth is shown (*top, right*) with the abandoned grade of the railroad plainly evident along the shoulder. Deeper in the canyon (behind camera) the railroad was built along the floor of the defile, subject to wash-outs with each rising of the waters. (*This page: Charles P. Atherton Collection; top, right: U. S. Geological Survey; bottom, right: U. S. Borax & Chemical Corporation.*)

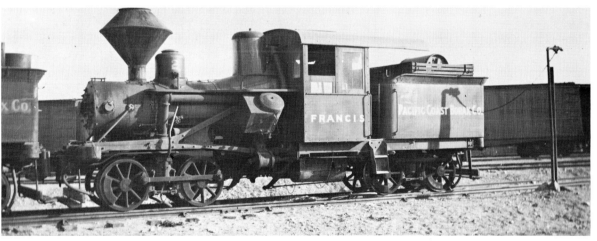

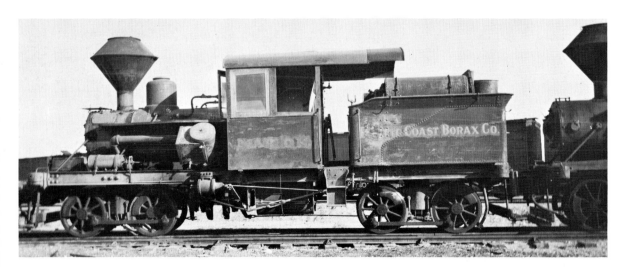

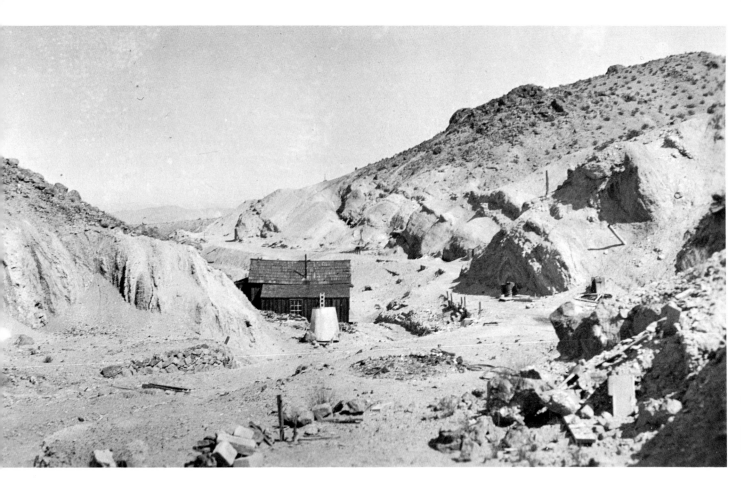

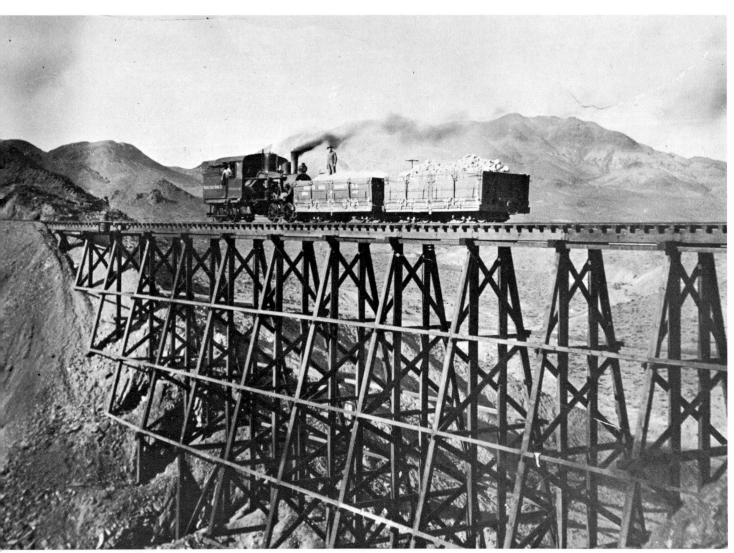

holdings at Coleman's former Lila C. mine near Death Valley, and development of that property was commenced. The story of Smith's efforts to bring transportation to that area will be found in the chapter on the Tonopah & Tidewater Railroad; at this point it need merely be noted that shipments of borax from the Lila C. were begun even before the T&T was completed in 1907, and with their beginning the decline of activity at Borate was foreordained.

As quickly as was expedient, the mines were closed; the town was abandoned; and the Borate & Daggett Railroad was taken up. Mule Canyon no longer echoed to the hooves of the living beast, nor to the exhaust of his mechanical counterpart; while the location of Marion became, with time and circumstance, an indistinguishable spot on the sage covered slope. A narrow auto road winds up Mule Canyon over the old railroad grade, but on the east side of the summit it diverges, dropping quickly into the canyon, while the right of way of the old Borate & Daggett continues to work its way along the hillsides without benefit of the trestles formerly used to bridge the gullies and hollows of the uneven terrain.

The locomotives FRANCIS and MARION were stored at Daggett for years. In 1914 the FRANCIS was retrieved and rejuvenated to assist in the building of the Death Valley Railroad (q.v.). Ultimately it became one of the last locomotives to see service on the ill-fated Nevada Short Line Railroad at Rochester, and eventually went on to further service with a lumber railroad in northern California. The disposition of the MARION is uncertain.

Western Mineral Railroad

The Calico-Daggett vicinity contained a number of deposits of low-grade borax shales, but until the late 1890's there was no known use for this material. Then it was found that, through a process of reduction, boric acid could be produced. As a consequence, a number of new companies began operating in this area.

W. P. Bartlett was one of the pioneers in this development, and his Western Mineral Co. reduction works was located on the flat a short distance west of Marion. High frames were constructed to hold sage brush piles, and the raw solution was pumped to the top of the piles for crystalization into boric acid.

Bartlett's mine was located 1½ miles north up the slope, so a narrow gauge railway was constructed to connect the mine with the reduction works.

Power was supplied by mules which pulled the empty cars (in trains) up the hill each morning. Gravity brought the cars down individually as required during the day, the last few being saved for the end of the shift when the miners could climb aboard for the ride home. A supply of feed kept at the mill enticed the mules to return after each single morning's trip to the mine.

The operation was hardly spectacular, but apparently it was successful. The works started around 1896 and continued in business until about 1907 when more prosaic methods of production were developed.

The Columbia Mine Railroad

Production of boric acid was the primary stimulus behind the operations of the Columbia Mining and Chemical Co. which owned the Columbia mine, four miles west of Calico. (This should not be confused with the *Columbus* mine located some four miles *south* of Daggett.) Ores were mined and teamed to the company's plant in Daggett which used a patented process developed by Henry Blumenberg, Jr. Operations started some time prior to 1894 and continued for seven years until the company was acquired by the American Borax Co., an affiliate of the Standard Sanitary Co. (bathtub manufacturer), in 1901.

To improve operations, the American Borax Co. immediately built a seven mile, narrow gauge railroad between the mine and the mill. From the mine, the rails headed southeasterly to a connection with the Waterloo Mining Company's railroad, thence used their rails for about a mile of route before branching off just short of the Oro Grande mill to continue on across the Mojave River to the plant in Daggett. The Waterloo Mining Co. also supplied the road's only locomotive.

But little can be learned about the operations of this industrial line. Apparently the only wreck of consequence on either of the two railroads occurred in 1903 just as "engineer" Connell was terminating his lease of the Waterloo mine. At the junction for the joint section of track, Connell had already entered the switch when the borax-line locomotive failed to stop and sideswiped the Waterloo engine. It was raining at the time, and the engineer of the borax line had drawn the cab curtains to keep out the moisture and did not realize Connell had already entered the track. Yells and whistles from Connell were to no avail; the other engineer simply did not hear him.

When the Waterloo Mining Company's railroad was abandoned in 1903, the American Borax Co. purchased the locomotive they had been using and acquired the one-mile section of track which had been part of the joint operation of both lines. Operations continued until November 1907, when the discovery of Colemanite in Tick Canyon (30 miles from Los Angeles) resulted in the closing of the Columbia mine and the plant in Daggett. The Tick Canyon ores were much richer than those at the Columbia mine, and the American Borax Company moved its entire operations to the new location, taking with them the old locomotive and rails of the narrow gauge line.

Ludlow and Southern Railway Company

Far out over the sandy wastes of the Mojave Desert in southern California, about 53 miles east of Barstow along the Santa Fe's A&P route, lies the town of Ludlow. Eight miles to the south lies the Rochester area (or Stagg or Stedman — several names were used), and between the two places during the early part of the twentieth century a railroad ran.

One might almost call this railroad the New York Central of the West — not because of any thoughts of a four-track main line or a Grand Central terminal (the Ludlow & Southern was hardly that efficacious) — but because its backers and its equipment largely came from the Empire State. At the time the Ludlow & Southern was organized around the turn of the century, a number of short lines in the upper part of the state of New York were being absorbed by the New York Central and considerable surplus equipment resulted. Mining railroads provided a ready market for secondhand equipment, and the L&S was no exception.

The Rochester area (originally known as the Buckeye Mining District) came about as the result of a discovery by John Suter, an Atlantic & Pacific Railroad roadmaster, who staked his claims to the south of Ludlow in the 1880's. The history of the principal mine, the Bagdad, has not been uncovered, but it is known that in 1900 John Suter & Co. was engaged in its development and had a dozen men at work on location. Others had been attracted by the activity as well, for John R. Gentry was

LUDLOW & SOUTHERN RAILWAY

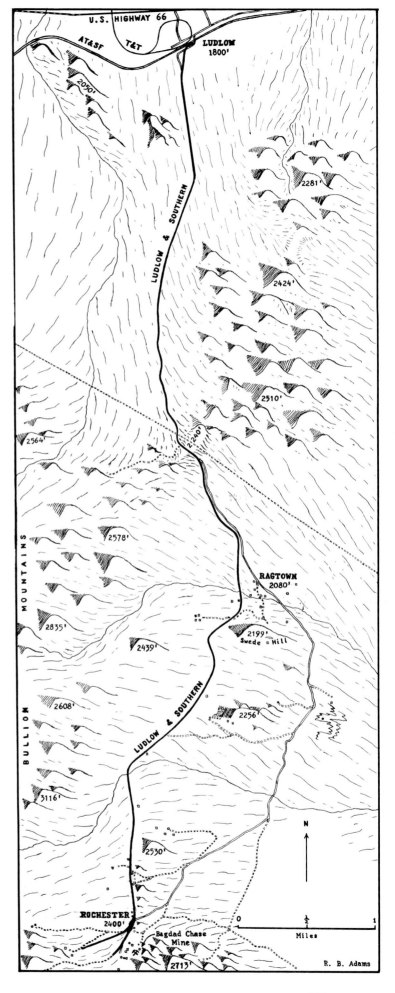

employing six men in the development of a neighboring mine.

Either Suter was unaware of the potentialities of his Bagdad property or else he had tired of earning his money the hard way, for he granted an option on the mine, and early in 1901 the property was purchased. The buyers were prominent men, some associated with the New York Central Railroad — Chauncey M. Depew of New York, John N. Beckley, Benjamin E. Chase and J. H. Stedman of Rochester, New York. A new company was organized to take over operations, the Bagdad Mining and Milling Co., and E. H. Stagg became the general manager. Production was immediately commenced at the mine as fast as preliminary work could be completed.

Late in December 1901 the first samples of ore were taken to the Randsburg-Santa Fe Reduction Company's 50-stamp mill at Barstow for processing. The same group of financiers owned this property, which had been erected to process ores from the Randsburg district. When the report was released that 1,000 tons of Bagdad ore yielded $17,111 after milling, consideration was immediately given to the moving of the mill from Barstow to Rochester. A second thought prevailed and it was decided to construct a railroad from the mines to the Santa Fe at Ludlow, and let the Santa Fe deliver the ores to the Barstow plant. A serious water problem was thus avoided.

Surveys for the railroad were begun in May 1902, and following incorporation of the Ludlow and Southern Railway in July of that year, contracts were let for its construction.

In the meantime many more claims were being made and filed under the Bagdad name to expand and protect the discoveries. For variety (and profit) the old Gentry mine was acquired by the Benjamin E. Chase Gold Mining Co., and it too was enlarged. Before long some 60 men were working at the Bagdad mine, while 15 others were required at the Chase. Subsequently, these two companies were brought together with the Roosevelt mine, and all were operated as one large company.

Grading for the railroad was completed in November 1902. By the beginning of 1903 ties were on the ground, while the Santa Fe's promised second hand rails arrived in April. Track laying followed in May, and by June 1903 the entire road was completed at a reported cost of $80,000.

Manager Stagg was considered to be something of a czar at the camp whose post office bore his name. Whether it was he or his wife and three daughters who dictated the "closed camp" policy has not been ascertained, but no liquor was allowed; furthermore, none was to be permitted to be hauled on the railroad. To uphold the family's views, Stagg made his brother the first engineer on the locomotive so he could keep his eye on matters railroading.

Fortunately for the hard-working miners, some diversion was to be found at the other end of the line in Ludlow. For there was Mother Preston, "a business woman who for many years bulked large in the town's history"; and there, too, were her financially successful restaurant, lodging house and saloon. As a demonstration of her versatility, Mother Preston occasionally took the boys on in a friendly game of poker; and in that field as well she proved herself to be highly skilled. Eventually she was able to retire and live out her remaining days in France.

The railroad was not quite as adept at managing its stable of iron horses. Equipment for the L&S invariably was acquired on the secondhand market. The first locomotive came from the New York Central. Some say that it bore the number 99; never, however, could it be confused with the famous No. 999 which set a speed record hauling the renowned *Empire State Express*. The next locomotive to grace the roster was a switcher from the Tonopah & Goldfield. Other temporary motive power came from the Tonopah & Tidewater at various times to power L&S trains. In fact, around 1910, it appeared that the T&T had a hand in the operations of the Ludlow & Southern, for T&T work trains made occasional trips over the line.

Included among the several passenger cars which graced Ludlow & Southern trains at one time or another (but not conjointly) was a reputedly former private car of Chauncey Depew, one-time president of the New York Central.

Little did the miners realize the decadent excellence of their vehicle of transportation as they rolled to Ludlow on paydays or returned to camp undoubtedly tired and broke. No doubt they were more concerned over the leisurely 12-miles-per-hour pace of their desert chariot, for the timetable of the period (1909) carded a full 40 minutes for the eight-mile run:

3:30 PM	Lv. Ludlow	Ar.	1:40 PM
4:10 PM	Ar. Camp Rochester	Lv.	1:00 PM

During the first decade of the twentieth century, the Bagdad Chase mine became the largest single source of copper and gold in San Bernardino Coun-

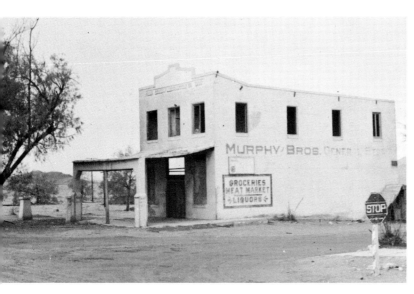

"Mother" Preston, "a business woman who for many years bulked large in the town's history," was a familiar figure along Ludlow Main Street or at the depot waiting for the trains to come in. Eventually she sold her extensive holdings to the Murphy Bros., whose abandoned store still stands today in an almost deserted town. Pleasure-bent miners from Rochester were treated to the panoramic view *(below)* as their northbound L&S train approached the desert oasis. The line of trees indicates the path of the Santa Fe; the L&S tracks have disappeared from the landscape; as have those of the Tonopah & Tidewater which approached from Broadwell Lake (to the rear) and terminated at center left where the shops and balloon track formerly were located. Times indeed had changed when this 1963 view was taken. *(Top: Mrs. Vernie Sherraden Collection.)*

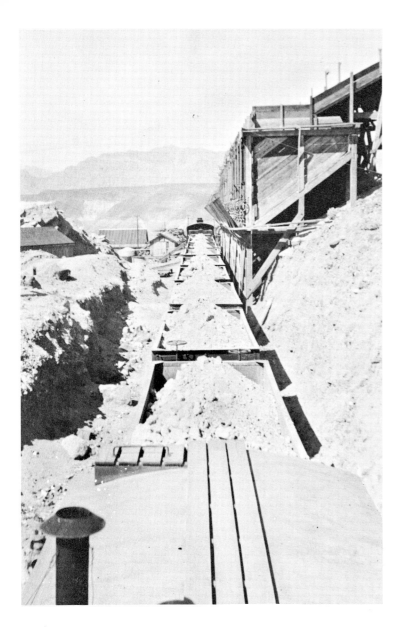

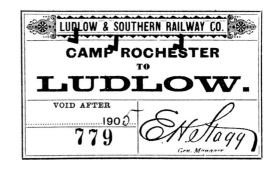

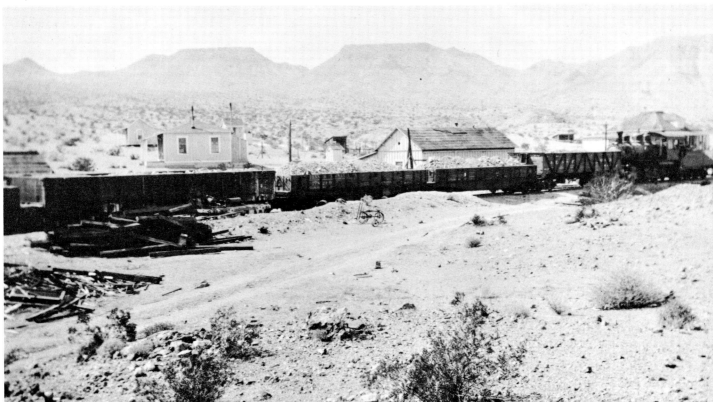

Ore for the mill at Barstow or the smelter in Arizona was loaded from these bins in Rochester and hauled to the Santa Fe connection at Ludlow behind L&S No. 1, a Baldwin 0-6-0 switcher of T&G ancestry, which appears in portrait *(bottom, right)*. Most notable feature of the engine house at Rochester *(top, right)* was the lengthy clerestory in the center of the roof in lieu of the usual smokejacks at either end. Handily to the right stands the Bagdad Chase Gold Mining Company store. *(All photos: D. A. Painter Collection; ticket: Alvin A. Fickewirth.)*

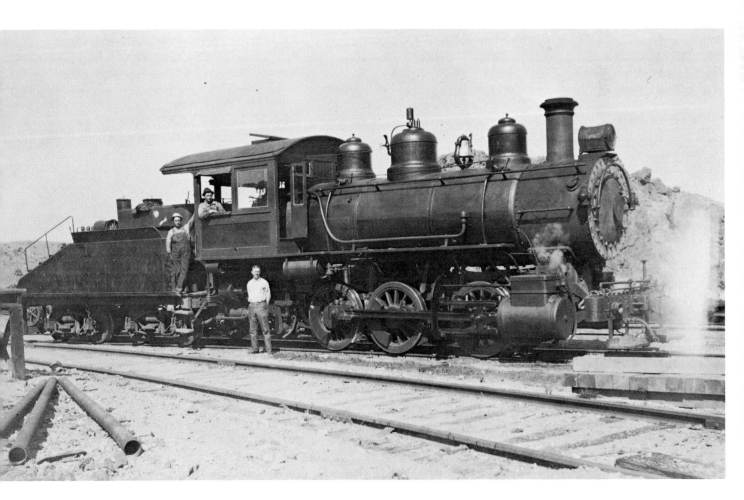

Searingly hot in summer, bitingly cold in winter, rainy in season, but generally parched and arid, Camp Rochester had little to recommend it to anyone except those few hardy unfortunate souls who were obliged to work and live in that remote sector of the vast Mojave Desert. The utilitarian, light clapboard housing was dispersed against the ever common danger of fire, a hazard of multiple proportion for a town virtually destitute of water. Unlike most mining camps, the property was largely under single own-ership. Thus saloons (and liquor) were prohibited, while the usual red light district was notorious by its absence.

In the panorama (above), the pattern of the town is evident. Ore loading bins for the railroad were located at far left-center and in the foreground (below). The single-track main line to Ludlow stretches northerly up the valley to the right. Locomotive No. 2, a (4-6-0) ten-wheeler report-edly from a New York Central subsidiary, stands in the

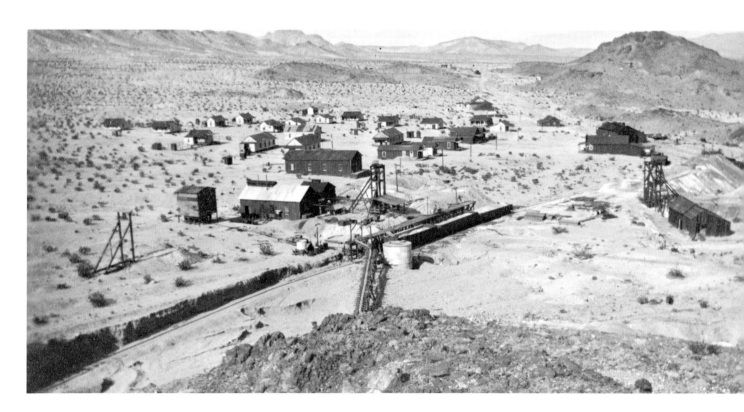

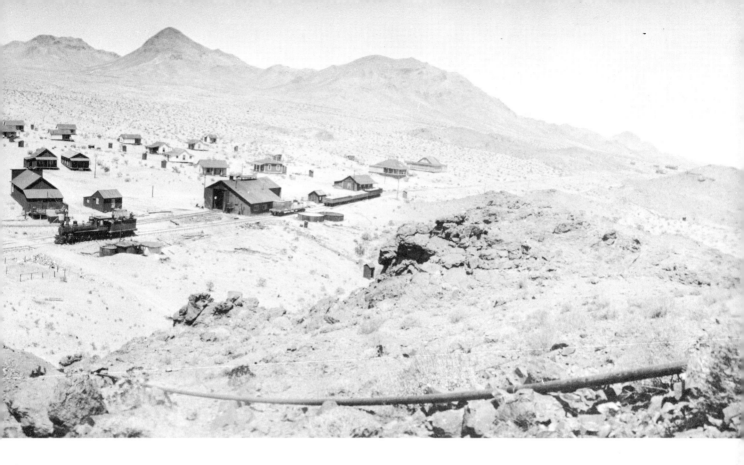

foreground, taking on a supply of fuel oil from the tanks next to the track which have been largely buried in the sand as protection from the heat. A flat car with two vertical water vats is spotted alongside the engine house for the draining of their precious liquid into the larger town storage tanks buried this side of the tracks. A number of minor mine shafts are visible toward the left.

The view (bottom, left) looks northerly from a point almost dead center, left in the picture (above), but at a slightly different time. Notice the small tramway from the dump in foreground to the ore bins across the track. No. 2 (below, right) seems to have some admirers as she switches a Wabash stake-sided gondola in front of the station. (All photos: D. A. Painter Collection.)

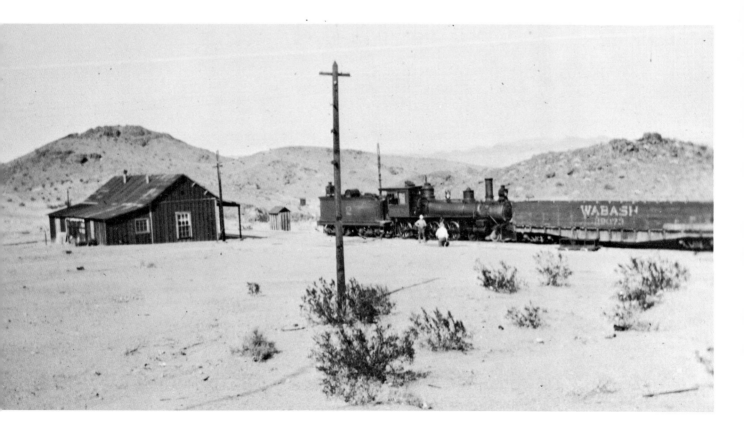

Among the last remaining relics of the Ludlow & Southern were the antiquated combine which sat on the ground about a mile north of the mine until consumed by fire in the fall of 1939, and the "modeler's delight" which seems to prove that there's a prototype for almost anything. When old No. 2 had outlived its usefulness, the cylinders, boiler and cab were removed from the running gear, and an attempt was made to improvise a homemade drive from a Holt tractor. The job was never finished, so historians can only speculate as to what type of superstructure was envisioned for this monstrosity. (*Above: Donald Love Collection; below: Richard Berry.*)

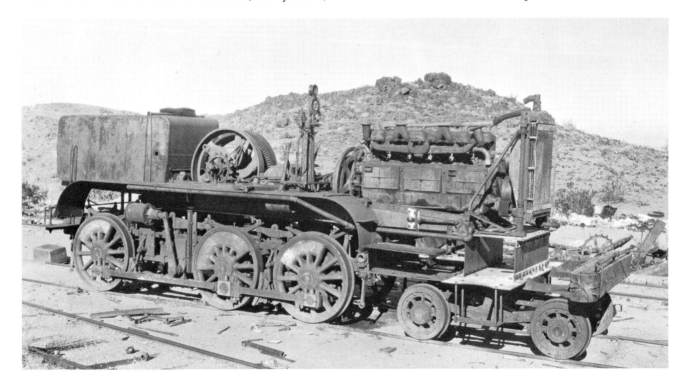

ty, all ores being treated at the cyanide mills in Barstow. From 1904 to 1910 gold production alone tallied $4,500,000, while of the county's total recorded production during the 70 years through 1950, one-half (or $6,000,000) came from this one mine. It was a truly remarkable performance, considering the number of mines in the county.

In 1910 control of the property passed to Frank Keith, Seeley W. Mudd and others at the suggestion of John Hays Hammond, the eminent mining engineer. For the next six years the property was operated as the Pacific Mines Corporation. Every day approximately 100 tons of ore went out over the little railroad to Ludlow, thence eastward via the Santa Fe to the United Verde smelter at Clarkdale, Arizona. But Hammond lost interest in the venture when petroleum prospects drew him to Mexico; the property went into receivership; and the mines lay idle for a period of approximately 15 years. In 1916 the Ludlow & Southern ceased operations as a common carrier.

Toward the latter part of 1932, while the railroad was standing idle, gasoline vapors in the engine house caught fire and the resulting conflagration virtually destroyed the building. Sitting on the track in the midst of the blaze, the ex-Tonopah & Goldfield switcher lost its wooden cab and was otherwise badly scorched. Spared from the holocaust was the frame and running gear of the ex-New York Central (4-6-0) 10-wheeler standing in the yard outside. As a substitute item of motive power, the latter was useless for its boiler and superstructures had been removed in a futile attempt to improvise a makeshift drive powered by a Holt gasoline tractor engine. For unknown reasons, work had been stopped before the job was completed.

Ultimately Frank Royer, formerly the mining advisor, was able to lease the property to others who operated it over a period of years. In the course of business, occasional trips to Los Angeles were necessary. Transportation was effected by running a "speeder" over the rails to Ludlow where connections were made with a Santa Fe train. To this end, the railroad was maintained in a reasonable condition until 1931.

Some time after the mine had closed down, the caretaker, yearning for the bright lights of the city, came down to Ludlow on the speeder and caught the Santa Fe for Los Angeles. Before his departure, he carefully removed and hid the spark plugs to thwart any unauthorized use of his motor car. While the caretaker was in Los Angeles, Jack and Vernie Sherraden, long-time Ludlow residents, hankered for an evening's ride to Rochester. With the aid of a flashlight, Jack found the plugs and off they went. The trip was enjoyable and was never suspected by the caretaker, for Jack was careful to leave the car in the same position as before and to return the plugs to their secret hiding place.

Being a mining railroad operation, the Ludlow & Southern never was given meticulous consideration. Originally the tracks had been laid in a gully with the expectation that they would be washed out every year, consequently no one was surprised when this happened. About 1932 a particularly heavy cloudburst took out virtually a mile of track, and no one bothered to repair it. The railroad remained idle over the years. In the summer of 1935, Botsford and Smith of San Francisco took up the rails; it is believed that they were sent to a sugar plantation in the Philippines.

In 1937 the locomotives were cut up for junk, although the tenders remained intact for another 20 years. The old passenger coach, sitting on the ground about a mile north of the mine, was consumed by fire in the fall of 1939. In such fashion the L&S quietly passed out of the picture, no one being able, specifically, to attach a date to its demise.

The mine continued to outlive the railroad for some time. In later years it went through a series of corporate name changes, and during World War II it was one of four gold mines in California to be allowed to operate due to the siliceous nature of its ores as a useful flux in smelting. Donald Love took over the lease from Frank Royer, and operated the mine until 1954, at which time it was closed down. Whether it will ever be operated again, to the ghosts of the Ludlow & Southern, is purely a matter for conjecture.

Amboy—Saltus

Amboy — Bristol Lake

Along the Santa Fe's main line near the middle of the Mojave Desert and virtually equidistant from Barstow and Needles, California, is the station of Amboy. Nearby is the well-known landmark, the extinct volcanic cone called the Amboy Crater, although possibly even greater fame attends the area's renowned summer heat which frequently reaches temperatures exceeding 120°. Amboy to-

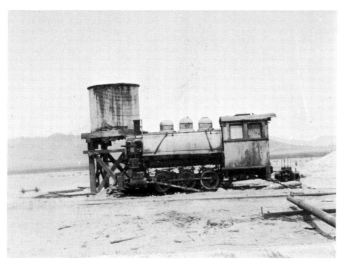

The narrow gauge 0-6-0-T saddle-tank locomotive with the over-sized air pump mounted on her smokebox came from Arden at the time that the U. S. Gypsum Company purchased that property and the Consolidated Pacific Cement Plaster Co. at Amboy in 1919. Shown here at the water tank near the Funston plant, it proved too heavy for the light rails of the former mule-powered railroad and had to be retired.

The corrosive action of salt on metal coupled with the pulsating vibrations of washboard roads in the Bristol Lake area rapidly reduced this Model T to its barest essentials.

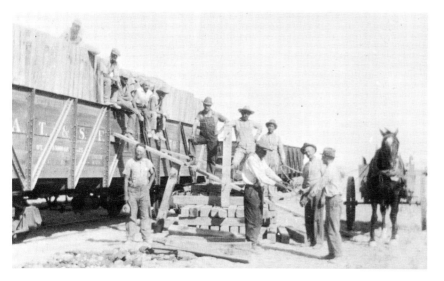

The Amboy gypsum mill *(bottom)* was an installation of no mean proportions at the height of its operations around 1914. Still, when the plant and railroad were dismantled *(left)*, a strange method must have been devised for removal of the railroad's rails without disturbing the spikes in the ties. *(Bottom: U. S. Geological Survey; all others: W. H. Robison Collection.)*

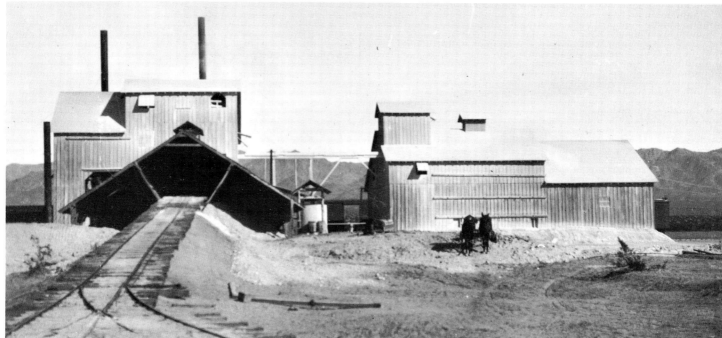

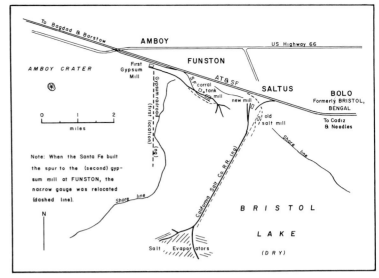

day is also a highway stop, complete with gasoline stations, restaurants and motels. Virtually no indication exists that once this was the terminus of a narrow gauge industrial railroad which operated for a score of years in the early 1900's.

One of the prime circumstances for Amboy's existence stemmed from the presence (to the south and east) of Bristol Lake, ordinarily dry and producing from time to time the most fabulous mirages. More valuable and more concrete production, however, was derived from the large deposits of salt and gypsum in the lake bed, which later measured approximately 10 miles across in length or breadth near its mid-point. Over the years a number of companies engaged in the business of recovering either of the two products, and in the course of their operations two separate railroads were built. The first of these, connecting from Amboy, was used to haul gypsum.

As a hydrous calcium sulfate, gypsum is a very common mineral, normally formed by the action of sulphate waters on limestone or by the evaporation of calcium-sulphate waters. Commercial or rock gypsum is largely used in the manufacture of plaster wallboard, plaster of Paris and cement, while the basic product is also used as a dressing for soils, particularly in California. Sculptors, on the other hand, prefer the fine-grained white, and frequently translucent, form of gypsum called alabaster.

Details of the early history of gypsum quarrying are not known, although it has been reported that the mineral was found here as a by-product of the operation of drilling prospecting holes for salt. The method of quarrying largely consisted of plowing and scraping the overburden to one side, then scraping the gypsum into piles for loading into animal-drawn cars which were hauled to the mill. At the mill the gypsum was crushed and washed to remove the dirt and salt accompanying the quarrying operation.

The Pacific Cement Plaster Company built a mill at Amboy as early as 1904 and commenced operations the following year. To feed the mill, a narrow gauge track about 1½ miles long was strung south to the gypsum beds in Bristol Lake, and mules were used to pull the loaded cars to the mill and return the empties to the quarry. By April 1909 when the property was sold to the Consolidated Pacific Cement Plaster Co., the inventory included seven head of mules complete with harnesses; six five-ton, all-steel dump cars; two two-ton, wooden, dump cars; and 2¼ miles of 36-inch gauge railway.

About 1913 the mules were replaced by a small steam locomotive, and the narrow gauge track was relocated. Instead of reaching south from Amboy, it was rebuilt in a southeasterly direction, almost paralleling the Santa Fe's main line, for a distance of approximately three miles to a new quarry site near Saltus. Three years later (in 1916) other changes came about. A new mill was erected nearer the mid-point of the little line and closer to the gypsum deposits, while the Santa Fe installed a half-mile spur to service the new installation. The name of the point of junction of the spur with the Santa Fe's main line remained undecided until one day in February 1917 when the train crew came in with the news that General Funston was dead. The General was well-known for his earlier military successes in the Philippines, later as general-in-charge of the military forces in San Francisco following the fire of 1906, and most recently engaged in chasing Pancho Villa in Mexico. The immediate selection of the hero's name for that of the new station was spontaneous and most logical.

The old mill at Amboy fell into disuse, but not so the railroad. Although extensive track rearrangement was required at the new mill to avoid a crossing with the Santa Fe's spur, connection with the line to Amboy was maintained. The problem was one of logistics. The only available living accommodations were located at Amboy, and the men were obliged to commute to their work at the mill or the quarry each day. Since wagons were deemed to be too slow a method of transportation to take the men to their jobs, a "commute" train was operated solely for this purpose. At first the locomotive was tied up at Funston each night, the locomotive facilities being installed at that point near the mill. A study of the situation revealed that this was impractical. Not only did it entail an extra round trip for the locomotive between the mill and Amboy

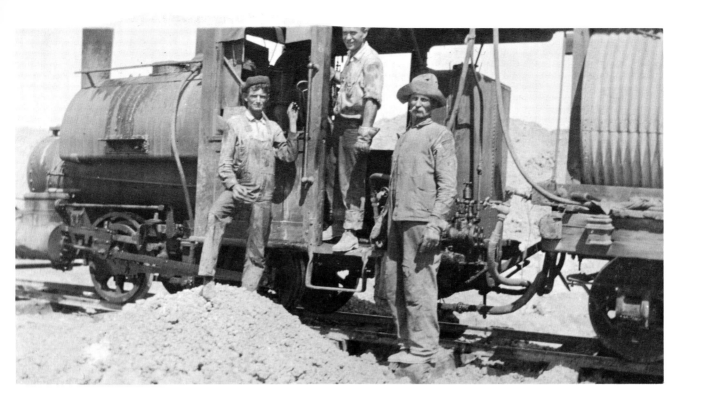

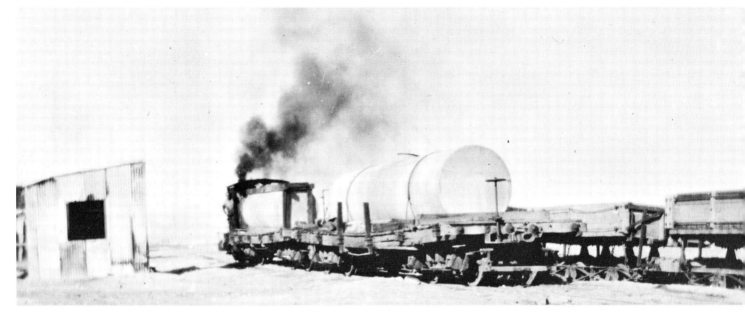

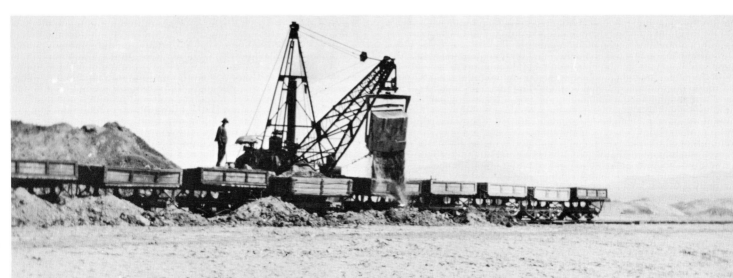

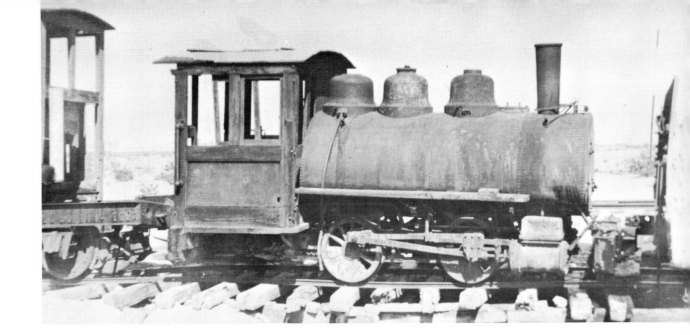

The narrow gauge railway at Saltus of the 1920's was a hand-me-down from predecessors to the California Rock Salt Company. Little Porter saddle-tank locomotives pulled a motley assortment of decadent link-and-pin equipment which eventually could be repaired no longer. The shack *(far left, center)* was one of the "living quarters" previously furnished to the workmen at the quarry site. The steam drag line *(bottom, left)* was mounted on skids and had to be pulled to each succeeding new location as the loading work progressed. W. H. Robison, provider of these pictures, is shown *(near left)* with the company's pioneer power drilling machine of 1921 vintage. His father, man with handle bar mustache *(top, left)*, also worked on the railroad.

The salt works operation prospered and grew over the years. By 1963 *(below)* Plymouth locomotives had replaced the steamers, and a heavily graded, tie-plated railroad connected the quarry and the mill. *(Top: A. Miller photo, R. P. Middlebrook Collection; all others except bottom: W. H. Robison photos.)*

each day, but it also involved a round trip by foot for the unlucky fireman who had to call for and leave his iron steed at the remote location. Moreover, it was difficult to find a fireman willing to arise at the screech of dawn each morning to walk a mile or two to raise steam in the boiler before starting on the daily rounds of train service. To circumvent the situation, arrangements were made to tie up the locomotive at Amboy each night, providing a welcome half hour of extended sleep for the weary fireman.

Just a month after acquiring the Arden Plaster Company near Las Vegas, the United States Gypsum Company purchased the properties of Consolidated Pacific Cement Plaster Co., at Amboy on September 2, 1919. Once again more changes were initiated. The track between Amboy and Funston was removed and, as part of the new arrangements, a larger locomotive was brought down from Arden. Unfortunately it was found to be too heavy for the light rails of the little line and had to be retired. The original locomotive was revitalized and continued to give service for several more years.

Operations of the property continued until 1924. Then the U. S. Gypsum Company closed the (Amboy) Funston plant completely and moved the facilities to Midland (Riverside County), California, at a point on the Blythe-Ripley branch of the Santa Fe near the Colorado River (about half way between Needles and Yuma). There a short (1½-mile) railroad was reassembled from the old components, and a gasoline locomotive was imported to furnish the motive power.

Except for the old grade, there is little to be found at Amboy today to suggest the formerly busy operation of the gypsum quarry, mill and connecting railroad. Bristol Lake lies to the southeast and, from time to time, still produces its fabulous mirages. The gypsum railroad will never be a part of them.

Saltus — Bristol Lake

A number of companies held claims on Bristol Lake from which salt was produced, but of them all only one is on record as having constructed and operated a railroad. Today's successor to the property is called the California Salt Company (affiliated with the Leslie Salt Company), but the history of the organization can be traced back over a period of more than 50 years and some five different corporate titles.

The first of these five entities was called the Crystal Salt Company. In the 1880-90 decade, the firm was operating a quarry at Danby Lake, to the southeast of Bristol Lake below the (A&P) Santa Fe's main line. Wagon loads of salt drawn by steam traction engines were used to bridge the 30 miles of sandy trails between the quarry and the railroad station of Danby. Here the output was shipped (largely) to the mills at Calico for use in the reduction of the silver ores.

The decline of Calico apparently adversely affected the company's operations, but it managed to survive to take a new lease on life. In 1909 the Crystal Salt Company was reported to be producing salt from Bristol Lake, and the following year (1910) a mill was built at a location called Saltus on the Santa Fe's main line just east of Amboy. Shortly thereafter a narrow gauge railroad was constructed from the quarry in the lake bed to the mill.

The act of quarrying involved removal of the overburden (four feet thick in 1913), then drilling holes and inserting dynamite to blast the salt bed. The resultant large chunks of rock salt were loaded into little railway cars for the trip to the processing plant where washing and grinding were accomplished. Water for the washing operation was obtained from wells on the property which, although too briney for domestic consumption, were sufficiently adaptable to the commercial usage. Domestic water for human consumption was brought in by Santa Fe Railroad tank car from Newberry Springs (a procedure which still pertains in 1963 for such towns as Amboy and Ludlow).

Judging by results, the early operations were not too successful financially. In 1916 the Consumer's Salt Company took over the property. Two years later the Pacific Rock Salt Company leased the operation, and in 1920 that company built a new plant. The following year (1921) the lease was transferred to the California Rock Salt Company and production was boosted. Full title to the leased property was acquired by the latter company in 1927, and it continued under the same guise until 1950 when the name was shortened to the present California Salt Company.

In the early 1920's men lived at the quarry on Bristol Lake, but under conditions which hardly could be described as elegant. Water was brought to their camp by train in a homemade tank car fashioned from a large section of corrugated iron pipe. In the absence of electricity, no ice was available, with the result that the temperature of the drinking water followed that of the seasons — extremely hot in summer and extremely cold in win-

ter. Virtually the same conditions prevailed in the sheet-iron shacks which the men were offered for housing at that remote location.

Over the years the little railroad continued to operate between the quarry and the mill. Motive power for hauling the diminutive salt cars was a small, saddle-tank locomotive. When the firebox eventually became broken and was deemed unsuitable for repair, another locomotive of the same type was acquired. Around 1924, when the Amboy-Funston gypsum plant was closed, William H. Robison, engineer for that narrow gauge, joined the salt company to handle the throttle on the Saltus-Bristol Lake line. In the late 1920's, the second of the tank locomotives became worn out, and Plymouth gasoline engines were acquired to power the trains.

Construction of a new plant at Saltus about the time of World War II necessitated the relocation of the Santa Fe's spur as well as a general reshuffling of the narrow gauge's yard track. At the same time the little railroad's main line was completely rebuilt to heavier standards. To avoid disrupting traffic, a new main, parallel to and some 20 feet west of the old main, was installed on heavier roadbed, fresh ties and tie plates to protect against excessive wear from the heavier traffic. For salt production was increased during the war to meet the needs of Basic Magnesium's plant at Henderson (near Las Vegas), Nevada.

The railroad is still actively operated today. Four Plymouth gasoline engines are kept busy bringing trains of 20 or more cars of rock salt from the quarry to the washer and crusher. The main line from the mill to the switch near the quarry is approximately four miles in length, while the tail tracks to various locations in the quarry bed extend for several additional miles. Accurate mileage figures are non-existent as the quarry tracks are frequently changed to accommodate each new center of activity. Production has been steady, the total probably amounts to a figure somewhat in excess of 2,000,000 tons of salt. With an assured supply and a ready market, the salt works and its little railroad appear to have a busy future ahead.

(Wm. E. Ver Planck photo.)

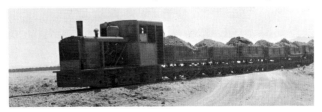

Nevada Southern Railway

Of all the multifarious names for Nevada railroad projects, either proposed or built in the state, the one which stands out most prominently and most frequently is "Nevada Southern." Strange, then, to relate that of all the railroads selecting this appellation for its title, only one ever reached the stage of actual construction and operation — and that one never touched Nevada soil.

The instigation for this Nevada Southern Railway evolved from the lengthy series of early mining camps which stemmed from the New York Mountains in southeastern California and stretched northeasterly in scattered profusion across California and Nevada all the way to Pioche near the Nevada-Utah state line. Old Ivanpah, California, for example, located on the eastern slope of Clarke Mountain, dated back to an 1865 founding and boomed in 1875 to a population of some 500 hardy souls. Virtually equidistant on the far side of the state line in Nevada lay Goodsprings in the heart of the Yellow Pine Mining District. Just short of the lucrative objective of Pioche another promising mining camp arose — first called Monkey Wrench, it passed through several transmutations before adopting the more permanent title of Delamar (see chapter on Pioche). The over-all pathway outlined by this sequence of camps roughly approximates the route of the Union Pacific Railroad of today, but in the early 1890's the territory was destitute of transportation other than by burro or the ubiquitous wagon team.

Isaac C. Blake, a Denver mining man, was one of the first to foresee the possibilities for developing the area in the early 1890's. If Needles, California, could be built into an ore milling center (using Colorado River water), the products of these neighboring mines could be funneled into Needles to the benefit of all. Needles was the hub of such transportation as was available at the time — Colorado River steamers ran both up and down-stream from its wharves; the A&P maintained its division terminal at Needles with service to east and west; other railroads, one from San Diego and one from Salt Lake City, were contemplating building to the center to form a blanket network of

transportation to service the entire surrounding area.

To complete the picture, Blake proposed to construct his own Nevada Southern Railway to tap the mines to the north of Needles, both in California and in Nevada. There was ample encouragement for such a project. In March 1892, for example, good reports were coming in from the Ibex Mine, 11 miles to the west, which had been purchased only the year before by P. K. Klinefelter. The prospects of additional ore tonnage had already prompted the A&P to add a new station to its original alphabetical listing. Expansion was in the air.

As part of the general scheme, Blake built a mill at Needles under the name of the Needles Reduction Company. Associated with him in the enterprise was Warren G. Purdy, then vice-president (and later president) of the Chicago, Rock Island & Pacific Railway Co. Thus on April 22, 1892, when the first run of the new property was made, it was not unexpected that both Purdy and his daughter, Fanny, were on hand to witness the event. For the town of Needles, the inauguration was a highlight of history, and miners from far in the hinterlands joined with the townspeople to witness the ceremonies.

At 3:00 P.M. steam from the boiler was admitted to the piping system; the machinery was started; and Supt. Morgan placed a sack of ore near the hopper of the crusher. Gallantly handing Miss Purdy a shovel, Morgan stepped aside while Fanny fed the contents of the sack into the crusher. People then watched while 12 more sacks of ore from Dan O'Leary's "up-the-river" mine were fed to the machinery, and in short order the ore was ground to powder. Since Dan's ore was knowledgeably considered to be the hardest rock in the area, the success of the experiment effectively removed any doubts concerning the efficiency of the new mill.

The success of the Needles Reduction Company enterprise, coupled with the good reports emanating from the new camp of Monkey Wrench and from Yellow Pine, stimulated Blake to further action. In December 1892 he confidently discussed his proposals with Samuel Godbe, a substantial mining operator with interests in Pioche as well as at Yellow Pine. The expressed intent was to have the first 30 miles of Nevada Southern Railway (from Goffs, on the Santa Fe, north to the New York Mining District) in operation by the end of January. Just how a 30-mile railroad was to be constructed in a scant two, short months was not revealed, but Godbe's backing and business were

earnestly solicited, and on December 15, 1892, the Nevada Southern Railway Company was incorporated under the laws of Colorado.

Blake called Godbe's attention to the beneficent circumstance that the wagon-hauls of ore from the latter's mill at Goodsprings to the new railhead in the New York Mountains would be 30 miles shorter than at present. He also implanted the hopeful thought that if Godbe could guarantee daily shipments of 200 tons of ore, the railroad would blithely continue construction right to his loading bins at Goodsprings. Quite possibly Blake fully expected to build to Goodsprings, either because of or in spite of Godbe's interest, for a March 1893 report revealed that he had purchased a quarter interest in the Keystone Mine from one C. O. Perry.

Theory and practicality were horses of two different colors, as Blake sadly found out. Actual work on the Nevada Southern did not commence until January 1893, and it was to be many months before the line could be placed in operation in spite of the initial light grading and ease of construction. By January 22, the 60 teams and 100 men put on the job had succeeded in throwing up only 12 miles of grade; material shortages had delayed the progress of the work; and all supplies, particularly water, had to be hauled in from Needles. On top of everything else, financing of the project proved to be difficult. The backing of the mine owners just did not come up to expectations. Blake finally evolved a formula whereby he constructed 10 miles of railroad, then mortgaged it heavily and used the proceeds to build the next section.

By March 1893 the first 30 miles of grading under contract were essentially completed, bringing the line to the top of the notch in the New York Mountains at a place which Blake unctuously named Manvel, for the boss of the Santa Fe. In turn, the Santa Fe reciprocated by changing the name of the station at the junction with the SF's main line from Goffs to Blake. Neither name survived the test of time, for when the Santa Fe took over the former Nevada Southern in 1902, the station at Manvel (sometimes confused with a station of the same name just south of Houston, Texas) was changed to Barnwell, and the junction at Blake reverted back to its original name of Goffs.

Immediately beyond the railhead of Manvel and down the north slope of the New York Mountains lay the young mining center of Vanderbilt. Its existence stemmed from the discovery of gold by an Indian named Bob Black only two years previous (in 1891) together with the location of the "great

Beatty Lode" by M. M. Beatty, the man who later achieved more lasting fame when his ranch near Rhyolite, Nevada, developed into a railroad terminal and town which bore his name. Vanderbilt received its main impetus when people flocked to the area following the rich strike made by a Mr. Taggart. In March 1893, as the Nevada Southern grade was approaching the edge of the mesa a few miles above the camp, the town consisted of about a dozen tents, of which one was a lodging house, another a general store, a third a Chinese laundry, while two others not unexpectedly became saloons. Of the 200 men in the area, only 20 were regularly employed — a contrast to the activity near the old New York lead-silver mine just six miles to the southwest where 80 men were reported to be on the payroll.

As the boom continued, people from the diminishingly productive camps of Providence and Ivanpah drifted into town. Proud cognizance was taken by local citizens of its newspaper, the *Vanderbilt Shaft*; subvertly concealed was any mention of the total lack of water facilities in the camp, all quantities of that precious liquid being imported from other localities. In recollecting back over a period of 66 years, pioneer O. J. Fisk recalls his arrival at Vanderbilt in the fall of 1891, the hardships of that early life, and the personal compulsion at one point of taking a 75-mile trip to Tecopa for the exclusive purpose of bathing in that resort's hot springs.

With interest at Vanderbilt centering upon the approaching railroad, numerous stories began to circulate about the Nevada Southern. Some contended that the line was part of the Utah Southern system (UP), while others rationalized its connection with westward plans of the Missouri Pacific. When Blake purchased the New York mine, one of the larger, low-grade producers in the area, local gossips attributed the act to an attempt to establish tonnage for his railroad. Perhaps the allegation was true. Although undoubtedly there was some friendly outside encouragement of sorts for the railroad project; still, when the chips were down and money was needed, none turned out to back the little line.

By June 1893 the railroad had been opened as far as Purdy, the third town to be named after a railroad official (as well as Blake's partner in Needles Reduction Co.), and the next five miles to Manvel were completed the following month. Some records indicate that the road was first operated on September 15, 1893, but whether this later dating amounts to a technical distinction has not been as-

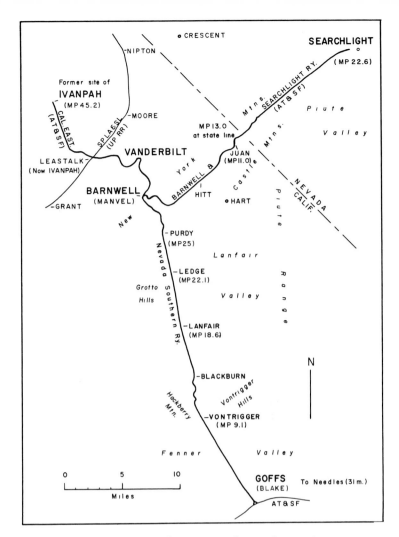

certained. The railhead at Manvel was located at the top of the mesa, virtually in the mouth of the notch through the mountains to Vanderbilt. For eight years a partly completed cut marked the spot where work was abruptly halted. Today an auto road utilizes the facility.

The riches of Vanderbilt, California, failed to live up to those of its namesake financier in the eastern part of the country. A number of affluent westerners — including Mackay and Hagin & Tevis, among others — were mentioned as purchasers of mines in the area, but any sales of property to the latter pair were never consumated. By September 1893 a quietude had settled upon the camp, and only a few men were working for wages. In spite of Blake's contentions to the contrary, the same situation prevailed upon the railroad.

For Vanderbilt's disappointments were weighing heavily upon the Nevada Southern, and expansion appeared to be the only salvation for the line. Blake contended that he had sufficient funds to extend the road to Goodsprings, but Godbe and others in the Pioche area were bending every effort to attract the line still farther to that locality. In

fact, a rousing Saturday night meeting, complete with speakers, was arranged in Pioche. The program ended with a resolution extending the hand of friendship and promising the heartiest cooperation and support — but no concrete mention was made of the thousands of dollars so necessary to enable the closing of the 200-mile gap in distance.

Turning in the other direction, Blake and C. Mulholland attempted to raise $80,000 for the railroad from the people in Southern California. A mass meeting held in Pasadena, described as "enthusiastic" (although wallets remained closed), prompted people in San Bernardino to request a similar meeting. Finally, shortly before Christmas 1893, some Los Angeles business houses pledged a sum total of $40,000 — one-half the desired amount.

In an attempt to whip up enthusiasm for the project throughout the area to be served, it was announced that work would go ahead on the railroad, and a large map was filed with the County Recorder at Pioche showing the then projected lines of Blake's road. Starting from Goffs, the line headed north through Manvel, passed east of Goodsprings (which was to be served by a branch), continued through Las Vegas and Muddy Valleys, passed east of Meadow Valley, thence on to St. George and the coal fields at Cedar City, Utah. Pioche was to be served by a branch, while another branch was projected to leave the main line at Vanderbilt and head north to Ash Meadows along the eastern fringe of Death Valley.

That these were but "champagne plans" based on a "beer pocketbook" became more evident as the year 1894 progressed. Instead of extending its lines in accordance with its expansive projections, the Nevada Southern was having greater and greater difficulty in finding traffic for its trains. The early reports from the region sounded promising enough. The *Vanderbilt Shaft*, for example, printed the story of the late evening blast at the Gold Bronze which created much excitement when it opened up a cave of free gold. A few weeks later the same paper carried another startling item that W. F. McAdams, the genial foreman of Campbell's Boomerang Mine, had almost fainted upon going to the 260-foot level and finding a rich vein over three feet wide. Both the Gold Bronze and the Boomerang mines were erecting small mills early in 1894, and still a third was under contemplation. Notwithstanding the comforting talk of new mills and surprising discoveries, most mining was not going at all well in Vanderbilt, and traffic was failing. As the times became more strenuous, the Ne-

vada Southern suffered accordingly. Beginning on February 13, 1894, the sheriff took over operations of the railroad.

Faced with these disheartening turns of events, Blake continued to propound his favorite project. In April 1894, after inspecting the Meadow Valley Wash, he joined with Sam Godbe and Capt. De Lamar and went over to Ferguson (Delamar) for a conference, the details of which were never disclosed. The results, though, were evident in September 1894 when Godbe (a "large" stockholder in the railroad) said that the Nevada Southern would be extended to Milford, Utah. Considering the after effects of the depression through which the entire nation was floundering at the time, and considering that the UP had been unable to finance its own extension of the OSL&UN from Milford south to Los Angeles, the boldness of Godbe's announcement was somewhat surprising.

Part of the plan was based upon the formation of a Utah Nevada Company, capitalized at $6,000,-000, to hold in trust the properties of the Pioche Consolidated (Godbe), the Keystone Consolidated (Godbe's mine near Goodsprings), the Gladiator Mining Company (Blake's property) and others. The report further stated that "the railroad has $2 million on hand for a starter, and the rest of the funds are provided for" — a very comforting statement in a depression year. For some inexplicable reason, the funds somehow became unavailable (as did Capt. De Lamar's reported backing), and Blake's own financial difficulties brought the house of cards a-tumbling down.

E. R. Woodbury promptly attached the railroad for $35,700 while Henry W. Dillon sought ways to recoup his $5,000. Woodbury apparently had many other fingers in the pie and obtained attachments on several of Blake's other properties: $30,000 on the Gladiator Mining Co. and $53,000 on the Needles Reduction Co. A receiver took the railroad over from the sheriff on December 23, 1894, and continued to operate it pending settlement of the problems of the situation. Even Godbe did not escape unscathed — a receiver took possession of his mine at Yellow Pine in June 1895, and ultimately the mine was closed in 1897.

Out of the shambles emerged a brand new California Eastern Railway, organized in 1895 by R. W. Woodbury and R. S. Siebert, former general manager of the Nevada Southern, to purchase the properties of that bankrupt road. Operations of the line continued in desultory fashion until just before the turn of the century when the Copper World Mine

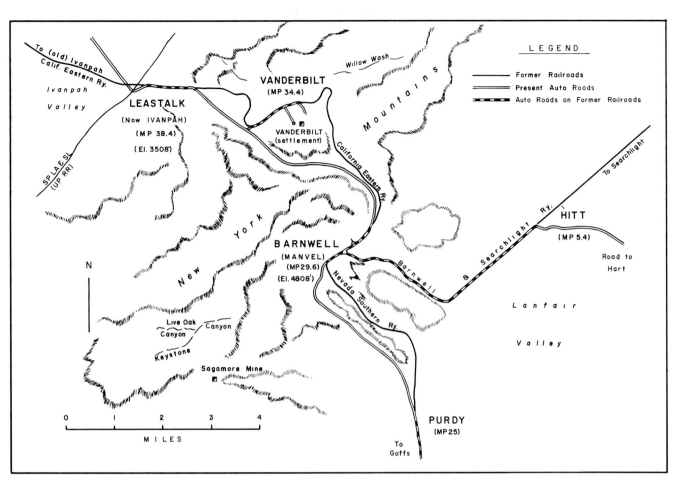

(Ivanpah Copper Co.) became active. Ores from this new operation were teamed five miles across the desert to the smelter at Valley Wells, located 35 miles northwest of the California Eastern rail-head at Manvel. Encouraged by news of the new smelter down at Needles then being installed the mine owners cast about for some way to shorten the 16-mile wagon haul and heavy teaming required to lift the ores up the 2,000-foot climb from the valley floor to the CE railhead at Manvel. They persuaded the railroad to extend its line down the steep canyon, around the horseshoe curve past Vanderbilt, thence out on the flat Ivanpah Valley to the north.

It was the Santa Fe that loaned the California Eastern the necessary funds to proceed with construction of the extension, taking a 49% stock interest in the road in return. The construction contract was awarded to Bright & Crandel of San Bernardino in April 1901, and Mojave Indians, sometimes numbering as high as 150, did all the grading by hand with only occasional assistance from low-grade glycerine powder. A year later the line was

finished to Ivanpah station (15 miles south of Old Ivanpah), and 25-30 people settled at the new terminus to eek out a subsistence through operation of the several stores which catered to the needs of the mine owners. Although the railroad was projected and surveyed as far as Goodsprings, 30 miles farther north, no construction was ever attempted on that extension.

Subsequently the Santa Fe purchased the remaining (51%) of the stock of the California Eastern and after July 1, 1902, operations of the line were conducted by that road. Mining activity in the Vanderbilt-Ivanpah-Goodsprings area continued for some years, and for a time in 1904 it appeared that traffic would be considerably augmented by additional business from "Borax" Smith's rock-base wagon road from Ivanpah north to his Lila C. mine on the eastern edge of Death Valley. Smith's traction engine failed on its initial trip; then the CE's virtual monopoly of local transportation was broken in 1905 with completion of the UP's Salt Lake Route (SP, LA&SL), which largely followed the originally projected extension of the

Goffs, 31 miles west of Needles, at one time boasted a turntable and other requisite facilities for handling helper engines up the hill from the Colorado River. More importantly, it became the junction point in 1893 for the ill-fated, misnamed Nevada Southern Railway which expired within a short 30 years. The semi-expansive facilities, shown *(top, left)* in 1946, were torn down 10 years later. *(Phillips C. Kauke photo.)*

Most Nevada Southern construction encountered no difficulties and largely followed a reasonably straight course. This trestle *(center, left)* on the connecting Searchlight branch between Hitt and Juan was one of the more troublesome spots. *(Phillips C. Kauke photo.)*

Manvel *(below and top, right)* was end of the line for the Nevada Southern until 1901-02, at which time the railroad, now the California Eastern, pushed its line (with Santa Fe backing) through the notch in the New York Mountains and down the hill into the Ivanpah Valley. At the same time, the town's name was changed to Barnwell. *(Both photos: Barbara Brown.)*

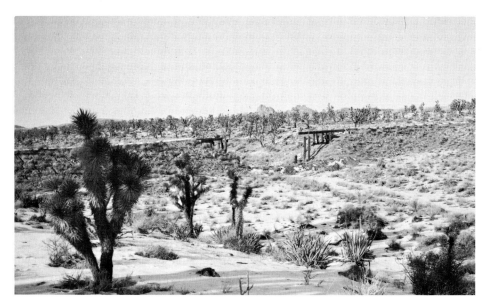

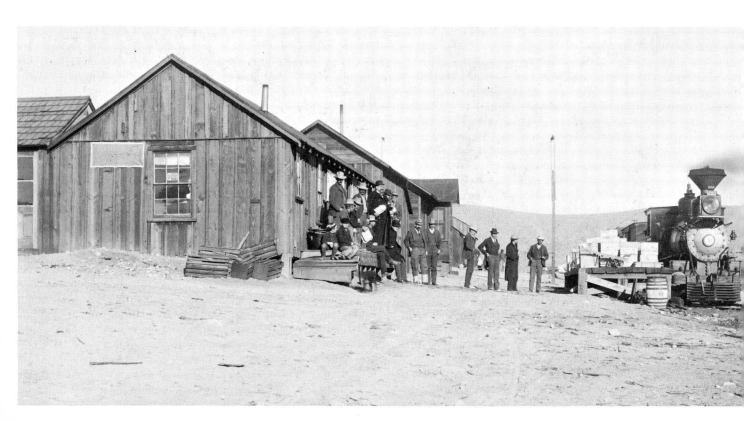

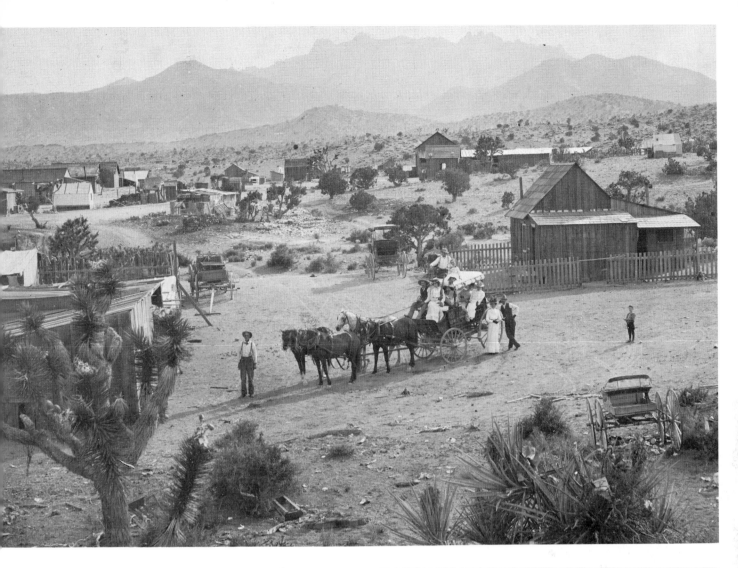

At Ivanpah, shown *(right)* on the Salt Lake Route, all traces of the former crossing with the California Eastern have disappeared. The Darling Mine *(below)* at Vanderbilt in the New York Mountains continued to operate until recently although the railroad which once served the district has long been gone.

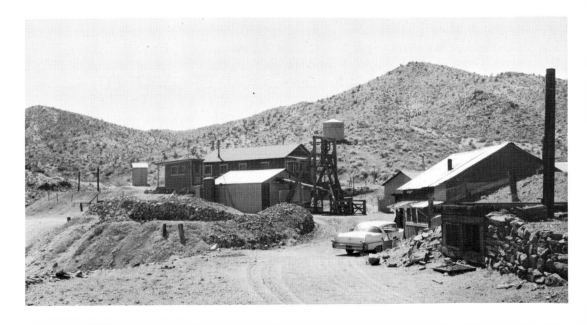

Nevada Southern. To top it off, completion of the Las Vegas & Tonopah and the Tonopah & Tidewater railroads (1905-07) effectively siphoned away any hopes for additional traffic from the north.

Thus a large portion of the CE's limited traffic was gradually diverted to newer and more convenient transportation systems. As a partial compensation for the loss, the Santa Fe built (in 1906-07) the Barnwell & Searchlight Railway (see chapter on Searchlight), but the anticipated volume of business failed to develop and operating results proved to be negligible.

Leastalk was the name given to the point of crossing between the California Eastern and the Salt Lake Route, upon completion of the latter road. In the natural course of events, the name subsequently was changed to South Ivanpah as being more accurately descriptive; and the title remained until February 1, 1918, when, following demise of the CE railhead of Ivanpah, the UP conveniently dropped the word "South" from its station name to leave Ivanpah — the third such location of the same name.

Weekly CE train service over the South Ivanpah crossing and up the valley to Ivanpah was provided up to 1913. Running time over the 15-mile northern extension (Barnwell-Ivanpah) was a complete, leisurely one full hour. After 1913 the seven miles of track from the Salt Lake Route crossing north to the terminal at Ivanpah were not used; instead weekly train service extended only to the crossing point at South Ivanpah until 1918. For the next three years "on call" service was provided to the crossing out of Barnwell until, on March 10, 1921, abandonment of the entire northern extension (Barnwell to Ivanpah) was authorized by the I. C. C.

Strikes and washouts plagued the California Eastern's abbreviated main line in the summer of 1921. The following year the word circulated that the Santa Fe was thinking of abandoning the remainder of its ill-fated branch. Severe washouts in 1923 clinched the decision, and abandonment of the entire line (including the branch to Searchlight) was accomplished in that year. Thus the "out of state" railroad came to an ignominious end with nary a mourner. Blake's dreams of empire had blown away, much as the storms of the desert dissipate their energies on the drifting sands.

Searchlight and Its Railroads

Down in the southern tip of Nevada, south of Las Vegas and Boulder City, lies El Dorado Canyon, the scene of considerable mining activity in 1857 and even before. Twenty miles farther south and high on the west side of the Colorado River in the El Dorado Mountains lies Searchlight, a later lucrative mining area, though hardly the glowing beacon its name appears to suggest. Initial discoveries of predominantly gold ore were first made at this location on May 6, 1897.

The IXL Claim was the first to be filed by G. F. Colton; later this became the Duplex Mine which was located to the south of the town proper. Immediately beyond was the Good Hope Mine, and to the south of that was the famed Quartette Mine, largest in the district, which was first explored in 1898. Of the other less exalted properties, the Cyrus Noble Mine was notorious in that its ownership was the result of a happy trade of a bottle of whiskey for a mining claim.

How did Searchlight obtain its name? Many and varied are the origins attributed to the appellation. Some contend that it was the brand name from a box of matches; others bespeak of a man named Lloyd Searchlight; still others prefer the axiom of the chance remark of a discouraged prospector just before making a find — "If there is any gold around here, you'll need a searchlight to find it!"

The Quartette Mining Company became the bellwether and mainstay of the Searchlight District. Col. C. W. Hopkins formed the company in 1900 as a combination of the Quartette, Boston and Chief of Hills mines. The property was developed, and in May 1901 an announcement was made that the Quartette would build a 16-mile narrow gauge railroad easterly from its mines down the hill to the Colorado River where the company's mill, utilizing river water, was located. The proposed innovation made startling news for the gossips of the region who hastily spread and amplified the subject, eventually causing a slightly jealous editor in far-off Pioche (whose town still had no outside rail connection) to jeer editorially: "And we suppose in the near future, a line of ocean steamers will be run in connection with the railroad for the purpose

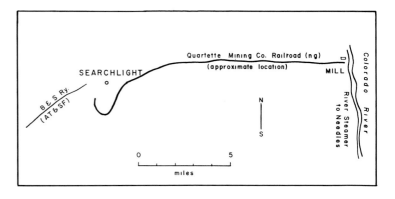

of conveying gold bars from the river mills to Boston and beans back to Searchlight."

The project, however, was not as ethereal as many liked to imagine. Following a short period for organizational and other preliminary work, Col. F. W. Dunn, a veteran railroader then in charge of the mine, announced that grading would begin on November 1, 1901. The excitement stimulated further talk that the Santa Fe would build into the camp from the south, as well as the prospective construction of an independent line which presumably was being surveyed north from Ibex, a station on the Santa Fe west of Needles.

Construction of the grade of the Quartette Mining Company's railroad was easy; not so the forgathering of rails and equipment on location. When the 18-ton locomotive, the mine cars and a supply of rails were delivered at Needles, they were placed aboard a barge to be towed up the Colorado River to the railhead. Within sight of its destination, the barge frustratingly and inconveniently became lodged on a sand bar, and three months of fussing and fuming at extrication were to no avail. It was only when high water returned to permit refloatation that the barge was effectively removed from its predicament and moored at the proper landing on February 12, 1902. A lesson had been learned. To avoid a recurrence of the trouble, the next shipment of rails was delivered via the Santa Fe's (Nevada Southern) California Eastern branch to Manvel and then hauled by teams over the remaining miles to town.

By the early part of March 1902 some six miles of rails had been spiked in place and the locomotive was activated for use in hauling construction materials and supplies. Mechanical foresight was amply demonstrated in that the engine was reportedly capable of burning either oil or wood interchangeably for fuel. At the Searchlight end of the line, oil could have been provided if necessary, but along the riverbank near the mill, Colorado River driftwood was abundantly available. When the line was finally opened in the middle of May 1902, the locomotive easily completed two round trips daily over the 16-mile main stem, taking ore down to the 20-stamp mill and bringing back supplies for the town whenever a boat docked at the river front wharf. As a matter of precautionary safety, the locomotive was never turned, being constantly headed toward Searchlight. This kept the firebox and crown sheet on the downhill side (toward the river) as a guarantee that, in the event of low boiler water, the crown sheet would be covered

until the very last moment before the boiler exploded.

With the advent of the railroad — in place and operating — Searchlight began to boom in 1902. People were attracted by the thriving industry; two newspapers were started; "wet grocers" arrived to supplement the venders of more plebeian groceries and thereby prevent any of the populace from "starving" of thirst. The future indeed looked bright in spite of occasional vicissitudes.

Just two months after the railroad had been placed in operation, unusually heavy rains washed out the track in several places. The term "unusual" should be taken advisedly, for Searchlight's normal rainfall could be counted upon to be double that which fell in Las Vegas, only a short distance to the north. A moisture problem of a different nature presented a new and surprising kind of trouble — gold in the boiler of the locomotive forced confinement of the engine to the shops the following month. The discovery of the water problem was made after the boiler tubes had been washed out and someone tried panning the rust-colored mud removed as residue. When a little string of gold flakes appeared, the surprise was both pleasant and exciting. The source of the water was quickly traced to the pumping station at the 500-foot level of the Golden Treasure mine.

On the return of the locomotive to regular service, daily schedules were rearranged to provide for an early morning departure from Searchlight to the mill. The new arrangement not only worked better from a production standpoint, but on steamer days such passengers as were accommodated could board the steamer (usually the *Searchlight*) for Needles and arrive at their destination late that night. In spite of the time consumed, this proved to be a decided improvement over any other mode of travel between the two centers.

From 1902 to 1906-07 Searchlight boomed. True, there was a mild recession of sorts in 1903 while the men in the mines and on the railroad engaged in a three-month strike. For a time there was even talk that the Quartette's owners might abandon

their operations completely. The company resumed production around the end of the year, possibly in anticipation of further economies to come. Wells drilled right at Searchlight developed sufficient quantities of water for milling purposes, and a new mill was erected close to the mine and connected with it by a surface tramway. By 1906 the narrow gauge railroad and the mill by the river became idle. The river mill was dismantled and brought to Searchlight where it was reassembled alongside the new facility, thus doubling the number of stamps to 40.

For the past several years the residents of the area had been looking hopefully to the Santa Fe Railroad to extend standard gauge rails into their town. In the summer of 1905 talk centered around the prospects of a branch from the south at Ibex on the main line. Then an independent road, the Needles, Searchlight & Northern, announced that it had completed its own survey from the exact same place. Hopes rose again, and then as quickly subsided. In December 1905 more positive action was taken; local citizens incorporated the Searchlight and Northern Railroad to build a 22-mile line from Searchlight northwesterly to a connection with the UP's Salt Lake Route at the booming camp of Nipton (originally shown as Nippeno on UP timetables). According to press reports, the new group contemplated utilizing the rails of the Quartette Mining Company's railroad for its own narrow gauge line, over which a gasoline motor car would provide two round trips daily. The following month surveys were started, and some right of way was acquired.

When the Santa Fe saw that the local residents meant business, and that that business would flow to a competing main line (UP), it immediately dispatched surveyors to the scene to see what could be done. The Barnwell & Searchlight Railway was then incorporated to build a 23.22-mile connecting link between Barnwell (Manvel, on the former Nevada Southern) and Searchlight. Some of the old right of way of the projected Searchlight & Northern was purchased. When grading was instituted, a portion of the contracts went to Seymour Alf, veteran resident of the Daggett, California, area.

For a short line with adequate financing, the job progressed unusually slowly. By the end of July 1906 only nine miles of grade had been completed, and track laying had yet to begin. The greatest difficulty centered around the incredible labor turnover. Men would come out from Los Angeles, work

but a few days, then suddenly leave without notice. At one of the two grading camps, 16 men checked in on a Friday night, yet by Saturday morning only one was left. In retrospect, timekeepers estimated that over one two-month period more than 7,000 men appeared on the payroll — of which perhaps 300-400 would start work one day and only half that number be available at the start of work the next morning. Quite possibly for many the objective was a free ride to the gold country; or else they may have considered that the work, when compared with a job (say) as bartender, was far too difficult. No concrete explanation of the phenomenon has been discovered.

Construction on the railroad did continue and by January 1907 the grade was virtually completed. Rail laying progressed, and trains began operating over the first nine miles of line. By the end of the month the "Front" had advanced to Mile Post 13, while the steel gang of 125 men managed to lay one mile of track in one week. The pace of the advance was delayed somewhat when a flat car loaded with men and steel rails struck an open switch and overturned, injuring a dozen men.

When the headlight of the construction train became visible from town, the citizens of Searchlight determined upon a celebration and a Railroad Day was scheduled for March 1. This meant that 10 miles of track would need to be completed within 30 days, a rather optimistic prediction based upon the previous performance of the construction gangs. Completion of the railroad was not the main topic of concern among the townspeople; conversations largely centered around the question: "Is the building of the railroad part and parcel of the townsite scheme?"

The terminal site selected for the railroad was about a mile from town and down the slope. The first public indication of this unfortunate circumstance occurred when large advertisements appeared in November 1906 under the banner of The Searchlight Townsite Company, outlining and amplifying the benefits of the new townsite which embraced the forthcoming railway depot and terminal. The citizens became incensed. Public statements that the town would move to the new terminal found little favor in Searchlight. Santa Fe officials disavowed any interest in the townsite, proclaiming that level ground determined the location of the yards and that to operate them along a spur into Searchlight on a 2.3% grade would be utterly impractical. Ill feelings continued to increase as uncertainty persisted over the location of

SEARCHLIGHT

ONE MILE

the depot either in Searchlight proper or in Ab-
bottsville (as the new location was colloquially
named after the townsite's manager). Finally, in
protest, shipments were diverted to competitive
routes.

On March 12, 1907, the rails reached Mile Post
20, just 3.22 miles from the end of the track, caus-
ing an inquiring reporter to visit the work for a
personal investigation. His resulting comments in
the editorial columns left little to the imagination.
"The construction train, loaded down with mate-
rial, follows closely after the track layers. When
one sees two hundred-odd Mexicans at work he
understands why faster progress is not made. Wear-
ing peaked sombreros and gaudy sashes, they work
in pairs, carrying cross ties on their shoulders
ahead of the tracklayers. With a tie aboard, they
scurry down the line at a lively gait, but once freed
of their burden, they come sauntering back smok-
ing cigarettes and chatting gaily. Then, too, they
are particular as to the weather, and on a cold or
rainy day, it is out of the question to get them out
on the grade."

Ten days later only 2,600 feet (one-half mile) of
main line lacked rails as the locomotive headed up
toward Hobson Street. On March 31, 1907, after a

year of waiting, the 23.22-mile railroad was finally
completed. (The station was at M.P. 22.63.) A
special train came in that day, consisting of two
cars, one of which was the private car of Supt.
R. H. Tuttle of the Santa Fe. The following day
regular service began with 18 passengers arriving
on the first train. The next weekend the postponed
Railroad Days celebration was held to the accom-
paniment of the usual grand barbeque plus visits
to the mines, rock drilling contests and band con-
certs.

Daily-except-Sunday train service was immedi-
ately provided, consisting of a mixed train which
left the junction at Goffs, proceeded to Barnwell,
then traveled the branch to Searchlight, arriving
2½ hours later. On Sundays the same train followed
the same routine, but covered the northern seg-
ment of the line from Barnwell to Ivanpah in lieu
of the stint to Searchlight.

In May 1907 additional excitement enlivened the
atmosphere. The American Prospecting and Devel-
oping Company proposed a large project in the
Searchlight area involving erection of both a smel-
ter and a mill along the Colorado River. As part of
the plan, the Quartette railroad was to be acquired
and rebuilt to connect with the Santa Fe at Search-

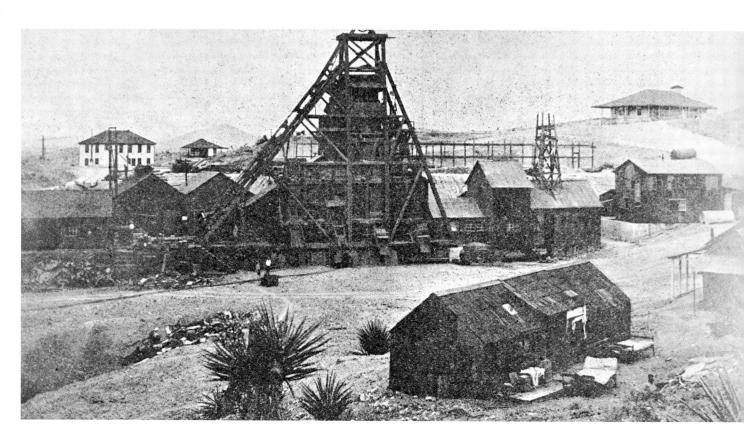

First railroad in the Searchlight area was the Quartette Mining Company's narrow gauge from the Quartette Mine *(above)* to the mill along the Colorado River to the east. Small saddle-tank locomotives hauled the little ore cars back and forth over the 16-mile line for the four years from 1902 to 1906 until the mill was moved to Searchlight proper and the need for the line ceased. *(Above: Nevada Historical Society; below: R. P. Middlebrook Collection.)*

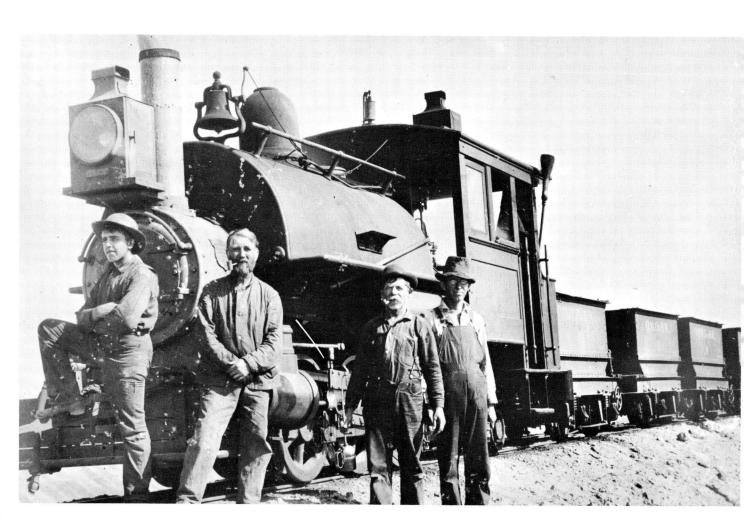

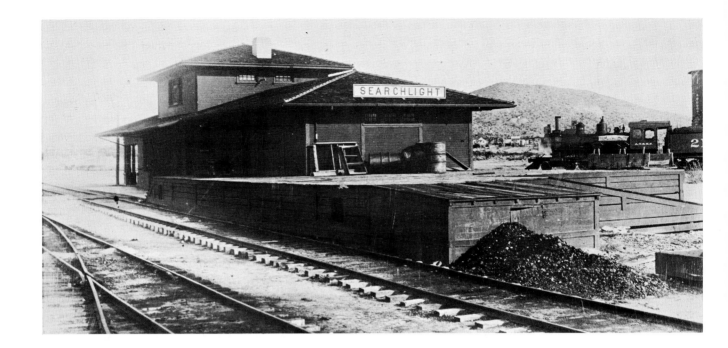

The long-awaited standard gauge Barnwell & Searchlight's 23-mile line reached Searchlight in 1907, but service only lasted until 1923. Citizens were provoked that the station, shown *(above)* with Santa Fe's No. 2168 at the water tank on the wye, was not located up the hill at the foot of Hobson Street *(below)* where patrons of the "New York Store, Men's Furnishings" and readers of "The News" could commute more conveniently to Needles or Los Angeles via the Santa Fe. *(Above: Charles Battye Collection; below: Nevada Historical Society.)*

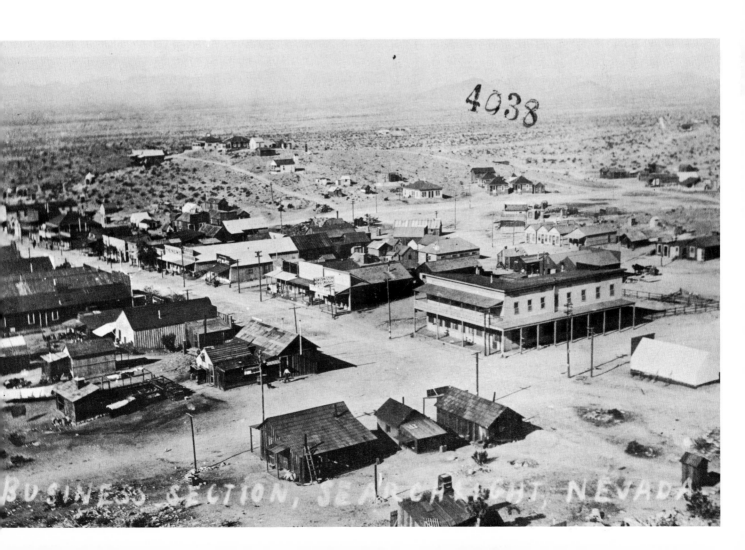

light, while additional extensions were to be constructed northward to El Dorado Canyon and southward to Camp Thurman and the Empire mine. Nothing came of the plan and eventually the narrow gauge railroad was sold to J. F. Kent, the 16 miles of rails being taken up in 1910 and re-used on the Yellow Pine line between Jean and Goodsprings.

The peak of Searchlight's boom was reached in 1906-07, although a moderate amount of ore production was recorded in virtually every year thereafter. Up to 1940 the total production amounted to $4.5 million. Approximately one-half of this amount originated at the Quartette mine, in spite of the fact that the Quartette's mill burned in 1913 following which the company faded, being superseded in 1917 by the Duplex. (The Duplex, it may be recalled, was the first mine in the area to ship ore — originally it was known as the IXL claim.)

By 1919 trains were operating over the Barnwell & Searchlight only on Mondays and Fridays. Then severe washouts on September 23, 1923, halted all traffic completely, causing some to reminisce about the storm in August 1909 which undermined the track and wrecked a slow-moving train, killing the engineer and seriously injuring the fireman. The Santa Fe looked back, too — at the financial figures. Operating results had continuously wound up in the red figures, so I. C. C. approval was sought to abandon the line in deference to making extensive repairs. The request was granted by a decision rendered on February 18, 1924, and train service was never restored.

To this day the roadbeds of both railroads may be seen in places in the Searchlight area. As late as 1963 some Quartette Railroad ore cars were found tucked away in a quiet ravine. But the beacon that was Searchlight had been extinguished.

Mohave and Milltown Railway

xx

Unique among the cartographically incorrect railroads is the Mohave and Milltown Railway. As late as 1925 the renowned Rand McNally depicted the line on a map as extending from Needles, California, across the Colorado River and on to Oatman, Arizona — this in spite of the fact that the road had not been operated for approximately 20

years. In actuality, the railroad was considerably shorter, connecting the Leland mine (some two miles west of Oatman) with a ferry landing on the east riverbank, opposite Needles, all within the state of Arizona. The ferry service was the only part of the operation which actually touched California soil.

The Leland group of gold mines near Oatman dated back to a time, many years before 1896, when A. A. Spear and J. B. Lane sold their properties to Bedell and J. H. West. In 1901 Bedell and West sold to Col. Thomas Ewing who, in turn the following summer, sold to a group of Philadelphia investors (including some men affiliated with the Tonopah & Goldfield Railroad). Perhaps the rapid turnover of the property should have been a warning to the prospective investors that the project necessarily would be short-lived.

The new owners formed the Mount Mohave Gold Mining Company to take title to the several mines and effectuate the various plans. As part of the scheme of operations, it was proposed to establish a mill at Mellen on the Colorado River and to run a standard gauge spur from the Santa Fe's main line to the mines using part of that road's former right of way (abandoned when the Colorado River bridge was relocated). At the mines, a double-track tunnel was to be bored into the hill, 800 feet below the level of the stopes, so that mine cars could dump their ores directly into waiting Santa Fe gondolas for the trip to the Needles smelter or to the proposed Colorado River mill.

Whatever the reasons, these plans were changed completely in short order. Instead, the mining company decided to shift the mill site from the river bank to a point six miles to the east toward the mines, on the edge of a barranca in a broad mesa at a point to be designated as Milltown. The water so essential to the milling operations was to be pumped by a Corliss engine from Spear's Lake and conveyed to the mill through an 8-inch pipe. To bring the ores from the mine to the mill, and to transport the men and materials from Needles, California, the company would build its own railroad westward from the Leland mine to the mill and on to the Colorado River.

To this end the Mohave and Milltown Railway was incorporated in March 1903. By June contracts had been awarded for construction of the 17-mile, narrow gauge road. C. W. Brown was appointed general manager of the line with offices in the Cottage Hotel Annex in Needles. Under his signature, advertising was placed seeking 500 men to

work on the new project, and grading commenced promptly.

The most immediate obstacle to be overcome was the crossing of the Colorado River. To accomplish this, Brown went to the county seat in San Bernardino, California, to secure a ferry franchise from the Supervisors. Competition reared its ugly head when the Lamar Brothers of Needles also petitioned to obtain the same franchise, but Brown had anticipated the difficulty. Before going to the meeting, he had carefully leased the logical ferry landing ground in Needles, and the weight of his foresight swung the decision in his favor. Tariffs were also set: Passengers were to be charged 25 cents (children 15 cents); a team and driver, $1.50. Young boys, if short of change, had an alternative on warm days of swimming across the river before boarding the train.

By August 1903 the *Needles Eye* was mentioning the new ferry connecting Needles, California, with "this new town of Needles, Arizona, which is also a railroad terminus, as it is where the new Mohave — not Mojave, that's in California — and Milltown railroad strikes navigable water. There are yards and machine shops, and the houses are going up as fast as men and lumber can be had. Several businesses have already been started, and as soon as the mines are reached the town will have hundreds of inhabitants. So don't laugh at Needles, Arizona, but rub your eyes, and try and keep up with the procession."

Rails were laid to a point near Boundary Cone Peak by the end of October, and the M&M had only four miles to go. Many bridges and some rock work were required, plus a particularly long trestle at the Leland mine. Current talk was reflecting an optimistic spirit then prevailing that the little railroad would continue right on past the mine and swing north and east on a roundabout route through Silver Creek to Gold Road. Whatever thinking may have prevailed at the time, no efforts were made to accomplish this construction.

By December 1903 the end was in sight. Another large trestle had been completed to the mill at Milltown, and a trial pumping had demonstrated that the pipeline to the big water tanks above the mill was successful. Coincidental with the commencement of regular train service about the end of the year, reduction of ores was begun at the mill.

Three locomotives appeared on the M&M's roster, one of which came from the Waterloo mine at Calico. Another arrived from the East after some difficulty. The cab was so large it would not clear the

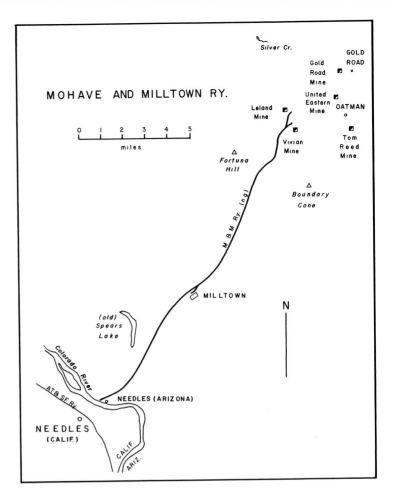

confines of the Santa Fe's Raton (New Mexico) tunnel, and it had to be detached from the boiler before the flat car bearing the engine could be cut into a westbound freight train.

The M&M's regular, daily train schedules were so arranged as to allow time for visitors to inspect the various mines at the eastern end of the line: the Leland, the Vivian, the Swiss American, or the Snowball. Returning in the afternoon, passengers shared the dust of the ore shipments which were brought down to the reduction plant at Milltown. Excursions proved to be another lucrative form of business. Charles Battye recalls one picnic excursion from Needles, using the ferry and train to Spear's Lake (formed by the back waters of the Colorado River and then much larger than at present). The day was spent in boating and fishing, following which the return trip was accomplished on the afternoon train which paused to accommodate the visiting sportsmen.

Although some $400,000 was spent on the Mohave & Milltown railroad and its reduction mill project, the venture was unsuccessful "mainly, it is stated, on account of the failure to save the gold values in the ore at the mill." In later years management was severely criticized for its hasty expenditures for a railroad without first determining the

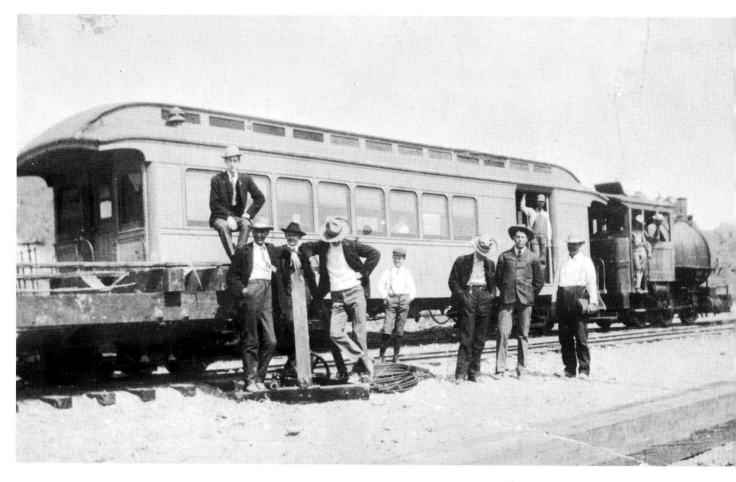

Rare indeed is this view of the Mohave & Milltown Railway's passenger train at the Needles, *Arizona,* terminus. In spite of the narrow gauge road's three locomotives and 17 miles of line, operations only lasted for about a year. Primary purpose was to bring ores from the Vivian mine *(below)* and the Leland to the mill nearer the Colorado River and to connect, via ferry, with Needles, *California,* and the Santa Fe. *(Above: Charles Battye Collection; below: U. S. Geological Survey.)*

extent of the ore in the mines. Only 4,500 tons of ore were treated at the Milltown plant, while the total value of the output of the Leland mine was estimated to be a mere $40,000.

Serious floods in the general area during September and October 1904 washed out virtually all of the track between the mill and the Colorado River. Although the Santa Fe suffered considerable damage as well, it had the finances to make the necessary repairs to its line. Not so the Mohave & Milltown. Dangling a string of unhappy creditors, it was forced into receivership in November 1904. No money was available with which to pay its bills unless it operated, and it could not operate without spending a tidy sum to replace some four miles of washed out track. Without the Mohave & Milltown, the mine and the mill were useless, and toward the end of the year 1904 both were closed down.

A few years later tentative plans were made to reopen the mine and repair the railroad, but the program never got beyond the talking stage. The mill continued to stand idle for many years, attaining a distinctive reputation as a haven for bats. The remaining "unwashed" track between the mine and the mill was taken up about 1912, but a stranded locomotive remained for many years near the old route of U. S. Highway 66 to serve as a guidepost for travelers and a reminder that here, high on the hillside, the little narrow gauge ore trains had once run.

Around 1915, a good 10 years after the railroad had ceased operations, rich ore was discovered in the United Eastern mine at Oatman. The town enjoyed a lively boom, but the Mohave & Milltown was never revived to participate. Scant traces of the little line may still be seen today by those of sharp eye who traverse the back roads of the region. Watch for them if you are in the vicinity.

Mojave Northern Railroad

Inextricably, the story of the Mojave Northern Railroad is connected with that of the development of the cement industry of Southern California, and of all the areas, probably that of the Oro Grande-Victorville region was the most productive, if special railroad mileage is considered a measure.

Situated to the north of San Bernardino and the vital Cajon Pass, the locale was reached by earliest prospectors by following the wayward path of the Mojave River. Melting winter snows along the north side of the San Bernardino Mountains fed this body of water through picturesque brooks cascading down rocky passages. The union of these rivulets combined to form the main stream which drained northerly and easterly through Victorville and Barstow into the Mojave Desert and an ignominious end in the Mojave Sink near the former crossing of the Tonopah & Tidewater and the Salt Lake Route at Crucero. Along the way the river developed some of the mysterious habits of the more northerly Amargosa River flowing into Death Valley, for as though to avoid the intense summer heat, Mojave River water occasionally deflected from the surface to travel underground for varying distance as it worked its way past Victorville, Oro Grande and Barstow.

Gold and silver — not cement — were the big attractions to the region in the earliest days. Of the outstanding properties, the Sidewinder Mine probably commanded more attention because of its colorful name than for its record of gold production, which was hardly noteworthy. Even with its poor performance, a 10-stamp mill was erected at Victorville in 1887 to handle the output of this mine. Another mill was built at Oro Grande (meaning "big gold") where a settlement developed along the Mojave River to sustain the workers employed in processing ores from the Oro Grande Mine located on Silver Mountain to the northeast. Other small mines were scattered throughout the surrounding barren hills but their output failed to be stimulated by the arrival in 1885 of convenient transportation in the form of the Southern California Railroad (Santa Fe), which constructed northward from San Bernardino via Cajon Pass to a connection at Barstow with the Atlantic & Pacific (q.v.).

The development of limestone quarrying in the area commenced toward the latter part of the 1880's. Limestone had been used to produce cement in California as early as 1860, but the first mill was not erected until 17 years later (1877) at Santa Cruz, south of San Francisco. By the 1890's mills were being set up in Southern California, and in 1906 the first cement company was formed to operate at Oro Grande.

Mrs. E. M. Potts
(Garner A. Beckett Collection.)

Golden State Portland Cement Company (Oro Grande)

A woman, Mrs. E. M. Potts, was a primary instigator behind the Golden State Portland Cement Company which set out in 1906 to produce cement from limestone quarries in the hills about a mile to the northeast of Oro Grande. Active female participation in the development of a western quarrying enterprise was most unusual, yet Mrs. Potts accomplished much in her management and promotion of the company's affairs.

Coming to the United States from England as a bride, she and her architect husband lived in Southern California before embarking on the cement-making venture. Not surprisingly the most disquieting factor, and one which plagued the cement operation for many years, was a typical shortage of money. To ease the situation, Mrs. Potts turned to her girlhood friends in England, and by selling stock in that country the bulk of early financing was obtained.

In 1908 work on the original, solitary kiln was begun, and two years later the first Bear Brand cement was produced. Due to the stringency of finances, the earliest production was ground in raw mills, the usual method of grinding the finished product being postponed while Mrs. Potts sailed to England in search of additional funds for expansion. Although additional moneys were realized, thanks to Mrs. Potts persuasive calls, the volume of dollars was never sufficient to permit the plant to be completely and properly developed. Still, production did continue.

Transportation of the limestone down Oro Grande Canyon from the quarry to the mill was originally accomplished through the use of mules to haul the hand-loaded limestone carts. Around 1912 a steam wagon superseded the mules for this laborious task, but the operation was short-lived. In 1915 a standard gauge railroad was constructed over the same route from the Original Quarry (a rail distance of 1.75 miles). The fact that the difference in elevation was in excess of 400 feet (an average grade of over 5%) suggested that the road's first motive power be a geared rather than a rod locomotive.

These and such other improvements as were made apparently taxed the company's finances to the utmost. In 1913, following the death of her husband, Mrs. Potts ordered a second kiln with which to expand and improve the company's operations. However, when the time for delivery and payment arrived, the treasury was almost depleted with the result that the kiln was sold to the Riverside Cement Company. Another kiln, ordered in 1917, suffered a similar fate — lack of funds forced its diversion to the Riverside Company. It was not until 1923, on the third try, that the additional kiln was successfully ordered, installed and payment made. Perhaps the Riverside Cement Company recognized the value of its neighboring cement plant, for in the same year that company took over the Golden State Portland Cement Company through an exchange of stock.

Under the control of Riverside Cement, the plant was expanded to seven kilns. The increased capacity necessitated the acquisition of a second, larger Shay locomotive to haul the limestone in ever-increasing quantities. Additional locomotives were supplied as demand occasioned, conveniently being withdrawn by the parent company from its Crestmore plant, located near Colton, California. In part, the necessity for such extra power arose from the several extensions of the railroad's tracks to additional sources of supply. A 3,000-foot eastward extension terminated in two spurs, one on the Humdinger claim and another on the Hardshell No. 1 claim. Two modest branches were constructed south from the main line. One stretched

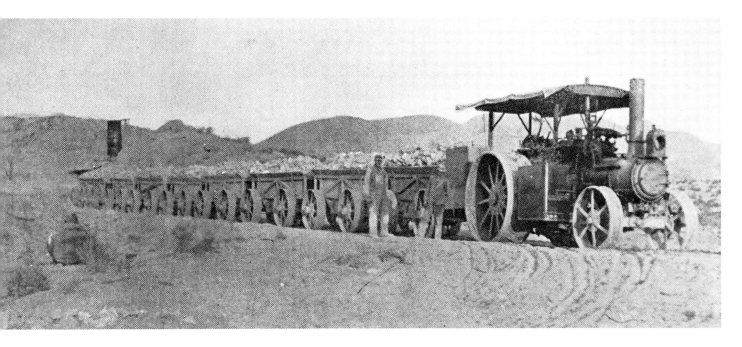

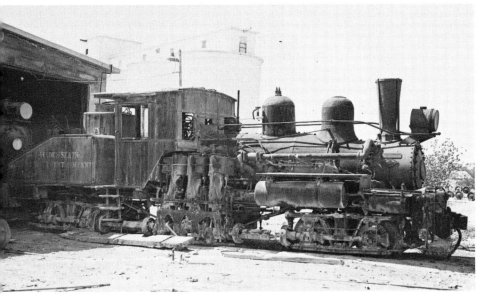

Golden State Portland Cement Company operations at Oro Grande commenced with the utilization of mule power, graduated to steam wagon about 1912, and culminated in the construction of a Shay-powered, standard gauge railroad between quarry and mill which was operated from 1915 to 1928. (Above and below: Garner A. Beckett Collection; left, center: Allan Youell photo.)

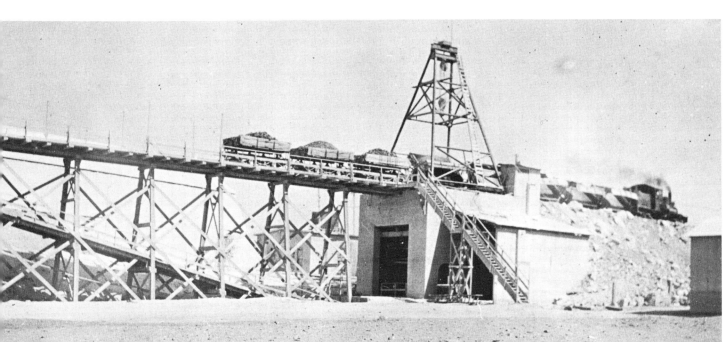

a half-mile to the Comet Quarry toward the east, while the other wound its way around the hills to the south, past the Shay Quarry to the Klondike Placer. Although an additional, major, four-mile line was projected to swing around the northern end to Sparkhule Mountain deposits, the project never reached fruition, all work being suspended after the surveys had been made.

The little railroad was relatively short-lived (13 years). On May 1, 1928, the Oro Grande cement clinker manufacturing plant was closed, the cessation of operations dictated the suspension of the Shay-powered trains with their 3-man crews. For the next 13 years the songs of the Shays were stilled, and the tracks lay idle and gathered rust. Finally in 1941 the rails were taken up and scrapped, together with the locomotives.

The Oro Grande cement plant proper did not suffer a similar fate. In 1942 the unit was reopened, trucks being utilized to haul the limestone over the short distance from the Klondike Quarry to the mill. Subsequently in 1948 a full scale plant modernization program was begun, and 10 years later the Riverside Cement Company itself was absorbed to become an important division of the American Cement Corporation.

Southwestern Portland Cement Company (Mojave Northern RR)

The largest cement operation along the Mojave River was that of the Southwestern Portland Cement Company, an organization formed by a group of Arizona lumber men in 1907 which located its original manufacturing plant at El Paso, Texas. The extensive limestone deposits just east of Quartzite Mountain, about six miles northeast of Victorville, California, interested the company due to their proximity to the California market, and the properties were acquired. In August 1915 ground was broken for the company's new cement manufacturing plant at a location designated as Leon, about a mile north of Victorville along the Mojave River.

The name for the new plant site may have been borrowed from that of the famous Spanish explorer, but more logically it was probably a derivative from Carl Leonardt, the man who headed the enterprise at the time of construction of the cement plant and its affiliated Mojave Northern Railroad. Not only was Carl Leonardt busy with the company's new construction project, but he was also active in the enterprise of lining Victorville's main street with new buildings to accommodate antici-

pated increased commerce resulting from the influx of new workers to the area.

The Mojave Northern Railroad was an essential adjunct to that part of the cement company's operations pertaining to the transportation of the limestone from the mountain quarries to the mill at Leon along the river bank. Surveys of the route indicated that 5.5 miles of railroad would be necessary to connect the two points, of which the upper (loading) area was to be designated by the name of Powell, in honor of F. H. Powell who later became a president of the Southwestern Portland Cement Co.

Construction of the line began in the fall of 1915. By the end of the year the *Victor Valley News-Herald* was proudly reporting the extent of the progress which anticipatedly would usher in a new era for Victorville. Tracks of the Mojave Northern had been laid from the mill site, across the Mojave River and extended northeasterly for approximately another two miles. With almost half the distance to the quarry now spanned by the rails, reportedly the balance of the work was "being pushed." At the mill, the railroad was being used to assist in construction work, while a substantial trestle — 1,200 feet long and as high as 30 feet — was taking form to carry the rails to the bins of the crusher. In all some 175 men were actively employed, both at the mill and at the quarry camp, and Carl Leonardt was busy keeping a close eye on the major as well as the minor but important details. Even the palatability of the food at the men's boarding house was tested when Leonardt joined the regular 100-odd patrons for a meal. A report in the *News-Herald* confirmed that the food was not only satisfactory but was to be praised for its consistent high quality.

In spite of his ever-watchful eye, Leonardt discovered he could not control every detail of construction. One major item was the weather, and in January 1916 Mother Nature seemed bent upon asserting her independence. Unusually heavy rains fell all over California, and Victor Valley received its full share. Progress on Mojave Northern track work was delayed, while the measuring station at the Upper Narrows of the Mojave River reported that the water was 12 feet above normal on a day in the middle of January. A part of Victorville became flooded, and the Santa Fe was hard pressed to gather sufficient riprap at (Joseph) Scheerer's siding to protect its main line embankment some miles to the north at Helendale where the Mojave River was continuing its rampage. For a time it was feared that the cement plant at Leon was

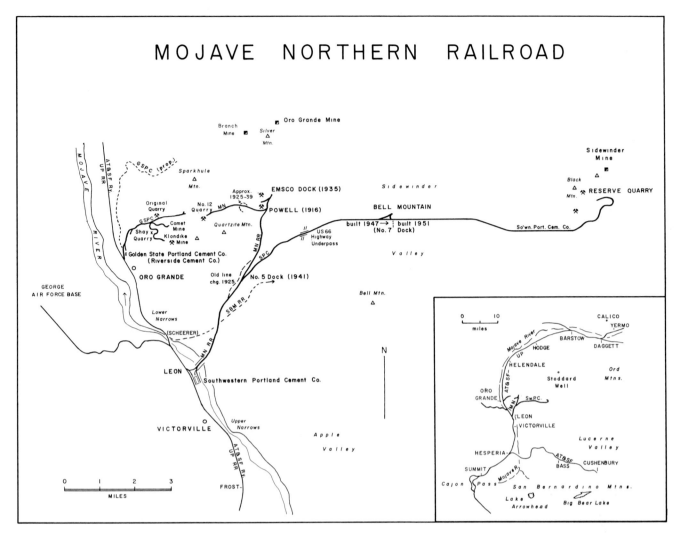

MOJAVE NORTHERN RAILROAD

damaged by the flood, but aside from delays to the work occasioned by the flood waters, the mill survived and was virtually unscathed.

In August 1916 the railroad was considered to be complete, although another 1½ miles of spur tracks were added to the railroad's system during the following year. Labor Day 1916 received added significance as an important holiday when the first "clinkers" of Victor Cement were produced at the new Leon plant.

Although the Mojave Northern was a relatively short railroad built primarily to serve one industry, it was operated as a common carrier during the early days. Passenger service — primarily the transportation of workers to and from the quarries — was definitely limited. During the year 1918, for example, some 4,702 passengers were carried which, by mathematical calculation, averaged out to eight passengers for each trip made over the line. Moreover, for a number of years the equipment roster

listed only two saddle-tank locomotives, six rock cars and a tank car. No passenger equipment was recorded.

Obviously the railroad was not out to drum up any tourist traffic. A review of selected issues of musty OFFICIAL GUIDES fails to reveal any mention of the facility among its exhaustive listings. Even the West Coast travel agent, Peck-Judah, does not carry the road's name in its RAILROAD BLUE BOOK. Apparently even *Poor's Manual* threw up its hands after 1920 as so little information was available on the line. Finally, for undisclosed reasons, the railroad changed from a "common carrier" to a "plant facility" status early in 1925.

Perhaps the change was occasioned by the increasing volume of business which taxed the limited capacity of the little line. The demand for cement in Southern California for building purposes increased greatly as immigrants swarmed

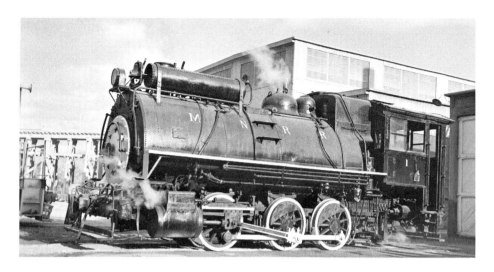

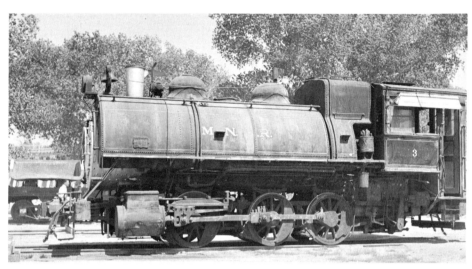

The Mojave Northern Railroad owned four steam locomotives during its entire period of steam operations. Nos. 1, 2 and 3 were all purchased new from the Davenport Locomotive Company, whereas No. 4 (a Porter) was obtained secondhand from the San Diego & Arizona Railroad. *(Left, top and center: Gerald M. Best; right, top and center: R. P. Middlebrook.)*

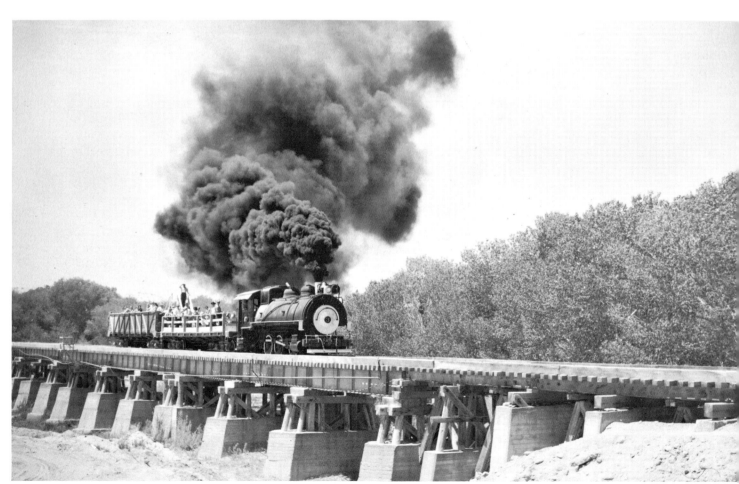

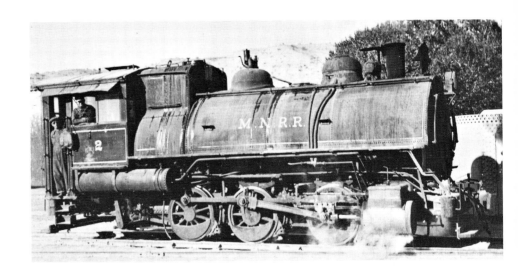

Passenger service on the Mojave Northern has been officially non-existent since the road ceased to be a common carrier in 1925. On May 5, 1957, the Southern California Chapter of the Railway & Locomotive Historical Society made special arrangements for a private fan trip behind meticulously refurbished No. 3 shown *(bottom, left)* crossing the Mojave River and *(below)* near the end of the line at Reserve Quarry. *(Both photos: Pacific Railway Journal.)*

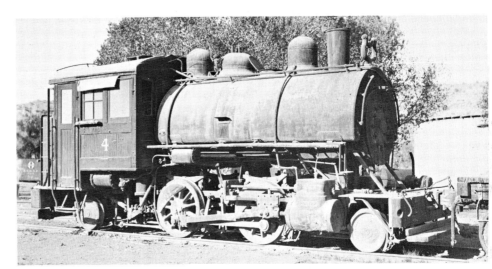

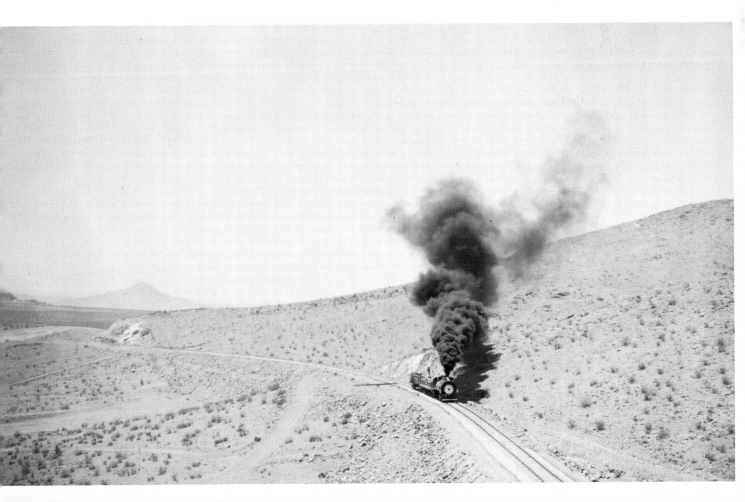

into the state. Reinforced concrete office buildings, residential foundations, plus new and expanded highway systems, all contributed to the swelling volume of orders for more and more cement. By 1926 four additional kilns had been placed in operation at the Leon plant along the Mojave River, and the Mojave Northern Railroad may have been so busy hauling limestone rock for its parent company that its management had no time to perform the requisite paper work demanded of a common carrier.

The little railroad was chugging merrily onward. Its equipment roster was expanded to include four small, saddle-tank locomotives, and from time to time over the years the various spur tracks were relocated or extended to follow the changing pattern of operations as new quarries were established to replace those which had become exhausted. In 1939 a major, mile-long spur was pushed westward across the hills to reach the new No. 12 Quarry.

In 1942 a new phase of the company's operations began. Another extensive quarry site was prepared about nine miles to the east on Black Mountain in the vicinity of the old Sidewinder Mine. To bring the limestone to transportation, a truck route was instituted between the new quarry and loading bins along the railroad known as the No. 5 Dock. Here the rock was transferred to cars of the Mojave Northern for the balance of the trip to the mill. This situation pertained for approximately five years until 1947 when, under Southwestern Portland Cement Co. ownership, the railroad was extended for a distance of five miles to the east to Bell Mountain. A new No. 7 Dock was then established to handle the rock from the Reserve Quarry which continued to be hauled by truck over the abbreviated route. It was not until 1951 that the SWPCo track was finally extended the additional seven miles to the Reserve Quarry itself, so that trains could operate the entire distance to the cement mill at Leon. This situation still prevails today and is expected to continue for some time to come.

The mutations of time have altered but little the physical appearance of the Mojave Northern Railroad, but its corporate complexities have shifted considerably. Today the Southwestern Portland Cement Company owns and operates all of the rolling stock of the line and leases the Mojave Northern trackage on an annual basis.

Other Railroads in the Area

Few concrete facts exist concerning the San Bernardino Mountain Railroad. It appears to have been a railroad projected to run eastward from the Santa Fe-Union Pacific main line in the Victor Valley area to an undisclosed objective. Information with regard to its ownership or its purpose was probably contained in obsolete files discarded many years ago. It does appear that the Southwestern Portland Cement Company may have participated in the project, although probably in a very limited way.

North of Leon along the Santa Fe-Union Pacific's right of way a 5-mile track branches off to the northwest. Known as the Adelanto Spur, the rails were laid for the U. S. Air Force in November 1942 to serve the George Air Force Base, and are still in place today.

Eight miles south of Victorville, but still on the north side of the San Bernardino Mountains, lies one of the longest stretches of new railroad construction to be built within the last decade. Known as the Lucerne Valley branch of the Santa Fe, this 29.2-mile line leaves the main line at Hesperia and wends its way eastward to Cushenberry, where the Permanente Cement Company erected a large cement plant. The Santa Fe's application for construction authority was filed with the Interstate Commerce Commission on September 1, 1955, and approval was granted by the end of November. Work commenced on construction almost immediately thereafter, as surveys had already been completed. Morrison-Knudsen Company, Inc. contracted to do the grading and bridging for the line, work on which began January 6, 1956.

The greatest difficulty in organizing for construction of the road lay in the procurement of the requisite right of way. Condemnation proceedings were necessary in many instances, usually due to a matter of price for the properties, but in one particular situation the owner refused to permit any railroad construction across his land until special court proceedings had been completed to grant the railroad the proper authority.

To guard against local flash floods, it was deemed advisable to construct some 180 culverts and 8 open-deck frame trestles along the line. A 700-foot bridge was necessary to cross the Mojave River. Work was finally completed and on July 19, 1956, the branch was placed in service.

Inbound supplies to be used in construction of the cement plant were among the earliest items to

move over the new line. Then the following April the Permanente Cement Company successfully recorded its first output from the new unit, raw limestone for the product mix being hauled to the mill from adjacent quarries by truck.

Traffic on the railroad largely matches the more favorable conditions of the branch. Adverse grades reaching to 2% are encountered eastbound near the Cushenberry end of the line, but these have small effect upon operations as most eastbound trains are comprised of empties returning to the mill. Westbound, the operating problems for loaded trains of finished cement largely consist of setting proper retainers, proper braking on the downgrade, and adequate control at all times. A short, stiff climb just west of Bass as trains approach Hesperia acts almost like a built-in safety check before the junction with the main line is reached.

Striking contrasts of dense black smoke and white highlight this early morning portrait of No. 2 backing a string of limestone loads into the mill at Leon. (*Southwestern Portland Cement Co. photo.*)

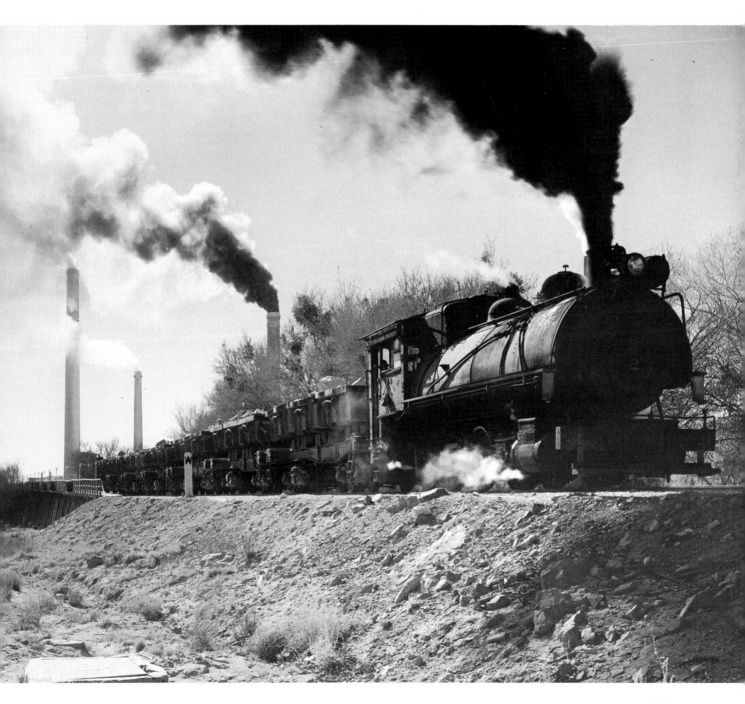

RENO STREETCAR LINES

In March 1889, when the Nevada legislature granted C. C. Powning, W. O. H. Martin and others the right to lay an iron railroad track in the streets of Reno for a streetcar line, the city was only about fourth or fifth in size out of a list of approximately eight cities in the state with over 1,000 population.

The franchise for Reno's pioneer enterprise specified horse or mule power; speeds should not exceed eight miles per hour (a fine not to exceed $100 for each offense was provided); and the use of the iron bridge over the Truckee River was specifically prohibited. Cars were to be run at convenient hours and were to transport freight as well as passengers. Perhaps the grantees felt that the restrictions were too confining, for they failed to perform any work under the franchise, and it was allowed to lapse.

Two years later, in March 1891, the Legislature again passed a similar act awarding virtually the same rights to F. G. Newlands, C. T. Bender, M. D. Foley and others. This time, provision was made for the substitution of electric power for animal power. A stimulation of sorts was provided in that work must be started not later than May 1, 1893. Although Newlands, Bender, Foley, et al. started off with good intentions, forming the Reno Electric Railway and Land Co. to perform the work of construction, unfortunately the company was still-born. No work was performed under the franchise, in spite of the fact that the incorporators returned to the legislature before the expiration of the time limit and received an extension of the starting date to July 1, 1894.

Three years later in July 1897 a W. G. Caffrey breezed into town and revitalized the whole trolley issue with the announcement that construction of an electric railway line would commence shortly on Fourth Street, starting at the corner of Ralston Street and running eastward to the Fair Grounds. Apparently building the railway would be but a minor matter, for by fall (a very few months later) Mr. Caffrey was expecting to be extending his lines to other parts of Reno. As though to demonstrate his expansiveness, Caffrey also announced that he was considering construction of an entirely sepa-

rate line to run from Olinghouse (near Wadsworth) south to the Truckee River, a somewhat premature venture considering that the original placer deposits at that camp were only located on Green Hill in the early part of the year and that no mines had had an opportunity to prove themselves. Another proposed Caffrey venture of imminent consummation was an electric line to run from Golconda to the mine at Adelaide, a project which would have been equally as premature as that at Olinghouse. Fortunately for the more sober and serious minded citizens of Reno, Mr. Caffrey did not remain in town long enough to turn so much as a spadeful of earth in Fourth Street, and news of his projects disappeared from the headlines equally as fast.

As ethereal as a flash of heat lightning, and lasting about as long, was a proposal for an electric railway propounded by the Nevada Power and Transportation Company just two years later. A brief mention appeared in the papers of the time; then silence as the project faded from the public's view.

Early in 1902 rumors began to circulate that Reno finally was going to have a street railway. The customary skepticism attending each such pronouncement was transformed into credibility about May of that year when the Southern Pacific announced that its shops at Wadsworth (34 miles to the east) would be moved to a new location just four miles east of Reno, at a location variously designated as East Reno, New Reno, Harriman, and finally Sparks (named for John Sparks, the governor of Nevada). Several ranches were purchased to acquire the necessary acreage on which to lay out the extensive yards and shops, while J. B. O'Sullivan bought the Frick Ranch in August 1903 for development of a residential subdivision. Here was a situation made to order for a streetcar line, and interest increased so greatly that three distinct groups appeared before the city council seeking franchises. (A new procedure had been instituted in 1901 whereby the legislature had delegated all authorizations for street railways to local governing bodies with the provision that franchises were to be advertised and sold to the highest responsible bidder.)

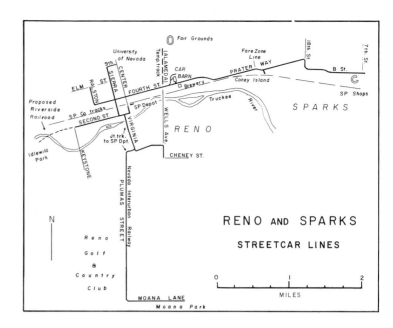

RENO AND SPARKS
STREETCAR LINES

First and foremost of the groups was that headed by J. B. O'Sullivan (developer of the Frick Ranch) in conjunction with Oscar J. Smith, a lawyer; John Sunderland, a long-established clothing merchant; and Judge Massey. A second group, titled the Reno Suburban Railway Co., was formed by T. F. Dunaway and E. R. Dodge, general manager and attorney of the N-C-O Railway, respectively, while George Nolan, as a third interested party, put in a bid. Nolan's bid was ruled out as his request for an exclusive franchise was considered objectionable; Dunaway's offer provided for 1% of the net earnings of the line to be paid to the city on the first year's business and 1½% the second year. O'Sullivan topped that bid with the best offer of a straight 2% of net earnings, and this the city council accepted.

A franchise was then prepared for submission to the voters on November 10, 1903. The document was comprised of 15 typewritten pages and was advertised in full in the newspaper. Aside from listing the route of the railway, the lawyers managed to include most every conceivable possibility or contingency which might arise. Electricity was specified as the one and only form of power to be used; no freight would be handled, only passengers and mail; policemen and mailmen would be carried free of charge; inside the city the fare would be 5¢, collectible only if a seat were available (except in emergency situations) or if a person boarded a car after (and in spite of) being informed that all seats were taken. Provision was also made that the city could buy the line at any time after January 1, 1914 (10 years), at a price equal to cost plus 7%, less any dividends paid.

In conjunction with the Reno city franchise, O'Sullivan was also granted a franchise by Washoe County to cover that portion of the line from the city limits across country to East Reno (Sparks).

The newspapers backed the new electric railway, publishing long lists of supporters of the project. As was natural, there were some objectors and objections: Why shouldn't the city of Reno own the line; and why should only one line of railway be allowed to blanket the city? The *Reno Gazette* answered the first question by pointing out that the city did not have the money with which to build the railway, nor did it have any convenient way of raising such funds under the then existing laws. If the railway were profitable, there was provision in the franchise whereby the city could buy it later; if not, then the city wouldn't want the railway under any circumstances. As to the second question, one street railway system was perfectly ade-

quate; Reno was not a large enough city to support two such organizations. Apparently the voters were complaisant; only one-third of those eligible to vote bothered to go to the polls at all, and of those that did 576 approved the franchise against 86 dissenters. Reno's first street railway had been given the diffident nod of public approval.

To satisfy the quirks of both city and county legalities, O'Sullivan's group formed two separate corporations — The Reno Transit Co. to operate within the city limits and the Washoe County Traction Co. to handle that portion of the line from the city limits to Sparks. Both were under the same basic management and control, one which (unfortunately) was beginning to show signs of wearying now that the franchise was assured. Almost two months passed before O'Sullivan announced on January 2, 1904, that the N-C-O was delivering ties for the new line and that rails were ready for shipment. Contractor F. R. Nicholson was scheduled to start work without delay, working in both directions from the city limits. The road would be opened to the public in April 1904. By 10 days later, with but a modicum of "franchise work" accomplished in the vicinity of the Reno Brewery, reports began to circulate of extended delays in the receipt of materials and it became apparent that nothing was being done to expedite the job.

The following month (February) O'Sullivan told reporters that a deal should shortly be closed whereby California interests would purchase stock in the company to give a needed boost to the waning finances. The next month, on March 17, 1904, he announced that the franchises of the railway together with his unsold lots in East Reno (Sparks) had been purchased by an agent on behalf of S. N. Griffith of Fresno, California. Griffith immediately

formed the Reno Street Railway Co. and generated an interested and enthusiastic audience through expansive talk of surveying an electric line all the way from Reno to Lake Tahoe, perhaps taking his clue from the previous year's survey for a trolley line to run from Placerville (to the west) eastward over the range to Lake Tahoe and thence northward to Truckee. As time passed, Griffith demonstrated that his expansiveness was mere talk and not constructive action toward building the railway. By June editorials were appearing in the press suggesting that Griffith return the franchises to the city, and still later O'Sullivan was obliged to go to court to collect his money on the sale of the properties.

O'Sullivan was naturally concerned. By June 1904 people were beginning to make the move from Wadsworth to the new center of Sparks; the streetcar line would solve the need for communication between that growing community and Reno's business center; at the same time it would enhance the value of O'Sullivan's properties at Sparks. Whether he wished it or not, J. B. O'Sullivan was back in the picture with both feet, suggesting that if the franchises were returned to the city of Reno, the public would then be in a position to build the

Reno Traction Co.
Street Car
Schedule

SPARKS LINE—Half hourly service between Reno and Sparks. Cars leave Commercial Row and Center Streets, every half hour from 6:30 a. m. to 8:00 p. m. and then every hour till 12 p. m. On Saturday and Sunday nights car leaves for Sparks also at 8:30 and 9:30 p. m. in addition to car leavng on the hour as above.
First car leaves Sparks 6:30 a. m.
Last car leaves Reno 12 p. m.
Last car leaves Sparks 12:30 a. m.
SECOND ST. LINE—Fifteen minute service from 6:30 a. m. to 11 p. m.
First car leaves Commercial Row and Center Sts., 6:30 a m.
Last car leaves Commercial Row and Center Streets 11:00 p. m.
FOURTH ST. LINE—Operated on same time and leaves from same point as Second St. Car
UNIVERSITY AND BURKE'S ADD. LINE—Sierra Street, S. Virginia St. and Wells Ave.—Cars leave switch near Riverside Hotel every twenty minutes from 6:20 a. m. to 11 p. m. Leave Burke's Add. and the University every twenty minutes from 6:30 a. m. to 11:10 p. m.

trolley line by investing in his Washoe County Traction Co. Nothing was to happen.

Reno businessmen were beginning to see the light as well. Dr. Reid, of the Gray, Reid and Wright Department Store, H. J. Darling, of Nevada Hardware, S. H. Wheeler, mining stockbroker, and H. J. Gosse, proprietor of the Riverside Hotel, banded together to take the matter up with the city fathers who agreed to call for a special election on July 23, 1904. In the interim, Phil Doyle started a second horse stage line to Sparks (supplementing a horse-drawn bus service inaugurated by the Overland Livery Stables on October 21, 1903) to handle the growing business, while proponents of the streetcars were out beating the drums for votes for a new franchise. At the election the new franchise won handily, receiving 506 votes to 22 against the proposition in a light vote.

Dr. Reid then organized another concern called the Nevada Transit Co. to carry out the terms of the franchise. Although there was little physical work that could be done until the franchise and related ordinances were completed late in August 1904, Reid was foresightedly busy purchasing three streetcars in San Francisco. Opinions vary as to the source of these cars; some people contend that they were remodeled cable cars, while others maintain that they were the small trolley cars used in the early days of the streetcar line connecting San Mateo with San Francisco.

Wheeler's Dog Valley mill (near Verdi) supplied the ties for the new electric railway by the thousands. Late in September grading began on the roadbed, and on the first of October 1904 over 100 men put down the first mile of track utilizing rail which weighed 40 pounds to the yard. In Sparks a few days later men began tearing up Harriman Avenue (now B Street) to prepare the grade for the ties. Tracks went down over the 4½-mile distance from Fourth and Lake Streets in Reno to the SP roundhouse in Sparks, the job being finished by October 10. Ballasting still remained to be done, and at the point where the N-C-O tracks crossed the right of way the grade had to be raised one foot before the crossing diamonds could be installed.

Early in November two of Nevada Transit's three bright yellow cars arrived, complete with four-wheel trucks and open-end platforms. A carbarn with a capacity of 15 cars was installed near the brewery on Fourth Street. The copper wire for the overhead was put up and allowed to sag for a week before it was stretched to proper tension and anchored. The AC-DC generators were connected

to the lines of the Reno Power, Light and Water Co.

People waited for the first car to move; some became a little impatient. A convention of Shriners threatened to open the line themselves even if they had to use horses but the threat came to naught; the men were well behaved and diverted their attentions elsewhere. Finally, on November 20, 1904, the first streetcar operated in Nevada when one of the yellow cars made its trial run under the scrutiny of a Westinghouse engineer. Last minute preparations continued for the next three days. On the night before regular operations were to commence, Dr. Reid staged a delightful trolley party in the course of which 50 people rode to Sparks and returned to the powerhouse for speeches and potables.

The official opening of the line to the public occurred on Thanksgiving Day, November 24, 1904. Nearly 3,000 people paid their dimes to travel to Sparks in 10 minutes, and in the pleasant weather prevailing the majority of the people rode outside on the open platforms. The following work day, traffic was described as brisk; the majority of people were traveling on business matters.

Meanwhile work continued on extending the tracks — westward on Fourth Street from Lake to Sierra Streets, then south on Sierra to Second Street, eastward one block to Virginia (Reno's main) Street, then south on Virginia approximately one block to the Truckee River. No rails were laid on the bridge over the Truckee River, and a temporary break in the line was left on Sierra Street where the tracks of the Southern Pacific had to be crossed. A special crossover had been ordered and was being manufactured in Pennsylvania, but delivery of the unit was not made until just before the year's end. Track forces worked all day and on into the night of December 31 to get it installed so that franchise requirements could be met. Just as the bells, horns and whistles of the celebrant public were welcoming in the New Year, the first car, with Superintendent Reid at the controls, shot over the crossing into the city and on to the Truckee River bridge. After the holiday, on January 2, 1905, regular service began over the entire line.

Nevada Transit's trolley fleet was increased to five units in April 1905 following the arrival of two larger cars. Built by the St. Louis Car Co. and equipped with two Westinghouse motors, these large-capacity trolleys had been on display at the St. Louis Exposition the year before. The larger hauling capacity made them ideal for handling

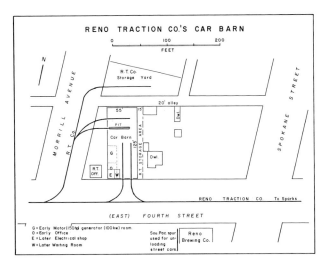

baseball crowds, while the greater power meant faster schedules on the Reno-Sparks run.

The public's reception of the new service was heartwarming — patronizingly so — with the result that in November and December 1905 Nevada Transit embarked on a project to extend its tracks over the Virginia Street bridge (across the Truckee River) and on south as far as Pine Street.

The month of December was also noteworthy for the first serious accident on the new street railway system. A work car loaded with rails suddenly went out of control near Alameda and smashed into a standing streetcar. Fortunately the passengers, acting on instructions from the conductor, were able to brace themselves for the impact and were shaken but otherwise unhurt.

In November 1906 work was started on an additional extension, this time of the Second Street line westward from Sierra Street to Keystone Avenue. The job was finished before the end of the following month and on December 30, 1906, a day of falling snow, cars began operating over the new line.

Commemoration of the event was properly noted in the press because the motorman succeeded in running off the end of the track. His explanation of the cause of the dastardly deed was simple in the extreme — snow had covered the street so completely that it was impossible to see the end of track. Quite naturally (and automatically) the incident marked the last run of the evening, and the trolley remained where it stood overnight. The following day it was pulled back on the rails by another car, and the regular 15-minute service was resumed. But snow continued to be troublesome all day. On the line to Sparks, the first trips were exceedingly slow. The greatest difficulty was en-

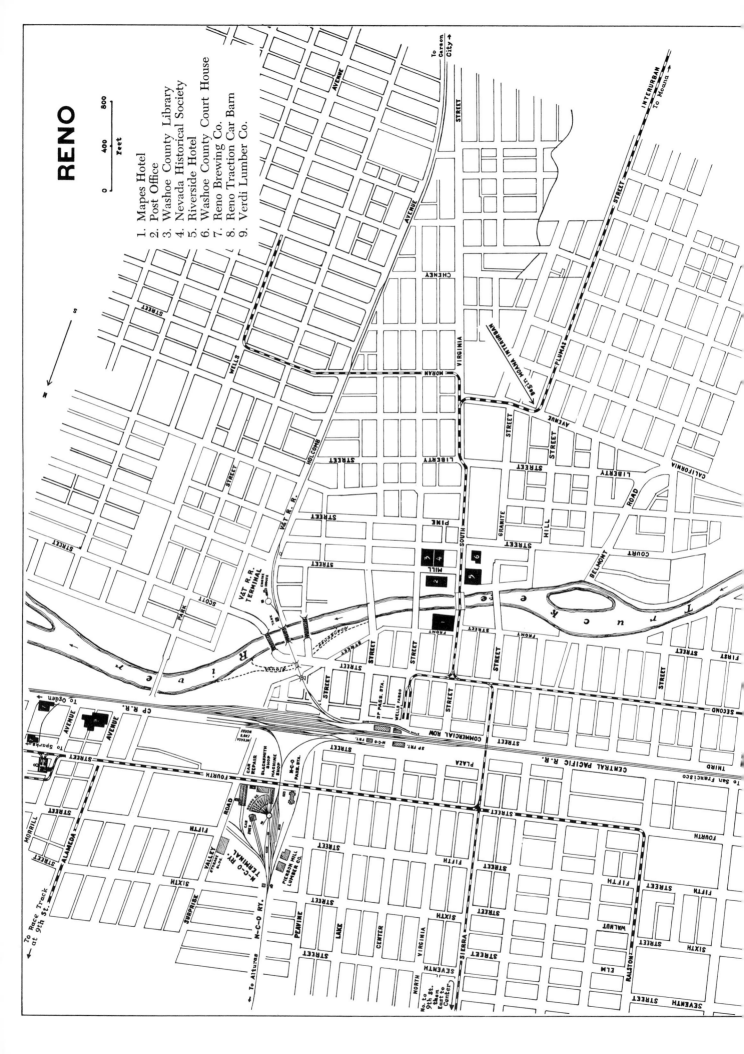

RENO

0 400 800
Feet

1. Mapes Hotel
2. Post Office
3. Washoe County Library
4. Nevada Historical Society
5. Riverside Hotel
6. Washoe County Court House
7. Reno Brewing Co.
8. Reno Traction Car Barn
9. Verdi Lumber Co.

countered on the sharp curves at Virginia, Second and Fourth Streets where the motormen had problems in getting their cars to move at all. When their cars slowed and stopped due to the snow, they promptly reversed their motors, backed up and took another flying start at the blockade. By repeating this process several times they were able to buck their way around the turns.

Even though Nevada Transit had been operating but little more than a year, times were changing and new developments in the transit field were coming thick and fast. The Fleishhacker interests of San Francisco became interested in the prospects at Reno and, after several months of negotiations, succeeded in acquiring both the electric power company and Dr. Reid's Nevada Transit Co. The sale of the latter property was consummated on January 17, 1906, and again there was a change of name — this time to Reno Traction Co., a designation that was to last the life of the trolley line.

The new owners continued to improve the property, and in March 1906 the Virginia Street line was extended from Pine Street south to Liberty Street. One evening early in 1906, a stranger boarded the Sparks car at a lonely spot and seated himself. After a few minutes of riding he moved into the motorman's compartment. Motorman Bridges kept his eye on the newcomer, and when he saw the stranger reach into his pocket, he yanked the heavy brass lever from the controller. The conductor rushed to help, and the intruder quickly deserted the moving car, rolling unhurt into the sagebrush and disappearing into the night. That not all such clandestine efforts could be averted was amply demonstrated when someone tampered with the switch near the carbarn and a crash resulted.

Supplemental Lines

Although the story of Nevada Transit-Reno Traction is the only one that has been developed thus far due to its importance as Reno's first operating trolley line, other nebulous and largely unsuccessful efforts were made to supplement and expand the system, one of which resulted in an operating railway. By and large, these extraneous projects were supplemental to the Reno city lines, starting from the city limits in the manner of interurbans.

In December 1903, immediately following the excitement over the letting of Reno's first major street railway franchise, Captain J. W. Hopkins applied for and was granted a franchise to build an electric railway from the city limits on the south side of town southward for approximately 11 miles to Steamboat Springs at the end of Truckee Meadows. Capt. Hopkins was in no hurry; his project was tentative. A month later he had good news — he had been able to refinance his obligations and therefore could go ahead with his planned hotel at Steamboat and the connecting electric line to Reno. A few weeks later he had mapped out a town, but there the project stalled. Apparently money problems continued to plague him as no action was taken for almost two years. Finally in October 1905 he obtained an extension of the franchise in order to postpone the date for the starting of work, yet even with the passage of another year (to 1906) he had progressed only to the point that he thought he had found a buyer who would be able to build the interurban. Again he was disappointed, and the project continued to languish.

Then, early in 1907 Capt. Hopkins engaged T. K. Stewart to make a survey for the 11-mile line to Steamboat, and in February 1907 Stewart announced that work would begin immediately. The words were empty; but little work was done. A few months later rumors were circulating that the Reno Development Co. would build the railway. Then in August 1907 Hopkins revealed that he had arranged to sell his Steamboat Springs property and franchise to George S. Phenix, a Reno mining and real estate man.

Phenix did little better. At the time he applied for another extension of the franchise, his promise was that work on the line would be rushed. To add interest, part of his plans included a sanitorium at Steamboat. In February 1908 when the actual transfer of the property was made, Phenix was still talking, but (expansively) Lake Tahoe had entered his conversations. A 300-foot tunnel under the crest of the Carson Range near Mount Rose would solve the physical problems, while $400,000 would provide the financial stimulus to extend the electric line to Glenbrook on the eastern shore of Lake Tahoe. Meanwhile, as the March 15, 1908, franchise deadline for commencement of work was approaching, something had to be done. On March 14 Phenix assembled a few men at the south edge of Reno where some innocuous scratching with pick and shovel comprised their efforts at token grading. Boldly it was announced that work had been scheduled to start the day before, but they had failed to realize that that was Black Friday.

More talk (but no action) ensued the following month. According to Phenix, work was progressing nicely — whatever that meant — and the line should be finished in six months. The Glenbrook objective

faded into oblivion, and conversation now shifted to Jumbo, a new name given to a revived mining district over the hills to the west of Virginia City. This was Virginia & Truckee Railway territory, and the V&T began to sit up, take notice, and do its share of the talking. The V&T plan encompassed electrification of their existing line from Reno as far as Steamboat — a far less expensive and considerably faster solution to the problem than building a whole new line of railway. Quite possibly this threat capped the climax for the Phenix line, for no further work was done and even talk of the line's construction faded and died.

The fascination of water fed by hot springs had a strong hold upon the public imagination of the day, and neither Capt. Hopkins nor his successor George Phenix had a monopoly of facilities. In October 1905, almost two years after Hopkins began expounding his plans for development, a new and nearer Moana Hot Springs was opened just four miles south of Reno. In spite of its closeness to the city, the public was reluctant to embark upon the lengthy carriage ride to the site, so the owners (borrowing a leaf from Capt. Hopkins' book) set about to obtain a franchise for an electric railway of their own. The line was to be 3.25 miles long extending from the Reno city limits to Moana (although there was some talk that it too might eventually be projected through to Lake Tahoe), and in June 1906 an agreeable Washoe County granted the necessary franchise. By December sufficient stock had been subscribed so that the owners could proceed with incorporation, and in January 1907 the Nevada Interurban Street Railway Co. was formed (the word "Street" being shortly eliminated from the company's name, as indicated on streetcar letterboards).

Late in February 1907 grading was started from the city limits (then at California Avenue) south along Plumas Street to Moana Springs. By May 15 the job was done, but further progress was blocked when tie and rail deliveries fell behind schedule. Finally, late in May, three carloads of ties (only 1,000 out of the 6,000 required) arrived, but another shipment followed in June. The tentative starting date of July 1 had to be forgotten when only part of the total order for rail was delivered from Pittsburgh. Actual tracklaying commenced on August 5 and, augmented by the receipt of another shipment of rail, was finally completed in September. Again there was a frustrating wait, this time of two weeks' duration, until the overhead copper wire arrived.

The first two Nevada Interurban trolley cars were already on hand by this time, having been rushed out from Llanerch, Pennsylvania, where they had formerly operated over the Philadelphia & West Chester Traction Co.'s right of way. Replete in fresh coats of red paint, the cars were brightly stenciled with the word "INTERURBAN" along the base of the body side-panels and the words "RENO & MOANA" at the ends. They represented the latest word in Reno trolley cars, for they were equipped with air brakes, a feature not found on the Reno Traction cars.

A work car carrying Nevada Interurban president L. W. Berrum, a former sheep rancher, made the first official trip over the line on October 24, 1907, but there was still much to be done. The track was not fully ballasted; there were innumerable small details to be attended to; Reno Traction was rushing the final rail link from the former end of their line at Liberty and Virginia Streets south on Virginia and west on California Street to Plumas; and because Nevada Interurban's cars used 600 volts current against Reno Traction's 550 volts, a second and separate trolley wire had to be strung adjacent to that of Reno Traction's over the latter's trackage east from Plumas Street via California and Virginia Streets to Second Street so that the Interurban's cars could make use of Reno Traction's trackage to reach the center of town. In spite of these complexities, regular service was scheduled to begin on Sunday, November 3, 1907, and two nights before the event the first car left Reno on a private tour of the new $65,000 line. Motorman McGrath piloted the guests over the four-mile route in a flat 15 minutes, his whistle loudly announcing that the road was finally in operation, but even the whistle failed to remove one obstruction. An unscheduled stop was necessary so that some of the huskier guests could remove a loaded handcar which section crews had innocently left standing on the tracks. In spite of this, manager Charlie Short was obligingly waiting at the end of the line to demonstrate Moana Springs' most cordial hospitality to the 25 guests. The following night the trip was repeated for another group of "distinguished guests" without any untoward incidents.

Still another hot springs was responsible for a third effort at light railway construction during the same era. Six miles west of Reno lay Lawton's (Laughton's) Springs, and in August 1906 a narrow gauge steam railroad was proposed to link the Springs with the Reno Traction Co.'s railway system. By the following month the plans had been

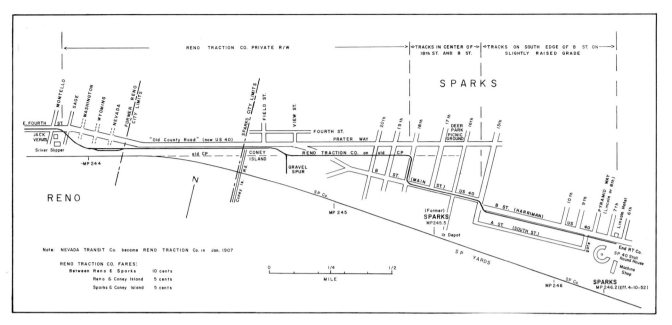

changed to a slight degree — the road would be of standard gauge, electric powered, and would not reach all the way to Lawton's. Instead, it would start from the west end of Reno Traction's Second Street line, cross the Truckee River to the south bank at Chism's Ranch and continue westerly until it reached the Mayberry Ranch. At this point the Riverside Park Co. would build a new hotel and a natatorium complete with hot water piped from Lawton's, a mile to the west. The same people involved in the Riverside Park Co. then formed the Riverside Railroad Co. to construct the railway. Contracts for the bridge across the Truckee River were awarded in October 1906, and some weeks later manager Herbert Nichols reported that grading was being done rapidly and that two miles of rail had been ordered.

In February 1907, following a wait of several months, ties for the Riverside Railroad arrived. Grading had been completed to the river, and the bridge piers had already been set in place (they may still be seen near Idlewild Park). Completion of the road was promised by June 1, 1907. Some 2,000 feet of track was laid along the (leased) SP right of way and, since the power lines for the trolley would not be ready in time for the opening, an ex-Manhattan Elevated Railway steam locomotive was purchased to help in construction and perform the honors. June 1 came and passed; still the railroad was not completed. In July 1907 it was reported that the Traction Company would operate the line until the Riverside Railroad obtained its own cars, and then the project faded. No record

has been found of the ultimate fate of the line or its secondhand locomotive, although it may reasonably be assumed that Reno Traction kept a good eye on the corpus delicti.

These, then, were the major elements of the Reno Traction's situation as it entered the busy year of 1907. True, there were other ethereal projects blowing about on the winds, for men's minds, once stimulated, seldom remain quiet. Even in the fall of 1906, for example, there was talk of various electric railways to Lake Tahoe. An eastern group actually surveyed for an electric road around the lake. A separate group of prominent Reno investors considered a 25-mile line to Brockway on the north shore of Lake Tahoe. Thomas B. Rickey, a banker and rancher, stated that he would start work on his Western Nevada Electric Railway, extending from the State Prison to Carson City (a few miles away) and Shaw's Spring (now Carson Hot Springs) together with a connection to the proposed Brockway line. Real estate companies were prone to think of traction lines in connection with their tract developments. Reno Improvement Co. and Reno Development Co. were two of the largest. The latter tried unsuccessfully to join forces one time with the Nevada Interurban.

Expansion

Reno Traction reigned supreme, operating the only streetcar lines in the city of Reno. The Reno Development Co., backed by Senator Newlands, wanted to buy the company from the Fleishhackers, but the stiff price asked resulted in a

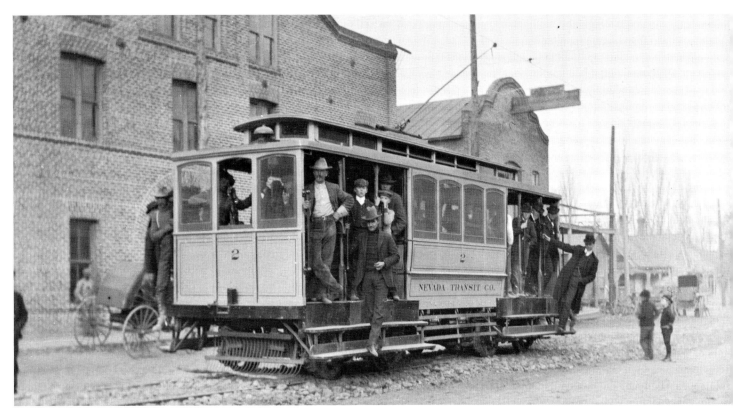

On November 20, 1904, the first streetcar to operate in Nevada *(above)* made its trial trip. Nevada Transit Co. was predecessor to the Reno Traction Co. of January 1906 which operated the street railways until the end in 1927. Few will remember the Riverside Hotel *(below)* in the days prior to 1908 when Reno Traction No. 5 departed across Virginia Street's Truckee River bridge on its tedious trek to Sparks. Minutes later it had swung up Second Street to Sierra and crossed the Southern Pacific's tracks to the McKissick Hotel *(below, right)*, a 1908 conversion of a former opera house built in 1888 by a Long Valley, California, rancher. It was later known as the Plaza Hotel.

The 1908 extension from Virginia Street east on Second Street and north on Sierra Street to the railroad station *(top, right)* became the terminus for the majority of Reno Traction runs as well as those of the Nevada Interurban. The short stretch of double track enabled cars to pass each other. The strange, double-side-entrance car in the foreground appears to be one of the early Nevada Transit open-enders with winter side-panels and abbreviated steps. *(Above and below: Stanley Palmer photos; top, right: Grahame Hardy Collection; bottom, right: Nevada Historical Society.)*

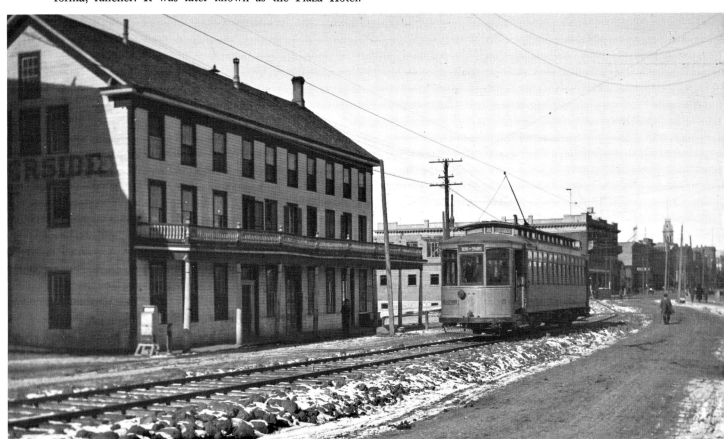

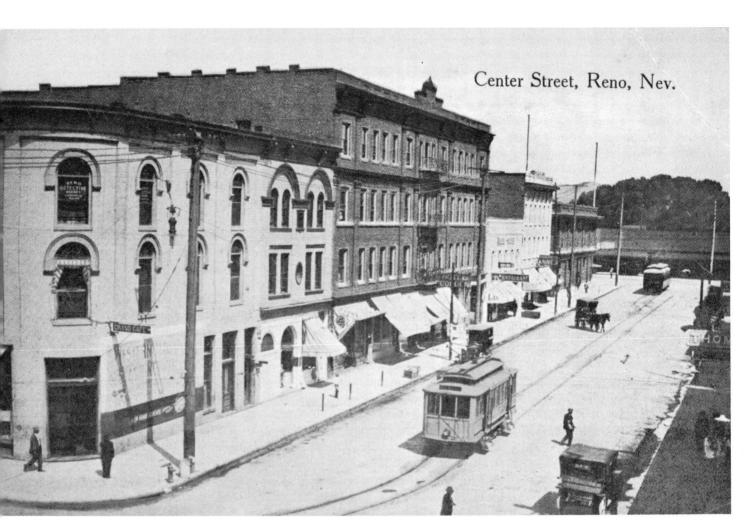

Center Street, Reno, Nev.

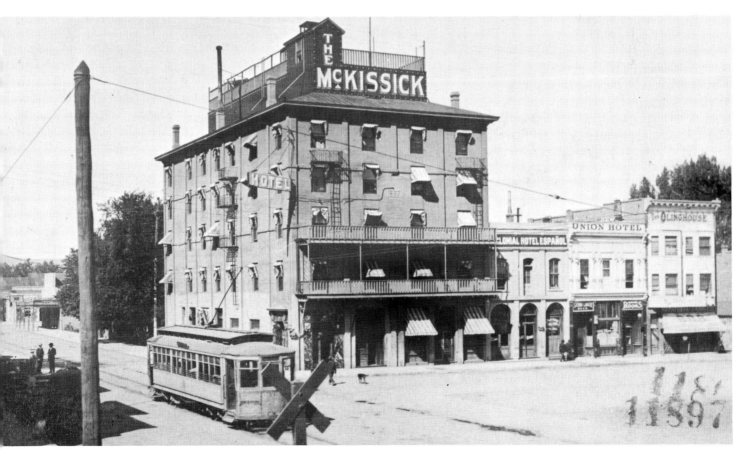

prompt "no sale." So Reno Traction set out to expand its line still further in an effort to increase its revenues and service to the community.

In March 1907 the company announced that it planned to build an extension of its lines up Sierra Street to the University of Nevada. Opposition reared its head when Walter J. Harris and J. E. Gignoux appeared before the city council and asked for a franchise for a line to form an inverted "U" in the northern section of Reno. One portion of their route would lie on Sierra Street between Eighth and Elm, a section already included in the Reno Traction franchise. To all intents and purposes, the Harris-Gignoux combine simply ignored the possible area of conflict and on May 29, 1907, put 50 men on the job of tearing up Sierra Street and laying ties. In the afternoon Harry Stewart and 100 men on the Reno Traction payroll appeared on the scene to survey the route for the Traction Company. While Stewart busied himself with the details of the survey, his men began spiking down Traction Company rails on the Harris-Gignoux ties, to the consternation of the latter's forces which were heavily outnumbered. While the Harris-Gignoux boss was out seeking reinforcements, Stewart ordered all the other men off the street. In view of the overwhelming odds, the men obeyed and Stewart had won his point; the franchise was protected; and the event, headlined as the "Street Car War," was ended.

Reno Traction continued to work on the Sierra Street line that summer, pushing the rails up Sierra Street from Fourth to Ninth and thence east on Ninth to the University gates at Center Street. The job was finished, and two small streetcars arrived from San Francisco to operate over the line, but still service could not be started. Construction of the connecting switch at Fourth Street had been delegated to the Nevada Engineering Works, and they had been so swamped with business the work had been delayed. When the switch was finally delivered, it was rushed into position and service over the line commenced on September 2, 1907.

The building of the Nevada Interurban Railway's line to Moana in the summer of 1907 dictated one additional expansion of Reno Traction's facilities. Since the Interurban started from the city limits at Plumas Street, Reno Traction had to extend its Virginia Street line a few hundred feet south from Liberty to California Street, then west to Plumas and connection with the Interurban. Manager Campbell announced that work would begin in May 1907, but when the Interurban con-

struction became halted for lack of rail, the Reno Traction forces were diverted elsewhere until more definite progress was indicated. In August, following completion of the Sierra Street line, 50 men were transferred to the Plumas Street connection. The entire job, including the parallel line of overhead wires for the Interurban's higher voltage, was finished and ready before the official opening day of the new system.

In spite of the fact that the banks had just closed their doors in the spreading Panic of 1907, and that November third fell on a normally quiet Sunday, the opening day of the Nevada Interurban Railway was a bonanza occasion. Cars started from Second and Virginia Streets, operated over the Reno Traction Co.'s rails to the city limits and thence over their own right of way to Moana and return. Over 1,500 people made the trip that first day even though power limitations restricted operations to one car only. Each capacity trip left more people waiting at the terminus for the next car, while the young and eager circumvented the line-up by climbing on top where there was more space and less crowding. At the Moana end of the line the excitement was equally intense and was heightened further for a time when a little brown bear escaped from his cage.

The next evening there was even more excitement. Gambler Jack O'Brien was reported to have been seen swimming at Moana with another woman, and Mrs. O'Brien took a dim view of this aquacade. Gun in hand, she rode to the Springs in search of her errant husband. Jack knocked the gun from her hand — so it was alleged — and into the water, then escorted her back to the streetcar. On the return trip Mrs. O'Brien was seated up front while Jack rode in back, but a wary eye was kept, one on the other. At Reno they were observed getting off the trolley together.

As if this weren't enough, the Interurban continued to make news the next day when the work car jumped the rails at high speed. Fortunately no one was hurt, and the car was soon returned to the tracks. There was a problem, however, with the big cars. Until the power company could enlarge its plant and increase the electrical output, a small Reno Traction trolley substituted for the Interurban equipment over the entire run. Once the power company's generating capacity had been increased, the Interurban cars again returned to their assigned tasks, and President Berrum was soon able to provide half-hourly service on Sundays and evenings. To stimulate the winter interest, a

large pond was dug at Moana for ice skating, although it was hardly anticipated that the patronage would include a horse which tried to climb aboard the car on California Street, shattering the glass as he dove through the door.

Reno Traction sustained its share of problems and incidents as well. Crossing the SP's main line at Sierra Street could be an unnerving experience. In the fall of 1907 a series of incidents occurred involving SP switchers. Switchmen had little concern for streetcar schedules and were making life most uncomfortable for manager Campbell by blocking the Sierra Street crossing with long cuts of cars or sitting on some of the spur tracks blocking the way to Sparks. One noon as a streetcar started across the SP tracks, the power suddenly went off leaving the car stranded squarely in the middle of the crossing. A passenger train was just pulling in from the west and the railroad engineer, thinking the streetcar would move ahead momentarily, did not stop until the very last moment. Fortunately the passengers had already deserted the electric car before the train approached, but it took a lowly team of horses to drag the trolley off the crossing. At the same spot, a few weeks later, a switcher almost hit another car. A female college student passenger went into hysterics with fright, and the conductor was accused of negligence.

Not all incidents revolved about the railroad crossing. Snow, ice, hotboxes and broken irrigation ditches created their share of problems, while more frequently accidents occurred with horse and buggies and suits were quickly filed. The big cars to Sparks were equipped with air brakes, but for a time the local cars were not. The Reno City Council ultimately passed an ordinance requiring all streetcars to have air brakes, and when the Traction Company failed to comply the city sued. Police Chief R. C. Leeper added a touch of notoriety to his colorful career when he attempted to arrest all the employees of the company as well as the streetcars themselves. Ironically, when Leeper later resigned to go into private business, he subsequently worked for the Reno Traction Co., first as a streetcar conductor and later as superintendent.

In keeping with the Christmas spirit of 1907, some public spirited souls in Reno thought it would be a fine idea if the Traction Co. would let the conductors keep one day's proceeds for themselves, but manager Campbell would have nothing to do with the scheme. An alternate plan, which was revived annually for several years, established Christmas as a "no change" day. Platform men pocketed all change in excess of the fare being paid.

Three more extensions of the Reno Traction Co.'s system were inaugurated in the next few years to bring the property to its maximum dimensions. In 1908, after several false starts, an abbreviated line was pushed eastward on Second Street from Virginia to Center Street, then north for one block to the SP depot. Tracks in the block on Center Street (to the depot) comprised the only stretch of double track roadbed on the entire system (other than those occasional points where passing tracks had been installed). The basic reason for this, of course, lay in the double usage of the terminus for both the streetcars and the Interurban.

Two men, Wheeler and Burke, acquired an independent franchise for a trolley line down Wells Street on the south side of town to serve their new real estate development. To protect their interests, Reno Traction arranged to take over the franchise, and late in 1909 the company rushed work on an extension from Virginia and California Streets eastward over Moran Street, then south on Wells. In order to begin operation of the line during the first days of 1910, every action was taken to speed the project, the men even working on Sundays.

About the same time (early in 1910), what was known as the Ralston Street line was built. Tracks were laid westward on Fourth Street from Sierra to Ralston, then northward on Ralston for approximately 1,000 feet.

Somewhat unusual was the "phantom" Fair Grounds line. Each year, during the summer racing season, a temporary track was laid on Alameda (Wells) Avenue northward from Fourth Street to the grounds themselves. No track connection was ever made at the Fourth Street interchange, but a single streetcar was "shoo-flied" from the main line to the branch to provide the shuttle service on the temporary track. At the end of each season the car was returned to its normal assignments and the temporary tracks removed.

Thus, after all the planning, talking and promotion over the years, Reno, Nevada, was served by just two operating companies. Reno Traction operated eight cars over its 7.5 miles of track (of which three miles of line constituted local street lines in the city of Reno), while Nevada Interurban operated four cars over its 3.25 miles of private trackage plus that segment of the Reno Traction lines from the city limits to the SP depot via California, Virginia, Second and Center Streets. No change in the power requirements of either com-

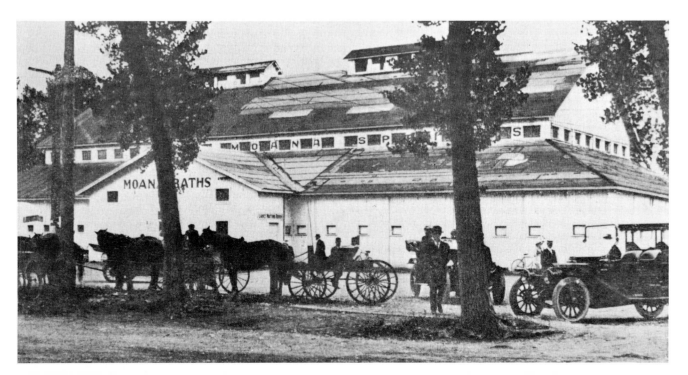

Nevada Interurban operated between the Reno City Limits and Moana Springs, but the company's trolleys continued their runs via Reno Traction tracks to the Center Street terminus at the railroad station. Denial of this privilege in 1920 brought the line to an abrupt end. The first two cars came from the Philadelphia & West Chester Traction Co. at Llanerch, Pa., of which No. 2 is seen *(top, left)* at the important stop between the Riverside Hotel and the Washoe County Court House and again in portrait *(center, left)*. Moana Springs *(bottom, left)*, at the far end of the line, became a major resort. In addition to the baths and lessons in swimming, dances were held every Sunday afternoon. For many years boxing, wrestling and other sporting activities were a major part of the agenda. Jim Jeffries trained at Moana when he came out of retirement in an effort to regain his title, only to be defeated by Jack Johnson in the fifteenth round.

All Nevada Interurban equipment, including big, heavy car No. 3 *(above)*, came to the line equipped with air brakes, a facility not enjoyed by the pioneer Nevada Transit trolleys seen *(below)* on the Virginia Street bridge over the Truckee River with the Riverside Hotel in the background. *(Top left: Sewell Thomas; center and bottom left and top right: Mrs. P. E. McInnes Collection; bottom right: Nevada Historical Society.)*

pany was ever made, so the dual trolley wires over the joint trackage remained throughout the lifetime of the service.

Under normal circumstances the Traction Company kept five cars in constant service. The two big cars covered the route from the SP depot to Sparks; one trolley handled the Wells-Sierra Street lines; while two shuttle trolleys operated on each of the stub lines on Ralston Street and on Second Street. The long streetcar route from Wells to Sierra and the University of Nevada campus was the most difficult on which to maintain an operating schedule. "Hop" Eaton, wearing a cap on the side of his head, seemed to be the only motorman capable of running this stretch with anything resembling an "on-time" performance. Even Eaton could not combat one winter's heavy snowstorm when a streetcar was abandoned for several days at the University end of the line. Quickly the students transformed the immobilized vehicle into a temporary clubhouse replete with an imported coal stove for insulation against the wintry blasts.

Mainstay of the Traction Co.'s system was the line to Sparks. Commutation between that railroad center and the more adequate shopping facilities in the heart of Reno was a housewife's "must," regardless of the incidental pleasure of a trip aboard the cars. On evenings and weekends in the summer and fall, business was equally brisk as the big cars carried revellers to Wieland's Park, the "Coney Island" of Nevada and popular amusement center. The Park being situated between Reno and Sparks, the Traction Company derived double benefit from the heavy traffic in both directions.

Unfortunately for the Nevada Interurban, it enjoyed no such admixture of utility, fun and amusement as its city rival. The line had been built for one specific purpose — to bring people to the Moana Hot Springs — and throughout its existence that remained the one important facet of its operations. True, people did move out into the suburbs to some extent, but the population explosion necessary to develop a substantial business just did not occur. Prosaic as its operations were, occasional incidents did occur to break the monotony of routine performance.

One of the more spectacular events took place at the northern end of the home rails at Reno's city limit. It had been the practice of the Interurban crew to tie the car up for the night on the siding at Plumas Street (near California), set the brakes and then walk to their homes nearby. In the morning, service was resumed after the first crew took the

car down to Moana to begin the full run into Reno and the SP depot. On one particular night, certain individuals (it has never been determined whether they were drunks or children) became overpowered with the temptation to play motorman on their way home. Raising the trolley pole against the wire, they entered the car and swung the controller open as far as it would go. Nothing happened, so the group departed leaving the trolley pole raised and the controller wide open for full speed ahead. They did not know that it was the custom of the operator at the power plant to turn off the electricity after the last run had been made for the night and to turn the power on again early in the morning before the first scheduled run of the new day. The following morning, when the overhead wires were energized, the trolley's motor automatically responded, and the lonely, empty car took off for Moana with no one aboard. Fortunately the nocturnal marauders had failed to release the air brakes so that, although there was no air in the braking system to hold the car immediately, the air pumps started working at the same time that the traction motors started turning. Before the car had progressed too far, the air pressure built up and applied the brakes, bringing the car to a halt. With the traction motors still on, the resistors in the electrical circuit became overheated and the car caught fire. The story ended at this point; but it is interesting to note that, over the years, constant repetition has expanded and magnified it to the point that current recitals envision the trolley starting off like a rocket, bursting into flames as it rolled over the uneven track and finally catapulting into a field when it failed to make the final turn. Perhaps the incident should be told that way — it certainly adds glamour for a more exciting story.

Reno's streetcar lines proved to be operating headaches and financial disappointments. Neither of the two companies paid a dividend, although there is an unconfirmed report that the early Nevada Transit Co. may have paid some dividends. In actuality, both systems were developed too late in the mechanical age — the automobile was then coming into its own.

The Reno Traction Company fared the better of the two, being able to maintain annual revenues of approximately $50,000 through 1923. In the early years, small net profits were the rule; but commencing with 1917, annual net losses became prevalent. Not enough money was available to pay the interest on the $36,000 of publicly held bonds, and no interest was paid on the $100,000 of bonds held

by the stockholders. Approximately 80% of the gross business came from operation of the Reno-Sparks cars on which a respectable operating profit was earned, but this was generally absorbed by the off-setting losses of the Reno local lines. In 1918, for example, the cash fare boxes of the local trolleys took in $10,000, but expenses tallied a generous $18,000 even before considering the city taxes or the usual street paving work of about $5,000 per year. To add to the difficulties, in the summer of 1919 the employees were granted a 40% wage increase to help them cope with the high cost of living; while the condition of the roadbed of the line to Sparks was allowed to continue to deteriorate as maintenance funds were diverted to pay the day-to-day costs of the local lines.

The Nevada Interurban, being shorter and smaller than its city cousin, fared even worse financially. As far back as 1908-09, its annual "take" amounted to $14,000; by the 1915-17 era, the revenues had fallen to a mere $5,000. In the majority of years, net losses were reported. An all-out effort was made in 1913 to make the line successful. L. W. Berrum took over most of the bonds and bought Moana Springs. Still the tide could not be stemmed.

The Interurban's greatest asset was the fact that it was a Berrum family affair. Father owned the line, and his upper teen-age children learned to take their turns as motormen. During the World War I years, each son succeeded the other as, one after another, the boys were called into the armed services. Finally their sister, Marie, donned the motorman's uniform and piloted the cars to Moana and return. Marie is remembered as being fearless, for she would set the controller of the car at full speed and then go back to collect the fares while the pilotless trolley was left to rock along its uneven track. Ground moisture was largely responsible for the soft condition of the roadbed; lack of maintenance only served to enhance and emphasize the high and low spots which caused the cars to rock and roll from side to side as they sped along. Local wits were fond of proclaiming that the Interurban was the only car line where passengers "could reach out and touch the ground."

In the later years of its operation, service on the Interurban would halt with the first snowfall as there was no business anyway. In October 1918 things were particularly difficult, and the line ceased for the winter without waiting for the snow. This time the Reno Golf and Country Club filed a formal protest before the Nevada Public Service Commission. Speaking for the Interurban, treasurer S. H. Rosenthal explained that the daily expense of the wages of the motormen plus the cost of the power (the rates had recently been raised) had increased to the point where it exceeded by almost a dollar a day the average daily take of $5.25. No provision had been made by the company for taxes or for maintenance; in fact, the Reno City Attorney had felt compelled to file a formal complaint before the Commission about the roadbed just the year before. Some new ties had been ordered from the Verdi Lumber Company, while Berrum himself had paid the wages of the laborers out of his own purse. Later Berrum found that he not only had to pay the bill on the ties (as the Interurban had no money), but when the taxes came due it was Berrum again who dug down in his own pocket to pay them.

The year 1919 was one of confusion and upset for Reno's trolley lines. Service was resumed on the Nevada Interurban in April, but pressure was brought to bear on Reno Traction not to renew its joint track agreement with the Interurban for use of the Virginia Street line. In turn, Reno Traction wanted to divest itself of all local street trolley operations with their attendant losses. With denial of trackage rights into Reno a certainty, and with abandonment of city limit trolley connections imminent, the life expectancy of the Nevada Interurban was suddenly and drastically shortened.

Reno Traction filed a petition in the fall of 1919 seeking to abandon its local streetcar lines (excluding the line to Sparks). Hearings were held before the Public Service Commission; citizens protested; and the city of Reno was offered a chance to lease the local routes for itself, which it declined. Abandonment of the trolleys was considered to be a backward step in the city's progress, and a petition with 400 protesting signatures was filed with the Commission. In spite of this, abandonment was approved, to become effective on January 15, 1920. A local citizen's group appealed the decision to the State Supreme Court, but that summer the Court upheld the Commission's order, and in July 1920 the wires were removed and the tracks torn up on all except the main route via Fourth and Second Streets to the SP depot.

With entry to the city of Reno thus forcibly denied to the Nevada Interurban, its patrons were obliged to walk from California to Virginia Streets to the center of downtown. The blow was fatal. In the fall of 1920 Ted Berrum took the last car to Moana, and operations came to a permanent end.

Eventually the Nevada Interurban's cars and rails were sold to the Red River Lumber Company of Westwood, California.

In spite of the loss of the street railway lines, the citizens of Reno were still vociferous in their criticisms of the operations of the remaining Reno-Sparks segment. Complaints were filed with the Nevada Public Service Commission to the point where that body ordered that the equipment and the roadbed of the Sparks line be upgraded. To do the job, Reno Traction brought in J. C. "Cal" Linabary in July 1920 and made him manager of Nevada's last streetcar line. Linabary's previous career had started with a motorman's job in Kansas City and later St. Louis. Then, coming to California, he added further variety to his background through employment with the Pacific Electric Railway, the Oakland, Antioch & Eastern, the Tidewater Southern and the Central California Traction Company, the latter also a Fleishhacker enterprise. The transfer from Central California Traction to Reno Traction represented a step up the ladder with the same employer.

Acting on the PSC orders to improve the line to Sparks, Linabary raised the tracks from 14″ to 18″ over a distance of ¾ of a mile. To improve the service. he borrowed two Central California Traction open-end cars (#110 and #112, formerly on the Cherokee Lane-Aurora Street line in Stockton), but the selection proved to be a poor one. The cars were most unpopular and eventually were relegated to extra service. Patrons objected to paying 10¢ to shiver all the way from Reno to Sparks, and as one commuter acidly commented, "The wire screen door was carefully kept closed (in winter) so that the icy blasts might be properly filtered."

The Commission continuously and successfully prodded Reno Traction to improve its service. It ordered that the cars be kept clean, that the seats be wiped at the end of each trip if necessary, and that the Company use every effort to prevent smoking and spitting in the cars. Patrons from the railroad shops at Sparks were not inclined to observe any amenities while riding the trolleys, either in keeping their feet off the seats or in otherwise cooperating with the management. Many preferred (and continued) to ride on the fender or on the roof top, and when the conductor finally persuaded them to get off, they would immediately climb back on the roof as soon as his back was turned. More than once the aid of the sheriff had to be enlisted, and finally a special officer was put on at

Sparks to limit riders to the normal areas of the cars.

Ordinarily about 20-40 passengers rode the half-hourly cars between Sparks and Reno, but when the day shift of the SP shops got out at 4:00 P.M., two cars were required to carry the crowd of 200 workers to points near their homes in Reno. The first car was always loaded to the hilt with men in dirty overalls soiling the seats and a preponderance still chewing their wad of tobacco and spitting on the floor. It was no wonder the majority of the other passengers preferred to wait for the second car. When one-man operation of the trolleys commenced on October 1, 1920, an exception had to be made for the four o'clock trip. A special conductor was provided to ride the first car west as far as Coney Island to collect the fares; then he returned to Sparks to work the second car when it left.

When a buzzer system was ultimately installed for the convenience of departing riders, motormen were threatened with insanity. Patrons delighted in wedging toothpicks in the push-buttons to keep the buzzers ringing constantly, and the noise could not be stopped without disconnecting the batteries. Other operating problems included the severe sagging of trolley wires in the extreme hot weather of summer with a corresponding contraction and snapping in the dead cold of winter. Too, electrolysis ate holes in water pipe lines adjoining the right of way as bond wires on the rails weakened and became broken. Indian troubles arose when one Indian section crew took an extreme dislike to its Italian boss and went on a sit-down strike. Only after an intermediary Indian was hired did the men return to work.

Potbelly stoves were used to heat the Sparks cars in winter, and during the years the SP locomotives burned coal (before conversion to oil burners), the streetcar conductors kept a sharp eye peeled along the neighboring right of way for any stray lumps which might have fallen from the tenders. A companion feature of the cars to the stove heat were the special arc lamps used for interior lighting which became the cynosure of all eyes as they sputtered and flickered under improper adjustment.

Informality of operation was the general rule on the Sparks run, and special arrangements became the order of the day. When the Masonic Dance in Sparks was well attended and the crowd didn't want to break up, the hat was passed among the revellers for a $10 collection with which to charter a special streetcar to leave an hour or so after the

last regular car for the night. Reno Traction obligingly would make the last-minute arrangements, and the dance would carry on.

Over the years from 1920 to 1925, Reno Traction continued to operate its hook-shaped line — south from the SP depot in Reno to Second Street, west on Second to Sierra, north to Fourth Street and then east to Sparks. In July 1925 the Company proposed moving the Reno terminus from the depot back to Second Street, just west of Virginia Street. In considering the matter, the Reno City Council went one step further and suggested that the terminal be moved back to Sierra Street near Fourth to avoid the grade crossing of the SP tracks. Anxious to trim costs, the Company readily accepted the idea; the public, however, was not so ebullient. When the new service became effective the following month, streetcars virtually disappeared from downtown Reno and there was a noticeable decline in patronage on the line.

Hardly had the declining trend of business become noticeable than, later in 1925, a Gardnerville bus operator sought authority to operate buses between Reno and Sparks. Linabary pointed out that this would mean the end of Reno Traction streetcar service, for there was not enough business to sustain one, let alone two, operators over the route. Public opinion inclined in favor of the streetcars; the mayors of both Sparks and Reno spoke for the car line, as did E. H. Walker, manager of the Reno Chamber of Commerce. (In the early days of the Nevada Public Service Commission, Walker had been its very active secretary.) The bus application was denied.

A year and a half passed by before, early in 1927, two other parties filed applications to provide bus service. One of the applications, in addition to offering service between Reno and Sparks, also proposed to institute local service in Reno. This aspect of the application appealed to civic bodies, the public and the Commission, and in spite of protests by Linabary and the Reno Traction, the Brown Brothers application was approved. Buses began operating on June 15, 1927, and the available traffic was quickly divided between the buses of the new Nevada Transit Co. and the electric trolleys of Reno Traction Co.

In August 1927 the Reno Traction Company announced that it was through. Although in the later years it had been able to earn its operating expenses and even managed to pay the interest on the publicly held bonds, by the latter part of 1926 things had taken a turn for the worse. Now, with the bus line skimming off its passengers, revenues were dropping alarmingly and it was obvious no earnings were in sight.

On September 2, 1927, the Commission held a short abandonment hearing. In negotiating with Reno City Attorney Pike over the matter of paying for the cost of removing the tracks, the attorney for the car line remarked: "You can have it lock, stock and barrel." To which Pike was heard to counter: "And a lot of bonded indebtedness with it, I suppose. Well, I don't care for the railroad." Even when it was suggested that the Traction Co. management might throw in $100,000 of the bonds, Pike still refused to take it. A. N. Baldwin, secretary of the Company, wanted to quit that very night saying "We know when we are licked." However, it was finally agreed that the last day of operation would be September 6, 1927. The people wanted buses; they could have them.

Jack Linabary, son of the manager and the last motorman for the line, wanted to have some sort of celebration to mark completion of Reno Traction's last trolley trip. Finally, he obtained permission from the Sparks police to tie down the whistle as the last car came into Sparks on its final run. Thus the last car shrieked into town in the first few minutes of September 7, 1927, the car's four passengers thoroughly enjoyed the music of Jack's celebration. Not so the local citizens, for although they had become inured to the pounding of flat wheels on the rails in the wee small hours of the night, the continuous whistling was a disturbingly unfamiliar noise. The following morning Police Chief Lee Walstrom complained to Linabary that people had kept him awake all night telephoning to complain about the noise. "What did you tell them?" Jack asked. To which Walstrom replied, "I said 'Go back to sleep, you bastards, you'll never hear it again!'"

Nevada's last trolley had come to the end of the line.

(Stanley Palmer photo.)

LOCOMOTIVE ROSTER

The following locomotive rosters have been compiled from such information as is available of the short line railroads described in these two volumes. Except where independent short lines become part of major systems, no rosters are included for the Southern Pacific, Union Pacific, Santa Fe and Western Pacific or their major predecessors such as the Central Pacific, Salt Lake Route or the Atlantic and Pacific, as these have been published previously elsewhere.

The data, arranged in columns, are (reading from left to right) the road number of the locomotive, wheel arrangement, builder, builder's number, date built, wheel size including tire (inches), cylinder diameter and piston stroke (inches), weight in pounds (generally the engine only in normal operating condition), boiler pressure (pounds per square inch) and tractive effort (in pounds). Notes concerning individual locomotives follow each tabular listing.

Wheel arrangements of steam locomotives are reported by the number of wheels in the lead (pony) truck, the number of driving wheels and the number of trailing wheels (under the fire box). A tank type locomotive (water and fuel tanks carried on the locomotive as opposed to being carried in a separate tender) is indicated by a "T" following the wheel arrangement. Wheel arrangements of a geared locomotive, used for heavy grades prevalent in logging and mining roads, is indicated by the number of wheel trucks, i.e., 2-T, 3-T or 4-T.

Although a count of U. S. locomotive builders would run well over 100, by far the largest number of locomotives were turned out by two firms or their predecessors, American Locomotive Company and The Baldwin Locomotive Works. The first company was formed in 1901 and within eight years acquired the business and plants of the following venerable companies: Schenectady, Brooks, Pittsburgh, Dickson, Rhode Island, Richmond, Manchester, Cooke and Rogers. Baldwin was a successor to Burnham Williams & Co. Geared locomotives were built by Lima (Shay), Heisler and Climax. The names of the smaller though no less colorful builders will be found sprinkled throughout these listings.

ARDEN PLASTER COMPANY (U. S. Gypsum Co.) Arden, Nevada. (Narrow Gauge. 1907-1930)

No. 1(?)	0-6-0T					
—	0-6-0	Davenport	1742	Oct. 1919	9x14	
16	0-6-0T					

The first locomotive is reported to have come from the Quartette Mining Co. at Searchlight. In 1924, it was sent to Amboy when U. S. Gypsum (owner since 1919) replaced the motive power with two 25-ton Porter saddle tank locomotives. These were sold in 1930.

AUSTIN CITY RAILWAY (Narrow Gauge. 1881-1889)

No. 1	MULES' RELIEF	0-4-2T	Baldwin	5586	1881	33	11x16

When first built, a large cab enclosed most of the locomotive. After the wreck in August 1882, the cab was considerably shortened.

BATTLE MOUNTAIN & LEWIS RAILWAY (Narrow Gauge. 1881-1890)

No. 22	JOHN D. HALL	2-4-0T	Prescott, Scott & Co.	23	1881		
	STARR GROVE	0-6-0	Prescott, Scott & Co.	27	1881	36	14x16

No. 22. Named for the president of the BM&L Ry. Built by Prescott, Scott & Co. (Union Iron Works), San Francisco, expressly for the heavy grades of this road, it arrived in August 1881, in September it was "returned at the expense of the builders" as it was too light for the job. It weighed 17 tons and cost $7500.

Starr Grove was an important mine in the area. The disposition of this locomotive is unknown. At various times the BM&L leased NC locomotives.

BATTLE MOUNTAIN MINES & DEVELOPMENT COMPANY (1916 - 18 ±)

This mine railroad, extending for about 1½ miles along Lewis Canyon, was built to haul ore from the mine to the mill. It was powered by a gasoline locomotive; its most notable feature being a double transmission developed by Lowell Smith, the engineer of the mill. Later Smith was to distinguish himself as the first man (according to local reports) to fly a U. S. plane around the world.

BLUESTONE MINING & SMELTING CO. (Standard Gauge. 1917-1929)

| No. 1 | 2-T | Heisler | 1351 | Dec. 1916 | 36 | 15x12 | 94,000 |

Sold to Mason Valley Mines Co., then was sold by the Eimco Corporation in Sept. 1939 to F. L. Botsford. In 1944 was sold to Blake Bros. quarry operators near Richmond, Calif., for use as a spare switcher. Sold to Bert Rudolph, Willits, California.

BOCA AND LOYALTON RR (Standard Gauge. 1900-1916)

No. 1	0-4-4T	Baldwin	13001	Oct. 1892	42	9 & 15x22	52,000	180	7700
2	4-6-0	Baldwin	—	1875	—	16x28	60,000		
3	2-6-0	Baldwin	3889	1876	48	17x24	75,000	130	16620
4	2-6-0	Baldwin	3891	1876	50½	16x24	82,300	135	14000
5	2-8-0	Baldwin	6085	1882	50	19½x24	108,000	150	23300
6	4-6-0	Rhode Is.	—	1875	—	17x24	96,000		
7	4-6-0	Pittsburgh	978	Jul. 1888	51	18x24	100,500	160	20800

No. 1 Baldwin Vauclain Compound. Purchased from Chicago South Side Elevated R.R. No. 27. Used in construction of Western Pacific. Sold Apr. 1912 to Natomas Consolidated Company, becoming their No. 2 and used at their gravel plant at Oroville, California. Scrapped in 1937.

No. 2 Purchased from Pennsylvania R.R. Used in construction of WP. Disposition unknown.

No. 3 Formerly V&T No. 23, purchased by B&L in 1901. Scrapped by WP at Jeffery Shops, Sacramento Nov. 15, 1916.

No. 4 Formerly V&T No. 24, then Verdi Lumber Co. first No. 2, purchased by B&L in 1902. Used in construction of WP, acquired by WP Nov. 30, 1916, as No.

123. Set aside November 1924, scrapped at Sacramento, June 1930.

No. 5 Formerly Cincinnati, New Orleans & Texas Pacific (Southern) No. 589 (prior numbers 555 and Cin. Sou. 55). Used in construction of WP, became No. 124 when acquired by WP Nov. 30, 1916. Sold for scrap Nov. 1949.

No. 6 Purchased second hand in 1902. Assigned to WP Western Division July 1, 1914, no record of disposal.

No. 7 Formerly Pittsburgh & Lake Erie R.R. No. 57. Used in construction of WP, became No. 125 when acquired by WP Nov. 30, 1916. Retired April 10, 1931, scrapped Dec. 1934.

BODIE AND BENTON RAILWAY (Narrow Gauge)

Bodie Railway and Lumber Co. (1881-1882)
The Bodie and Benton Railway & Commercial Co. (1882-1893)
Bodie Railway and Lumber Co. (1893-1906)
Mono Lake Railway and Lumber Co. (1907)
Mono Lake Railway (1907-1917)

No. 1	0-6-0T	Prescott Scott		24	1881	36	14x16	
2	0-6-0T	Prescott Scott		25	1881	36	14x16	
Second 2	2-6-0							
3	2-6-0	Baldwin		3638	1874	40	12x16	(Ex E&P No. 2)
4	0-4-0T	Porter		494	1882	36	12x18	

Second No. 2 was called INYO; No. 3, MONO; No. 4, BODIE.

BORATE & DAGGETT RAILROAD (Narrow Gauge. 1898-1907) (Daggett, Calif.)

No. 1 MARION		2T	Heisler	1018	Feb. 1898		50,000
2 FRANCIS		2T	Heisler	1026	Jan. 1899		70,000
PCB 1498	0-4-0T		Davenport	1498	Mar. 1916	10x16	

No. 2 was used in the construction of the Death Valley R.R. Later it was sold to Nevada Short Line (No. 2), then Terry Lumber Co. at Round Mountain, Calif.

PCB 1498. From Thorkildsen Mather Co. (Sterling Borax Co.) at Lang, Calif. Sold to Pacific Coast Borax Co. for stationary boiler service for laundry of Amargosa Hotel Co. at Death Valley Jct.

BULLFROG GOLDFIELD RAILROAD (Standard Gauge. 1906-1928)

No.										
No. 3	0-6-0	SW.	Baldwin	29712	Dec. 1906	52	20x26	135,000	180	
4	0-6-0	SW.	Baldwin	29713	Dec. 1906	52	20x26	135,000	180	
11	4-6-0	Pas.	Baldwin	29726	Dec. 1906	(Ex. BG No. 13)				
12	4-6-0	Pas.	Baldwin	29727	Dec. 1906	63	21x28	170,000	180	
13	4-6-0	Pas.	Baldwin	29726	Dec. 1906	63	21x28	170,000	180	
14	4-6-0	Pas.	Baldwin	29727	Dec. 1906	(Ex. BG No. 12)				
54	2-8-0	Frt.	Baldwin	29265	Nov. 1906	55	22x28	183,000	180	
55	2-8-0	Frt.	Baldwin	29266	Nov. 1906		22x28	183,000	180	

No. 3 Sold to LV&T Second No. 3, L&S No. 3 Utah Copper Co. No. 400.

No. 4 Sold to Utah Copper Co. No. 401, later sold to Peninsula Terminal Co. near Portland, Oregon, as their No. 401. Scrapped 1953.

No. 11 Formerly BG No. 13, number changed by 1910. Sold to NWP No. 178 in 1917. Scrapped at Tiburon Jan. 12, 1954.

No. 12 Formerly BG No. 14. Boiler destroyed in an explosion Dec. 29, 1910 between Beatty and Hot Springs. Not rebuilt by BG. Bell used at Ludlow School House. Later frame and tender sold to SP

Co. for SD&A. New boiler added at SP's Los Angeles Shops Nov. 1918. Became SD&A No. 20, Dec. 1918. Leased to SP Co. (No. 2385) June 19, 1941 to Apr. 24, 1943. Returned to SD&AE No. 20, Sept. 1948. Retired June 12, 1950.

No. 13 Wrecked in washout Aug. 9, 1908. Became No. 11 by 1910.

No. 14 Locomotive No. 14 changed to No. 12 Sept. 13, 1908.

Nos. 54-55 No record of disposition. On BG RR roster of June 30, 1915. Probably sold to AS&R in 1917 then to National Railways of Mexico in 1923.

CALIFORNIA SALT COMPANY

CRYSTAL SALT CO. (1909), CONSUMERS SALT CO. (1916), PACIFIC ROCK SALT CO. (1918), CALIFORNIA ROCK SALT CO. (1921), CALIFORNIA SALT CO. (1950). Operates narrow gauge railroad from Saltus (near Amboy) to quarries in Bristol Lake.

Early locomotives include an 0-4-0T Porter followed by a saddle tank replacement, probably also a Porter. About 1927 this second locomotive was retired, following the acquisition of Plymouth gasoline locomotives. In March 1963, four such locomotives were in service. One was rated at eight tons, two at three tons and one at 15 tons.

CARSON & COLORADO (Narrow Gauge. 1880-1905)

NEVADA & CALIFORNIA RAILWAY (Standard and Narrow Gauge. 1905-1912)

(All locomotives shown below were narrow gauge and built by Baldwin Locomotive Works. N&C standard gauge locomotives were supplied by S.P. Co.)

N&C No.	C&C No.								Date Initials Change to N&C	Date Scrapped
1	1	4-4-0	5285	Oct. 1880	41	14x18	48,000	Mar. 17, 1906	See Note	
2	2	4-4-0	5430	Apr. 1881	41	14x18	48,000		July 31, 1907	
3	3	4-4-0	5428	Feb. 1881	41	14x18	48,000	Mar. 24, 1906	Sept. 23, 1908	
4	4	4-4-0	5782	Sept. 1881	44	14x18	48,000	Apr. 4, 1906	See Note	
5	5	4-4-0	6089	Apr. 1882	44	14x18	48,000	Mar. 31, 1906	See Note	
6	6	4-4-0	6090	Apr. 1882	44	14x18	48,000		July 31, 1907	
7	7	4-4-0	6687	Apr. 1883	44	14x18	48,000	Apr. 12, 1906	See Note	
8	8	4-4-0	6689	Apr. 1883	44	14x18	48,000	Mar. 21, 1906	See Note	

At the time of the Tonopah boom, additional locomotives were sent over from the South Pacific Coast Ry. (also an SP affiliate, operating between Alameda and Santa Cruz, California).

N&C	SPC									
9	16	4-4-0	7604	June 1885	48	15x18	52,000	Aug. 2, 1906	Feb. 10, 1911	
10	17	4-4-0	7605	June 1885	48	15x18	52,000	Aug. 2, 1906	Apr. 20, 1933	
11	11	4-6-0	5649	May 1881	43	15x18	49,900	July 11, 1906	July 6, 1934	
12	12	4-6-0	5650	May 1881	43	15x18	49,900	July 9, 1906	June 30, 1934	
13	13	2-8-0	6157	April 1882	36	15x18	57,100	Oct. 26, 1906	See Note	
14	18	4-6-0	7939	June 1886	48	16x20	74,000	July 1, 1906	See Note	
15	22	4-6-0	9929	June 1889	48	16x20	74,000	July 1, 1906	Dec. 21, 1935	
16	19	4-6-0	7941	June 1886	48	16x20	74,000	Aug. 1, 1907	Dec. 27, 1935	
17	21	4-6-0	8487	June 1887	48	16x20	74,000	Aug. 1, 1907	See Note	

In 1912, the N&C was absorbed by the CP and N&C locomotive numbers became SP (CP) numbers.

Notes:

N&C No. 1 Sold to Eureka & Palisade Ry. April 20, 1907 to become E&P No. 9.

No. 4 Laid aside at Sparks, Jan. 31, 1929. Sold to Nevada County Narrow Gauge R.R. May 27, 1929 to become NCNG No. 7. Scrapped Jan. 1937.

No. 5 Laid aside at Sparks, Jan. 31, 1929. Dismantled at Sacramento, Jan. 20, 1932.

No. 7 Rebuilt Aug. 11, 1923. Laid aside at Sparks, Jan. 31, 1929. Dismantled Sacramento, Jan. 20, 1932.

No. 8 Laid aside Sparks, Jan. 31, 1929. Dismantled Sacramento, Feb. 10, 1932.

No. 10 Laid aside Sparks, Jan. 31, 1929. Dismantled Sacramento, April 20, 1933.

No. 11 Laid aside July 14, 1923, rebuilt Jan. 19, 1924. Retired at Mina May 31, 1932. Dismantled Sacramento, July 6, 1934.

No. 12 Laid aside June 30, 1921, rebuilt Dec. 31, 1921. Retired Mina, May 31, 1932. Dismantled Sacramento, June 21, 1934.

No. 13 Originally laid aside Dec. 1909. Dropped from locomotive list April 1915, account leased to Lake Tahoe Ry. & Trans. Co. Returned to SP Co. April 1927. Dismantled Sacramento, Nov. 9, 1927.

No. 14 To stationary boiler service, Colfax, Calif., Dec. 10, 1945. Scrapped Oct. 18, 1951.

No. 15 Laid aside Mina, Jan. 1, 1934. Dismantled Sacramento, Dec. 21, 1935.

No. 16 Laid aside Sparks, Oct. 31, 1921. Rebuilt Sparks, Nov. 30, 1921. Retired Mina, Jan. 31, 1934. Dismantled Sacramento, Dec. 27, 1935.

No. 17 To stationary boiler service, Salem, Oregon, Dec. 10, 1945. Scrapped April 10, 1952.

C&C Locomotives Nos. 1 to 8 bore the following names: (1) CANDELARIA, (2) BODIE, (3) COLORADO, (4) CHURCHILL, (5) BELLEVILLE, (6) HAWTHORNE, (7) BENTON, (8) DARWIN.

With the broad gauging of 144 miles of the former C&C between Mound House and Mina and Tonopah Jct. in 1905, there was left 155 miles of narrow gauge line between Tonopah Jct. and Keeler (and Candelaria Branch). Nine miles of the standard gauge track was equipped with a third rail to facilitate narrow gauge operations to Mina.

Only one additional locomotive was acquired in the next two decades. Built by Baldwin in 1877, it began service on the South Pacific Coast Ry. as No. 6. It was (second) No. 6 on the San Bernardino & Redlands branch of the SP from 1906 to February 1917. Brought to Mina, it was restored to service Nov. 1, 1917 only to be vacated at Sparks November 30, 1921 and scrapped there May 4, 1926.

After the Nevada-California-Oregon Railway was taken over by SP and then widened 1927-8, the Mina-Keeler trackage was the only place on the SP where narrow gauge engines could be utilized. N-C-O Nos. 8, 9, 14, 18 and 22 were used on the Mina branch. Details of other locomotives will be found in the N-C-O section.

SP No.	N-C-O No.							
8	8	4-6-0	Baldwin	31445	1907	44	16x20	87,150
9	9	4-6-0	Baldwin	34035	1909	44	16x20	87,150
1	14	2-8-0	Baldwin	41300	1914	40	17x20	94,000
18	12	4-6-0	Baldwin	37395	1911	44	16x20	87,150
22	22	4-6-0	Schen.	5399	1899	45	16x20	89,400

No. 8 Restored April 26, 1930. Donated to State of Nevada May 9, 1955. On display in Carson City, at 310 Mountain Street.

No. 9 Restored Sparks, Feb. 21, 1930. Last narrow gauge steam locomotive on SP. Donated to City of Bishop and Inyo County April 30, 1960. On display at Laws, Calif.

No. 1 Bought May 11, 1928 from N-C-O Ry. Sold to NCNG RR (No. 9) Dec. 31, 1933.

No. 18 Donated to Eastern California Museum Association May 13, 1955 (Del. July 19, 1955). On display at Independence, Calif.

No. 22 Ex Florence & Cripple Creek 22. Purchased by N-C-O in 1915. Rebuilt by SP for N-C-O at Sparks in 1925. Worn out, dismantled at Bayshore Shops (near San Francisco) March 28, 1949.

Note: In October 1954, General Electric delivered a 450 hp diesel locomotive especially built for the SP narrow gauge. Numbered SP 1. Sold to Pan American Engineering Co., Dallas, Texas, dealers, April 17, 1961. Resold to C. A. Manera de Cananea, Cananea, Sonora, Mexico.

CLOVER VALLEY LUMBER COMPANY (Standard Gauge. 1917-1957)

No. 3	3-T	Lima (Shay)	2672	Jun. 1913	36	12x15	155,000	200	30,350
4	2-6-6-2T	Baldwin	57684	Mar. 1924	45	17&26x24	219,000	200	37,500
8	2-6-2	Baldwin	32160	Nov. 1907	44	16x24	108,000	170	20,100
11	2-T	Lima (Shay)	788	Jul. 1903	36	12x12	110,000	180	21,500
50	2-T	Lima (Shay)	2093	Jun. 1908	32	11x12	113,000	200	22,580
60	2-T	Lima (Shay)	959	Nov. 1904	36	12x12	116,000	200	23,900

CLOVER VALLEY LUMBER COMPANY — *continued*

No. 3 Ex Verdi Lumber Co. No. 3. Purchased about 1927. Scrapped by 1955.

4 Formerly used in main line service. After Dec. 1957, moved to lumber mill west of Reno, Nev. for stationary boiler service. Acquired by Pacific Locomotive Association in 1973.

8 Formerly Hobart Southern No. 8, bought Aug. 1938 and used as woods switcher. Acquired by Feather River Short Line Ry. March 1958. Now on display at Quincy, Calif.

11 Purchased July 1938. Formerly Verdi Lumber Co. No. 11.

50 Ex-Argentine Central R.R. No. 6. Converted to standard gauge; scrapped by 1955.

60 Formerly Nevada Railroad Co., then Western Pine Lumber Co.

Note: During the 1930's, CVL purchased Verdi Lumber Co.'s No. 7 (three-truck Shay) and unsuccessfully attempted to use frame and running gear as part of a diesel locomotive.

CONSOLIDATED COPPER MINES COMPANY, Kimberly, Nevada (Standard Gauge. 1914-1922)

0-4-0T	Alco (Cooke)	55813	Aug. 1916	Bought new, sold
0-4-0T	Alco (Cooke)	59889	Mar. 1918	or scrapped after 1926.

CORTEZ MINES, LTD.

(Mine at Tenabo, nearest main line railroad at Beowawe, Nevada)

0-4-0T	Porter	1196	July 1890	7x12	(Gauge 29¾")

In 1948, sold to the Last Frontier Hotel in Las Vegas. Now on display at Boulder City. Nev.

DAYTON, SUTRO & CARSON VALLEY R.R. (Lyon Mill & Mining Co.) (Narrow Gauge. 1881-1896)

LM&M Co.

No. 1	ERNIE BIRDSALL	2-4-2T	Baldwin	6035	1881	30	8x12	12,000
2	FRED	0-4-0T	Porter	453	Sept. 1881	—	9x16	

DS&CV

JOE DOUGLASS	0-4-2T	Porter	513	Aug. 1882	8x12

LM&M Co. No. 1 went to San Joaquin & Sierra Nevada R.R. in 1882 to become their No. 1, later SP No. 1023.

LM&M Co. No. 2 (Described as more compact and stronger). Went to Towle Bros. (lumber) in California in 1882.

DEATH VALLEY RAILROAD CO. (Narrow Gauge. 1914-1931)

No. 1	2-8-0	Baldwin	41473	June 1914	42	18x20	120,000
2	2-8-0	Baldwin	42864	Feb. 1916	42	18x20	120,000
5	Rail Motor Car (Brill 1928)						

After the DVRR was abandoned in 1931, the locomotives and other equipment were sold to the U.S. Potash Co. at Carlsbad, N. M. The locomotives were used between the potash mine and the factory. In 1956, No. 2 was returned to Death Valley and is on display at the museum at the Furnace Creek Ranch.

DEEP CREEK RAILROAD (Standard Gauge. 1917-1939)

No. 1	4-6-0	New York	539	Oct. 1889	60	18x24	114,000	160
2	2-8-0	Baldwin	11251	Oct. 1890	47	20x24	115,000	151

No. 1. Ex-RGW No. 36, D&RG 543. Purchased by DC R.R. in 1917, scrapped Sept. 1930.

No. 2. Ex-D&RG 597. Purchased by DC R.R. in 1917, scrapped 1939. DC R.R. leased WP No. 122 at one time.

EAGLE SALT WORKS RAILROAD CO. (Standard Gauge. 1903-1916)

No. 3	0-4-0T	Rhode Is.	—	35	10x16

No. 3 (coal burner) acquired second hand from the East to become L. A. Ostrich Farm Ry. No. 1, L. A. County R.R. No. 1, Santa Ana & Newport Railway No. 1. Sold to ESW Sept. 24, 1903. ESW also had a gasoline locomotive.

EUREKA MILL RAILROAD (Empire or Dayton, Nev.) (30" Gauge. 1872-1892 ±)

No.	—	0-4-0T	Porter					
	—	0-4-0	Porter	848	May 1887	23	6x10	12,000

EUREKA & PALISADE (Narrow Gauge. 1874-1912. See Eureka-Nevada)

No.		Name	Type	Builder	No.	Date				
No.	1	EUREKA	2-6-0	Brooks	167	June	1873	38	11x16	
	2	ONWARD	2-6-0	Baldwin	3638	Aug.	1874	40	12x16	
	3	TYBO	2-6-0	Baldwin	3701	Mar.	1875	40	12x16	
	4	EUREKA	4-4-0	Baldwin	3763	July	1875	42	12x16	45,000
	5	PALISADE	4-4-0	Baldwin	3826	Jan.	1876	42	12x16	45,000
	6	REVEILLE	2-6-0	Baldwin	4375	July	1878	40	13x18	46,000
	7	P. EVARTS	4-4-0	Baldwin	6662	Feb.	1883	41	14x18	48,000
	8		2-8-0	Baldwin	28806	Sept.	1906	38	16x20	81,500
	9		4-4-0	Baldwin	5285	Sept.	1880	41	14x18	48,000
	10		2-8-0	Baldwin	11075	June	1890	38	16x20	

No. 1 Built for the Salt Lake, Sevier Valley & Pioche R.R. No. 2, named KATE CONNOR. Delivered to SLSV&P, stored for a year, then sold to E&P. Later sold to Nevada Central No. 1.

2 Sold to Bodie & Benton No. 3 in 1882.

3 Tybo was an active mining town 80 miles south of Eureka.

4 Sold to SNW&L Co. (No. 5) in 1896, to Hyman Michaels, S.F., to Warner Bros. August 1940. Restored and operated at California Railfair in 1991.

6 Reveille was an active mining town about 100 miles south of Eureka.

7 P. Evarts was the superintendent of the E&P.

8 Became Sumpter Valley No. 14 in 1912.

9 Formerly Carson & Colorado No. 1, purchased by E&P April 20, 1907 for $2,500.

10 Ex Alberta Coal & Ry. Co. No. 7. Bought at the time of the 1910 washout but not used on E&P. Immediately resold to Sumpter Valley No. 15.

EUREKA-NEVADA RAILWAY (ng) (1912-1938. See Eureka & Palisade)

		Type	Builder	No.	Date						
No.	6	0-4-4T	Baldwin	21848	Mar.	1903	30	9x14	30,000	150	4,800
No.	7	2-6-2	Porter	5724	Aug.	1915	36	12x16	50,000		
Sec. No.	7	0-4-4T	Baldwin	21991	Apr.	1903					
No.	8	2-4-4T	Porter	5637	Mar.	1915	36	10x14	50,000		
Sec. No.	8	0-4-2T	Baldwin	22002		1903	30	9x14	30,000	150	4,800
No.	9	2-6-0	Brooks	530	Apr.	1881	41	14x18	45,800	180	13,165
No.	10	2-6-4T	Porter	5893	July	1916	36	12x16	54,500	180	9,790
Sec. No.	10	2-8-0	Baldwin	24271	May	1904	36	14x18	64,000	160	13,400
No.	11	2-8-0	Porter	6515	Jun.	1920	36	14x18	64,000	170	14,160
No.	12	2-8-0	Vulcan	3322	Mar.	1923	33	13x16	56,000	180	12,530
Sec. No.	12	2-8-0	Baldwin	14771	Mar.	1896	37	16x20	70,800	175	20,600
No.	15	4-4-0	Baldwin	4982	Feb.	1880	44	12x16	37,500	125	5,605
No.	23	Rail Motor Car									

No. 6 Ex USA No. 6, Ft. Stevens, Ore. Purchased 1920 but on E-N for only a brief period.

No. 7 Purchased new. Sold to Parker Lyon (Pony Express Museum), Alhambra, Calif. 1939. Purchased by Bill Harrah, Reno, 1955. Rebuilt by Wilmington Iron Works, Los Angeles.

Sec. No. 7 Ex USA No. 7. (See No. 6)

No. 8 Purchased new.

Sec. No. 8 Ex USA No. 8 (See No. 6)

No. 9 Ex OSL & UN No. 88, Utah & Northern No. 31, (Third) Sumpter Valley No. 5, to E-N No. 5 in 1912, rebuilt in 1919 and renumbered E-N No. 9.

No. 10 Purchased new.

Sec. No. 10 Ex Uintah No. 10.

No. 11 Purchased new.

No. 12 Purchased new.

Sec. No. 12 Ex F&CC No. 10, CC&CS 36, Uintah No. 12. On display at Ely.

No. 15 Purchased 1912 from Sumpter Valley RR.

No. 23 Powered by a Ford engine.

FRUIT GROWERS SUPPLY COMPANY. Susanville and Westwood, California (Standard Gauge. Built 1920-29)

		Type	Builder	No.	Date					
No.	1	2-6-0	Baldwin	39760	1913	57	21x28	160,400	180	33,200
	2	2-6-2	Baldwin	54849	1921	44	17x24	123,200	175	23,400
	3	2-6-0	Baldwin	23256	1904	54	18x24	91,000	160	19,600
	4	3-T	Lima (Shay)	2401	1915	36	14½x15	180,000	200	40,400
	5	3-T	Lima (Shay)	2402	1915	36	14½x15	180,000	200	40,400
	32	2-6-0	Baldwin	41395	1913	57	20x26	141,900	180	27,900
	33	Renumbered to No. 2								
	34	Renumbered to No. 3								
Second	34	Renumbered to No. 1								
	101	2-8-0	Baldwin	30686	1907	63	24x28	203,000	180	39,300
	102	2-8-0	Baldwin	30734	1907	63	24x28	203,000	180	39,300
	103	2-8-2	Baldwin	37539	1912	48	20½x28	173,000	170	35,700
	104	2-8-2	Baldwin	38035	1912	48	20x26	171,700	180	35,100
	105	2-8-2	Baldwin	53255	1920	48	20½x28	175,500	170	35,400

FRUIT GROWERS SUPPLY COMPANY – *continued*

No. 1 Ex Ocean Shore No. 21, The Pacific Lumber Co. No. 34, Red River Lumber Co. No. 34, Fruit Growers Supply Sec. No. 34. Renumbered August 1950.

2 Bought new. Formerly No. 33.

3 Ex Quakertown & Eastern No. 1, Ocean Shore No. 4, San Vicente Lbr. Co. No. 4, FGS First No. 34.

4 Ex McCloud River Ry. First No. 16. Purchased in 1924.

5 Ex McCloud River Ry First No. 17. Purchased in 1924.

32 Ex Ocean Shore No. 32, FGS No. 32, Red River Lumber Co. No. 32, returned to FGS, No. 32.

101 to 105 were acquired from the Red River Lumber Co. Details of past service recorded there.

GIROUX CONSOLIDATED MINES COMPANY, Kimberly, Nevada (Narrow Gauge. 1907-1912)

0-4-0T	Porter	3904	May 1907	8x14

Bought new. This locomotive was called ALPHA, the name of the principal mine shaft at Kimberly, Nevada.

GOLCONDA & ADELAIDE RAILROAD (Narrow Gauge. 1899-1913)

2-6-0	Baldwin	4562	1879	40	12x18	39,000

See Nevada Short Line and Nevada Central (No. 6) for details. This locomotive was called PEARL, according to some reports.

GOLDEN STATE PORTLAND CEMENT COMPANY (Riverside Portland Cement Company)
(Standard Gauge. 1915-1928) Oro Grande, Calif.

No. 1	2-T	Lima (Shay)	380	Nov. 1891	29½	10x10	56,000
No. 2	2-T	Lima (Shay)	2740	May 1914	27½	8x10	
Sec. No. 2	3-T	Lima (Shay)	2959	Jan. 1918	29½	10x12	84,000
No. 3	0-4-0T	Porter	5539	Mar. 1914	36	12x18	
No. 3A	0-6-0	American	42774	Jun. 1907	44	18x24	60,000

No. 1 Ex Beaver Creek Lumber Co. No. 2. Scrapped.

No. 2 Bought new. Returned to Lima as it was too light. Resold to California Barrel Co. (No. 1) Dec. 29, 1916.

Sec. 2 Ex Lima Locomotive Works No. 1. Purchased June 9, 1922. Scrapped 1941.

No. 3 From Riverside Portland Cement Co. 1923.

No. 3A Ex Crescent City Ry. No. 1, 1910, Riverside, Rialto & Pacific RR No. 1, 1915, to Riverside Portland Cement Co. Transferred to Oro Grande about 1923.

GOLDFIELD CONSOLIDATED MINES CO. (1908-9)
GOLDFIELD CONSOLIDATED MILLING AND TRANSPORTATION CO. (1909-15) (Standard Gauge)

GCM	1	0-6-0T	Baldwin	32804	June 1908	44	15x24	
GCM&T	2	2-6-0	Dickson	454	Nov. 1883	57¾	19x24	106,000

Formerly DL&W No. 161, 85 (Buffalo Division), then 671. Sold to T&T (No. 2), then to GCM&T.

LAKE TAHOE RAILROADS

CARSON AND TAHOE LUMBER AND FLUMING CO. (Glenbrook, Nevada) (Narrow Gauge. 1875-1898)

No. 1	TAHOE	2-6-0	Baldwin	3709	1875	41	13x16	46,000	130	7290
2	GLENBROOK	2-6-0	Baldwin	3712	1875	41	13x16	46,000	130	7290
3	—	2-6-0	Baldwin	4062	Apr. 1877	41	13x16	46,000	130	7290
4	—	0-6-0T	Porter	218	May 1875	25	9½x14	30,000	130	5950
5	—	0-4-0T	Porter Bell	147	1873	28	9x12			

No. 1 Sold to Nevada County Narrow Gauge R.R. (No. 5) in 1900.

No. 2 Sold to Lake Tahoe Railway and Transportation Co. No. 1 Jan. 31, 1899. Later donated by Bliss family to Nevada State Museum at Carson City.

No. 3 Sold to Lake Tahoe Railway and Navigation Co. (No. 3) Jan. 31, 1899. Scrapped 1926.

No. 4 Ex Lake Valley No. 4, ex N-C-O No. 1. Sold to Nevada County Narrow Gauge Railroad.

No. 5 From Sutro Tunnel Railroad, No. 1, W. D. KELLEY.

M. C. GARDNER (Camp Richardson, Calif.) (Standard Gauge. 1875-1885±)

It is reported that this logging railroad had two locomotives. One was the former V&T No. 2, ORMSBY. (See V&T roster for details.)

G. W. CHUBBUCK – LAKE VALLEY RAILROAD (Bijou, Nevada) (Narrow Gauge. 1886-1898)

First locomotive appears to be the SANTA CRUZ (see N-C-O roster for details) acquired in 1886. Another locomotive reportedly came from the Sutro Tunnel R.R. (built by Vulcan Iron Works, San Francisco).

SIERRA NEVADA WOOD AND LUMBER CO., Incline (Crystal Bay), Nevada (Narrow Gauge. 1881-1896)

No. 1	0-4-0T	Porter	430	Apr. 1881	8x16
2	0-4-0T	Porter	1026	May 1889	10x16

No. 1 was formerly Virginia City & Gold Hill Water Co. Sent to Hobart Mills.

No. 2 was sent to Hobart Mills.

SIERRA NEVADA WOOD AND LUMBER CO., Hobart Mills, Calif.

(SNW&L Co. 1896-1917. Narrow Gauge and Standard Gauge)

(Hobart Estate Co. 1917-1937. Narrow Gauge and Standard Gauge)

(Hobart Southern R.R. 1932-1937. Standard Gauge)

Standard gauge operations were conducted between Truckee and Hobart Mills. Tracks to the woods were narrow gauge and both gauges prevailed at Hobart Mills.

Narrow Gauge Locomotives:

No. 1	0-4-0T	Porter	430	Apr. 1881	—	8x16			
2	0-4-0T	Porter	1026	May 1889	—	10x16			
5	4-4-0	Baldwin	3763	July 1875	42	11x16	125	45,000	6,000
6	2-6-0	Baldwin	27923	Apr. 1906	42	14x20	165	65,000	12,950
7	2-T	Lima (Shay)	1895	June 1907	29½	10x10	180	75,000	14,100
9	3-T	Lima (Shay)	2645	May 1913	32	11x12	200	118,000	25,830
10	3-T	Lima (Shay)	2835	June 1916	32	11x12	200	117,000	25,830

Standard Gauge Locomotives:

No. 3	2-4-0	Baldwin	3689		1875	48¼	14x22	130	65,000	9,970
4	2-6-2	Baldwin	18665	Feb.	1901	44	13x22	160	76,000	13,120
8	2-6-2	Baldwin	32160	Nov.	1907	44	16x24	170	108,000	20,100

Nos. 1 & 2 From SNW&L Co., Incline, Lake Tahoe, Nev.

No. 5 Purchased from E&P (No. 4) in 1896, sold to Warner Bros. 1938.

No. 6 Bought new.

No. 7 Bought new. Sold to Hyman-Michaels Co., San Francisco, 1938.

No. 9 Bought new. Sold to Hyman-Michaels, then to West Side Lumber Co. (No. 15) 1939.

No. 10 Bought new. Sold to Hyman-Michaels, then to West Side Lumber Co. (No. 14) 1939.

No. 3 Ex V&T No. 21, the famed J. W. BOWKER. Acquired by the SNW&L Co. in 1896 donated to the Pacific Coast Chapter, Railway and Locomotive Historical Society.

No. 4 Bought new.

No. 8 Sold to Clover Valley Lumber Co. (No. 8) August 1938. Now on display at Quincy, Calif.

There was also a little Milwaukee gasoline switcher and there is a report of a 2-2-0T locomotive (No. 4).

LAKE TAHOE RAILWAY AND TRANSPORTATION CO., Truckee to Tahoe City, Calif.

(Narrow Gauge. 1900-1926)

No. 1	2-6-0	Baldwin	3712		1875	41	13x16	46,000	130	7,290
3	2-6-0	Baldwin	4062	Apr.	1877	41	13x16	46,000	130	7,290
5	4-4-0	Baldwin	4222	Dec.	1877	43	12x18	45,500	130	6,500
13	2-8-0	Baldwin	6157		1882	36	15x18	57,100	130	12,430

No. 1 Ex-Carson and Tahoe Fluming and Lumber Co. No. 2. Purchased Jan. 31, 1899.

No. 3 Ex-Carson and Tahoe Fluming and Lumber Co. No. 3. Purchased Jan. 31, 1899. Scrapped 1926.

No. 5 Ex-South Pacific Coast No. 5. Purchased October 15, 1906. Scrapped 1926.

No. 13 Ex-South Pacific Coast No. 13. Purchased Aug. 31, 1915. (Another report says leased 1915-1927). Scrapped Nov. 1927.

TRUCKEE LUMBER COMPANY (1880-1912. 36″ gauge. One report says 42″)

	0-4-0T	Porter	699	July 1885	7x12

PACIFIC LUMBER AND WOOD COMPANY, Clinton, Calif. (Narrow Gauge. 1878-1903)

No. 1	0-6-0T	Baldwin	4036	1876	42	12x16	36,000	130	7,100
2	0-6-0T	Baldwin	12015	1892	30	9x14	24,000	130	4,180
3		Porter	147 or 148						

No. 1 Ex-Ruby Hill Railroad No. 2 (?). To Swayne Lumber Co. No. A. Scrapped 1940.

2 To Swayne Lumber Co. No. B. Scrapped 1940.

Additional Locomotive Notes (Lake Tahoe Area):
Fibreboard Products Inc. (Hobart Mills, Calif.) used a 70-ton General Electric diesel in 1952-1953.

Richardson Brothers (Martis Creek, near Truckee, California) operated a locomotive with side concave wheels on a log railroad in the 1875-1890 era.

George Schaffer (near Truckee, Calif.) acquired a steam locomotive for his short logging railroad in 1886.

CROWN-WILLAMETTE PAPER CO., Floriston, Calif. (Standard Gauge)

No. 11	2T	Lima (Shay)	3272	April 1925	36	12x12	150,200	200	27,300

Ex Pacific Coast Supply Co. No. 1. To Lewis & Clark R.R., Clatsop, Oregon, April 1934. Later to Cathlamet, Washington, lumber operations as No. 11, scrapped 1959.

LASSEN LUMBER AND BOX COMPANY (Lasco, California) (Standard Gauge. Built 1923-29)

According to best information available, this company had three locomotives, Nos. 21, 23, and 25 which were sold to the Red River Lumber Co. in 1929. The numbers remained unchanged on the latter road.

LAS VEGAS AND TONOPAH RAILROAD (Standard Gauge. 1906-1918)

No. 1	4-6-0	Baldwin	11867	May	1891	54	18x24	134,000
2	4-6-0	Baldwin	12204	Sept.	1891	54	18x24	134,000
3	2-8-0	Brooks			1900		20x30	194,000
Sec. 3	0-6-0	Baldwin	29712	Dec.	1906	52	20x26	135,000
4	4-6-0	Baldwin	30105	Feb.	1907	57	21x26	178,400
5	4-6-0	Baldwin	30106	Feb.	1907	57	21x26	178,400
6	4-6-0	Baldwin	30107	Feb.	1907	57	21x26	178,400
7	4-6-0	Baldwin	31093	Jun.	1907	57	21x26	178,400
8	4-6-0	Baldwin	31094	Jun.	1907	57	21x26	178,400
9	4-6-0	Baldwin	32250	Nov.	1907	63	21x26	178,400
10	4-6-0	Baldwin	32251	Nov.	1907	63	21x26	178,400
11	4-6-0	Baldwin	32360	Dec.	1907	63	21x26	178,400
12	4-6-0	Schen.	44753	Jan.	1908	63	21x26	188,600
30	2-8-0	Brooks	44750	Dec.	1907	57	22x30	220,500
31	2-8-0	Brooks	44751	Dec.	1907	57	22x30	220,500
32	2-8-0	Brooks	44752	Dec.	1907	57	22x30	220,500

Notes:

No. 1 Ex L. A. Terminal Ry. No. 5, SPLA&SL No. 7 (No. 50). Purchased by LV&T in Dec. 1905 and sold to Outer Harbor Terminal Ry. in 1917 (Second No. 1). Scrapped 1946.

No. 2 Ex L. A. Terminal Ry. No. 7, Ex SPLA&SL No. 7 (No. 51). Purchased by LV&T in Jan. 1906 and sold to Nevada Copper Belt R.R. in 1909.

No. 3 Purchased second hand, possibly from T&T. Remained on LV&T roster of June 30, 1915. Disposition unknown.

Second
No. 3 Purchased from BGRR, No. 3 probably after 1915. Sold to L&S No. 3, then Utah Copper Co. No. 400.

No. 4 Sold to Northwestern Pacific R.R. (No. 170) June 30, 1918. Scrapped at Tiburon, Dec. 21, 1950.

No. 5 Sold to Northwestern Pacific R.R. (No. 171) June 30, 1918. Scrapped at Sacramento, Dec. 14, 1936.

No. 6 Stored, then sold to T&T and later to Six Companies, Inc. (No. 7101).

No. 7 Sold to San Diego and Arizona R.R. (No. 24). Scrapped Sept. 1940.

No. 8 Sold to NWP R.R. June 30, 1918 (No. 172). Scrapped at Tiburon Nov. 18, 1848.

No. 9 Sold to SD&A (No. 25). Scrapped Sept. 1940.

No. 10 Sold to SD&A (No. 26). Leased to SP Co. (No. 2386) June 19, 1941. Returned to SD&AE (No. 26) Sept. 1948. Sold to National Metals Co. for scrap, delivered Nov. 2, 1951.

No. 11 Sold to SD&A (No. 27). Leased to SP Co. June 14, 1946 to May 23, 1947. Retired Nov. 20, 1950.

No. 12 Sold to NWP (No. 129, then 179). Scrapped Aug. 4, 1952 at Tiburon.

No. 30 Sold to LA&SL in 1917 (No. 3675), changed to UPRR No. 6084 in 1922. Scrapped Nov. 1928.

No. 31 Sold to LA&SL in 1917 (No. 3676), changed to UPRR No. 6085 in 1922. Scrapped April 1948.

No. 32 Sold to LA&SL in 1917 (No. 3677), changed to UPRR No. 6086 in 1922. Scrapped Dec. 1933.

LOGGING RAILROADS — FEATHER RIVER AREA

DAVIES-JOHNSON LUMBER COMPANY, Calpine, California (Standard Gauge)

No. 4	2-T	Lima (Shay)	3208	1923	32	11x12	120,000	200
26	2-6-0	Baldwin	32646	1908	48	18x24	124,000	180

No. 4 Ex Portland Railway Light & Power Co. No. 4, Manary Logging Co. No. 4. To Oakdale & South San Joaquin Irrigation District No. 4, United Commercial Co. No. 4.

No. 26 Ex Ocean Shore No. 6, Sierra Railway No. 26. Purchased in 1924, sold for scrap, Oct. 1939.

FEATHER RIVER LUMBER COMPANY, Delleker, California (Narrow Gauge)

Loyalton, California (Standard Gauge)

No. 1	2-T	Lima (Shay)	1833	1907	32	11x12	100,000	200
2	2-T	Lima (Shay)	1832	1907	32	11x12	100,000	200
3	2-T	Lima (Shay)	2183	1909	29	8x12	64,000	160
Sec. 3	2-T	Lima (Shay)	3054	1920				
4	2-6-6-2T	Baldwin	57684	1924	45	17 & 26x24	219,000	200
6	3-T	Lima (Shay)	3302	1927	32	11x12	133,500	200

(All locomotives except No. 4 are narrow gauge.)

No. 1 Ex Argentine Central No. 5.
2 Ex Argentine Central No. 4.
3 Ex Marsh Lumber Co. No. 3.
Second
3 Ex Uintah Ry. No. 6.

4 Before the Clover Valley Lumber Co. was completely closed down, the standard gauge railroad was operated for a short while by the Feather River Lumber Co.

6 Ex Madera Sugar Pine Co. No. 6. Sold to Michigan-California Lumber Co., Third No. 6.

MARSH LOGGING COMPANY, Sierra Valley, California (Standard and 36" Gauge)

No. 3	2-T	Lima (Shay)	2183	1909	29	8x12	64,000	160

To Feather River Lumber Co. No. 3, Scanlon Lumber Co. No. 3, Michigan-California Lumber Co. No. 14 (not used on M-C L Co.)

LOGGING RAILROADS — MODOC COUNTY, CALIF.

BIG LAKES BOX COMPANY—R. L. SMITH LUMBER COMPANY (Standard Gauge) Canby, California

No. 1	3-T	Lima (Shay)	3334	April	1929	36	13x15	187,400	200
91	3-T	Lima (Shay)	2811	June	1915	36	14½x15	180,000	200
104	3-T	Willamette	23	May	1926	36	12x15	148,320	200

No. 1 Ex Tideport Logging Co. No. 1, Consolidated Timber Co. No. 1, Glendale, Oregon. Sold to British Columbia Forest Products Co., No. 19, Port Renfrew, British Columbia.

91 Ex Champion Lumber Co. No. 91, Crestmont, N.C., Red River Lumber Co. No. 91, Westwood, Calif. Boiler exploded Feb. 24, 1948, scrapped 1949.
104 Purchased new.

Note: Big Lakes Box Co.'s roster included only 91 and 104, while all three were on the R. L. Smith roster.

CRANE CREEK LUMBER CO., Willow Ranch, California (Standard Gauge. 1928-29)

No. 1	2-T	Lima (Shay)	2733	1914	29½	10x10	84,000	180

Ex Crookston Lumber Co. No. 4. Purchased in 1928.

PICKERING LUMBER COMPANY (Hackamore, Modoc County operation) (Standard Gauge. 1929-1930)

No. 1	3-T	Heisler	1271	Feb.	1913	40	18x16	170,000	180
7	2-T	Heisler	1105		1906	40	16¾x14	100,000	160

No. 1 From Pickering operations at Standard, Calif. Ex Sunset Lumber Co., Dempsey Lumber Co. Returned to Standard operations.

7 From Pickering operations at Standard, Calif. Ex Dempsey Lumber Co. No. 1, Hetch Hetchy R.R. No. 1. Returned to Standard operations.

LONG BEACH SALT CO.

DIAMOND SALT CO. (1911-12), CONSOLIDATED SALT CO. (1914-33), LONG BEACH SALT CO. (1927-1963). Plant at Saltdale quarry at Koehn Lake, both on SP Owenyo Branch not far from Mojave. They now use a Plymouth engine and may have had a steam locomotive.

LOS ANGELES, CITY OF (Aqueduct Construction Project) (All Narrow Gauge)

No.										
1	0-4-0T	Vulcan	438	June	1903	30	9x14	26,600		
2	0-4-0T	Vulcan	1256	Nov.	1908	30	10x16	36,000		
3	0-4-0T	Vulcan	1407	Nov.	1909	30	12x18	56,000		
4	0-4-0T	Vulcan	1770		1911	30	11x16	40,000	150	8270
5	0-4-0T	Vulcan	1776	Feb.	1911	30	11x16	40,000	150	8270
6	0-4-0T	Vulcan	1777	Feb.	1911	30	11x16	40,000	150	8270

No. 1 Used at Haiwee Dam. Acquired from Thomas Mc-Nalley, ex Erickson & Peterson No. 3, Bowman, Calif.

2 Used at Aqueduct, Calif. Bought new. Sold to U. S. Potash Co.

3 Used at Monolith, Calif. cement plant (near Aqueduct). Bought new. Sold to Monolith Portland Cement Co. to U. S. Potash Co.

4 Used at Haiwee Dam. Bought new. Sold to Palmer, McBride & Quale, then to Harron Rickard & McCone, to State of California. Sold to Pacific Coast Aggregates #4 at Lapis, Calif. in 1943.

5 Used at Haiwee Dam. Bought new. Sold to Harron Rickard & McCone.

6 Used at Haiwee Dam. Bought new. Sold to Santa Cruz Portland Cement Co.

LUDLOW AND SOUTHERN RY. (Pacific Mines Corporation) (Standard Gauge)

No.								
1	0-6-0	Baldwin	25124	Feb.	1905	51	20x26	135,000
2	4-6-0							
3	0-6-0	Baldwin	29712	Dec.	1906	52	20x26	135,000

No. 1 was T&G No. 1 and was sold by them to the Shannahan Bros. for the L&S Ry.

No. 2 is reported to be from a short line (probably Saranac & Lake Placid No. 1-Schen.) in Northern New York which was absorbed by the New York Central Railroad about 1900. An unsuccessful attempt was made to convert it to a gasoline locomotive.

No. 3 Ex BG No. 3, LV&T No. 3, sold to Utah Copper Co. No. 400.

MOHAVE & MILLTOWN R.R. From near Needles to Leland Mine, near Oatman, Ariz. (Narrow Gauge)

No. 1	0-6-0T	Porter	2970	Dec. 1903	—	12x18

There were two other locomotives, one being from the Waterloo Mining Co. at Calico.

MOJAVE NORTHERN RAILROAD COMPANY (Southwestern Portland Cement Co.) (Standard Gauge. Built 1916)

No.									
1	0-6-0T	Davenport	1550	Dec.	1915		17x24		190
2	0-6-0T	Davenport	1584	Aug.	1917		17x24		190
3	0-6-0T	Davenport	1972	Nov.	1923		17x24		190
4	2-4-2T	Porter	5111	July	1912	44	14x20	83,900	170
5	B-B	Gen. Elec.			1948		660 hp	140,000	
6	B-B	Gen. Elec.	29469	Mar.	1948		660 hp	140,000	
7	B-B	Gen. Elec.	29952	July	1948			140,000	

Nos. 1, 2 and 3 were purchased new.
No. 4 Ex SD&A No. 5. Purchased 1923, scrapped 1948.

No. 5 Named LEONARDT, after an early president.
No. 6 Ex Mississippi Export Co. No. 16.

NEVADA RAILROAD COMPANY (Standard Gauge. 1907-1909)

—	2T	Lima	959	Nov.	1904	36	12x12	116,000

Built for White Oak Cannel Coal Co., Caney Ky. (No. 3). Sold to Chinn-Knight Co., Maple Falls, Wisc., then to Western Pine Lumber Co., Klickitat, Wash., then to Clover Valley Lumber Co. in April 1920 (No. 60).

This road had two geared locomotives. During construction, it leased SP No. 1425 (4-4-0) from about Sept. 15, 1906 to some time in 1907 at $10 daily.

NEVADA-CALIFORNIA-OREGON RAILWAY (Narrow Gauge until 1927)

Nevada and Oregon Railway (1880-1885)

Nevada and California Railroad (1885-1893)

No.										
No.	SANTA CRUZ	0-6-0	Porter Bell	218	May 1875	28	9½x14	30,000	140	5,950
1		4-4-0	Baldwin	7527	Dec. 1884	44	12x18	41,600	130	6,660
2		4-4-0	Baldwin	7528	Dec. 1884	44	12x18	41,600	130	6,660
3	ERASMUS GEST	4-4-0	Baldwin	8791	Aug. 1887	44	12x18	41,600	130	6,660
4	CHARLES MORAN	2-8-0	Baldwin	9519	Sept. 1888	38	16x20	82,000	135	15,460
Sec. 4	COMYN	4-6-0	Baldwin	17123	Oct. 1899	44	15x18	72,690	160	12,520
5	AMEDEE	4-6-0	Baldwin	17124	Nov. 1899	44	15x18	72,690	160	12,520
6	COMYN	4-6-0	Baldwin	17123	Became Second No. 4 (1904)					
Sec. 6		4-6-0	Baldwin	22020	Apr. 1903	44	15x20	72,690	160	13,900
7		4-6-0	Baldwin	22012	Apr. 1903	44	15x20	72,690	160	13,900
8		4-6-0	Baldwin	22020	Became Second No. 6 (1904)					
Sec. 8		4-6-0	Baldwin	31445	Aug. 1907	44	16x20	87,150	180	17,800
9		4-6-0	Baldwin	34035	Nov. 1909	44	16x20	87,150	180	17,800
10		4-6-0	Baldwin	34528	Apr. 1910	44	16x20	87,150	180	17,800
11		4-6-0	Baldwin	37394	Dec. 1911	44	16x20	89,200	180	17,800
12		4-6-0	Baldwin	37395	Dec. 1911	44	16x20	89,200	180	17,800
14		2-8-0	Baldwin	41300	Apr. 1914	44	17x20	94,000	180	22,110
22		4-6-0	Schen.	5399	Nov. 1899	42	16x20	87,400	180	18,650
23		4-6-0	Schen.	5420	Jan. 1900	42	16x20	87,400	180	18,650

N-C-O Standard Gauge Locomotives (1927-1929)

No.										
24		2-6-0	Schen.	4956	Mar. 1899	63	20x28	146,000	190	28,710
25		2-6-0	Cooke	2435	May 1899	63	20x28	146,000	190	28,710
26		2-6-0	Cooke	2553	Aug. 1900	63	20x28	146,000	190	28,710
27		2-6-0	Cooke	2608	Jan. 1901	63	20x28	146,000	190	28,710

The N-C-O had two track passenger automobiles:

No. 15 HELEN Acquired Feb. 1, 1917 No. 16 MARTHA Acquired Aug. 1, 1916

(Named for daughters of S. H. McCartney, general manager.)

There was also a four-cylinder Buick purchased Aug. 1, 1910, classified under "Work Equipment."

N-C-O- Locomotive Notes:

SANTA CRUZ: Acquired from Santa Cruz & Felton Railroad in Aug. 1881 and used on N&O. Purchased by Manning & Berry under sheriff's sale Feb. 18, 1882, then leased to N&O until about Jan. 1885. Then sold to Lake Valley Railroad (No. 4), Carson & Tahoe and Lumber & Fluming Co. No. 4, and finally Nevada County Narrow Gauge R.R. (No. 4) in 1900. Scrapped in 1915.

Nos. 1 and 2 were retired in 1915 and on Dec. 31, 1918 respectively. Originally ordered by N&O R.R. No. 2 cost $4,750, f.o.b. Philadelphia.

No. 3 out of service July 1916. Retired from accounts on Dec. 31, 1918, but restored April 30, 1923. Sold to S.P. Sept. 1, 1929, becoming their No. 3. Broken up at Sacramento Sept. 14, 1934. Nos. 3 and 4 ordered by N&C R.R.

No. 4 sold to Tonopah R.R. in Feb. 1904. Sold by T&G R.R. to Sumpter Valley R.R. in 1910, became S.V. No. 3. Although not used after Sept. 18, 1918, locomotive was not retired until April 1930.

Second
No. 4 was purchased as No. 6, changed in 1904. Purchased by S.P. Sept. 1, 1929, becoming their No. 4. Broken up Sept. 12, 1934 at Sacramento.

No. 5 Rebuilt July 1925, acquired by S.P. Sept. 1, 1929, reported scrapped 1934.

Second
No. 6 was purchased as No. 8, changed in 1904. Out of service Nov. 30, 1916 to at least March 1919. Acquired by S.P. Sept. 1, 1929, reported scrapped 1934.

No. 7 Acquired by S.P. Sept. 1, 1929. Scrapped Sacramento May 15, 1935.

No. 8 Acquired by S.P. Sept. 1, 1929, became S.P. No. 8, restored at Sparks April 26, 1930 and used in Owens Valley service. Donated to State of Nevada May 1955. On display at 310 Mountain Street, Carson City, Nevada.

No. 9 Acquired by S.P. Sept. 1, 1929. Became S.P. No. 9, restored at Sparks Feb. 21, 1930. Used in Owens Valley service until Oct. 1954, then held for stand-by service. Donated to City of Bishop and Inyo County, April 30, 1960. Now on display at Laws, Calif.

Nos. 10 and 11 sold to United Commercial Co., then sold to Pacific Coast Railway, becoming Nos. 110 and 111 May 1928. No. 111 was later sold to Oahu Railway and Land Co. No. 110 scrapped 1948, No. 111 scrapped 1950.

No. 12 Purchased by S.P. May 11, 1928, becoming No. 18. Used in Owens Valley service, donated to Eastern California Museum Association May 13, 1955, now on display at Independence, Calif. Delivered July 19, 1955.

No. 14 Purchased by S.P. May 11, 1928, became No. 1. Sold to NCNG R.R. becoming their No. 9. Thence sold to the U. S. Navy in 1944, and was last reported being sent to Africa. Cost, f.o.b. Philadelphia, $10,823.00. (One report says sold to U. S. Navy, No. 17, at Pearl Harbor, 1942).

No. 22 Built for the Florence & Cripple Creek as their No. 22 and named VINDICATOR. Acquired by N-C-O May 1915. Reconstructed at Sparks May 1, 1925. Acquired by S.P. Sept. 1, 1929. Diameter of drivers increased from 42" to 45" May 20, 1937 at Ogden. Worn out and dismantled at Bayshore, March 28, 1949.

No. 23 Built for F&CC as their No. 23, named GRANITE.

Acquired by N-C-O May 1915, and retired as of May 31, 1921. Cost, f.o.b. Canon City, Colorado, $5,121.00.

No. 24 Ex SP 1618. On N-C-O Oct. 15, 1927 to Sept. 1, 1929. Broken up July 21, 1936 at Ogden. (One report says Sacramento Aug. 4, 1936.)

No. 25 Ex SP 1667. On N-C-O Oct. 15, 1927 to Sept. 1, 1929. Broken up Feb. 13, 1930 at Sacramento.

No. 27 Ex SP 1638. On N-C-O June 1, 1928 to Sept. 1, 1929. Broken up March 26, 1934 at Sparks. (One report says Sacramento.)

No. 26 Ex SP 1670. On N-C-O Sept. 29, 1927 to Sept. 1, 1929. Broken up Dec. 8, 1933 at Sacramento.

NEVADA CENTRAL (Narrow Gauge. 1880-1938)

No.								
No. 1	2-6-0	Brooks	167	June	1873	38	11x16	
2	0-4-0T	Porter-Bell	148		1873	28	9x12	
3	2-6-0	Baldwin	3625	July	1874	40	12x16	
4	4-4-0	Baldwin	3682	Jan.	1875	47	13x18	
5	4-4-0	Baldwin	3843	Mar.	1876	42	12x16	44,400
Sec. 1	2-6-0	Baldwin	5569	April	1881	41	13x18	
Sec. 2	2-6-0	Baldwin	5575	April	1881	41	13x18	
6	2-6-0	Baldwin	4562	Mar.	1879	40	12x18	39,000
3	Rail Motor Car							

No. 1 BATTLE MOUNTAIN—Acquired from Eureka & Palisade (No. 1) late 1879 or early 1880. In October 1880 locomotives Nos. 1 and 3, along with ten flat cars and caboose, were sold to Utah Eastern R.R., then building from Salt Lake City to coal fields. Became UP No. 1 in 1885.

No. 2 AUSTIN (also called "the dinky") was Sutro Tunnel No. 2, bought by NC in 1879. Used in construction of three railroads (including NC), and in late 1880 to haul passenger and express train. (?)

No. 3 ANSON P. STOKES (named for financial backer). No. 3 and No. 4 were former Monterey & Salinas Valley Railroad (Calif.) locomotives. For additional remarks, see No. 1. To Utah Eastern No. 3, to UP 289 in 1885, to Kilpatrick Bros. & Collins in 1894, to Laurel Ry. Oct. 1911.

No. 4 DANIEL B. HATCH was purchased from M&SV R.R. (No. 2). In March 1880 it handled the construction train then completing the NC between Bridges and Austin.

No. 5 This locomotive had been the No. 12, SONOMA on the North Pacific Coast Railroad (Calif.). Sold to NC late in 1879 or early 1880. At first was called GEN. J. H. LEDLIE and in March 1880 was used in yard switching at Battle Mountain and construction

nearby. James H. Ledlie of Utica, New York, was in charge of construction of the NC. Later (by Nov. 1880) the locomotive was renamed Jos. COLLETT who was then the general manager, and was used in freight service. No. 5 played the part of Central Pacific's JUPITER while No. 6 played the part of Union Pacific's 119 in the pageant of the 1939 Exposition at Treasure Island, San Francisco. Now owned by Pacific Coast Chapter, Railway and Locomotive Historical Society.

Second
No. 1 S. H. H. CLARK

Second
No. 2 SIDNEY DILLON
Late in 1880, Joseph Collett bought two larger locomotives and sold old No. 1 and No. 3 to the Untah Eastern R.R. After the Union Pacific bought control in June 1881, these locomotives were named for Clark, the general superintendent of the UP and president of the Nevada Central and for Dillon, president of the UP. No. 1 was scrapped in 1938 and in Oct. 1938 No. 2 was sold to the Grizzly Flats R.R. No. 2 in Southern California.

No. 6 See Nevada Short Line No. 1; also NC No. 5.

NEVADA CONSOLIDATED COPPER COMPANY (Kennecott Copper Co.) (Standard and Narrow Gauge. 1907-1958)

Nevada Consolidated Copper Co.:

No.								
No. 6	0-6-0	Pitts.	48184	Aug.	1910	51	20x26	
22	0-6-0T	Schen.	58735	Oct.	1919	51	21x26	160,000
37	0-6-0T	Bald.	42624	Oct.	1915	50	21x24	154,000
38	0-6-0T	Bald.	42625	Oct.	1915	50	21x24	154,000
71	0-6-2T	Bald.	42620	Oct.	1915	50	21x24	152,000

72	0-6-2T	Bald.	42621	Oct.	1915	50	21x24	152,000
73	0-6-2T	Bald.	42622	Oct.	1915	50	21x24	152,000
74	0-6-2T	Bald.	42623	Oct.	1915	50	21x24	152,000
77	0-6-2T	Bald.	45434	Apr.	1917	50	21x24	152,000
78	0-6-2T	Bald.	45435	Apr.	1917	50	21x24	152,000
79	0-6-2T	Bald.	45436	Apr.	1917	50	21x24	152,000
80	0-6-2T	Bald.	45437	Apr.	1917	50	21x24	152,000
81	0-6-2T	Bald.	57016	Sept.	1923	50	21x24	156,000
82	0-6-2T	Bald.	57019	Sept.	1923	50	21x24	156,000
83	0-6-2T	Bald.	57020	Sept.	1923	50	21x24	156,000
84	0-6-2T	Bald.	57091	Sept.	1923	50	21x24	156,000
85	0-6-2T	Bald.	57092	Sept.	1923	50	21x24	156,000
86	0-6-2T	Bald.	57768	Apr.	1924	50	21x24	156,000
87	0-6-2T	Bald.	57769	Apr.	1924	50	21x24	156,000
88	0-6-2T	Bald.	57770	Apr.	1924	50	21x24	156,000
300	0-6-0	Bald.	37668	Apr.	1912	51	22x26	172,500
301	0-4-0T	Dickson	41752	Apr.	1907	44	14x22	
302	0-4-0T	Dickson	42526	June	1907	30	10x16	27,600n.g.
303	0-4-0T	Dickson	42527	June	1907	30	10x16	27,600n.g.
304	0-4-0T	Porter	3464	May	1906		8x14	
305	0-4-0T	Porter	3465	May	1906		8x14	
306	0-4-0T	Porter	3466	May	1906		8x14	
307	0-4-0T	Porter	4329	Apr.	1909		8x14	
308	0-4-0T	Porter	4454	Nov.	1909	30	10x14	34,000
309	0-4-0T	Porter	5247	Jan.	1913	30	10x14	34,000
310	0-4-0T	Porter	5846	July	1916	30	10x14	34,000
330	0-4-0T	Schen.	40773	Aug.	1907	50	16x24	85,000
331	0-4-0T	Schen.	44250	Aug.	1907	50	16x24	85,000
332	0-4-0T	Schen.	44251	Aug.	1907	50	16x24	85,000
333	0-4-0T	Schen.	43291	Nov.	1907	50	16x24	85,000
334	0-4-0T	Schen.	43292	Nov.	1907	50	16x24	85,000
335	0-4-0T	Schen.	44390	Aug.	1907	50	16x24	85,000
336	0-4-0T	Schen.	44391	Aug.	1907	50	16x24	85,000
337	0-6-0T	Bald.	33928	Oct.	1909	44	18x24	116,000
338	0-6-0T	Bald.	35380	Oct.	1910	44	18x24	116,000
339	0-6-0T	Bald.	35398	Oct.	1910	44	18x24	116,000
340	0-6-0T	Bald.	35399	Oct.	1910	44	18x24	116,000
341	0-6-0T	Bald.	35460	Oct.	1910	44	18x24	116,000
500	0-6-2T	Bald.	44795	Jan.	1917	46	19x26	162,000
501	0-6-2T	Bald.	44796	Jan.	1917	46	19x26	162,000
502	0-6-2T	Richm'd	65745	July	1924	46	19x26	
503	0-6-2T	Richm'd	65746	July	1924	46	19x26	
600	0-6-0	Schen.	25875	Feb.	1902	50	19x26	109,200

Some of these locomotives were acquired in the names of affiliated companies. The Steptoe Valley Mining & Smelting Company (SVM & S), an affiliated company operating a smelter at McGill, was reported to have its own industrial railroad (S.G.) with nine locomotives, including one switcher. The NCC Co. was controlled by the American Smelters Securities Co. (ASS Co.) and the American Smelting and Refining Co. through the Utah Copper Co. These companies purchased locomotives which were later sold to NCC Co. Presumably all steam locomotives have been scrapped following the change in operations in 1958.

Notes:

No. 6 Ex Nevada Northern No. 6

No. 22 Acquired from Chino Mines Division (N.M.) in early 1940's.

No. 37 Ex Chino Mines 37, Utah Copper 75, Bingham & Garfield 75. Scrapped 1951.

No. 38 Ex Chino Mines 38. UC 76. B & G 76. Scrapped 1951.

No. 71 Ex UC 71, B & G 71.

No. 72 Ex UC 72, B & G 72.

No. 73 Ex UC 73, B & G 73.

No. 74 Ex UC 74, B & G 74.

No. 77 Ex UC 77.

No. 78 Ex UC 78.

No. 79 Ex Chino Mines 35, UC 79, scrapped 1951.

No. 80 Ex Chino Mines 36, UC 80.

No. 81 Ex UC 81. Scrapped 1951.

No. 82 Ex Chino Mines 33, UC 82.

No. 83 Ex UC 83.

No. 84 Ex UC 84. Scrapped 1951.

No. 85 Ex Chino Mines 34, UC 85.

No. 86 Ex UC 86. Scrapped 1951.

No. 87 Ex UC 87.

No. 88 Ex UC 88. Scrapped 1951.
(Some of the 0-6-2T locomotives were rebuilt as 0-6-0T.)

No. 300 Purchased Oct. 1937, formerly B & G 302.

No. 301 Ex ASS Co. No. 4

No. 302 Ex ASS Co. No. 12 (36" gauge).

No. 303 Ex ASS Co. No. 13 (36" gauge).

No. 304 Ex (first) 300

No. 305 Ex (first) 301

No. 306 Ex (first) 302

No. 307 Ex SVM & S. No. 1

No. 308 Ex SVM & S No. 2.

No. 309 Ex SVM & S No. 3.

No. 310 Bought new.

No. 330 Bought new.

No. 331 Sold, rebuilt by Amador Central RR, Martell, Calif. (to keep shop forces busy), for resale to Pacific States Steel Co., Decoto, Calif., 1942. PSS No. 331, later Judson Pacific Corp. 331.

No. 332

No. 333

No. 334 Ex ASS Co. 334. Sold, rebuilt by ACRR, used at firebrick plant at Ione when burned trestle severed line to Martell in 1939. Stored dead at Ione until sold to Pacific States Steel Co., Decoto, Calif., PSS No. 334, 1941.

No. 335 Ex ASS Co. No. 335. Sold, rebuilt by AC RR, sold to A. D. Schader (No. 335) for use as switcher on Treasure Island (San Francisco Bay) 1939. Sold to Granite Rock Co., Logan, Calif. (GR Co. No.9).

No. 336 Ex ASS Co. No. 336.

No. 337 Scrapped 1951.

No. 338 Sold to U. S. Maritime Commission No. 5, Richmond, Calif. May 1942.

No. 339

No. 340

No. 341

No. 500 Scrapped 1951.

No. 501 Scrapped 1951.

No. 502 Scrapped 1951.

No. 503 Scrapped 1951.

No. 600 Purchased Oct. 1916. Ex Elwood, Anderson & La Pelle RR No. 3, purchased through SI & E Co. No. 1075.

Electric Locomotives of Nevada Consolidated Copper Co.

Mine Locomotives:

4-0	30" gauge	70hp	Baldwin	30414	Mar. 1907	
0	30" gauge	70hp	Baldwin	30429	Mar. 1907	
	30" gauge	70hp	Baldwin	30981	May 1907	Ex ASS Co.
	30" gauge	70hp	Baldwin	31034	May 1907	Ex ASS Co. 4
,-0	30" gauge	20hp	Baldwin	35694	Dec. 1910	Ex ASS Co. 3
∪-4-0	30" gauge	20hp	Baldwin	35695	Dec. 1910	Ex ASS Co. Sec. 4
0-4-0	44" gauge	150hp	Baldwin	36723	Sept. 1911	Ex ASS Co. 13A
0-4-0	44" gauge	150hp	Baldwin	36724	Sept. 1911	Ex ASS Co. 13B
0-4-0	44" gauge	150hp	Baldwin	39347	Feb. 1913	Ex ASS Co.

In 1937, Kennecott Copper Co. purchased an electric freight locomotive from General Electric. As No. 80, it is still (1963) in use at McGill for switching at smelter, using 750 volt current.

Kennecott Copper Company has the following diesels in use:

KCC Co. 100	B-B	Alco	75950	1948	1,500hp
101	B-B	Alco	75951	1948	1,500hp
901	C-C	Bald.	73474	1947	1,500hp

STEPTOE VALLEY MINING AND SMELTING CO. (1906-1914)

Of the nine locomotives reported to be in its ownership, three are accounted for as going to NCC Co., their numbers 307, 308, 309. (Porter 4329, 4454 and 5247). Two others, 0-4-0T, were built by Alco (Rogers) in July 1910 (Builders numbers 47392, 47393) for SVM & S, although it appears that orders were placed in the name of the Ely Construction Co., acting as agent.

There are also ASS Co. locomotives for which disposition is uncertain. They include:

ASS Co. No. 2	0-6-0	Rogers	40689	Sept. 1906	53	20x26	134,000

No. 2 may have been the first NCC Co. No. 300.

NEVADA COPPER BELT RAILROAD (Standard Gauge. 1909-1947)

No.							
No. 1	4-6-0	Baldwin	12204	Sept. 1891	54	18x24	
2	2-8-0	Lima	1091	Jan. 1910	50	18x24	134,550
3	2-8-0	Baldwin	37577	Mar. 1912	50	20x26	163,000
4	2-8-0	Baldwin					
5	2-8-0	Richmond	66302	May 1925	51	19x26	150,000
6	Six wheel 150hp, 30 ton, gasoline switcher. Built by Fate-Root-Heath, Plymouth, Ohio.						

No. 1 Ex L.A. Terminal No. 7, SPLA & SL 51 (1901), LV&T No. 2. Damaged by fire Mason round house, scrapped 1916.

No. 2 Purchased new. Scrapped 1947.

No. 3 Sold to Sierra Ry. No. 24, 1921. Sold to Purdy, South San Francisco, Sept. 1955. Scrapped Nov. 1955.

No. 4 Reports are that this locomotive, a secondhand coal burner from the East, arrived in Sparks to be converted to oil and was never used on the NCB. Tender later used on No. 2.

No. 5 Designed for NCB as 2-8-2 type but trailing truck never installed. Sold V&T in April 1947 to become their second No. 5.

No. 6 Acquired from contractor at Grand Coulee Dam in 1945.

NCB Motor Cars

No. 20 A small 35 passenger car and trailer built by Fairbanks-Morse. Wood construction, combination passenger-mail, equipped with chain drive. Burned on the road.

No. 21 A 54 foot Hall-Scott (No. 5) combination motor car, built 1910. Brill trucks; wood body, built by W. L. Holman & Co., San Francisco. Now property of (San Francisco) Bay Area Electric Railway Association.

No. 22 A 60 foot, Hall-Scott (No. 13) combination motor car, built 1914. Hall-Scott trucks; steel body built by W. L. Holman & Co., San Francisco. Formerly on Salt Lake & Utah R.R. Now used as warehouse south of Carson City with V & T (McKeen) No. 22..

NEVADA NORTHERN RAILWAY (Standard Gauge. Built 1905)

No.								
1	4-4-0	Schen.	566	June 1869	64	16x24	80,150	
2	4-6-0	Schen.	1307	Jan. 1881	57	18x24	89,100	
3	4-6-0	Schen.	1592	Mar. 1883	57	18x24	89,100	
4	4-6-0	Dickson	41240	Sept. 1906	62	20x26	154,000	
5	2-8-0	Brooks	41327	Oct. 1906	48	19x26	225,000	
6	0-6-0	Pitts.	48184	Aug. 1910	51	20x26		
7	4-6-0	Dickson	42662	Apr. 1907	62	20x26	150,000	
8	4-6-0	Schen.	37573	Feb. 1907	58	19x26	153,000	
10	4-6-0	Renumbered, formerly No. 4						
11	4-6-0	Renumbered, formerly No. 7						
20	4-6-0	Renumbered, formerly No. 8						
21	4-6-0	Brooks	46077	Mar. 1909	58	19x26	153,000	
40	4-6-0	Baldwin	34942	July 1910	62	19x26	102,500	
80	2-8-0	Renumbered, formerly No. 5						
81	2-8-0	Baldwin	45351	Mar. 1917	51	21x26	155,000	
B		Cooke	44596	Nov. 1907	Rotary Snowplow		143,400	
401C-C		EMD		1952	1500hp SD-7 (Diesel)			

No. 1 Formerly CP 161, SP 1228, purchased Nov. 18, 1905 for $4,018.00, scrapped 1931.

No. 2 Formerly SP of Arizona 26, SP 106, SP 1609, SP 2045, purchased Dec. 13, 1905 for $5,425.00, scrapped 1931.

No. 3 Formerly SP of Arizona 73, SP 153, SP 1645, SP 2075, purchased Dec. 13, 1905, scrapped 1934.

No. 4 Renumbered No. 10 about 1910, sold for scrap May 1951.

No. 5 Operated for short time as 2-8-2 T, renumbered 80 about 1910, sold for scrap May 1951 (Orig. ASS Co. No. 5)

No. 6 Sold to Nevada Consolidated Copper Co. NCC Co. No. 6.

No. 7 Renumbered No. 11 about 1910, sold for scrap May 1951.

No. 8 Renumbered No. 20 about 1910, scrapped (Orig. ASS Co. No. 8.)

No. 21 Scrapped.

No. 40 Stored, used for special excursion trains.

No. 81 Donated to White Pine Museum, Ely (1959). Now on display.

Nevada Northern Ry. — Locomotives transferred to Nevada Consolidated Copper Co. (Kennecott Copper Corp. after 1942)

No.							
90	2-8-0	Pitts.	43289	April 1908	51	21x30	187,000
91	2-8-0	Pitts.	43290	April 1908	51	21x30	187,000
92	2-8-0	Schen.	44603	Oct. 1908	51	21x30	187,000
93	2-8-0	Schen.	44604	Jan. 1909	51	21x30	187,000
94	2-8-0	Pitts.	46927	Nov. 1909	51	21x30	195,000
95	2-8-0	Brooks	54661	1914	51	21x30	195,000
96	2-8-0	Brooks	56218	Jan. 1916	51	21x30	195,000
97	2-8-0	Brooks	47766	Apr. 1910	51	21x26	196,000
98	2-8-0	Schen.	67943	Apr. 1929	51	23x28	222,000

No. 90 Sold for scrap May 1951.
No. 91 Scrapped.
No. 92 Sold for scrap May 1951
No. 93 Donated to White Pine Museum, Ely (1959). Now on display.
No. 94 Sold for scrap May 1951.

No. 95 Scrapped.
No. 96 Sold for scrap May 1951.
No. 97 Purchased secondhand 1917. Formerly Sharp & Fellows No. 31, Buffalo & Susq. No. 171, not delivered to B&S, sold to S&F June 1915. Scrapped.
No. 98 Sold for scrap May 1951.

NEVADA SHORT LINE RAILWAY (Narrow Gauge. 1913-1920)

No. 1	2-6-0	Baldwin	4562	Mar. 1879	40	12x18
2	2T	Heisler	1026	Jan. 1899	Francis	

No. 1 Originally sold to Utah & Northern R.R. (No. 13). Later OSL&UN No. 17. Acquired by Golconda & Adelaide in 1899. G & A was scrapped by Sugarman Iron & Metal Co. in 1913 and this locomotive was sold to NSL in 1914. After NSL was scrapped in 1920, this locomotive was advertised for sale in *Railway Age*. In 1924 it was bought by the Nevada Central to become their No. 6.

No. 2 The Francis came from the Borate & Daggett RR (Calico) via Death Valley RR to NSL in 1916. To Terry Lumber Co., Round Mountain, Calif. Other motive power included: a gasoline locomotive (purchased in San Francisco in 1916), a 60 H.P. Winton auto engine mounted on railroad trucks which was called Mike, a track passenger car (formerly NCO) a leased locomotive from Hobart Mills and a Shay from the Iron Mountain Ry. Indications are that the NSL may have had two other locomotives, which were destroyed by fire in 1915. References are made to a 24 ton Porter, and pictures show a No. 6 on the boiler front of one NSL engine.

NEVADA SOUTHERN RAILWAY (Standard Gauge. 1893 to 1896, then Calif. Eastern to 1902, then Santa Fe)

No. 1	4-6-0	Baldwin	13748	Oct. 1893	57	19x27	12370	160

Renumbered AT & SF (2nd) No. 142. Scrapped at Calwa, California February 26, 1927.

ORO GRANDE MINING CO. (WATERLOO MINING CO. after 1889)
(Narrow Gauge Railroads at Calico, California)

	0-4-0T	Porter	937	June 1888	7x12
	0-6-0T	Porter	962	Aug. 1888	8x14

One was called Emil and the other Sanger. For a few years after 1901, one was used by the American Borax Co. at Calico, and later at Tick Canyon, near Lang, California, until about 1922. The other went to the Mohave and Milltown Railroad in 1903.

PACIFIC CEMENT PLASTER CO. (1904-9)
CONSOLIDATED PACIFIC CEMENT PLASTER CO. (1909-19)
U. S. GYPSUM COMPANY (1919-24)
(Narrow Gauge. Located at Amboy and Funston, Calif.)

This company had one small saddle tank locomotive. An 0-6-0T was brought in from Arden, Nevada, but proved to be too heavy for the track.

PACIFIC PORTLAND CEMENT CO. (Gerlach, Nevada) (Standard Gauge)

No. 1	0-6-0	Baldwin	32607	Jan. 1908	51	19x26	145,000	175
5	2-6-0	Baldwin	32627	1908	48	18x24	124,000	180
10	0-6-0	Baldwin	57209	Sept. 1923	51	20x24	145,000	175
156	0-6-0	Pitts.	46505	1909	51	20x26	146,000	180
158	0-6-0	Pitts.	46507	Sept. 1909	51	20x26	146,000	180
301	0-6-0T	Baldwin	55721	1922				
501	2-6-0	Baldwin	3091	1873	49	16x24	70,000	

No. 1 Ex State Belt R.R. (Calif.) Second No. 1. Scrapped 1950.

5 Ex Ocean Shore No. 5, Central California No. 5

10 Ex State Belt R.R. (Calif.) No. 10. Purchased May 1946, scrapped 1954.

156 Ex Western Pacific No. 156. Scrapped 1955.

158 Ex Western Pacific No. 158. Scrapped 1955.

301 Side rod diesel locomotive.

501 Ex Virginia & Truckee No. 13. Donated to Pacific Coast Chapter, Railway and Locomotive Society.

Operations are now conducted with a 70-ton diesel locomotive purchased in April 1954.

PIOCHE RAILROADS
PIOCHE AND BULLIONVILLE R.R.

(Also known as Central Nevada R.R. or Nevada Central R.R.). Operations of this narrow gauge railroad began in 1873 with the Colonel J. F. Carter. It had three sets of drivers, a single pony, 11-inch stroke and weighed 36,000 pounds. When the railroad was abandoned and sold Jan. 1884, it had a 23-ton passenger locomotive (Grant) and a 24-ton freight locomotive (Dawson Bailey).

PIOCHE PACIFIC TRANSPORTATION CO.
(Narrow Gauge)
(Nevada-Utah Mines & Smelting Corp.) (Bristol Silver Mines Co.)

No.								
1								
2	2-T	Lima (Shay)	362	1891	21	6x10	20,000	
(a)	0-6-2T	Porter	4125	Mar. 1908		9x14		
Second 1	2-T	Lima (Shay)	892	July 1904	26	8x12		
3	2-T	Lima (Shay)	2194	July 1909	26½	8x8	48,000	
279	2-6-0	Schen.	50829	1912	43	11x18	54,000	150

No. 1 Reported to be an ex-D&RG locomotive purchased in 1891.

No. 2 Disposition uncertain.

(a) No number recorded. Bought by the Nevada-Utah Mines & Smelting Corporation, NUM&S lettering on tank. Disposition unknown.

Second No. 1 Lima records say it was ordered by Birce & Smart, to PG&E, Lake Spaulding, 1912, to Amalgamated Pioche Mines & Smelters Corporation (operating Pioche Pacific).

No. 3 Originally on Santa Barbara Tie & Pole Co., a New Mexico lumber affiliate of the AT&SF Ry. Sold to Zelnicker Supply Co. of St. Louis, Mo., then to Cottonwood Transportation Co., Salt Lake City, then Pioche Pacific, then Bristol Silver Mines Co. On display at Last Frontier Hotel, Las Vegas.

No. 279 Formerly CNW 279. Operated by Bristol Silver Mines Co. Now on display at the new Lincoln County Court House, Pioche.

PRINCE CONSOLIDATED MINING CO.
(Standard Gauge) (Prince Consolidated Mining & Smelting Co.)

No.								
25	2-8-0	Central Pac.	50	1887	51	19x30	111,350	150
2503	2-8-0	Central Pac.	67	1888	51	19x30	114,850	150
2511	2-8-0	Central Pac.	64	1888	51	19x30	111,350	150

No. 25 Ex O&C 47, SP 1910, 2510. Sold to Twohy Bros. in Jan. 1909 (No. 25), then Prince Cons. The number 25 apparently came from a stamping on the brass plate from the side of the steam chest on the cylinder where it appeared under "S.P. 1889." Some photos show this locomotive with "Pioche Pacific" written on the side of the cab. This is the work of an unauthorized person, for the Pioche Pacific was always narrow gauge.

2503 Most reports say this locomotive was never on the Prince Cons. R.R.

2511 Ex O&C 48, SP 1911, 2511. Sold to Prince Cons. Dec. 28, 1915.

PITTSBURG SILVER PEAK GOLD MINING CO., Blair, Nevada
(1906-1918 — 24-inch gauge)

0-4-0T	Porter	4560	April 1910	5x10	(Bought New)	

QUARTETTE MINING CO., Searchlight, Nevada (Narrow Gauge. 1902-1908)

0-6-2T	Porter	2423	Nov. 1901	—	10x14
0-8-0T	Porter	2685	Mar. 1903	—	11x14

RANDSBURG RAILWAY CO. (Standard Gauge. Built 1897-8, sold to AT&SF 1903)

No.								
1	4-6-0	Richmond	2427	1894	63	20 & 32x26	145,000	200

A cross-compound locomotive built by the Richmond Locomotive Works in 1894. It worked on various railroads as a demonstrator, in fact, so many that it is called the "Richmond Tramp." Sold to the Randsburg Ry. in 1898, then to Arizona & Utah R.R. (No. 2) and then AT&SF (second) No. 260.

RED RIVER LUMBER COMPANY, Westwood, California (Standard Gauge)

No.								
3	2-8-0	Brooks			57	22x30	143,800	180
4	0-4-4T							
21	0-4-4T	Rhode Is.	2252	1889	42	12x16	56,500	
23	0-6-0	New York			44	18x26	94,600	150
25	2-6-2	Baldwin	56403	1923	46	16x24	101,000	180
32	2-6-0	Baldwin	41393	1914	57	20x26	141,900	200
34	2-6-0	Baldwin	39760	1913	57	21x28	137,800	180

No.	Type	Builder	Serial	Year	Drivers	Cylinders	Weight	Pressure
91	3-T	Lima (Shay)	2811	1915	36	14½x15	180,000	200
92	4-T	Lima (Shay)	1893	1907	46	17x18	213,700	200
100	2-8-0	Baldwin	30671	1907	63	24x28	203,000	180
101	2-8-0	Baldwin	30686	1907	63	24x28	203,000	180
102	2-8-0	Baldwin	30734	1907	63	24x28	203,000	180
103	2-8-2	Baldwin	37539	1912	48	20½x28	173,000	170
104	2-8-2	Baldwin	38035	1912	48	20x26	171,700	180
105	2-8-2	Baldwin	53255	1920	48	20½x28	175,500	170
110	3-T	Lima (Shay)	2534	1912	32	11x12	120,000	200
111	3-T	Lima (Shay)	2606	1912	32	11x12	120,000	200
300	4-T	Lima (Shay)	1840	1907	46	17x18	300,000	200
1341	4-4-0	Schen.	1457	1881	63	17x24	73,700	140
1349	4-4-0	Schen.	1558	1882	63	17x24	73,700	140

Electric Locomotives:

No.	Type	Builder	Year		Weight	
203	B-B	Baldwin	1927		120,000	
204	B-B	Baldwin	1927		120,000	

Diesel Locomotives:

No.	Type	Builder			
21	B-B	Plymouth		300 hp	
502	B-B	Gen. Elec.-Alco-Ing. Rand	1926		
12		McKeen Gasoline Motor Car			

No.

3 Wrecked in 1929. Some reports say 4-8-0 type.

4 Ex New York Elevated R.R. Scrapped 1934.

21 Ex LA, P&G No. 1, LAT No. 1, SPLA&SL No. 21, Stone & Webster No. 6, Lassen Lumber & Box No. 21. Purchased 1929, scrapped 1940.

23 Ex Sierra Railway Second No. 2, Lassen Lumber & Box No. 23. Purchased 1929, scrapped 1940.

25 Ex Lassen Lumber & Box No. 25. Sold to Modesto & Empire Traction Co. in 1938 (No. 7).

32 Ex Ocean Shore R.R. No. 32, Fruit Growers Supply No. 32. Bought 1924, later sold back to Fruit Growers Supply Co.

34 Ex Ocean Shore R.R. No. 21, The Pacific Lumber Co. No. 34. Purchased 1942, later sold to Fruit Growers Supply Co., Second No. 34.

91 Ex Champion Lumber No. 91, Crestmont, N.C. Sold to Walker-Hovey, Canby, Calif., 1934, to Big Lake Box Co., R. L. Smith Lumber Co.

92 Ex N&W No. 1 (or No. 56), EP&SW R.R. No. 99. Purchased in 1920, scrapped 1934. Some reports say it carried Red River No. 99.

100 Ex Tonopah and Goldfield No. 100. Purchased 1914. Scrapped 1937.

101 Ex Tonopah and Goldfield No. 101. Purchased 1914, sold to Fruit Growers Supply Co., No. 101. Scrapped 1956.

102 Ex Tonopah and Goldfield No. 102. Purchased 1914, sold to Fruit Growers Supply Co., No. 102. Scrapped 1956.

103 Ex Weyerhaeuser Timber Co. No. 103, Twin Falls Logging Co. No. 101, Purchased 1943. Sold to Fruit Growers Supply Co., No. 103.

104 Ex Pacific & Idaho Northern No. 200, Newaukum Valley No. 200, Carlisle Lumber Co., Onalaska, Washington, No. 900. Purchased 1943, sold to Fruit Growers Supply Co., No. 104.

105 Ex English Lumber Co., Mt. Vernon, Washington, No. 10. Purchased in 1943. Sold to Fruit Growers Supply Co., No. 105.

110 Ex Big Creek (Project) R.R., Auberry, Calif., No. 101, San Joaquin & Eastern, No. 101. Purchased 1916. Sold 1937, shipped to Philippine Islands.

111 Ex Big Creek (Project) R.R. No. 104, to San Joaquin & Eastern No. 104. Purchased 1916, scrapped 1940.

300 Ex Carolina & Northwestern No. 300. Purchased 1922 from Georgia Car and Locomotive Co. Scrapped 1937.

1341 Ex Southern Pacific No. 11, 170, 1341, Anderson & Bella Vista R.R. No. 1341 (March 10, 1909). Purchased 1923, scrapped 1937.

1349 Ex Central Pacific No. 110, Southern Pacific No. 1278, 1349. Purchased March 1, 1923, scrapped 1940.

203-204 Sold to Central California Traction Co. in 1945 (No. 23 and No. 24).

502 Sold 1940.

12 Ex Silver Peak Railroad MARY.

RUBY HILL RAILROAD (Narrow Gauge. 1875-)

No.	Name	Type	Builder	Serial	Year	Drivers	Cylinders	Weight	Pressure	
No. 1	RUBY HILL	0-6-0T	Baldwin	3732	1875	36	10x16			
2	DEWEY	0-6-0	Baldwin	4036	1876	42	12x16	36,000	130	7,100

No. 2 Sold to E&P, Pacific Lumber & Wood Co., Truckee Lumber Co., then Butte & Plumas Ry., No. 1. The Ruby Hill also had an 0-4-0 "dinky."

SIERRA VALLEYS RAILWAY (Narrow Gauge)

Sierra Valley & Mohawk Railroad (1885-1887)
Sierra Valleys Railway (1894-1911. Controlled by N-C-O 1900-1911)
Sierra & Mohawk Railway (1911-1915)

No. 1 PLUMAS	2-6-0	Porter	375	July	1880	35½	12x16	36,000
2	2-6-0	Porter	376	Aug.	1880	35½	12x16	36,000
3	2-6-0	Porter	374	Jun.	1880	35½	12x16	36,000

All three locomotives were acquired from SP Co. No. 1 was built for the Oregon Railway as No. 2, DALLAS, to become Oregonian Railroad No. 6. No. 2 was built as No. 3, SCIO, to become No. 7. The *Plumas National,* a newspaper at Quincy, Calif., on Nov. 1, 1894 reported that [Bowen had] ordered two locomotives, 15 flat cars, five box cars and one passenger car. On Thursday, Nov. 22, 1894, it reported that the new engine, named PLUMAS, was fired up Sunday afternoon and tested. However, there is a pencil notation in the 1891 SP locomotive book that Oregonian R.R. Nos. 6 and 7 were sold to the Sierra Valleys Ry. on Jan. 26, 1895.

No. 3 was acquired by the SV Ry. following the wreck June 21, 1899, in which a locomotive was destroyed (believed to be No. 1). It was probably Oregonian R.R. No. 5.

At the time of the construction of the SV&M, it was reported in November 1886 that a standard gauge locomotive had been converted to narrow gauge, renamed MOHAWK, for use in the construction of this railroad.

The Sierra Valleys also had a No. 21 on its roster in 1903-4, and possibly a No. 20, both with 2-6-0 wheel arrangements. No record is available to indicate if these locomotives were owned or leased. After 1910, the SV owned no locomotives (N-C-O supplied the necessary power) and beginning in 1912 the S&M leased one locomotive.

SILVER PEAK RAILROAD CO. (Standard Gauge. 1906-18)

No. 1	4-6-0	Cooke	2076	Jan.	1891	51	19½x24	131,200	170	25,857
2	4-4-0	Baldwin	8372	Feb.	1887	63	18x26	105,700	150	17,320
4	4-4-0									

12 MARY, McKeen Motor Car. Sold to Red River Lumber Co. No. 12.

No. 1 Formerly OSL 642, acquired by SPK June 1906. Returned to OSL Nov. 1909 in exchange for No. 2. OSL 642 numbering restored, thence UP 1529.
No. 2 Formerly OSL 301, acquired by SPK Nov. 1909.

Scrapped by United Commercial Co., San Francisco, 1922.
No. 4 Probably ex-OSL. Scrapped by United Commercial Co., San Francisco, about 1922.

SIX COMPANIES, INC. (Standard Gauge. At Hoover Dam 1931-36)

No. 5	2-T	Lima (Shay)	1666		1906	28	10x10	74,000	(See note)
8	2-T	Lima (Shay)	2505	Apr.	1912		(Same as No. 4001)		
2701	2-8-2	Alco	54395	Jan.	1914	63	26x28	285,000	200
2707	2-8-2	Alco	54401	Jan.	1914	63	26x28	285,000	200
2732	2-8-2	Baldwin	39961	May	1913	63	26x28	285,000	200
4001	2-T	Lima (Shay)	2505	Apr.	1912	28	10x10	74,000	180
4002	3-T	Lima (Shay)	2655	July	1913	36	14½x15	180,000	200
6011	2-8-0	Baldwin	24857	Jan.	1905	57	22x30	345,500	200
6018	2-8-0	Baldwin	24887	Jan.	1905	57	22x30	345,500	200
6022	2-8-0	Baldwin	24891	Jan.	1905	57	22x30	345,500	200
6023	2-8-0	Baldwin	24892	Jan.	1905	57	22x30	345,500	200
6036	2-8-0	Baldwin	24942	Jan.	1905	57	22x30	345,500	200
6038	2-8-0	Baldwin	24969	Jan.	1905	57	22x30	345,500	200
6058	2-8-0	Baldwin	31577	Oct.	1907	57	22x30	345,500	200
6062	2-8-0	Brooks	44638	Dec.	1907	57	22x30	379,130	200
7101	4-6-0	Baldwin	30107	Feb.	1907	57	21x26	178,400	

Six Companies, Inc. initially purchased five Consolidation type locomotives from the Union Pacific and a former T&T 10-wheel locomotive. The numbering plan was based on the weight (tons) on the driving wheels, with the Consolidations being numbered 9901 to 9905 and the 10-wheeler 7101. This system was in operation for less than a year for, when the Mikados were purchased in Sept. 1932, complications arose which caused Six Companies to revert back to the former UP numbering. One factor was varying number of locomotives of former UP ownership on this short railroad. Trading was a common practice, and Consolidation and Mikado locomotives were leased from the Union Pacific at $6.79 and $12.01 a day, respectively. In addition to the locomotives listed, Six Companies, Inc. also had a number of Plymouth gasoline locomotives.

No. 5 Ex MtT&MW No. 5. Sold to Six Companies as a replacement for 4001. Overhauled and relettered by NWP at Tiburon for Six Companies but not delivered as a heavier Shay was desired.

No. 8 See No. 4001.

No. 2701 Ex SPLA&SL 3701, UP 2701 (1921). Purchased from UP Sept. 1932. Sold through United Commercial Co. to Trona Railway in 1936.

No. 2707 Ex SPLA&SL 3707, UP 2707 (1921). Purchased from UP in Sept. 1932. Sold back to UP March 1936. Scrapped April 1948.

No. 2732 Ex OSL 1214, UP 2514 (1915), UP 2732 (1923). Purchased from UP Sept. 1932. Sold back to UP March 1936. Scrapped Dec. 1947.

No. 4001 Ex MtT&MW No. 8. Assigned Six Cos. No. 4001 but never renumbered. Involved in a runaway between Gravel Plant and Shea in train of ten cars of gravel with retainers turned up. As it threw its rods, not considered worthy of repair, hence it was discarded.

No. 4002 Ex East Butte Copper Mining Co., Pittsmont Copper Co., Montana. Acquired as a replacement for No. 4001.

No. 6011 Ex SPLA&SL 602, 3602 UP 6011 (1921). Purchased by Six Co.s Feb. 1932. Scrapped Las Vegas, Sept. 1936.

No. 6018 Ex SPLA&SL 609, 3609, UP 6018 (1921). Purchased Feb. 1932, sold back to UP April 1932 (traded for No. 6036). Scrapped.

No. 6022 Ex SPLA&SL 613, 3613, UP 6022.

No. 6023 Ex SPLA&SL 614, 3614, UP 6023 (1921). Purchased Oct. 1932, sold back to UP Aug. 1934 (traded No. 6058). Scrapped Dec. 1947.

No. 6036 Ex SPLA&SL 627, 3627, UP 6036 (1921). Purchased April 1932. Scrapped at Las Vegas Jan. 1937.

No. 6038 Ex SPLA&SL 629, 3629, UP 6038 (1921). Purchased April 1932. Scrapped at Las Vegas Sept. 1936.

No. 6058 Ex SPLA&SL 3649, UP 6058 (1921). Purchased Aug. 1934. Scrapped.

No. 6062 Ex SPLA&SL 3653, UP 6062 (1921). Scrapped at Las Vegas Sept. 1936.

No. 7101 Ex LV&T 6, T&T Second 6. Scrapped at Las Vegas

Among the locomotives leased by UP to Six Companies were 2714, 2715, 6028, 6053, 6056 and 6069.

TECOPA RAILROAD CO. (Standard Gauge. 1910-1932)

| No. 1 | 2-6-2T | Baldwin | Nov. 1909 | 34089 | 44 | 17x24 | 140,000 |

Purchased by Tecopa Consolidated Mining Co., affiliated with Tecopa Railroad Co. For many years this saddle tank locomotive stood idle at Tecopa and was scrapped about 1946. (There may have been an earlier locomotive.)

TONOPAH AND GOLDFIELD R.R.

This was a combination of the Tonopah Railroad, built in 1904 as a narrow gauge line (36″) and converted to standard gauge in 1905, and the Goldfield Railroad, built as standard gauge in 1905. The re-assignment of numbers is as follows:

Tonopah R.R. Numbers	Goldfield R.R. Numbers	Tonopah and Goldfield R.R. Numbers
No. 1-4 (Narrow Gauge)	—	—
5 (Standard Gauge)	—	No. 11 Passenger
6 " "	—	12 Passenger
7 " "	—	51 Freight
8 " "	—	52 Freight
9 " "	—	53 Freight
10 " "	—	1 Switch
	No. 1 (Standard Gauge)	10 Passenger
	2 " "	50 Freight
	3 " "	2 Switch

TONOPAH RAILROAD (Narrow Gauge. 36″)

First No. 1	2-6-0	Baldwin	23763	Feb.	1904	Order diverted at Baldwin to Kahului R.R. No. 5, Maunaolu
Second No. 1	2-6-0	Baldwin	19211	July	1901	Ex Chateaugay R.R. No. 16
2	2-6-0	Baldwin	19210	July	1901	Ex Chateaugay R.R. No. 15
3	2-8-0	Baldwin	9519	Sept.	1888	Ex Nevada-Calif.-Oregon No. 4
4	2-6-0	Baldwin	24689	Sept.	1904	Purch. new from BLW.

The Chateaugay R.R., about to widen their tracks, apparently cancelled their order; Tonopah probably the first purchaser. Tonopah R.R. also leased a n.g. engine in March, 1904 probably SP Co. No. 9. Tonopah R.R. Nos. 1 and 2 became (Second) Sumpter Valley Nos. 1 and 2, Nos. 3 and 4 became Sumpter Valley Nos. 3 and 4.

TONOPAH AND GOLDFIELD R.R.

No.									
1	0-6-0	Baldwin	25124	Feb.	1905	51	20x26	135,000	To L & S Ry. No. 1
2	0-6-0	Baldwin	25125	Feb.	1905	51	20x26	135,000	Retired 1920.
10	4-6-0	Baldwin	25269	Mar.	1905	63	21x28		Retired 1926
11	4-6-0	Baldwin	25234	Mar.	1905	63	21x28		Retired 1917

12	4-6-0	Baldwin	25235	Mar.	1905	63	21x28		Retired 1923
50	2-8-0	Baldwin	25233	Mar.	1905	55	22x28	185,000	Scrapped 1948
51	2-S-0	Baldwin	25141	Feb.	1905	55	22x28	185,000	Retired 1940.
52	2-8-0	Baldwin	25169	Feb.	1905	55	22x28	185,000	Scrapped 1948
53	2-8-0	Baldwin	25183	Feb.	1905	55	22x28	185,000	Retired 1940
56	2-8-0	Baldwin	31690	Sept.	1907	55	22x28	185,000	Scrapped 1948
57	2-8-0	Baldwin	31728	Sept.	1907	55	22x28	185,000	Scrapped 1948
100	2-8-0	Baldwin	30671	May	1907	63	24x28	203,000	Sold 1914
101	2-8-0	Baldwin	30686	May	1907	63	24x28	203,000	Sold 1914
102	2-8-0	Baldwin	30734	May	1907	63	24x28	203,000	Sold 1914
Second 11	2-8-2	Baldwin	41299	April	1914	48	20½x28	175,000	Scrapped 1948
Second 53	2-8-0	Baldwin	31750	Sept.	1907	55	22x28	183,800	Scrapped 1948
269	2-8-0	Brooks	26469	Jan.	1903	57	21x28	184,000	Scrapped 1948

M-102 Rail motor car M-103 Rail motor car

Nos. 100-102 were sold to the Red River Lumber Co. (California) in 1914. No. 100 was scrapped in 1937. Nos. 101-2 resold to Fruit Growers Supply Co., scrapped in 1956.

Sec. No. 11: Formerly Mason County Logging Co. No. 9, then Carlton & Coast R.R. No. 11. Purchased by T & G April 1945. Scrapped 1948.

Sec. No. 53: Formerly T & T No. 7. Bought by T & G 1944. Scrapped 1948.

No. 269: Formerly BR & P No. 269, then C A & S No. 269. Bought by T & G Dec. 1944. Scrapped 1948.

M-103 Ex Wheeling & Lake Erie.

In September 1945, the T & G leased two diesels from the U. S. Army (Nos. 8105, 8106). One was returned July 3, 1946, the other October 1, 1946.

At the T & G Board of Directors meeting of January 29, 1908, there is a reference to a letter from Baldwin dated January 2, 1908 concerning settlement of accounts. Apparently the two locomotives already in Tonopah (presumably Nos. 56 and 57) were retained by the T & G but four additional locomotives, ordered by and built for the T & G were diverted by Baldwin to other railroads.

TONOPAH AND TIDEWATER R.R. (Standard Gauge. 1907-1940)

No.	1	4-6-0	Baldwin	14418	Sept.	1895	63	19x24	124,690	180
	2	2-6-0	Dickson	454	Nov.	1883	57¾	19x24	106,000	180
	3	2-6-0	Brooks				54	18x24	110,000	140
	4	2-6-0	Baldwin	29312	Nov.	1906	50	18x24	112,000	180
	5	2-8-0	Baldwin	31418	Aug.	1907	50	20x24	142,000	180
	6	2-8-0	Baldwin	31419	Aug.	1907	50	20x24	142,000	180
Sec.	6	4-6-0	Baldwin	30107	Feb.	1907	57	21x26	178,000	
	7	2-8-0	Baldwin	31750	Sept.	1907	55	22x28	183,800	180
	8	2-8-0	Baldwin	31791	Sept.	1907	55	22x28	183,800	180
	9	4-6-0	Baldwin	32292	Sept.	1907	63	19x26	146,500	180
	10	4-6-0	Baldwin	32293	Nov.	1907	63	19x26	146,500	180
	99		St. Louis Car. Co. (See Notes) Rail Motor Car							

T & T roster (1910) included Bullfrog Goldfield R.R. Nos. 3, 4, 11, 12, 54 and 55.

No. 1 Ex Wisconsin & Michigan (first) No. 8, then AT & SF first 260, 641, 856. Bought by T & T 1905, used in passenger service. Scrapped 1941.

No. 2 Ex DL & W 671, DL & W – Buffalo Div. 5, DL & W 161. Bought by T & T Aug. 1906. through Fitzhugh-Luther Co., although received by T & T July 14, 1906. Cost $8,900 plus $1,708 freight. Sold by 1915 to Goldfield CM & T Co. No. 2.

No. 3 Purchased from Fitzhugh-Luther Co. at cost of $5,027 plus $1,499 freight.

No. 4 Sold to Santa Maria Valley R.R. in 1913. Operated as SMV No. 2, then No. 12. Scrapped in 1937.

No. 5 Sold to Santa Maria Valley R.R. in 1913. Operated as SMV (second) No. 1, then No. 15. Scrapped in 1933.

No. 6 Sold to Pacific Portland Cement Co. at Auburn, Calif. (No. 6).

Sec.
No. 6 Formerly LV & T No. 6. Boiler blew up at Death Valley Jct. March 1927. Restored and sold to Six Companies, Inc. (No. 7101).

No. 7 Sold to T & G in 1944 (Second No. 53). Scrapped April 1948.

No. 8 Sold to Kaiser Steel Co., Fontana, Calif. 1944. Rebuilt as switcher (0-8-0), later scrapped.

No. 9 Sold to Morrison-Knudson Co. (No. 9). Scrapped in 1946.

No. 10 Sold to Morrison-Knudson Co. (No. 10). Scrapped in 1946.

No. 99 Built in shops of St. Louis Car Co. for Electro Motive Co. Powered by Winton No. 120 Engine, 6 cyl. 275 HP. Westingtouse 500 volt generator, two Westinghouse traction motors. Delivered to T & T Dec. 19, 1928.

TRONA RAILWAY COMPANY (Standard Gauge. Built 1914)

No.	1	2-8-0	Baldwin	41159	Feb.	1914	57	22x30	208,000	200	
	2	2-8-0	Baldwin	41158	Feb.	1914	57	22x30	208,000	200	
	2701	2-8-2	Alco	54395	Jan.	1915	63	26x28	284,000	200	
No.	50	c-c	Baldwin	74123	(Six Axle, Six Motor)				2,000 hp.		April 1949
	51	c-c	Baldwin	74124	(Six Axle, Six Motor)				2,000 hp.		April 1949
	52	c-c	Baldwin	75835					1,600 hp.		Mar. 1954
	53	c-c	Baldwin						1,600 hp.		1951
	22	Rail Motor Car	Skagit Steel Co. 1926								

Nos. 1 and 2 were acquired new. They could handle between 600 to 750 gross tons, or 400 to 500 net tons. After being equipped with super heaters in 1929, net tonnage was increased to 600 tons.

No. 2701 was acquired after use on Six Companies, Inc. in 1935. Superheated, this locomotive could handle 1,000 gross tons or 675 net tons over the railroad. Originally SPLA & SL, LA & SL 3701. Sold for scrap 1954.

The first diesels were purchased new from Baldwin and together they can handle 2,900 gross tons or 1,980 net tons. When No. 52 was received in 1954, the last steam locomotive was retired. On Nov. 30, 1960 a Baldwin diesel was acquired from Southern Pacific (Ex SP No. 5249).

The rail motor car was sold to the California Western Railway in 1941, now CW Ry. No. M200.

VERDI LUMBER COMPANY (Standard Gauge. 1900-1927)

No.	1 ROBERTS	2-6-0	Baldwin	3685		1875	48	17x24	75,000		
	2	2-6-0	Baldwin	3891		1876	48	17x24	75,000	130	16,620
Sec.	2	2T	Lima (Shay)	771	May	1903	32	11x12	90,000		
	3	3T	Lima (Shay)	2672	June	1913	36	12x15	155,000	200	30,350
	7	3T	Lima (Shay)	847	Jan.	1905	32	12x15	130,000		
	11	2T	Lima (Shay)	788	Jul.	1903	36	12x12	110,000	180	21,500
	20	2T	Lima (Shay)	1829	May	1907	40	12x12	110,000		

No. 1 Formerly V &T No. 19. Purchased by VL Co. 1901.

No. 2 Formerly V&T No. 24. Purchased by VL Co. 1901, however, not definite that it was used on VL Co. Sold to Boca & Loyalton RR No. 4 in 1902.

Sec.
No. 2 Bought new. Burned in 1926 VL Co. roundhouse fire, sold to R. C. Storrie & Co.

No. 3 Burned in 1926 VL Co. roundhouse fire, sold to Clover Valley Lumber Co. No. 3

No. 7 Purchased secondhand about 1926. Ex-Escanaba & Lake Superior No. 7 (new), Wells, Michigan, then J. W. Wells Lumber Co., Menominee, Michigan in June 1920. Sold to Southern Iron & Equipment Co., Atlanta, Georgia (dealers) in April 1925, thence VL Co. Owned by United Bank of Nevada, stored at V & T engine house at Carson City, October 23, 1930. (See CVL Co. notes, No. 7).

No. 11 Purchased secondhand, date unknown. Ex-Sierra Railway No. 11 (new), Standard Lumber Co., Pickering Lumber Corp. (first) No. 11, VL Co., then United Bank of Nevada, stored at V & T engine house at Carson City, October 23, 1930. Sold to Clover Valley Lumber Co. No. 11, July 1938.

No. 20 Purchased secondhand, date unknown. Ex-Marysville & Northern Ry. No. 20 (new), Bryant, Washington, then Bureau of Air Products, Clatsop, Oregon, VL Co., Oshkosh Land & Timber Co. No. 20, Ivan, Oregon, to Braymill White Pine Co. No. 20, Braymill, Ore. Scrapped prior to 1951.

VIRGINIA & TRUCKEE RAILWAY (Standard Gauge. 1869-1950)

No.	1	2-6-0	Booth & Co.	11	1869	40	14x22	
	2	2-6-0	Booth & Co.	12	1869	40	14x22	
	3	2-6-0	Booth & Co.	13	1869	43	16x22	
	4	2-6-0	Baldwin	1946	1869	48	16x24	55,000
	5	2-6-0	Baldwin	1947	1869	48	16x24	55,000
Sec.	5	2-8-0	American	66302	1925	51	19x26	150,000
	6	2-6-0	Baldwin	2094	1870	48	16x24	55,000
	7	2-6-0	Baldwin	2200	1870	48	16x24	55,000
	8	2-6-0	Baldwin	2198	1870	48	16x24	55,000
	9	2-4-0	Baldwin	2199	1870	48	14x22	
	10	2-6-0	Baldwin	2719	1871	48	16x24	55,000
	11	4-4-0	Baldwin	2816	1872	57	16x24	65,000
	12	4-4-0	Baldwin	3090	1872	57	16x24	65,000
	13	2-6-0	Baldwin	3091	1872	49	16x24	70,000
	14	2-6-0	Baldwin	3094	1872	49	16x24	70,000

No.		Builder					
15	2-6-0	Cooke	884	1872	49	17x22	
Sec. 15	2-6-0	Baldwin	3091	1872	49	16x24	70,000
16	2-6-0	Cooke	885	1872	49	17x22	
17	4-4-0	Central Pacific	5	1873	60	17x24	77,700
18	4-4-0	Central Pacific	6	1873	60	17x24	78,000
19	2-6-0	Baldwin	3685	1875	48	17x24	75,000
20	2-6-0	Baldwin	3687	1875	48	17x24	75,000
21	2-4-0	Baldwin	3689	1875	48	14x22	65,000
22	4-4-0	Baldwin	3693	1875	57	16x24	68,000
23	2-6-0	Baldwin	3889	1876	48	17x24	75,000
24	2-6-0	Baldwin	3891	1876	48	17x24	75,000
25	4-4-0	Rhode Island	2173	1889	62	18x26	100,000
Sec. 25	4-6-0	Baldwin	25016	1905	60	17x24	90,000
26	4-6-0	Baldwin	31341	1907	56	18x24	121,000
27	4-6-0	Baldwin	39453	1913	56	18x24	121,000

In 1879, as V & T traffic was falling, reflecting the long decline in production of Comstock ores, the V & T had a roster of 24 locomotives, 14 passenger train cars and 367 freight cars. In 1881-83, many locomotives were sold and by 1900 the locomotive fleet totaled 13 and freight cars were down to 257. Principal purchasers were D. O. Mills & Co. (Mills, a banker and heavy owner of the V & T, was also in the railroad construction business) who acquired four to use in the construction of a portion of the Canadian Pacific Railway in British Columbia. The Oregon Railway and Navigation Company (UPRR) also purchased four.

No. 1 LYON. Scrapped, probably before 1900.

No. 2 ORMSBY. Scrapped, probably before 1900. From 1875 to 1882 was at Lake Tahoe (M. C. Gardner, Camp Richardson).

No. 3 STOREY. Sold in 1881 to A. Onderdonk, manager of D. O. Mills & Co. Locomotive became D. O. Mills & Co. No. 1 YALE, later Intercolonial Railway (Nova Scotia) No. 188, finally Canadian National Railways 7082. Scrapped 1920.

No. 4 VIRGINIA. Scrapped 1903.

No. 5 CARSON. Sold in 1883 to D. O. Mills & Co. (No. 4 SAVONA), Int. Ry. Scrapped 1926.

Sec. No. 5 Bought secondhand from Nevada Copper Belt No. 5 1947. Scrapped 1950.

No. 6 COMSTOCK. Sold in 1881 to O.R. & N. Co.

No. 7 NEVADA. Sold in 1883 to D. O. Mills & Co. (No. 5 LYTTON), Int. Ry. No. 191, scrapped 1920.

No. 8 HUMBOLDT. Sold in 1882 to D. O. Mills & Co. (No. 3 NEW WESTMINSTER), Int. Ry. 189, scrapped 1918.

No. 9 I. E. JAMES. Only two locomotives were named for individuals, all the rest were named for cities, counties, etc. James was the engineer who laid out the railway from Virginia to Carson City. Sold in 1907 to Willett & Burr, contractors. Scrapped 1946, Decoto, Calif.

No. 10 WASHOE. Sold to O.R. & N. Co. in 1881.

No. 11 RENO. Sold to MGM Pictures for $5,000 in 1945. Now at "Old Tucson," Arizona.

No. 12 GENOA. Appeared in *Railroads on Parade* at New York World's Fair in 1939 and Railroad Fair at Chicago 1948-49. Presented to Pacific Coast Chapter, Railway & Locomotive Historical Society.

No. 13 EMPIRE. After No. 15 was sold in 1881, this locomotive was assigned that number as "13" was unpopular. Sold in 1924 to Pacific Portland Cement Co. at Gerlach, Nevada. (No. 501). Presented to the R & LHS 1938. Now at California RR Museum.

No. 14 ESMERALDA. Sold to a Mexican railroad in 1901.

No. 15 AURORA. Sold to O.R. & N. Co. in 1881. Originally named W. C. RALSTON.

Sec. No. 15 EMPIRE. (formerly No. 13, q.v.).

No. 16 OPHIR. Sold to O. R. & N. Co. in 1881. Originally named WM. SHARON.

No. 17 COLUMBUS. ICC Val. Rept. of June 30, 1917 says "laid aside."

No. 18 DAYTON. Sold to Paramount Pictures in 1938. Now at Carson City Museum.

No. 19 TRUCKEE. Sold to Verdi Lumber Co. in 1901. Became VL No. 1 ROBERTS.

No. 20 TAHOE. Sold in 1942 to C. C. Bong Constr. Co., El Monte, Calif. Restored. Now at Strasburg, Penn., Museum.

No. 21 J. W. BOWKER. Named for an early master mechanic of the V & T. Later renamed MEXICO. Sold in 1896 to Sierra Nevada Wood & Lumber Co. at Hobart Mills, Calif. Presented to Railway & Locomotive Historical Society in 1937 and has since appeared in various movies, pageants and celebrations.

No. 22 INYO. Sold to Paramount Pictures in March 1937.

No. 23 SANTIAGO. Named for an ore stamp mill in Carson River Canyon. Sold to Boca & Loyalton RR No. 3 in 1901. Scrapped Nov. 1916.

No. 24 MERRIMAC. Sold to Verdi Lumber Co. No. 2 in 1901. Later sold to Boca & Loyalton RR (No. 4), then Western Pacific No. 123. Scrapped June 1930.

No. 25 Bought secondhand from Union Pacific in Nov. 1901 (UP 655). As it was unsatisfactory for V & T operations, it was sold July 9, 1902 to Towle Bros. lumber railroad (California), eventually sold to American Fruit Express Co. No. 25 at Macdoel, in Northern California.

Sec. No. 25 Sold to RKO Studios April 1947. Became property of Desilu Studios. Now at Carson City Museum.

No. 26 No. 26 and 27 (and perhaps Second 25) were purchased by the Virginia & Truckee Railroad Co. No. 26 destroyed by fire May 2, 1950.

No. 27 Retired Oct. 1, 1948; now at Virginia City.

YELLOW ASTER MINING CO. (Randsburg) (Thirty-inch Gauge)

0-4-0T	Porter	4126	May 1908	6x10	
0-4-0T	Porter	4467	Dec. 1909	6x10	
0-4-0T	Porter	4468	Dec. 1909	6x10	

(No. 3) is on display at the museum at Randsburg.

YELLOW PINE MINING CO. (Narrow Gauge. 1911-34)

No. 1	2T	Lima (Shay)	2500	Jan. 5, 1912	29	8x12	44,200
2	2T	Lima (Shay)	2793	July 15, 1916	29	8x12	44,200

The first locomotive was a gasoline engine. In November 1914 the first Shay was badly damaged in a wreck; several months were required for repairs. During this time a new Shay was ordered. In August 1927, No. 2 was involved in a wreck and was not repaired.

In 1928 a Whitcomb gasoline was used and in 1929 a Plymouth gasoline engine was used on this railroad.

An ex Quartette Mining Co. locomotive may have been used in the road's early days.

INDUSTRIAL, CONSTRUCTION AND MILITARY LOCOMOTIVES

Various construction or industrial locomotives were operated in Nevada from time to time. While this list is by no means complete, they included:

Basic Magnesium Corp. Henderson, Nevada.

Erickson & Peterson Co. Contractor at Ryndon, Nevada.

No. 3	0-4-0ST	Vulcan	438	June 1903	30	9x14	26,600	(36" gauge)

Kilpatrick Brothers & Collins. Contractor: Clark to Wadsworth 1902 on SP re-location job, had six narrow gauge locomotives.

Warren & Co. and Stone Bros. were contractors on the Truckee-Carson irrigation project near Fallon (1903).

Nevada and California Lumber Co. (near Truckee) may have had a locomotive in the 1870's.

Boca Mill and Ice Company, Boca, California, is reported to have had one locomotive about 1888. This may be the same company as the Boca Railroad & Transportation Co. which purchased a standard gauge 4-4-0 built by H. J. Booth in 1888 (HJB No. 22). (63", 14x22).

UNITED STATES GOVERNMENT OPERATIONS

Various branches of the U. S. Government maintained locomotives for switching operations at military and reclamation installations.

U. S. Army:

Sierra Ordnance Depot, Herlong, California.

U. S. Air Force:

Flight Test Center, Edwards, California.

U. S. Navy

Naval Ordnance Test Station, Inyokern, Calif.

Naval Amunition Depot, Hawthorne, Nevada.

U. S. Bureau of Reclamation:

Fallon, Nevada;

Boulder City, Nevada.

At Fallon, the Bureau had four 0-4-0T Porter 36 inch gauge locomotives. Three, Porter Nos. 4877-79 inclusive, were built in March 1911. One, No. 4937, was built in June 1911. Cylinder dimensions were 9x14 inches.

*denotes picture reference
†denotes map reference
 pages 1-453 are in Volume I
 pages 454-908 are in Volume II

— A —

A&P Jct., N.M., 763
Ackerly, W. K. "Dolly", 777
Acme, Calif., 569*, 586, 587, 588,
 591, 596†
Acree, Bert, 70
Adams, Charles Francis, 72, 178, 625
Adams, Harry, 316
Adams Hill, 90, 93†
Adelaide Copper Mine, 63
Adelaide Star Mines, Ltd., 63
Adelanto Spur, 861†, 864
Afton, Calif., 660, 673*, 674*, 765†
Afton Canyon, Calif., 672*, 673*,
 674*
Ah Sam, 171
Akeley, Minn., 41
Alabama Hills, 197*
Alameda, Calif., 557, 823
Alberger, W. R., 526
Albuquerque, N. M., 763, 763†, 771,
 788
Albuquerque Short Line, 764*, 770
Albus, Paul C., 333
Alcatraz Island, Nevada, 293, 293†
Alder Creek, Calif., 440†, 443
Alf, Seymour, 850
Alkali Bill, 602
"Alkali Limited", 487, 494
Allen, Grant S. "Red", 746, 750
Allen, Lem, 627
Alpha, Nevada, 90, 91†, 101, 110*
Alpha shaft, 133†, 134, 135
Alta, Calif., 3
Althouse & La Grande, 534, 535
Alturas, Calif., 340†, 356, 357†, 357,
 358, 359, 368-9*, 376, 379*, 380*,
 382†, 382
Alturas (sleeping car), 359
Amador Mill, 687
Amalgamated Pioche Mines & Smelt-
 ers Corp., 718, 722, 727
Amargosa Canyon, Calif., 467, 548,
 555, 556, 567*, 569*
 wreck, 569*, 586, 587, 593
Amargosa Canyon, Nevada, 460, 471,
 471†, 486, 510
Amargosa Construction Co., 262,
 508, 518
Amargosa Desert, Nevada, 464†, 475

Amargosa Hotel, 555†, 572*, 575*,
 610
Amargosa (LV&T), Nevada, 468*,
 470, 494, 498, 499, 601*
Amargosa Narrows, Nevada, 462,
 471†, 517†
Amargosa (near Rhyolite), Nevada,
 456
Amargosa Palisades, Calif., 569*
Amargosa River, 455, 465†, 468*,
 547, 548, 549, 559, 570*
Amargosa Valley, 796
Amargosa Valley Railroad, 587
Amboy, Calif., 765†, 766, 835, 836*,
 837, 837†, 840
Amboy Crater, 766, 835, 837†
Amedee, Calif., 40†, 43, 353, 354,
 358, 363*, 383
Amedee Geyser, The, 353
Amedee Hotel, 353, 364*, 383
American Borax Co., 822, 826, 827
"American Canyon Route", 436
American Carrara Marble Co., 502,
 604-07
American Cement Corp., 860
American Flag mill, mine, 686, 699
American Flat, Nevada, 137, 146*,
 160†, 161
American Fork, Utah, 454†, 628*
American Magnesium Co., 808, 810,
 811
American Mine Hoisting Works, 138
American Potash & Chemical Corp.,
 804*, 808
American Prospecting and Developing
 Co., 851
American Trona Co., 798, 802, 808
American Valley, Calif., 385
Anaconda Copper Mining Co., 597,
 753
Anaconda, Montana, 63
Anderson, Miss Mildred, 662
Anderson, Sol, 788
Andres, Augusta, 318
Andrews Spring, Calif., 314
Annas, Capt., 308
Antelope, Calif., 347, 351
Antelope Mine, Nevada, 358
Antelope Valley, Nevada, 161
Antioch, Calif., 443
App, Harry, 521
Apple Valley Inn, 593
April Fool Mine, 709, 709†, 713
Aqueduct Lands and Orchards Co.,
 314

Arabia District, 57
Arcade Hall (Rhyolite), 466
Arden, Nevada, 645, 646†, 647, 760,
 760*, 761†
Arden, N. Y., 760
Arden Plaster Co. R.R., 760, 760*,
 761†, 836*, 840, 884
Argenta, 13, 18†, 19
Arizona & California Jct., Ariz., 792
Arizona Gravel Pit, Deposits, 735,
 735†, 740
Arizona-Mexican Mining & Smelting
 Co., 596
Army Air Force Base, 280*, 286, 287
Arnold Loop, Nevada, 331
Arrowhead, Nevada, 643†, 662
Arrowhead, The, 664*, 676*
Ash Fork, Arizona, 769
Ash Hill, Calif., 765†, 782*, 787, 793
Ash Meadows, Nevada, 464†, 466,
 548, 548†, 588, 598, 602, 609†,
 610, 844
Ashton, Raymond, 798, 799, 800*
AT&SF-Coast Lines, 791
Atchison, Topeka & Santa Fe, 86, 87†,
 88, 89, 161, 177, 205, 762, 763,
 763†, 765†. Also see Santa Fe Ry.
Atlanta Mines Co., 491*
Atlanta, Nevada, 687†, 703*, 718,
 720†, 732
Atlantic & Pacific Railroad, 762-93,
 817, 827, 841, 842, 857
Aultman Street, Ely, 114, 116
Aurora, Nevada, 39, 161, 166, 172,
 204, 227, 299, 299†, 306, 313,
 317, 331, 342
Austin, Nevada, 12, 13, 66, 68*, 69*,
 70, 71, 72, 73, 83, 84, 230, 236,
 237, 238, 258, 545, 548
Austin City Railway, 72, 83-4, 884
Austin Jct. (Ledlie), 84
Austin Mining Co., 71*, 73
Austrians, 487, 644
Autos, mfrd. at Rhyolite, 518
Automobiles, 106, 230, 234, 555, 590
Automobiles—stranded, 555, 607
Auto Stages, 41, 78, 228, 230, 258,
 456, 461, 510, 511, 536, 685
Avawatz Mountains, 587
Ayers, A. H. "Gus", 751

— B —

Babcock & Wilcox, 743
Baby Gauge Railroad, 609, 609†, 611,
 619*, 620*

Bagdad, Calif., 765†, 766, 787
Bagdad Chase Gold Mining Co., 831°
Bagdad (Chase) Mine, 797, 828
Bagdad Mining and Milling Co., 828
Bahten, D., 816
Bailey, George, 354
Bailey's, 70†, 71°, 73 (flood)
Baker, Calif., 548†, 591
Baker City, Oregon, 71
Baker Mine, Boron, 610
Baker, Ray T., 542
Balch, Daniel W., 344, 346, 347, 348
Baldwin, A. N., 883
Baldwin, A. R., 376
Baldwin, Harry, 736
Baldwin Hotel, 66
Baldwin Locomotive Works, 240, 256, 262
Ballarat, 465†, 559, 607, 797, 808
Ball, Lynn Bradbury, 82
Balloon Hill, 230, 232°
Baltimore & Ohio R.R., 240
Baltimore, Md., 542
Bamberger Delamar Gold Mng. Co., 713
Bamberger, Simon, 84, 238, 713
Bancroft, W. H., 626, 640, 642
B&L Jct., Calif., 398†, 408, 409
Band Mill, Kerby, 389
Banishment (with canteen), 462
Bank of California, 90, 136, 696
Banks & banking, 66, 90, 106, 136, 229, 257, 265, 285, 289, 342, 343, 438, 462, 489, 508, 535
Banking Crisis (1907), 319, 520
Banning, Calif., 644
Banvard, Nevada, 38
Barber Mill, 817
Barclay, Nevada, 643†, 661
Bare Mountain, Nevada, 464†, 606
Barges, 175, 849
Baring Bros., London, 31
Barlow, Ben, 611
Bartlett mine, 815, 815†
Bartlett, W. P., 826
Barnett, W. J., 406
Barney, Charles D., 506
Barrell House, Rawhide, 232°
Barnwell, Calif., 842, 843†, 845†, 848, 851
Barnwell & Searchlight Ry., 843†, 846°, 848, 850, 851, 851†, 853°, 854
Barstow, 86, 87†, 88, 593, 623, 624†, 644, 765, 765†, 774, 777†, 779°, 781°, 787, 792, 793, 796, 747, 797, 814, 815†, 815, 823, 828, 835
Barton, Orrin, 413°
Baruch, Bernard, 289
Basalt, Nevada, 73, 172†, 208, 312, 313
Baseball, 70, 243, 411, 606, 802
Basic Magnesium Corp., 841, 908

Basin, Calif., 672°, 760
Bates, Phi, 349, 438
Battle Mountain, 18†, 29†, 32, 39, 32, 39, 63, 66, 68°, 69°, 70†, 71, 71°, 73, 77°, 78, 79†, 82, 86, 87†, 88, 208, 230, 238, 331, 333, 337, 341
Battle Mountain & Lewis Ry., 72, 78-82, 236, 885
Battle Mountain Messenger, 71
Battle Mountain Mines & Development Co., 83, 885
Battye, Charles, 787, 855
Bauer, Utah, 726
Baugh, Bill, 80
Baxter, Calif., 672°, 760, 765†
Baxter and Ballardie Quarry, 760
Bayonne, N. J., 546, 557
Beachey, Hill, 18, 155
Beal, Calif., 786†, 787
Bear Brand cement, 858
Bear Creek, 436
Beard, H. N., 314
Bear Valley, Sierra County, Calif., 411, 412†, 412, 414°
Beatty, Nevada, 261, 273°, 284, 454†, 457†, 460, 462, 466, 467, 470, 474, 475, 478, 486, 487, 496-7°, 522, 536, 556, 559, 590°, 593, 606, 623
Beatty, Bessie, 498
Beatty Lode, 843
Beatty, M. M., 511, 843
Beatty Promotion Committee, 466
Bechtel Mine, 306
Bechtel, W. A., 738
Beck, H. H., 53
Beckley, J. M., 793, 796, 828
Beckwith (Beckwourth), Calif., 385, 391, 395, 396, 397
Beckwith, Lt. E. G., 385
Beckwith Hotel, 389
Beckwourth, Calif., 384†, 385, 390°
Beckwourth, James, 385
Beckwourth Pass, Calif., 317, 317†, 319, 321°, 331, 342, 343, 345, 351, 352, 356, 384, 384†, 385, 386°, 388°, 396, 623, 624
Bedell & West, 854
Bell Boy mining claim, 470
Bell, Frank, 310
Bell Mountain, 861†, 864
Bell, Thomas, 90
Belleville, Nevada, 169, 172†, 173, 174, 175, 176, 177, 178, 179, 341
Belmont, Nevada, 52, 66, 71, 72, 236, 237, 341
Belmont mine, 264, 282°. Also see Tonopah Belmont Dev. Co.
Bend City, Calif., 174
Bender, C. T., 866
Bender, D. A., 166, 177
Bender's switch, Nevada, 211
Bengal, Calif., 766, 837†

Benjamin E. Chase Gold Mining Co., 828
Bennett-Manley party, 545
Bennett Spring Range, 708
Benson, Arizona, 770, 788, 791
Benton, Calif., 169†, 174, 175, 209, 311, 313
Bentonite, 591
Beowawe, 29†, 32
Berlin, Nevada, 73
Bernice, Nevada, 82
Berrum, L. W., 872, 873, 881
Berrum, Marie, 881
Berrum, Ted, 881
Berry, W. F., 344, 349, 350, 351
Best Traction Engine, 400°, 444°, 596
Betts, H. G. "Stingy Bill", 598
Betty O'Neal Mine (Mill), 79, 79†, 82, 83
Bews, Nevada, 317†, 318
B G terminal (Goldfield), 265
Biddle, Henry W., 508
Biddy McCarty Mine, 586, 598, 608, 613°
Bieber, Calif., 40, 40†, 317†
Bieber Gateway, 333
Big Bonanza, 157
"Big Four", 1, 29, 179, 764
Big Lakes Box (& Lumber) Co., 382†, 383, 893
Big Pine, Calif., 175†, 314
"Big Red Apple—The Money Tree, The", 314
Big Smokey Valley, Nevada, 293
Bijou, Lake Tahoe, 417†, 423, 424, 430
Billerica & Bedford R.R., 385
Birdsall and Carpenter, 210
Birdsall's Ditch, 169
Birdsall, Fred, 210, 211
Bird Spring (Pass), 643, 761†
Birney, Fred, 598, 599
Bishop (Creek), Calif., 174, 175†, 210, 313, 314, 315, 315†, 539, 542
Bismark Canyon, 817
Black, Bob, 598, 842
Blackburns, Nevada, 91†, 99°, 101
Black Mountains, Calif., 465†, 597†, 598, 861†, 864
Black Canyon, 734, 735†, 736, 738, 742, 745°
Black, Joe, 478
Blairsden, Calif., 332
Blair, John I., 292
Blair Junction, Nevada, 237†, 293, 293†
Blair, Nevada, 237†, 293, 293†, 294, 296°, 298
Blake, Calif., 842, 843†
Blake Bros. Quarry, Calif., 220°, 227
Blake, Isaac C., 712, 841, 842, 843†, 848

Blind Springs Hill, Calif., 175
Bliss, C. T., 418°
Bliss, Duane L., 166, 417, 418°, 422, 423, 430
Blizzards, 114, 115, 357, 358, 406
Blue Diamond Corp., 760, 761†
Blue Light Mine, 175, 203
Bluestone Copper Co., 220°, 221°, 227, 885
Bluestone Mining & Smelting Co., 220°, 227, 885
Bluestone Smelter, 214
Bluff Rocks, Nevada, 230
Blumenberg, Jr., Henry, 826
Boats—See also barges and steamers, 771, 841, 849
Boca & Loyalton R.R., 318, 331, 396, 398-409, 410, 411, 412†, 440†, 441, 884
Boca Beer, 400°
Boca Brewing Co., 399, 400°
Boca, Calif., 398, 398†, 399, 399†, 400°, 406, 436, 438
Boca Mill & Ice Co., 399, 439, 908
Boca Railroad & Transp. Co., 908
Bodey, William S., 299
Bodie, 39, 166, 169, 171, 172, 175, 176, 226, 227, 263, 298, 299†, 299°, 303°, 306, 312, 313, 342, 346
"Bodie" (Chinese cook), 353
Bodie & Benton Ry., 157, 194°, 298-313, 885
Bodie & Mono Lake R.R., 311
Bodie & Benton Railway & Commercial Co., 311, 885
Bodie Bank, 342
Bodie Bluff, 302†, 310
Bodie Consolidated Mining Co., 306, 312
Bodie Division (N&O), 342
Bodie Extension of V&T, 166
Bodie Free Press, 306, 308, 310, 346
Bodie Hotel, 306, 308
Bodie House, 306
Bodie Ridge, 307
Bodie Ry. & Lumber Co., 307-13, 885
Bodie Syndicate Mine, 310, 312
Bodie Tunnel (Mine), 312
Bodie Water Co., 310
Bodie Wood & Lumber Co., 307
Bogue, Virgil, 317, 400°, 623, 625
Boland, Calif., 178
Bonanza King Mine, 770
Bonanza Kings, 157
Bonanza Mountain Gold Mining Co., 467, 475
Bonanza Mountain, Nevada, 456, 463, 479, 479†, 480°, 486, 487, 517†
Bonanza, Nevada, 456, 511
Boney, Sam, 373°

Bonnie Claire & Ubehebe R.R., 539-43, 541†
Bonnie Claire Bullfrog Mining Co., 541
Bonnie Claire, Nevada, 478, 487, 499, 505†, 520, 529°, 535, 536, 539-43
Bonnie Claire Townsite Co., 541
Bonnie Clare and Gold Mountain R.R., 542
Bonnifield, Judge M. S., 179
Boomerang mine, 844
Boot Hill (Pioche), 685
Booth, W. W., 229, 238, 241
Boozeburg, Calif., 396
Borate and Daggett Railroad, 61°, 608, 815†, 823, 824°, 826, 885
Borate, Calif., 545, 546, 557, 815†, 823, 826
Borax, 179, 260, 545, 557, 559, 798, 816, 823
Borax Consolidated, Ltd., 89, 545, 557, 591, 608
Borax, Nevada, 644
Borax wagon, 667°
Boric acid, 826
Boron, 580°, 585
Boron, Calif., 587, 589, 610, 621°, 765†, 792, 797†
Borosolvay, Calif., 799†, 808†
Boston & Albany R.R., 797
Boston, Mass., 83, 859
Boston mine, 848
Bothwell, Supt., 79, 82
Bottle house, 242†, 479†, 503
Bovard, Nevada, 230
Bovberg, Fred, 607
Boulder Canyon, 734, 735†
Boulder Canyon Project Act, 734
Boulder City, 734, 735†, 736, 737°, 738, 746, 752
Boulder City branch (UP), 736, 761, 761†
Boulder Dam, 734, 735
Boulder Jct., 734, 737°, 761†
Bousfield, W. C., 137
Bowen, Henry A., 386°, 389, 391°, 392, 396
Bowers, Mrs. T. L., 53
Bowers Mansion, 137†, 159
Bowery Mill, 686
Boyd, Nevada, 643†, 660
Boyle, Gov. E. G., 502
Bracken, J. W., 640
Bradford, Calif., 587, 591, 609†, 610, 611
Bradford, John, 610
Bradshaw, Mark, 288
Bragg & Folsom Dam, 439
Bragg & Schooling's sawmill, 348, 350, 351
Bragg, H. W., 438
Braun, John F., 240

Brazzanovich, Martin, 175, 186°
Breyfogle, Jacob, 455, 545
Brickell, 436
Bricks, imported, 684
Bridgeport, Calif., 226, 227, 312
Bridgeport Chronicle-Union, 161
Bridges, Col. Lyman, 66, 71, 72
Bridges, Nevada, 70, 70†, 71°
Bridges-trestles, 1°, 9°, 10°, 11°, 105°, 130°, 164°, 221°, 290°, 319°, 320°, 393°, 741°, 766
Bright & Crandel, 845
Bringham, Marion, 389, 392
Brissell, Judge John P., 521
Bristol, Calif., 766, 837†
Bristol City, Nevada, 687†, 698, 708
Bristol Cons. Mining & Smelting Co., 722
Bristol Lake, 837, 837†, 840
Bristol mine, 719
Bristol Pass, 640, 642, 687†
Bristol Range, 687†, 698, 722
Bristol Silver Mines Co., 703°, 706°, 707°, 727, 728, 729, 730, 732, 733
British Columbia (mine), 626
Broadwell Lake, Calif., 548, 553°, 829°
Brock, Arthur, 237, 508
Brock, John, 237, 240, 257, 260, 263, 455, 462, 467, 506, 508, 510, 518, 596, 597, 604
Brockmans, Calif., 367°
Brock Mountain, Nevada, 244°
Brockway, Calif., 417†, 439, 873
Brong, W. F. "Alkali Bill", 601°, 602
Brookville Locomotive Co., 284
Brotherhood of Railway Trainmen, 494
Brougher, Wilson, 236
Brown Bros., 883
Brown, C. W., 854, 855
Brown, E. C. (Store), 364°
Brown, James, 603
Brown Monster mine, 175
Brown Mountain, Calif., 584°
Brown-Parker Garage, 265, 267
Brown, R. R., 168
Brown, Sen. Charles & Mrs., 210, 588
Brown('s), Nevada, 31, 50†, 51
Brubeck's Ranch, 353, 364°
Brunswick Hotel, 59
Bryan, W. C., 470
Buckeye Mining District, 827
Buckingham and Hecht shoes, 787
Buel Copper Mining Co., 39
Buffalo Canyon, Nevada, 331
Buhl, Idaho, 334, 334†
Bullfrog District, Nevada, 260, 455, 456, 457, 460, 462, 463, 467, 478, 507, 517†, 552°
Bullfrog Goldfield R.R., 203, 259, 262, 264, 267°, 273°, 284, 455, 460, 462, 467, 471, 471†, 474, 486,

Bullfrog Goldfield R.R. *continued*
487, 488†, 489, 498, 499, 504-43,
556, 557, 591, 886
Bullfrog Jct., Nevada, 266†, 488†,
509
Bullfrog, Nevada, 236, 456, 471
Bullfrog Map, 522°
Bullfrog Miner, 473°, 522°
Bullfrog Stage Line, 271°
Bullfrog Syndicate, 114, 263, 467,
507, 508, 518, 520, 535, 557
Bullfrog Terrible Mining Co., The,
462
Bullion, Nevada, 91†, 107
Bullionville, Nevada, 684, 686, 687†,
689°, 696, 699, 714, 718, 723
Bullionville Mining & Red. Co., 712
Bullitt Building (Phil.), 240, 511
"Bull Pen" (Rhyolite), 494
Bull wheels, 425, 427°, 428
Bulwer Consolidated (Mining Co.),
306, 310
Buol Tract, Las Vegas, 546
Burke, C. H., 877
Burke claim (shaft), 684, 685†, 696
Burke Dike, 727
Burke Tunnel, 685†, 727
Bur(c)khalter, Fred, 438
Burkhalter, Mrs. M. E., 439
Burkhardt & Grassie Mill, 395°
Burning Moscow mine, 815, 816
Busch Peak, Nevada, 483°
Busch, Pete, 456
Butler, Jim, 179, 180, 236, 237, 241,
243, 244°
Butler Post Office, Nevada, 237
Butte & Plumas Railway Co., 436
Butte, Montana, 463, 597, 603, 626
Butterfield, SLR Agent, 660
Butters, Henry A., 354, 396
Buttes, The (Calif.), 384†, 389, 392

— C —

Cabin No. 2 mine, 52†, 52, 53
Cable cars (S. F.), 428
Cable railroad, 607
Cactus, Nevada, 59
Cadiz, Calif., 765†, 766, 792
Caffrey, W. G., 866
Cajon (Summit) Pass, 624†, 644, 660,
765, 774, 791, 792, 857, 861†
Cahill, W. W. "Wash.," 534, 546, 548,
580°, 585, 588, 590°
Cain, Harry, 504°
Calico, Calif., 545,547, 766, 770, 798,
815, 815†, 816, 817, 818°, 820°,
822, 823, 826, 840
Calico & Odessa RR, 820°, 823
Calico Hills, Nevada, 494
Calico Print, 770, 815, 816, 822
Calico Railroad, 815†, 822
Calico Stage Line, 817
Calico Townsite Co., 816

Caliente, Nevada, 624†, 641†, 642,
643†, 644, 645, 647, 651°, 660,
663, 714, 728
Caliente & Pioche R.R., 687†, 713-14,
715°, 717°, 718, 719, 720†
Caliente Ballast Pit, 761
Caliente Cyaniding Co., 713
California Auto Transportation Co.,
226
California & Nevada RR, 311
California, Arizona and Santa Fe Ry.,
791
California Central Ry., 172, 292
California Construction Co., 231
California Eastern Ry., 545, 546, 844,
845, 845†, 848
California Land & Timber Co., 385,
389
California Midland RR, 238
California-Nevada Mining Co., 722
California, Oregon & Idaho Stage, 238
California Pine Box and Lumber Co.,
410
California Portland Cement Co., 760
California Railroad Commission, 313,
376, 591, 608
California Rock Salt Co., 839°, 840,
886
California Safe Deposit and Trust Co.,
406
California Salt Co., 840, 886
California Southern Rail Road, 774,
777†
California Trona Co., 798
California Western RR, 808
California White Pine Lumber Co.,
406, 408†
California Zephyr, 332
Calpine, Calif., 327°, 332, 338°
Cambridge, Charlie, 306
Cameron, Calif., 340†, 355
Campbell, Geo. A., 876, 877
Campbell, James, 796
Campbell, Nevada, 215, 215†, 216
Campbell, Robert W., 89
Campbell's Ranch, Steptoe Val., 116
Camp Creek, Oregon, 376
Camp 18, Calif., 438
Camp Ham., Calif., 353
"Camp of a thousand failures," 235
Camp Pixley, Calif., 411, 412†
Camp Richardson, Calif., 417†, 423-4
Camp 24, Nevada, 2
Canavan, Capt., 171
Canby (Ghent), Calif., 383
Canby Railroad Co., 382†, 383
Cantil, Calif., 169†, 205, 208°
Canyon Railroad, 742, 746, 747°
C&C Shaft, 139†, 139°, 142°
Candelaria, Nevada, 166, 169†, 172†,
173, 174, 175, 176, 177, 178, 180,
181†, 187-89°, 209, 238, 289, 341,
355

Canning, P., 309
Cannon, P. H., 132
Canon, Nevada, 454°, 494
Canteens (banishment), 462
Cape Horn, Nevada, 742, 745°
Capital Hotel, 66, 78
Carey, George C., 313
Cariboo Hill, 90, 91, 93†
Carlin, Nevada, 18†, 19, 26, 30°, 31°,
38, 91†, 333
Carlsbad, N. M., 611
Carmen, T. O., 55
Carpenter, E. E., 114
Carpenter Valley, Calif., 440†, 441
Carp, Nevada, 643†, 655°, 661
Carrara, Italy, 604
Carrara, Nevada, 517†, 604-07
Carrara Obelisk, 606
Carrara Townsite Co., 606
Carr, Harry C., 645
Carson & Colorado RR, 166-210, 31,
72, 157, 158, 237, 238, 289, 292,
312, 341, 347, 380°, 502, 793, 796,
886
Carson & Colorado RR, Second Div.,
173; Third Div., 173
Carson & Colorado Ry., 176
Carson and Tahoe Lumber and Flum-
ing Co., 416†, 417-23, 422, 423,
425, 890
Carson City, Nev., 136, 137, 137†,
149°, 150°, 154, 155, 155°, 157,
158, 159†, 166, 176, 179, 180, 241,
342, 640, 873
Carson Division (N&O), 342
Carson Hot Springs, Nevada, 873
Carson Index, 346
Carson, John, 787
Carson Lake, 317
Carson River, 136, 137, 147°, 157,
160†, 168, 178, 210, 342
Carson Sink, 38
Carson Valley, 161
Carson Valley Mill, 211
Carter Bros., 347
Carters, Calif., 422
Caselton, Nevada, 687†, 720†, 728,
729, 730, 731°, 732, 733
Caselton, James A., 729
Caselton Shaft, 685†, 730, 731°
Casey & Arden, 250°
Casey Hotel, 263
Cattermole, R. W., 267, 285, 313
Cavanaugh, Charles, 288
Cedar City, Utah, 697, 844
Cedarville, Calif., 40†, 40, 331, 356
Central Nevada Railroad Co., 686,
696
Central New England Ry., 259, 508
Central Pacific R.R., 1-49, 51, 78,
101†, 168, 177, 179, 310, 316, 341,
626, 644, 764, 796

Centralized Traffic Control (C.T.C.), 46, 663
Celestials — See Chinese
Centennial Guards picnic, 91
Central California Traction Co., 882
Cerro Gordo, Calif., 172, 173, 175, 175†, 178
Cerro de Pasco Copper Corp., 135
Chadwick Racers, 230, 234°
Chainman mine, 100, 113
Chalfant, Pleasant, 175
Chalfant, W. A., 307
Challenger, 679°
Challenger-Domeliner, 679°
Chambers (Engineer), 390°, 393°, 395, 397
Chapman, Charles, 358, 368°
Charcoal burners' war, 91
Charleston, Nevada, 454†, 498
Charleston Peak, Nevada, 465†, 470
Chase, Benjamin E., 828
Chat, Calif., 331, 340†, 351, 352, 355, 362°, 385†, 392
Cherokee mine, 210
Cherry Creek, Nevada, 112†, 116, 120°, 132, 714
Cheyenne, Wyo., 626
Chiatovich, John, 292
Chicago & Eastern Illinois RR, 86
Chicago & Northwestern Ry., 703°, 796
Chicago, Burlington & Quincy R.R., 333, 626, 627
"Chicago of the West," 511
Chicago, Rock Island & Pacific Ry., 333, 788, 842
Chico, Calif., 406
Chief of Hills mine, 848
Chilcoot, Calif., 317, 317†, 319, 321°, 388°, 395
Chilcoot tunnel, 40†, 41, 318, 319, 321†, 331
"Chimneys, The," 101
China Ranch, 586, 596†
Chinese, 3, 12, 18, 19, 137, 138, 168, 169, 174, 180, 181, 211, 306, 307, 308, 309, 311, 344, 352, 353, 385, 389, 392, 425, 439, 761, 765, 787, 843
Chism's Ranch, 873
Chollar mine, 210
Chubbuck, G. W., 424-5, 351, 417†, 422, 430, 891
Churches, 229, 712
Churchill, Nevada, 38, 160, 169†, 209 (also see Fort Churchill)
Churchill Canyon, Nevada, 171, 173
Churchmen, Ney, 687
Chutes, log, 437, 438
Cisco, Calif., 3
Citrus, Calif., 174, 175†, 202
City of Las Vegas, 674°
City of San Francisco, 17°, 46

Claim jumping, 542, 685
Clairville, Calif., 318, 355, 388°, 389, 391°, 392, 395, 395°, 396, 397
Clairville Hotel, 391°, 392, 395
Clairville Lumber Co., 384†, 392, 397
Clark, Calif., 597†, 599, 603
Clark, C. H., 392
Clark, F. B., 487
"Clark-Harriman War," 626
Clark, J. Ross, 214, 316, 455, 456°, 462, 463, 474, 475, 478, 487, 494, 499, 526, 527, 627, 714
Clark, Patrick "Patsy," 597, 598, 603
"Clark Road," 760
Clark, Sen. W. A., 134, 260, 261, 264, 316, 455, 457, 460, 461, 462, 463, 467, 471, 474, 489, 526, 527, 535, 544, 546, 559, 626, 627, 660, 662, 760
Clarkdale, Ariz., 835
Clarke Mountain, 841
Clark('s), Nevada, 25, 32, 33
Clifton, Nevada, 70, 77°, 83
Clinton, Calif., 417†, 438-9, 428
Clinton Narrow Gauge R.R., 438-9
Clio, Calif., 318, 321†, 355, 389, 391°, 395, 396, 397
Cloverdale, Nevada, 84
Clover Valley, Calif., 396, 406, 408
Clover Valley Lumber Co., 398†, 406, 407°, 409, 887
Clover (Creek) Valley, Nevada, 625, 627, 633°, 648°, 657°, 660, 661, 670°
Clugage & Parker's Stage, 78
Coal, 26, 134, 243, 536
Coaldale, Nevada, 237†, 240, 241, 243, 265, 277°, 313
Coaldale Merger Oil Co., 265
Coal Wells, Nevada, 241
Coats (thread mfgrs.), 63, 65
Cobre, Nevada, 112†, 114, 115, 128, 132
Coburn's Station (Truckee), 3
Codd, Arthur Ashton, 57
Codd Lease, 57, 58, 59
Coffin, Trenmor, 346
Cohn, Mrs. H. A., 708
Colcord, R. K., 310
Cold Creek (Placer County, Calif), 442
Cold Creek Canyon (Lake Tahoe), Nevada, 417†, 425, 442
Cold Creek Canyon (Calif.), 441
Cold Spring, Nevada, 345, 345†, 351
Colemanite, 557, 610, 827
Col(e)manite, Calif., 609, 609†, 613°
Coleman, Wm. T., 545, 816, 823
Cole-Ryan interests, 135
Colgate interests, 357
Collins & Young, 240
Colonel J. F. Carter, 686
Colonial Trust Co. (Phil.), 239, 240

Colorado & Southern Ry., 354
Colorado Division, SPRR, 770, 770°, 771, 774
Colorado Fuel & Iron Co., 115
Colorado River, 166, 734, 735†, 736, 738, 740, 742, 750†, 765, 765†, 766, 769†, 772°, 776, 786°, 786†, 849, 854, 855, 857
Colorado River bridges, 740, 741°, 766, 768-9, 772°, 776-77, 786°, 786†, 790°, 791
Colton, Calif., 644, 766, 791, 858
Colton, G. F., 848
Columbia mine, 815, 815†, 826, 827
Columbia Mining & Chemical Co., 826
Columbia Mountain, Nevada, 256, 266†, 267°, 289, 290°, 292
Columbia, Nevada, 266†, 267°, 272°, 273°, 488†, 509, 514°
Columbia River, Ore., 40, 71, 343, 356, 373°
Columbia Sampling and Ore Co., 259
Columbia St. (Goldfield), 266†, 267°
Columbus, Nevada, 71
Columbus District, Nevada, 166
Columbus mine, 826
Combination mine, mill, 256, 259, 266†, 267°, 492°, 488†, 509, 511°
Combined Metals, Inc., 722, 726
Combined Metals Reduction Co., 726, 727, 729, 730, 732
Comet Quarry, 860, 861†
Commercial & Financial Chronicle, 788
Como, Nevada, 161°, 210
Comstock Lode, 51, 53, 136, 159, 166, 180, 210, 214, 306, 341, 342, 463, 684, 817
Conaway, Joseph, 627
Condon, J. F., 410
Condor Canyon, Nevada, 625, 640, 686, 687†, 689°, 696, 712, 713, 715°, 717°
Condor Mill, 689°, 696
Coney Island (Reno), 873°, 880, 882
Congestion, freight, 256, 259, 260
Congress, U. S., 762, 788
Conley's Stage, 392
Connell, D. D., 822, 826
Connelly, S. W., 539
Conner's Fishery, 436
Connor, Gen. P. E., 684, 685
Consolidated Copper Mines Co., 135, 888
Cons. Gold Fields of South Africa, Ltd., 798
Consolidated Nevada-Utah Corp., 718

*denotes picture reference
†denotes map reference
pages 1-453 are in Volume I
pages 454-908 are in Volume II

Consolidated Pacific Cement Plaster Co., 837, 840, 900
Consolidated Salt Co., 894
Con. Virginia Mine, 139†, 139°
Constantia, Calif., 340†, 354
Consumer's Salt Co., 840, 886
Contact, Nevada, 334, 334†, 335, 337
Cook, Daniel, 307
Cook, Jay (III), 506
Cook Bank, J. S., 265, 267, 470, 480†, 483, 489, 535
Cook, Seth, 307
Coolidge, Calvin, 736
Copper Basin, Nevada, 78
Copper Blue Claim, shaft, 599, 601
Copper Canyon, Nevada, 63, 78
Copper City, Calif., 548†, 555
Copper Flat, Nevada, 121°, 122°, 124-125°, 128, 128†, 131, 132, 133, 133†, 134, 238
Copper Handbook, 604
Copper King mine, 174
"Copper King of Nevada," 599
Copper River & Northwestern RR, 286
Copper World mine, 465†, 844
Corbett-Fitzsimmons fight, 158
Corey Bros., 131
Corn Creek, Nevada, 454†, 463
Coronado Copper and Zinc Co., 759
Corporation Ranch, 355†, 356
Cortez Mines, Ltd., 337, 888
Cosmopolitan Hotel (Elko), 33°
Coso, Calif., 174, 175†
Coso Range, 793
Cottage Hotel Annex, 854
Cottonwood Branch (C&C), 178, 183°, 203
Cottonwood Canyon, Calif., 175, 175†
Cottonwood, Esmeralda County, Nevada, 178
Cottrell, J. A., 475
Courbet mine, 539, 542
Covered Bridge, near Wadsworth, 20°
Cow Camp, Nevada, 294
Cox, Ramsey M., 356, 358
"Coyote Special," 556, 792
CP-SP Unmerger Case, 45, 209
Crackerjack, Calif., 548, 548†
Crane Creek Lumber Co., 382†, 383, 893
Creasor, Phil, 598, 599
Crest, Calif., 383
Crestline, Nevada, 640, 643†, 660
Crocker, Charles, 1, 2, 13, 19, 764
Crocker, Judge E. B., 13
Crocker National Bank, 489
Crockwell, J. H., 139°
Crosby & McCoy's Hotel, 53°
Cross, Ed, 455, 456
Crossties, 18, 410, 546, 633°, 646
Crow Springs, Nevada, 237
Crowe, 746, 748

Crowe, Frank T., 738, 752
Crown Point Ravine (Trestle), 137, 138, 138†, 145°, 157, 159
Crown Willamette Paper Co., 442-3, 440†, 892
Crucero, Calif., 547, 548, 548†, 554°, 660
Crum Canyon, 78, 79†
Crumley, J. G., Blair Hotel, 294, 296°
Crump, Judge, 231
Crystal Bay, Nevada, 425, 427°, 428, 429, 429†
Crystal Bay Railroad, 427°, 428
Crystal Peak Lumber Co., 410, 437
Crystal Hills Wash, 809
Crystal Salt Co., 840, 886
Cuba, P. O., Calif., 351, 362°
Culverwell, "Mayor," 642
Culverwell (Caliente), Nevada, 627, 640, 641, 642
Cumberland, Nevada, 63
Cumberland-Ely Co., 134
Cuprite, Nevada, 505†, 509, 510, 514°, 539
Currie's (Ranch), 112†, 115, 116, 120°
Curry, Wm., 817
Curtis, Allen A., 66, 83
Curtis, Melville, 70
Curtis, M. J., 410
Curtis, Uri, 535
Cushenbury, Calif., 861†, 864-5
Cushman, Professor, 55
Cutter, M. B., 263, 264, 267, 284, 313, 499
Cutting, Henry C., vi, 244°
Cyrus Noble mine, 848, 851†

— D —

Daggett, 624†, 644, 647, 663, 766, 770, 791, 814†, 816, 817, 822, 823, 826, 850
Daggett and Calico RR, 817
Daggett, Rollin M., 210
Dailey, Capt. P., 211
Dallimore, George, 55
Dalton, R. J. & Son, 733
Danby, Calif., 765†, 766, 787
Danby Lake, 840
Dangberg, Fred, 162
Dantes View, Calif., 541†, 545, 597†
Darling, H. J., 868
Darling mine, 847°
Darwin, Calif., 174, 175†
Daugherty, A. A., 793, 796
Davies Creek (B&L), 411, 412†, 440†, 441
Davies Johnson Lumber Co., 332, 338°, 893
Davies Mill, Calif., 331, 332, 357, 384†, 397
Davis Creek (NCO), 340†, 356, 371°, 374°

Davis, "Diamondfield" Jack, 462
Davis, John T., 341, 342, 343, 346
Day & Como stage, 230
Day Bristol Cons. Min. & Smelt. Co., 722
Day, Capt. H. H., 696
Day, Col., 389
Day mine, 698, 722
Dayton, Nevada, 25, 160†, 163, 166, 169, 170°, 171, 181, 210, 211, 212°, 213†
Dayton, Sutro & Carson Valley RR, 210-11, 212°, 213†, 888
Dead Horse Canyon, Calif., 602
Dead Horse Wells, Nevada, 234°
Dead Horse Well Water Co., 229
Deadman's Cut, Nevada, 211
Dead Ox Canyon, Nevada, 41
Deal Bros., & Mendenhall, 461, 642, 714
Dean, Sheriff, 389
Death Valley, Calif., 260, 542, 545, 548†, 548, 559, 586, 598, 611, 667°, 809, 826
Death Valley Chuckwalla, 603
Death Valley Clay Co., 610
Death Valley Jct., Calif., 465†, 541†, 548†, 555†, 572°, 580°, 585, 587, 591, 608, 609†
Death Valley RR, 572°, 586, 587, 589, 602, 608-21, 826, 888
Death Valley View Hotel, 610, 617°
Deep Creek Mining District, Utah, 337
Deep Creek RR, 317†, 337, 338°, 888
Deep Springs Valley, Calif., 175†, 536
Deep Wells, Nevada, 237†, 240, 243, 256
Deep Wells (Luning), Nevada, 172, 173
Deeth, Nevada, 29†, 32, 319
Defiance Hoisting Works, 308, 309
Delamar, Nevada, 641, 643†, 708-13, 841, 844
De Lamar, Capt. J. R., 227, 712, 844
De Lamar, Idaho, 712
Delamar Lode, The, 714
Delamar mine, 709†, 712
Delamar Nevada Gold Mining Co., 713
Delleker, Calif., 384†, 388°, 397
Delphi Springs, Nev., 226
De Mille, Cecil B., 668°
Demurrage, 259, 494
Denton, J. M., 709
Denver claim, 456
Denver, Colo., 52, 54, 262
Denver & Rio Grande Western, 316, 318, 333, 626, 698, 699
Depew, Chauncey M., 828
Depot Hotel (Reno), 14°, 343

Derby Switch, Nevada, 50†
Deschutes River Canyon, 40
"Desert Love Buggy," 668°
Desert Mill, Nevada, 249°, 261
Desert Power and Mill Co., 248°
Desert Springs, Utah, 623
Des Granges, L., 810
Despain (engineer), 596
Desperados, 319
Detch, Milton, 258
Devair, Calif., 608
Devil's Corral, 40†, 45
Devine, Mickey, 575°
de Wendel, Charles, 357
Deykes, Utah, 318
Diamondfield Summit, Nevada, 457†, 460
Diamond Match Co., 406
Diamond mine, 478
Diamond Mountain District, Calif., 358
Diamond Salt Co., 894
Dillon, Henry W., 844
Dillon, Nevada, 70†, 73
Dillon, Sidney, 625
Dimmick, George, 606
Dinwiddie Creek, Calif., 385, 386°
Divide District, Nevada, 535
Dixon, Mace, 699
Doan, L. E., 399
Doan Steam Wagon, 413°
Dodge, E. R., 867
Dodge, Fred, 336
Dog Valley, Calif., 398, 410, 437, 868
Dog Valley Creek, 410
Dog Valley First Summit, Calif., 412†
Dog Valley Second Summit, Calif., 408, 411, 412†, 414°
Dolomite, Calif., 197°
Donahue, Mike, 263
Dondero mill, 52†, 53
Donner (Summit) Pass, Calif., 2, 2†, 3, 4°, 5°, 436, 437, 440†
Donner Tunnel, 11, 12
Doris Montgomery Pass, Nevada, 463, 467, 470, 474, 476°, 496-7°, 517†
Dorris Bridge, Calif., 356
Dorris Mill, 685†
Dorris, P. S., 358
Doten, Alf, 137
Douglas Hill, Nevada, 216
Douglas Mill, 211, 212°
Douglass, Jimmy, 696
Douglass, J. M., 211
Dowling's Blacksmith Shop, 25
Downer Bros. Assay Office, 271°
Downieville, Calif., 385
Downieville, Nevada, 73, 174
Doyle, Calif., 41, 340†, 353, 358
Doyle, Phil, 868
Drinkwater Mine, Trail, 292, 293†, 294, 295°
Drum, Ben, 309

Dry Lake, Nevada, 645, 661
Dry Valley, Nevada, 686, 687, 687†; 696, 697, 723
Duck Creek, Nevada, 113, 117
Dudley Hoisting Works (Bodie), 307
Duff, Charles G., 736
Duffy, Frank, 84
Dulien Steel Products, Inc., 279° 285, 286
Dumont, Calif., 548, 548†, 587
Dunaway, T. F., 354, 356, 867
Dunbar, H. G., 59
Dunes Hotel, The, 638°
Dunn, Col. F. W., 848
Dunning, C. C., 229
Duplex mine, 848, 851†, 854
Dutch Flat, Calif., 2, 2†, 3
Dutch Flat Company, 12
Dutch Flat Enquirer, 3
Dutch Flat, Nevada, 625
Dutch Mountains, Utah, 317
Dutertre, L., 63

— E —

Eagle Lake, Calif., 352
Eagle (Mill) mine, 78, 79†, 82
Eagle Mountain, Calif., 559
Eagle Salt Works Co., 51
Eagle Salt Works Railroad Co., 50†, 51, 888
Eagle Valley, Nevada, 136, 137
Earl, D. W., 351
Earp, Wyatt, 237
East Butte Copper Mining Co., 751
East Calico, 816, 817
East Ely, Nevada, 116, 121°
Eastern Contact mine, 467
Eastern Exploration Co., 285
Eastern Nevada Railroad, 106
East Reno (Sparks), 33, 866
East Rochester Townsite, 59
East San Pedro, Calif., 624°, 662, 663
East Verdi, Nevada, 411†
Eaton, "Hop," 880
Eccles, David, 626
Eccles, Nevada, 643†, 648°
Eccles, S. W., 115, 128, 131
Eck, Harry, 751
Eclipse mine, 175
Eddy's Addition (Rhyolite), 478
Edson, Calif., 766
Edwards Air Force Base, 765†, 792
Edwards Creek, 72
Effinger, Martin L., 293
El Capitan, 793
El Dorado Canyon, Nevada, 210, 213†, 735, 848, 854
Electrical service, 229, 486, 607
Electric railroads, 45, 130°, 161, 221°, 227, 230, 542, 709°, 727, 742, 743°, 746, 748, 750

Elgin, Nevada, 643†, 653°, 655°, 660, 661
Elizadle Company, 607
Elko, Nevada, 18†, 19, 29†, 32°, 33°, 106, 317†, 319, 322°, 329°, 333, 336, 684
Elko County, Nevada, 334
Elks Club (Goldfield), 535
Elliott, John Paul, 336, 735
Elliott, Ole, 243
Ellis, A. C., 709, 712
Ellis, Rudolph, 508
Ellis, Supt. (Tecopa), 596
Ellsworth, Nevada, 341
Elna, Calif., 175, 175†, 209
El Paso, Tex., 763†, 764, 771
El Paso Summit, Calif., 205, 798
El Rancho Motel, 593
Ely, Nevada, 100, 106, 112†, 113, 115, 116, 117-18°, 131, 132, 134, 254°, 318, 334, 684, 714
Ely City, Nevada, 117, 128, 131, 132
Ely Commercial Club, 117, 128
Ely District (Pioche), 684
Ely, John H., 684
Ely Range, 687†, 704°, 718
Ely, Smith, 113
Ely Townsite Co., 117
Ely Valley mine, 695°, 720†, 727, 730
Emerald, 424
Emerald Bay, Calif., 422
Emigrant Canyon, Calif., 607
Emigrant mine, 210
Empire, Nevada, 157, 160†, 337
Empire State Express, 828
Empire Zinc Co., 753
Empy, Mart, 722
Engel, Calif., 319
Engel mine (Calif.), 227
Engle, J. M., 390°, 395
Enslow, Robert, 62
Epizootic, 686
Epsomite, 811
Epsom Salts Railroad, 808-14
Erickson & Peterson Co., 908
Erie Railroad, 350
Erie, Nevada, 645, 646†, 647, 761†
Escalente Desert, Utah, 624
Esden, Henry, 53
Esmeralda (private car), 359
Esmeralda County Bank, 176
Esmeralda County, Nevada, 174, 176, 204, 535
Esmeralda Mining District, Nevada, 166
Essex, Calif., 766, 783°
Eugene, Ore., 343
Euers Valley, Calif., 440†, 443
Eureka, Nevada, 13, 66, 91†, 92-3†, 100, 107, 113, 116, 238, 623
Eureka & Colorado RR, 91†, 92-3†, 95°, 99

Eureka & Palisade RR, 90-111, 113, 157, 307, 685, 889
Eureka & Palisade Ry., 100, 101, 106, 116, 238, 317
Eureka & Ruby Hill Narrow Gauge RR, 91, 100
Eureka Consolidated Mining Co., 90, 91, 92-3†, 95°
Eureka Copper Pit, 115, 131, 132
Eureka County Bank, 106
Eureka County Chamber of Commerce, 111
Eureka Leader, 25
Eureka Mill, Benton, Calif., 175
Eureka Mill, Nevada, 160†, 163, 165°
Eureka Mill RR, 163, 164-5°, 888
Eureka-Nevada Ry., 62, 78, 86, 87†, 88, 107, 111, 888
Eureka Sentinel, 106, 238
Evans, Calif., 345†, 347
Evans, David, 347, 348, 350
Evans' Field (Reno), 343
Evan's Well, Calif., 817
Evelyn, Calif., 465†, 555
Everill, John, 86
Everts, Supt. P., 91
Ewing, Thomas, 771, 854
Excelsior Mill, 425
Exchange (Block) Club, Beatty, 473, 497°
Excursion trains, 55, 132, 475, 478, 479, 557, 589, 647, 662 696, 697 697
Exposition Flyer, 327°

— F —
Fairbanks, Mayor Fred, 215
Fairbanks, R. J. "Dad," 588, 602, 604
Fairday claims, 59
Fairbanks-Morse, 229
Fairport (private car), 359, 379°
Fairport, Calif., 358, 359
Fairview, Nev., 229, 230, 331
Fallon, Nevada, 38, 39, 107, 202, 230, 234°, 317
Fares, passenger, 132, 261, 471, 556, 873†
Farrell, M. J., 66
Farren, Joseph, 63
Feather River, Calif., 317, 318, 319, 352, 356, 384, 389, 392, 397, 406, 408
Feather River Lumber Co., 893
Fenelon, Nevada, 32
Fenner, Calif., 766
Fenton, A. M., 226
Ferber Mining District (Utah), 337
Ferguson, John E., 708, 712
Ferguson Lode, The, 709
Ferguson Mining District, 708, 709
Ferguson, Nevada, 708, 709, 709†
Fernley, Nevada, 24°, 40†, 41, 50†, 332†, 356, 376

Fernley & Lassen Ry. (CP), 40†, 41, 45, 58, 356, 363
Fesler, A. J., 117, 128
Field in the Cloth of Gold (saloon), 171
Feather River Lumber Co., 395, 396, 397
Fibreboard Products, Inc., 443
Fidelity Trust Co., 508
Field, Calif., 644
Fights, Prize, 158, 260
Filben, Nevada, 172†, 173
Fillmore, J. A., 29
Fires, 12, 14°, 59, 80, 91, 131, 149°, 176, 233°, 235, 263, 264, 265, 353, 358, 383, 392, 395, 410, 411, 415°, 428, 438, 439, 441, 471, 494, 603, 685, 699, 708, 712, 722, 754, 760, 771, 816, 835, 854, vi
Fish Lake Merger Oil Co., 265
Fish Lake Valley, 265
Fish Pond Station, 815†
Fisk, O. J., 544, 548, 753, 754, 843
Flagstaff, Ariz., 822
Flanigan, Nevada, 40†, 41, 332†, 333
Flanigan, Sen. P. L., 354, 355
Fleish, 11°, 12°
Fleishhacker interests, 871, 873, 882
Fletcher, F. N., 534
Flinn, Senator William, 293, 298
Floods, 13, 62, 73, 91, 101, 106, 171, 178, 235, 264, 319, 352, 355, 356, 474, 554, 559, 562-63°, 570°, 723, 754, 761, 779°. Also see Washouts.
Florence & Cripple Creek RR, 357
Florence Annex mine, 491°
Florence, Colo., 726
Florence Crittenden Mission, 585
Florence, mill, mine, 259, 266†, 267°, 488†, 491°, 492°, 511°, 713
Floriston, Calif., 410, 412
Flourine, Nevada, 464†, 559
Flowery Lake Tunnel, 318, 319
Flumes, 154, 155, 155°, 157, 175, 410, 417, 428, 429, 436
Flumeville, Calif., 441
Flying ME Ranch, 152°, vi
Fogarty, William, 285
Foley, M. D., 866
Folsom, G. N., 438
Foot, Moy, 385, 389
Fordson tractor, 810, 811
Forester, W. D., 267
Fort Churchill, Nevada, 38, 169, 181
Fort Conroy, Mono Lake, Calif., 308
Fort Homestead Tunnel, 137, 145°, 159
Fort Las Vegas, 458°, 645†
Fort McDermitt, 31
Fort Mohave, 166, 771
Forty-Niner (train), 46
Fourth Street National Bank (Phil.), 240, 508

Fowler, Frank F., 341, 342, 346, 347, 348
Fraizer, Lois, 216
Fraizer, W. C., 661
Frances-Mohawk Lease, 270°, 289
Francisco, Herbert, 314
Frankovitch, 52
Franktown, Nevada, 137†, 152°, 159, 417†, 425
Frazier, F. O., 463
Freight teams, 12, 52, 166, 237, 307, 309, 417, 424, 529, 545, 558, 722
Fremont Hotel, Las Vegas, 637°
Frémont, John C., 593
Fremont Street, Las Vegas, 635°, 636°
French, Elmer, 569°
French's Wells, Nevada, 240
Fresno River, Calif., 238
Fresno scraper (grader), 240, 631°, 645
Freudenthal, H. E., 626
Frick Ranch, 866
Friedman, L. A., 59
Friedman Tunnel, 62
Fruit Growers Supply Co., 889
Frisco, Utah, 622†, 623, 624†
Frisco Ry. (SL&SF), 762, 763, 765, 771, 774, 788
Frontier Airlines, 292
Front, The, 766, 850
Fulton, John, 352
Fulton, Robert L., 31
Funeral Mountains, Calif., 465†, 541†, 545, 572°
Funston, Calif., 837, 837† 840
Funston, Gen. F., 837
Furnace, Calif., 597†, 599, 603
Furnace Creek Copper Co., 599, 601°, 603
Furnace Creek Inn, 575°, 610, 611, 611†
Furnace Creek Ranch, 541†, 610, 611†, 611, 823
Furnace Creek Wash, 572°, 598, 608, 609, 609†, 617°

— G —
Galena, Nevada, 70† 78, 79, 79†
Gallagher, Senator W. C., 116
Gamble, G. S., 231
Gans-Nelson Fight, 260
Garden Pass, Nevada, 90, 91†, 101, 317
Garden (Clark) St., Ely, 116, 117, 123°
Garden Station, Calif., 799†, 800°
Gardiner, Bob, 611
Gardner, James Horace, 423
Gardner, M. C., 155, 423-424, 890
Gardner Mountain, Calif., 424
Gardner's Camp, Calif., 424
Gardnerville, Nev., 162

Gardnerville *Record-Courier,* 162
Gardnerville and Southern RR, 162
Garfield Canyon, Calif., 815, 816
Garfield District, Nevada, 175
Garfield, Utah, 628*
Garlock, Calif., 793, 794*, 795, 797†, 799†
Garnet, Nevada, 645
Garrett, Elton, 736
Gary, Judge, E. H., 89
Gasaway, H. E., 358, 363*
Gates, H. D., 82
Gates, I. E., 788
Geiger Grade, 155
Geisendorfer, 436
Gemmill, David B., 723, 726
Gemmill, David L., 728
Gemmill, Paul, 728
Genoa (Mormon Station), Nevada, 1, 157
Gentry, John R., 827
Geoppert & Son, Geo., 232*
George Air Force Base, 861†, 864
George, E. J., 78
Geppert, Capt., 604
Gerlach, Nevada, 46, 317†, 324*, 331, 332†, 337
German-American mill, 753
Gerstley, Calif., 548†, 587
Gest, Erasmus, 19, 352
Getchell, L. W., 82
Getchell Mines, Inc., 292
Getchell, Noble, 83
Ghent, (Canby), Calif., 383
Gibbon, T. E., 643
Gibralter mine, 478, 479
Giffen, George, 439
Gignoux, J. E., 876
GILA, 772*
Gilbert, Jct., Nevada, 237†
Gilbert, Nevada, 237†, 248*, 267
Gilchrest, Charles, 310
Gilchrest & Sharp (Mono Mills), 309, 311
Gilles, Betty, 575*, 615*
Gillette, E. W., 486
Gillis, Donald, 599
Gilmer & Salisbury, 90, 173, 685
Gilmore, John C., 239, 240
Giroux Consolidated Mines Co., 134-5, 133†, 890
Giroux, Joseph L., 100, 134
Gladiator Mining Co., 844
Glascock, Carl B., 603
Glasgow & Western Exploration Co., 63, 319
Glasgow & Western RR, 65
Glenbrook, Nevada, 155, 155*, 309, 416†, 417-23, 424, 425, 430, 436, 871
Glyn, Mrs. Elinor, 230
Goat Island, Nevada, 293, 293†
Goblerville, Calif., 816

Godbe, A. H., 709
Godbe Bros., 718, 723, 726
Godbe, S. T., 709, 712, 753, 842, 843, 844
Godbe, W. S., 625, 697, 698, 699, 708, 712, 714
Godshall, Dr. L. D., 596, 597
Goffs, 765†, 766, 770, 770*, 777, 782*, 793, 842, 843†, 844, 846*, 851
Golconda, 29†, 32, 63-65, 866
Golconda & Adelaide RR, 60*, 63-65, 319, 890
Golconda Hot Springs, 63, 64*
Gold Bar (mine), Nevada, 467, 478, 517†
Goldberg-Bowen (grocers), 389
Goldberg, Jacob, 389
Gold Bronze mine, 844
Gold Canyon, Nevada, 170*, 210
Gold Center, Nevada, 261, 284, 454†, 461, 462, 468*, 470, 471†, 474, 475, 478, 510, 547, 548, 548†, 604
Golden City, Nevada, 708
Golden Nugget Gambling Hall, Las Vegas, 637*
Golden Sceptre mine, 470, 475
Golden State Portland Cement Co., 858-60, 861†, 890
Golden Street, Rhyolite, 462, 470, 479†, 483*, 517, 584*
Golden Treasure mine, 849
Goldfield, Nevada, 106, 167†, 203, 204, 229, 230, 231, 237†, 243, 256-7, 264, 265, 266†, 267-73*, 283*, 284, 285, 454†, 455, 456, 457, 457†, 460, 464†, 478, 486, 487, 488†, 489, 490-93*, 505†, 509, 511-14*, 535, 548, 606
Goldfield and Lida (Auto) Stage, 537*
Goldfield Athletic Club, 489
Goldfield Bank and Trust Co., 257
Goldfield Chamber of Commerce, 262, 489
Goldfield Commercial Association, 264
Goldfield Cons. Milling & Transp. Co., 265, 266†, 267*, 270*, 288-92, 488†, 492*, 890
Goldfield Consolidated Mines Co., 56, 227, 288, 290*, 292, 535, 890
Goldfield Fire Department, 258
Goldfield Hippodrome Orchestra, 606
Goldfield Hotel, 260
Goldfield Jct., Nevada, 237†, 241, 243, 256, 257, 261, 488†, 509
Goldfield Mining Co., 289
Goldfield Mohawk mine, 288
Goldfield News, 256, 535, 539, 549
Goldfield News Boys Union, No. 555, 258
Goldfield Railroad, 256-58, 259

Goldfield Review, 52, 509
Goldfield Sun, 474
Goldfield Syndicate, 257, 258, 259, 506
Goldfield Tribune, 502, 511, 535, 536
Gold Hill, Nevada, 19, 136, 137, 137†, 138, 138†, 14*, 154, 157, 160†
Gold Hill News, 2, 12, 13, 137, 138, 424
Gold Hill, Utah, 317, 317†, 337, 338*
Gold Lake, Calif., 384, 385
Gold Mountain, Nev., 71, 172, 454*, 505†, 509, 536, 539, 541, 542
Gold Mountain Railroad Co., 542
Gold Point, Nevada, 494, 505†, 538*, 539, 542
Gold Road, Ariz., 855, 855†
Gold Roads, 455, 464-5†
Gold Run Mining District, 63
Goler, Calif., 793, 794*, 797†, 799†
Goler Canyon, 793
Goodenough, A. D., 539
Good Hope mine, 848, 851†
Good, Joe, 753
Good News, 580*, 585
Goodsprings, Nevada, 559, 753, 753†, 754, 757*, 759, 761†, 841, 842, 843, 844, 845
Goodsprings Gazette, 754
Goodsprings Hotel, 754, 757*
Goodsprings Mining District, 753
Goodwin, BG Agent, 521
Goodwin, Nat C., 230
Goose Creek, Nevada, 336
Goose Lake (Calif.-Ore.), 342, 356, 359
Gordon Campbell & Co., 470
Gorilla mine, tramway, 312
Gorrill Building, 480
Gosse, Harry J., vi, 868
Gottschalk, Supt., 596
Gouge-Eye Saloon, 52†, 53, 53*
Gould & Curry mine, 154
Gould, George, 40, 73, 316, 318, 626
Gould, Jay, 316, 353, 625, 764, 765
Gould, Wm. L., 363*
Goumaz Siding, Calif., 42*
Government Jct., Nevada, 734, 735†, 740
Gower, Harry P., 609
Gower, Mrs. Harry P., 590*
Grace, Frank M., 461, 463, 464, 499, 546
Graeagle, Calif., 332
Graeagle Lumber Co., 397
Graham, W. B., 113
Grand Central Hotel, 306

*denotes picture reference
†denotes map reference
pages 1-453 are in Volume I
pages 454-908 are in Volume II

Grand Canyon Limited, 781°, 793
Grandpa, Nevada, 256
Grand Gulch Copper Co., 662
Granite Basin, Calif., 436
Grannan, Riley (funeral), 230
Grantsville, Nevada, 71, 72, 341
Grapevine Canyon (Nevada-Calif.),
 541†, 542
Grape Vine Station, Calif., 777†
Grasshoppers, 342
Gravel Bank and Crystal Lake RR,
 802
Gravel Pit, Ariz., 735†, 746, 748, 750
Gravel Plant, Nevada, 735, 735†, 740,
 741°, 742, 746, 748, 750, 752
Graves, R. N., 307, 312
Gray, Britt, 823
Gray, Carl R. (UPRR), 336
Gray, Reid & Wright Co., 868
Great Northern Railway, 40, 40†, 89,
 333, 382
"Great Northern, The" (N-C-O), 354
Great Salt Basin Mining and Milling
 Co., 292
Great Salt Lake, Utah, 29†, 31, 36,
 37, 48°, 49°, 684
Great Western mine, 542
Greek George, 180
Greeks, 37, 73, 318, 487, 494, 607,
 645
Greenfield, Nevada, 168, 214
Green, Frank, 531°, 595
Green, H. T., 471, 486
Green, Johnathan, 78
Green Hill, Nevada, 52
Green Hill Mining Co., 54
Greenwater & Death Valley Copper
 Co., 597†, 599, 603
Greenwater, Calif., 462, 486, 507,
 510, 541†, 542, 545, 555, 559, 588,
 597-604
Greenwater Copper Co., 599
Greenwater Copper Mines & Smelter
 Co., 603, 604
Greenwater Furnace Creek Copper
 Co., 604
Greenwater Miner, 603
Greenwater Range, Calif., 608, 609†,
 615°
Greenwater Spring, Calif., 597†, 598
Greenwater Times, 603
Greenwater Valley, Calif., 597†, 602
Greenwood Leasing Co., 722
Greenwood Shaft, 685†, 719
Grey Eagle Mine, 63
Griffith, S. N., 867, 868
Grignon, "Tubby," 413°
Grigsby, Dr. Edward S., 470
Grimes Ranch, Nevada, 230
Grizzly Creek, Calif., 404°, 406
Grizzley Creek Branch (WP), 331,
 408
Groom Mine, Nevada, 454†, 502

Grutt Brothers, 229, 230
Grutt, Eugene, 56
Grutt, Fred, 230, 235
Grutt Hill, 230, 232°
Grutt Hill Coalition, 230
Grutt's General Store, 53°
Guaymas, Mex., 763, 763†, 791
Guelph, Nevada, 643†, 660, 661
Guggenheim Exploration Co., 134
Guggenheim interests, 115, 134
Guild, Judge Clark J., 288
Gulling, Calif., 398†, 404°
Gulling Branch (WP), 331, 408
Gulling, Charles, 406, 408, 409
Gunn and Thompson, 214, 216
Gunn, George E., 216
Gunsight Mine, 555, 593, 596, 596†
Gypsum, 337, 586, 610, 662, 760,
 761, 836°, 837

— H —

Hackamore, Calif., 382
Hackett, James, 718
Hackstaff, Calif., 317†, 331, 356, 357,
 358, 359, 374°, 376
Haehnlen, W. L., 89, 284, 285
Haft, Edward L., 54
Hagin & Tevis, 843
Haiwee (Reservoir), 205
Hale & Norcross mine, 143°
Hale, J. F. F., 84
Half Moon mine (road), 697, 720†
Hall, E. S., 229, 496°
Hallowell Hardware Co., Susanville,
 41
Hall Scott motor cars, 223°, 225°,
 226, 228
Halls Flat, Calif., 40, 40†
Hallsville, Nevada, 70
Halsey, L. W., 506
Hamblin, Wm., 684
Hamilton, Nevada, 19, 66, 90, 99,
 100, 106, 116
Hamilton, John (stage), 53
Ham Light's Station, 687, 687†
Hamlin, H. R., 263
Hammond, J., 240
Hammond, John Hays, 292, 597, 835
Hampton's omnibuses, 138
Hanksite, Calif., 799†, 802, 804†
Happy Hooligan mine, Rawhide, 230
Happy Hooligan mine, Rhyolite, 478
Happy Kelly mine, 542
Harden, R. W., 389
Hard Luck mine, 539, 542
Hardshell No. 1 claim, 858
Hardyville, Ariz., 768
Hardy, W. H., 768
Harmony Borax Works, 545
Harriman, E. H., 31, 36, 37, 114, 160,
 181, 204, 238, 239, 316, 318, 460,
 474, 625, 626, 627, 640, 734, 760
Harriman (Sparks), Nevada, 33, 866

Harris, Frank "Shorty," 455, 456
Harrison, A. W., 814
Harris Track Laying Machine, 321,
 463, 468°, 476°
Harris, Walter J., 876
Hart, Bob, 256
Hartoum, Calif., 765† 766
Hartwell, Calif., 319, 322°
Harvey, Fred, 773
Haskell, D. A., 13
Hatch, A. J., 342, 343, 344, 347
Havoli, 580°
Hawgood, Henry, 626
Hawkins, Alex "Dad," 356
Hawley, Calif. (WP), 384†, 398†,
 409
Hawley (Keeler), Calif., 174, 175,
 175†, 192°
Hawley's Station, 815†, 816
Hawthorne, Nevada, 166, 169, 169†,
 171, 171†, 172, 177, 178, 180, 203,
 204, 205, 237, 239, 307, 309
Hayes-Monnette, Lease, 262, 270°,
 289
Hayward, Alvinza, 425
Hazen, Nevada, 24°, 31, 38, 50†, 51,
 160, 203, 209, 210, 260
Hazen Cut-Off, 115, 160, 161, 166,
 181, 202, 257
Hedden, John F., 259, 263, 479, 508,
 510, 520
Heller Butte, Nevada, 244°
Heller, Clyde A., 240
Hellman, I. W., 100
Heintz, George W., 106
Heinze, F. Augustus, 597
Heisler, H. H., 524°
Helendale, Calif., 860, 861†
Helene, Nevada, 708, 709, 709†
Henderson, Nevada, 751°, 752, 841
Henderson Industrial Park, 752
Heriot, Edgar L., 351, 352
Heriot's Place, Calif., 352
Herlong, Calif., 331, 358
Hermes mine, Pioche, 685, 685†
Hershey, Oscar, 114
Hesperia, Calif., 861†, 864, 865
Hicks, Joel W., 231
Hick's Hot Springs, Nevada, 510
Higbee, C. A., 237, 507
Higginson mine, 270
High Grade District, Calif., 358,
 371°
Highgrading, 204, 261, 262
Highland Brewery, 699
Highland Chief mine, mill, 79†, 80,
 82
High Line (LV&T), 466, 467, 474, 499
High Line (SLR), 661, 662, 670°
High line wagon road, 57, 60°
Hiko, Nevada, 709, 712
Hiline (Jct.), Nevada, 116, 128†,
 130°, 131

Hilliard, Sam, 345
Hill Line, Pioche, 701°, 720†, 727, 728, 729, 732
Hill, James J., 40
Hill, Louis, 40
Himix, Nevada, 734, 735†, 738, 743°, 745°, 746, 748, 749, 750†, 752
Hinds Hot Springs, Nevada, 226
Hiskey & Walker's Mill, 536
Hiskey, J. M., 78, 286
Hitt, Calif., 843†, 845†, 846°
Hobart Estate Co., 440†, 441, 442, 891
Hobart Mills, Calif., 58, 439, 440†, 441, 442, 443, 444° 445°, 451°, 452°
Hobart Southern RR, 440†, 442, 443, 443°, 891
Hobart, W. S., 425, 428, 439
Hoffman, Charles E., 684
Hog Flat, Calif., 41
Holabird, W. H., 238
Hollenbeck, Capt., 810
Holmes, J. J., 344, 351, 422
Holmes Mining Co., 176
Holmes, Raymond, 310
Holmes, Silas M., 341
Holt, (Supt.) Thomas, 307, 308, 310, 311
Homer, Calif., 624, 765†, 766
Homer Mining District (Lundy), 307
Homer Mining Index, Lundy, 307
Homestead Tunnel, 137, 145°, 159
Honerine Mill, 726
Honey Lake, Calif., 352, 354
Hood, Calif., 768
Hood, William, 33, 114, 765
Hooligan Hill, 230, 232°
Hoover Dam, 636°, 662, 734, 735†, 736, 749°, 750†
Hoover, Herbert, 736
Hoot Owls (Wells), 337
Hope Valley, Calif., 161
Hopkins, Col. C. W., 848
Hopkins, Capt. J. W., 871, 872
Hopkins, Mark, 1, 13
Hordon, "Doc," 376, 382
Hornsey, John W., 798
Hornsilver, Nevada, 494, 505†, 538°, 539
Horse Lake, Calif., 340†, 364°
Horse Shoe Curve, Nevada, 640
Horton, Ben, 564°, 608
Horton Bros., 406
Horton, Calif., 572°, 586, 587, 608, 609, 609†
Horton Jct., Calif., 396, 398, 406, 407°, 408, 409
Hotel Carrara, 607, 605°
Hotel Esmeralda, 271°
Hotel Fayle, 754, 757°
Hotel Mina, 183°

Hotel Netherlands (NYC), 239
Hotels, 12, 14°, 59, 123°, 250°, 260, 607, 778°, 817, 874°
Hot Springs, 63, 226, 354, 872, 873
Hot Springs, Calif. (NCO), 354, 358
Hot Springs grade, 31, 51
Hot Springs, Lake Tahoe, Calif., 439
Hovey, Charles L., 409
Howell, John, 175
Howell's Ranch, 520
Hoya, Nevada, 643†, 647, 661
Hoyt, E. S., 471
Hudson, J. R., 71
Hudson, Nev., 215†, 225°, 226, 227, 228
Huffaker's, Nevada, 137†, 157
Hughes Construction Co., 216
Humboldt Beer Hall (Bodie), 310
Humboldt Canal, 63
Humboldt (House), 26, 39°
Humboldt Lake, 27°
Humboldt River, 19, 28°, 46, 63, 101†, 105°, 318, 319, 327°, 332, 333
Humboldt Smelting & Reduction Co., 65
Humboldt (Wells), Nevada, 13; also see Wells.
Humbug Creek, Calif., 384
Humdinger claim, 858
Humphries, H. J., 62
Hunter, J. M., 13
Huntington, Collis P., 1, 12, 13, 18, 31, 179, 181, 396, 626, 764, 765, 771, 774, 788
Huntington-Gould Agreement, 764
Huntington, Mrs. Collis P., 316
Huntington, Ore., 353
Huntsman Canyon, Nevada, 658°
Hyman-Michaels, 77°, 78

— I —

Ibex, Calif., 765†, 766, 849
Ibex mine, 842
Ibis, Calif., 765†, 777, 782°
Ice harvesting, 404°, 409
Idaho Central Railroad, 334-335, 336
Idlewild Park, 867†, 873
Iglehart, Paul, 240, 256
Imlay, Nevada, 24-25°, 38
Imperial Valley, Calif., 734
Incline Creek, Nevada, 425, 429†
Incline, Nevada, 427°, 428, 429†, 439
Independence, Calif., 174, 175, 175†, 178, 202, 209
Independence, Nevada, 26
Independence Lake, Calif., 439, 440†, 441
Indian Creek, Nevada, 463
Indian Queen mine, 172†, 175
Indians, 18, 166, 174, 177, 179, 208, 211 236, 348, 352, 354, 382, 384,

499, 543, 598, 660, 684, 763, 787, 815, 842, 845, 882
Indian Springs, Nevada, 454† 457†, 463, 466, 502
Indian Valley RR, 227, 319
Ingalls, J. Aaron "Buck," 53
Ingalls, W. A., 244°
Inman, Claude, 260, 519
"Inside Route," 333
International Hotel (Austin), 68°, 83
International Hotel (Virginia City), 139°
International Smelting Co., 729, 730, 753
Interstate Commerce Commission (I. C. C.), 45, 209, 228, 288, 332, 333, 334, 335, 431, 436, 442, 509, 535, 591, 593, 730, 732, 736, 854
Inyo County, Calif., 174, 175, 176, 210
Inyo Development Co. RR, 175, 179, 194°
Inyo Independent, 311
Inyo Marble (Works) Co., 179, 410
Inyo Mountains, Calif., 197°, 198°
Inyo Register, 307, 314
Ione, Nevada, 71, 73
Islen, Nevada, 633°, 643†
Isleta, N. M., 763, 788
Ivanpah, Calif., 545, 546, 770, 843†, 845, 845†, 847°, 848, 851
Ivanpah Copper Co., 845
Ivanpah (old); Calif., 841, 843, 845
I.W.W., 131, 289, 487, 517
IXL Claim, 848, 854

— J —

Jack Ah, 344
Jackling, D. C., 113
Jackrabbit (mine), 687°, 698, 699, 702°, 706°, 719, 720, 722, 727, 728
Jackrabbit Road, 698, 732
Jackson, Clyde, 239
Jackson, Utah, 37
Jacobs, H. H., 437
Jacobs, Winnefred, 615
Jacobsville, Nevada, 66, 67, 317
James, Arthur Curtis, 89
James, Isaac E., 137, 138
James, Sam, 815
Janet (private car), 277°
Janney, John, 695°, 727, 730
January mine, 258, 289
Jarman, Harold, 759
Java, Calif., 765†, 766
"Jawbone, The," 205
Jean, Nevada, 646†, 753†, 754, 759, 761†
Jeffers, William M., 730
Jenifer, F. M., 531°, 534
Jensen, Arendt, 162
Jenvey, Rev. W. R., 343

Jerome, Ariz., 463
Jiggerville, Calif., 178
Jim Crow mine, 712
Joburg, 795, 796
Johannesburg, Calif., 462, 559, 793, 794°, 795, 796, 797†, 798, 799†
Johnnie (LV&T), Nevada, 468, 470, 602
Johnnie (townsite), Nevada, 470
Johnson, A. M., 536, 792
Johnson, Charles E., 313
Johnson, H. A., 286
Johnston's Spring, Nevada, 510
Johnsville, Calif., 384
Jones and Sharp, 306
Jones Club, 719
Jones, J. Noble, 40, 355
Joshua Hendy Iron Works, 54
Juab, Utah, 454†, 628°
Juan, Calif., 843†, 846°
Judah, Theodore J., 1, 2, 51
Judell, Adolph, 114, 115, 117, 131
"Julian Special" C. C., 589
Jumbo Annex mine, 270
Jumbo Extension mine, 542
Jumbo Mine, 257, 289
Jumbo, Nevada, 872
Jumbotown, Nevada, 266†, 488†, 511°
Junction (Filben), Nevada, 173, 174
Junction (House), Calif., 351, 385†, 352, 362°
Juniper Creek, Calif., 417†, 438, 440†
Jungo, Nevada, 327°

— K —
Kaiser, Henry J., 738
Kaiser Steel plant, 593
K&L Railroad, 178
Karlo, Calif., 364°
Katz & Henry, 343, 410, 436
Keane Springs (South Bullfrog), Nevada, 462
Keane Wonder Mining Co., 470, 534
Kearney, Will, 54
Kearns, Thomas, 627
Kearsarge, Calif., 174, 175†, 202
Kearsarge mine, 175, 175†
Keddie, Arthur, 348, 385
Keddie, Calif., 41, 317†, 318, 321°
Keeler, Calif., 174, 175, 175†, 177, 178, 179, 192°, 194°, 205, 209, 359, 598, 796
Keeler, Capt. J. M., 175, 177, 192°
Keith, Frank, 279°, 835
Keith, Nevada, 509
Keith, W. W., 279°
Kelly, Alma, 575°, 615°
Kelly, Judge, 406
Kelly mine, 797
Kelly, Virgil, 641
Kelsey's, Nevada, 241
Kelton, Utah, 18†, 19, 37

Kendall, Nate, 345, 350
Kendall, Mrs. Zeb, 243, 247°
Kendall, Zeb, 243
Kennecott Copper Corp., 123°, 133, 134, 135, 896-98
Kennedy, Nevada, 63†, 65
Kennett, Calif., 62, 267
Kent, J. F., 753, 754
Kentuck mine, 137
Kerby, Alex, 385
Kerby band mill, 389
Kerby, Calif., 384†, 385, 385†, 389
Kerens, Richard C., 463, 625, 627
Kern Weekly Record, 765
Kerosene Kate, 117
Kerr, Mark B., 313
Kershaw P. O., Nevada, 712
Ketchum, Idaho, 25, 622†
Keyser, Charles, 441
Keystone, Nevada, 131, 133†
Keystone mine, 753, 842
Kiernan, John, 644
Kiernan Ranch, Nevada, 642, 643†, 644
Kilker, Thomas, 470
Kilpatrick Brothers & Collins, 32, 624, 908
Kimball Brothers stage, 230, 466, 602
Kimberly, Nevada, 125°, 131, 133†, 134
King, E. W., 231
King, John C., 815, 823
King, Thomas M., 240, 263
King's Canyon flume, 154
Kingston Mountains, Calif., 549
Kinkead, J. H., 171
Kirby (Mills), Calif., 392, 396, 397
Kirman, Richard, 54
Kitchen stage line, 456
Kitchen, Wm., 271
Klamath Falls, Oregon, 40, 332, 343, 376, 382†, 382
Klondike, Calif., 766
Klondike District, Nevada, 236
Klondike Quarry, 860, 861†
Knapp & Laws Store, 178
Knapp, Jim, 204
Kneiss, Gilbert, 78
Knickerbocker Trust Co., 489
Knickerbocker, W. H., 230
Knight, George F., 475
Knight, Goodwin J., 227, 759
Knight Investment Co., 227, 754
Knight, Jesse, 227, 753†, 754, 759
Knott's Berry Farm, 804°. 823
Knott, Walter, 822
Knox and Holmes, 385
Knox, Charles E., 263, 312-13
Knox, H. L. N., 343, 344, 353, 389, 392
Kramer, Calif., 765†, 795, 796, 797, 797†
Kruger, W. H., 436

Krum Canyon (See Crum Canyon), 78, 79†
Kruttschnitt, Julius, 33, 179, 239
Kruttschnitt, Col. T. H., 286
Kunze, Arthur, 598, 599, 603
Kunze, Calif., 597†, 599, 602
Kunze, C. E., 603

— L —
Ladd Mountain, Nevada, 456, 468°, 479†, 511
Laguna mine, 289
Lake Canyon, Calif., 307
Lake Lahontan, Nevada, 181
Lake Mead, Nevada, 662, 735†, 736, 752
Lake Mead Base, 761, 761†
Lake, Myron C., 13
Lake's Crossing, 13
Lake Shore House (Tahoe), 418°
Lake Tahoe, 155, 309, 416-438, 868, 871, 872, 873
Lake Tahoe (Narrow Gauge R.R.), 345, 422, 430
Lake Tahoe Railway & Transportation Co., 417†, 423, 425, 430-36, 891
"Lake Tahoe Route", 436
Lake Tahoe Transportation Co., 430
Lake Valley, Calif., 417†, 424, 425
Lake Valley Railroad, 424-425, 430
Lakeview Hotel (Keeler), 192
Lakeview (Sierra County, Calif.), 411, 412†
Lakeview (Summit), Nevada, 137†, 149°, 157, 159, 417†, 425, 428
Lakeview, Oregon, 340†, 356, 359, 373°, 376, 379°, 380°, 382, 382†
Lakeview (private car), 359
Lamar Bros., 855
Lander County, Nevada, 66, 67
Lane City, Nevada, 113, 128, 131, 133†
Lane, Amos, 354
Lane, Charlie, 100
Lane, J. B., 854
Lane, Mrs. Lucy, 822
Lansdale, John, 604
Lassen Advocate, 41, 352
Lassen Creek, Calif., 383
Lassen Development League, 41
Lassen Lumber & Box Co., 892
Last Chance Creek, Calif., 384
Last Frontier Village, 701°
Last spike, 19, 58, 70, 116, 157, 243, 258, 264, 289, 511, 556, 645, 646, 646†, 647, 662
Las Vegas, Nevada, 260, 261, 454†, 455, 457, 458-61°, 462, 463, 466, 467, 470, 474, 486, 487, 489, 546, 631°, 634-39°, 643, 644, 647, 662, 663†, 664-68°, 669†, 701°, 735, 738, 751, 753, 754, 760, 761, 761†
Las Vegas Advance, 647

Las Vegas Age, 502, 603, 647, 660
Las Vegas & Tonopah R.R., 115, 203, 229, 261, 263, 264, 265, 267*, 289, 454-503, 520, 534, 539, 541, 556, 587, 604, 892
Las Vegas Land and Water Co., 662
Las Vegas Rancho, 635*, 644, 645†
Las Vegas Times, 647
Laughton, Nevada, 31
Lava Mountains, 793, 799†
Lawler, Nevada, 735, 735†, 740, 746
Laws, Calif., 174, 175†, 200*, 209, 313, 314, 315†
Laws, Robert J., 168, 174, 177, 179
Lawson, Thos. W., 714, 718
Lawton Springs (Reno), 872, 873
Layton Canyon, Calif., 809, 809†, 811, 812*
Layton Pass, 809, 809†, 813*
Layton Springs, 812*
Lazard Freres, 698
Lazy Station, Calif., 410, 411
Leadfield, Calif., 541†, 548†, 589
Leastalk, Calif., 843†, 845†, 848
Le Cyr, Joseph, 817
Ledlie, General, 67
Ledlie, Nevada, 70†, 72, 82, 84
Lee, Calif., 464†, 486, 548†, 556
Leeland, Nevada, 556, 464†, 548†
Leeper, R. C., 877
Lee's Wells, Nevada, 555
Leete, B. F., 51
Leete's Salt Works, 51
Leevining Canyon, Calif., 175
Lehi (Jct.), Utah, 454†, 622†, 623, 686
Lehman, Philip, 713
Leith, Nevada, 643†, 655*, 660
Leland mine, 854, 855, 855†, 857
Lemmon, Fielding, 351
Lemmon Valley, Nevada, 345, 345†, 351, 352
Lemon Canyon, Calif., 411, 412†, 412
Lemon, C. S., 239, 240
Leonardt, Carl, 860
Leon, Calif., 860, 861†, 861, 864
Leschen Wire Rope Co., 62, 227
Leslie Salt Co., 840
Lewis brothers, 398
Lewis Canyon, Nevada, 78, 79, 79†
Lewis Construction Co., 740
Lewis Herald, 80
Lewis Hotel (Lou Pugh), 80
Lewis Junction (Galena), 79, 79†, 72†, 82
Lewis Mill, Calif., 398, 399, 402*
Lewis, Nevada, 71, 78-83
Lewis Station (Lowertown), 79, 79†
Lewis, W. S., 398, 399, 400*
Liberty (Eureka) Pit, 125*, 132, 133, 133†
Lida, Nevada, 176, 294, 509, 536-39
Lida Restaurant, 537*

Lida Valley (District), Nevada, 166, 172, 536
Lida Valley R.R., 505†, 514, 536-39
Lidgerwood cable system, 607
Liegan, Calif., 353
Lightner mine, 685†, 690*, 697, 727
Lightning Express, 26
Likely, Calif., 340†, 355, 355†, 356, 367*, 373*, 379*, 380*, 382†, 382
Lila C. mine, 260, 455, 545, 546, 547, 555, 557, 559, 570*, 572*, 585, 586, 587, 602, 608, 609†, 823, 845
Lila C. Railroad, 587
Lime Kiln, Calif., 299†, 304*, 310, 311
Lime Point, Nevada (See Gold Point)
Limerick Canyon, Nevada, 57, 57†, 58
Linabary, Jack, 883
Linabary, J. C. "Cal", 882, 883
Lincoln County Lumber Co., 470
Lincoln County, Nevada, 625, 626, 627, 641-2
Lincoln Trust Co., 506
Lindley, Judge Curtis, 114, 117
Lindsay, Oscar, 441
Linkville, Oregon, 340†, 343
Lippincott Mill, J., 529*, 543
Little Lake, Calif., 169†, 205
Little Summit, Nevada, 172†, 173
Little Truckee River, 439, 440†, 441
Little Valley, Nevada, 425, 429†
Llanerch, Pa., 872
Lloyd Bros. sawmill, 392, 395
Lloyd, Harold, 752
Locomotives, Cab-in-Front, 4*, 10*, 17*, 36-37*, 46*, 46
Locomotives, geared, 54, 55, 59, 61*, 382, 383, 412, 414*, 415*, 441, 442, 452*, 542, 698, 699, 751, 752*, 754, 823, 824*, 858, 859*
Lodge, Robert, 25
Lodi, Nevada, 90, 91†
Loftus, James, 286, 287
Logan, Garfield, 293, 294
Lomix, Nevada, 735, 735†, 742, 745*, 746, 748, 750†, 751
Lone Pine, Calif., 174, 175†, 205, 208
Long Beach Salt Co., 894
Long, J. W., 113
Longstreet's Ranch, 602
Long Valley, Calif., 342, 347, 348, 350, 352
Long Valley Canyon, Calif., 410
Long Valley Creek, Calif., 353, 355
Lonkey, Ed, 413*
Lonkey, Oliver, 410
Lord, C. K., 263, 520
Loretto, 241
Los Angeles, Calif., 73, 177, 178, 203, 205, 316, 319, 454†, 486, 549, 625, 624†, 626, 627, 776,

795, 796, 811, 844
Los Angeles & Nevada R.R., 86, 87†, 88
Los Angeles & Salt Lake R.R., 316, 627 (See Salt Lake Route, 622-683)
Los Angeles Aqueduct, 205, 315, 894
Los Angeles Daily Times, 646
Los Angeles Limited, 653*, 663, 676*
Los Angeles Porcupine, 787
Los Angeles Terminal Ry., 625, 626, 628*, 796
Los Angeles Times, 795
Louisville & Nashville R.R., 494
Lousetown Creek, Nevada, 136
Love, Commodore Robert, 306
Love, Donald, 835
Lovelock, George, 65
Lovelock, Nevada, 18, 18†, 29†, 57†, 332
Lower Biddy Mine, 609, 610
Lower Narrows, 674*, 871†
Lower Pray Meadows, Nevada, 416†, 420*, 422, 423
Lower Prosser Creek, Calif., 439
Lower Rochester, Nevada, 58, 58†, 59, 62
Loyalton, Calif., 398†, 399, 402*, 406, 408†, 408, 409
Loyalton Branch (WP), 331
Lucas, Jean, 585
Luce, Israel, 179
Lucerne Valley, Nevada, 861†, 864
Lucin, Utah, 31, 32, 36, 37
Lucin Cut-Off, 31, 36, 37, 38, 48*, 49*
Lucky Boy mine, 171†, 204
Ludlow, Calif., 461, 462, 465†, 470, 489, 547, 548†, 551*, 552*, 560-61†, 576*, 578*, 585, 591, 592, 593, 623, 765†, 766, 770, 782*, 787, 797, 827, 827†, 828, 829*, 835, 840
Ludlow & Southern Ry., 797, 827-35, 894
Ludwig, John, 214
Ludwig Mine, 214, 216
Ludwig, Nevada, 215†, 226, 226*, 228
Lumber traffic, 373*, 376, 382, 398
Lundy, Calif., 307, 312
Lundy, C. A., 385
Lundy Lake, Calif., 299†, 307
Luning, Nevada, 173, 174, 178, 230, 234
Luning, Nicholas B., 173, 177, 178
Luria Bros., 752
Luva, Nevada, 50†, 51

*denotes picture reference
†denotes map reference
pages 1-453 are in Volume I
pages 454-908 are in Volume II

Lyman, Dr. J. Grant, 598
Lynch, Phillip, 2, 13
Lyon County Bank, 215
Lyon County Farm Bureau, 228
Lyon County, Nevada, 174
Lyon Mill and Mining Co., 210, 211
Lyon quartz mill, 210

— M —

MacDonald & Kahn Co., 738
MacDonald, Sheriff, 462
Machado, M., 536
Mackay, John W., 843
Mack, Judge C. E., 54, 215
Mack, Mary J., 56
MacVichie, Capt. Duncan, 215, 216
Madeline, Calif., 340†, 354, 355,
 355†, 366°, 367°
Madeline Hill, Calif., 355, 355†, 382
Madeline Hotel, 366°
Madeline Meadows Land and
 Irrigation Co., 355
Madeline Plains, 40
Madeline (sleeping car), 359
Magma Arizona Railroad, 287
Magnesia, Calif., 799†, 802, 808†,
 809, 810, 811, 814
Magnesium Siding, Calif., 809
Magnet Mill, 686
Magnolia claim, mine, 708, 709,
 712, 713
Maguire, Arthur, 457†, 461, 463
Mahaffie, Stewart, 728
Mahan, J. Harold, 359, 377°
Mahoney Bros., 753
Main Line Jct., Nevada, 237†, 257,
 261, 267
Maître de Forges, 357
Malley, Sheriff, 499
Maloney, Andrew J., 240
Malpais Mesa, Nevada, 266†, 267°,
 271°
Mammoth (City), Calif., 175, 306
Mammoth Copper Co., 62, 267
Mammoth mine, 817
Mammoth Pass, Calif., 238
M&M Pushcar Line, 771, 771†
Manhattan Elevated Ry., 873
Manhattan, Nevada, 73, 208, 248°,
 259, 267, 298, 499
Manhattan Silver Mining Co., 66, 73,
 83
Manning & Berry, 347, 348, 349, 350
Manning, A. J., 344, 349, 350
Manning, Jerry J., 708
Manse, Nevada, 544°, 547
Manson, Frank, 62
Manvel, Allan, 788
Manvel, Calif., 842, 843, 843†, 844,
 845, 845†, 846°, 847
Marble, 179, 410, 587
Marion, Calif., 815†, 823, 826
Marion Tribune (Ohio), 607

Marks, William, 473
Marlette & Folsom (store), 427
Marlette Lake, Nevada, 417†, 428
Marlette, S. H., 425
Marsh, Calif., 408
Marshalltown, Iowa, 215
Marsh (Logging) Lumber Co., 407°,
 408†, 893
Marsh, William, 256
Marston, Calif., 319
Martin, Joe G., 729
Martin, Henry, 422
Martin, Will, 478
Martin, W. O. H., 866
Martis Creek, Calif., 437, 441†
Martis Creek Station, Calif., 438
Martis Valley, Calif., 437
Mary mine, 294
Mason (City), Nevada, 215†, 216,
 217†, 225°, 226, 227, 228
Masonic, Calif., 39, 161
Mason Valley Mines Co., 214, 216,
 226, 227
Mason Valley, Nevada, 166, 169,
 214, 215, 215†, 230
Massey, W. A., 867
Mayberry Ranch, 873
Mayer, Wm. M. "Blackie", 575°
Mayflower mine, 467, 517
Mayflower Bullfrog mine, 467
May Lundy mine, Calif., 307, 312
McAdams, W. F., 844
McAdoo, Wm. G., 502
McBride's Pass, Nevada, 172, 173
McCarthy, Alfred J., 239
McCartney, H. M., 624, 625, 543
McCartney, S. H., 376
McClane, Brooks, 52
McClanesburg, Nevada, 52
McClellan, E. C., 344
McClellan, Rody, 399
McClure (T&T eng.), 549
McCormack Addition (Rhyolite),
 470
McCormack, J. C., 470
McCoy Hill, Nevada, 90, 92†
McCoy's Hotel, 53°
McCraney, Orlando, 293, 294
McCune, A. W., 625, 626
McCune, Utah, 626
Macdonald, Malcolm, 235, 599
McDougall, Thomas, 334, 335
McGill Jct., Nevada, 117, 134
McGill, Nevada, 117, 128, 128†,
 130°, 131, 132, 134, 135
McGill, William, 113, 116
McHenry, John, 89
McKeen Motor Car, 11°, 296°
McKee, W., 730
McKissick Hotel, 874°
McKissick, Jake, 348
McLean and McSweeney, 240, 293
McLean and Ottman, 509

McLean, Neil, 312, 314, 542
McLean's, Nevada, 237†, 267
McLoed, C. A., 229
McMecham, James, 341, 346
McMillan, Thomas F., 309
McMurray, Hugh J., 344, 347, 348,
 349
McNamara Mining Co., 239, 242†
McSweeney, Charles, 243
McSweeney Cut-Off (T&G), 267
McTarnahan, John C., 169, 341, 342
Mead Lake, Nevada, 683°
Meadow Valley Mining Co., 684,
 685†, 686, 696, 697, 698, 699, 727
Meadow Valley Wash, Nevada, 467,
 624†, 627, 640, 642, 643†, 644,
 645, 647, 653-58°, 660-61, 679,
 712, 713, 844
Meehan, "Red", 532°
Meiklejohn, Hon. George D., 511
Mellen, Arizona, 791, 854
Mellen, Capt. Jack, 791
Mellier, Augustus, 239, 240
Melrose Smelting Co., 174
Mendha, Nevada, 687†, 699, 718,
 720†
Merchants Hotel (Tonopah), 250°
Merchants Hotel (Manhattan), 248°
Merrill, Calif., 398†, 406, 408, 411,
 412†, 440, 441†, 442
Merrimac, Nevada, 147°, 154°, 160†,
 161
Merritt, Chapman and Scott, 736
Metropolis, Nevada, 29†, 40, 333,
 338
Meyers, Calif., 417†, 425, 430
Meylert's Stage, 348, 351
Middletown, Nevada, 80
Midland, Calif., 840
Mid Pacific R.R., 73, 86-89
Midvale, Utah, 723
MIKE (motor car), 59, 62
Milford, Utah, 178, 622†, 623, 624,
 624†, 625, 628°, 631°, 640, 643,
 644, 709, 844
Mill City, Nevada, 337
Mill Creek, Nevada, 425, 429†
Miller & Lux, 227
Miller, Elna, 175
Miller, Gov. Charles R., 237, 261,
 279, 280°
Miller, Maud, 383
Millers, Nevada, 86, 87†, 88, 237†,
 248°, 250°, 261, 262, 263, 264,
 277°
Millerville, Nevada, 162
Mills Building, San Francisco, 179
Mills, Darius O., 71, 90, 100, 106,
 136, 155°, 161, 166, 174, 177-78,
 312, 341, 685
Mills, Edgar, 90
Mills, Ogden, 89, 162

922 —

Milltown, Arizona, 854, 855, 855†, 857
Milltown, Nevada, 259, 265, 266†, 267*, 488†, 509
Mina Canyon, Nevada, 313
Mina, Nevada, 179, 183*, 185*, 202-3†, 203, 209, 256, 262, 312, 313, 359, 380*, 486
Minden, Nevada, 137†, 152*, 158†, 161, 162
Mine railroads, 125*, 220*, 221*, 227, 294, 298, 713, 727
Mineral City (Lane City), Nevada, 113, 622†, 623
Mineral County, Nevada, 204
Mineral, Nevada, 91†, 99*, 101
Mineral Ridge, Nevada, 293†, 295*
Miners, ex-Comstock, 168, 176
Miners Union Hall (Bodie), 307
Minidoka & Southwestern Railroad, 334
Minidoka, Idaho, 334, 334†
Mining & Scientific Press, 603
Mining Investor, 601*
Minnie Moody, 428
Minto, Nevada, 643†, 647, 648*
Missouri Pacific, 316, 333, 843
Mizpah claim, shaft, 237, 250*, 277*
Mizpah (private car), 282*, 284, 520
Mizpah Hotel (Tonopah), 250*
Moana Springs, Nevada, 867†, 872, 876, 877, 879*, 880, 881
Moapa Gypsum Co., 662
Moapa, Nevada, 624†, 642, 643, 643†, 644, 660, 661, 662, 670*, 734
Modena, Utah, 626, 643†, 648*, 661
Modoc County, Calif., 353, 356
Modoc Indians, 382
Modoc Land & Livestock Co., 354
Modoc Line (SP), 332, 382, 383
Modoc, Nevada, 171†, 231
Mohave (steamer), 765
Mohave & Milltown R.R., 822, 854-857, 894
Mohave Indians, 787, 845
Mohawk, Calif., 352, 355, 356, 384†, 385, 389, 396, 397
Mohawk Ledge Mining Co., 270
Mohawk mine, 270*, 289, 492*, 511
Mohawk Valley, Calif., 331, 384, 385, 392, 396, 397
Mojave, Calif., 173, 177, 178, 179, 202, 205, 206*, 208*, 209, 210, 622†, 623, 762, 763†, 765, 765†, 766, 771, 774†, 775*, 776†, 788, 791, 793, 795, 798
Mojave Desert, 676*, 762, 770, 774, 792, 793, 857
Mojave Northern Railroad, 860-64, 894

Mojave River, 559, 670*, 672*, 673*, 674*, 760, 765, 765†, 766, 777, 779*, 815, 815†, 816, 823, 827, 860, 861†, 864
Monaghan, Frank, 771, 771†
Monitor mine, 709†, 712
Monkey Wrench mine, 708, 709†, 713
Mono Lake, Calif., 299†, 307, 308, 309, 313
Mono Lake Railway, 263, 313
Mono Lake Railway & Lumber Co., 312
Mono Mills, Calif., 299†, 304*, 309, 310, 311, 312, 313
Monorail, 808-14
Mono mine, Bodie, 303*, 308, 309
Montana Station, Nevada, 510, 539
Montana-Tonopah Mining Co., 242†, 243, 312
Montello, Nevada, 26, 29†, 38, 44*
Monterey & Salinas Valley R.R., 67
Montezuma Club, 258, 489
Montezuma mine, Nevada, 57
Montezuma mine, Calif., 175
Montgomery, Calif., 175
Montgomery, E. A. (Bob), 456, 466
Montgomery Hotel (Beatty), 466, 471, 471†, 473*, 478, 497*
Montgomery Mountain, Nevada, 485*
Montgomery-Shoshone mine, 456, 466, 467, 474, 476*, 479, 485*, 486, 517†
Moore, Col. Thomas, 331, 341, 342, 343, 344, 345, 346, 347, 348, 349, 358
Moorman Ranch, Nevada, 116
Moran, Amedee Depau, 350, 354
Moran & Iselin, 350
Moran Bros., 343, 344, 348, 350-1, 353, 373
Moran, Calif., 351, 362, 383
Moran, Charles, I, 345, 349
Moran, Charles, II, 351*, 356, 357, 376
Moran, D. Comyn, 350, 356
Moran, W. J., 215
Morgan, Oscar, 16*, 55
Morganthau, Henry, 713
Mormon (Portola), Calif., 318, 396, 397, 406, 408
Mormons, 416, 644, 753
Mormon Station, Nevada, 1
Morris, Duff, 422
Morrison, Calif., 569*, 586, 596†
Morrison-Knudsen Co., 738, 761, 864
Morris, Ross, 287
Mosel, Nevada, 29†, 32
Moulton, J. H., 100
Mound House, Nevada, 31, 38, 159, 160, 160†, 161*, 162, 163, 166, 167*, 168, 168†, 169, 169†, 170*,

174, 177, 179, 180, 181, 202, 202†, 209, 237, 238, 240, 241, 254*, 256, 486
Mount Blanco, Calif., 609
Mt. Brougher, Nevada, 244*
Mt. Butler, Nevada, 244*
Mount Charleston, Nevada, 638*
Mt. Diablo Mining Co., 176
Mount Ely, Nevada, 697, 704*, 720†
Mt. Langley, Calif., 197*
Mount Mohave Gold Mining Co., 854
Mt. Montgomery (Pass), Nevada, 172, 172†, 173, 175, 178, 179, 191, 209, 312
Mt. Oddie, Nevada, 242†, 243, 279*, 282*
Mt. Rose, Nevada, 438
Mount Tamalpais & Muir Woods Ry., 751, 752*
Mt. Whitney, Calif., 175†, 197*, 545
Muck Siding, Calif., 591
Mud Springs (Summit), Nevada, 454†, 464†, 466, 474, 499, 517†
Mudd, Litti R., 54
Mudd, Seeley W., 835
Muddy River, Nevada, 643†, 683*
Mule Canyon, 815, 815†, 816, 823, 826
Mulholland, C., 844
Mulholland, William, 205
Mumm's Extra Dry mining claim, 470
Muroc, Calif., 792, 793
Murphy Bros., 829*
Murphy, Dan, 771, 771†
Murray, Utah (smelter), 596
Murry Creek, Ely, 117
Myers, Al, 256

— N —

Naileigh District, Nevada, 171
Narrow Gap, Nevada, 317
Narrows, The (Esm. County), 239
Narrows, The (Lin. County), 643†, 662
Narrow Gauge Saloon, 168
National Bank claim, 456
National City, Nevada, 698
National Lead Co., 726
Nation, A. T., 385
Natural Soda Products Co. (railroad), 175
N-C-O Realty Co., 357
N-C-O Shops (Reno), 354, 357, 358, 359†
Needles, Arizona, 855, 855†, 856*
Needles Eye, 855
Needles Reduction Co., 842, 844
Needles, Searchlight & Northern Ry., 850
Needles, The, Calif., 542, 596, 763†, 765, 765†, 766, 768-69†, 769, 770, 771, 771†, 773*, 774, 777, 786†,

Needles, The *continued*
788, 789°, 791, 835, 841, 844, 845, 849, 854, 855†
Nellis Air Base, 761, 761†
Nenzel Hill, Nevada, 57, 57†, 60°, 62, 63
Nenzel, Joseph F., 57, 59
Nevada & Arizona R.R., 341
Nevada and California Lumber Co., 439, 908
Nevada & California R.R., 313, 314, 351, 360°
Nevada & California Ry. (ex C&C), 167°, 202, 203, 209, 312, 486, 886
Nevada and Oregon Railroad Co., 344, 385
Nevada and Oregon Railroad Co., The, 342, 343
Nevada Cable Traction Co., 230
Nevada-California-Oregon Ry. (N-C-O Ry.), 19, 33, 40, 62, 166, 209, 318, 319, 324°, 331, 333, 340-83, 395, 396, 867, 895
Nevada Central Extension R.R., 86, 87†, 88
Nevada Central Motor Lines (Hiskey Stages), 78
Nevada Central R.R., 73, 230, 236, 237, 258, 286, 331, 341
Nevada Central Railroad (Pioche), 686, 687, 689°, 696, 697, 900
Nevada Central Ry., 66-78, 82, 83, 84, 86, 87†, 88, 896
Nevada Company, 73
Nevada Consolidated Copper Co., 114, 115, 133, 134, 135, 896-98
Nevada Consolidated Copper Corp., 134
Nevada Consolidated Mining and Milling Co., 54, 55°
Nevada Construction Co., 84
Nevada Copper Belt R.R., 56, 86, 87†, 88, 161, 168, 214-29, 267, 898
Nevada Department of Highways, 503
Nevada Douglas Copper Co., 214, 226, 227, 228
Nevada Engineering Works, 226, 876
Nevada First National Bank, 535
Nevada Goldfield Mining Co., 541
Nevada Hardware & Supply Co., 868
Nevada Interurban (Street) Ry., 872, 873, 876, 877, 879°, 880, 881
Nevada Manhattan Corporation, 86
Nevada Massachusetts Co., 337
Nevada Midland Railroad Co., 84, 86, 73, 238
Nevada Mining News, 230
Nevada Mobile Transit Co., 531°
Nevada New Mines Co., 235

Nevada Northern Ry., 100, 106, 112-34, 254°, 318, 319, 334, 899
Nevada Northern Railway, First Division, 71, 72, 78, 333
Nevada Pacific Railway, 623
Nevada Power & Transportation Co., 866
Nevada, Public Service Commission (See Nevada, Railroad Commission)
Nevada Reduction Works, 163
Nevada, Railroad Commission of, 107, 111, 117, 132, 161, 227, 228, 229, 262, 286, 287, 288, 289, 494, 499, 502, 527, 534, 729, 754, 881, 882, 883
Nevada Railroad Co., 52-56, 215, 894
Nevada Railway, 66
Nevada Rapid Transit Co., 461
Nevada Short Line Ry., 57-63, 65, 900
Nevada Southern Railroad (Mid Pac.), 86, 87†, 88
Nevada Southern Ry., 709, 712, 753, 841-848, 900
Nevada Southern Railway, First Division, 71, 72, 78
Nevada State Herald, 336
Nevada State Journal, 55
Nevada Trading and Transportation Co., 461
Nevada Transit Co., 868, 869, 871, 874°, 880
Nevada Transit Co. (bus), 883
Nevada Transportation Co., 107
Nevada Tribune, 174
Nevada United Mines Co., 106
Nevada-Utah Mines & Smelting Corp., 702°, 714, 717, 722
Newberry Springs, Calif., 87†, 88, 765†, 787, 840
New Bonnie Claire Mining & Milling Co., 542
New Boston (Pass), Nevada, 172, 174, 181†, 243
Newcastle, Calif., 289
Newlands, Senator Francis G., 116, 866, 873
New Mohawk (Clio), Calif., 396
New Pass, Nevada, 70, 73†, 317
New Reno, Nevada, 866
Newtown (Clio), Calif., 396
New York Canyon, Nevada, 90, 92†
New York Central R.R., 796, 797, 827, 828, 832°, 835
New York mine, 843
New York Mining District, 842
New York Mountains, Calif., 841, 842, 843†
Nezelda, silver mine, 51
Nicholson, F. R., 867
Nicklin, T. G., 522

Nippeno, Calif., 850
Nipton, Calif., 843†, 850
Nixon, George S., 288, 289, 489
Nixon, Nevada, 58
No. 1 Shaft (Pioche) 685†, 692°, 693°, 704°, 727, 728, 729
No. 3 Shaft (Pioche), 697, 727
No. 5 Dock, Calif., 861†, 864
No. 7 Dock, Calif., 861†, 864
No. 12 Quarry, Calif., 861†, 864
Nogales, Ariz., 763†, 788
Nolan, George, 867
Nome, Alaska, 237
Nome, Calif., 766
Noonday mine (Bodie), 306, 309, 312
Noonday mine (Tecopa), 555, 593, 595°, 596, 596†
Nordyke, Nevada, 215†, 216, 217
Norfolk & Western Ry., 240
Norrington, Robt. W., 541
North Battle Mountain, Nevada, 70†, 79†, 86, 87†, 88, 89°
North Noonday Mine (Bodie), 306
North Rawhide Addition, 235
Northern Belle Co. (mine), 166, 173, 176
"Northern California Outrage," 354, 363°
Northern Hotel, Ely, 117, 123°, 128
Northern Pacific R.R., 333
Northern Saloon: Rawhide, 230, 232°; Tonopah, 237; Goldfield, 260, 489
Northwestern Pacific R.R. (NWP), 500°, 503
Nugent, Nevada, 230
Nye & Ormsby County Bank, 489
Nye County, 535
Nyopolis, Nevada, 467

— O —

Oakland, Calif., 238, 316, 317†, 318, 332, 771, 774
Oakland Mole, Calif., 257
Oatman, Ariz., 854, 855†, 857
O'Brien, Jack, 876
O'Brien, James, 257
O'Brien, P. E., 56
Occidental Hotel, 306
Occidental mine (Calico), 817, 822
Occidental mine (Comstock), 210
O'Conner, Dan, 13
Oddie, Clarence, 240
Oddie, Tasker, 73, 86, 89, 236, 240, 597
Odessa Canyon, Calif., 815, 815†, 820°
Odett's house, Olinghouse, 53°
O'Farrell house, Olinghouse, 53°
Official Guide, 255, 802, 861
Ogden, Utah, 26, 36, 73, 116, 208, 316, 382

Ogden Standard, 29, 31
O'Keefe stages, 241
Olancha, Calif., 175†, 205
Old Jct., Nevada, 237†, 259, 266†, 267°, 488†, 509
Old Spanish Trail, 593, 644
Old Woman Springs, 815
O'Leary, Dan, 842
Olinghouse, Elias, 52
Olinghouse, Henry I., 52
Olinghouse Jct., Nevada, 50†, 55
Olinghouse, Nevada, 33, 50†, 52-56, 215, 229, 866
Oliver, Charles, 441
Oliver, George D., 441
Oliver, George T., 293
Oliver, James T., 173, 307
Oneida, Calif., 345†, 347, 348, 350, 351
Onion Creek, Calif., 439, 440†
Onion Valley, Calif., 440†, 441
Ophir Flat, Nevada, 210
Ophir mine, 139†, 139°
Ora mine, 54
Orange Blossom mine, 787
Ora P. O., Nevada, 52
Ore Line (N. N. Ry.), 128†, 131
Oreana, Nevada, 18†, 29†, 31, 57, 57†
Oregon Short Line R.R., 36, 202, 316, 623, 625, 626, 640, 714
Oregon Short Line (Twin Falls-Wells), 332, 333-337
Oregon Short Line & Utah Northern Ry. (OSL&UN), 62, 624, 625, 627, 628°, 640-41
Oregon Trunk Railway, 40
Orem, A. J., 214, 215
Orem, A. J. & Co., 216, 217
Orem, Walter C., 215, 217, 226
Oriental Mine, 815, 816, 822
Original Bullfrog claim, 456
Original Quarry, 858, 861°
Oro Grande, Calif., 857, 858, 861†
Oro Grande Mining Co., 816, 817, 822, 900
Oroville, Calif., 436
Orr, E. L., 549
Osborne, J. B., 593
O'Sullivan, J. B., 866, 867, 868
Otis, Calif., 647
Overbury Building, 480, 517
Overbury, John T., 240, 279°
Overland (SLR), 661
Overland Limited (SP), 29, 262
Overland Livery Stables, 868
Overland Route, 376
Overton, Calif., 439, 441
Overton, J. B., 425, 441
Overton, Nevada, 643†, 662, 683°
Owens Lake, Calif., 174, 175, 175† 177, 179, 194°
Owens, Nevada, 454†, 464†, 470

Owens River, Calif., 174, 175†, 205, 209, 314, 315
Owens River Valley Electric Railway Co., 313-315
Owens Valley, Calif., 73, 173, 174, 175, 175†, 176, 177, 179, 197°, 202, 205, 313, 314, 319
Owens Valley Bank, 314
Owenyo, Calif., 169†, 175†, 198°, 205, 208, 209, 210, 793, 802
Owenyo Hotel, 198°
Owlshead Mtns., Calif., 808, 809†
Owyhee District, 18

— P —
Pacific Bank (San Francisco), 348
Pacific Bridge Co., 738
Pacific Cement Plaster Co., 837, 900
Pacific Coast Borax Co., 62, 545, 555†, 557, 575°, 586, 587, 589, 591, 608, 609, 610-11, 813°, 816, 823, 824°
Pacific Construction Co., 257
Pacific Electric Railway, 376, 750
Pacific Gas & Electric Co., 786°
Pacific Improvement Co., 770
Pacific Limited, 28°
Pacific Livestock Co. (Miller & Lux), 227
Pacific Lumber and Wood Co., 428, 438-9, 892
Pacific Mines Corporation, 835
Pacific Portland Cement Co., 337, 338°, 900
Pacific Railroad Act, 1, 12
Pacific Reclamation Co., 40
Pacific Rock Salt Co., 840, 886
Pacific Rolling Mills, 67, 344
Pacific Wood, Lumber and Fluming Co., 438
Page & Panaca shaft, 685†, 727
Page, Gen. A. L., 686, 687
Pahranagat Valley, Nevada, 622†, 661, 684
Pahrump Valley, Nevada, 544
Palace Hotel (Wabuska), 217
Palace Saloon (Keeler), 192°
Palisade, Nevada, 18†, 19, 28°, 32, 90, 91†, 98°, 99°, 101, 101†, 102-5°, 108-9°, 110, 208, 318, 319, 327°
Palmer, E. E. (store), 497°
Panaca, Nevada, 640, 643†, 661, 684, 697, 717
Panacare, Nevada, 684
Panacker Lode, 684
Panama, Nevada, 57, 57†
Panamint, Calif., 174, 175†, 797
Panamint Valley, 794†, 802, 809, 809†, 810, 811
Pancho Villa, 837
Paoha Island, Mono Lake, Calif., 299†, 308

Parker, Ariz., 792
Parker, Sam, 258
Parkinson, Bill, 564°
Parkinson, Ralph, 564°
Parrot's (gunsmith), 346
Parr Terminal Co., 228
Pasadena, Calif., 844
Patrick, L. L., 535
Paul, Frank, 627
Paxton, Calif., 319
Paxton, Curtis & Co., 343
Payne mine, 625
Peard, Hill & Co., 542
Peavine, Calif., 331
Peavine Mountain, Nevada, 331, 345, 345†, 351, 358
Peck brothers, 398
Peck-Judah, 861
Peck, Supt. Jack, 286
Pedrini & Ramelli, 395
Pedrini, Pompey, 395
Peerless, auto, truck, 230, 234°, 799
Pegleg Mountain, Calif., 41
Pepper, Miss Belle, 243, 247°
Pequop Mountains, Nevada, 26, 31, 32, 114, 318, 329°
Perkins, A. B., 607
Perkins, P. V., 606, 607
Permanente Cement Co., 864-5
Perry, C. O., 842
Perry, J. W. S., 823
Peterson, A. A., 258
Peterson, Emil, 287
Peterson, Harry, 494
Phelan, Sam, 359
Phelps Dodge, 66
Phenix, George S., 871, 872
Philadelphia & West Chester Traction Co., 872
Philadelphia interests, 237, 239, 240, 260, 506-8, 518, 854
Philippine cement operation, 607
Phillips, Dr. W. S., 511
Phillips, John, 740
Phillips, Joseph, 336
Phoenix, Ariz., 792
Phoenix Reduction Co., 708
Pickering Lumber Co., 382, 382†, 893
Pickhandle Gulch, Nevada, 187°, 189°
Picnic Trains, 70, 353, 415°, 520, 697, 855
Pike, Leroy, 883
Pilot Knob, Nevada, 100, 133†, 134
Pine Valley, Nevada, 101, 106, 107, 109°
Pinnacles, The, 804°

°denotes picture reference
†denotes map reference
pages 1-453 are in Volume I
pages 454-908 are in Volume II

Pinto Summit, Nevada, 99
Pioche & Bullionville R.R., 685†,
 687†, 689°, 697, 715°, 718, 721†,
 727, 900; Also see Nevada Central
 R.R. (Pioche)
Pioche Cons. Mining & Reduction
 Co., 698, 699, 708, 714, 844
Pioche Cons. Mining Co., 697
Pioche, F. L. A., 684
Pioche Mines Co., 727, 733†
Pioche Mines Consolidated, Inc.,
 695°, 704°, 727
Pioche, Nevada, 99, 99°, 238, 454†,
 623, 624, 624†, 625, 626, 640,
 642, 684-85, 685†, 687†, 690-95°,
 704-05°, 709, 713, 714, 718, 720-
 21†, 733†, 761, 841, 843, 844,
 848
Pioche Pacific Railroad, 718, 719,
 720†, 722, 727, 728, 729, 732,
 733†
Pioche Pacific Transportation Co.,
 685†, 687†, 698, 699, 701°, 702°,
 703°, 704°, 705°, 706°, 714, 718,
 901
Pioche Record, 647, 686, 697, 719
Pioche Water Works, 718
Pioneer Mine, Nevada, 514°, 516°
Pioneer, Nevada, 473°, 514°, 517†,
 535
Pioneer Quartz Mill, 815†, 816
Pioneer Saloon, 753†, 757°
Pioneer Stage Co., 2
Piper's Opera House, 139†, 139°
Pit River, Calif., 340†, 371°, 382†
Pittman, Senator Key, 502
Pittman Silver Purchase Act, 265
Pittsburg & Greenwater Copper Co.
 (H. G. Betts), 601°
Pittsburg Silver Peak Gold Mining
 Co., 293, 901
Pittsburgh Steel Car Co., 217
Pizen Switch, Nevada, 168, 214
Placerville, Calif., 2†, 430, 868
Placerville & Sacramento Valley Rail-
 road, 2†, 12
Plane, F., 52
Platt, A. T., 208
Platt, H. V., 208
Played Out mine, 613°
Pleasanton, Calif., 33
Plumas Box Factory, 402°, 408†
Plumas Branch (N-C-O), 331, 357,
 358, 397
Plumas County, Calif., 319, 344, 384
Plumas-Eureka mine, Calif., 351, 384
Plumas Jct., Calif., 340†, 355, 358,
 384†, 385, 385†, 386°, 392
Plumas National, 395
Pluth, Marcus, 822
Plymouth gas engines, 610, 742, 751,
 759, 839°, 841
Poeville, Nevada, 345†, 358

Point, The (Nevada), 718, 720†
Pollock, P. A., 106
Pony Express, 66
Pony Express, 653°
Poole, C. W., 62
Poor's Manuals, 52
Poor's ranch (Reno), 33
Porphyry Gulch, Nevada, 753, 754†
Port Arthur, Calif., 410, 412†, 413°
Porter, H. D., 534
Porter, H. D. & L. D. store, 461,
 462, 486
Porter, L. D., 526
Portland Florence mine, 491°
Portland, Ore., 359, 382
Portola, Calif., 318, 322°, 329°,
 396, 397, 398†, 400°, 406, 408
Potosi mine, 559, 753, 761†
Potosi Springs, 753
Potosi Zinc and Lead Co., 753, 755°
Pott's Chamber, 90, 93†
Potts, Mrs. E. M., 858, 858°
Poverty Hills, Calif., 200°
Powell, Calif., 860, 861†
Powell, Capt., 428
Power Plant, Nevada, 712, 713
Powning, C. C., 866
Prairie Flower Mine Co., 754†, 759
Pray, A. W., 416, 417, 418°
Prescott Scott & Co., 307
Preston, "Mother," 828, 829°
Price, H. E., 128
Price, Tom, 746
Prichitt & Dahl's claim, 53
Prince Cons. Mining & Smelting Co.,
 718, 723, 726
Prince Cons. Mining Co., 726, 728,
 730
Prince Cons. Railroad, 687†, 718-19,
 719†, 720†, 723, 724°, 726, 727,
 728, 730, 733, 733†, 901
Prince Mine, 718, 719, 719†, 723,
 724°, 726, 728
Private Cars, 54, 56, 241, 277°, 285,
 359, 379°, 580°
Proctor, Nevada, 331
Promentory, Utah, 18, 18†, 19
Promontory Point, Utah, 37
Prosser Creek, Calif., 439, 440†, 441,
 443
Prospect Mountain, Nevada, 90, 92†
Providence, Calif., 765†, 766, 770,
 843
Providence Mountains, Calif., 465†,
 766
Pugh, Lou, 80
Pump Station, Nevada, 712
Purdy, Calif. (NCO), 331, 345, 345†,
 358
Purdy, Calif. (NSRy), 843, 843†,
 845†
Purdy Creek Camp., Calif., 410
Purdy, Fanny, 842

Purdy, Warren G., 842
Putman, Charlotte, 258
Pyne, P. D., 257
Pyramid Lake ,Nevada, 40†, 40, 41,
 42°, 58

— Q —

Qualey, F. D., 313
Quartette mine, 848, 851†, 852°, 854
Quartette Mining Co. R.R., 760, 848,
 849, 849†, 850, 851†, 852°, 854,
 901
Quartz Gold Mining Co., 494
Quartzite Mountain, 860, 861†
Queen, Nevada, 172†, 175
Quicksand, 768
Quincy, Calif. 319, 322°, 344, 392
Quincy Junction, Calif., 319, 322°
Quincy Railroad, 319, 322°, 414°
Quong, Ah, 168

— R —

Rabbit Springs Canyon, Nevada, 264
Racetrack (Valley), The, 529°, 540°,
 541†, 542, 543°
Rademacher Canyon, Calif., 205
Ragtown, Calif., 441
Railroad Day, celebrations, 41, 55,
 70, 91, 116-17, 118-19°, 231,
 241, 247°, 257-8, 336, 473°, 475,
 478, 486, 489, 511, 662, 719, 850,
 851
Railroad Hotel (Daggett), 817
Railroad Pass (SNRy), 72
Railroad Pass (UP), 735, 735†
RAINER (steamer), 217
Raines (Crossing), Nevada, 91†, 107
Ralston, Nevada, 454†, 487, 505†,
 536
Ralston Desert, Nevada, 509
Ralston Valley, Nevada, 457†, 460
Ralston, William C., 136
Ramish and Marsh, 795, 796
RAMON, 592°
Ramsey, Calif., 597†, 599, 602
Rand McNally, 854
Rand Mining District, 793, 797, 798
Rand Mountains, Calif., 793, 799†
Randsburg, Calif., 462, 793, 794°,
 796, 797†, 798, 799†, 809
Randsburg Miner, 607, 797
Randsburg Railway, 793-798
Randsburg-Santa Fe Reduction Co.,
 777†, 779°, 796, 797, 828
Rasor, Calif., 548, 548†, 591
Rasor, Clarence, 546, 548, 567°
Rattlesnake Island, Calif., 662-63
Rattlesnake Mine, 539, 542
Ravendale, Calif., 356, 366°, 383
Rawhide Coalition Mine, 235
Rawhide Consolidated Mining Co.,
 229
Rawhide Grutt Mining Co., 229

Rawhide Junction, Nevada, 171†, 231, 235
Rawhide Light & Power Co., 229
Rawhide, Nevada, 169†, 229-235, 331
Rawhide Northern Mining Co., 235
Rawhide Press-Times, 231
Rawhide Queen Mine, 235
Rawhide Rustler, 229
Rawhide Townsite Co., 229
Rawhide Victory Mining Co., 229
Rawhide Western Ry., 229-235
Ray & Gila Valley R.R., 134
Ray, Colonel (toll house), 91
Ray Consolidated Copper Co., 134
Ray Flat, Nevada, 243
Ray, Judge Lorin O., 463, 466
Raymond & Ely Mining Co., 684, 685, 685†, 686, 692°, 696, 698, 699
Raymond, Wm. H. "Uncle Billy," 684, 686, 696
Real Del Monte Co. (mine), 166
Rebarb, Eugene, 261
Reconstruction Finance Corp., 285
Red Bluff Independent, 3
Red Cloud Mine, 312
Red Cut, Calif., 567°
Redlands, Calif., 627
Redlands Citrograph, 787
Redlich, Nevada, 237†, 267
Redman, C. E., 499, 502
Red Mountain, 793, 797†, 797
Red River Lumber Co., 41, 45, 62, 296°, 356, 882, 901
Red Rock, Ariz., 776, 791
Red Rock, Calif. (NCO), 353
Red Rock Canyon (Calif.), 205
Red Rock Railroad, 205
Red Top Mining Co., 258, 259, 289
Reed, Charles W., 231, 235
Reed, Ed, 171
Reed Teaming Co., 231
Reese, E. L., 312
Reese River Mining District, 66
Reese River Reveille, 70, 71, 72, 80, 84
Reese River (Valley), 72, 73, 317
Reeves, Nevada, 709, 709†, 712
Reeves, D. A., 709, 712
Reeves, D. M., 736
Regent Mining District, Nevada, 229
Reid, H. E., 868, 869, 871
Reinhart Bros.' store, 63
Reinhart, J. W., 263
Remfry, Nicholas, 687
Renard Road train, 799
Renfro, A. G., 231
Reno, 13, 14-16°, 18†, 26, 29†, 31, 33, 52, 55, 116, 137†, 156†, 157, 177, 179, 243, 317†, 324°, 331, 332†, 340†, 341-45, 345†, 348,

356-59, 359†, 360-61°, 384, 389, 392, 866-83
Reno Brewery, 867, 867†
Reno Crescent, 155
Reno Development Co., 871, 873
Reno Division (N&O), 342
Reno Electric Railway and Land Co., 866
Reno Evening Gazette, 16°, 32, 55, 178, 343, 344, 626, 867
Reno Fair Grounds, 355, 866, 867†, 877
Reno Golf & Country Club, 881
Reno Improvement Club, 410
Reno Improvement Co., 873
Reno, Jesse Lee, 13
Reno Junction, Calif., 321°, 331, 332†
Reno Mill & Lumber Co., 354, 402°, 406, 408†
Reno Power, Light and Water Co., 869
Reno streetcars, 331, 866-883
Reno Street Railway Co., 868
Reno Streets:
 Alameda St., 870†, 877
 Center St., 870†, 874°, 877
 Fourth St., 868, 869, 869†, 870†, 871, 881, 883
 Pine St., 869, 870†, 871
 Plumas St., 867†, 872, 876, 880
 Ralston St., 870†, 877, 880
 Second St., 869, 870†, 871, 872, 873, 881, 883
 Sierra St., 869, 870†, 876, 877, 880, 883
 Virginia St., 869, 870†, 871, 872, 874°, 881
 Wells Ave., 870†, 877, 880
Reno Suburban Ry., 867
Reno Traction Co., 871, 872, 873, 873†, 874°, 876, 877, 880, 881, 882-3
Reno Transit Co., 867
Reno Wheelman Club, 355, 410
Requa, Isaac, 29, 90, 100
Requa, Mark, 100, 106, 113, 114, 115, 119°, 128, 134, 238, 430
"Requa's Island," 132
Reserve Quarry, 861†, 864
Reservoir Mill, 211
Resting Springs, Calif., 593, 596†
Reveille, Nevada, 622†, 623
Revert, A. L., 411
Reward Mine, 175
Reynard, Nevada, 331
Rhodes, A. J., 341
Rhodes, Nevada, 237†, 238, 239, 240, 241, 243
Rhodes Salt Marsh, (A. J.), 177, 341
Rhyolite Board of Trade, 463, 466, 470, 478, 556, 557

Rhyolite Daily Bulletin, 520, 521, 556
Rhyolite Foundry & Machine Supply Co. (autos), 518
Rhyolite Herald, The, 456, 474, 478, 508, 510, 541
Rhyolite Light, Heat & Power Co., 486
Rhyolite, Nevada, 204, 229, 236, 261, 264, 273°, 454†, 455-57, 462, 463, 466-67, 471, 474-75, 476°, 478, 479†, 480-84°, 494, 499, 502, 517, 517†, 518, 521, 524°, 527, 534, 556, 557, 584°, 599, 604, 606, 843
Rice, George Graham, 230, 235
Rice, T., 80
Richardson Bros., 437-8
Richardson, George W., 437
Richardson, Warren, 437
Richmond Consolidated Mining Co., 90, 92-3†, 99
Richmond-Eureka Mining Co., 100, 106, 107
Rickard, George L. "Tex," 123°, 128, 229, 230, 231, 235, 260, 489
Rickey, T. B., 161, 250°, 873
Ridge & Curry Lease, 247°
Riepe, Richard, 132
Riepetown, Nevada, 125°, 133†
Right of Way Committee (Rhyolite), 466, 470, 475, 478
Riley, Tom, 211
Rink Hall, 215
River ferry, 855
River Smelting & Refining Co., 726
Riverside, Calif., 424†, 644, 791
Riverside Cement Co., 858, 860, 861†
Riverside Hotel, Reno, vi, 289, 361°, 868, 874°, 879°
Riverside Park Band, 55
Riverside Park Co., 873
Riverside Railroad Co., 867†, 873
Road building holiday, 520
Robberies, 25, 26, 204, 342, 352, 362°
Roberts, Bedford, 352
Roberts, Capt. John H., 398, 399, 406, 410
Roberts, Chat, 351, 391°, 392
Roberts Lumber Co., 402°, 406, 408†
Robertson, Alex, 78
Robins, "Curly" Dan, 238
Robinson, John (circus), 350
Robinson Canyon, Nevada, 114, 128, 131, 134
Robison, Ralph, 782°
Robison, W. H., 839°, 841
Rocco Homestake Mine, 100
Rochester, Calif., 797, 827, 827†, 831°, 832, 833°
Rochester Canyon, Nevada, 57, 57†, 58, 60°

Rochester Hills Mining Co., 57
Rochester Mines Co., 57, 58†, 59, 61°
Rochester, Nevada, 57-63, 65
Rochester, N. Y., 793
Rock drilling contests, 243, 272°, 478
ROCKET (steamer), 306, 308, 309, 310
Rock Island Mill, 146°
Rock Point Mill, 160†, 163, 210, 211, 212°
Rock Springs, Nevada, 230
Rodyville, Calif., 399
Roff's band, 349
Rogerson Branch (OSL-UP), 333-337, 332, 334
Rogerson, Idaho, 334, 334†, 336
Rogue River Valley, Ore., 343
Rooker's Ranch, 72
Roosevelt Mine, 828
Roseberry, T. A., 229
Rose Heath Fisk Co., 548
Rosenberg, Harry, 593
Roseville (Junction), Calif., 2, 2†
Rose and Palmer's Well (Rosewell), Nevada, 470
Rosenthal, S. H., 881
Rosewell, Nevada, 454†, 464†, 470, 474, 475
Ross, A. E., 353, 354
Ross, A. G., 26
Ross Hotel (Rawhide), 230
Ross, Norman, 813
Rossi, Carlo, 760
Roundhouses, enginehouses, 76, 20-23°, 24, 26, 33, 35°, 59, 110°, 150°, 279°, 325°, 368°, 395°, 418°, 522°, 726, 770, 773°, 789°
Round Mountain (Gordon), Nevada, 73, 267
Round Valley, Calif., 314
Rowan, W. L., 314
Rowson, Capt. Walter, 286
Rox, Nevada, 642, 643†, 670°
Royal City, Nevada, 687†, 698, 699
Royal Gorge, 327°, 329°
Royer, Frank, 797, 835
Ruby Hill, Nevada, 90, 91, 91†, 93†, 95°, 96°, 97°, 100
Ruby Hill Railroad, 91, 93†, 99, 100, 106, 107, 902
Ruby Lake, Mountains, Nevada, 317
Ruby mining claim, 470
Rulison, C. H., 211
Runaway cars, etc., 262, 408, 442, 569°, 586, 742, 751, 759, 760, 777, 799
Rupert, Idaho, 334, 334†
Rushton, Richard H., 240
Russell, Mrs. Amy Requa, 119
Ruth mine, 113, 118°, 133†
Ruth, Nevada, 131, 133†

Rutland, Vermont, 606
Ryan, John, 544°, 546, 610
Ryan (new), Calif., 548†, 586, 591, 608-20
Ryndon, Nevada, 29†, 32, 38
Ryan (old), Calif., 608, 609†

— S —

Sabin, Judge George M., 346, 349
Sacramento & Sierra R.R., 430
Sacramento, Calif., 2, 18, 19, 54, 235
Sacramento Southern, 231
Sacramento Northern Ry., 592°
Sacramento Valley R.R., 2†, 12
Sadler, Gov. Reinhold, 100, 627
Sadler, Henry, 719
Safety (spur) track, 52†, 243†, 262
Sagebrush Flat, Nevada, 211
Sage Hen, Calif., 355, 355†, 367°, 373°, 380°, 382, 382†
Sagehen Creek, Calif., 440†, 441
St. Elmo, Calif., 795, 797†
St. George, Utah, 684
St. Louis, Mo., 762, 763, 763†
St. Louis and San Francisco Ry., 762, 763†, 788
St. Louis Car Co., 869
St. Mary's Church, Virginia City, 139°
St. Thomas, Nevada, 624†, 643†, 661, 662, 683°
Sailors Union of the Pacific, 474
Salina, Utah, 698
Saline Valley Salt, 313
Salsberry, John, 542, 599, 602
Salt Basin, Calif., 587
Salt Lake & Ogden Railway, 84
Salt Lake & Western Railway, 72
Salt Lake City, 52, 100, 106, 116, 132, 238, 454†, 623, 624†, 625, 626, 660, 663, 676°, 709, 719, 788, 841
Salt Lake Cut-Off, 29, 48°, 49°
Salt Lake Division (SP), 210, 259
Salt Lake Mining Journal, 709
Salt Lake Route, 132, 152°, 316, 455, 457, 458°, 459°, 460, 462, 467, 470, 474, 487, 502, 503, 588, 591, 622-83, 697, 713, 718, 753, 753†, 754, 760, 761 (See also San Pedro, Los Angeles & Salt Lake R.R.)
Salt Lake, Sevier Valley & Pioche R.R., 98°, 685
Salton Sea, Calif., 734
Saltus, Calif., 837†, 839°, 841
Sammann, Louis, 308
San Antonio, Texas, 539
San Bernardino, 774, 776, 795, 844, 845
San Bernardino Air Base, 593
San Bernardino County, 762, 828
San Bernardino Mountain R.R., 861†, 864

Sanborn, Calif., 792
Sand Harbor, Nevada, 429, 429†
Sand Springs, Nevada, 230
Sandstorm Claim, 289
San Diego, 500°, 547, 763†, 774, 776, 777†, 841
San Diego & Arizona Eastern Ry., 500°, 503, 862°
San Francisco, 3, 45, 46, 316, 317†, 340†, 762, 763†, 767°, 770, 771, 774, 776, 868
San Francisco Call, 316
San Francisco Evening Bulletin, 766
San Francisco Examiner, 627
San Francisco Freight Traffic Committee, 502
San Francisco, Oakland & San Jose R.R., 580°
San Francisco-Overland Limited, 132
San Francisco Post, 346
San Francisco & Washoe R.R., Co., 12
Sanger, C. M., 816, 822
San Joaquin & Sierra Nevada R.R., 211
San Joaquin Division (SP), 210
San Joaquin Valley, 764
San Mateo, Calif., 868
San Pedro, Los Angeles & Salt Lake R.R. (SP, LA&SL), 455, 457†. 546, 627, 713, 791 (See also Salt Lake Route)
Santa Cruz, Calif., 238, 857
Santa Fe Chief, 793
Santa Fe District, Nevada, 173
Santa Fe Connecting R.R., 86, 87†, 88
Santa Fe, N. M., 763, 763†
Santa Fe Pacific R.R., 788, 791
Santa Fe Ry., 260, 261, 262, 263, 333, 536, 546, 551°, 556, 559, 591, 627, 644, 661, 762, 765, 771, 788, 796, 797, 815†, 823, 828, 837, 837†, 840, 842, 845, 849, 850, 854, 857, 860, 861†, 864-5 (See also Atchison, Topeka & Santa Fe R.R.)
Sarcobatus Flat, Nevada, 464†, 509, 517†
Sardine Valley, Calif., 398, 409, 411, 412†, 440†, 441
Satterwait, W. W., 279°
Scales, Nevada, 146°, 152°, 154°, 160†
Schaffer Opera House, 712
Schaffer, George, 437
Scheerer's siding, Calif., 860, 861†
Schmidt, F. Sommer, 113
Schmitt, Dr. Wilhelm, 354
Schoedler and Wasson, 229
Schooling, Jerry, 349
Schumacher, T. M., 89
Schurz, Nevada, 169, 169†, 171†, 230, 231, 234°, 235

Schwab, Calif., 464†, 486, 548†, 556
Schwab, Charles M., 204, 235, 241, 466, 519, 597, 599, 603
"Schwab Company", 599, 603
Schwab mines, 470
Scott, John, 211
Scotty, Death Valley, 258, 536, 556-7, 663, 792
 Castle, 536, 540*, 541†, 542, 584*, 792
Scott, J. A., 494
Scott, John, 239
Scott, Walter, 792
Scoville, Squire C., 345
Scranton, Calif., 464†, 556
Searchlight and Northern R.R., 850
Searchlight, Lloyd, 848
Searchlight, Nevada, 754, 760, 843†, 848-54
SEARCHLIGHT (steamer), 849
Searchlight Townsite Co., 850
Searles, Calif., 169†, 205, 206*, 208*, 798, 799, 799†, 802
Searles, John W., 798
Searles Lake, 796, 798, 799, 799†, 800*, 804*, 809, 814
Secret Canyon, Nevada, 53
Secrettown Trestle xvi*, 2†
Secret Valley, Calif., 354
Selby smelter, Calif., 204, 237
Selby, Thomas, 113
Selby Copper Mining & Smelting Co., 113
Sells-Floto Circus, 486
Sevenoaks, John, 709
Sexton, John E., 107, 111
Shafe-Malcolm Enterprises, 823
Shafter, Nevada, 317†, 318
Shakespeare Point, Lake Tahoe, 416†, 418*
Shanahan, "Big Jim", 660
Sharp, John, 623, 624
Sharp, Joseph, 708
Sharp, Tom, 308, 310
Sharp and Fellows, 593
Sharon, William, 90, 136, 137, 138, 154, 155, 174, 177
Shaughnessy, Com. John F., 111
Shaw, Harry, 313, 314
Shaw's Spring, Nevada, 873
Shay Quarry, 860, 861†
Shea, Charles A., 742
Shea, J. F., Co., 738
Shea, Nevada, 742
Sheldon, W. B., 36
Sherer & Co., Robt., 799
Sherman, R. P., 726
Sherraden, Jack & Vernie, 835
Short, Charlie, 872
Shoshone, Calif., 465†, 548†, 559, 587, 588, 604
Shoshone Mike, 456
Showers, Sheriff Jim, 308, 310

Siam, Calif., 766
Siberia, Calif., 765†, 766
Sides, Johnson, 179
Sidewinder mine, 857, 861†
Siding No. 31, Nevada, 645, 647
Siebert, Fred, 244*
Siebert Mountain, Nevada, 244
Siebert, R. S., 844
Sierra & Mohawk Ry., 357, 397, 903
Sierra Blanca, Texas, 763†, 764
Sierra House, Lake Tahoe, 417†, 425, 430
Sierra Iron & Quincy R.R., 385
Sierra Iron Co., 385
Sierra Nevada Wood & Lumber Co., Hobart Mills, 439-53, 891
 Incline, 425-30, 891
Sierra Railway, 312
Sierra Valley & Mohawk R.R., 318, 352, 384†, 385, 385†, 386*, 397, 903
Sierra Valley, Calif., 384, 384†, 385†, 396, 397
Sierra Valleys Ry., 321*, 354, 386*, 392, 395, 396, 397, 903
Sierraville, Calif., 385
Sierraville Summit, Calif., 440†, 441
Silver Belt Railroad (NSL), 58
Silver City, Nevada, 137†, 157, 161
Silver King mine, 815, 816, 817, 822
Silver King Mining Co., 822
Silver Lake, Calif., 467, 547, 548†, 548, 549, 559, 562-3*, 586, 660
Silver, Lowery, 815
Silver Mountain District, 816, 857, 861†
Silver Odessa mine, 816, 817, 822
Silver Party, 289
Silver Peak (T&G), 237†, 243
Silver Peak-Valcalda Mine, 298
Silver Peak, Nevada, 71, 72, 166, 172, 237†, 239, 240, 243, 292, 293, 294, 295*, 298
Silver Peak, Nevada (T&G), 237†, 243
Silver Peak Mill, 295*, 296*, 298
Silver Peak R.R., 237†, 259, 292-98, 903
Silver Star Canyon, Nevada, 243
Silver State (coach), 74*, 78
Silver Zone Pass, Nevada, 329*, 331
Simkins, William, 58
Singaste Range, Nevada, 215
Six Companies, Inc., 734-752
Six Cos. Railroad, 734, 735, 735†, 740-742, 746-748, 749-52, 903
Six Mile House, Nevada, 116
Skidoo, Calif., 462, 541†, 559
Skookum mine, 478
Slate Range, Calif., 809, 810, 811, 814
Slaughter House Canyon, Nevada, 416†, 422, 423

Slim's Adobe (Rhyolite), 475
Sloan, Nevada, 647, 679*, 761†
Smelters, etc., 57, 59, 63, 64*, 65, 90, 95, 100, 106, 113, 117, 131, 132, 134, 135*, 258, 467, 494, 542, 684, 698, 699, 723, 727
Smith, Albert, 793, 796
Smith & Owsley Bldg., 603
Smith Barney & Co., 506
Smith, Charles, 65
Smith, Ed, 377*
Smith, E. W., 244*
Smith, F. M. "Borax," 179, 260, 263, 455, 457, 460, 462, 467, 475, 544*, 545, 548, 555, 609, 816, 823
Smith, "Lying-Truthful" Bill, 753
Smithneck Canyon, Calif., 398, 399, 408, 409, 409*, 413*
Smith, Oscar J., 867
Smith-Preston murder trial, 204
Smith, Ralph L., Lumber Co., 383, 893
Smith, R. N., 351
Smith's Neck, Calif., 399
Smith, S. P., 166
Smith, T. Allie, 377*
Smith, Townsend, 704*
Smithvale, Nevada, 226
Smith Valley, Nevada, 161, 162, 226, 226*
Smith, W. Hinckle, 114, 508
Smith, White, 313
Smoot, Reed, 627
Snake River, Idaho, 71, 334
Snedaker, J. A., 134
Snow (storms, drifts), 2, 3, 4*-7*, 45, 78, 115, 128, 311, 336, 343, 350, 353, 357, 373*, 385, 396, 404*, 449*, 510
Snow Bird mine, 815†, 816, 817
Snow blockades, 13, 26, 179, 431, 699, 703*
Snow Storm Creek, Calif., 354
Snowball mine, 855
Snowbound, The, 26
Snowgoose, Dan, 229
Snowsheds, 4*, 441
Snyder, E. H., 719, 722, 726, 727
Soda Spring, Calif., 546
Soda Springs, Nevada, 172, 174, 176, 186*, 203, 256
Sodaville, Nevada, 172, 173, 180, 181, 181†, 186*, 237, 237†, 239, 240, 243, 256
Sodaville Tonopah Tel. & Tel. Co., 271*
Sommers, E., 816
Sonoma Valley Prismoidal Ry., 810

*denotes picture reference
†denotes map reference
pages 1-453 are in Volume I
pages 454-908 are in Volume II

Sonora-Baja California R.R., 592*
Sonora Pass, Calif., 312
Sooysmith & Co., 777
Southern California Railroad, 857
Southern Nevada Railway, 72
Southern Pacific Co., 29, 51, 86, 87†,
 113, 114, 116, 179, 205, 227, 238,
 239, 240, 284, 285, 287, 313, 316,
 333, 376, 396, 626, 627, 726, 734,
 869, 877, 883
Southern Pacific R.R., 71, 173, 410,
 762, 763†, 764, 765, 766, 769, 770,
 771, 774, 774†, 775*, 776, 776†,
 788, 791
Southern Ry., 240
South Ivanpah, Calif., 848
South Pacific Coast Ry., 209, 238,
 253*
South Trona, Calif., 808†
Southwestern Portland Cement Co.,
 860-64
Spanish Creek (viaduct), Calif., 321
Sparkhule Mtn., 860, 861†
Sparks, Harriman Ave., 868, 873†
Sparks, John (Gov.), 33, 54, 55, 116,
 239, 243, 317, 318, 475, 486, 866
Sparks, Nevada, 23*, 31, 33, 34-35*,
 36, 54, 55, 59, 181, 204, 231, 867,
 867†, 868, 868*, 873†, 880, 881,
 882, 883
Spear, A. A., 854
Spear's Lake, Arizona, 854, 855, 855†
Spencer, E. V. (Judge), 342, 352
Sperry, Calif., 809
Spokane, Wash., 597, 599
Sponogle's drugstore (Lewis), 80
Spooner's Summit, Nevada, 416†,
 417, 417†, 420*, 422, 423
Springdale, Nevada, 505†, 510, 514*,
 516*, 519, 520
Springfield-Nevada Mining Co., 52
Spring Garden, Calif., 318
Spring Garden Tunnel, 318
Springmeyer, H. H., 162
Springmeyer, Louis, 162
Spring Mountains, Nevada, 760, 761†
Springville, Utah, 461
Sproule, William, 45, 376
Squattersville, Nevada, 456, 481*
Squaw Summit, Calif., 782*
Squaw Valley, Calif., 417†, 430, 437
Squires, Howard W., 723, 726
Stages and stage lines (See also Auto
 stages), 2, 13, 18, 53, 78, 116,
 118*, 132, 155, 204, 230, 237, 238,
 240, 241, 243, 248*, 250*, 271*,
 306, 354, 456, 462, 686, 787
Stagg, E. H., 797, 828
Stagg P. O., Calif., 827
Stahlman, Otto, 65
Standard Bulwer mine, 303*
Standard Consolidated Mining Co.,
 306, 310, 311, 312, 313

Standard Mill (Bodie), 299*, 302*,
 303*, 312
Standard Sanitary Co., 826
Stanford, 54
Stanford, Calif., 440†, 442
Stanford, Leland, 1, 19, 25, 29
Stanwood, Calif., 436
Star Mine (Cherry Creek), 63
Star Mine (Wedekind), 32
Star Pointer Mine, 113
Star Pointer Shaft, 131, 133†
Starr (&) Grove Mine, 78, 79, 79†,
 80, 81*, 82
State Bank & Trust Co., 250*, 489
State Line Mining District (Nevada-
 Utah), 625
Stead Air Force Base, Nevada, 332
Steamboat Springs, 137†, 157, 871,
 872
Steamers, 49, 166, 359, 424, 430,
 433*, 684, 765, 772*, 849
Steam wagons, 398, 400*, 444*, 545,
 859*
Stedman, Calif., 827
Steptoe Valley Mining & Smelting
 Co., 134, 898
Steptoe Valley, Nevada, 100, 113,
 114, 117
Stevens, J. B., 113
Stevenson, Andrew, 86, 89
Stevenson, C. C., Mill, 212*
Stevenson, William L., 54, 55, 55*,
 56
Stewart, Harry, 876
Stewart, Joseph L., 334, 335
Stewart, Nevada, 161
Stewart, T. K., 871
Stewart Ranch House (Las Vegas),
 645†, 647
Stewart, Robert, 203
Stewart, Senator William, 463, 475,
 511
Stimler, Harry, 256
Stine, Marcus, 713
Stine, Nevada, 643†, 712
Stingaree Gulch, 230, 232*, 235
Stock Report, The San Francisco
 Daily, 303*
Stockton & Ione Railroad, 67
Stockton, Calif., 89, 161, 211, 316,
 317†, 882
Stoddard, "Gold Lake", 384
Stoddard, Sam, 696
Stokes, Anson Phelps, 66, 73
Stokes, J. G. Phelps, 71*, 72*, 73,
 78, 258
Stokes Tower (Castle), 72*, 73
Stone Bros., 38
Stone & Gates Crossing, Nevada, 13
Stone House, Nevada, 29†, 32
Stonewall, Nevada, 454†, 487, 494,
 539
Stove Pipe Wells Hotel, 610, 541†

Stow, Joe, 310
Streamlined train—UP, 743*, 747*,
 752
Strikes, miners & others, 79, 91, 262,
 518, 849
Strikes—railroad men, 12, 169, 262,
 487, 520, 521, 848
Strong, Wm. Barstow, 765
Sturgeon, John, 343, 345
Suckow, John K., 610
Sue mine (Calico), 817
Sugarman Iron & Metal Co., 65
Sullivan Trust Co., L. M., 230
Summit Construction Co., 54
Summit Flume Co., 417
Summit House (Plumas County),
 388*
Summit Mill (Pioche), 685†, 697,
 698, 708
Summit, Nevada (E&P), 90, 91†
Summit, Nevada (NCO), 345†, 358
Summit, Nevada (Six Cos.), 734,
 735, 735†, 736, 738
Sumpter, John, 351
Sunderland, John, 346, 347, 867
Sunland, 54, 56
Sunland District (Bishop), Calif.,
 314
Sunset Route, 770
Sunshine Mining & Development Co.,
 534
Super Chief, 793
Supreme Court—California, 353
Surprise Station, Calif., 358
Surprise Valley, Calif., 40, 40†, 331
Surveyor General (Nevada), 342,
 429
Susanville, Calif., 41, 45, 342, 348,
 352, 356
Suter, John, 827, 828
Sutor, Nevada, 646†, 647
Sutro, Nevada, 160†, 161*, 211, 213†
Swansea, Calif., 175, 175†, 200*
Swayne Lumber Co., 97*
Sweetwater (Station), Nevada, 306
Swindler, F. P., 699
Swiss American mine, 855
Switchbacks, 59, 80, 83, 310, 410,
 411, 422
Sword, Jim, 230

— T —
TAHOE, 430, 433*
Tahoe City, Calif., 425, 430, 431†,
 432-4*, 436, 437, 441
Tahoe Tavern, 430, 435, 436
Talc (mining), 209, 591
Talcott, William H., 66
Tammey, Vic, 478
"T&T all the way", 526, 536, 557
"Tarantula Pete", 544*
Taylor, Thomas, 697, 698
Tecoma, Nevada, 29†, 39

Tecopa, Calif., 548, 548†, 555, 569*, 591, 593, 595*, 596†, 843

Tecopa Consolidated Mining Co., 593, 596

Tecopa Pass, Calif., 549, 596†

Tecopa R.R. Co., 465†, 548†, 549, 555, 593-97, 904

Teel's Marsh, Nevada, 179, 545

Tehachapi Mountains, 762, 766†

Tehachapi Pass, 764, 765, 775*

Telephone claim, 722

Teller, Louis, 258, 259, 261, 506, 507, 508, 518

Teller vs. T&G, 506

Tenabo, Nevada, 70†, 91†, 337

Terminal Island, Calif., 662, 663

Termo, Calif., 340†, 354, 356, 364*, 367*

Terrace, Utah, 18†, 26, 37, 38

Territorial Enterprise, 72

Tesla (coal fields), Calif., 316

Texas & Pacific Ry., 763, 763†, 764

Texas Central R.R., 351, 356

Texum, Oregon, 382

The Dalles, Oregon, 356, 373*

"The Switch" (Battle Mountain), 80

Thibault, Pat, 442

Third Creek, Nevada, 429, 429†

Thirty-fifth Parallel Trans-Cont. Line, 769

Thisbee, Nevada, 50†, 51

Thomas Creek, Oregon, 376

Thomas, Frederick, 113

Thomas, Hues, 815

Thomas, J. M., 54

Thompson, Geo. C. Construction Co., 719

Thompson (smelter), Nevada, 216, 218*, 226, 227

Thompson, William B., 216, 318

Thorn, Senator Frank, 239

Thorne, Nevada, 171†, 204

Thorp's Wells, Nevada, 539, 542

"Thousand failures, camp of", 235

Three-Way Jct., Nevada, 735, 742, 746

Thurman, Camp (Nev.), 854

Tiburon, Calif., 500*

Tiby, Benjamin T., 226

Tichnor, H. C., 309

Tick Canyon, Calif., 827

Tie Canyon, Calif., 536, 540*

Tier, Andy, 564*, 569*

"Tiger Lil", 588

Tilden, Augustus J., 235

Tillamook Bay, Oregon, 436

Tilton, Edward G., 238, 646

Timetables, 71, 99, 154, 208, 255, 510, 518, 589, 609, 687, 802

Tinemaha Reservoir, 175†, 209

Tintic, Utah, 132

Tippets, J. A., 730

Titanic, 264, 499

Titlow, R. S., 285

Toano, Nevada, 18†, 26, 32, 38

Tobey, W. S., 430

Tobin, W. J., 535

Toland Bros., 506

Toledo, Peoria & Western, 351

Tom, Calif., 209

Tomas, Utah, 643†, 661

Tombstone Epitaph, 816, 817

Tonopah, vi, 73, 84, 100, 179, 180, 181, 203, 204, 236, 237, 237†, 238, 239, 242†, 243, 244*, 256, 257, 258, 260, 261, 267, 277*, 454†, 455, 457, 457†, 464†, 486, 547, 548

Tonopah Belmont Development Co., 243†, 250, 251*, 264

Tonopah and Goldfield Auto Co., 457

Tonopah and Goldfield R.R., 86, 87†, 88, 203, 209, 231, 236-88, 312, 314, 455, 471, 486, 487, 489, 502, 507, 520, 521, 526, 527, 591, 828, 904-05

Tonopah & Greenwater R.R., 555, 570, 603-4

Tonopah & Manhattan Stage Line, 248*

Tonopah & Tidewater Co., 499, 526, 557, 558†

Tonopah & Tidewater R.R., 86, 87†, 88, 231, 260, 455, 460, 461, 462, 463, 467, 470, 498, 499, 509, 520, 522*, 526, 535-36, 544-93, 602, 603, 609, 610, 660, 751, 828, 829*, 905

Tonopah Army Air Base, 286, 287

Tonopah Banking Corp., 250, 285

Tonopah Bonanza, 238

Tonopah Club, 289

Tonopah-Divide District, Nevada, 265

Tonopah-Divide Mercantile Co., 265

Tonopah-Divide Stock Exchange, 535

Tonopah Dramatic Club, 243

Tonopah Express, 45

Tonopah Extension Mining Co., 284

Tonopah Goldfield Bullfrog (BGRR), 532*

Tonopah-Goldfield stage, 536

Tonopah-Goldfield Trust Co., 462, 466

Tonopah Jct., Nevada, 169†, 180, 181, 181†, 202, 203, 209, 237†, 239, 240, 313

Tonopah Lumber Co., 411, 599

Tonopah Mine Operators Assn., 535

Tonopah Mining Co., 237, 238, 240, 244*, 248*, 257, 258, 259, 263, 284, 285, 506, 507, 542

Tonopah R.R., 160, 180, 181†, 202, 236-56, 257, 258, 260, 359, 454†, 464†, 904

Toole, Utah, 729

Topock, Arizona, 777, 786*, 786†, 790*, 791

Tornado, 722

Toronto, Hamilton & Buffalo Ry., 796

Torpey, F. T., 230

Total Wreck (Burcham) mine, 822

Totten Mill, 384†, 395, 397

Towle Brothers (lumber), 211

Townsend, Capt. J. W. E. ("Lying Jim"), 307

Traction engines, 398, 400*, 444*, 545, 859*

Tramps Consolidated mine, 204, 478, 499, 511, 517†, 519, 534

Tramp No. 1 mining claim, 470

Tramways—aerial, 39, 62, 175, 175†, 203, 227, 294, 303*, 307, 312, 442, 542, 695, 722, 727, 732, 753

Tramways—surface, 52†, 53, 59, 62, 163, 175, 644, 713, 723, 727, 753, 817, 820*, 823

Track laying machines, 321*, 468*, 476*

Transvaal Extension Mining Co., 470

Transvaal, Nevada, 467

Treadwell Yukon Co. Ltd., 242†, 285

Treasure City, Nevada, 622†, 623

Treasure Hill, Pioche, 685†, 705*, 720†, 722, 727

Treat, J. D., 33*

Tripp, Alonzo, 240, 241, 243, 247*, 256, 258, 259, 264

Tripp Pit, 125, 133†

Trona, Calif., 798, 799†, 802, 804*

Trona Ry., 798-808, 809, 810, 906

Trout Creek, Lake Tahoe, 417†, 425

TRUCKEE (Lake steamer), 424

TRUCKEE (Ocean steamer), 436

Truckee-Carson irrigation project, 38

Truckee (Coburn's), 3, 6*, 7*, 18, 26, 181, 352, 385, 410, 417†, 428, 430, 431, 435*, 436, 439, 440†, 441, 442, 443, 868

Truckee Lumber Co., 436-437, 410, 422, 430, 431, 891

Truckee Meadows, Nevada, 2

Truckee River (Canyon), 3, 8-11*, 13, 17*, 136, 155, 156†, 157, 398, 399, 410, 411†, 415*, 430, 436, 437, 866, 867†, 869, 870†, 873, 879*, 883*

Truett Lease (mine), 230

Truitt Mill, 235

Trumbo, Andrew J., 542

Tucson, 56

Tule (Canyon) District, Nevada, 176, 539

Tunnels, 3, 41, 45, 46, 128, 131, 137, 138-39†, 139*, 149*, 159, 173, 318, 319, 331, 422, 428, 429†, 624, 627, 647, 661, 673*, 674*, 738, 739*, 855, 871

Turner Bros., 406
Turner, Oscar A., 506
Turner, William Jay, 240, 258
Turntables, 7*, 25*, 103*, 110*, 200*, 279*, 687, 766, 770
Tuscarora, Nevada, 65, 78
Tuttle, Nevada, 29†, 39
Tuttle, R. H., 851
Twain, Mark, 299
Twelve Mile Canyon, Nevada, 19
Twenty-mule Teams, 545
Twin Falls, Idaho, 334, 334†, 335
Twin Peaks, Calif., 424
Tybo, Nevada, 238, 267, 284, 285

— U —
Ubehebe, Calif., 529*, 541†, 542, 543, 543*, 599
Ubehebe Copper Mines & Smelter Co., 540*, 542, 543*
Ubehebe Crater, Calif., 175†, 541†, 542
Ubehebe Peak, Calif., 175†, 541†, 542
Ubehebe Townsite Co., 542
Umbria Jct., Utah, 36
Union Ice Co., 400*
Union Mill Co., 163
Union Mill & Mining Co., 136
Union mine, 139†, 139*, 142*
Union Pacific, 2, 12, 19, 52, 72, 152*, 178, 316, 335, 336, 359, 455, 460, 536, 662, 663, 726, 728, 730, 734, 735†, 736, 738, 743, 751, 752; See also: Oregon Short Line, 333-37; Salt Lake Route, 622-83, 760; Pioche, 684-733; Six Companies, Inc., 734-52
Union Pacific (film), 668*
Union Pacific Railway, 622†,
Union Saloon, 53
Union Trust Co., 349
United Comstock Merger Mine (mill), 146*, 161
United Eastern mine, 855†, 857
United Greenwater Copper Mining Co., 603
United Verde Copper Co., 134, 463, 835
University of Nevada, 867†, 876, 880
Upper Narrows, 860, 861†
Upper Rochester, 57
Upper Truckee River, Calif., 422
U. S. Air Force, 864, 908
U. S. Army, 908
U. S. Borax & Chemical Corp., 621*
U. S. Bureau of Reclamation, 734, 738, 908
U. S. Government Construction R.R., 734, 735†, 738-40, 749, 750†, 752
U. S. Gypsum Co., 337, 760, 836*, 840, 900
U. S. Land Office, 626, 627, 640

U. S. Navy, 209, 908
U. S. Navy Ammunition Depot, 205, 908
U. S. Railroad Administration, 265, 502, 534, 586
U. S. Smelting, Refining & Mining Co., 100, 106
U. S. Supreme Court, 45, 90, 349
U. S. Transportation Corps, 282*
Utah and California R.R. (U&CRR), 626, 627, 640-1
Utah and Pacific R.R., 625, 626, 640
Utah Central Ry., 623, 628*
Utah Coal Route, 701*
Utah Construction Co., 41, 58, 115, 319, 336, 382, 644, 661, 738
Utah Copper Co., 134
Utah, Nevada & California R.R., 626, 627, 640, 643
Utah Nevada Co., 844
Utah Parks Co. (buses), 611
Utah Southern R.R. (Extension), 623, 628*, 843
Utah Western Ry., 628*
Uvada Copper Co., 722, 727
Uvada, Utah, 625-6, 627, 640, 642, 643†, 648*, 661

— V —
Vahrenkamp, Fred H., 478, 541
Vail, E. A., 84
Vallejo Jct., Calif., 556
Valley, Nevada, 761, 761†
Valley View Claim, 243†, 277*
Valley Wells, Calif., 465†, 845
Vanderbilt, Calif., 842, 843, 843†, 844, 845, 845†, 847*
Vanderbilt interests, 796
Vanderbilt Shaft, 843, 844
Van Dyke, E. D., 534
Van Etten, Edgar, 797
Van Loan's stages, 354, 355
Van Sweringen Bros., 89
Verdi Lumber Co., 242†, 408, 410-15, 440†, 441, 881, 906
Verdi Mill Co., 410
Verdi, Nevada, 13, 25, 159, 398, 399, 409, 410-412
Verdi Scenic Railway, 410
Verzan, John, 131
Veteran, Nevada, 112†, 128†, 131, 132
Veteran Pit, 125*, 133†
Victor Cement, 861
Victor Shaft, 287
Victor Valley News-Herald, 860
Victorville, Calif., 674*, 857, 860, 861†, 864
Villard, Henry, 71
Vinton, Calif., 384†, 385†, 389, 392, 395, 397
Virginia & Truckee River Rail Road Co., 136

Virginia & Truckee R.R., 31, 33, 86, 87†, 88, 90, 136-62, 163, 166, 176, 177, 179, 180, 181, 319, 341, 342, 349, 350, 486, 669*, 872, 906-07
Virginia & Truckee Ry., 161
Virginia, Carson & Truckee Railroad Co., 136, 155
Virginia Chronicle, 258
Virginia City, 2†, 3, 12, 13, 19, 25, 90, 136, 137, 137†, 138-9†, 139-45*, 154, 155, 157, 161, 162, 163, 210, 342, 346, 352, 428
Virginia City and Gold Hill Water Co., 425, 428
Virginia Louise Development Co., 723
Virginia Louise mine, 719†, 720†, 722, 723, 724*, 726
Virginia Louise Mining Co., 723
Virginia Stage, 168
Virgin River (Nevada-Utah), 622†, 661
Vivian mine, 855, 855†, 856
Von Gorp, Ltd., 29
vonRichthofen, Baron, 385
Vulcan, Nevada, 132

— W —
Wabash Ry., 86
Wabuska, Nevada, 161, 168, 169, 169†, 177, 179, 214, 215, 215†, 216, 217, 218*, 227, 228, 256
Wadsworth Electric Light & Power Co., 53
Wadsworth, Nevada, 13, 18, 18†, 20-23*, 26, 33, 34, 36, 38, 50†, 51, 54, 240, 317, 341, 866
Wages — railroad men, 169, 487, 534, 642, 751, 881
Wagner, Nevada, 454†, 487
Wagontown, Idaho, 712
Walker and Hovey, 282*, 383
Walker Copper Mine, Calif., 409
Walker, E. H., 883
Walker Lake, Nevada, 166, 169, 169†, 171, 171†, 174, 180
Walker Lake Tribune, 239
Walker Mill Jct., 40
 Also see Westwood Jct.
Walker River Indian Reservation, 166
Walker River, (Nevada-Calif.), 169, 214, 215, 226, 342
Walker, T. B., 41
Wall Ranch, Mary, 8*, 33
Wall Street Canyon, Calif., 815, 815†, 817, 818*, 822, 823
Walstrom, Lee, 883
Walters, Nevada, 70, 70†, 71*
Ward Creek, Calif., 417†, 430, 431, 431†, 437
Warden, S. C., 815
Ward, Neil, 173
Ward, Nevada, 106

Warm Springs, Calif., 309, 310, 311, 312, 313
Warner Mountains, Calif., 358
Warner, "Slim," 532*
Warren & Co., 38
Warren, Ann M., 54
Warren, Tom, 80
Washington Creek, Calif., 436
Washoe County Bank, 62
Washoe County Court House, 879*
Washoe County Traction Co., 867, 868
Washoe Summit, Nevada, 342
Washoe Valley, Nevada, 136, 137
Washout, Nevada, 178
Washouts, 178, 243, 256, 385, 411, 494, 647, 649*, 657*, 660-61, 670*, 672*, 738, 752, 776, 777, 792, 849, 854, 857
Wash Post Office, Calif., 396
Wasson and Schaedler, 229
Wasson Meadows, Calif., 312
Water, domestic, 171, 205, 229, 602, 770, 787, 793, 840
Waterloo Mill, 820*
Waterloo mine, 815†, 817, 822
Waterloo Mining Co., 815†, 818*, 822, 826, 855
Waterman, Calif., 765, 766, 777†, 816
Waterman, Robt. W., 765, 815
Wattis, Supt. W. H., 115
Waverly, Calif., 340†, 382
Webb and Wren, 795
Webber Lake, Calif., 440†, 443
Webster, Judge, 350
Wedekind, George, 32
Wellington, Nevada, 161
Wells Fargo, 26, 91, 181, 192*, 204, 230, 238, 271*, 306, 389, 576*
Wells, Mrs. R. E., 646
Wells, Nevada, 18†, 19,, 29†, 32, 40, 100, 113, 114, 317†, 328*, 332, 333, 334†, 335, 335†, 336, 337, 714
Wells, R. E., 646
Wells Opera House, 337
Wendel, Calif., 363*, 376, 379* (also see de Wendel)
Wendel Cash Grocery, 363*
Wendover, Utah, 317†, 324*, 328*, 337
Weske, Richard, 336
Weso, Nevada, 332, 332†, 333
West Calico District, 817
Westend, Calif., 799†, 802, 804, 808, 808†
Westend Chemical Co., 804*
Western Federation of Miners, 520
Western Gypsum Co., 226
Western Mineral Co. R.R., 815†, 826
Western Nevada Electric Ry., 873
Western Nevada Railroad Co., 341

Western Ore Purchasing Co., 167*
Western Pacific Hotel (Clio, Calif.), 395*
Western Pacific R.R., 331
Western Pacific Ry., 40, 41, 73, 88, 89, 101†, 205, 227, 316-33, 345, 356, 358, 374*, 376, 396, 397
West, J. H., 854
West Point, Pioche, 698, 699
Westwood, Calif., 40†, 40, 62, 332†, 356, 882
Westwood Jct., Calif., 40†, 41
Wheeler, Frank, 53
Wheeler, Jim, 726, 728
Wheeler, Judge E. D., 344, 346
Wheeler Monument, 685†
Wheeler, S. H., 868, 877
Whiskey Flat, Nevada, 171†, 312, 313
White, C. A., 287
White Caps mine, 298
White, Harsha, 544*, 547
White Mountains, Calif., 314
White Pine Copper Co., 113
White Pine News, 115, 116, 708
White Plains Hill, Nevada, 31, 51
White Star Plaster Co., 761
White Star Plaster Mill, 662
Whitfield, J. B., 815
Whittell, George, 107
Whittemore, Charles O., 463, 466, 467 478, 487, 534, 627, 640, 642, 647
Widow mine, 609, 609†, 610, 619*
Wilbur, Ray Lyman, 736
Wildasinn, C. F., 313
Wieland's Park, 880
Williams, J. P., 542
Willow Creek, Calif. (T&T), 586
Willow Creek (Viaduct), Calif., 321, 322*, 396
Willow Ranch, Calif., 340†, 371*, 382†, 383
Wilmington, Calif., 811, 814
Wilson's (Billy) Stage, 155
Wilson Canyon, Nevada, 214, 215†, 216, 217, 222*, 226, 228
Wilson, Frank, 709, 712
Wilson, J. E., 215
Wilson, J. I., 228
Wilson, Lt. Noel, 287
Wilson, Uncle Billy, 217
Wilson, Woodrow, 502
Wingate Pass, Calif., 809, 809†, 810, 811
Wingate Wash, Calif., 809, 809†
Wingfield, George, 57, 227, 288, 289, 306
Winnemucca, 18, 18†, 19, 26, 27*, 29†, 63†, 63, 319, 327*, 332†, 333, 337
Withington, J. P., 90
Wonder, Nevada, 230, 331

Woodbridge, Calif., 211
Woodbridge Company, 73
Woodbury, E. R., 844
Woodbury, R. W., 844
Wood, lumber, etc., 18, 298, 307, 309, 310, 311, 319, 348, 350, 351, 392, 398, 410-15, 416-53
Wood, "Red," 38
Woods, Gov. George L., 341, 342, 343, 344
Woods, Lafayette, 641
Wood Yard, Nevada, 293†, 298
Workman, William, 625
Wrecks, 191, 390*, 520, 559, 569*, 586, 647, 657*, 659*, 787
Wright, Andy, 84
Wright, Thomas, 808, 809, 810

— Y —

Yankee Girl Mine, 467
Yates, Bernard, 286, 287
Yellow Aster mine, 793, 794*, 796, 797†, 908
Yellowstone Bar (Rawhide), 232*
Yellow Pine Mining Co. R.R., 753-759, 908
Yellow Pine mine, 753, 753†, 754, 754†, 758*, 759, 761†, 842, 844, 854
Yerington, H. M., 137, 138, 155*, 161, 166, 168, 178, 179, 214, 307, 341
Yerington Jct., Nevada, 228
Yerington Mountain Mining Co., 65
Yerington, Nevada, 39, 168, 169†, 214, 215, 215†, 216, 222*, 227, 228, 230
Yerington Times, 214, 216, 217, 226, 228
Yermo, Calif., 682*
Young, Brigham, 684
Young, Supt. Joe, 640, 641
Yount, S. E., 753
Yuba Consolidated Mining & Reduction Co., 698, 699, 708
Yuba Dike, 727
Yuba River, Calif., 385
Yucca, Ariz., 769
Yuma, Ariz., 763†, 764, 770

— Z —

Zabriskie, Calif., 548†, 555, 570*, 588, 603
Zabriskie, Chris. B., 179, 526, 555
Zenda Gold Mining Co., 822
Zenoiba, Nevada, 45
Zepherette, 329*
Zerbino, 258

*denotes picture reference
†denotes map reference
pages 1-453 are in Volume I
pages 454-908 are in Volume II